THE COLOR
ENCYCLOPEDIA
OF
WORLD ART

Degas, *Dancer*, bronze, Louvre, Paris.

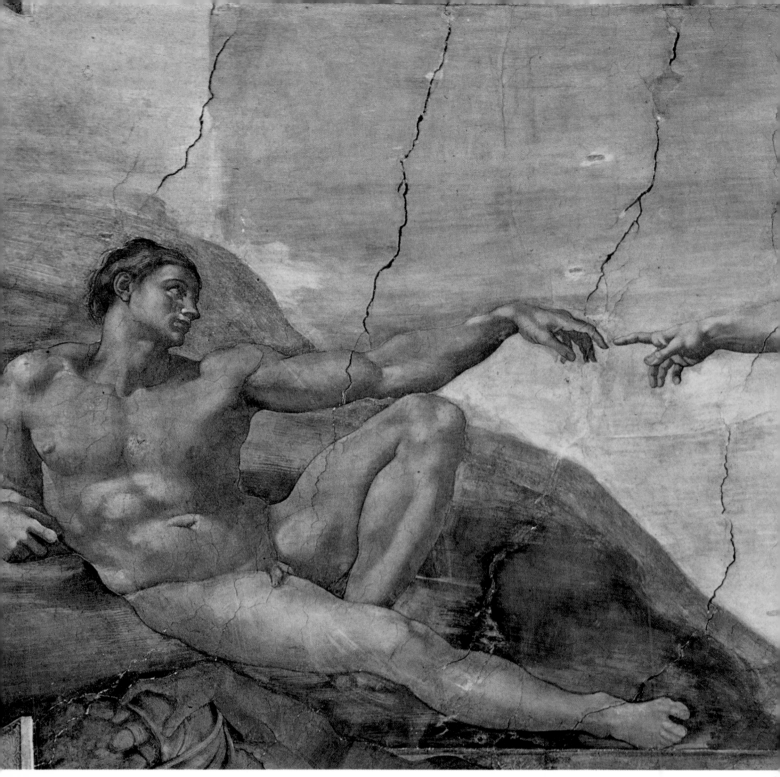

Michelangelo, *The Creation of Adam*,
Sistine Chapel, St. Peter's, Vatican.

THE COLOR
ENCYCLOPEDIA

OF ART
WORLD

by JAY JACOBS

CROWN PUBLISHERS, INC · NEW YORK

ACKNOWLEDGMENT

The author is deeply indebted to the McGraw-Hill Book Co. for permission to use the spelling of individual names and place names, as well as birth and death dates of artists, as they appear in the modestly titled five-volume *McGraw-Hill Dictionary of Art*, edited by Dr. Bernard S. Myers, to my mind an admirable example for other comprehensive reference sets to follow. In the arcane and sometimes cobwebby annals of the art world, where a name like Niccolo Dell'Abbate is spelled half a dozen different ways in as many reference works, with equal variations of dates, McGraw-Hill's encyclopedic and highly readable work is a model of clarity and consistency.

THE PUBLISHERS

Picture credits: Mondadori (pp. 1, 10, 13a, 13b, 14a, 14b, 15a, 17, 21, 22, 25, 29, 31, 37, 38, 40a, 40b, 41, 42, 45b, 48, 52, 54, 55, 57, 58, 67, 70, 72, 75, 77, 79, 80, 82, 90, 93, 94, 102, 106, 107a, 109, 110, 112, 113, 116l, 117, 118b, 120, 126, 128, 130, 131, 133, 134, 139a, 142a, 144a, 148, 159, 160, 169, 171, 172, 174a, 176, 179, 182, 185, 191, 192, 199l, 199r, 211, 213, 215b, 217, 229, 230, 233, 246, 251, 252, 272, 282a, 286, 288, 290, 299a, 299b, 300, 303, 310, b&w 314–20); Kodansha Ltd. Tokyo (pp. 2–3, 16, 30, 39, 43, 51, 53, 59, 63, 69a, 71, 95, 96, 98, 105, 118a, 127, 129, 135, 137, 140, 145, 153, 155, 174b, 175, 181, 188, 223, 225, 234, 237, 238, 240a, 240b, 241, 242, 244a, 248, 253, 278, 279, 280, 283, 291, 293, 295, 297, 298, 305, 307, 311a); Held (pp. 5, 89, 92, 136, 183, 193, 205, 231, 244b, 245, 260, 269, 287, 289); Giraudon (pp. 7, 60, 61, 73, 85, 99, 103a, 107b, 108, 122, 144b, 147, 150, 158, 161, 167, 170, 173, 189, 194, 203, 207, 208, 209, 210, 212, 226, 243, 261, 265, 266, 282b, 302); Scala (pp. 8, 15b, 32, 47b, 103b, 123, 216, 236, 256–57); Vineyard Books (pp. 9, 56a, 69b, 86, 97, 138b, 141a, 141b, 152a, 157a, 162, 177, 178, 268, 304); Paul Popper, London (p. 11a); Madanjeet Singh, New Delhi (p. 11b); Metropolitan Museum of Art, New York (pp. 12, 47a, 78, 116r, 149, 254); Bevilacqua (pp. 18, 197, 249a); Darmstadt Museum (p. 19a); Desiré Daniel (p. 19b); Ridge Press (p. 20); Marlborough Fine Art, London (p. 23); Brompton Studio, London (p. 24, 34, 259); National Gallery of Scotland, Edinburgh (p. 27); Bayerische Staatsgemäldesammlungen, Munich (p. 28); Museum of Modern Art, New York (pp. 35, 215a, 227ar, 227b, 228, 274); Tate Gallery, London (pp. 36, 157b); Hans Hinz (p. 44); Hamlyn (pp. 45a, 285); Mella (pp. 46, 88, 124, 220, 262); Mercurio (pp. 50, 115, 163a, 163b, 195, 232, 308); National Gallery, Washington (p. 56b); Freer Gallery, Washington (p. 62); Giacomelli, Venice (p. 64); Mas, Barcelona (p. 65); Wadsworth Atheneum, Hartford, Conn. (p. 81); José Pierre, Paris (pp. 87, 132); Philadelphia Museum of Art (pp. 91, 164, 222); Gal. André François Petit, Paris (p. 100); Garanger (pp. 104, 186, 227al, 250); Goldner (p. 114); Walter Mori (p. 119); Art Institute, Chicago (pp. 138a, 263); Jean Willemin, Paris (pp. 139b, 152b, 311b); A. Kempter, Bavaria Verlag (pp. 142b, 156); Fototeca ASAC, Biennale, Venice (p. 143); Coll. Lord Iveagh, London (p. 146); Museum of Fine Arts, Boston (p. 151); Georges Fall (p. 165); Hudson's Bay Co., London (p. 166); Brooklyn Museum, New York (p. 184); Davisson Coll., Westwood, Mass. (p. 187); Romor Film (pp. 200–1); Galerie Maeght, Paris (p. 204); Peter Grunert, Zurich (p. 206); Imperial War Museum, London (p. 214); John G. Powers Coll., Aspen, Col. (p. 218); Lehman Coll., New York—Giraudon (p. 243); Olivier Garros (p. 247); Geoffrey Clements, New York (pp. 249b, 271); TWA (p. 255); Detroit Institute of Art (p. 267); Enrique Franco Torrijos (p. 273); Fotochronika Tass (p. 275); Marzari (p. 277); National Gallery, London (p. 292); Hedrich-Blessing, Chicago (p. 309); H. Josse (p. 313)

© S.P.A.D.E.M. – A.D.A.G.P., Paris 1975

If any oversight in the credits has occurred, the author and publisher extend their sincere apologies.

Published by
CROWN PUBLISHERS, INC.

An original work created and produced by
VINEYARD BOOKS, INC.
159 East 64th Street
New York, N.Y. 10021

Library of Congress Catalogue Card Number: 75-4067
ISBN: 0-517-52208X

Illustrations copyright: © 1975 Arnoldo Mondadori Editore S.p.A.

All Rights Reserved.

Printed in Italy by Arnoldo Mondadori Editore, S.p.A.

Library of Congress Cataloging in Publication Data

Jacobs, Jay.
 The color encyclopedia of world art.

 1. Art—Dictionaries. I. Title.
N31.J32 703 75-4067
ISBN 0-517-52208-X

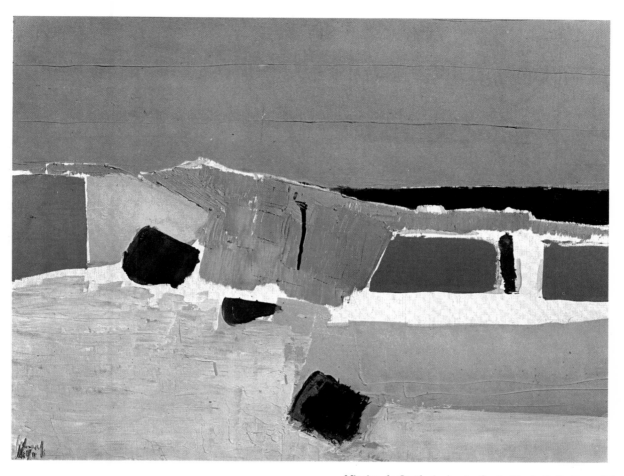

Nicolas de Staël, *Agrigente,* Sonja Henie Collection, Oslo.

Preface

Although I have tried within the limitations of the format to make this the most comprehensive, accurate and useful book of its kind, it was designed as and essentially remains a book for the broadly interested layman, not the scholar or specialist. Insofar as has been practicable, the aim has been to include essential information and to exclude material of a speculative, uncertain or irrevelant nature. Biographical data has been minimized, except when the events of a particular artist's life clearly and directly affected the nature of his work or constitute his chief claim to attention. Such time-honored but meaningless constructions as "he traveled to Rome, where he met Michelangelo" have been excluded wherever it has been impossible to ascertain that such a meeting was of artistic importance.

Whenever a text as wide-ranging as this is the product of a single hand, it would be ridiculous to pretend that it is to any significant extent a work of primary scholarship and original research. Where scores of relatively

obscure artists are concerned, I have consulted numerous standard reference works, attempting to collate often variant and contradictory information and opinion and to reflect a reasonable consensus. In many cases I have let my eye be my guide, freely asserting the existence of obvious influences or derivations, even in cases where no documentation for such assertions—other than visual evidence—could be found. In the matter of dating, conflicting information has been reconciled—except in cases where conflicting dates vary significantly—by choosing a reasonable compromise and adding the qualifier "circa."

Except where clearly identifiable and localized schools of art are concerned, no attempt has been made to survey art geographically for two reasons. For one, such categories as "French art," "Italian art" and the like are so inclusive as to be meaningless and usually presuppose continuing native characteristics and a state of aesthetic quarantine that seldom in fact exist. Also, to treat in any meaningful way such categories as *do* make sense would necessitate the inclusion of articles of prohibitive length in a volume designed to be concise and portable.

To attempt to present the entire spectrum of world art with complete fairness and objectivity from a particular locus in time and space is, I'm afraid, an impossibility. If some contemporary artists seem to have been given more or less attention than the ultimate perspective of history may accord them, it is because they seem either more significant or more representative at this time than they may at a later date. If others, including personal friends, have been omitted, it is because I have tried to suppress my personal enthusiasms in favor of more widespread or demonstrably durable acceptance.

Finally, great stress has been laid on master-pupil relationships and artistic influences in general, chiefly because art is not created in cultural vacuums but almost invariably springs from previous—and in turn shapes subsequent—art.

—J.J.

THE COLOR
ENCYCLOPEDIA
OF
WORLD ART

Henri Matisse, *Intérieur aux Aubergines*, Grenoble Museum.

Niccolo Dell' Abbate, *Matteo Maria Boiardo Writes L'Orlando in Love,* Pinacoteca, Modena.

A

AA, VAN DER, FAMILIES. Two probably related families of Dutch 17th- and 18th-century printmakers, sculptors, painters and illustrators, one centered in Leyden, the other in The Hague. Dirk Van Der Aa (1731–1809), of The Hague, was a noted TROMPE L'OEIL painter.

AACHEN: CATHEDRAL (Cathedral of Aix-la-Chapelle). Palatine chapel built for Charlemagne between ca. 790 and 805 (the latter date being the year of its designation as a cathedral), extensively rebuilt in the late 10th century and restored in 1881. The original chapel, burial place of Charlemagne and coronation site for later German kings, is considered the finest extant example of CAROLINGIAN architecture. Additions of the GOTHIC and later eras include a cupola, a spacious choir, several chapels and a slate-covered steeple.

AACHEN, HANS VON (1552–1615). German painter who, after studies in Italy, was named court painter to Rudolph II at Prague. Best known for his portraits and lively mannerist mythological scenes.

AALTO, ALVAR (1899–). Finnish architect, designer and urban planner. Noted for adapting Finnish traditions to modern international techniques, for his plywood furniture and for such structures as the Baker House Dormitory, Cambridge, Massachusetts (1948), and the House of Culture, Helsinki (1958).

ABBATE, NICCOLO DELL' (ca. 1510–1571). Italian muralist noted for his illustrations of *The Aeneid, Orlando Furioso*, etc., and for such genre scenes as his frescoes of drinkers and card players at the University of Bologna.

ACHILLES PAINTER, THE (fl. ca. 450–425 B.C.). Attic vase painter noted for the restrained color he applied to white grounds.

ADAM, ALBRECHT (1786–1862), **AND FAMILY**. Bavarian painter of battle scenes and horses; and his painter-sons Benno, Franz and Eugen.

ADAM, LAMBERT SIGISBERT (1670–1747). French sculptor. Son and student of Jacob Adam and brother of Nicolas Sébastien and François Balthasar Gaspard Adam, all sculptors, he was influenced by BERNINI and known for such groups as his *Triumph of Neptune and Amphitrite*, Versailles.

ADAM, ROBERT (1728–1792). One of four architect sons of the Scottish architect William Adam. His studies in Italy preceded his appointment as Royal Architect (1761–1768) and his later emergence as a pioneer of the NEOCLASSIC STYLE and developer of the urban row house. Such Adam interiors as that of Home House, London, are notable for the simplicity with which antique and BAROQUE forms and motifs were handled.

ADLER, DANKMAR (1844–1900). German-born U.S. architect, architectural writer and partner (1881–1895) of LOUIS SULLIVAN.

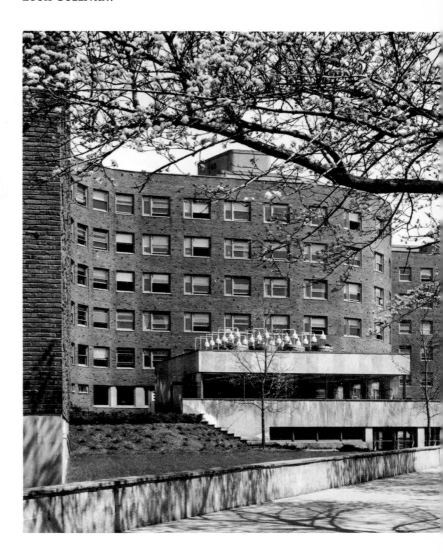

Alvar Aalto, Baker House Dormitory, M.I.T. Historical Collections, Cambridge, Massachusetts.

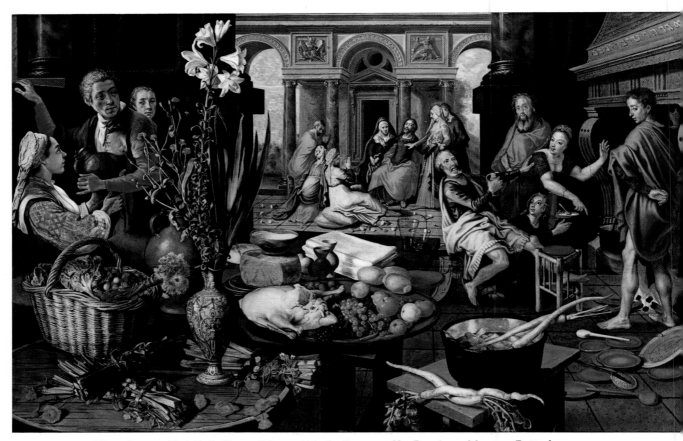

Pieter Aertsen, *Christ in the House of Mary and Martha,* Boymans-Van Beuningen Museum, Rotterdam.

ADRIANSSEN, ALEXANDER (1587–1661). Flemish still-life painter celebrated for the purity of his color.

AEGINA: TEMPLE OF APHAIA. DORIC structure built ca. 490 B.C. and originally embellished with unusually fine pedimental sculptures (now in Munich). Damaged by an earthquake some ten years after its completion, necessitating installation of a new pediment on its eastern end, which, taken with the original pediment opposite, embodies the transition between late archaic and early classical architecture.

AEKEN, HIERONYMUS VAN. See **BOSCH, HIERONYMUS.**

AERTSEN, PIETER (ca. 1508–1575). Netherlandish history and GENRE painter who worked in his native Amsterdam and, for some twenty years, in Antwerp. Although not a still-life painter per se, he is considered a forerunner of the great Netherlandish still-life tradition because of his prominent use of still-life elements in genre and religious scenes. His pupils included his sons Aert Pietersz and Pieter Pietersz Aertsen and his nephew Joachim Beuckelaer.

AFRO (Afro Basaldella) (1912–). Italian abstract painter and muralist known for his warm, vibrant color and his rejection, during the 1950s, of aesthetic theory in favor of "instinct."

AGAM, YAACOV (1928–). Israeli painter who lives and works in France. His characteristic, severely geometric polychrome constructions "change" with shifts in the onlooker's viewpoint and bear a tenuous relationship to OP ART and KINETIC ART.

AGOSTINO DI DUCCIO (1418–ca. 1481). Florentine sculptor and architect known for the rhythmic linearity of his relief scenes at Modena and Rimini and for his façade of S. Bernadino, Perugia. Ironically, one of his aborted projects provided the raw marble from which MICHELANGELO, an altogether different sort of artist, was to carve his *David.*

AHMEDABAD: JAMI MASJID. Mosque completed in 1423 and an outstanding example of western Indian Moslem architecture. It is unusually large and splendidly decorated in a style much influenced by Hindu architecture.

AIX-LA-CHAPELLE, CATHEDRAL OF. See **AACHEN: CATHEDRAL.**

AJANTA: "CAVE" PAINTINGS. A cycle of religious wall paintings adorning a number of shrines or "caves" cut into a cliff in the Ajanta Range in Maharashtra State, India. Executed between the 2nd or 1st century B.C. and ca. A.D. 700, they are considered perhaps the finest examples of Gupta paintings in existence.

Jami Masjid, Ahmedabad.

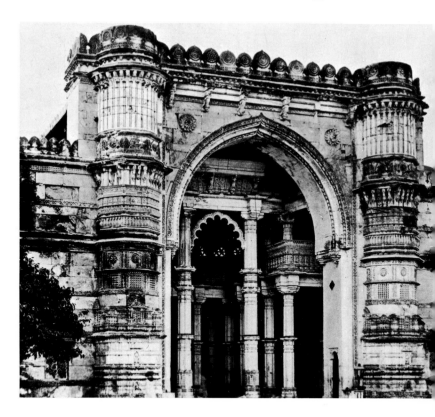

AKKADIAN RULER, THE. Name given to a portrait head found at Nineveh and now in Baghdad. Possibly meant to represent Sargon (ca. 2340 B.C.), it is of cast bronze, and if it was indeed made in the early Akkad dynasty (of which Sargon was the first king), it represents a striking change in Sumerian art from stylization to naturalism.

ALBANI (Albano), FRANCESCO (1578–1660). Bolognese painter trained by the CARRACCI (particularly ANNIBALE CARRACCI, with whom he traveled to Rome), whose influences he combined somewhat clumsily with the influences of the High Renaissance, as exemplified by RAPHAEL.

ALBERS, JOSEF (1888–). German-born U.S. painter, printmaker and teacher. Studied, and later taught industrial design, at the BAUHAUS before emigrating to the U.S., where he was to become known as a tireless investigator of the visual phenomena created by the interaction of various closely calculated and precisely juxtaposed hues. In his most characteristic motif, he employs a simple format of squares within squares to demonstrate that no single color can be perfectly apprehended by the eye and that visual perception is sub-

Detail from cave paintings, Ajanta.

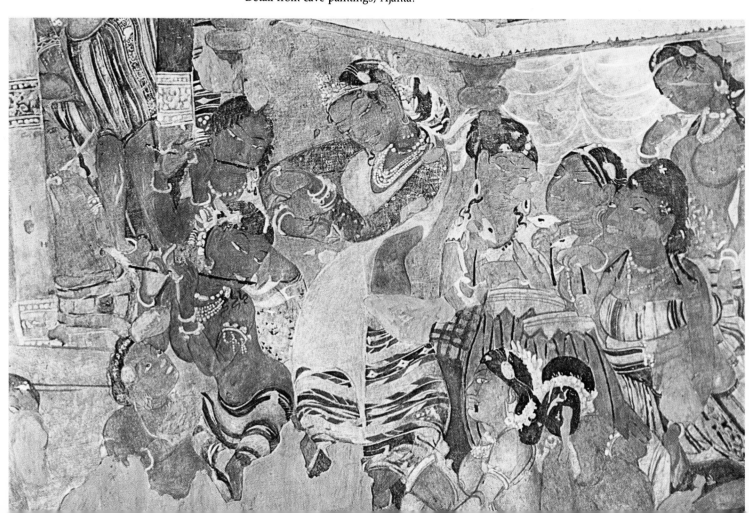

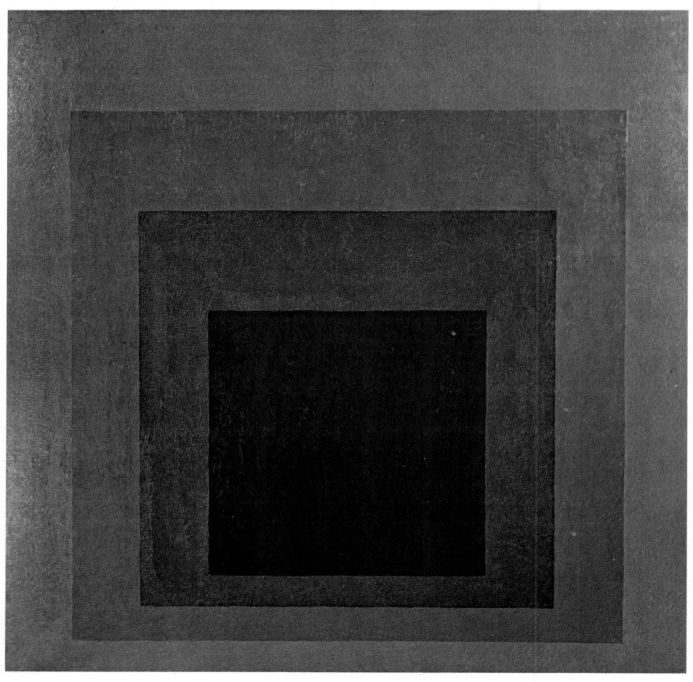

Josef Albers, *Homage to the Square: Delaying*, Metropolitan Museum of Art, New York.

ject to predictably reciprocal influences. Through his works, teaching and theoretical writings, he has had a widespread influence on younger artists, particularly adherents of the OP ART movement of the mid-1960s.

ALBERTI, LEON BATTISTA (1404–1472). Italian architect, humanist and essayist, generally considered one of the key figures of the Renaissance. Born illegitimately in Genoa and educated at Padua, he went to Florence while still in his early twenties and there fell in with the leading artists of the day. His *Della Pittura* (1436) contains the first coherent treatise on perspective, and a later book, *De re aedificatoria*, became the first printed work of architectural theory. In it, he equated beauty with mathematical symmetry and just proportion and strove to make the appreciation of beauty a logical process based on definable criteria instead of subjective reaction.

Alberti's own architectural projects included the Rucellai Palace (begun 1446) and the façade of Sta. Maria

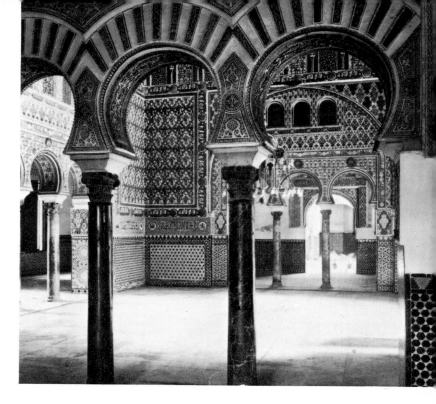

Hall of the Ambassadors, Alcazar, Seville.

Novella (completed 1470), both in Florence, and, in Mantua, the churches of S. Sebastiano (begun 1460) and Sant' Andrea (begun 1470 and completed after his death by LUCA FANCELLI). In all these works he drew heavily on classical models and substituted humanistic concepts and civic concerns for the more narrowly religious ideas and functions of Medieval architecture. His buildings (or those that are still recognizably his) are distinguished by their impressive alternation of solid volumes with open space and the dramatic progression of their subordinate elements to their focal areas. In both the theory and practice of architecture and aesthetics, and by his use of classical forms, he had an immeasurable impact on the Renaissance itself and on later thought and art.

ALBERTINELLI, MARIOTTO (?1474–1515). Florentine classicist painter who worked in collaboration with FRA BARTOLOMMEO before repudiating art for an innkeeper's career.

ALBI: CATHEDRAL OF ST. CECILIA. Massive brick fortress-church in southern France. It was begun in 1282, as both a house of worship and a stronghold in the event of a resurgence of the Albigensian heresy, and completed about a century later. The structure's outer walls rise to a height of 130 feet, and its majestically simple nave, uninterrupted by columns or transept, is 320 feet long, 63 feet wide and 100 feet high.

ALBRIGHT, IVAN LE LORRAINE (1897–). U.S. painter known for his dramatically lighted, meticulously detailed renderings of fleshly decay and corruption, a concern shared but not as successfully exploited by his sculptor-painter twin brother Malvin Marr Albright.

ALCAZAR, SEVILLE. Moorish fortified palace built in the ALMOHAD period of Spain but extensively reconstructed in the MUDÉJAR STYLE in the 17th century. Famed for the richness of its decorative detail.

ALDOBRANDINI MARRIAGE, THE. Roman fresco of the 1st century B.C. noted for the freshness and clarity of its color (Vatican Museums).

ALECHINSKY, PIERRE (1927–). Belgian expressionist painter and one of the founders (1949) of the COBRA GROUP.

ALEXANDER MOSAIC, THE. Roman copy of a Greek work attributed to Philoxenus of Eretria (fl. 4th century B.C.). Executed in reds, whites, blacks and yellows, it depicts a battle between Alexander the Great and Darius and was found at Pompeii (Naples: National Museum).

ALEXANDER SARCOPHAGUS, THE. Hellenistic sarcophagus found in the Phoenician city of Sidon, where it was constructed ca. 325–300 B.C. Shaped like a temple, it is richly ornamented with reliefs that still bear traces of their original polychrome (Naples: National Museum).

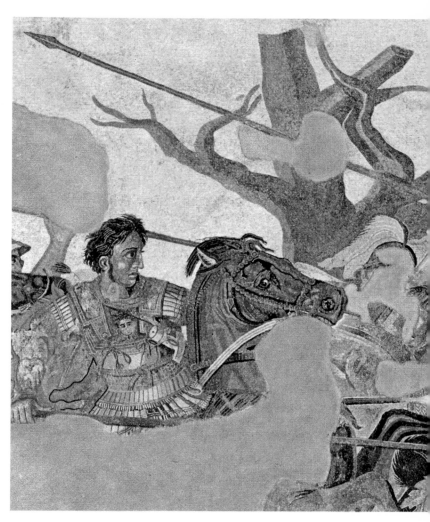

Detail from the Alexander Mosaic.

14

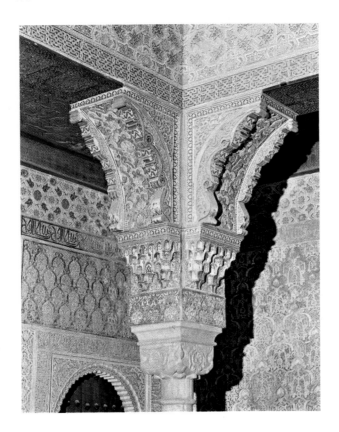

Alhambra, capital in the Sala de las Canas, Granada.

ALGARDI, ALESSANDRO (1595–1654). Bolognese BAROQUE sculptor who studied with LUDOVICO CARRACCI and then worked in Rome, where he obtained such important commissions as the tomb of Pope Leo XI (ca. 1645) and the relief sculpture *Pope Leo Driving Attila from Rome* (1650). Algardi is known for his contorted forms and flamboyant action, but his works were nonetheless somewhat more restrained than those of his chief rival, BERNINI.

ALHAMBRA, GRANADA. 14th-century citadel of the sultans of Granada and the outstanding example of late Moorish architecture in Spain. Of the two principal courts enclosed within its plain, red, fortified walls, the small Court of the Lions is particularly renowned for the delicacy and splendor of its filigree stucco decoration and for the graceful columned arcade that surrounds it.

ALLORI, ALESSANDRO (1535–1607). Italian mannerist painter, adoptive son of BRONZINO, to whose workshop he was apprenticed, and father of the painter Cristofano Allori.

ALLSTON, WASHINGTON (1779–1843). U.S. painter who studied in England (with BENJAMIN WEST), France and Italy. Such theatrical canvases as *Moonlit Landscape* (Boston: Museum of Fine Arts) established him as the first American exponent of ROMANTIC PAINTING, but his later works tended toward more serenity and set the tone for the "poetic" painting of his student SAMUEL F. B. MORSE and other followers.

ALMA-TADEMA, SIR LAWRENCE (1836–1912). Dutch-born British painter whose carefully researched, meticulously rendered scenes of ancient life enjoyed a considerable vogue during his now largely forgotten career.

ALSLOOT, DENIS VAN (ca. 1570–ca. 1626). Flemish painter and tapestry designer best known for the realistic GENRE scenes of his later years.

ALTAMIRA, CAVE PAINTINGS OF. The supreme artistic expression, so far as has been discovered, of the later Magdalenian epoch, these vigorous, startlingly lifelike depictions of bison, deer, oxen, horses and other animals were discovered in Santander Province, Spain, in 1879. Of some 150 individual polychrome figures, most of them life-size and some accentuated with incised outlines, the best preserved are the ceiling paintings of the "Great Hall." Although executed some 15,000 years ago, these animal "portraits" are as lively, skillful and psychologically convincing as any in the subsequent history of art.

ALTDORFER, ALBRECHT (ca. 1480–1538). German painter, architect, printmaker and woodcut designer who, with CRANACH and DÜRER, was among the first of

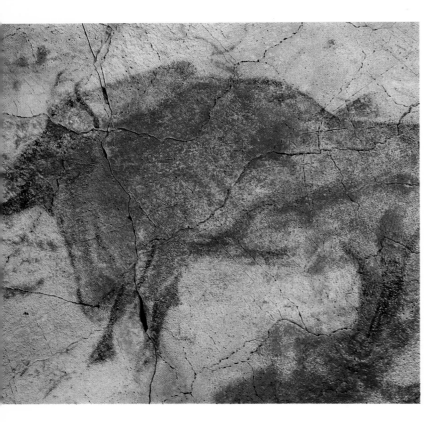

Cave painting, Altamira.

Albrecht Altdorfer, *St. George*, Alte Pinakothek, Munich.

the great Western artists to appreciate landscape as a worthwhile pictorial subject in itself. He is perhaps best known for such masterfully organized battle scenes as *The Battle of Issus* and *The Battle of Alexander* (both Munich: Pinakothek), in which hordes of figures are deployed over vast stretches of terrain.

ALTICHIERO (ca. 1320–1385). Italian painter generally credited with having founded the Veronese School, although documentation of his life is scanty and little of his work survives. The influence of GIOTTO can be seen in his frescoes for the Cavalli Chapel of S. Anastasia, Verona.

AMARAVATI STUPA. Remains of a Buddhist stupa built in Amaravati, south India, in the 1st and 2nd centuries A.D. Richly ornamented with sculptures and reliefs depicting the life of the Buddha, it was executed in a mixture of Roman and indigenous styles and markedly influenced much of the later art of Southeast Asia.

AMBERGER, CRISTOPH (ca. 1500–ca. 1562). German portrait painter, influenced by the VENETIAN SCHOOL and best known for his meticulous handling of raiment and jewelry.

AMBOISE, CHATEAU OF. Architecturally notable French Loire Valley chateau, built in the 1470s and enlarged by Charles VIII in the late 15th century, when Renaissance elements were added to its original GOTHIC design. A small, superbly designed extension, the

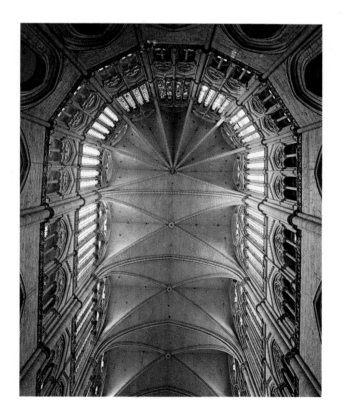

Chapel of St. Hubert, is thought to be the burial place of LEONARDO DA VINCI.

AMIENS: CATHEDRAL OF NOTRE DAME. Among the finest of all GOTHIC structures, with perhaps the most imposing nave in existence, France's largest cathedral was begun in 1220 and largely completed by 1269. Marked by a soaring verticality virtually unbroken by horizontal elements, it is generally considered one of the purest and most complete statements of the HIGH GOTHIC and is further notable for its open, graceful design and the wealth of lively sculptural ornamentation on its façade.

AMMANATI, BARTOLOMMEO (1511–1592). Florentine mannerist sculptor and architect and protégé of MICHELANGELO. His best-known work is the fountain of the Piazza della Signoria, Florence, which he was chosen

The roof of Amiens Cathedral above the choir.

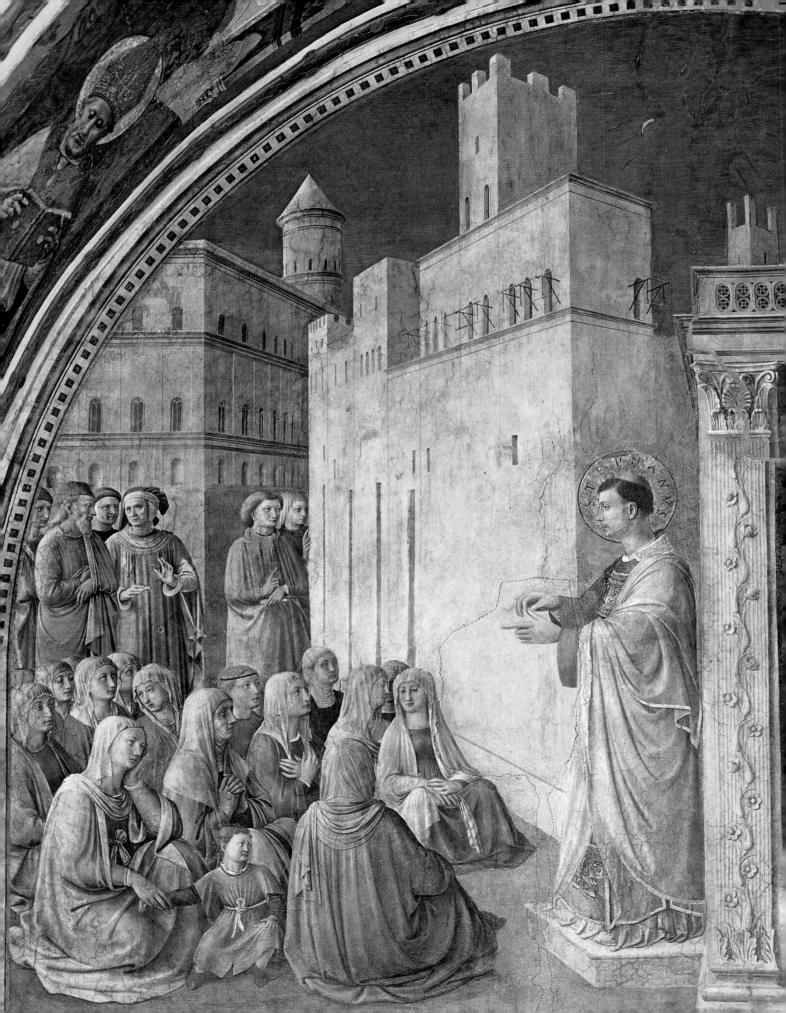

Antonello da Messina, *Portrait of a Man*, Uffizi, Florence.

to execute in competition with such rivals as GIOVANNI BOLOGNA and BENVENUTO CELLINI but which one contemporary described as a waste of good marble.

AMSTEL, JAN VAN (ca. 1500–ca. 1543). Dutch history and landscape painter of whose work little survives but who may have influenced PIETER BRUEGHEL THE ELDER.

ANDRÉ, CARL (1935–). U.S. sculptor, generally considered one of the most cerebral and difficult of the exponents of the MINIMAL SCULPTURE of the 1960s.

ANDREA DA FIRENZE (called **Bonaiuti**) (ca. 1320–ca. 1380). Florentine mural painter of whom little is known but whose fresco cycle in the "Spanish Chapel" of Sta. Maria Novella, Florence, executed during the intensive spiritual reappraisals that followed the Black Death plagues of the mid-14th century, is considered one of the supreme artistic summations of the prevailing mood of its era.

ANDREA DA MURANO (fl. 1462–1502). Venetian painter and sometime collaborator with BARTOLOMMEO VIVARINI. Influenced by MANTEGNA, he was known for the sculptural modeling of his figures.

ANDREA DEL CASTAGNO. See **CASTAGNO, ANDREA DEL.**

ANDREA DEL SARTO. See **SARTO, ANDREA DEL.**

ANDREA DI BARTOLO (ca. 1370–1428). Sienese painter, son and pupil of BARTOLO DI FREDI and a specialist in decorative altarpieces.

ANDREA DI CIONE. See **ORCAGNA, ANDREA.**

ANDREA PISANO. See **PISANO, ANDREA.**

ANGELICO, GUIDO DI PIETRO (FRA) (before 1401–ca. 1455), also known as **Fra Giovanni Da Fiesole.** Italian painter and Dominican friar. Technically influenced by the simplicity of form of GIOTTO and MASACCIO, his art is simple, direct and devoted to didactic, not aesthetic, ends—a circumstance that may account for the 19th-century English critic JOHN RUSKIN's patronizing and misleading observation that "Angelico is not an artist . . . but an inspired saint." However saintly Fra Angelico may have been, he was a professional artist whose work was much sought after in cities as scattered as Fiesole, Florence and Rome, whose influence extended to Perugia (and possibly northward to the Low Countries) and whose purity of form was highly esteemed and much imitated during the artist's lifetime and into the 16th century. Although his compositions lacked the strict, almost mathematical organization of those of his great follower PIERO DELLA FRANCESCA, they are distinguished by a comparable unity of form and by a freshness and sweetness of color unique not only in its own time but, possibly, in any time.

Fra Angelico, detail from the *Lives of St. Stephen and St. Lawrence*, Chapel of Nicholas V, Vatican.

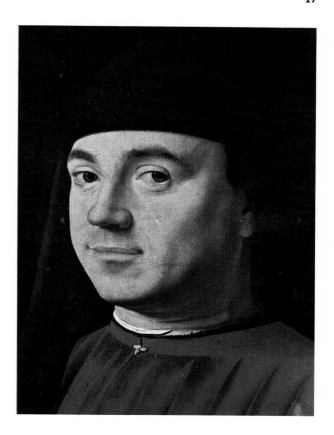

ANGKOR WAT. An immense, richly carved temple, containing a shrine of the Hindu god Vishnu, in the ancient capital of the Khmer Empire, Cambodia.

ANGUIER, FRANÇOIS (ca. 1604–1669) and **MICHEL** (1613–1686). French sculptors who studied in Italy and based their work on the Roman BAROQUE, which they introduced to France.

ANSHUTZ, THOMAS (1851–1912). U.S. realist painter, much influenced by his teacher THOMAS EAKINS and in turn an influence on the painters of THE EIGHT.

ANTELAMI, BENEDETTO (ca. 1150–ca. 1233). Italian sculptor and architect best known for the design of the Parma Baptistery, a successful blend of GOTHIC and ROMANESQUE elements, and for his relief sculpture *The Deposition*, Parma. Stylistic affinities have led to speculation that he may have worked for a time in southern France, but the hypothesis is undocumented and little is known of his life.

ANTONELLO DA MESSINA (ca. 1430–1479). Sicilian painter who, according to VASARI, studied with JAN VAN EYCK and introduced oil painting to Italy. Both claims are dubious, but he is generally conceded to be the only southern Italian painter of consequence in the 15th century and one of the indisputably great painters of the early Renaissance. His characteristic works are marked by a solidity and simplicity of form that has led him to be compared with PIERO DELLA FRANCESCA and PAUL CÉZANNE.

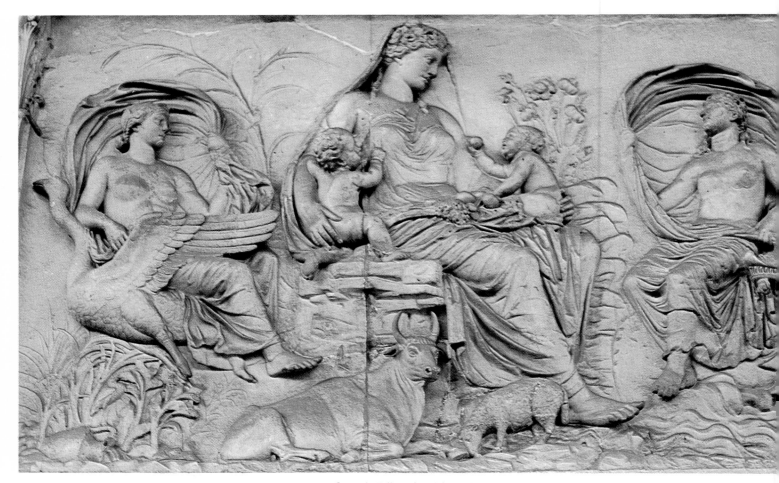

Saturnia Tellus, detail from the Ara Pacis.

ANTONIO MASSARI DA VITERBO (Pastura) (fl. 1478–1509). Italian painter best known for his fresco cycle *The Life of the Virgin,* Tarquinia.

ANUSZKIEWICZ, RICHARD (1930–). U.S. painter and printmaker and a leading exponent of OP ART. Some years after studying with JOSEF ALBERS, he developed a distinctive style in which thin, precisely calibrated bands of clearly defined flat color modify one another to create startling effects in the eye of the beholder.

APELLES (fl. ca. 350–300 B.C.). Greek painter and writer, none of whose work survives and of whom almost nothing reliable is known but who was regarded by his contemporaries and near-contemporaries as perhaps the greatest artist of his era.

APHRODITE OF MELOS. See **VENUS DE MILO.**

APOLLO BELVEDERE. Roman copy in marble of a lost Hellenistic bronze figure of Apollo believed to have been made by the Greek sculptor Leochares in the latter half of the 4th century B.C. For four centuries after its discovery in the late 15th century, it was considered one of the supreme masterpieces of antiquity, but waned in popularity with the subsequent discovery of older, more graceful works (Vatican Museums).

APOLLODORUS (fl. late 5th century B.C.). Athenian painter who, according to Pliny, invented chiaroscuro. No works survive.

APPEL, KAREL (1921–). Dutch abstract and, more recently, figurative expressionist painter and a founder of the COBRA GROUP.

ARA PACIS. The Altar of Peace built on Rome's Campus Martius in the late 1st century B.C. to commemorate the return of Augustus after his victories in Spain and Gaul. Probably the outstanding work of the Augustan period, it marks the first use of actual historical events as artistic motifs and is notable for the unity and naturalness of its relief sculptures.

ARCHIPENKO, ALEXANDER (1887–1964). Russian-born U.S. sculptor who lived, worked and taught in western Europe before emigrating to New York in 1923 and who associated himself with CUBISM in its earliest stages. A stylistic innovator, he was one of the first artists to espouse the validity of sculpture as its own *raison d'être* (as opposed to a vehicle for the depiction of observable phenomena) and to recognize the plastic opportunities afforded by "opening" sculptural forms by stressing concavity and even piercing through solids.

ARCIMBOLDO, GIUSEPPE (ca. 1527–1593). Milanese mannerist portrait painter and designer best known for his grotesque allegorical figures, in which various combi-

Alexander Archipenko, *Standing Figure*, Hessian Landesmuseum, Darmstadt.

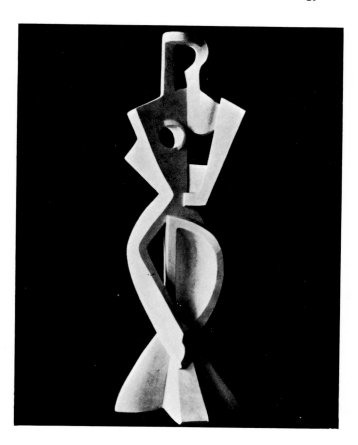

nations of flora, fauna and man-made objects were arranged to resemble human beings. Typical of these is his *Portrait of John Calvin* (Gripsholm: Royal Castle), a work that came to be much admired during the heyday of SURREALISM.

ARMITAGE, KENNETH (1916–). English abstract and semifigurative sculptor who works mostly in cast bronze and is known for his vague but disturbing references to the human condition.

ARNOLFO DI CAMBIO (ca. 1245–ca. 1308). Italian architect and sculptor. A pupil of NICOLA PISANO, he drew up the original plans for FLORENCE CATHEDRAL and is credited with having been one of the first portrait sculptors. One of the important precursors of the Renaissance, in such works as his *Madonna and Child*, Florence, he infused his figures with a lively verisimilitude far beyond the talents of most of his contemporaries.

ARP, JEAN (Hans) (1887–1966). Alsatian-born French sculptor, painter, printmaker, and poet. He was associated with the BLUE RIDER, helped found the DADA movement in 1916 and contributed to the 1st Surrealist Exhibition in 1925. His later abstract works, less concerned with ideological positions than with self-expression, are rhythmic, pure of form and bear strong suggestions of organic, and particularly sexual, motifs.

Jean (Hans) Arp, *Shirt Front and Fork*, F.-C. Graindorge Collection, Liège.

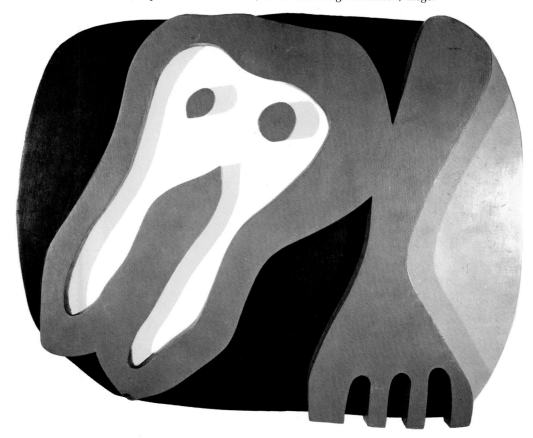

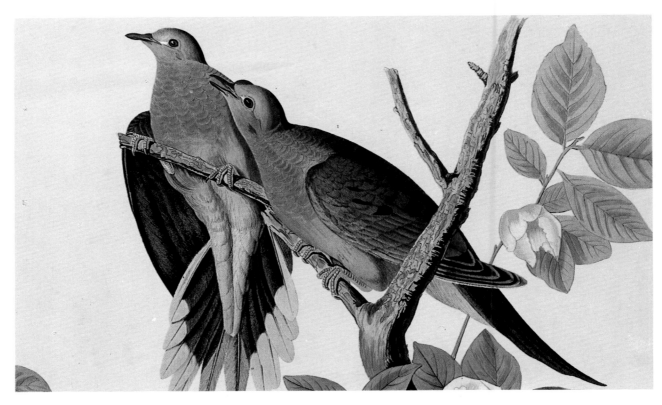

John James Audubon, detail of "Mourning Dove," from *The Birds of America*.

ARTHOIS, JACQUES D' (1613–1686). Flemish landscape painter. Influenced early in his career by DENIS VAN ALSLOOT, he later emulated certain stylistic devices of RUBENS. The works of his brother Nicolas and son Jean-Baptiste largely have been subsumed under his name.

ASAM, COSMAS DAMIAN (1686–1739) and **EGID QUIRIN** (1692–1750). Bavarian architects, artists and decorators. The brothers combined the decorative tradition of their homeland with concepts of the Italian BAROQUE to create ornate, light-flooded, theatrical interiors, such as that of the Church of St. John Nepomuk, Munich.

ATHENS: THE ACROPOLIS. A complex of structures erected during the Periclean Age on the hilltop site of a Mycenaean citadel. The most important buildings remaining on the site are the PARTHENON (447–432 B.C.), the Erechtheum (421–407), the Propylaea, or gateway (437–432), and the Temple of Athena Nike (ca. 425), but fragments of earlier structures, destroyed in the Persian sack of Athens in 480, can be seen on the grounds.

AUDUBON, JOHN JAMES (Jean Jacques) (1785–1851). Haitian-born U.S. painter and naturalist. He studied painting in France, for a time under JACQUES-LOUIS DAVID, before returning to the U.S. in 1803 and embarking on a business career that soon foundered. After a precarious period as a portraitist, he returned to his first interest, ornithological illustration, a field to which he devoted most of the rest of his career and in which he reigns supreme. What differentiates his watercolors of birds (and the lithographs copied from them) from all others, above the liveliness and accuracy with which they are portrayed, are the breadth and scope of his compositions and their masterful organization.

AUTUN: CATHEDRAL OF SAINT-LAZARE. French pilgrimage shrine consecrated in 1130 and completed ca. 1150. Although notable for its architecture, the cathedral's chief claims to fame are the relief carvings on its west tympanum, the work, along with some fifty capitals in the nave, of GISLEBERTUS.

AUXERRE: SAINT-GERMAIN. French abbey church begun in the 9th century on the site of a 6th-century basilica. Its vaulted crypt (ca. 841) was embellished with a fresco cycle (ca. 850) depicting the martyrdom of St. Stephen and thought to be the oldest mural paintings in France. The edifice also is noted for its architectural complexity and its graceful 12th-century detached bell tower.

AVERCAMP, HENDRICK (1585–1634). Dutch landscape and genre painter known for his detailed portrayals of ordinary folk at leisure.

AVERY, MILTON (1893–1965). U.S. painter known for his thinly painted, highly simplified figures in outdoor settings.

AZAY-LE-RIDEAU, CHATEAU OF. Chateau built in France's Loire Valley between 1518 and 1527 for Gilles Bertelot. It is known for its harmonious, delicate fusion of late GOTHIC and Renaissance design.

B

BAALBECK: RUINS. Architectural remains of an ancient city devoted to worship of Baal (Bel), the sun god, and called Heliopolis in Roman times. Located in Lebanon, between Beirut and Damascus, it is notable for its fragment, consisting of six Corinthian columns and a portion of their entablature, of the temple of Jupiter, built largely during the reign of Caracalla (A.D. 211–217). The site also contains two Corinthian temples, probably dedicated to Bacchus and Venus, both completed during the 3rd century.

BABUREN, DIRCK VAN (ca. 1595–1624). Dutch history and genre painter who worked in Rome, where he was influenced by CARAVAGGIO, before returning to his homeland. He was a founder of the UTRECHT SCHOOL, and his work was admired by VERMEER.

BABYLON: RUINS. Fragmentary remains of walls and buildings erected by Nebuchadnezzar II on the site of the capital of Babylonia, in central Mesopotamia. During his reign (ca. 605–562 B.C.), Babylon was one of the most magnificent cities of the ancient world, famous for its Hanging Gardens, superb statuary and a processional way that passed through the Ishtar Gate to the seven-tiered ziggurat that, with the sumptuously ornamented Temple of Marduk at its summit, formed the biblical Tower of Babel.

Temple of Jupiter, Baalbek Ruins.

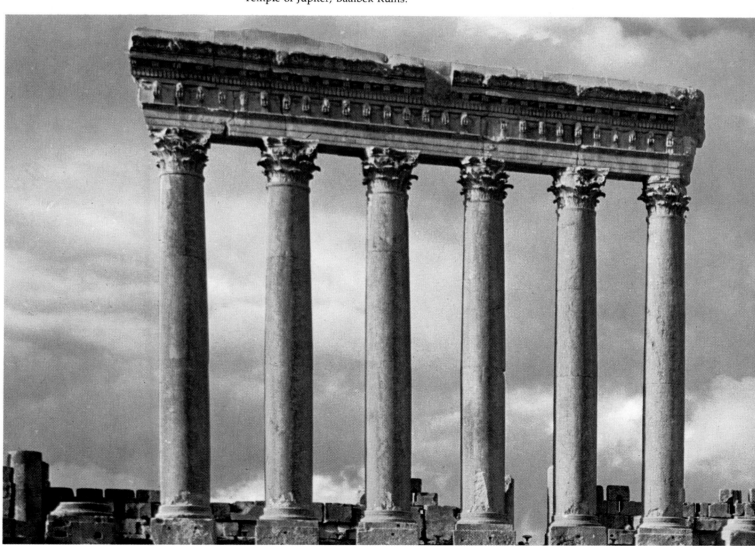

BACCHIACCA (Francesco d'Ubertino) (1494–1557). Italian narrative and genre painter who studied with PERUGINO and whose work is marked by the artist's keen observation of animated subjects and use of bold color.

BACHOT, JACQUES (1493–1526). Sculptor (and perhaps painter) of whose major works only one, a *Deposition* in the GOTHIC style, survives.

BACICCIA. See GIOVANNI BATTISTA GAULLI.

BACKER, JACOB ADRIAENSZ. (1608–1651). Dutch portrait painter who worked in the style of REMBRANDT.

BACO, JAIME (ca. 1413–1461). Spanish painter, called Jacomart, reputed to have been the leading Valencian painter of his day, but of whose certainly authenticated works none survive.

BACON, FRANCIS (1910–). Dublin-born English self-taught painter. He has been recognized since the mid-1940s as one of the most controversial artists of the century. Known for their anguished, distorted portrayals of screaming figures enclosed in ambiguously sketchy frames or cages, his works are suggestive of the "black"

paintings of GOYA's later years. Of his pictorial aims, Bacon has said he strives for "a trail of the human presence and memory trace of past events [left by the subject] as the snail leaves its slime."

BACON, PEGGY (1895–). American painter, illustrator and printmaker known for her wit and a thin, light style that borders on caricature.

BADALONI, PAOLO DI STEFANO (1397–1478). Italian painter (also called Paolo Schiavo) of religious groups. Influenced by MASOLINO, he is best known for a 1440 fresco (Florence: S. Apollonia) depicting the crucified Christ with angels, nuns and donors.

BADGER, JOSEPH (1708–1765). The first native American portrait painter of consequence, he was self-taught, but influenced by SMIBERT, and is best known for his somewhat stilted likenesses of Boston children.

BAEGERT, DERICK (ca. 1440–1515). Westphalian painter influenced by BOUTS and best known for large altarpieces.

BAERZE, JACQUES DE (fl. ca. 1375–1400). Flemish sculptor of stylized religious figures and altarpieces executed in the INTERNATIONAL GOTHIC manner.

BAILLIE-SCOTT, MACKAY HUGH (1865–1945). Manx-born Scottish architect and designer known for his use of Tudor forms in the design of English country houses and for his severely rectilinear furniture.

BAIZERMAN, SAUL (1889–1957). Russian-born American sculptor who worked primarily in hammered metal and used the human torso as a vehicle of emotional response to a variety of subjects.

BAKHUYSEN, LUDOLF (1631–1708). Dutch marine painter much influenced by WILLEM VAN DE VELDE THE YOUNGER. His characteristic works depict storm-tossed seas dramatically, but with little of Van de Velde's subtlety or acuteness of observation.

BAKST, LÉON (1866–1924). Russian-born painter and scenic designer who pursued his career in Paris, where he designed vibrantly colorful sets and costumes, derived in large part from Oriental motifs, for Diaghilev's Ballets Russes. He was a founder of the avant-garde group Mir Iskusstva, which loosely paralleled the ART NOUVEAU movement.

BALBAS, GERONIMO (1670–1760). Spanish architectural designer who spent his mature years in Mexico, where he was one of the chief developers (with Lorenzo Rodriguez) of the eclectic melange of styles that combined to create the style characteristic of colonial Mexico in the 18th century. Best known for such elaborate sculptural-architectural designs as his Altar of the Kings in the Mexico City cathedral.

Léon Bakst, *La Péri* (costume design for the Ballets Russes' production of *Scheherazade*), Arsenal Museum, Paris.

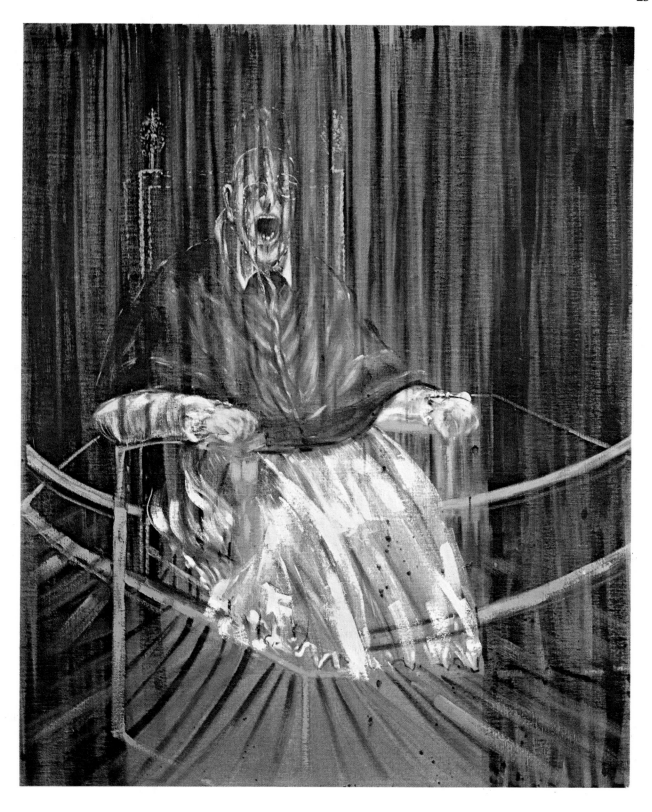

Francis Bacon, *Study After Velasquez's Portrait of Pope Innocent X*, **Carter Burden Collection**, New York.

Giacomo Balla, *The Violinist's Hands*, Sir Eric Estorick Collection, London.

BALDOVINETTI, ALESSO (ca. 1425–1499). Florentine painter much influenced by Domenico Veneziano, Castagno and Piero della francesca, he is credited with the revival of mosaic as a major Italian art form. The frescoes of his mature style are marked by a grandeur of concept and boldness of design, the painter's painstaking attention to detail notwithstanding. He is widely considered the last of the Italian primitives. His experimentation was far more concerned with technique than style, but his use of closely observed landscape passages in religious pictures and his original handling of color were innovative, and his draftsmanship was much imitated.

BALDUNG-GRIEN, HANS (ca. 1476–1545). German painter who studied under Dürer a decade before completing his major work, the high altar of freiburg cathedral. He painted a number of altarpieces and some portraits but is best known for his demonic allegories, which characteristically are painted in a style reflecting Dürer's cool classicism and the expressionism of Grünewald, the first artist of the upper Rhine besides Baldung to work in the Renaissance style. A prolific printmaker, he made extensive use of chiaroscuro in woodcuts and engravings marked by great vitality and immediacy.

BALEN, HENDRICK VAN, THE ELDER (1575–1632). A popular Flemish painter of religious and mythological pictures, he maintained a very active workshop to which Van Dyck was apprenticed at one time. Highly esteemed for the mannerist nudes of his middle period, he later imitated Rubens with indifferent success.

BALESTRA, ANTONIO)1666–1740). Although born and trained in Verona, he combined the sprightly grace of the venetian school with the solidity of the Roman ters and particularly his greatest single influence, Carlo Maratta.

BALLA, GIACOMO (1871–1958). Italian painter and a leading influence upon and exponent of futurism. After discovering divisionism and the concern of such painters as Seurat and Signac with color and light, he returned from Paris to Italy, where he passed his findings on to Boccioni and Severini. An established artist when Marinetti issued the 1st Futurist Manifesto, he embraced the new style in 1910 but never quite as mechanistically as did many of his colleagues. Balla's most widely known work, *Dynamism of a Dog on a Leash* (1912; New York: Museum of Modern Art), anticipates modern multiple-flash stroboscopic photography with an eerie verisimilitude.

BALTHUS (Klossowski de Rola) (1908–). French painter, reared in England and Switzerland and, although both his parents were painters, largely self-taught. Closely figurative but not "realistic," his paintings, characteristically of adolescents in stark interiors, are dreamlike and seem vaguely portentous.

BAMBERG: CATHEDRAL. German structure, begun by Emperor Henry II in 1107, finished later in the century in the high ROMANESQUE style, and later Gothicized around the end of the 12th century, when such notable works of sculpture as the "Disputing Prophets" of the choir screen, the tympanum group *The Last Judgment* and the equestrian figure known as *The Bamberg Rider* were installed.

BANDINELLI, BACCIO (1493?–1560). Italian sculptor, influenced to the point of caricature by MICHELANGELO and best known for his 1534 work *Hercules and Cacus* (Florence: Palazzo Vecchio) and his relief figures for the choir screen of FLORENCE CATHEDRAL.

BANNARD, WALTER DARBY (1934–). American painter and art critic, exponent of COLOR-FIELD PAINTING. His concern is with a balanced use of close-hued, pallid colors divested of all nonintrinsic associations.

BARBARI, JACOPO DE (post-1450–pre-1516). Venetian painter and engraver who worked in Germany and Flanders from ca. 1500 onward. He was court painter to five different northern rulers in his later years, and an earlier work, *Old Man Embracing a Young Girl* (Philadelphia: Museum of Art), is generally considered to be the first treatment of a theme that was to gain widespread currency in German and Netherlandish art. He is also credited with having painted the first still life, but, although its authorship is not certain, the best-known work generally attributed to Barbari is *Fra Luca Pacioli Explaining a Theorem to a Young Man* (Naples: National Museum). Barbari's very elegant engravings derive largely from the work of such northern artists as SCHONGAUER and LUCAS VAN LEYDEN, but his painting style, although sometimes said to be similarly influenced, is more probably indebted to the work of ALVISE VIVARINI.

BARBIERE, DOMENICO RICOVERI DEL (Domenico Fiorentino) (ca. 1501–ca. 1565). An Italian painter, engraver, sculptor and architect, he spent his artistic career in France, producing etchings and engravings of elegance and verve, paintings, minor architecture and much manneristic funerary sculpture.

BARDI, GIOVANNI D'ANTONIO MINELLO DE' (1460–1527) and **ANTONIO GIOVANNI MINELLO DE'** (1480–post-1524). Italian sculptors, father and son, and sometime collaborators. Born of a noble family in Padua, the elder Bardi's best-known works are the funeral decorations for the Chapel of San Antonio in that city. His son, usually in collaboration with other artists, worked on various projects in Padua, Venice and Bologna.

BARENDSZ, DIRCK. (1534–1592). Dutch painter of portraits and historical subjects who worked in Italy, under TITIAN and others, before returning to his homeland. Although he was prolific, few of his works survive, the most important of these being a large altarpiece in Gouda, much influenced by various Italian masters.

Ernst Barlach, *Lilith, the Lust-Woman,* a xylograph for Goethe's *Walpurgisnacht,* Goethe Museum, Frankfurt.

BARISANO DA TRANI (fl. 4th quarter of 12th century). Italian relief sculptor best known for his bronze church doors such as those at the cathedrals of Trani, Ravello and Monreale, of which those at Ravello, dated 1179, are the most impressive and well ordered. His later work was basically in the ROMANESQUE style, although his reuse of old molds makes a clear view of his development difficult.

BARNET, WILL (1911–). An American painter, printmaker and teacher known for both his representational works and abstractions.

BARLACH, ERNST (1870–1938). German sculptor, ceramist, printmaker and playwright. He was a powerful influence on the American sculptors of the 1930s. His wood carvings of peasants, themselves stylistically influenced by late Medieval sculpture, were condemned as "degenerate" during the Nazi regime. Spiritually akin to KATHE KOLLWITZ in his compassionate humanistic outlook, he was a prolific printmaker and book illustrator, although his first graphic works were undertaken when he was past 40.

BARNABA DA MODENA (fl. 1362–1383). Italian painter trained in the BYZANTINE tradition and best known for portrayals of the Virgin and Child executed in a blend of the Byzantine and Giottoesque styles.

BARNA DA SIENA (fl. ca. 1330–ca. 1360). Sienese painter, taught by SIMONE MARTINI and known for the dramatic power with which he invested such late works as a fresco cycle, depicting *The Life of Christ,* in the Collegiata, San Gimignano. His highly expressive use of angular forms, harsh color and dynamic compositional devices,

possibly reflecting the general mood of the years immediately after the decimation of Tuscany by the Black Death, constitutes a radical departure from the softer, more lyrical outlook of his mentor Martini and signals an abrupt end to the early Sienese style.

BARNARD, GEORGE GRAY (1863–1938). An American sculptor who studied in Chicago and later in Paris, where his best-known work, *The Struggle of the Two Natures of Man* (New York: Metropolitan Museum), was first exhibited in the Salon of 1894 and set the tone for much of his output, which was rooted stylistically in the works of MICHELANGELO and RODIN. An admirer of Medieval carvings, he assembled a collection now housed in the Cloisters, New York.

BAROCCI, FEDERICO (1528–1615). A largely self-taught Italian painter who, aside from a sojourn in Rome (1561–1563), where he painted some frescoes for Pius IV, spent most of his life in various provincial towns in central Italy but was known as far afield as Madrid. Characterized by fresh, carefully modulated, rather pretty color, much verisimilitude of detail, a frequent use of sweeping diagonals and a heavy dependence on the expressive effects of chiaroscuro, his best work anticipates the BAROQUE style in general and CARAVAGGIO in particular.

BARONZIO, GIOVANNI (ca. 1300–before 1352). Italian painter, trained in the BYZANTINE manner but influenced by GIOTTO and considered the outstanding painter of his region, the Marches, during his lifetime.

BARRY, SIR CHARLES (1795–1860). English architect who worked in the Roman and Florentine Renaissance styles, both of which owed their revival in England to his widespread influence. Designer of London's Houses of Parliament (but not of their GOTHIC detail and furnishings) and of Halifax Town Hall, completed by Edward Middleton Barry, one of his three architect-sons.

BARRY, JAMES (1741–1806). Irish history painter, protégé of Edmund Burke and Royal Academician, best known for *The Progress of Human Culture*, a cycle of ambitious but stilted history paintings executed according to precepts laid down by REYNOLDS.

BARTHOLDI, FRÉDÉRIC AUGUSTE (1834–1904). French sculptor of *The Lion of Belfort* and similar academically rendered patriotic themes. His fame rests largely on the colossal *Liberty Enlightening the World* ("The Statue of Liberty") in New York harbor.

BARTOLO DI FREDI (ca. 1330–1410). Italian eclectic painter of the SIENESE SCHOOL, influenced by the LORENZETTIS, MEMMI and BARNA DA SIENA, among others.

BARTOLOMMEO, FRA (Baccio della Porta) (1475–1517). Italian painter and Dominican friar and the leading exponent of the High Renaissance style in Florence after 1508. Influenced by both LEONARDO and MICHELANGELO, he lacked the former's subtlety and the latter's dynamism. Another major, if less direct, influence was Savonarola. In his best works he achieved a somewhat austere monumentality whose purity was diluted to a degree by his rather rhetorical use of chiaroscuro.

BARTOLOMMEO DELLA GATTA (Piero d'Antonio Dei) (1448–1502). Italian painter and architect of the Arezzo school, much influenced by PIERO DELLA FRANCESCA, ANTONIO DEL POLLAIUOLO, DOMENICO VENEZIANO and LUCA SIGNORELLI, on which influences he built a compelling personal style.

BARTOLOMMEO VENETO (fl. 1502–1530). Venetian painter noted for his elaborate, rather romantic portraits of Renaissance types. In contrast to the hard linearity of his early work, his later paintings are subtler and more softly modulated.

BARTOLOZZI, FRANCESCO (1727–1815). Italian engraver known for his mastery of the stipple technique, through which he influenced many English engravers while serving as engraver to George III in London, where he became one of the first members of the Royal Academy. Although a fine original graphic artist, he devoted much of his career to reproducing the works of various painters.

BARTSCH, ADAM VON (1757–1821). Austrian etcher, engraver, print curator and writer. The majority of his graphic works were etchings and engravings after the great painters. His 21-volume work *Le Peintre-graveur* is an indispensable part of the print literature.

BARYE, ANTOINE LOUIS (1796–1875). French romantic sculptor known for such lifelike animal sculptures as *Lion Crushing a Serpent* and *Tiger Devouring a Crocodile*, both in the Louvre, Paris.

BASAITI, MARCO (fl. 1496–1530). Venetian painter influenced by ALVISE VIVARINI, CARPACCIO and GIORGIONE and best known for his interpretations of such New Testament themes as *Christ Calling the Sons of Zebedee* (Venice Academy).

BASCHENIS, EVARISTO (ca. 1607–1677). Italian painter of still lifes, particularly of musical instruments. Known for his extreme realism and compositional assurance.

BASKIN, LEONARD (1922–). An American expressionist sculptor and printmaker, he is known for his morbid bronze figures and his incisive, often outsize woodcuts.

BASSA, FERRER (ca. 1290–1348). Spanish court painter and founder of the early Catalan school. A single work, a mural at the convent of Pedralbes, near Barcelona, survives.

BASSANO, JACOPO (ca. 1517–1592). Most celebrated member of a family of Italian painters called Da Ponte, after the northern Italian town that was the center of their activity. After studying under BONIFAZIO VERONESE in Venice, he worked almost exclusively in the town of Bassano, where he produced a large body of rustic genre scenes marked by an energetic style and a dependence on sturdy figures rendered in heavy chiaroscuro and thick impasto. He was a pioneer in the incorporation of still-life and genre elements and Venetian atmospherics into religious paintings and is known for the fluency of his brushwork and the vivacity of his color. His sons, Francesco (1549–1592), Giralmo (1566–1621) and Leandro

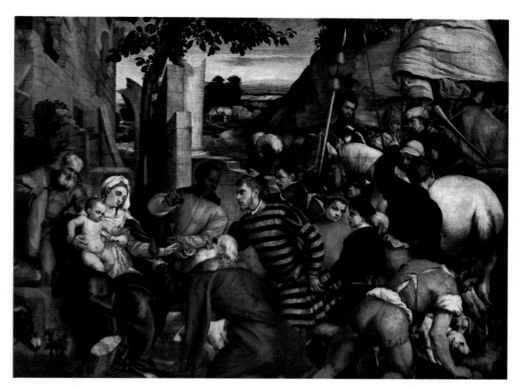

Jacopo Bassano, *Adoration of the Kings*, National Gallery of Scotland, Edinburgh.

(1557–1622), were noted painters, as was his father, Francesco (1470–1540), a follower and imitator of MANTEGNA.

BASTIEN-LEPAGE, JULES (1848–1848). French painter who enjoyed a certain vogue in his short lifetime for such sentimental rustic genre scenes as *The Haymakers* (Paris: Louvre).

BATONI (or **Battoni**), **POMPEO** (1708–1787). Italian painter of the Bolognese school, important chiefly for his influence on MENGS, DAVID and the English portraitists of the late 18th century.

BAUERMEISTER, MARY (1934–). German-born American artist known for her intricate, multilayered, transparent constructions.

BAUMEISTER, WILLI (1889–1955). German abstract painter and teacher, designated as "degenerate" during the Nazi regime.

BAYEUX TAPESTRY. An embroidered linen strip, 230 feet long and 18 inches high, depicting the conquest of England by William of Normandy. Although unreliably reputed to have been executed by William's wife Mathilde, it is indubitably of the 11th century and is housed near the Romanesque-Gothic Cathedral of Notre Dame, in the Norman town of Bayeux.

BAYEU Y SUBIAS, FRANCISCO (1734–1795). Spanish painter and designer and brother-in-law of GOYA, whom he influenced. Like the young Goya, he drew heavily on TIEPOLO, but, unlike Goya, he failed to develop a personal vision of consequence.

BAZILLE, FRÉDÉRIC (1841–1870). One of the original and most promising of the French painters who came to be known as the Impressionists. Killed in the Franco-Prussian War at age 29, he left behind some 60 paintings which, considering his age and the general development of the movement at that time, constitute an important and impressive segment of the early Impressionist oeuvre.

BAZIOTES, WILLIAM (1912–1963). American abstract-expressionist painter and an early adherent of the style that came to be known as ACTION PAINTING.

BEARDEN, ROMARE HOWARD (1914–). American painter and collagist best known for his depictions, often incorporating symbolic and abstract elements, of life among American blacks.

BEARDSLEY, AUBREY VINCENT (1872–1898). An English draftsman and illustrator, he was a leading exponent of AESTHETICISM and, because of the decadence, eroticism and morbidity of his subject matter, one of the most controversial artists of his day. Influenced by the PRE-RAPHAELITES, Greek vase painting, WHISTLER and (through the latter) the Japanese printmakers, he was a superb decorative artist whose work is marked by its sly wit, sinuous ART-NOUVEAU line and masterful disposition of black and white masses.

BEAUNEVEU, ANDRÉ (ca. 1330–before 1416). Franco-Flemish painter and sculptor. Although relatively little is known of his life, he was an important influence on the art of France in the late 14th century, especially through his guidance of Jean de France, Duc de Berry, a leading

28

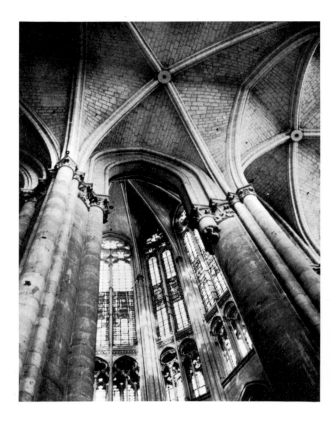

Choir vaulting, Cathedral of St.-Pierre, Beauvais.

forced to leave a professorship at the Frankfurt Academy, sought refuge in Berlin and eventually emigrated, first to Holland and then to the U.S., where he died. First influenced by the German impressionists, he later turned to late Medieval art for inspiration, but much of the anguished imagery of his mature work is believed to stem from the psychologial impact of his experiences as a medical corpsman during World War I.

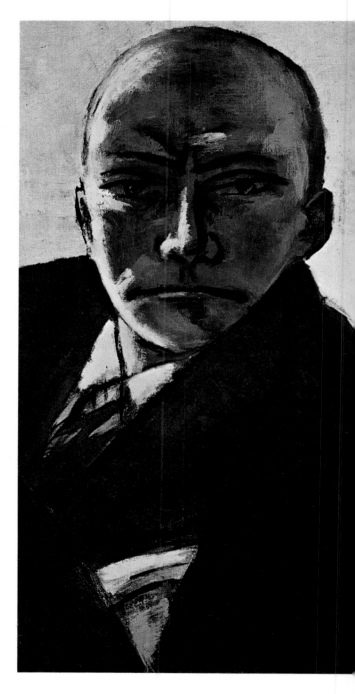

patron of the late Middle Ages. His surviving works include a recumbent figure of Charles V, carved for the royal tombs at Saint-Denis, and an effigy of St. Catherine from the tomb of Louis de Mâle. He was also a renowned illuminator and is generally credited as the author of a superb cycle of grisaille miniatures executed for the Duke of Berry.

BEAUVAIS: CATHEDRAL OF ST-PIERRE. Although never finished and lacking a nave, this ambitious northern French structure, begun in 1225, represents the culmination of the GOTHIC style. Rising to a height of 158 feet, its choir is the world's tallest.

BECCAFUMI, DOMENICO (Domenico della Pace) (ca. 1486–1551). Sienese painter influenced in turn by PERUGINO and SODOMA and known for the often erratic play of light and the shimmering color of his best works. He was also an important designer, decorator and muralist.

BECKMANN, MAX (1884–1950). German painter and printmaker. Although not closely identified with any of the expressionist movements that flourished in Germany before World War II, he is considered one of the century's major exponents of EXPRESSIONISM, known for his dramatic use of form and resonant color and for his convincing visual expression of such nonvisual sensations as sound. Condemned as "degenerate" during the Nazi era, he was

Max Beckmann,
Self-portrait, Bayerische Staatsgemäldesammlungen, Munich.

BEDFORD MASTER (fl. 1405–1430). French miniaturist best known for illuminations commissioned by John of Lancaster, Duke of Bedford and Regent of France. His figures are marked by a highly developed naturalism, while his floral border decorations are characterized by their complexity.

BEECHEY, SIR WILLIAM (1753–1839). An English portrait painter and Royal Academician. His work resembles that of LAWRENCE but is distinguished by its greater probity.

BEGA, CORNELIS PIETERSZ. (ca. 1631–1664). Dutch painter and etcher best known for genre scenes inspired by ADRIAEN VAN OSTADE.

BEGARELLI, ANTONIO (1499–ca. 1565) and **LODOVICO** (1524–ca. 1576). Uncle and nephew, they were Italian sculptors who worked chiefly in terra cotta in the Lombard tradition and most of whose religious figures were made for various churches in Modena.

BEHAM, HANS SEBALD (1500–1550). German printmaker, miniaturist and glass designer. Much influenced by (and accused of plagiarizing) DÜRER, he was a highly controversial figure and prolific interpreter of religious, mythological and allegorical themes.

BELL, LARRY (1939–). American MINIMAL sculptor best known for the seeming insubstantiality of his transparent box constructions.

BELLA, STEFANO DELLA (1610–1664). Italian printmaker. Influenced by CALLOT and later by REMBRANDT and the Dutch landscapists, he is best known for his documentary depictions of warfare.

BELLECHOSE, HENRI (fl. 1415–1440). A Franco-Flemish painter, he was in 1415 made Burgundian court painter at Dijon, where he is believed to have completed JEAN MALOUEL's *Martyrdom of St. Denis* (Paris: Louvre).

BELLEGAMBE, JEAN (ca. 1480–1535). Flemish religious painter much influenced by JAN VAN EYCK and characterized by his warm color, elaborate compositions and the somewhat indecisive handling of his figures.

BELLING, RUDOLF (1886–). German sculptor whose oeuvre ranges from an expressionist to a cubist to a constructivist orientation.

BELLINI, GENTILE (1429–1507). Venetian painter, son of JACOPO BELLINI and brother (or half-brother) of GIOVANNI BELLINI. After working in his father's studio until Jacopo's death, he was named official painter to the Venetian senate in 1474. He was considered the leading portrait and scene painter of his time, but many of his larger works were destroyed by fire 70 years after his death.

BELLINI, GIOVANNI (ca. 1430–1516). Venetian painter, son (probably illegitimate) of JACOPO BELLINI and brother (or half-brother) of GENTILE BELLINI. He was the greatest painter of his time, the teacher of GIORGIONE,

TITIAN, SEBASTIANO DEL PIOMBO and PALMA VECCHIO and one of the most influential masters in the history of art. He was the fountainhead of the Venetian school that was to come to full flower in the next generation. His influence was felt as far afield as Germany, where it was called by DÜRER, who had written from Venice in 1506 that Bellini was "very old, but still the best in painting."

Little is known of his early life. He certainly worked in the studio of his father for a time but was influenced less by the elder Bellini than by his brother-in-law MANTEGNA and ANTONELLO DA MESSINA, who visited Venice in the 1470s. He may have been working independently by 1459 but rejoined Gentile about a decade later, after Jacopo's death. In 1479, when Gentile was sent to Constantinople at the sultan's request, Giovanni replaced him as conservator of paintings in the Doge's Palace—a post he retained for the rest of his life. His first indubitable masterpiece, *The Agony in the Garden* (London: National Gallery), painted around 1465, shortly after Mantegna treated the same theme, shows both his indebtedness to the latter artist and his emerging originality of style. Although both pictures' figures and some compositional elements are similar, Bellini's is marked by less conceptualization, a more atmospheric treatment of the landscape, far closer observation of the effects of light and a generally softer, more lyrical outlook—qualities that prefigure the chief interests of Venetian painting in the age of Titian.

The chronology of his stylistic development is somewhat confused, largely because of the destruction by fire of the large works that occupied several extended periods of his career, and a fully rounded view of his oeuvre is impossible for the same reason. It is generally agreed, however, that by the mid–1470s he had absorbed all that Mantegna had to impart and that the soft, glowing pic-

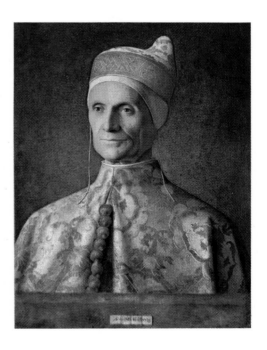

Giovanni Bellini, *Doge Leonardo Loredan*, National Gallery, London.

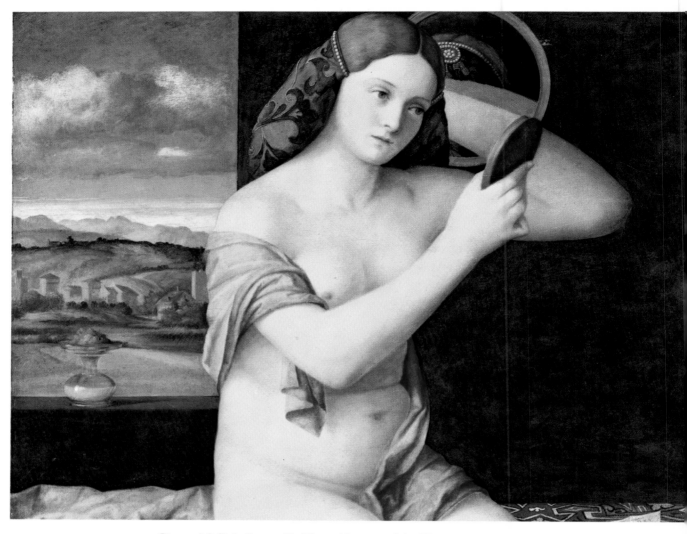

Giovanni Bellini, *Venus with Mirror*, Museum of Art History, Vienna.

tures of Antonello da Messina had become a stronger influence on his work. Antonello's impact notwithstanding, he soon demonstrated his self-sufficiency—and versatility—with *St. Francis in Ecstasy* (New York: Frick Collection), in which he eschewed the soft warm-toned light both he and Antonello usually favored for a more severe bluer light. From the 1480s onward, his figures became increasingly dominant, seeming almost to embody their own worlds, with landscape backgrounds no longer necessary as props. In such pictures of his later years as *Madonna and Saints* (Venice: S. Zaccaria), the last traces of rhetoric have been dispensed with and a profound sense of communion suffuses the scene.

BELLINI, JACOPO (ca. 1400–ca. 1470). The father of GENTILE and GIOVANNI BELLINI, he was the first Venetian painter of the Renaissance. A pupil of GENTILE DA FABRIANO, he sojourned in Florence in 1423–1424 and came into prominence in 1441, when he bested PISANELLO in a portrait competition. Much of his work is now lost, but such surviving paintings as *Crucifixion* (Verona: Castelvecchio Museum) displayed an interest in

uniting pictorial with real space—an interest carried to greater lengths by his son-in-law MANTEGNA and son Giovanni.

BELLOTTO, BERNARDO (1720–1780). Italian painter and nephew of CANALETTO. Like his uncle, whose name he sometimes used, he specialized in *veduti*, or topographic views, but his color is somewhat colder. He traveled extensively in quest of commissions and died in Warsaw, a city he portrayed with such exactitude that his pictures were consulted when it was reconstructed after World War II.

BELLOWS, GEORGE WESLEY (1882–1925). American painter and printmaker, a National Academician at 31. His early works, strongly influenced by his teacher, HENRI, were typical of the so-called ASHCAN SCHOOL. As he matured, the realism and bravura of that period gave way to a more theoretical, less vivid style. Although his early landscapes and late portraits are among his best works, he is known chiefly for his somewhat hyperbolic prizefight scenes.

Bonaventura Berlinghieri, detail from *The Sermon to the Birds*, Bardi Chapel, Church of S. Croce, Florence.

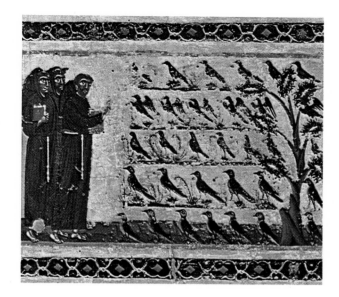

BENI HASSAN: TEMPLE AND TOMBS. Archaeological site on the Nile in Middle Egypt. Its temple of the cat goddess Pakhet was built by Hatshepsut, and a number of tombs, cut into rock, date from the 11th and 12th dynasties. Columns in these tombs anticipate the Greek Doric order by some 15 centuries, and a number of mural paintings depict various aspects of life in the region.

BENSON, AMBROSIUS (fl. 1519–1550). Flemish painter who was prominent in Bruges for three decades, during which time he painted chiefly for foreign clients. Little is known of his formative years, but he appears at some point to have come from Lombardy and to have been trained there. His work combines Flemish and Italian characteristics.

BENTON, THOMAS HART (1889–1975). American painter, muralist, printmaker and author who, with GRANT WOOD and JOHN STEUART CURRY, spearheaded the regionalist movement in the 1930s. His mannered canvases and wall paintings are marked by sinuous forms, rhythmic groupings and, often, saccharine textures.

BENTON, FLETCHER (1931–). American constructivist sculptor whose work is marked by precise craftsmanship, sleek finish, color and subtle mechanical movement.

BENVENUTO DI GIOVANNI (1438–1518?). An Italian painter of the SIENESE SCHOOL, he is better known for his decorative talent than for depth of feeling.

BERARD, CHRISTIAN (1902–1949). A French painter, stage designer and illustrator, influenced first by the NABIS and later by the PICASSO of the Blue Period, he is best known as a painter for his subjective portraits of artistic contemporaries. For the most part, his fame rests on his theatrical designs and fashion illustrations.

BERCHAM CLAES (Nicolaes) PIETERSZ. (1620–1683). Known for his landscapes, cityscapes and animal prints, he was one of the most prolific of the Dutch Italianate painters. Trained by his father, Pieter Claesz. Bercham, and influenced by JAN VAN GOYEN, among others, he seems to have traveled to Italy sometime in the early 1650s, although Italian stylistic traces, probably absorbed from other Dutch painters, appear in his earlier works. His influence on French and English landscape painting was considerable.

BERCKHEYDE, GERRIT ADRIAENSZ. (1638–1698). Dutch painter who specialized in poetic but topographically accurate architectural views of Haarlem and Amsterdam.

BERCKHEYDE, JOB ADRIAENSZ. (1630–1693). Dutch painter, chiefly of architecture and interiors, and teacher of his younger brother, GERRIT ADRIAENSZ BERCKHEYDE.

BERGOGNONE (Borgognone), AMBROGIO DA FOS-SANO (fl. 1481–1522). Milanese painter of altarpieces and frescoes. The gray tonalities of his early work show the influence of FOPPA, while a later, somewhat superficial reading of LEONARDO and the Flemish masters led to a heightening of his color.

BERLINGHIERI, BERLINGHIERO (late 12th century–before 1243). The first Italian panel painter whose name is known, he is famed as the father of BONAVENTURA BERLINGHIERI, as the author of a signed *Crucifix* (Lucca: S. Maria degli Angeli) marked by its use of Byzantine and Romanesque forms and as a considerable influence on the Florentine painting of his time.

BERLINGHIERI, BONAVENTURA (fl. 1228–1274). Italian painter and son of BERLINGHIERO BERLINGHIERI. His one certain work is a gabled panel depicting St. Francis and incidents from his life (Pescia: S. Francesco), the first known example of what later became a traditional form of representation. With its restrained, hieratic central figure and six surrounding vignettes, it is a major work of Italian Medieval art.

BERMAN, EUGENE (1889–1972). Russian-born American painter and stage designer who studied in Paris under BONNARD. With BÉRARD and TCHELITCHEW he formed the group known as "Neoromantics" in reaction against the analytical tendencies of SYNTHETIC CUBISM. In both his paintings and stage designs he relied heavily on Italian and classical motifs set in deep, deserted perspectives.

BERMEJO, BARTOLOME (fl. 1474–1498). Spanish painter active in Catalonia and influenced by both Italian and Flemish painting. Known for his elaborate ornamentation, fluent oil technique, probing portraiture and narrative force.

BERNARD, ÉMILE (1868–1941). A French painter, poet and critic, he influenced GAUGUIN while the two artists were at Pont-Aven in the late 1880s but never approached importance as a painter in his own right. He is remembered chiefly as a critic of POST-IMPRESSIONISM.

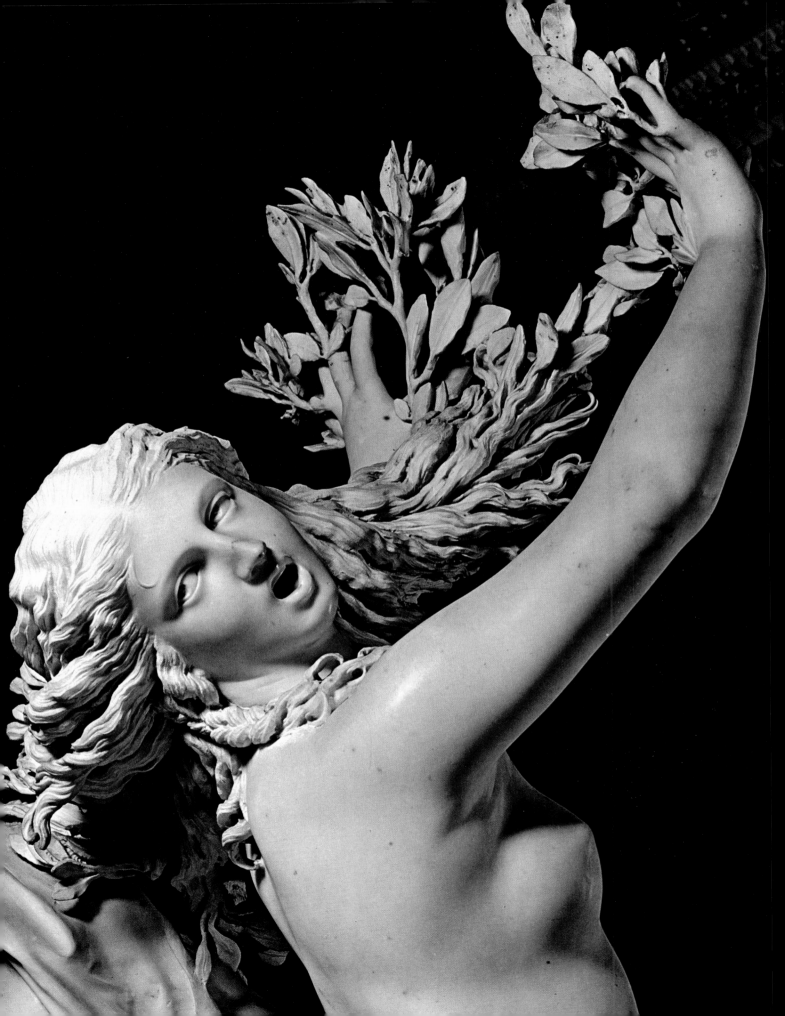

BERNINI, GIANLORENZO (1598–1680). Italian sculptor, architect, playwright and the embodiment of the Italian BAROQUE. He was born in Naples, the son of Pietro Bernini, a sculptor famed for his manipulation of marble and much in demand for his architectural decorations. By the end of his career, Bernini had shaped the course of European sculpture for the next century and left behind an oeuvre that included numerous architectural landmarks in Rome and the Vatican, along with an important body of portrait busts. He was also a writer of comedies, a popular caricaturist, a famous wit and an accomplished but little-known painter.

Trained by his father, who worked in the mannerist style, he was influenced chiefly by the paintings of AN-NIBALE CARRACCI and the sculpture and architecture of classical antiquity, and even in his earliest works he demonstrated great technical virtuosity and a marked talent for psychological penetration, the latter apparently developed through his frequent essays at self-portraiture. And while his father's considerable influence doubtless was a help, Gianlorenzo's precocity is borne out by his having been commissioned at age 21 to execute a series of life-size statues for Cardinal Scipione Borghese. By 1625, with the series completed and Bernini only 27, he was considered the greatest artist of his time and a marble sculptor of dazzling vivacity and technical brilliance.

With the elevation of his friend Maffeo Barberini to the papacy, he embarked on a series of commissions that began with a figure of *S. Bibiana* and the great bronze baldacchino in St. Peter's. By 1629 he was appointed architect of St. Peter's and began both a cycle of heroic statues for the church's crossing piers and niches and the tomb of his patron Pope Urban VIII. In such subsequent works as his portrait figure *Cardinal Scipione Borghese* (Rome: Galleria Borghese), the artist infused his marble with what appeared to be the very breath of life, creating figures caught in motion, instead of carefully struck formal poses. Indeed, even his portrait busts seem to be cut from full moving figures and, in retrospect, to be the physical and spiritual manifestations of the age he shaped and was shaped by.

Much of Bernini's architecture was undertaken after his reputation as a sculptor was secure. After an abortive attempt to erect façade towers for St. Peter's—a technical fiasco that nearly put an end to his architectural career—he designed several of Rome's most magnificent fountains and a number of churches and palaces based on his studies of the Pantheon, along with such unexecuted but highly influential projects as a new plan for the Louvre in Paris. His architectural masterpiece was the design for the vast plaza before St. Peter's, with its double series of free-standing columns—a brilliant technical solution to the problem of a vexingly awkward space and a profound and moving statement of the church's spiritual function.

Bernini himself predicted that his reputation would undergo a decline after his death, and so it did, although

Gianlorenzo Bernini, detail from Apollo and Daphne, *Borghese Gallery, Rome.*

his influence remained pervasive for more than a century. Today, however, he is recognized as a historical figure of the first importance and the last of the universal Italian geniuses.

BERRUGUETE, ALONSO (ca. 1488–1561). Spanish sculptor and son of PEDRO BERRUGUETE. Working in the mannerist style, he was known for his expressiveness and emotive power and for a spiritual fervor that anticipated—and even exceeded—that of EL GRECO.

BERRUGUETE, PEDRO (fl. 1477–ca. 1503). Spanish painter who studied and worked in Italy before his appointment as court painter to Ferdinand and Isabella. He was the father of ALONSO BERRUGUETE. His Italian Renaissance style, modified by Flemish influences, is marked by strong, fluent modeling, a usually somber, highly charged mood and a heavily geometrical compositional scheme relieved by strategically placed diagonals.

BERTOIA, HARRY (1915–). Italian-born American sculptor and designer known for his abstract, geometric screenlike metal constructions.

BERTOLDO DI GIOVANNI (ca. 1420–1491). Italian sculptor taught by DONATELLO and himself the teacher of MICHELANGELO. His work is characterized by its clarity, linearity, compositional tension and psychological insight.

BESNARD, ALBERT (1849–1934). French painter who combined impressionist principles with a silver-gray palette to produce a number of large mural cycles.

BEUCKELAER, JOACHIM (ca. 1530–ca. 1573). Flemish painter of somewhat confused religious, history and genre pictures in which elevated themes and mundane motifs tend to compete for attention.

BEWICK, THOMAS (1753–1828). English engraver and illustrator mainly responsible for the revival of interest in wood engraving in the 19th century. Known best for vignette illustrations, rich in tone and texture, of birds and quadrupeds.

BHUVANESVARA: TEMPLES. Architectural site in Orissa State, India, renowned for the elaboration of its 12th- and 13th-century carvings.

BIBIENA FAMILY. Bolognese family of three generations of theatrical designers and architects, of whom the best-known members were the brothers Ferdinando (1657–1743) and Francesco (1659–1739) and the latter's son Giuseppe (1696–1757) and grandson Carlo (1728–1787). The family style, originated by Ferdinando, was BAROQUE throughout, characteristically asymmetrical and much given to receding architectural perspectives.

BICCI DI LORENZO (1373–1452). An Italian painter of the FLORENTINE SCHOOL, he was a prolific producer of religious frescoes and altarpieces. Working in a late Medieval style shaped by AGNOLO GADDI, LORENZO MONACO and GENTILE DA FABRIANO, he added nothing of significance to it.

BIEDERMAN, CHARLES (Karel) JOSEPH (1906–). American sculptor and writer and a leading exponent of STRUCTURISM.

BIERSTADT, ALBERT (1830–1902). German-born American painter who enjoyed enormous popularity, almost from the outset of his career, for his vast canvases depicting the western American wilderness. Essentially of the Düsseldorf school, he invested his panoramas with dramatic lighting and a scrupulous description of surface texture. His sketches, although less immediately impressive than his finished works, reveal an artist of surprising grasp and immediacy.

BILL, MAX (1908–). Swiss sculptor, painter, architect, designer and writer. Heavily influenced by the BAUHAUS, his characteristic sculpture is nonfigurative, spare and based on "the correlation of elements on a surface or in space."

BINGHAM, GEORGE CALEB (1811–1879). American painter and politician. Largely self-taught, he began his career as a portrait painter and later traveled to Europe, where he worked mainly in Düsseldorf. He is best known for such Missouri genre scenes as *Raftsmen Playing Cards* (St. Louis: City Art Museum) and *Fur Traders Descending the Missouri* (New York: Metropolitan Museum), which characteristically are infused with an almost palpable atmosphere, an eerie stillness and an ineffable poignancy.

BISHOP, ISOBEL (1902–). American painter and printmaker known for her RUBENS-derived style, friezelike compositions and her depictions of New York working women.

BISSIER, JULIUS (1893–1965). German-born Swiss painter, graphic artist and designer. His characteristic works are small, vaguely Oriental in spirit and, although largely nonfigurative, bear a tenuous, somewhat tantalizing relationship to observable phenomena. Typically, his elegant compositions are at once sparse, opulent, calm and tense.

BLADEN, RONALD (1918–). Canadian-born American sculptor and one of the earliest adherents of the MINIMAL style that came into prominence in the mid-1960s.

BLAKE, WILLIAM (1757–1827). English painter, engraver, poet and philosopher. An admirer of FUSELI and JAMES BARRY and an aesthetic adversary of REYNOLDS, he was one of the great visionaries of all time but was somewhat deficient in imparting tangible form to his visions.

William Blake, *Watercolor for Shakespeare's "A Midsummer Night's Dream"*, Tate Gallery, London.

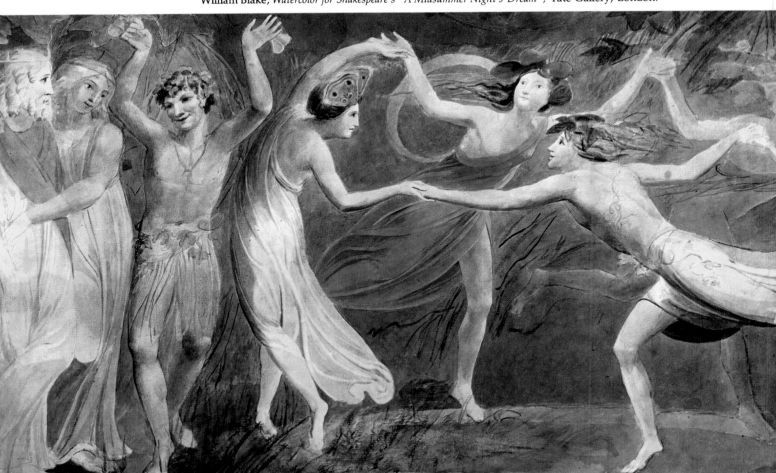

Umberto Boccioni, *Unique Forms of Continuity in Space*, Museum of Modern Art, New York.

Nonetheless, his watercolors and illustrated books, eccentric, influenced by such diverse sources as GOTHIC art and MICHELANGELO and curiously prefiguring ART NOUVEAU, are unique.

BLAKELOCK, RALPH ALBERT (1847–1919). Self-taught American painter of landscapes and American Indian life. Although his early works were quite naturalistic, he is now best known for the melancholic nocturnes of his later, neglected years. Confined to a mental institution for the last 17 years of his life, he was unaware of his considerable, if belated, popular acceptance.

BLANCH, ARNOLD (1896–1968). American painter, illustrator and printmaker. After the early influence of such ASHCAN SCHOOL painters as SLOAN and HENRI, he moved from EXPRESSIONISM to fantasy and, in his last works, leaned toward abstraction.

BLANCHARD, JACQUES (1600–1638). French painter trained in the mannerist style and heavily influenced, during a trip to Italy, by the works of VOUET and GUIDO RENI. Called the "French TITIAN," he fused Italian decoration with northern realism and was an invigorating influence on the French art of his time.

BLARENBERGHE, LOUIS-NICOLAS VAN (Le Grand) (1716–1794). Foremost member of a family of five generations of French miniature painters. Trained by his father, he achieved renown as a battle painter.

BLES, HERRI MET DE (fl. 1535–1550). Flemish landscape painter and supposed nephew of PATINIR, with whom he is often confused. Works ascribed to him are characterized by small figures in panoramic landscapes.

BLOEMAERT, ABRAHAM (1564–1651). Dutch painter and member of a prominent family of artists. Esteemed by RUBENS, among others, he painted in the BAROQUE style and designed stained-glass windows.

BLONDEEL, LANCELOT (ca. 1497–1561). Flemish painter, architect, engraver and designer. A transitional figure in northern painting, he incorporated Italian Renaissance elements into an essentially Netherlandish flamboyant GOTHIC style. Typically, his pictures are ingenious tours de force, but lack cohesion, with his ostensible subjects overwhelmed by fascinating but irrelevant architectural detail. As a designer of sculpture, he is best known for the *Cheminée de France* in the Bruges Palace of Justice.

BLUHM, NORMAN (1920–). American "second generation" abstract-expressionist painter of large gestural canvases.

BLUME, PETER (1906–). Russian-born American painter of precisely rendered, rather fanciful imagery, often incorporating incongruous elements. His best-known work, *The Eternal City* (New York: Museum of Modern Art), a condemnation of Italian Fascism, generated considerable controversy in the 1930s.

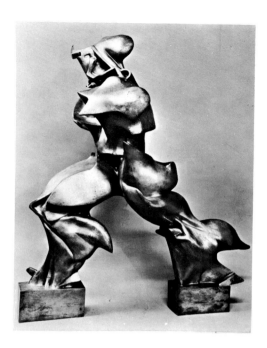

BOCCIONI, UMBERTO (1882–1916). Italian painter and sculptor. One of the leaders and most articulate theoreticians of FUTURISM and that movement's sole sculptor of importance. Although he never implemented the idea himself, he was perhaps the first advocate of motorized sculpture and was one of the earliest artists to combine various metals in a single work, two innovations that were to play prominent roles in CONSTRUCTIVISM. In reaction to IMPRESSIONISM's goal of rendering a particular instant in time, he sought, in both his paintings and sculpture, to depict his subjects in a temporal continuum. Of all the Futurists, he was the least concerned with machine forms and the most humanistic.

BOCKLIN, ARNOLD (1827–1901). Swiss painter, muralist and teacher, best known for his idealized landscapes and allegorical pictures and, in his later works, by a frequent use of symbolism that some authorities have seen as an influence on the SURREALISM of DE CHIRICO.

BOFFRAND, GABRIEL-GERMAIN (1667–1754). French ROCOCO architect known for the luxuriance of his interiors, the relative austerity of his exteriors and his wide-ranging eclecticism.

BOHROD, AARON (1907–). American painter and printmaker. An adherent of Midwestern REGIONALISM during the 1930s, he later turned to still lifes rendered with painstaking meticulousness.

BOILLY, LOUIS-LÉOPOLD (1761–1845). French painter and printmaker best known for his somewhat outmoded, highly detailed genre scenes and small, rather superficial portraits.

BOL, FERDINAND (1618–1680). Dutch painter and etcher who worked in the studio of REMBRANDT and, largely, in his master's style.

BOLDINI, GIOVANNI (1845–1931). An Italian society portraitist whose superficial panache has been likened to that of his contemporary, SARGENT, but whose work suffers from an underlying vacuity.

BOLGI, ANDREA (1605–1656). Italian sculptor and pupil of BERNINI, best known for his colossal *St. Helena* in the crossing of St. Peter's.

BOLOGNA, GIOVANNI (ca. 1529–1608). Flemish-born Italian sculptor who emigrated to Italy in the mid-1550s, studied in Rome and settled in Florence, where he benefited from the patronage of the MEDICI, among others. He took his name from his first important commission, the Fountain of Neptune in Bologna, which was completed shortly after the death of MICHELANGELO and clearly established Giovanni as the preeminent surviving Florentine sculptor. Known for the liveliness and vitality of his works, he worked in a mannerist style that looked forward to the BAROQUE.

BOLSWERT, SCHELTE VAN (ca. 1576–1659). Dutch engraver largely influenced by his friend RUBENS, after whose paintings he made nearly 100 prints.

BOLTRAFFIO, GIOVANNI ANTONIO (ca. 1466–1516). Italian painter and pupil of DA VINCI, best known for his portraits and Madonnas. His drawings in silverpoint were admired by his master, who mentions them in his notebooks.

BOMBOIS, CAMILLE (1883–1970). French self-taught painter known for his convincing delineation of form, the solidity of his figures and the subtle balance of his compositions. Although much of his output consists of street scenes, he is best known for his depictions of the circus life he had experienced first hand as a wrestler.

BONE, SIR MUIRHEAD (1876–1953). Scottish printmaker and painter who, although largely self-taught, is

known for the technical virtuosity of his heavily architectural etchings of current events and for his masterful handling of chiaroscuro.

BONFIGLI, BENEDETTO (ca. 1420–1496). Italian painter and a leading figure of the Umbrian school. Most of his working life was spent in Perugia, where he was much influenced by paintings executed there by FRA ANGELICO, DOMENICO VENEZIANO and FRA LIPPO LIPPI.

BONHEUR, ROSA (1822–1899). French painter and sculptor best known for animal subjects, as exemplified by *The Horse Fair* (New York: Metropolitan Museum), once an enormously popular work but no longer taken with much seriousness.

BONIFAZIO VERONESE (Bonifazio de' Pitati) (1487–1553). Venetian painter and pupil of PALMA VECCHIO, best known for his vast canvases on which religious subjects are depicted in contemporary terms and a Titianesque style.

BONINGTON, RICHARD PARKES (1802–1828). French-trained English painter and watercolorist who was influenced by GIRTIN, CONSTABLE, his teacher GROS and his friend DELACROIX. His early work is markedly romantic, but he soon turned to a more naturalistic style marked by a lightness of approach much admired by Delacroix. At its best, particularly in the watercolors, his work is fluent, spontaneous, immediate and, despite its small dimensions, invested with grandeur. His untimely death cut short a career that seemed destined for true greatness.

BONNARD, PIERRE (1867–1947). French painter. An early associate of the NABIS and a lifelong practitioner of INTIMISM, he was influenced at first by SÉRUSIER and, to a lesser extent, GAUGUIN and TOULOUSE-LAUTREC but later by IMPRESSIONISM. Typically his best works combine the luminosity of Impressionism with the patterning of the Nabis and are distinguished by the refulgence of their color, their general air of serenity, their predominantly warm tonalities and the solidity of their compositional structure. He was also a masterful lithographer whose best prints rival those of his friend Toulouse-Lautrec.

BONNAT, LÉON (1834–1923). French painter of religious and genre scenes and, later in his career, mostly of portraits. Although a poor colorist, he was popular during his lifetime, both as a painter and teacher.

BONTECOU, LEE (1931–). American abstract sculptor best known for her constructions, usually executed in high relief with emphasis on their segmented nature and underlying hollowness and with frank acknowledgment paid to the inherent qualities of the materials used.

BORDONE, PARIS (1500–1571). A Venetian painter and pupil of TITIAN, he retained the latter's bright palette but

Richard Parkes Bonington, *View of Normandy*, Tate Gallery, London.

Francesco Borromini, interior of dome, S. Carlo alle Quattro Fontane, Rome.

lacked both his finesse and profundity. His most successful work is the Titianesque *Fishermen Consigning a Ring to the Doge* (Venice: Academy), painted around 1534.

BORGLUM, GUTZON (1867–1941) and **SOLON HANNIBAL** (1868–1922). American sculptor-brothers best known for public statuary, of which the most famous example is Gutzon's colossal Presidential group on the face of Mt. Rushmore, South Dakota. Solon, less grandiose, also is known for his small depictions of western themes.

BORRASSA, LLUIS (fl. ca. 1400–1425). Catalan painter who worked in the Kingdom of Aragon, where he was famous for elaborate, somewhat unfocused altarpieces that combined Sienese influences with the emergent IN-TERNATIONAL GOTHIC style.

BORROMINI, FRANCESCO (1599–1667). One of the outstanding Italian architects of the BAROQUE era, he became BERNINI's chief assistant in 1631, after first working under CARLO MADERNA, a relative, but had a falling out with Bernini and thenceforth operated independently. His first important commission resulted in the rhythmic design for the small church of S. Carlo alle Quattro Fontane, which is marked by its oval plan, generous use of counterpoised concavities and convexities and its unusual honeycombed dome. This was followed by his masterwork, the design for Sant' Ivo della Sapienza (1642–1660), an inventive structure that seems to seethe with

ascending movement and typifies the aesthetics of the High Baroque. His highly original, often eccentric designs strongly influenced the late Baroque architecture of central Europe.

BOSCH, HIERONYMUS (Hieronymus van Aeken) (ca. 1450?–1515). Flemish painter. A unique and perhaps the most enigmatic and most diversely interpreted figure in the history of Western art, he was born in 's Hertogenbosch, an obscure town in Brabant, and, insofar as is known, never left there. By whom (or even whether) he was trained is unknown. Data on his life are almost nonexistent. There is little affinity between his own and contemporaneous painting, either stylistically or iconographically, and his religious and philosophical beliefs are conjectural in the extreme and the subjects of endless debate. All that is known for a certainty is that he was one of the indubitable geniuses not only of the waning Middle Ages but of all time, one of the very few artistic creators who conceived and fully and convincingly populated a world of his own imagining.

In its totality, Bosch's fantastic imagery constitutes an original and richly comprehensive flight of the imagination almost without parallel in whole cultures, let alone the oeuvre of single artists. Hardly less astonishing was the awesome sweep and total command of his more ambitious pictures, which take the form of panoramic views peopled with hundreds of moving figures and seen as though from a vantage point high above the action—in itself a near-inconceivably imaginative flight of fancy for an artist working in the flat lowlands.

Thus far, all attempts to posit Bosch stylistically, iconographically or in terms of influences (the influences of others upon him or of his own on such later movements as SURREALISM) have raised more questions than they have answered. His *Garden of Earthly Delights* (Madrid: Prado) is generally considered to be among a handful of the most affecting pictures ever painted, although few of its innumerable exegetes have agreed on any matters concerning it. Like its author, it and the rest of Bosch's output are singular, inexplicable phenomena.

BOSSE, ABRAHAM (1602–1676). French etcher, engraver and author of the first book published on engraving whose various series on such subjects as *The Five Senses* and *The Four Seasons* document the life and trappings of his times in great detail.

BOTERO, FERNANDO (1932–). Colombian painter of grotesque, dwarflike enigmatic figures.

BOTH, ANDRIES DIRKSZ. (ca. 1612—1641) and **JAN** (ca. 1617–1652). Dutch painters, Andries specializing in genre and religious pictures and his brother in landscapes. They both studied with their father Dirck Both and with ABRAHAM BLOEMAERT and ended their careers in Venice.

Hieronymus Bosch, the central section of the triptych *The Gardens of Earthly Delights*, Prado, Madrid.

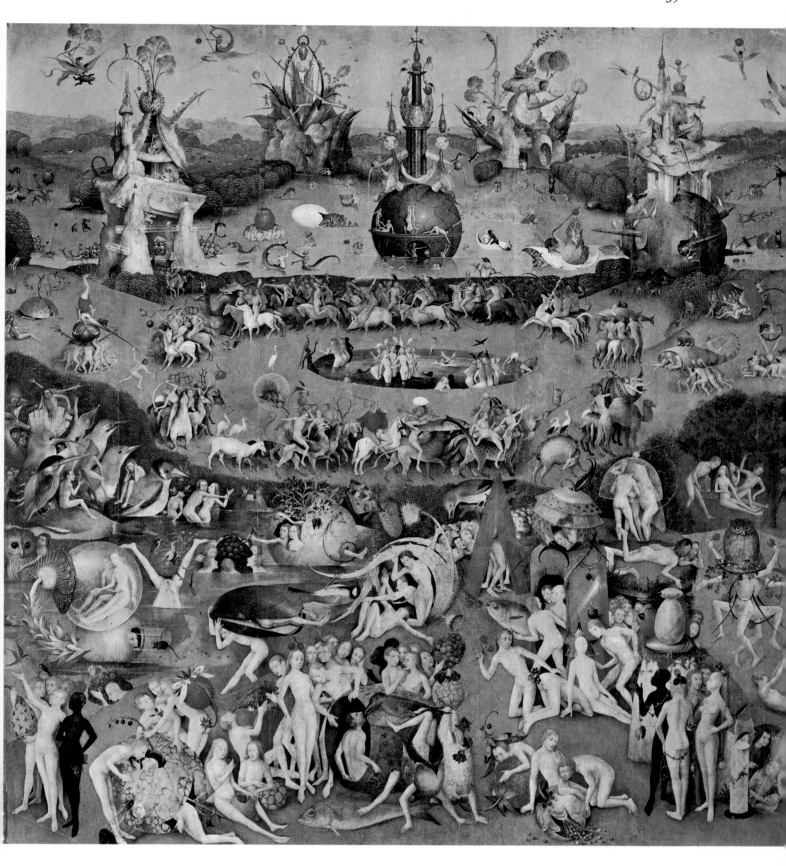

Sandro Botticelli, *Man with a Medal*, Uffizi, Florence.

BOTTICELLI, SANDRO (Alessandro di Mariano Filipepi) (ca. 1445–1510). Florentine painter. Apprenticed to a goldsmith in his early youth, he later may have been taught by FRA FILIPPO LIPPI and eventually fell under the influence of PIERO and ANTONIO POLLAIUOLO and VERROCCHIO. The greatest of those late quattrocento painters who rejected the naturalism of MASACCIO and created a GOTHIC revival of sorts, he is unrivaled for the supple linearity of his mature period, which began in the early 1480s, when, with PERUGINO and ROSSELLI, he worked on the fresco cycle in the SISTINE CHAPEL. Best known for such mythological allegories as the *Primavera* and the *Birth of Venus* (both in Florence: Uffizi) —allegories that some observers consider to be less concerned with their ostensibly pagan themes than with the Platonic ideas then being espoused by Marsilio Ficino —his later works, possibly influenced by the preachings of Savonarola, are far more fervent and visionary, anticipating MANNERISM much as the lyrical work of the 1480s anticipated the work of the PRE-RAPHAELITES in the latter half of the 19th century.

BOTTICINI, FRANCESCO (1446–1497). An Italian painter of the FLORENTINE SCHOOL, he worked in an eclectic style derived from the masters of the quattrocento.

BOUCHARDON, EDMÉ (1698–1762). French sculptor and medalist and an initiator of the classical reaction against the ROCOCO style. Best known for his *Fountain of the Seasons*, Paris.

BOUCHER, FRANÇOIS (1703–1770). French decorative painter and tapestry designer. Described by the Goncourts as "one of those men who typify the tastes of a century," he was the preeminent visual chronicler of the frivolous life as it was lived (by those who had the means to live it) in France around the mid-18th century. Taught by LEMOYNE, associated closely with WATTEAU and influenced by RUBENS, he traveled early in his career to Rome, where he absorbed certain stylistic elements from ALBANI and TIEPOLO. Best known for his insouciant *scènes galantes*, he was frequently attacked during his lifetime for his failure to come to grips with reality—a charge he countered by condemning nature as "too green and badly lit." In his own work and that of his most gifted pupil, FRAGONARD, the French ROCOCO reached its peak.

BOUCICAUT MASTER (fl. 1410–1415). An anonymous Franco-Flemish illuminator, he is named for the book of hours he decorated for Jean le Meingre, known as Boucicaut II (Paris: Musée Jacquemart-André), and important for his spatial and perspectival inventiveness and innovative use of genre motifs.

BOUDIN, EUGÈNE LOUIS (1824–1898). French landscapist best known for his almost invariably horizontal, proto-impressionistic studies of beaches, skies and the

François Boucher, *Madame de Pompadour*, Wallace Collection, London.

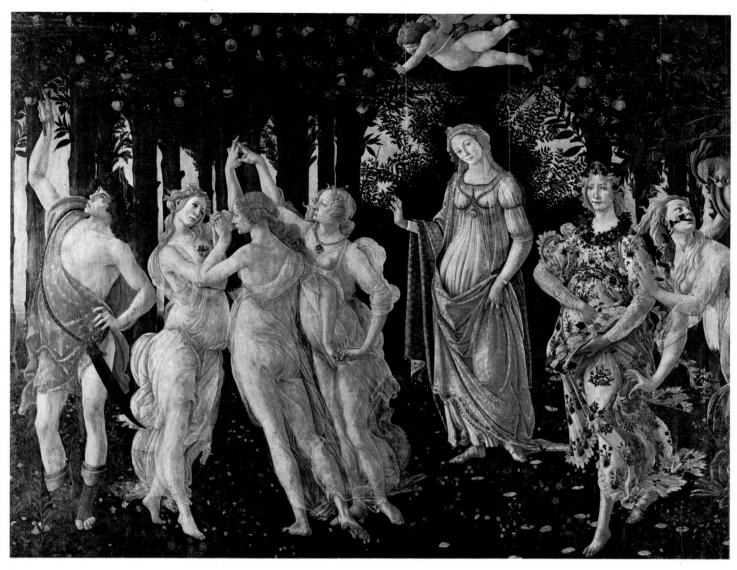

Sandro Botticelli, *La Primavera (Spring)*, detail, Uffizi, Florence.

changing aspects of the sea and for his early recognition and encouragement of MONET. Influenced by JONGKIND and, in a more theoretical way, by Baudelaire, his popular beach scenes were infused with a freshness, immediacy and gaiety most closely paralleled, until the onset of IMPRESSIONISM, by the oil sketches of CONSTABLE.

BOUGUEREAU, ADOLPHE WILLIAM (1825–1905). A French painter, immensely popular during his lifetime but now largely scorned, of meticulously rendered, somewhat erotic mythological scenes.

BOURDELLE, ÉMILE ANTOINE (1861–1929). French sculptor and teacher. After working as an assistant to RODIN, he reacted against the latter's romanticism and developed a more classical style. During the last two decades of his life, he taught sculpture in a Paris studio that later became the art school La Grande Chaumière.

BOURDIN, MICHEL I (fl. 1610–ca. 1635) and **MICHEL II** (1609–1678). French sculptors, largely of funerary works, of whom the father is considered the more important.

BOURDON, SEBASTIEN (1616–1671). French eclectic painter who worked in the styles of LE NAIN, CLAUDE LORRAINE, POUSSIN, the Dutch genre painters and others and for a two-year period was court painter to Queen Christina of Sweden.

BOURGES: CATHEDRAL OF ST. STEPHEN. One of the finest edifices of the GOTHIC era, it was begun in the late 12th century on the site of earlier structures and largely finished by 1324. Its crypt is the largest and most splendid in France, and its five-doored façade, with its great central gable and window and pedestal of 15 steps, designed by Guy de Dammartin, is in itself a masterpiece

Donato Bramante, Tempietto, Rome.

of the Gothic style. The cathedral's nave, unbroken by transepts, is notable for its unity.

BOUTS, DIERIK (1410?–1475). Netherlandish painter who worked in Louvain and served as a stylistic link between such early northern masters as the VAN EYCKS and ROGIER VAN DER WEYDEN and those of MEMLING's generation. His known works, derived largely from Van der Weyden, are distinguished by their masterful use of linear perspective to create a convincing illusion of deep space. His sons Aelbrecht (ca. 1460–1549) and Dierik (d. ca. 1490) were among younger painters he influenced.

BRACQUEMOND, FÉLIX (1833–1914). French etcher, painter and designer, best known for his portraits, bird etchings and reproductive prints.

BRAMANTE, DONATO (1444–1514). The greatest Italian architect of the High Renaissance, he began his career as a painter and subsequently put his highly developed knowledge of perspective to use in his first building, Sta. Maria presso S. Satiro, a small Milanese church begun in 1482 and notable for the illusion of depth and amplitude conveyed by its shallow apse and dome. In 1499, with the defeat of Ludovico Sforza by Louis XII, he left Milan for Rome, where he was commissioned to design the cloister of S. Maria della Pace. From 1505 onward, he worked for Pope Julius II on a variety of projects that established his claim to preeminence among the architects of his century. His Roman works, in which the examples of classical antiquity blend with the residual influence of BRUNELLESCHI, are distinguished by their emphasis on sculptural

Constantin Brancusi, *The Golden Fish*, Museum of Fine Arts, Boston, W.F. Warden Fund.

form, severity and monumentality and their eschewal of Bramante's earlier painterly and decorative concerns.

Under Julius' patronage, which began with a commission for the Belvedere courtyard, Bramante's career came to its full, final flowering with his design for the new ST. PETER'S CATHEDRAL (although his destruction of the original building earned him the sobriquet Il Ruinante). His plan, complicated after his death by a succession of lesser architects and finally adopted in somewhat modified form by MICHELANGELO, called for a Greek cross enclosed in a square, with a Pantheon-like drum surmounted by a dome at the crossing and with smaller domes at the square's corners. As *capomaestro* of St. Peter's, he trained a host of younger architects who carried his influence well into the 16th century until BERNINI created the BAROQUE style in reaction against it.

BRANCUSI, CONSTANTIN (1876–1957). Rumanian sculptor who worked in Paris after studying in Bucharest (where he executed an anatomical study later used in medical schools), Vienna and Munich. Abandoning the naturalism of his student years, he had by 1906 developed a personal style influenced by African sculpture and marked by its simplicity of outline and cohesiveness of form. He was an extremely controversial artist during his lifetime, and a lawsuit against the U.S. Bureau of Customs, which refused to recognize his most famous

work, *Bird in Space*, as art, was a *cause célèbre* in the 1920s. His mature works, marked by the extreme simplicity to which he reduced natural forms and by craftsmanship and surface finish of the highest order, are among the most influential of the monolithic works of modern art.

BRANDT, WARREN (1918–). An American painter who, after working in the abstract-expressionist style, reverted to a figurative style derived from MATISSE.

BRANGWYN, SIR FRANK (1867–1956). English painter, muralist and etcher born in Bruges of Welsh parentage. Best known for his marine subjects and his posters he designed during World War I.

BRAQUE, GEORGES (1882–1963). French painter, co-creator, with PICASSO, of CUBISM and one of the indisputable giants of modern art. After studying in Le Havre and Paris, he befriended FRIESZ around 1905 and fell heavily under the influence of FAUVISM, although his work from the outset was more rigorously ordered than that of the other Fauve painters. In 1907, his natural tendency toward structured composition was reinforced by what he saw at the Salon d'Automne's great retrospective exhibition of the works of CÉZANNE, who had died some months earlier. He met Picasso the same year and, stimulated by African sculpture, the two men soon formulated

Georges Braque, *The Portuguese*, Public Art Collections, Basel.

Georges Braque, *Still Life with Fish*, Tate Gallery, London.

the theoretical basis for Cubism and painted the first Cubist pictures. Within four years, both artists had created some of the masterworks of ANALYTICAL CUBISM and, consequently, of modern art in the West.

Although he and Picasso generally are given joint credit for the invention of Cubism, it would seem that the first use of collage elements (and with it the advent of Synthetic Cubism) can be ascribed to Braque alone, who glued to his canvases cut and torn paper and veneers of the type his father, a designer-craftsman, had worked with during the artist's youth. After World War I, in which he was seriously wounded, his style became less monochromatic (as did Picasso's) and his form flatter and less dependent on the overlapping, interlocking planes of Analytical Cubism. As his career progressed, his work grew subtler, more lyrical, more broadly patterned and more masterfully orchestrated. In his last years, birds in flight became an almost obsessive motif and the subject of works as varied as public murals and richly textured illustrations for a poem by St. John Perse.

BRAY (Braij), DIRCK DE (ca. 1650–1700), **JAN SALOMONSZ. DE** (ca. 1626–1697) and **SALOMON DE** (1597–1664). Dutch painters. Like his father Salomon, Jan was an architect as well as a specialist in portraits and historical subjects. Jan's brother Dirck was primarily a printmaker specializing in birds and botanical studies.

BRESDIN, RODOLPHE (1822–1885). French printmaker known for his prolix and often grotesque Gothic landscapes and genre scenes.

BRETON, ANDRÉ (1896–1966). French poet, critic and belles-lettrist and a leading exponent and formulator first of the DADA movement and later of SURREALISM. He was the author of two Surrealist manifestoes, and his theoretical views greatly influenced the Surrealist painters.

Agnolo Bronzino, *Eleanora di Toledo and Her Son*, Uffizi, Florence.

BREU, JORG (1475–1537). German eclectic painter, printmaker and illustrator, noted for his mastery of landscape elements and his grotesque, rather caricatural figures.

BREUER, MARCEL (1902–). Hungarian-born, BAUHAUS-educated American architect and designer and former partner of GROPIUS. One of the pioneers and foremost exponents of the use of modular units and tubular steel, both in his furniture design and severely geometrical architecture (the latter's austerity often softened by an astute use of texture), as well as his teaching at Harvard University, he has been widely influential. He designed the Whitney Museum of American Art, New York, and was co-designer of the UNESCO Headquarters Building, Paris.

BRIL, MATTHYS (1550–1583) and **PAUL** (1554–1626). Flemish brothers and painters who worked and died in Rome. Paul was much admired in his time and to some extent foreshadowed POUSSIN and LORRAINE.

BRIOSCO, ANDREA (ca. 1470–1532). Italian sculptor, goldsmith and architect known for his metalwork.

BROEDERLAM, MELCHOIR (fl. 1385–1400). Franco-Flemish painter best known for his masterful organization of the decorations for an altarpiece made for his patron Philip the Bold of Burgundy (Dijon: Musée de la Ville), the earliest surviving work in the Franco-Flemish style that later was subsumed into the INTERNATIONAL GOTHIC.

BRONZINO, AGNOLO (Agnolo di Cosimo di Mariano) (1503–1572). Italian mannerist painter. An apprentice and later assistant to PONTORMO until that master's death, he worked mostly in Florence, where he earned the influential patronage of the Medici, whose portraits he painted with consummate elegance and dazzling finish in a style derived from Pontormo but much modified by his own

sensibilities. His religious works, painted in much the same style as his portraits, border on the ludicrous, but the latter, although much imitated, constitute a unique corpus of work and the very embodiment of Medici self-esteem during the reign of Cosimo I.

BROOKS, JAMES (1906–). American painter and a leading exponent of ACTION PAINTING.

BROUWER, ADRIAEN (ca. 1605–1638). Flemish painter who either studied under or was less directly influenced by FRANS HALS and was much admired by RUBENS. Best known for his raffish genre scenes of carousing peasants, painted in warm tones and fluent strokes, he showed great promise as a landscapist toward the end of his life.

BROWN, FORD MADOX (1821–1893). An English painter and designer contemporaneous with the PRE-RAPHAELITE BROTHERHOOD, which he influenced and was influenced by. His landscapes, free of the excessive sentimentality of his narrative and allegorical pictures, are still much admired.

BRUCE, PATRICK HENRY (1880–1937). American abstract and semi-abstract painter who studied with MATISSE in Paris and later became identified with ORPHISM.

BRUEGHEL. Variously spelled surname of a family of Flemish painters active in the 16th, 17th and 18th centuries.

BRUEGHEL, JAN THE ELDER (Velvet Brueghel) (1568–1625). Flemish painter, second son of PIETER BRUEGHEL THE ELDER and associate of RUBENS, he supposedly studied with CONINXLOO. Perhaps the finest

still-life painter of his time, he was an exquisite landscapist and the creator of such complex allegorical cycles as "The Five Senses" and "The Four Elements."

BRUEGHEL, PIETER THE ELDER (Peasant Brueghel) (ca. 1527–1569). The preeminent Flemish painter of his time and one of the reigning masters of all time, he was trained by PIETER COECKE VAN AELST and by HIERONYMUS COCK, through whose engravings he was introduced to the works of BOSCH. Registered as a master painter in Antwerp in 1551, he traveled to Rome sometime thereafter and from 1555 onward worked in Antwerp and Brussels.

Although strongly influenced by Bosch throughout his career, he was a radically innovative painter who moved from religious to satirical to fantastic to allegorical to genre subjects with complete facility, often with a subtlety that made it difficult for viewers to differentiate one type from another and always with an astute eye for telling detail and rightness of gesture. Typically, his pictures seem almost to have been "snapped" at what the photographer Cartier-Bresson has called "the precise moment": the frozen instant in which they yield up their ultimate potentiality. In his later period, moreover, he developed into a landscapist of breathtaking capability, depicting vast panoramic vistas almost as they might appear in a horizon-to-horizon visual sweep and punctuating them with bits of minutiae that have about them an eerie inevitablity.

Brueghel's keen observation of visual detail was matched by his penetrating insights into the nature of human behavior, insights he expressed in such turbulent compositions as *The Triumph of Death* (Madrid: Prado). As he matured his ability to depict movement, apparent in his earliest works, progressed from a mastery of surface rhythm to one that extended into pictorial space, while his style became looser and more perfunctory. At no time in his career did his travels in Italy appear to affect him stylistically, and although he worked within the traditions of prior Netherlandish painting, his oeuvre represents a quantum jump that transformed those traditions radically and whose influence was widespread and ongoing.

Despite his sobriquet (which derived from his keen and sympathetic observation of peasant life), Brueghel was one of the most sophisticated humanists of his time and, from the internal evidence of such works as *The Massacre of the Innocents* (Vienna: Museum of Art History), seems to have risked the fury of the Spanish oppressors of the Low Countries. He was also a prolific printmaker whose engravings were widely disseminated among, and had great impact upon, the artists of his own and the following generations.

BRUEGHEL, PIETER THE YOUNGER (Hell Brueghel) (1564–1638). Flemish painter of genre and religious scenes, brother of JAN BRUEGHEL and pupil of CONINXLOO and his grandmother Maria Verhulst. Much influenced

Pieter Brueghel the Elder, detail from *The Painter and the Connoisseur*, Graphische Sammlung Albertina, Vienna.

Pieter Brueghel the Elder, *The Harvest*, Metropolitan Museum of Art, New York.

by his father, of whose works he made numerous copies, he in turn influenced FRANS SNYDERS and his own son, Pieter III.

BRUNELLESCHI, FILIPPO (1377–1446). Italian architect and sculptor and one of the prime movers of the Italian Renaissance. A master goldsmith at 27, he effected repairs on the Ponte a Mare, Pisa, about a decade later and by 1417 is recorded to have been vying for what three years later was to become his best-known commission: construction of the dome of the FLORENCE CATHEDRAL. Much influenced by Roman architectural forms and engineering and by his study of mathematics, his mature works, unlike his earlier buildings with their linear emphasis, are notable for their sculptural plasticity. Although his plans often were frustrated, he was one of the earliest architects concerned with the contexts in which buildings were to be placed and not just with buildings as self-contained entities.

His greatest feat, raising the dome of Florence Cathedral, solved a problem that long had vexed a succession of predecessors that had begun with ARNOLFO DI CAMBIO and included GIOTTO, ANDREA PISANO and FRANCESCO TALENTI. The space to be covered was vast, and Brunel-

Pieter Brueghel the Elder, detail from *Harbor with Ships*, Doria Pamphili Gallery, Rome.

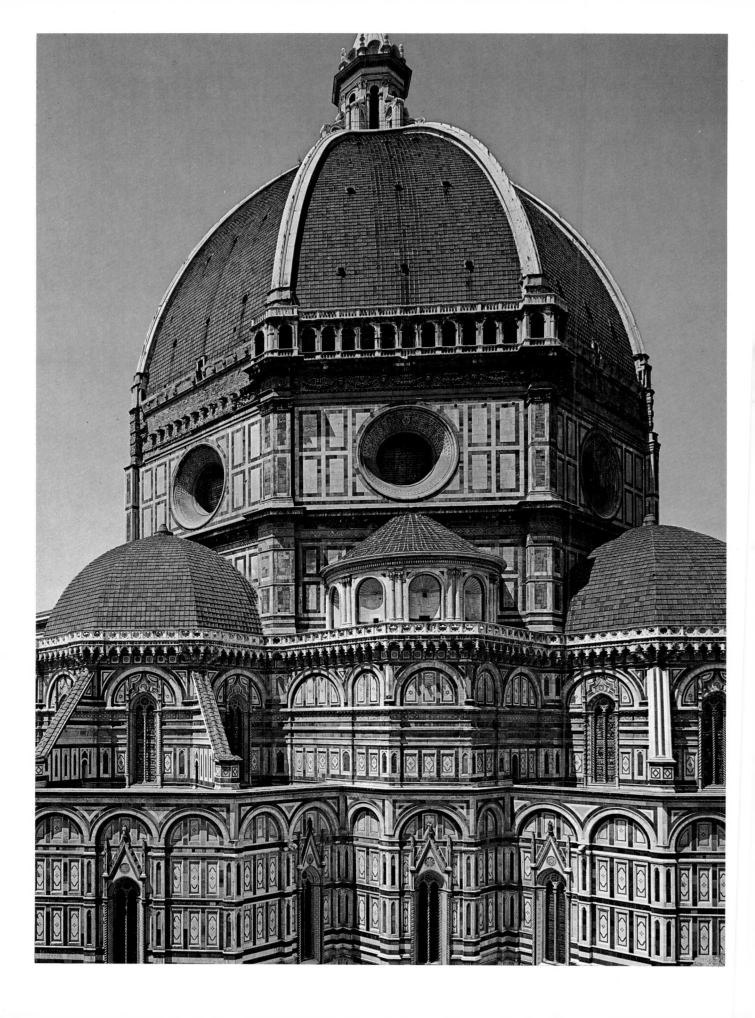

leschi audaciously proposed to erect his dome without centering (temporary supports). To effect his plan, he buttressed the walls of the octagonal crossing with three half-domed chapels, then constructed a system of external ribs that culminated in a central apex and, in effect, hung the dome's shell from those ribs. Although the device was essentially GOTHIC, its use was highly innovative in that it marked the first time that a dome's exterior was as strongly sculptural and as deliberately designed as its interior.

BRUYN, BARTHEL (or Bartholomaus), THE ELDER (1493–1555). German painter known for his successful fusion of the late Netherlandish and Renaissance styles and considered to be an outstanding portraitist of the 16th century. A native of Wesel, he spent most of his life in Cologne, where he attained political eminence.

BRYGOS PAINTER (fl. 500–475 B.C.). An Attic vase painter in the red-figured style, he depicted both genre and narrative subjects with great virtuosity.

BUFFET, BERNARD (1928–). French expressionist painter whose spare, somber figurative pictures enjoyed a considerable international vogue in the 1950s but are taken less seriously today.

BULFINCH, CHARLES (1763–1844). American self-taught architect influenced by ROBERT ADAM and other English architects. Known for his blocks of residences in Boston and for the Massachusetts and Connecticut statehouses, in which he combined NEOCLASSICAL and PALLADIAN influences, he worked on the U.S. national Capitol (1813–1830) as successor to LATROBE.

BUON (or Bono) FAMILY. A workshop of related Italian sculptors and architects of whom the best known were Giovanni (fl. ca. 1390– ca. 1443) and his son Bartolommeo (ca. 1374– ca. 1465), who worked in and around Venice.

BUONTALENTI, BERNARDO (1536–1608). Florentine architect, sculptor, painter, designer and military engineer. A pupil of MICHELANGELO and follower of AMMANATI, he worked chiefly for the Medici grand dukes, for whom he finished VASARI's Uffizi and designed parts of Palazzo Vecchio, among other commissions. Known as ''Della Girandole'' for his elaborate fireworks displays.

BURCHFIELD, CHARLES (1893–1967). American romantic painter known for his vaguely surrealistic landscapes, townscapes and somewhat sinister depictions of rain-washed buildings and trees.

BURGKMAIR, HANS THE ELDER (1473–1531). German painter and woodcut designer. Trained by his father and SCHONGAUER, he probably traveled in Italy before settling in his native Augsburg. His paintings are distinguished by their Italianate warmth of color, and his woodcut designs are technically influenced by DÜRER, with whom he shared the patronage of Maximilian I.

Filippo Brunelleschi, dome, Cathedral of Sta. Maria del Fiore, Florence.

BURGOS CATHEDRAL. Spanish multi-spired edifice begun in the lst quarter of the 12th century and completed in the 18th century. Known for its variety of forms, its openwork pinnacles and vault, its fanciful silhouette, the profusion of its sculptural embellishments and its octagonal Condestable Chapel designed by the German father-and-son architects Juan and Simon de Colonia.

BURLIN, PAUL (1886–1969). American painter and printmaker. One of the first Americans to be influenced by the European modernist movement, he exhibited in the 1913 ARMORY SHOW. Later, he was influenced more directly by the Indian art of the American Southwest and CUBISM as exemplified by GLEIZES and still later by PICASSO and ABSTRACT EXPRESSIONISM.

BURLIUK, DAVID (1882–1967). Russian-born American painter who, after working in various manners derived from CUBISM and FUTURISM, developed a characteristic expressionist style more reminiscent of VAN GOGH.

BURNE-JONES, SIR EDWARD COLEY (1833–1898). English painter and designer. After deciding on a career in the church, he befriended WILLIAM MORRIS at Oxford and, with him, soon turned to art. Trained by ROSSETTI, whom he later worked with, he traveled in Italy, where he was influenced by various 15th-century painters and by Byzantine mosaics. For the last two decades of his life, he was enormously popular for his meticulously rendered but nonetheless dreamlike, markedly erotic pictures of Medieval subjects and for his stained-glass designs and book illustrations.

BURNHAM, DANIEL HUDSON (1846–1912). American architect and city planner best known for the Flatiron Building, New York, of which he was co-designer.

BURRI, ALBERTO (1915–). Italian abstract painter known for his assemblages in which the nature of such materials as raw burlap, charred wood and jagged sheet metal is stressed to the exclusion of other pictorial considerations.

BURY, POL (1922–). Belgian sculptor and printmaker best known for kinetic works whose action consists of a barely perceptible volumetric waxing and waning.

BUSHNELL, JOHN (fl. last 3rd of 17th century; d. 1701). English sculptor who traveled in Italy and is of importance chiefly as a conduit through which the BAROQUE style was introduced into England.

BUTLER, REG (Reginald Cottrell) (1913–). English sculptor and teacher. His best-known work was *The Unknown Political Prisoner* (destroyed), which generated a storm of controversy when it won the Grand Prize in the International Sculpture Exhibition in 1954 (a maquette survives in New York: Museum of Modern Art). His vaguely figural, rather skeletal metal shapes suggest mantises and dragonflies.

BUTTERFIELD, WILLIAM (1814–1900). English architect whose work is characterized by its geometric polychrome surface decoration.

C

CABANEL, ALEXANDRE (1823–1889). French painter best known for the thinly disguised eroticism of his academically painted historical and mythological pictures.

CABRERA, MIGUEL (1695–1768). A Mexican painter, chiefly of portraits and religious subjects. His work is characterized by its flatness, simplicity and attention to detail.

CADMUS, PAUL (1904–). American realist painter of meticulously rendered satirical subjects.

CAFFA, MELCHIORRE (1635–1667). Italian sculptor and follower of BERNINI, he was one of the most promising artists of the BAROQUE but died before realizing his potential.

CAILLEBOTTE, GUSTAVE (1848–1894). French impressionist painter best known for his advocacy of MONET and RENOIR and as a discriminating art collector.

CALAME, ALEXANDER (1810–1864). Swiss painter and printmaker best known for his romantic landscapes.

CALCAR, JAN STEPHAN VON (1499–ca. 1548). German painter and woodcut designer who worked in Italy, where he studied with TITIAN and designed the superb anatomical illustrations for Vesalius' *De humani corporis fabrica* and related works.

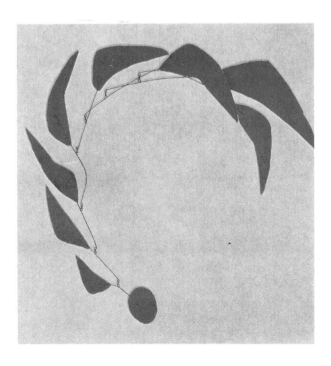

CALDECOTT, RANDOLPH (1846–1886). English painter and humorous illustrator of *Punch* and similar publications.

CALDER, ALEXANDER (1898–). American sculptor, painter and printmaker. Although his father and grandfather were sculptors, he began his career as an engineer but later became an illustrator and then a serious painter. After moving to Paris and taking up wood sculpture, around 1926 he began experimenting with wire, a medium in which he created the kind of three-dimensional line drawing that characterizes much of his intricate whimsical work, *The Circus*, an agglomeration of manually operated toys that made him quite well known in European artistic circles and that now is on extended loan to the Whitney Museum, New York. His single most innovative contribution to sculpture, the MOBILE (a term coined for his work by DUCHAMP), doubtless evolved out of *The Circus* and first took a manually impelled form in 1931. A year later he made the first of innumerable mobiles designed to move as random air currents washed against their small saillike elements. Much of Calder's work is characterized by its lightness, whimsy and charm, but many of his pieces, particularly the so-called "stabiles," are invested with an almost intimidating scale and presence. In his sculpture, his primary concern has been spatial, with volume described rather than realized.

CALDER, ALEXANDER STIRLING (1870–1945). American sculptor, son of the sculptor Alexander Milne Calder, whose figure of William Penn surmounts Philadelphia City Hall, and father of ALEXANDER CALDER. Known best for such portraits as those of Audubon and Penn in the American Hall of Fame, New York.

CALLOT, JACQUES (1592/3–1635). French etcher and engraver who worked for a time in the Medici court, depicting Florentine life in a series of sprightly prints. Known for his wide range of subject matter, his technical skill and his thematic influence on later artists, especially GOYA, whose *Disasters of War* were patterned in large part on Callot's *Grandes Misères de la Guerre*.

CALVAERT (Calraet), ABRAHAM VAN (1642–1722). Dutch painter and probable pupil of CUIP, with whose work much of his own is confused.

CALVAERT, DENIS (1540–1619). Flemish mannerist painter who spent most of his career in Bologna, where he founded an academy and heavily influenced such pupils as ALBANI, DOMENICHINO and RENI.

CALVERT, EDWARD (1799–1883). English painter and printmaker much influenced by BLAKE and, to a lesser degree, by PALMER. His early, and probably best, work comprises a visionary, detailed and sensitively realized celebration of nature, but he later adopted a more formal style.

CAMBIASO, LUCA (1527–1585). Italian painter who worked chiefly in Genoa, where he was the city's dominant painter, and, at the end of his life, in Spain, where

Alexander Stirling Calder, *Mobile*, private collection, Paris.

Canaletto, *The Bay of S. Marco in Venice*, Museum of Fine Arts, Boston, Ch. E. French Fund.

he worked at the ESCORIAL at the invitation of Philip II. He was influenced by BECAFUMI, PERINO DEL VAGA, CORREGGIO and MICHELANGELO. His work is characterized by its simplification of form, dry texture and limited use of color. His figures tend to be schematic, and, not surprisingly, in many of his drawings the human figure is reduced to a series of blocky geometric forms.

CAMPAGNA, GIROLAMO (ca. 1550–1626). Italian sculptor and architect who executed much public statuary in Venice.

CAMPAGNOLA, DOMENICO (1500–ca. 1581). Italian painter and engraver and adoptive son and pupil of GIULIO CAMPAGNOLA. Much influenced by TITIAN, with whom he may have worked for a time, he in turn influenced WATTEAU.

CAMPAGNOLA, GIULIO (ca. 1482–ca. 1517). Italian engraver, sculptor and poet whose early prints are characterized by their linearity but whose later work employs a kind of stipple effect in emulation of the soft, merging forms of GIORGIONE.

CAMPANA, PEDRO (Pieter Kempeneer). Flemish painter, architect and sculptor who worked in Italy and mostly in Spain. Painting in a mannerist style derived in part from RAPHAEL and TINTORETTO, he considerably influenced Spanish art in his time.

CAMPEN, JACOB VAN (1595–1657). Dutch painter and architect best known for his design for the Royal Palace of Amsterdam.

CAMPENDONK, HEINRICH (1889–1957). German painter, printmaker and teacher loosely associated with and heavily influenced by the BLUE RIDER group at the outset of his career and, successively, by CHAGALL and SYNTHETIC CUBISM.

CAMPHUYSEN, GOVERT DIRCKSZ. (1623/24–1672) and **RAFAEL GOVERTSZ.** (1597/98–1657). Dutch brothers and painters. Govert painted landscapes and animal and genre subjects in a style resembling that of PAULUS POTTER. Rafael's known works are chiefly landscapes. A third brother, Jochem, also painted.

CAMPI, ANTONIO (ca. 1525–1587). The best-known member of a family of 16th-century Italian painters. His frescoes, many of them in nocturnal settings.

CAMPIN, ROBERT. See MASTER OF FLÉMALLE.

CANALETTO (Giovanni Antonio Canal) (1697–1768). Venetian view painter. After being trained as a theatrical decorator by his father, he traveled to Rome, where he fell under the influence of various topographical artists. On his return to Venice he took up view painting under the patronage of a largely English clientele. Although his

early works in the genre were warm-toned and rather broadly painted, his pictures from about 1730 onward are distinguished by greater linearity and clarity and a lighter, cooler palette. In the views of the next decade, however, he reverted to darker tones and strongly contrasting chiaroscuro. He spent the years 1745–1755 in England, where he was much in demand for his views of London and paintings of great houses, then returned to Venice, where he remained until his death. Though he was a superb etcher himself, his paintings were widely known throughout Europe and Britain through the many reproductions of them by Antonio Visentini and other engravers. While the works of his English and final Venetian days are rather mannered and often quite mechanical, at his best Canaletto was a superb observer and a master of pictorial organization. His much imitated canvases, suffused with light and air, had a marked influence on 19th-century landscape painting in England and on the Continent.

CANO, ALONSO (1601–1667). Spanish sculptor, painter and architect. One of the stormiest figures in the history

of Spanish art, he was the son of a minor artist, Miguel Cano, and was trained as a painter by PACHECO and Juan del Castillo, the teacher of MURILLO, and influenced in his sculpture by MONTAÑES. Having left Seville, his boyhood home, as a result of a blood feud with another artist, he worked in Madrid, where, as a restorer of the royal collection, he got to know, and fell under the influence of, the works of the Venetian masters. Forced to flee the capital after his wife was murdered in another vendetta, he settled in Granada, where he produced several pieces of sculpture whose grace and serenity hardly reflected his own life style. After a violent falling-out with the clergy, he returned to Madrid. Four years later he was back in Granada, where he designed the cathedral façade and produced his finest sculpture—a group of polychrome works distinguished by their grace, harmony, masterful modeling and dramatic use of lighting. His paintings, though less successful and somewhat mawkish, are nonetheless skillfully executed.

CANOGAR, RAFAEL (1935–). Spanish painter known for collages that incorporate figurative and abstract elements and subtle use of color, some of which "bleeds" through from the backs of his canvases.

CANOVA, ANTONIO (1757–1822). Italian sculptor and a foremost exponent of NEOCLASSICISM. His work is characterized by its extremely high finish, its curiously linear, somewhat two-dimensional appearance and the peculiar aura of chilly sensuousness exuded by such works as his *Venus Victrix*, a recumbent figure of Pauline Borghese (Rome: Villa Borghese). He was admired by Napoleon for his occasional exercises in sheer flatulence, but his attempts to deal with Bonaparte as a classical nude and Washington as a Roman conqueror border on the ludicrous.

CANTARINI, SIMONE (1621–1648). Italian painter and engraver. His eclectic style anticipated and probably influenced late-17th-century painting in his adopted city of Bologna.

CANTERBURY CATHEDRAL. English ROMANESQUE cathedral begun in 1070 and enlarged and rebuilt at various times during the next several centuries, when various GOTHIC and TUDOR elements were added. Its crypt is one of the largest in Britain, and its central tower, designed by John Wastell in the late 15th century, is notable, as is its early-13th-century stained glass.

CAPPELLE, JAN VAN DE (ca. 1624–1679). Self-taught Dutch painter and art collector known for the luminosity of his marine subjects.

CARACALLA, BATHS OF, ROME. Unusually complete remains of Roman baths constructed in the early 3rd century by Marcus Aurelius Antoninus and the site of excavations, begun under Pope Julius II, that uncovered such works as the FARNESE BULL and the FARNESE HER-

Antonio Canovo, detail from *Pauline Borghese*, Borghese Gallery, Rome.

Caravaggio, *The Fortune Teller*, Louvre, Paris.

CULES. Among the most splendid of late Roman architectural achievements, they remained in use until the 6th century.

CARACCIOLO, GIOVANNI BATTISTA (1570–1637). Italian painter who served as the Neapolitan nexus between MANNERISM and the naturalism of his principal influence, CARAVAGGIO. His work is characterized by its strongly contrasted light and shade.

CARAVAGGIO, MICHELANGELO MERISI DA (1573–1610). Italian painter and the outstanding figure of the early BAROQUE. Despite a short life punctuated by frequent violence and spent largely as a fugitive, he produced a body of work of striking originality and unprecedented credibility in a style that necessitated a new terminology and profoundly influenced Western art for generations. Although trained only by an obscure pupil of TITIAN, he seems to have had an early and thorough grasp of VENETIAN painting and an admiration for such artists as LOTTO and SAVOLDO. He is known to have worked in Rome by 1592, to have been criticized there for his habit of working directly from the model instead of from preliminary sketches or cartoons and to have endured considerable privation until he found a friend and protector in Cardinal del Monte. By 1606, after achieving a measure of solvency and considerable notoriety, he stabbed a tennis opponent to death and fled the capital for Naples. Whether he had been better known in Rome for his ungovernable temper and frequent brushes with the law or for his "blasphemous" treatment of religious subjects is a moot point. It is known, however, that various church commissions were rejected because of an earthy naturalism that had little in common with the somewhat sanctimonious classicism of the much admired CARRACCI.

Caravaggio's naturalism and the notoriety it inspired—his model for the *Death of the Virgin* (Paris:

Caravaggio, *The Young Bacchus*, Uffizi, Florence:

tled as his life had been, however, he left a body of work whose influence spread from Naples to every corner of Europe and contributed to styles as disparate as those of RUBENS and LA TOUR, the LE NAIN brothers and REMBRANDT.

CARDUCHO, BARTOLOME (Bartolommeo Carducci) (ca. 1560–1608). Italian painter and brother of VICENTE CARDUCHO. After studying in Italy with AMMANATI and ZUCCARI, he accompanied the latter to Spain, where he spent the rest of his life and was made court painter to Philip III. As the conduit whereby the early BAROQUE was transmitted to Spain, his influence was of prime importance.

CARDUCHO, VICENTE (Vincenzo Carducci) (1576–1638). Italo-Spanish painter and brother of BARTOLOME CARDUCHO. A native Florentine, he went to Spain with his brother while a child and was educated there. A rival of VELAZQUEZ, he had rather sanctimonious notions of art's purposes that put him in direct opposition to the younger painter and to Caravaggesque painting in general. His own work—dramatic, somewhat overblown and full of high moral purpose—was much respected in its time but had little influence on subsequent painting.

CARIANI, GIOVANNI (ca. 1480–1548). A Venetian painter of delicate, somewhat angular portraits and altarpieces, he worked mostly in Bergamo.

CARLEVARIS, LUCA (ca. 1664–1731). Italian view painter and printmaker. Influenced by the Dutch topographical artist VANVITELLI, he was the first Italian *vedutiste* of note and the pioneer of a genre most successfully exploited by CANALETTO and GUARDI.

CARLONE FAMILY. 17th- and 18th-century Italian painters, sculptors, architects and artisans from the neighboring towns of Scaria and Rovio. The best-known members of the family were Giovanni Andrea Carlone (1590–1630), a fresco painter who worked mainly in Genoa; Giovanni Battista Carlone (1592–1677), also a fresco painter who worked for the most part in Genoa; and Taddeo Carlone (1543–1613), a sculptor and decorator.

CARLOS FREI (fl. ca. 1517–1540). Portuguese painter, probably Flemish-born, of altarpieces and other religious works. Called the "Portuguese Fra Angelico" for the gentleness of his style.

CARNEVALE, FRA (ca. 1420–1484). Italian painter and architect of whose works none is known to exist, although he was once credited with authorship of *The Birth of the Virgin* (New York: Metropolitan Museum) and *The Presentation in the Temple* (Boston: Museum of Fine Arts).

CARO, ANTHONY (1924–). English sculptor. After working as an assistant to HENRY MOORE, he taught sculpture in London and later in the United States, where he was deeply influenced by the work of DAVID SMITH. His mature works are constructivist and monochromatic

Louvre) was said to have been a whore found drowned in the Tiber—has tended to overshadow the spiritual intensity, superb organization, masterful plasticity and dramatic immediacy of his characteristic late works. Actually, such details as dirty feet and varicose veins, for all the verisimilitude they lent his pictures, were only incidental to a visionary logic that was never confused with the appearance of the "real" world. With his unparalleled use of chiaroscuro, Caravaggio made light the palpable, unifying and energizing force that invested his works with their characteristically unshakable credibility. The light he painted, though, was purely an element of his pictorial syntax and cannot be found in nature.

Two years after fleeing Rome, Caravaggio turned up in Malta, where he was knighted but soon fell out with his superiors and again was forced to flee, first to Massina and Palermo and finally to Naples, where his Maltese pursuers found him and brutally disfigured him. Then, in 1610, awaiting a papal pardon that had already been granted him and hoping to return to Rome, he was arrested at Port' Ercole, released in time to see the ship bearing his belongings put out to sea, went into the last of his monumental rages and died of fever. Short and unset-

Annibale Carraci, *Quo Vadis, Domine*, National Gallery, London.

and characteristically employ a horizontal axislike member, pitched at an angle and supported by vertical elements that rest on the floor or ground.

CARPACCIO, VITTORE (ca. 1465–ca. 1525). Venetian painter, influenced by GENTILE BELLINI and to a lesser extent by GIOVANNI BELLINI (whom he worked under for a time), ANTONELLO DA MASSINA and perhaps Lazzaro Bastiani and GIORGIONE. His mastery of the narrative form, much admired during the 19th century by Ruskin and others, is particularly evident in the cycle *Scenes from the Life of St. Ursula* (Venice: Accademia di Belle Arte). His best work is characterized by the solidity of its basically geometric form, its anecdotal liveliness, pleasing color and, despite a wealth of incident, its frequent use of calm, open intervals.

CARPEAUX, JEAN BAPTISTE (1827–1875). The leading French sculptor of his time, he is known for the vitality of his figures and the liveliness of his compositions, qualities exemplified by his best-known work, *The Dance*, for the façade of the Paris Opéra (Paris: Louvre). A leading exponent of the use of chiaroscuro in sculpture, he anticipated—and influenced—the works of RODIN and ROSSO. He was also an accomplished painter and engraver.

CARPI, UGO DA (ca. 1479–1532). Italian woodcut engraver. Although unimportant as an original artist, his woodcuts after the compositions of DÜRER, RAPHAEL, PARMIGIANINO and other masters greatly increased the expressive capabilities of the medium, particularly in their innovative use of chiaroscuro.

CARRA, CARLO (1881–1966). Italian painter. After training and working as a decorator and studying classical painting in Milan, he was attracted to FUTURISM in 1909. Six years later he met DE CHIRICO and, under his influence, worked for a while in a metaphysical vein. Although he was associated with various movements and styles at various times, his work consistently was based on the principles of CUBISM and the example of CÉZANNE and, later, GIOTTO.

CARRACCI, AGOSTINO (1557–1602). Italian painter and engraver, brother of ANNIBALE CARRACCI and cousin of LUDOVICO CARRACCI. After working in a markedly eclectic manner, he developed a personal brand of classicism late in life. As a painter, his greatest influence was on DOMENICHINO, but his engravings after the Venetian masters of the High Renaissance were of the utmost importance to the final reaction against MANNERISM and the growth of the classicist revival in the 17th century.

CARRACCI, ANNIBALE (1560–1609). Italian painter, brother of AGOSTINO CARRACCI and pupil of his cousin LUDOVICO CARRACCI. The outstanding among the Carracci, he fell ill at age 45 and personally produced little

work between then and his early death four years later. He was one of the most influential painters in the history of art, and his frescoes in the Farnese Gallery, Rome, rank with the supreme decorative schemes produced by Western art and have been surpassed only by RAPHAEL's decorations for the Stanze and the Farnesina and MICHELANGELO's ceiling in the SISTINE CHAPEL. In this masterful cycle, he provided the basis for the classicism of the 17th century and, to some extent, the impetus for those artists who, like CARVAGGIO, turned to naturalism in reaction against it.

CARRACCI, LUDOVICO (1555–1619). Italian painter and cousin of AGOSTINO and ANNIBALE CARRACCI, with whom he established an academy in Bologna that, under his direction, profoundly influenced such students as DOMENICHINO, ALBANI, RENI and GUERCINO. His characteristic work is less classicist than that of Agostino and Annibale and marked by more spatial emphasis and a somewhat expressionistic use of light, characteristics that pointed the way toward the BAROQUE.

CARREÑO DE MIRANDA, JUAN (1614–1685). Spanish portraitist and First Painter to King Carlos II, whose systematic decline he traced in a remarkable series of pictures painted over a considerable period of the king's life. A leading artist of the late BAROQUE, he was also known for religious frescoes of great elegance and facility.

Mary Cassatt, *The Cup of Tea*, Metropolitan Museum of Art, New York, anonymous gift, 1922.

CARRIERA, ROSALBA GIOVANNA (1675–1757). Italian portrait painter and pastelist. An extremely fashionable miniaturist, she traveled extensively in Europe, portraying nobility and royalty.

CARRIÈRE, EUGÈNE. (1849–1906) French painter whose later portraits are almost monochromatic and marked by their emphatic chiaroscuro.

CARSTENS, ASMUS JAKOB (1754–1798). Danish-German painter and sculptor of allegorical subjects, much influenced by RAPHAEL and MICHELANGELO. Few of his major works survive.

CASSAT, MARY STEVENSON (1845–1926). American impressionist painter and printmaker. After studying at the Pennsylvania Academy of Fine Arts, she traveled in Italy and undertook further study in Paris, where she came under the influence of COURBET, MANET and DEGAS, whose protégé she was to become. Later (and ticularly in her color prints) she absorbed considerable influence from the Japanese woodcuts then extremely popular among French impressionist painters. Characteristically, she portrayed mothers and children in clear, fresh color, using the cool, flat light of IMPRESSIONISM and a linearity derived largely from her friend Degas. As an adviser of prominent American collectors she had much to do with the international popularity of the impressionist painters, although, in an era when well-brought-up young ladies were not expected to work seriously in bohemian surroundings, her own work was not readily accepted.

CASSINARI, BRUNO (1917–). Italian painter of highly colored, extremely intricate cubist-derived pictures.

CASTAGNO, ANDREA DEL (before 1421–1457). Italian painter. Little of his life is documented and much of his work has been lost, but he is generally considered one of the outstanding painters of the generation following MASACCIO, who was one of his chief influences. His characteristic earlier works are distinguished by their intense dramatic presence, bold design and emphasis on movement, but his work from around 1449 onward conforms more closely to the decorative aesthetic of the INTERNATIONAL GOTHIC and has been called the painterly equivalent of the sculpture of DONATELLO. Maligned by VASARI, he received little attention until the early 20th century but is now acknowledged to have been a painter of great vigor and far-reaching influence.

CASTELLO, GIOVANNI BATTISTA (Il Bergamasco) (ca. 1509–1569). An Italian mannerist painter and architect, he spent the last year of his life in Spain, where he was given charge of the ESCORIAL, to which he added an ornate stairway and several monumental paintings.

CASTELSEPRIO. Site near Milzu, Italy, of a chapel notable for a fresco cycle depicting the life of the Virgin and

Andrea del Castagno, *The Young David*, National Gallery of Art, Washington, D. C., Widener Collection.

Benvenuto Cellini, *Perseus with the Head of Medusa*, Loggia dei Lanzi, Florence.

childhood of Christ. The subject of considerable debate, the paintings, discovered in the 20th century, may have been executed by BYZANTINE artists and are distinguished by their vigorous illusionism.

CASTIGLIONE, GIOVANNI BENEDETTO (ca. 1600–ca. 1665). An Italian painter and printmaker and inventor of the MONOTYPE. Known for his depictions of animals, he studied under VAN DYCK and was influenced by such northern masters as REMBRANDT, RUBENS and POUSSIN.

CASTILLO, ANTONIO DEL (1616–1668). Spanish painter of religious subjects. His work is somewhat clumsy and archaic but was well received in its time.

CASTILLO, JOSÉ DEL (1737–1793). Spanish painter and designer. A child prodigy and student of MENGS, he is best known for his cartoons for Madrid's Royal Tapestry Factory.

CATENA, VINCENZO (ca. 1480–1531). Venetian painter of religious subjects and portraits, influenced by RAPHAEL, CIMA, TITIAN and GIORGIONE. His mature works are characterized by their glowing light and warm color.

CATLIN, GEORGE (1796–1872). American self-taught painter, notably of Indian life in the western United States. Although he was not a great artist per se, his pictures are notable for their good design and as invaluable historical documentation.

CAVALLINI, PIETRO (ca. 1250–ca. 1330). Italian painter generally credited with having had decisive, if indirect, influence on GIOTTO. His mosaics and frescoes are perhaps the first to be based on the forms of classical antiquity and are historically significant for their rejection of BYZANTINE forms.

CAVALLINO, BERNARDO (1616–1656). Neapolitan painter who studied with VACCARO and STANZIONE and was much influenced by RIBERA, ARTEMISIA GENTILESCHI, CARAVAGGIO, TITIAN and others. Noted for his compositional skill, his masterful contrasts of lights and textures and his graceful fusion of CARAVAGGIO's chiaroscuro with classical forms.

CAVALLON, GIORGIO (1904–). Italian-born American painter whose characteristic works invest the NEO-PLASTICISM of MONDRIAN with the diffuse, lyrical luminosity of sunlight seen through fog.

CAZIN, JEAN-CHARLES (1841–1901). French painter, ceramic designer and printmaker, best known for his late poetic landscapes.

CEFALÙ: CATHEDRAL. Romanesque church in Sicily renowned for its Sicilian-BYZANTINE mosaics, particularly the powerful portrayal of *Christ Pantocrator* in the half-dome of the apse.

CELLINI, BENVENUTO (1500–1571). Florentine mannerist sculptor and goldsmith. Although the outstanding

metal worker of the Italian Renaissance, he is best known for his *Autobiography*, a picaresque, somewhat exaggerated account of his amorous escapades, his heroism in the defense of Rome during the siege of 1527 and the details of creative life in the 16th century. He spent the years 1540–1545 in the service of François I of France, for whom he made the saltcellar (Vienna: Museum of Art History) generally considered the greatest work of the goldsmith's art ever produced. As a sculptor his importance is debatable. His sculptural masterpiece, *Perseus with the Head of Medusa* (Florence: Loggia dei Lanzi), although a technical tour de force, seems merely a magnified example of goldsmith's work beside the work of the sculptural giants of the period.

CENNINI, CENNINO (ca. 1370–1440). Italian painter and author of *Il libro dell'arte*, an invaluable historical document on the purposes and methods of Florentine painting in the latter Middle Ages.

CEREZO, MATEO (ca. 1626–1666). Spanish BAROQUE eclectic painter of such religious subjects as *The Assumption* (Madrid: Prado), many of which fell somewhat short of the lofty spirituality to which they aspired.

CERQUOZZI, MICHELANGELO (1602–1660). Italian painter of genre scenes and battle pictures.

CERTOSA, THE, PAVIA. GOTHIC Carthusian monastery outside Pavia, Italy, noted for its richly embellished Renaissance west front.

CERUTI, GIACOMO (Il Pitocchotto) (fl. 1728–1760). Italian painter, principally of religious themes and portraits. The latter, mostly of social outcasts, were widely collected during Ceruti's lifetime.

CÉSAR (César Baldaccini) (1921–). French sculptor who characteristically incorporates into his work such industrial detritus as compacted automobiles, foundry debris and the like.

CESPEDES, PABLO DE (1538–1608). Spanish painter, influenced by MICHELANGELO, RAPHAEL, CORREGGIO and the ZUCCARIS while traveling in Italy. His paintings (he was also a sculptor and architect) are characterized by exaggerated chiaroscuro and perspective.

CÉZANNE, PAUL (1839–1906). French painter and one of the seminal forces in the modern movement. Born in Aix-en-Provence, where he began the study of law and art, he went to Paris in 1861 at the urging of his friend Emile Zola. In the next five years he painted in a markedly romantic vein, developing a crude but original style, influenced by COURBET, MANET and, perhaps, DAUMIER,

Paul Cézanne, *The Little Bridge, Mennecy*, Louvre, Paris.

Paul Cézanne, *Madame Cézanne in a Red Chair*, Museum of Fine Arts, Boston, gift of R. T. Paine II.

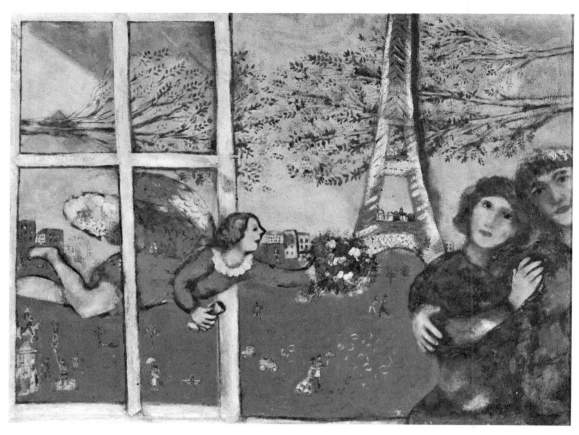

Marc Chagall, *The Couple of the Eiffel Tower*, private collection, Paris.

with dark tones laid on thickly in broad strokes of the palette knife. He next began to lighten both his palette and paint texture and to meet Manet, DEGAS, PISSARRO and like-minded painters at the Café Guerbois, by 1872 was working with Pissarro and in 1874 participated in the first impressionist exhibition. Around this time his palette, style and method underwent further revision, with transparent primary colors, applied in terse strokes, replacing the dark unctuous impasto of his early period and with more stress placed on painting outdoors, directly from nature. But while these changes were precipitated by the then emergent IMPRESSIONISM, Cézanne departed from the impressionists in his refusal to concern himself exclusively with the transitory and atmospheric effects of light, preferring, as he put it, to make of the shimmering new style "something solid, like the art of the museums." To this end he retreated to Aix, his home city, where after 1881 he worked more or less in isolation, doggedly pursuing his dream of a solid, enduring painterly synthesis of observed phenomena.

In his greatest period, the 1880s and 1890s, Cézanne achieved a mastery of form coupled with a clarity of color unprecedented in 19th-century art and managed to suffuse apparently weighty geometric solids with the strong natural light of Impressionism while avoiding the pitfall of purely retinal illusionism. His landscapes, still lifes and portraits, painted in staccato interlocking strokes, represent a modification from visual to intellectual priorities and, as such, were perhaps the most revolutionary innovation since the era of MASACCIO.

Although he failed to win public acceptance during his lifetime, Cézanne was highly respected by his artistic contemporaries and, with the retrospective exhibition held the year after his death, profoundly influenced such major figures of the next generation as PICASSO, BRAQUE and MATISSE and, through them, the invention of CUBISM and the subsequent development of modern art.

CHADWICK, LYNN (1914–). English abstract sculptor. Originally influenced by CALDER, he later turned from mobiles to "balanced" sculptures that, along with the work of DAVID SMITH, LASSAW and a few others, effectively liberated sculpture from the base, plinth or pedestal.

CHAGALL, MARC (1887–). Russian-born French painter, influenced in turn by BAKST, CUBISM, SURREALISM and EXPRESSIONISM. His style is nonetheless highly personal and distinctly literary. Notable for the

Marc Chagall, *Double Portrait with Wineglass*, National Museum of Modern Art, Paris.

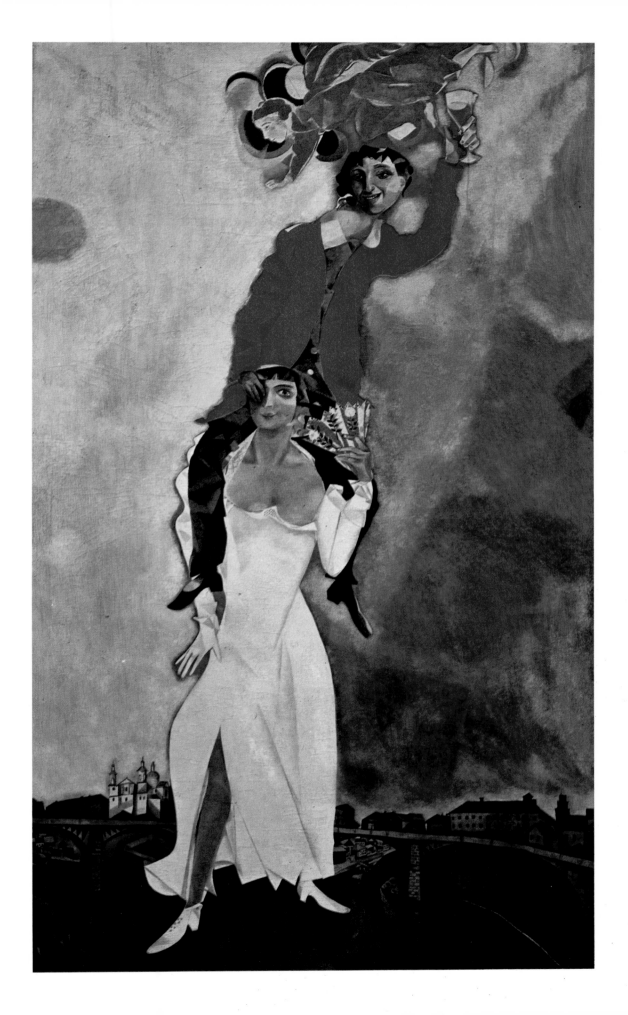

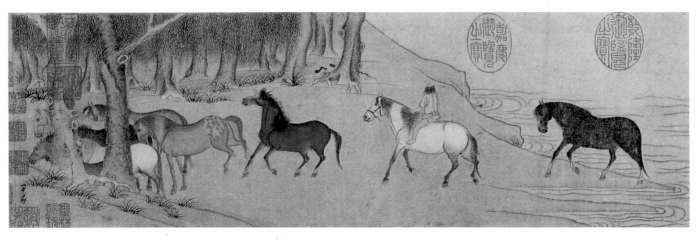

Chao Meng-Fu, *Horses Crossing a Stream*, Freer Gallery, Washington, D. C.

richness of its color, his work is much given to fantasy (although he himself claims it is purely reminiscent) and to subjects from Russian-Jewish folklore. A prolific illustrator, printmaker, theater designer and decorator, he enjoys a worldwide popularity accorded few artists and at his best ranks with the century's great expressionists.

CHALGRIN, JEAN-FRANÇOIS-THÉRÈSE (1739–1811). French architect best known for the Arc de Triomphe de l'Étoile, Paris.

CHAMBERLAIN, JOHN (1927–). American sculptor of abstract-expressionist works fabricated from crumpled automobile parts.

CHAMBERS, SIR WILLIAM (1723–1796). Swedish-born British architect whose best work is marked by the influence of the conservative eclecticism he observed while studying in France and Italy. A rival of ROBERT ADAM, he was a founder of the Royal Academy and one of the most powerful figures in English aesthetic life. His chief buildings are Somerset House, London, and the Casino at Marino, Dublin.

CHAMPAIGNE, PHILIPPE DE (1602–1674). Flemish painter who worked and died in Paris. The most popular portrait painter of his time, he was a close friend of POUSSIN and a protégé of Louis XIII and Richelieu. Introduced to Jansenism in 1643, he was profoundly influ- by the order, whose puristic tenets were reflected thenceforth in the increasing austerity of his works.

CHANG SENG-YU (fl. 502–557). Although no authenticated works by this Chinese painter survive, he is celebrated in literature for the dimensional verisimilitude of his wall paintings.

CHANG TA-CH'IEN (1899–). Chinese painter and copyist. Said to be the last great exponent of traditional painting, he is a master of past styles. His full-size copies of cave frescoes at Tun-huang are of great importance to scholars.

CHAO MENG-FU (Chao Tzu-ang) (fl. ca. 1300–1322).

Chinese painter and calligrapher in the court of Kublai Khan, best known for his scroll depictions of horses and his landscapes.

CHAO PO-CHU (fl. mid-12th century). Chinese painter known for his richly colored, gold-outlined forms.

CHARDIN, JEAN-BAPTISTE-SIMÉON (1699–1779). French painter of still-life and genre subjects. Independently working in an understated naturalistic vein during the height of the French ROCOCO (BOUCHER was his exact contemporary), he was influenced by the Dutch little masters and VERMEER but developed a complex, characteristically Gallic pictorial logic that invested his pictures with a unique solidity, intimacy and unpretentious dignity. Throughout his career, in his genre pictures and still lifes and in a remarkable late series of pastel portraits, he strove for solidity of form and pictorial integrity and kept his pictures entirely free of sentimentality or, indeed, overt emotional involvement of any kind, although they remain strangely affecting nonetheless. His genius was recognized early, especially by Diderot, but largely for the wrong reasons. Later in his career he was unjustly subjected to some critical disfavor, but his works were widely known through engraved copies. His quietly glowing pictures, with their solid construction, respect for form and inimitable surface texture, have had subtle but considerable influence on much of the painting of the 20th century.

CHARENTON (Charonton), ENGUERRAND. See **QUARTON.**

CHARLET, NICOLAS-TOUSSAINT (1792–1845). French painter and lithographer known for his Napoleonic subjects.

CHARLOT, JEAN (1898–). French-born Mexican painter, author and teacher. One of the pioneer Mexican muralists, he collaborated with DIEGO RIVERA in several projects and also did innovative work in color lithography. His characteristic style represents a fusion of CUBISM and PRE-COLUMBIAN forms.

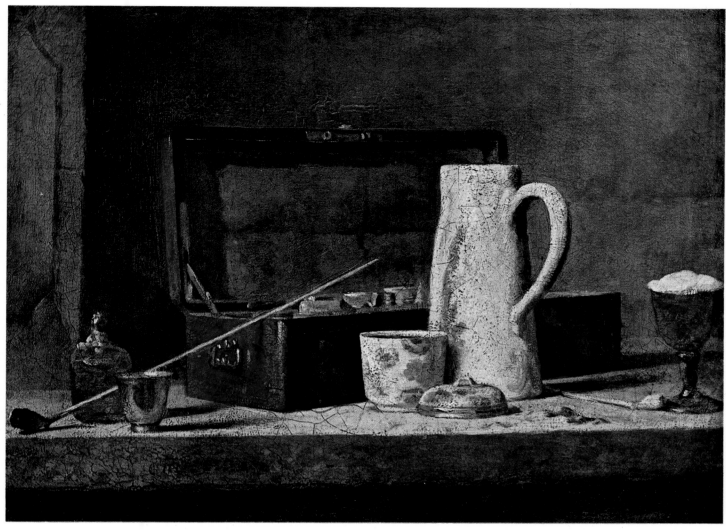

Jean-Baptiste-Siméon Chardin, *Still Life with Pipe*, Louvre, Paris.

CHARTRES: CATHEDRAL OF NOTRE DAME. Generally considered the epitome of GOTHIC architecture, this northern French edifice was built in a relatively brief length of time during one of the most intensively sustained efforts in all architectural history. As a consequence, it is particularly notable for its stylistic purity. Called by Henry Adams the expression of "an emotion, the deepest man ever felt," the present cathedral's west front, notable for its Portal royal, and crypt originally belonged to an earlier church on the same site and dating from the mid-12th and early 11th century, respectively. The building's details were influenced by those of LAON CATHEDRAL, but its general design, with its tall arcades and clerestory windows surrounding its narrow triforium, was highly innovative, and its decorative embellishments include many works that are in themselves masterpieces of the first order. Among the most notable of the latter are the cathedral's magnificent stained glass, with its incomparable "Chartres blue," the superb high relief carvings of the tympana and the figured porches of the transepts.

CHASE, WILLIAM MERRITT (1849–1916). American painter and teacher who studied in the United States and Germany and later established an influential art school near Southampton, New York. He was influenced by FRANS HALS, MANET, VELAZQUEZ and WHISTLER. His style was brilliant and fluent but lacked the panache of his similarly influenced contemporary, SARGENT.

CH'A SHIH-PIAO (1615–1698). Chinese eclectic landscape painter known for his poetic solemnity.

CHASSERIAU, THEODORE (1819–1856). West Indian-born French painter who studied under INGRES, whose influence, blended with that of DELACROIX, shaped his mature style, which was definite of contour and high-keyed. Best known for his Shakespearean illustrations, portraits and Algerian subjects, he influenced MOREAU, REDON and PUVIS DE CHAVANNES.

CHAVEZ MORADO, JOSÉ (1909–). Mexican painter and printmaker best known for his murals, especially the vast mosaic for the Ministry of Communications and Public Works, Mexico City.

CH'EN JUNG (fl. mid-13th century). Chinese painter, poet and scholar who specialized in depictions of dragons executed in a kind of proto-abstract-expressionist technique.

CHENONCEAUX, CHATEAU OF. French residential castle projecting into the Cher River, which passes through a tunnel in the structure's foundation. A graceful blend of GOTHIC and Renaissance forms, the chateau belonged in turn to Diane de Poitiers and Catherine de' Médicis.

CHEOPS, PYRAMID OF. Largest of the monumental tomb structures at Giza, Egypt, and one of the wonders of the ancient world, it is roughly 750 feet square and 480 feet high.

CHICHEN ITZA. A Mayan ceremonial site on Mexico's Yucatan Peninsula, it was largely rebuilt by the Toltecs in the 12th century and comprises an imposing ziggurat, splendid temples, a vast game court, a snail-shaped astronomical observatory and a wealth of magnificently carved reliefs.

CH'IEN HSUAN (ca. 1235–after 1300). A Chinese painter of whose work little survives, he was praised by his followers for his naturalism and fluency of execution.

CHILLIDA, EDUARDO (1924–). Spanish abstract sculptor. After studying architecture in Madrid and sculpture in Paris, he returned to Spain to work on his characteristic rough-textured curvilinear forms, at first predominantly in hammered metal and later in wood. Basically, his works concern themselves with a dominant theme and variations, with enclosed space acting as a negative reverberation of positive form.

CHING HAO (fl. 1st half of 10th century). Chinese landscape painter and aesthetician known principally through his surviving treatises on brushwork and landscape techniques.

CHINNERY, GEORGE (1774–1852). English portrait and landscape painter who spent the last two thirds of his life in the Far East, where he developed a fluent calligraphic style that enabled him to record a multiplicity of visual impressions very rapidly.

CHIPPENDALE, THOMAS (before 1718–1779). English cabinetmaker. The second of three cabinetmakers of the same name, he was known for his elaborate carving and the flamboyance of his eclectic designs, which were derived from such styles as the QUEEN ANNE, GEORGIAN, GOTHIC, Chinese and French ROCOCO. His greatest influence was on furniture design in the United States.

CHIRICO, GIORGIO DE (1888–). Italian metaphysical painter born in Greece. After studying there and in Italy and Germany, he settled in Florence, where he painted a series of enigmatic pictures in which a variety of anomalous elements were eerily poised in dreamlike, green-toned cityscapes. During the years 1910–1920 he developed a highly personal style that was influenced by neither of the decade's dominant styles, CUBISM and FUTURISM, but which had considerable influence on CARRA and, later, MORANDI. Violently opposed to

Giorgio de Chirico, *The Pink Tower*, Peggy Guggenheim Collection, Venice.

FUTURISM, he returned to Paris in 1924, where he was lionized as a precursor of SURREALISM. After extensive technical researches into the Italian primitives and the Venetian school, he painted a number of his finest and most characteristic pictures, but around 1930 his work had begun to seem repetitious and never again approached the originality, profundity and importance of his early phase.

CH'IU YING (fl. ca. 1525–ca. 1555). A Chinese painter and pupil of Chou Ch'en, he is best known for his depictions of courtly life and of elegant, slender women. A much imitated master of the "blue-and-green" style, he was one of the outstanding painters of the Ming dynasty.

CHODOWIECKI, DANIEL NICHOLAUS (1726–1801). German painter, printmaker and illustrator whose best-known works are his intimate graphic depictions of bourgeois life executed in a style influenced by WATTEAU, LANCRET, HOGARTH and GREUZE.

CHOU FANG (fl. late 8th century). Chinese T'ang-dynasty painter, principally of stately ladies of the court.

CHRISTIAN, JOHANN JOSEPH (1706–1777). German architectural ROCOCO sculptor whose best-known works embellish churches designed by JOHANN MICHAEL FISCHER at Ottobbeureau and Zewifolten.

CHRISTO (Christo Javacheff) (1935–). Bulgarian-born American sculptor who characteristically wraps or screens objects or natural areas in plastics or fabrics to accomplish "revelation through concealment," in the phrase of critic David Bourdon. His more ambitious projects have included wrapping a mile of Australian coastline and Chicago's Museum of Contemporary Art and hanging a curtain across a 365-foot canyon in Colorado.

CHRISTUS, PETRUS (ca. 1410–ca. 1472). Flemish painter who worked in the VAN EYCK tradition and may have been trained by JAN VAN EYCK. He was influenced to some extent by ROGIER VAN DER WEYDEN and is particularly notable for his convincing handling of space. His characteristic works are distinguished by a solidity and serenity that tend to be overshadowed by a somewhat finicky attention to detail. He was the outstanding painter of Bruges after Jan Van Eyck's death.

CHRYSSA (Varda Chryssa) (1933–). Greek-born American sculptor and a pioneer in the use of neon-light tubes as a sculptural vehicle. In such characteristic works as those of her "Ampersand" series, greatly enlarged typographical elements are mounted inside transparent housings, and various electrical components are not hidden but form integral design components.

CHU-JAN (fl. 2nd half of 10th century). Chinese landscape painter and priest of the Jung court who worked in the style of Tung Yüan. Best known for his depictions of mountains and his free, expressive use of coarse brushwork, blots and the like.

CHURCH, FREDERICK EDWIN (1826–1900). American landscape painter of the HUDSON RIVER SCHOOL. A friend and pupil of THOMAS COLE, he was the most successful exponent of Cole's grand manner, his style characterized by acuity of observation and precision of detail with sweeping panoramic breadth and an emphasis on light and atmosphere unprecedented in American landscape painting. He traveled widely in the Arctic, tropical South America and the Near East in search of subjects. "Olana," the "Persianized" mansion he designed for himself near Hudson, New York, is one of the great works of American eccentric architecture.

CHURRIGUERA, JOSÉ BENITO DE (1665–ca. 1724). Spanish architect, painter, sculptor and designer and leader of a family of two generations of prominent architects. Under his influence his native city, Salamanca—he was chief architect of the cathedral—was transformed into a landmark of the excessively elaborate BAROQUE style that came to be called—with some derision—Churrigueresque, although his own best work was relatively restrained and rarely compromised architectural integrity.

José Benito de Churriguera, high altar of the Church of San Esteban, Salamanca.

CHU TA (Pa-ta shan-jen) (1625–ca. 1700). Chinese painter and monk, esteemed for his bizarre, somewhat anthropomorphic studies of fauna, which he depicted in a casual, cursory system of notation characterized by great expressiveness, and for his more conventional landscapes. He was a much speculated-about personality, and legend has it that he was a drunkard, a madman or both.

CIGNANI, CAROL (1628–1719). An Italian painter and pupil of ALBANI, he served as a nexus between the CARRACCI and the BAROQUE style.

CIGOLI, LUDOVICO CARDA (1559–1613). Italian eclectic painter and architect whose dramatic effects and compelling immediacy made him a minor, but pioneer, member of the BAROQUE.

CIMA (Cima da Conegliano), GIOVANNI BATTISTA (ca. 1460–ca. 1517). Venetian painter, chiefly of Madonnas that somewhat resemble those of his contemporary, GIOVANNI BELLINI, one of his chief stylistic influences along with ANTONELLO, DA VINCI and GIORGIONE. Best known for his effective lighting and convincing modeling.

CIMABUE (Cenni di Pepi) (ca. 1240–after 1302). Italian painter of the Florentine school and possibly the teacher of GIOTTO, who, according to Dante, superseded him as the greatest painter in Italy ("Cimabue thought he held the field in painting, but now Giotto is acclaimed and his fame obscured."—*Il Purgatorio*). Little that can be attributed to him with certainty survives, and his reputation rests in large part on Dante's evaluation, which was perpetuated by such later commentators as GHIBERTI and VASARI. Although he is traditionally credited as the painter who first rejected BYZANTINE formulae in favor of a more classical approach, CAVALLINI, whose work may have had a direct influence on Cimabue's development, is probably a more legitimate claimant to the honor. To judge by those works generally ascribed to him (chiefly a series of frescoes in the Church of S. Francesco, Assisi), his oeuvre represents not so much the beginning of the naturalist tradition but the end of the Byzantine—a style he invested with a final monumentality and dynamism before it gave way to the new art of Giotto and his followers.

CIONE, ANDREA DI. See ORCAGNA, ANDREA.

CIONE, JACOPO DI (fl. 1365–1398) and **NARDO DI** (fl. 1343; d. 1356). Italian painters of the Florentine school, specialists in altarpieces and brothers of ANDREA ORCAGNA. Nardo, whose influence is evident in Jacopo's work, was the outstanding Florentine painter of his era.

CLAESZ, PIETER (ca. 1597–ca. 1661). Westphalian-born Dutch still-life painter who specialized in "breakfast" pictures.

CLARKE, JOHN CLEM (1937–). American realist painter of vaguely parodic versions of works by such earlier painters as VAN DYCK, HALS and MANET. While his works resemble photomechanical enlargements of their ostensible subjects, the application of his paint creates a *trompe l'oeil* effect that suggests the texture of various woven materials.

CLAUDE. See LORRAINE, CLAUDE.

CLAVÉ, ANTONI (1913–). Spanish-born French painter, designer and illustrator whose work derives partly from PICASSO and is characterized by a forceful use of blacks, reds and whites.

CLEITUS (Klitias) (fl. late 5th century B. C.). Attic vase painter generally considered the earliest narrative painter of consequence.

CLEVE, JOOS VAN (ca. 1485–1540). Flemish painter. A master painter of Antwerp, he traveled to the courts of England, France and Italy and was much influenced by DA VINCI, especially in his later works. Best known for his portraits, he also painted a number of religious subjects in a pleasant, somewhat sentimental style and in the bourgeois Netherlandish settings and costumes of his time.

CLODION (Claude Michel) (1738–1814). A French ROCOCO sculptor and nephew and student of LAMBERT SIGISBERT ADAM, he specialized in allegorical and mythological subjects and decorative groups.

CLOUET, FRANÇOIS (before 1510–1572). French court painter and son of JEAN CLOUET. Best known for his portraits, particularly those of *Elizabeth of Austria, Queen of France* (Paris: Louvre) and *Diane de Poitiers* (Washington: National Gallery).

CLOUET, JEAN II (Janet) (d. ca. 1540/41). A French court portraitist and the father of FRANÇOIS CLOUET, he painted highly individualized likenesses in a somewhat Italianate manner.

CLOVIO, GIULIO (1488–1578). Croatian-born painter, illuminator and monk who spent his adult life in Italy, where he was markedly influenced by MICHELANGELO and RAPHAEL.

COCK, HIERONYMUS (ca. 1510–1570). Flemish painter, printmaker and publisher of reproductive engravings that markedly influenced Netherlandish art, particularly that of PIETER BRUEGHEL THE ELDER.

COCKERELL, CHARLES ROBERT (1788–1863). English architect, archaeologist and teacher whose style combined English BAROQUE and classical influences.

COCTEAU, JEAN (1892–1963). French painter, illustrator, poet, belle-lettrist and filmmaker. Although not a painter of the first rank, Cocteau achieved considerable importance in the visual arts in France as a theorist, impresario and general catalyst. His own paintings, illustrations and films were markedly surrealistic, but he never formally allied himself with SURREALISM.

CODDE, PIETER JACOBSZ. (1599–1678). Dutch painter and poet who specialized in portraits and genre subjects and was made influenced by FRANS HALS.

Cimabue, *Madonna in Majesty*, Louvre, Paris.

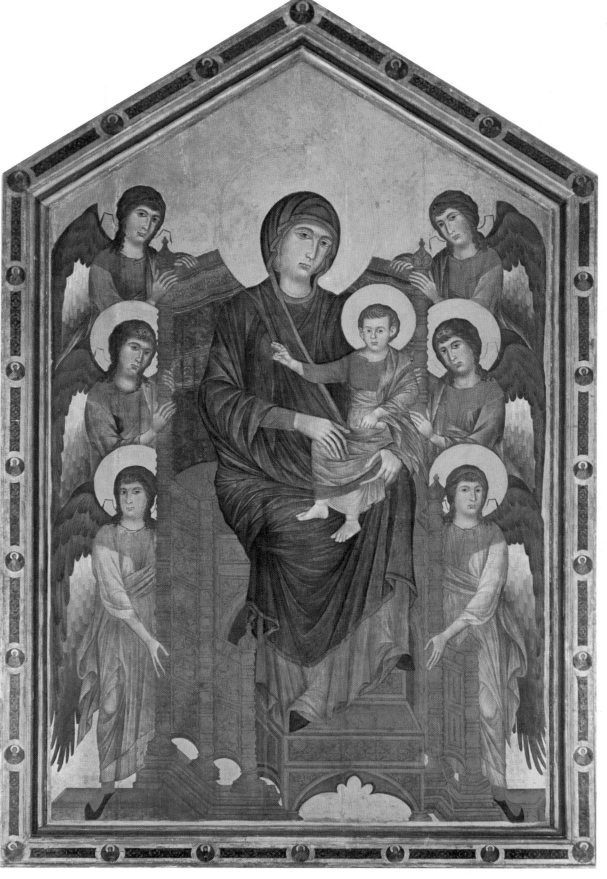

COECK VAN AELST, PIETER (1502–1550). Flemish painter of religious and historical subjects, dean of the Antwerp Guild and teacher of his son-in-law PIETER BRUEGHEL THE ELDER. His own work bears the influence of his teacher, BERNAERT VAN ORLEY, but is more mannered and energetic. His chief importance, however, lies in his literary works, which brought a greater understanding of the Italian Renaissance to the north. He was also an architect, sculptor and designer.

COELLO, CLAUDIO (1642–1693). Spanish court painter who welded influences of RUBENS, DOLCI, TITIAN, CORREGGIO and others into a distinctive style of his own. His principal aesthetic concern lay in the area between art and reality, a gap he attempted and came close to bridging in his masterpiece, *The Adoration of the Holy Eucharist* (El Escorial: sacristy), in which the ambiance of the picture is an illusionistic continuation of the real space in which it is housed. Stylistically, he was vigorous, histrionic and grandiose, infusing spiritual themes with a corporeality unique in Spanish art.

COLE, THOMAS (1801–1848). English-born American landscape painter and leader of the HUDSON RIVER SCHOOL. His works are markedly romantic, often quite theatrical and make dramatic use of chiaroscuro. After traveling in Europe, he found America to be "the abode of virtue," and such works as his lyrical American landscape *The Oxbow* (New York: Metropolitan Museum) are in marked contrast to such later allegorical works as his "Course of Empire" series, with its apocalyptic view of European history. Cole had considerable influence on such later Hudson River painters as CHURCH and DURAND, who portrayed Cole and the poet Bryant in his *Kindred Spirits* (New York Public Library).

COLEMAN, GLENN O. (1887–1932). American painter, printmaker and illustrator affiliated with the ASHCAN SCHOOL and known for his empathetic depictions of urban life.

COLLANTES, FRANCISCO (1599–1656). Spanish romantic painter taught by CARDUCHO, influenced by RIBERA and given to apocalyptic themes.

COLOGNE CATHEDRAL. German cathedral patterned loosely on the Cathedral of AMIENS. Begun in 1248 by Master Gerard, it was not completed until the 19th century. The largest GOTHIC cathedral in northern Europe, it houses a number of superb sculptures.

COLOMBE, JEAN (fl. last 3rd of 15th century; d. 1529). French illuminator known chiefly for his completion of the *Très Riches Heures of the Duke of Berry* and as one of the earliest non-Italians to work in the Renaissance style.

COLOMBE, MICHEL (ca. 1431–ca. 1512). French sculptor who, like his supposed brother JEAN COLOMBE, combined native traditions with the Italian Renaissance style.

COLOSSEUM, THE. Well-preserved remains of a Roman amphitheater, built by Vespasian in the 1st century and used for gladiatorial contests and similar spectacles. 157 feet high and 617 feet long, it is elliptical in shape and comprises four stories, of which the original lower three are pierced by a continuous series of arches separated by high relief columns of, from top to bottom, the Corinthian, Ionic and Tuscan orders. Located near the southeast end of The Forum, it held some 45,000 spectators and is the most imposing of existing Roman edifices.

CONCA, SEBASTIANO (1679–1764). Italian painter, chiefly of church frescoes executed in the BAROQUE manner.

CONINXLOO, GILLIS VAN (1544–1607). Flemish painter who worked mostly in Amsterdam. A pupil of PIETER COECKE VAN AELST, he was famous for his poetic forest scenes and, through such followers as JAN BRUEGHEL, had considerable influence on 17th-century painting.

CONSAGRA, PIETRO (1920–). Italian abstract sculptor and one of the pioneers of non-figurative Italian art.

CONSTABLE, JOHN (1776–1837). English painter and, with TURNER, one of the two preeminent figures in the history of British art. After indifferent training, he became a protégé of sorts of BENJAMIN WEST but for the most part developed his talent for landscape painting by copying the works of such masters as CLAUDE LORRAINE, GAINSBOROUGH and RUISDAEL. As he matured, his chief concern became "a pure apprehension of natural effect"—which is to say, an attempt to see and paint nature as it is, unobscured by painterly traditions. In this concern, he, with Turner (whose works he termed "airy visions, painted with tinted steam"), anticipated the underlying aim of such impressionists as MONET, who knew and admired his work. And like Monet after him, Constable was much concerned with capturing the evanescent effects of constantly changing light. In such landscapes as *Wivenhoe Park* (Washington: National Gallery), he conveys the movement of clouds and change of light—almost the movement of the gentlest breeze—with astonishing conviction. To this end he painted innumerable "sketches"—studies of such transitory phenomena as cloud formations, executed in a kind of shorthand but, except for their lack of formal design, fully realized pictures nonetheless. These sketches, much admired today for their superficial resemblances to ABSTRACT EXPRESSIONISM, greatly affected DELACROIX, among others. Ironically, Constable had little influence on the English painting that followed, but his influence in France was considerable.

CONSTANTINE, ARCH OF. The largest, best-preserved triumphal arch in Rome, it commemorates the victory of Constantine I at the Milvian Bridge and was completed in 315, three years after the emperor's defeat of Maxentius. Decorated with earlier reliefs, the structure consists of a large central arch flanked by two smaller arches, with all three flanked by CORINTHIAN columns.

COOPER, ALEXANDER (before 1609–after 1660) and **SAMUEL** (1609–1672). English brothers and miniaturists trained by their uncle, JOHN HOSKINS. Little survives of

John Constable, *Wivenhoe Park, Essex*, National Gallery, Washington D.C., Widener Collection.

Alexander's oeuvre, which was mainly produced on the Continent, but Samuel's portraits are notable for their broad, painterly handling.

COPLEY, JOHN SINGLETON (1738–1815). American portrait and historical painter who spent the latter half of his life in England. Encouraged by his engraver-stepfather to take up painting, he knew and was influenced by his fellow Bostonian SMIBERT and the latter's gallery of copies of works by the European masters. Other influences included the English ROCOCO portraitists, the Anglo-American portraitists Joseph Blackburn and ROBERT FEKE, but whatever early training he had was informal and haphazard. He soon emerged, nonetheless, as the most forceful native-born portraitist of the American Colonial era. His early successes notwithstanding, Copley tended to see himself as a provincial lacking a cultural heritage, and, with the encouragement of REYNOLDS and WEST, who had seen his *Boy with a Squirrel* (Boston: private collection) in England, he sailed for London in 1774. After a tour of Italy, he returned to London, settled there for good and by 1779 was a Royal Academician.

John Singleton Copley, *Midshipman Augustus Brine*, Metropolitan Museum of Art, New York, bequest of Richard De Wolfe Brixey.

Lovis Corinth, *Lithography for Schiller's "William Tell,"* Schiller National Museum, Marbach Am Neckar.

The historical works of Copley's London period were more ambitious and more knowingly composed than the less sophisticated portraits he had executed in America. Still, it is on the basis of those portraits—direct, convincing and distinguished by a masterly use of paint—that his reputation as America's first artistic giant rests. Historically, however, his importance lies in his development of a new modern-dress approach to history painting and his formative influence on the work of such Europeans as GROS and particularly GÉRICAULT, whose *Raft of the Medusa* (Paris: Louvre) inevitably recalls Copley's *Watson and the Shark* (Boston: Museum of Fine Arts).

COPPO DI MARCOVALDO (fl. 1260–1274). Italian painter and a founder of the monumental tradition of Tuscan painting. In such works as his *Crucifix* (San Gimignano: Civic Museum), he brought a sculptural corporeality to traditional BYZANTINE design.

COQUES, GONZALES (ca. 1616–1684). A Flemish painter and follower of PIETER BRUEGHEL THE YOUNGER, he was a popular portraitist and a rather eclectic genre painter who came to be called "Little Van Dyck."

CORBETT, HARVEY WILEY (1873–1954). American architect and early exponent of the skyscraper. Designer of the Bush Terminal Office Building, New York, and co-designer of Rockefeller Center in the same city.

CORDOBA, PEDRO DE (fl. 2nd half of 15th century). Spanish painter of altarpieces and the leading Cordovan painter of his time.

CORINTH, LOVIS (1858–1925). German painter and printmaker whose early works were in the naturalist tradition but who later turned toward EXPRESSIONISM after first opposing the style.

CORNEILLE (Cornelis van Beverloo) (1922–). Belgian-born Dutch painter of the COBRA GROUP.

CORNEILLE DE LYON (ca. 1500–1574). French court painter possibly born in The Hague. The head of an active workshop, he was influenced by JOOS VAN CLEVE and painted portraits exclusively—typically small in format, with well-modeled, elegant and psychologically convincing heads set against somewhat perfunctory backgrounds. His portrait of *Catherine de Médicis* (Versailles) was praised by the sitter, and his work was so much in demand that many portraits attributed to him may be partly or wholly by other hands.

CORNELISZ, JACOB VAN OOSTSANEN (ca. 1470–ca. 1532). Dutch painter and printmaker known for his effective rendering of texture.

CORNELIUS, PETER (1783–1867). German eclectic painter of the NAZARENE GROUP known for the monumentality of his compositions.

CORNELL, JOSEPH (1903–1972). American assemblagist and collagist. He was a unique figure in 20th-century art, his work extremely personal, intensely poetic and, despite surrealist and DADA affinities, altogether original. Typically, his three-dimensional pieces take the form of small showcaselike boxes wherein ready-made objects and mass-produced images form enigmatic but evocative arrangements. His influence has been considerable, both in the work of JOHNS and other fine artists and in contemporary commercial illustration.

COROT, JEAN-BAPTISTE-CAMILLE (1796–1875). French landscape painter. Trained chiefly in a classicist tradition of highly formalized landscape painting, he was influenced to a degree by CONSTABLE, with whom he is ranked as one of the supreme landscapists of the 19th century, and MICHEL, who provided him with the precedent of creating aerial perspective through tonal means. His travels in Italy also contributed to the development of a style that eventually became the object of widespread plagiarism. This style, employed during the decade ca. 1845–1855, was characterized by its almost palpably moist atmosphere, silvery gray-green tonality, dreamlike serenity and masterful organization of form in both two- and three-dimensional space. Idyllic and deeply poetic, the pictures of this period are imaginary landscapes, sparsely peopled with such stock characters as shepherdesses and flower-gatherers, and hark back to Corot's early classicist training. Underlying and invigorating the best of them, though, is an incisive naturalism developed by painting innumerable small sketches directly from

nature—sketches that accord more closely with today's aesthetic and account for much of the current revival of interest in Corot after a period of relative neglect.

Corot himself was extremely successful during the later years of his life, when much of his work was more or less mass-produced and clearly inferior to the landscapes of his prime. His figure paintings of the same period, though, perhaps because they were less popular and painted to please only himself, were superb, as were the small matter-of-fact landscapes done for his own amusement.

CORREGGIO (Antonio Allegri) (ca. 1489–1534). Italian painter and one of the leading figures of the Renaissance. After studying in Modena, he came under the influence of MANTEGNA, for whose funeral chapel he painted four Evangelists (Mantua: S. Andrea), LORENZO COSTA, MICHELANGELO and DA VINCI. His characteristic works are atmospheric, elegant, somewhat sentimental and make eloquent use of light, gesture and a soft, master-fully handled sfumato derived from Leonardo. His first commission of importance (ca. 1515) was for an altarpiece for a church in his native city, Correggio, and three years later he was assigned the decoration of the abbess' room in the convent of S. Paolo, Parma. For this assignment he chose a secular theme devoted to Diana, goddess of the hunt, whose life and attributes he depicted symbolically in a charmingly insubstantial series of ovoid ceiling decorations marked by the oblique assymetry that was to become the hallmark of such later compositions as *Antiope* (Paris: Louvre). He next embarked on two commissions for dome paintings in which he refined an illusionist technique, previously explored by Mantegna, which treated the ceiling as though it were an open sky against which the action of the painting was unfolding. In following works, he refined his foreshortening, thereby increasing the illusion of reality, and pointed the way toward works as disparate as those of BOUCHER and the CARRACCI.

Jean-Baptiste-Camille Corot, *Souvenir of Mortefontaine*, Louvre, Paris.

Correggio, *The Sleep of Antiope*, Louvre, Paris.

Gustave Courbet, *The Cliffs of Etretat*, Louvre, Paris.

CORTONA, PIETRO BERRETTINI DA (1596–1669). Italian BAROQUE painter and architect best known for his illusionistic ceiling paintings in the Barbarini Palace, Rome, which constitute a tour de force in which the boundary between actual and painted space effectively is obliterated.

COSMATIS, THE. Loosely allied Italian marble workers, active in and around Rome from the early 12th to the 14th century. Their specialty was inlay.

COSSA, FRANCESCO DEL (ca. 1435–1477). Italian painter, chiefly of frescoes and altarpieces.

COSSIERS, JAN (1600–1671). Flemish painter who specialized in mythological and religious subjects and worked under the influence of RUBENS.

COSTA, LORENZO (ca. 1460–1535). Italian painter who succeeded MANTEGNA at the court of Mantua and influenced CORREGGIO.

COTER (variously spelled), **COLIJN (Colin van)** (fl. late 15th century). Flemish painter of altarpieces derived from THE MASTER OF FLEMALLE and ROGIER VAN DER WEYDEN.

COTMAN, JOHN SELL (1782–1842). English watercolor landscapist of the NORWICH SCHOOL. Influenced very early in his career by GIRTIN, he quickly developed an original style that employed flat washes of color, often superimposed and close-toned, to define form. Atypically, Cotman's early period, during which he produced a body of somewhat aloof but brilliantly handled topographical views, was by far his best. Later on, in trying to emulate the romanticism of Girtin and TURNER, he produced a great many unresolved, clearly inferior works. He was also an etcher and occasionally worked in oils.

COTTET, CHARLES (1863–1925). French painter of dark-toned, somewhat expressionist pictures marked by a strong, sinuous linearity.

COURBET, GUSTAVE (1819–1877). French realist painter and one of the seminal artists of the 19th century. After repudiating the academicism of his teachers, he trained himself by observing nature and studying such masters as REMBRANDT, PAOLO VERONESE, CARAVAGGIO, VELAZQUEZ, RIBERA and ZURBARÁN, along with his near contemporaries DELACROIX and GÉRICAULT. After work-

ing briefly in the romantic tradition, he turned to a blunt, simple, solidly composed brand of naturalism marked by strong chiaroscuro and an enthusiastic, somewhat self-indulgent use of thick impasto. By the age of twenty-five, he had purged his work almost completely of an earlier tendency toward sentimentality and imposed his own honest vision on themes usually subjected to trite formulae. Two works exhibited at the Paris Salon of 1850 brought him to the attention of a public that found itself sharply divided on the issue of his talent. Of the two the more controversial was *Funeral at Ornans* (Paris: Louvre), which was widely condemned for its "clumsiness," "ugliness" and lack of feeling but praised by some observers for its realism and technical virtuosity. Five years later, still going his own stubborn way, he showed forty of his works at the Paris World's Fair in a pavilion of his own devoted to *"Le Réalisme."* Of these works, the vast canvas entitled *The Studio: Allegory of Realism* (Paris: Louvre) generally is considered his magnum opus and one of the masterpieces of 19th-century art. In the years that followed he concentrated on landscapes—particularly forest settings—and solidly constructed, heavily fleshed nudes, often combining the two and sometimes charging his pictures with an undisguised eroticism that shocked a public used to less frank exercises in prurience.

A political as well as an artistic revolutionary, Courbet was named president of the arts commission after the fall of Napoleon III. As such, he was held responsible for the destruction of the Vêndome Column and imprisoned after the Paris Commune fell. After his release, constantly harassed by the Bonapartists, he fled to Switzerland, where he was to die in exile. His great contribution to painting was a rejection of nonpictorial associations out of which grew an art of palpable presence and credibility.

COURTOIS, GUILLAUME (1628–1679) and **JACQUES** (1621–1676). French history painters and brothers. Best known for their battle pictures, they worked and died in Rome.

COUSIN, JEAN (ca. 1490–1560) and **JEAN THE YOUNGER** (ca. 1522–ca. 1594). French artists, father and son, who between them worked in most of the then existing media and in a similar mannerist style.

COUSTOU, GUILLAUME (1677–1746) and **NICOLAS** (1658–1733). French brothers, sculptors and sometime collaborators, they specialized in public commissions executed in a classicist-BAROQUE style.

COUTANCES: CATHEDRAL OF NOTRE-DAME. 13th-century Norman GOTHIC edifice in northwest France. The most nearly perfect surviving building of its period and style, it is notable for its clarity of form and integrity of line, its great central lantern tower and twin west towers and the tall double aisles of its chevet.

COUTURE, THOMAS (1815–1879). A French painter and teacher, notably of MANET and FANTIN-LATOUR, he is best known for his sumptuous color and his depictions of orgies and their aftermaths.

COVARRUBIAS, MIGUEL (1904–1957). Mexican painter, caricaturist, archaeologist and ethnologist. Although an unimportant painter, he is remembered as an extremely original illustrator and caricaturist and one of the leading authorities on PRE-COLUMBIAN Mexico and its art.

COX, DAVID (1783–1859). English watercolorist best known for his quickly executed atmospheric landscapes and considered a nexus between CONSTABLE and IMPRESSIONISM.

COX, KENYON (1856–1919). An American academic painter taught by DURAN and GÉRÔME. His best works were murals executed in the Venetian manner.

COYPEL, ANTOINE (1661–1722). French court painter who worked in an Italian BAROQUE style that pointed the way to the ROCOCO.

COYPEL, CHARLES-ANTOINE (1694–1752). A French painter and son of ANTOINE COYPEL, he was more influential as a theorist than as an artist.

COYPEL, NOEL (1628–1707). French history painter, father of ANTOINE COYPEL and first of three generations of influential painters. As director of the Paris Academy, he was instrumental in modernizing its programs.

COYSEVOX, ANTOINE (1640–1721). French sculptor whose career moved from classical beginnings to the BAROQUE and who was esteemed for the psychological insights of his portrait busts.

COZENS, ALEXANDER (ca. 1717–1786). Russian-born English draftsman and watercolorist. One of the first English landscapists, he was a noted theoretician who ·advocated the cultivation of fortuitous elements in the composition of pictures.

COZENS, JOHN ROBERT (1752–1797). English watercolor landscapist and son of ALEXANDER COZENS. "Cozens," according to CONSTABLE, "was all poetry" and "the greatest genius who ever touched landscape." His influence on such painters as GIRTIN, TURNER and Constable himself was considerable, and in his works, as in many of Turner's, nature is seen as an ominous, inhospitable force.

CRAESBEECK, JOOS VAN (ca. 1606–1654). Flemish genre painter influenced by BROUWER and, later, by REMBRANDT.

CRANACH, LUCAS THE ELDER (1472–1553). German painter and printmaker. The details of his early life and training are obscure, but he is known to have been working in Vienna around 1502. In 1504 he was court painter to the Saxon elector Frederick III in Wittenberg, where he remained, under three successive electors, until 1550, when he accompanied the last of the line, John Frederick, into exile. Unfortunately, Cranach's work at court constitutes a record of decline, and his relatively early works, characterized by their sinuous nudes in landscapes of

Lucas Cranach, *Venus*, Louvre, Paris.

astonishing clarity, are by far his best. He painted numerous portraits of his close friend Martin Luther, under whose direction he painted the first Protestant pictures, and was politically active, often to the detriment of his artistic productivity, in the latter part of his life. Although his attempts to embrace the Renaissance style were stilted and essentially Medieval, his paintings were extremely popular in their time and were produced in large numbers by Cranach himself and, under his supervision, by his son Lucas The Younger (1515–1586).

CRANE, WALTER (1845–1915). English painter, illustrator, writer, follower of the PRE-RAPHAELITES and a leading figure in the ARTS AND CRAFTS MOVEMENT spearheaded by WILLIAM MORRIS.

CRAWFORD, RALSTON (1906–). Canadian-born American PRECISIONIST painter known for his clean-lined reductive cityscapes.

CRAYER, GASPARD DE (ca. 1583–1669). Flemish portraitist and painter of religious subjects, influenced by the early work of RUBENS. His best compositions are characterized by their emphatic diagonals and assymetric balance.

CREDI, LORENZI DI (ca. 1458–1537). Italian painter, sculptor and metalsmith. Trained alongside DA VINCI in the studio of VERROCCHIO, he completed his teacher's equestrian statue of Bartolommeo Colleoni in Venice after Verrocchio's death. His surviving paintings are mostly of religious subjects characterized by high finish and meticulous attention to detail. A reputedly large body of secular works is believed to have been destroyed in accordance with the strictures of Savonarola.

CRESPI, DANIELE (ca. 1600–1630). Italian painter of somewhat austere religious pictures distinguished by their clarity of form.

CRESPI, GIOVANNI BATTISTA (1575–1632). Italian eclectic painter and sculptor, influenced by MICHELANGELO and the VENETIAN SCHOOL and known for his astute handling of color and light.

CRESPI, GIUSEPPE MARIA (1664–1747). Italian eclectic painter of the BOLOGNESE SCHOOL whose work is characterized by its compelling emotive qualities.

CRIVELLI, CARLO (fl. 1457–1493). Italian painter of the VENETIAN SCHOOL and leading painter of his era in the Marches. His early works are characterized by an unusually incisive linearity and a lightness of tone, while his later pictures are marked by a greater emphasis on form and a darker palette. Throughout his career, his work remained somewhat schematized, with objects and figures juxtaposed in arbitrary proportions and with emblematic devices often given a *trompe l'oeil* emphasis that tends to obscure his central themes.

CRIVELLI, TADDEO (ca. 1425–1485). Italian miniaturist known for the richness and inventiveness of his illuminations.

CROME, JOHN (Old Crome) (1768–1821). Largely self-taught English landscape painter whose style was formed by his study of HOBBEMA, GAINSBOROUGH, RICHARD WIL-

SON and perhaps REMBRANDT, among others. He was the central figure of the NORWICH school. His works are distinguished by their breadth and simplicity of conception, their unerring cohesiveness and their imposing monumentality—qualities epitomized by his dictum "Keep the masses large and in good and beautiful lines."

CRONACA, IL (Simoneda Pollaiuolo) (1457–1508). Italian architect best known for the influence his design for the church of S. Francesco al Monte (near S. Miniato) had on MICHELANGELO.

CROPSEY, JASPER FRANCIS (1823–1900). American painter of the HUDSON RIVER SCHOOL and a specialist in autumnal landscapes.

CROSS, HENRI-EDMOND (Henri Delacroix) (1856–1910). French neo-impressionist follower of SEURAT and SIGNAC whose colorful brand of DIVISIONISM had a considerable impact on the development of FAUVISM.

CRUIKSHANK, GEORGE (1792–1878). Self-taught English illustrator and caricaturist. Although less mordant than such satirists as HOGARTH, GILLRAY and ROWLANDSON, his work was remarkably expressive, and in his ability to anthropomorphize inanimate objects he anticipated much of the work of LEAR.

CUEVAS, JOSÉ LUIS (1933–). A Mexican graphic artist and chronicler of social inequities whose style is highly expressionist and, at its most powerful, somewhat disorienting.

CUIXART, MODESTO (1925–). Spanish painter whose bizarre, enigmatic figurative works, with their strong overlay of abstraction, unconventional colors and occasional collage elements, suggest the art of RICHARD LINDNER.

CUIJP, AELBERT (1620–1691). Dutch painter who specialized in landscapes and animal subjects and, through such travelers as JAN BOTH, absorbed many Italian influences. Also influenced by VAN GOYEN, his style in turn influenced a number of 17th-century little masters.

CUNHA, MANOEL DA (1737–1807). Brazilian painter born in slavery and trained in Portugal. A specialist in religious murals and altarpieces, he was also Brazil's first portraitist.

CURRIER AND IVES American lithographic firm specializing in hand-colored genre subjects, patriotic motifs and historical subjects. Founded by Nathaniel Currier (1813–1888) and co-owned by James Merritt Ives (1824–1895), it was the most prolific producer of popular art in the U.S. in the 19th century, and rarer examples of its output are much prized today.

CURRY, JOHN STEUART (1897–1946). American regionalist painter, printmaker and illustrator who specialized in rural subjects and circus scenes.

CUVILLIES, FRANÇOIS DE, THE ELDER (1695–1768). French-born German court architect and decorator trained in Paris. A specialist in noble private residences, he was influential in introducing French ROCOCO forms into Germany.

D

DADDI, BERNARDO (1290–1348). An Italian painter of the Florentine school, he may have been a pupil of GIOTTO, by whom he was in any case influenced, as he was by LORENZETTI. One of the leading Florentine painters of his time, he fused Giottoesque form with the Sienese style.

DAHL, JOHAN CHRISTIAN (1788–1857). Norwegian romantic landscape painter whose works are characterized by a strongly nationalistic flavor.

DAHL, MICHAEL (1659–1743). Swedish ROCOCO portrait painter who worked for the most part in London, where he achieved considerable eminence after the death of KNELLER.

DALI, SALVADOR (1904–). Spanish painter, designer, illustrator, filmmaker and author. After first working in a cubist vein, he was attracted to the metaphysics of CHIRICO and CARRA and attracted early attention through his facile draftsmanship and meticulous rendering. After absorbing further influences through PICASSO, MIRÓ, TANGUY and SURREALISM, he began producing pictures characterized by their strongly Freudian content, hallucinatory atmosphere, enigmatic symbolism and a bizarre use of juxtaposition that suggested much, but yielded little, meaning. Throughout his career Dali has been accused of cheap showmanship, glib commercialism and lack of seriousness, and while there is much justification in the charges, such haunting works as his 1931 *Persistence of Memory* (New York: Museum of Modern Art) assure him a place in the history of modern art.

DALMAU, LUIS (fl. 1428–1406). Spanish painter who was much influenced by Flemish art, particularly that of JAN VAN EYCK, and who served as a conduit whereby the Netherlandish style permeated Spanish painting of the next generation.

Salvador Dali, *Temptation of St. Anthony*, collection of the artist.

Charles-François Daubigny, *Evening Landscape*, Metropolitan Museum of Art, New York, bequest of R. G. Dun, 1911.

DALOU, AIMÉ-JULES (1838–1902). French monumental naturalist sculptor, best known for his *Triumph of the Republic* in the Place de la Nation, Paris.

DANTI, VICENZO (1530–1576). Italian sculptor, painter, goldsmith, architect and author. Heavily influenced by MICHELANGELO, his best-known works are a bronze portrait of Julius III (Perugia), the *Beheading of John the Baptist* (Florence: Baptistry) and the ground plan for the ESCORIAL.

DAPHNI, CHURCH OF. A BYZANTINE domed church built near Athens, Greece, in the late 11th century, it is most notable for the magnificence of the mosaics that cover much of its interior, particularly a representation of Christ Pantocrator in the central dome.

D'ARCANGELO, ALLAN (1930–). American painter of strong, hard-edged, emblematic images based on traffic signs and the landscape of the American highway.

DARET, JACQUES (ca. 1404–ca. 1468). Flemish painter trained in the workshop of the MASTER OF FLEMALLE, whose tradition he helped continue in and around Tournai.

DARET, PIERRE (ca. 1604–1678). French painter and engraver best known for his straightforward classical portrait engravings.

DAUBIGNY, CHARLES-FRANÇOIS (1817–1878). French BARBIZON painter and printmaker. A transitional figure between COROT and IMPRESSIONISM, he was a friend of, and influence on, MONET and one of the first in a long line of *plein-air* painters who were to concern themselves primarily with direct observation of the effects of natural light on landscape. Significantly, Théophile Gautier praised his talent but condemned him for being "satisfied by an *impression* and neglect[ing] de-

tails," and REDON wrote: "It is impossible not to recognize the exact hour at which M. Daubigny has been working. He is the painter of a moment, of an impression." Despite Daubigny's preoccupation with light and its transitory effects, there is a pleasing, rather homely solidity about his best work that harks back to the Dutch landscapes of HOBBEMA and RUISDAEL and that anticipates some of the less obsessive characteristics of VAN GOGH. He was also an accomplished, prolific and popular etcher.

DAUCHER, ADOLF (ca. 1460–ca.1523) and **HANS** (ca. 1485–1538). German sculptors, of whom Adolf was the more influential as an exponent of the new Renaissance style. His son Hans was renowned for his bronze miniatures.

DAUMIER, HONORÉ (1808–1879). French lithographer, painter, sculptor, caricaturist and illustrator. Although academically trained, he rejected the tenets of academicism to develop an intensely personal style characterized by its highly charged contours, mordant apprehension of character and rigorous suppression of nonessential embellishment or detail. As did GOYA before him, he seized on the relatively new technique of lithography—a medium peculiarly suited to his talent—as a vehicle for social satire, but, unlike Goya's, even his most biting indictments of corruption and injustice reflected an underlying optimism, a belief that society was perfectable. At the outset of his career he drew political cartoons for *Caricature*, an anti-government weekly, and soon found himself sentenced to six months in jail for portraying Louis Philippe as "Gargantua swallowing bags of gold extorted from the people." With government suppression of the paper in 1835, he turned to social themes but returned to political subjects with Louis Philippe's abdication during the February Revolution of 1848.

Although he executed some 4,000 lithographs and was known chiefly as a lithographer during his lifetime, Daumier's paintings (of which he was given a single major exhibition during his lifetime and that just a year before his death) won wide posthumous acclaim and influenced such later artists as CÉZANNE, VAN GOGH, PICASSO, ENSOR and KOLLWITZ. Composed almost entirely of figures, with backgrounds only suggested in thin washes of color, his paintings are quite small, extremely expressive and influenced in their handling of chiaroscuro by REMBRANDT and coloristically by DELACROIX. Another major influence was detected early by Balzac, who said of Daumier, "That boy has MICHELANGELO under his skin."

Although he often dealt with peasant types similar to those painted by his contemporary, MILLET, Daumier, unlike Millet, captured the inherent dignity of his subjects while managing not to sentimentalize them. Blind and impoverished in his last years, he was supported by COROT.

DAVID, GERARD (ca. 1460–1523). Influenced by JAN VAN EYCK, ROGIER VAN DER WEYDEN, MEMLING and the MASTER OF FLEMALLE, he may have been a pupil of VAN OUWATER and probably of GEERTGEN TOT SINT JANS and

Honoré Daumier, *Don Quixote and Sancho Panza*, Tate Gallery, London.

Jacques-Louis David, *Portrait of Madame Julie Récamier*, Louvre, Paris.

generally is considered to be the last of the great Flemish primitives. Notable for his handling of space and volume, he used chiaroscuro more freely than did his predecessors and incorporated into his pictures such Renaissance motifs as putti and flowered garlands. Although figures in his earlier works tend to be somewhat stiff and so closely grouped that they appear almost to be bunched for compositional support, his finest known late work, *The Baptism of Christ* (Bruges: Municipal Museum), is distinguished by a compositional assurance that ranges freely over the centerpiece and wings of a triptych. David's backgrounds prove him to have been a master landscapist. His most notable followers were YSEN-BRANDT and BENSON.

DAVID, JACQUES-LOUIS (1748–1825). French painter. A distant cousin and protégé of BOUCHER, he was the most powerful and influential painter of the Napoleonic era. Trained in the NEOCLASSICAL style by VIEN, he won the Prix de Rome in 1774 and the following year left with his teacher for Rome, where he studied the art of antiquity and divested himself of the last traces of Boucher's influence. Returning to France in 1780, he was elected to the French Academy three years later and soon was much acclaimed for such works as *The Oath of the Horatii* (Paris: Louvre) and *The Death of Socrates* (New York: Metropoli-

tan Museum), works that closely conformed to the eclectic doctrine of MENGS. With the Revolution of 1789, his style—and particularly the content of his pictures—took on a more moralistic and naturalistic flavor as he turned his attention to such themes as the assassination of Lepelletier de Saint-Fargeau, the death of Bara and *The Death of Marat* (Brussels: Museum of Modern Art). An active participant in the Revolution, he became a Deputy, voted to send Louis XIV to the guillotine and, as dictator of the arts, abolished the Academy and helped replace it with the Institute. With the fall of Robespierre, he was imprisoned in the Luxembourg but was released after pledging to abstain from political activity.

David exhibited *The Sabine Women* (Paris: Louvre) in 1799, thereby re-establishing his reputation. His next major work, an equestrian portrait of Napoleon, resulted in his eventual appointment as First Painter to the Emperor, an appointment he celebrated by executing such testimonials to Bonaparte's puissance as *The Distribution of the Eagles* (Versailles Museum) and the vast, portrait-thronged *Coronation* (Paris: Louvre). In general, the works of this period are less austere and more romantic than those that pre-date *The Sabine Women*, although a number of fine portraits are executed in the somewhat more severe style of David's earlier years. With the fall of Napoleon, the painter went into exile in Brussels, where

he spent the last decade of his life, while his disciple Gros carried on the Davidian school in Paris.

One of those few artists who, for better or worse, epitomize an age, David's influence was pervasive in his own and following generations, first as the arbiter of the prevailing "official" style and later as the entrenched force against which the romantics—and eventually the impressionists—reacted. Besides Gros, he numbered Girodet, Gérard, Prud'hon, Ingres, Guerin and Géricault among his pupils, protégés or followers at one remove. To a greater or lesser extent he influenced 19th-century painting throughout Europe and as far afield as the United States.

DAVID, PIERRE-JEAN (David d'Angers) (1788–1856). French sculptor whose work embodies a transition from classicism to realism and who is best known for his high reliefs on the pediment of the panthéon in Paris.

DAVIES, ARTHUR BOWEN (1862–1928). American painter, sculptor and graphic artist. He was chief organizer of the armory show of 1913. His style derived from a variety of sources and, at its most characteristic, took the form of friezelike arrangements of figures in rather moody classical landscapes. He was also a noted designer of tapestries.

DAVIS, GENE (1920–). An American painter of the so-called Washington Color school that emerged in the mid-1960s. His characteristic work, related to op art, is composed of series of thin vertical stripes

DAVIS, STUART (1894–1964). American semi-abstract painter and one of the pioneers of modernist art in the United States. First influenced by what he saw of cubism and post-impressionism in the 1913 armory show (in which he was represented by five watercolors), he later

Stuart Davis, *Midi*, Wadsworth Atheneum, Hartford, Connecticut.

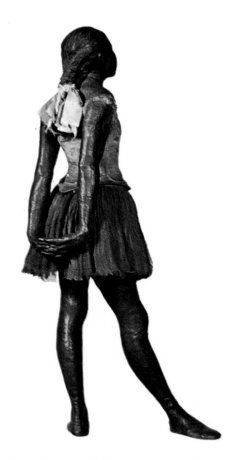

developed a style derived from LÉGER, in which flat patterns, hard edges, ribbonlike calligraphic forms, actual words and bright, resonant color were combined with the fragmentary images of commercial advertising to produce dynamic, witty compositions that frequently have been described as the visual equivalents of jazz.

DAYES, EDWARD (1763–1804). English watercolorist and illustrator best known as the teacher of GIRTIN.

DE BROSSE FAMILY. Related French 16th- and 17th-century architects, of whom the most successful was Salomon De Brosse (1571–1626), whose best-known work is the Luxembourg Chateau he designed for Marie de Médicis.

DECAMPS, ALEXANDRE-GABRIEL (1803–1860). Mostly self-taught French painter and printmaker of Oriental and historical subjects depicted in the academic manner.

DE COTTE, ROBERT (1656–1735). French architect. One of the innovators of the ROCOCO, he is best known for his interior decoration.

DE CREEFT, JOSÉ (1884–). Spanish-born American sculptor known for his swelling, rounded carvings.

DE CRITZ FAMILY. A family of Flemish painters who worked in England in the 16th and 17th centuries. Predominantly portraitists, the best-known members were John (before 1552–1642) and his son Emmanuel (before 1609–1655).

DEGAS (Hilaire Germain), EDGAR (1834–1917). French painter and sculptor who studied in Paris under Louis Lamothe, through whom he absorbed the influence of INGRES, and in Italy, where he copied the works of the Renaissance masters. After starting his artistic career with a series of historical paintings, he met MANET, was introduced to his circle and turned to such contemporary subjects as racing scenes, ballet rehearsals, café life and the like. Although he participated in all but one of the Impressionist exhibitions and generally is associated with the rise of IMPRESSIONISM, his essentially classicist work bore only superficial resemblances to the style, hardly concerned itself with the fleeting effects of light and atmosphere and the fortuitous "compositions" that preoccupied the Impressionists and was marked by the precision of its draftsmanship and deliberateness of its composition.

Degas is considered one of the greatest draftsmen who ever lived, a portraitist of keen psychological insight and an unsurpassed observer of bodies—both human and equine—in action, under stress and in exhaustion. His compositions, much influenced by Japanese prints and often unconventionally cropped or viewed from unusual angles, were highly innovative and lent a kind of photographic credibility to his work. Like DAUMIER, his pictures were concerned almost exclusively with figures, their surroundings only sketchily suggested, and like Daumier's his depictions of simple working women projected great human dignity through the rigorous suppression of sentimentality. As a painter in pastels he revolutionized a medium in which little of consequence ever had been produced, investing his pictures of bathers and dancers with a luminosity, vigor, power and richness of color that were never again to be achieved in pastel. Turning to sculpture later in life as his eyesight failed, he produced a body of small waxes (later cast in bronze) of extraordinary grace, solidity and simplicity—works RENOIR ranked above those of RODIN.

DEHN, ADOLF (1895–1968). American painter and printmaker known for his mildly satirical depictions of modern life and his soft-toned landscapes.

DEIR EL BAHARI. Site, in western Thebes, of two ancient Egyptian burial temples, one built during the 11th dynasty for Pharaoh Mentuhotep and the other during the 18th dynasty for Queen Hatshepsut. The former takes the shape of a terraced pyramid; the latter, designed to be seen frontally, is notable for its integration with the natural rock formations of the site and for its lively relief carvings and paintings.

DE KOONING, WILLEM (1904–). Dutch-born American painter, a leading exponent of ABSTRACT EXPRESSIONISM and one of the major figures in the mid-20th-century emergence of American abstract painting of the so-called NEW YORK SCHOOL. After collaborating on a mural project with LÉGER and participating in the Federal Art Project in the 1930s, he turned to black-and-white

abstractions during the 1940s and, by the time of his first one-man exhibition in 1948, was recognized, with POL-LOCK, as a leader of a movement that was profoundly to change the course of 20th-century art throughout the world. His "Woman" series of the 1950s, in which he used brusque, crudely brushed, erotically charged figurative elements, comprised some of the masterpieces of ACTION PAINTING and firmly established his reputation as a modern master. Although thematically and stylistically similar, his later essays into sculpture have been less successful than his major paintings and collages.

DELACROIX (Ferdinand-Victor-) EUGÈNE (1798–1863). French painter and, as a polarizing force in the reaction against Davidian classicism, one of the most influential artists of the 19th century. After studying briefly alongside GÉRICAULT in the studio of Pierre Guérin, he continued his artistic education by copying RUBENS, PAOLO VERONESE and the Venetian masters at the Louvre, where he met BONINGTON, who introduced

him to English watercolor painting, Shakespeare and English romantic literature. After generating considerable controversy with his *Dante and Virgil* (Paris: Louvre), a work that owed a great deal to Géricault's *Raft of the Medusa* (and that was purchased by the state, presumably through the influence of his supposed father, Talleyrand), at the 1822 Salon he scandalized Paris with his *Massacre at Chios* of 1824, a picture influenced to a considerable extent by his discovery of CONSTABLE, described by Baudelaire as a hymn to "doom and irremediable suffering"—and, again, bought by the state. His next major work, *The Death of Sardanapalus* (Paris: Louvre), a vast, brilliantly painted but altogether self-indulgent picture, brought him into widespread disfavor and incurred the hatred of the "classicists," although Delacroix himself sought to uphold what he defined as the classical tradition. *Liberty Leading the People* (Paris: Louvre), painted in 1831, was a far more popular work and marked the onset of a more restrained, less operatic style distinguished by

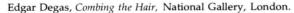

Edgar Degas, *Combing the Hair,* National Gallery, London.

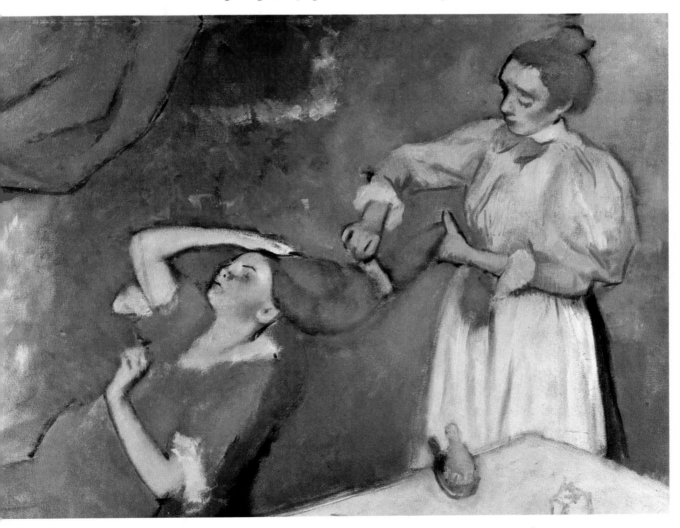

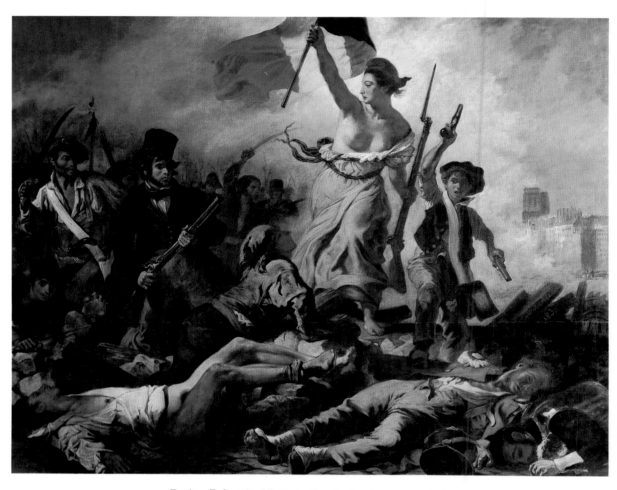

Eugène Delacroix, *Liberty Leading the People*, Louvre, Paris.

greater monumentality and true grandeur. During the next year Delacroix traveled in North Africa, finding there a wealth of subject matter ideally suited to his love of color and exoticism and a fund of motifs from which he was to draw throughout the rest of his career.

Today Delacroix is recognized as one of history's great colorists, one of the last painters in the grand manner, perhaps the last muralist who can be compared with the great BAROQUE masters and a unique fiqure who, while he left no direct successors, exerted a deep and lasting influence on Western art. His personal *Journal* (1823–1854) is one of the great artistic documents, and his lithographic illustrations for Shakespeare and Goethe are among the most sumptuous and expressive ever produced.

DELAROCHE, PAUL (1797–1856). Popular French history painter perhaps best known for his *Apotheosis of Art* in the dome of the Palais des Beaux-Arts, Paris.

DELATRE (Delattre), JEAN MARIE (1745–1840). French reproductive engraver and illustrator who worked in England.

DELAUNAY, ROBERT (1885–1941). French Cubist painter and a founder of ORPHISM who was much admired in Germany, where he exhibited with the BLUE RIDER. The husband of SONIA DELAUNAY and one of the earliest abstract painters in France, he was widely influential through his researches into color, kinetics and their interrelationship.

DELAUNAY, SONIA (née **Sonia Terk**) (1885–). Ukrainian-born French painter and designer and wife of ROBERT DELAUNAY. Originally an adherent of FAUVISM, she collaborated later on her husband's researches into the use of color in CUBISM and ORPHISM. After his death she worked with other artists, notably ARP, and produced a number of widely admired tapestry designs.

DELLO DI NICCOLO DELLI (Nicolao Fiorentino) (ca. 1404–ca. 1470). Italian painter who worked mostly in Spain, where he was responsible for the introduction of early Renaissance concepts.

DE L'ORME (Delorme), PHILIBERT (ca. 1513–1570). French architect in the court of Henry II and, much later, Catherine de Médicis. Little of his work survives aside from two architectural treatises that were written while

he was in disfavor in court and that had considerable influence among younger 16th-century architects. Markedly nationalistic, he advocated the addition of a new French Order to the accepted Orders of Architecture.

DE LOUTHERBOURG, JACQUES PHILIPPE (Philipp Jakob) (1740–1812). French painter and designer who worked in London, where he was known chiefly as a designer of stage sets and moving panoramas.

DELVAUX, LAURENT (1697–1778). A Belgian sculptor, principally of church pulpits, who was influenced by BERNINI and worked in England and Italy at various times.

DELVAUX, PAUL (1897–). Belgian surrealist painter, characteristically of enigmatic dreamlike pictures in which nude women inhabit such incongruous settings as railroad yards.

DEMUTH, CHARLES (1883–1935). An American watercolorist who studied with ANSCHUTZ and was influenced by GLEIZES and METZINGER, he is best known for his delicate, almost fragile figure studies and still lifes.

DENDERA. Ancient site, on the Nile in Upper Egypt, of the Temple of Hathor (begun in the 1st century B.C. and decorated under later Roman emperors), three subsidiary temples, a 5th-century Coptic church, a rectangular lake, baths and a massive protecting wall, all in an unusually good state of preservation.

DENIS, MAURICE (1870–1943). French painter who, as a member of the NABIS, formulated an influential body of theory, of which the best-known fragment is his dictum that a picture "is essentially a flat surface covered with colors arranged in a certain order."

DERAIN, ANDRÉ (1880–1954). French painter who with MATISSE, VLAMINCK and others pioneered FAUVISM and who was an early adherent of CUBISM, which he influenced through his early "discovery" of AFRICAN SCULPTURE. Although he later developed an eclectic style of no great consequence, his most notable accomplishments occurred during the period 1905–1912, when he painted numerous landscapes with great vigor and audacity, using almost pure color and a nervous, slashing brush stroke that prefigures ABSTRACT EXPRESSIONISM by almost half a century. He was also a noted illustrator and theatrical designer.

DER KINDEREN, ANTON JOHAN (1859–1925). Dutch painter, printmaker and stained-glass designer best known for his advocacy of monumental decoration integrally incorporated into architecture.

André Derain, *Boats,* private collection, Paris.

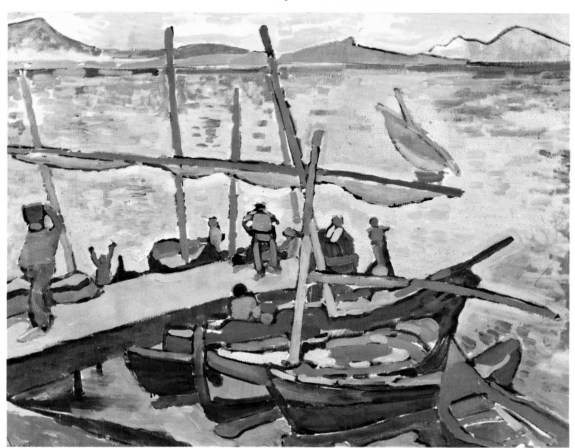

DERUET, CLAUDE (ca. 1588–1660). French portrait and history painter and engraver remembered chiefly as the teacher of CLAUDE LORRAINE.

DE SAINT-PHALLE, NIKI (1930–). French sculptor known primarily for her witty, monumental, fancifully polychromed figures of women, many of which are at once toylike, grotesquely distended and curiously erotic.

DESCHAMPS, JEAN and **PIERRE** (fl. 2nd half of 13th and early 14th centuries). French architects, possibly father and son, who worked in south-central France in a style derived from the northern French GOTHIC.

DESIDERIO DA SETTIGNANO (ca. 1430–1464). Italian sculptor of the Florentine school. A virtuoso carver in marble, he specialized in low reliefs following the example of DONATELLO. He was esteemed for his delicacy and the fastidiousness of his design. His modeling was sensitive and subtle and his technique was brilliant, especially in its exploitation of polychrome effects.

DESPIAU, CHARLES (1874–1946). French sculptor and follower, early in his career, of RODIN best known for his subtly nuanced portrait busts.

DESPORTES, ALEXANDRE-FRANÇOIS (1661–1743). French painter of animals and hunt subjects and designer of tapestries. One of the earliest artists to paint landscapes directly from nature.

DETAILLE, ÉDOUARD (1848–1912). French painter who, like his teacher MEISSONIER, specialized in military subjects.

DEUTSCH, NIKLAUS MANUEL (ca. 1484–1530). Swiss painter and designer who specialized in macabre subjects.

DEVIS, ARTHUR (1711–1787). English painter of portraits and conversation pieces.

DEWING, THOMAS WILMER (1851–1938). American portraitist and figure painter who studied with and was influenced by DUVENECK. Best known for his somewhat reverential pictures of women.

DE WINT, PETER (1784–1849). An English painter of Dutch-American extraction, he was influenced by GIRTIN and COTMAN and is best known for his watercolor landscapes, which are distinguished by their richness of color, the clarity of their washes and the simplicity of their organization.

DIAMANTE, FRA (1430–ca. 1500). An Italian painter and follower of FILIPPO LIPPI, he worked with his mentor on the fresco and mosaic decorations for the cathedrals of Prato and Spoleto.

DIANA, BARTOLOMMEO (Benedetto Rusconi) (fl. 1482–1525). Italian painter, chiefly of altarpieces characterized by a distinctive bluish tonality.

DIAZ DE LA PEÑA, NARCISSE-VIRGILE (1807–1876). French painter of the BARBIZON group. His romantic forest scenes, extremely popular in their time, were painted in a heavy, somewhat affected impasto that moved Baudelaire to remark that Diaz mistook palettes for pictures. Nonetheless, he was admired by DELACROIX, influenced FANTIN-LATOUR and MONTICELLI and to some degree prefigured IMPRESSIONISM.

DICKINSON, EDWIN (1891–). American romantic expressionist painter of close-toned montages carefully composed of architectural and natural elements.

DICKINSON, PRESTON (1891–1930). American painter best known for his cubist-derived cityscapes, industrial subjects and still lifes. Although loosely associated with PRECISIONISM in the 1920s, his painterly qualities were never subordinated to the stylistic austerity of the true Precisionists.

DIEBENKORN, RICHARD (1922–). American painter who began his career as an exponent of ABSTRACT EXPRESSIONISM, achieved widespread recognition in the 1960s for figurative and landscape paintings of great facility and remarkable presence and, more recently, has returned to a loosely geometric abstract configuration that embodies characteristics of both earlier styles.

Richard Diebenkorn, *Ocean Park #19,* courtesy of Marlborough Gallery, Inc., New York.

Otto Dix, *The Hall of Mirrors in Brussels,* Siegfried and Gesche Poppe Collection, Hamburg.

DIETZENHOFER FAMILY. Highly influential German BAROQUE architects of the 17th and 18th centuries, of whom the most notable were Georg (1643–1689); Christoph (1655–1722), his brother, who worked in Bohemia; Christoph's son Kilian Ignaz (1689–1751), the foremost exponent of the late Baroque in Bohemia; and Johann (1663–1726), who, like his brother Georg, worked in Franconia.

DILLER, BURGOYNE (1906–1965). An American abstract painter and follower of MONDRIAN. His works are characterized by blacks, whites and primary colors arranged in hard-edged rectangles on an underlying grid. He was the first American to work in the tradition of DE STIJL.

DINE, JIM (1935–). American painter best known for his close attention to the line of demarcation between art and reality. He was an early exponent of HAPPENINGS. His typical later works juxtapose actual and depicted objects with considerable wit.

DISCOBOLUS. Lost Greek bronze of a discus thrower by MYRON, of the mid-5th century B.C., now known through Roman copies and famous for its rhythmic appearance of arrested motion.

DI SUVERO, MARK (1933–). American sculptor, characteristically of constructions made up of found and industrial elements, often weathered or otherwise eroded.

DIX, OTTO (1891–1969). German painter who studied and taught at the Düsseldorf Academy and in Dresden. Although he worked in a wide variety of styles during his career, his most notable work was produced during the 1920s, when, with GROSZ, he founded the NEUE SACHLIICHKEIT movement and took the folly and brutality of contemporary life as the subjects for a series of repellently candid paintings.

DOBELL, SIR WILLIAM (1899–1970). An English-trained Australian painter of expressionistic portraits, he became a center of parochial controversy in 1944, when a prize awarded to him was contested in the courts by a reactionary group.

DOBSON, FRANK (1887–1963). English sculptor influenced first by CUBISM and later by MAILLOL, DESPIAU and GAUDIER-BRZESKA. Best known for his portraits and female nudes.

DOBSON, WILLIAM (1611–1646). Described by Aubrey as "the most excellent painter that England hath yet bred," he specialized in portraits, chiefly of Royalist officers of the Civil War, and generally is considered the outstanding native English portraitist before HOGARTH.

DOESBURG, THEO VAN (C. E. M. Kupper) (1883–1931). Dutch painter, critic, architect and poet and a major force behind the international impact of DE STIJL, which he helped found and for which he prosyletized throughout Europe. In his most characteristic cubist-

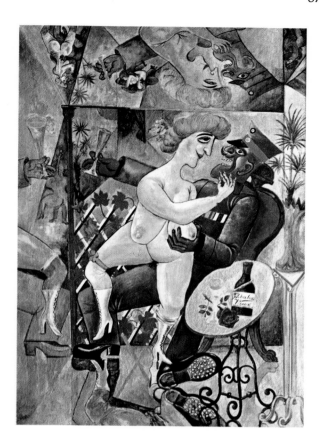

derived works he sought to represent natural forms geometrically and, like his colleague MONDRIAN, limited his palette to black, white and the primary colors.

DOMELA (Domela-Nieuwenhuis), CESAR (1900–). Dutch sculptor. A member of DE STIJL in his early years as a painter, he abandoned the neo-plastic discipline in 1928, turned to free form and, and soon thereafter, to constructivist sculpture that bore influences of GABO and PEVSNER.

DOMENICHINO (Domenico Zampieri) (1581–1641). Italian painter of the BOLOGNESE school who studied and worked under CALVAERT and the CARRACCI and who was strongly influenced by RAPHAEL. Considered the outstanding classicist of his time, he flirted for a while with the BAROQUE style—a flirtation that was ill-advised and led to considerable controversy, unpopularity and even physical peril. A consummate landscapist, he was much admired by, and exerted great influence on, POUSSIN and CLAUDE LORRAINE.

DOMENICO DA CORTONA (Le Boccador) (1470–1559). Italian architect and sculptor who worked in France, where his designs for the Chateau of Chambord and the Hotel de Ville, Paris, were to influence French design over the next two centuries.

DOMENICO DI BARTOLO GHEZZI (ca. 1400–ca. 1445). Italian painter of the Sienese school influenced by MASACCIO, DELLA QUERCIA and DELLA ROBBIA. His fres-

coes in Siena's Hospital della Scala reflect his awareness of Florentine Renaissance innovation.

DOMENICO VENEZIANO (ca. 1400–1462). Italian painter who worked chiefly in Florence, where he is dubiously credited by VASARI as having introduced oil painting into Tuscany. Notable for his masterly handling of form and harmonious orchestration of color, he was innovative in his use of color as a means of creating aerial perspective. Although relatively little authenticated work from his hand survives, existing documentation indicates that he was enormously influential in his time and that he numbered PIERO DELLA FRANCESCA among his assistants.

DONATELLO (Donato di Niccolo di Betto Bardi) (ca. 1382–1466). Italian sculptor and the most influential artist of the 15th century. Called by VASARI the pattern of all other artists who followed and the equal of the sculptors of classical antiquity, he was the dominant figure in the transition from the GOTHIC era to the early Renaissance.

He is known to have worked as an assistant to GHIBERTI during the years 1404–1407, when Ghiberti's bronze doors for the Florence Baptistery were taking form, and he also worked on commissions of his own during part of the same period. By 1411 he had mastered the flat relief technique and coherent organization of perspective for which he was to become famous, and had executed a marble statue of St. George that, with its spirited, somewhat daunting aspect, prefigured much of his later work. After spending the years 1431–1433 in

Donatello, *The Descent from the Cross,* pulpit in Church of S. Lorenzo, Florence.

Kees van Dongen, *Nude,* collection of the artist.

Rome, where he apparently devoted intensive study to the city's classical relics, he increasingly invested his works with the spirit of antiquity but always in combination with an incisive realism, extraordinary psychological insight and a protoexpressionistic use of distortion and exaggeration that added an unprecedented degree of emotive force to his depictions of various characters from the Old and New Testaments. Later in his career he more or less abandoned the principles of classical antiquity, increasingly distorting his forms in the interests of expressiveness. In such late works as the high reliefs he designed for S. Lorenzo in Florence and the carved wood Magdalen in that city's Baptistery he provided a dramatic basis for exploration by such subsequent masters as CASTAGNO, BOTTICELLO, MANTEGNA, BELLINI and MICHELANGELO. He was the first artist to exploit fully the possibilities of such previously shunned subjects as old age and ugliness and for sheer range and versatility has had few equals in the history of art.

DONGEN, KEES VAN (1877–1968). Dutch painter who, after an early, productive attraction to FAUVISM, when his work was notable for its coloristic assurance, spent the last half century of his life pursuing an increasingly sterile career as a painter of celebrities and society women.

DONNER, GEORG RAPHAEL (1693–1741). Austrian sculptor whose early work was executed in the BAROQUE style but who later became a leading figure in the return to classicism.

DORÉ, GUSTAVE (1832–1883). French graphic artist, painter, sculptor and the most popular woodcut illustrator of his day. His illustrations for the Bible, *The Inferno, The Rime of the Ancient Mariner* and *Gargantua,* largely forgotten during the second and third quarters of the 20th century—and largely the work of numerous assistants—are distinguished by their technical mastery and somewhat decadent imaginativeness. His painting and sculpture, mostly the work of his later years, is unimportant.

DOSSI, DOSSO GIOVANNI LUTERI (ca. 1490–1542). Italian painter of the FERRARESIE SCHOOL. He is believed to have studied in Venice, possibly with TITIAN, although VASARI credited COSTA as his teacher. In any case, he was also influenced by GIORGIONE and RAPHAEL. As court painter to the Duke of Ferrara he produced numerous stage sets, and his paintings bear evidence of his theatrical interests. His best works (e.g., *Circe;* Rome: Villa Borghese) are notable for their dreamlike quality and tranquil, vaguely mysterious atmosphere—an atmosphere rather too ethereal for the thick, stolid figures that populate it.

DOU, GERRIT (Gerard) (1613–1675). Dutch portrait, genre and history painter who studied with REMBRANDT after first training under his father, a glass painter. A master of the Leyden painters' guild, he is best known for

meticulously rendered genre scenes that markedly influenced various followers, of whom the most important was METSU.

DOUFFET, GERARD (1594–between 1661–1665). Flemish history, genre and portrait painter who worked under RUBENS before traveling in Italy, where he was influenced by CARAVAGGIO. A popular teacher, he founded the Liege school.

DOUGHTY, THOMAS (1793–1856). An American self-taught landscape painter, he was one of the founders of the HUDSON RIVER SCHOOL. His importance lies chiefly in his early recognition of landscape as a subject that was to dominate American painting of the 19th century and that continues to exert trace influences on much contemporary art.

DOURIS (fl. ca. 500–470 B.C.). Attic vase painter of whose works some 200—an unusually large surviving body—are known. Esteemed for his sure draftsmanship, narrative skill and compositional mastery.

DOVE, ARTHUR G. (1880–1946). American abstract painter and collagist who early in his career traveled to France, where he was influenced to a degree by FAUVISM. On his return to the United States he painted and showed ten "extractions"—abstract works markedly similar to those KANDINSKY was developing at the same time. His most characteristic works are marked by an indefinable mysticism and are made up of simple modulated shapes based on such natural forms as plants and trees. At their best they have a resonance about them that almost seems audible.

DOWNMAN, JOHN (ca. 1750–1824). English portrait painter. A pupil of WEST and colleague of WRIGHT OF DERBY, with whom he traveled in Italy, he is known best for his small, delicate portraits in pencil, watercolor and crayon.

DOYLE, RICHARD (1824–1883). English satirical illustrator and watercolorist, noted for his precocious sketches of contemporary life and later humorous drawings for *Punch*.

DROESHOUT, MARTIN (b. 1601–fl. 1623). Netherlandish engraver who worked in London, where he earned a permanent niche in history with his portrait frontispiece to Shakespeare's First Folio.

Duccio, *The Madonna of the Franciscans*, Pinacoteca, Siena.

Marcel Duchamp, *The Bride,* Museum of Art, Philadelphia.

DROLLING, MARTIN (1752–1817). A French painter of portraits and somewhat sentimental genre scenes in the manner of GREUZE.

DROUAIS, FRANÇOIS-HUBERT (1727–1775). French painter. A student of BOUCHER, among others, he became a protégé of Mme. du Barry and was popular for his elegant depictions of court women as mythological personages.

DRYSDALE, GEORGE RUSSELL (1912–). English-born Australian painter whose work resembles that of the American regionalists of the 1930s and 1940s.

DUBREUIL, TOUSSAINT (1561–1602). French history painter best known in his time for his ceiling painting *The Battle of the Titans* (since destroyed) at the Louvre.

DUBROEUCQ, JACQUES (between 1500/10–1584). Flemish sculptor and architect who worked for a time in Rome, where BOLOGNA was his pupil. His architecture derived from French models and bridged the Renaissance and BAROQUE styles.

DUBUFFET, JEAN (1901–). Largely self-taught French painter and inventor of *l'art brut* (raw art), an art based on that of the insane, children, graffiti and the textural effects of the natural and man-made environment. His work incorporates elements or traces of DADA, SURREALISM, TACHISME and other styles, and in recent years he has produced a considerable body of sculpture, which, like his later paintings, is characterized by its boldly segmented appearance and its reliance on black, white and flat, bright blues and reds.

DUCA, GIACOMO DEL (ca. 1520–ca. 1602). Sicilian architect and sculptor who worked with MICHELANGELO in the latter's last years and whose works are now largely destroyed.

DUCCIO (Duccio di Buoninsegna) (fl. 1278–1319). The leading painter of the SIENESE SCHOOL in the first half of the 14th century and the brother of SEGNA DI BONAVENTURA. His work resembles (and often is confused with) that of CIMABUE, and his historical importance lies in his role as a transitional figure between the BYZANTINE and GOTHIC styles. He was an outstanding narrative painter, investing his pictures with an extraordinary momentum that depended for its effect on the subtle interweaving of a multiplicity of pictorial effects. His influence on later Sienese painting was considerable and lasted for upward of a century and a half, as various followers strove to emulate his line, color and unique tenderness. Although his position in the Sienese school was akin to that of GIOTTO's in Florence, he lacked Giotto's naturalism, instead infusing the hieratic figures of the Byzantine tradition with a more theoretical brand of humanism.

DUCERCEAU (Du Cerceau) FAMILY. A French family of 16th- and early 17th-century architects and designers of whom Jean Ducerceau (ca. 1585–after 1647) is the best known, chiefly for his Paris townhouses, Hotel de Sully and the horseshoe stairs he designed for FONTAINEBLEAU.

DUCHAMP, MARCEL (1887–1968). French painter, sculptor and creator of unclassifiable works of art. Brother of DUCHAMP-VILLON and half-brother of VILLON, he first gained notice with his *Nude Descending a Staircase* (Philadelphia Museum of Art). Based on cubist and futurist principles, the painting created a furor at the ARMORY SHOW of 1913. Duchamp next embarked on a series of "ready-mades," commonplace objects (urinals, bottle racks, bicycle wheels and the like) that were transformed into works of art by virtue of his so designating them. His magnum opus is *The Bride Stripped Bare by Her Bachelors, Even* (The Large Glass) (Philadelphia Museum of Art), a construction of plate glass, wire and painted foil which was accidently broken—to the obvious delight of the artist, who welcomed the unplanned radiating cracks in its surface. Soon after "completion" of The Large Glass, Duchamp more or less abandoned the creation of art to concentrate on chess. Rediscovered in the late 1950s and early 1960s by RAUSCHENBERG, JOHNS and others, he continues to exert an influence on contemporary art.

Raoul Dufy, *The Hindu,* Louis Carré Gallery, Paris.

DUCHAMP-VILLON, RAYMOND (1876–1918). Sculptor, architect and brother of VILLON and DUCHAMP. After first working in the manner of RODIN, he became an early adherent of CUBISM and applied the style to both his architecture and sculpture. Best known for a series of horses in which cubist theory is intensively explored.

DUCK, JACOB (ca. 1600–1667). A Dutch genre painter and etcher who worked in Utrecht and The Hague, he is best known for his interior settings for domestic or drinking scenes.

DUDOCK, WILLEM MARINUS (1884–). Dutch architect influenced by Hendrick Petrus Berlage (1856–1934), DE STIJL and WRIGHT. His finest and best-known work is the Hilversum Town Hall, finished in 1931.

DUFRESNOY, CHARLES ALPHONSE (1611–1668). French painter. A pupil of PERRIER and VOUET, his chief importance lies in his theoretical writings, which influenced academic painting, especially in England, for a century or more.

DUFY, RAOUL (1877–1953). French painter. After starting out as an impressionist, he turned to FAUVISM in 1905 in emulation of MATISSE and later worked with BRAQUE, painting somewhat somber near-cubist pictures derived in large part from CÉZANNE. Unlike Braque, he did not continue in the style that was to culminate in CUBISM but, delighted with the results of some experiments with textile design, turned to a more colorful, spontaneous style and subjects that lent themselves to his fluent—and sometimes glib—brushwork. He continued to work in this style for the rest of his life, constantly refining his facility. His best works are magnificently orchestrated hymns to the good life as it was lived on the Riviera and at race tracks and concert halls. His high-spirited paintings and watercolors are vibrant with color into which his sketchily delineated figures often seem to melt.

DUGHET, GASPARD (Gaspard Poussin) (ca. 1615–1675). A French landscape painter and brother-in-law of NICOLAS POUSSIN, whose surname he appropriated, he was born and spent his life in Rome. Influenced by Poussin and CLAUDE LORRAINE, his dramatic compositions in turn influenced the work of many younger northern European and English painters in Rome.

DUJARDIN, KAREL (1622–1678). Dutch painter and etcher whose scenes of country life reflect the influences of his teacher BERCHAM, POTTER and VAN DE VELDE. Also known for paintings and etchings of landscapes, portraits and religious themes.

DUMONSTER FAMILY. 16th- and 17th-century family of French court portrait painters.

DUNLAP, WILLIAM (1766–1839). An American painter and pupil, in London, of WEST, he is most notable as the author of one of the earliest histories of American art.

DUNOYER DE SEGONZAC, ANDRÉ (1884–1974). French painter known for his thickly impasted, somber-toned oils and somewhat more colorful watercolors. Generally considered one of the leading representational painters in an era of predominantly abstract painting.

DUPRÉ, JULES (1811–1889). A French romantic painter, he was influenced by COROT and various Dutch and English landscapists. Best known for his highly subjective, often poetic approach to the landscape.

DUQUE CORNEJO, PEDRO (1677–1757). Spanish painter, sculptor and architect known for the Berninesque dynamism of his figures and elaborate works in which painting, sculpture and architecture are fused into a coherent whole.

DUQUESNOY FAMILY. Family of Flemish sculptors consisting of Jerome Duquesnoy the Elder (before 1570–1641) and his sons François (1594–1643) and Jerome the Younger (1602–1654), of whom the most important was François, an assistant to BERNINI and protégé of POUSSIN, who worked in Italy and is best known for small bronzes similar to those of BOLOGNA.

DURAN, (Carolus-Duran) CHARLES-AUGUSTE-ÉMILE (1838–1917). French portrait painter and muralist who abandoned an early interest in realism and adopted an academic style.

DURAND, ASHER BROWN (1796–1886). American painter and engraver. A member of the HUDSON RIVER SCHOOL, he worked in a meticulous style derived from his early training as an engraver, depicting the landscape as a poetic, often sentimental setting for man and his works. Best known for his painting *Kindred Spirits* (New York Public Library).

DÜRER, ALBRECHT (1471–1528). Painter, engraver and woodcut designer, the supreme genius of German art and a pivotal figure in the cultural history of Europe. Originally trained as a goldsmith by his father, who had studied in the Netherlands "with the great masters," he later was apprenticed to the workshop of WOLGEMUT, under whom he learned the techniques and principles of painting and was instructed, more intensively, in the craft of the woodcut, a medium he was to revolutionize and which was to make him famous throughout Europe

Albrecht Dürer, *Knight, Death, and the Devil,* engraving.

almost from the onset of his career. During his more than three years in Wolgemut's Nuremberg establishment, Dürer absorbed a great deal from such outside influences as the Alsatian master SCHONGAUER and the HOUSEBOOK MASTER, who worked in the Middle Rhenish region and who may have been the object of the young Dürer's perplexingly erratic "bachelor's journey" throughout Germany. Having reached Colmar, his ostensible destination, a year after Schongauer's death, he was sent by Schongauer's family to Basel, where he established connections with the publishing industry through Schongauer's brother Georg and where his title-page woodcut illustration for *The Letters of St. Jerome* immediately produced a widespread demand for his work. During the next few years, he worked in Strassburg and then traveled to Italy, thereby setting a precedent that was to be followed by generations of northern European artists and art lovers.

The importance of Dürer's sojourn in Italy cannot be overstated, for it marked the end of Medievalism and the advent of the Renaissance in the north. Moreover, there was nothing fortuitous about the transition. Dürer had learned a good deal about the humanist revolution in Italy through his close lifetime friend, the scholar Willibald Pirkheimer (1470–1530), who was then studying there, and he set out quite deliberately to conquer the "new kingdom" of Italian culture and to use what he found there to initiate a "regrowth" of the arts—and not just the visual arts—of Germany.

Albrecht Dürer, *Self-portrait*, Prado, Madrid.

For the next decade Dürer remained in his native Nuremberg, where he established his own workshop, embarked on a period of intense productivity and participated in the learned life of the city's humanist circles. In 1505 he returned to Italy for a two-year stay, during which he was awarded a number of prestigious and lucrative commissions, befriended GIOVANNI BELLINI and antagonized other Italian artists, undertook a study of the "secret art of perspective" and basked in the sort of lionization he ruefully predicted he would not find on his return home. If his second Italian journey lacked the impact of the first, it nonetheless reinforced Dürer's respect for humanism and his determination to infuse German culture with its spirit, and it established Dürer himself as an international figure. As far as his stylistic development was concerned, the trip led to a successful fusion of his GOTHIC heritage and Renaissance ideals.

Dürer's reputation would be secure solely on the basis of his paintings, drawings and watercolors, but he was above all a printmaker, and his exposure to Bellini and other Italian colorists soon made itself felt in his engravings, in which he invented revolutionary techniques for revitalizing the medium and infusing his black-and-white prints with an unprecedented tonal richness. His keen understanding of the inherent characteristics of the engraver's burin allowed him to exploit the medium to its full potential, and such works as his *Melancholia I, St. Jerome in His Study* and *Knight, Death and the Devil* represent the epitome of the engraver's art. Finally, he was an art theorist and scientific writer of the first importance and, indeed, is credited by the foremost Dürer scholar, Panofsky, with singlehandedly inventing German scientific prose and developing the first systematic body of knowledge (as opposed to simple codes of instruction) in

northern Europe. His influence on the art, thought and very texture of his time was enormous, and he ranks with such universal geniuses as LEONARDO and MICHELANGELO.

DURHAM CATHEDRAL. A 12th-century ROMANESQUE edifice in northern England, it has been called "the most complete and least altered of all the early Anglo-Norman churches" and generally is considered the crowning achievement of the Anglo-Norman school. It is perhaps the oldest completely rib-vaulted church in Western Europe and boasts the earliest high-vault pointed arches known. Its interior, massive, stately and awesomely powerful, is a masterpiece of Anglo-Norman proportion.

DUVENECK, FRANK (1848–1919). Munich-trained American painter, printmaker and teacher. Much influenced by REMBRANDT, VELAZQUEZ, HALS and, in his etching, by WHISTLER, he painted in a broad, loose style that marked the beginning of the American reaction against the prevailing DÜSSELDORF style. He exerted a formative influence on early 20th-century American painting, both as a painter and popular teacher.

DYCK, SIR ANTHONY VAN (1599–1641). Flemish portrait painter who became chief assistant to RUBENS while still in his teens and later traveled extensively in Italy, where he absorbed various Venetian and other influences. A considerable portion of his career was spent in England, where he was knighted and named "Principalle Paynter in ordinary" to the Court of St. James's. Characteristically, his work is marked by bravura, compositional assurance, great elegance and an intensely personal, somewhat monochromatic rephrasing of Venetian color as adapted by Rubens. If his finest work lacks the probity of the very greatest portraitists, it is marked by a kind of theatricality and an integration of figure and landscape that became the model for an English way of life, at least in the more rarefied social circles, and even set the tone for much of the English romantic literature of a much later era.

DYING GAUL, THE (Rome: Capitoline Museum). Roman marble copy of a Pergamene work of ca. 200 B.C., representing a Gaul wounded in the course of a victorious battle waged by Attalus I. The figure, quite expressively rendered, lies on a shield, its face contorted with pain.

Anthony van Dyck, *The Artist with Sir Endymion Porter,* Prado, Madrid.

E

EAKINS, THOMAS COWPERTHWAITE (1844–1916).
American painter, photographer and teacher. Trained in
the United States and then in France, principally under
GÉRÔME, he was influenced by REMBRANDT, RIBERA
and VELAZQUEZ. Characteristically, his pictures are
distinguished by their uncompromising realism and
homogeneous light—a light that progressed from bright,
hard, rather cool tones to a mellower, more Rem-
brandtesque glow as his art ripened. An outstanding
anatomist and a fine landscapist, he turned increasingly
to single and group portraits in his later years, exploring
the character of his sitters with great assurance and probi-
ty. *Max Schmitt in a Single Scull* (New York: Metropolitan
Museum), one of many sculling scenes executed early in
his career, is a masterpiece of its kind, combining clarity
of light and exactitude of observation with impressive
compositional logic. His great historical contributions lay
in his insistence on carrying the American realist tradition
forward and his refusal, in his own work and his teach-
ing, to allow the painterly aspects of art to become subor-
dinate to drawing. His influence was considerable, nota-
bly upon ANSHUTZ and THE EIGHT, and his importance as
an experimental photographer, largely overlooked until
recently, rivals that of his older contemporary Eadweard
Muybridge.

EAMES, CHARLES (1907–). American architect, de-
signer and filmmaker. After an early association with
ELIEL and EERO SAARINEN, he has since collaborated with
his wife, RAY KAISER, and is best known for his molded
plywood or plastic "Eames chairs." His Case Study
House in Santa Monica, California, constructed almost
completely of standard factory-produced parts, is notable
for its airy lightness, variety of pattern, color and texture
and superb integration of its interior with the outdoors.

EARL, RALPH (1751–1801). Largely self-taught Ameri-
can painter, best known for interior group portraits with
sharply delineated landscapes glimpsed through win-
dows. His *Chief Justice and Mrs. Oliver Ellsworth* (Hartford,
Connecticut: Wadsworth Atheneum), distinguished by
its strong patterning, linear assurance and compositional
ingenuity, is one of the outstanding works of the post-
Colonial period, although more influenced by a sojourn
in England than his four-square earlier efforts.

Thomas Eakins, *The Dean's Roll Call,* Museum of Fine Arts,
Boston, A. Shuman Fund.

Stone images of Easter Island.

EARLOM, RICHARD (1743–1822). English reproductive mezzotintist best known for his 200 prints after CLAUDE LORRAINE's *Liber veritatis* and for his technical mastery in the use of an etched line on a mezzotint ground.

EASTER ISLAND CARVINGS. Huge monolithic sculptures found on the slopes of the easternmost island in Polynesia, representing human heads and truncated figures. Their age, origins, purpose and meaning have been the subject of much speculation, but their great power, superb disposition of planes and volumes and awesome solemnity are unarguable.

EASTLAKE, SIR CHARLES LOCK (1793–1865). English history and genre painter, author and museum administrator. A pupil of HAYDON, he spent part of his career in Italy, where he was to die and where he produced his popular depictions of peasant life.

EASTMAN, SETH (1808–1875). American painter of Indian life in the western U.S. whose work is notable chiefly for its documentary value.

EBERZ, JOSEF (1880–1942). German painter of religious subjects and, later in his career, highly colored expressionistic landscapes and figures.

ECKERSBERG, KRISTOFFER VILHELM (1783–1853). Danish painter and teacher who studied under J.-L. DAVID and in Rome, where he executed a number of admirable view paintings combining naturalistic observation with classical composition. His later portraits were notable for their purity of line and neoclassic clarity.

EDELINCK, GERARD (1640–1707). Flemish-born French engraver best known for his portraits and reproductive prints.

EDFU. Egyptian site on the Nile, south of Luxor, of the Temple of Horus, ca. 236–257 B.C., a remarkably well-preserved work of the Ptolemaic period, and of auxiliary structures and walls and a number of mounds containing artifacts from the various cultures that have settled there.

EDRIDGE, HENRY (1769–1821). English painter, chiefly of portraits, of which his miniatures are best known.

EDWARDS, EDWARD (1738–1806). English landscape and history painter, teacher and writer.

EDZARD, DIETZ (1893–1963). A German-born French painter and illustrator best known for his somewhat impressionistic treatment of Parisian women. His most serious works were the landscapes he produced early in his career.

EECKHOUT, GERBRANDT VAN DEN (1621–1674). Dutch painter and pupil and friend of REMBRANDT. Although considered Rembrandt's best and most faithful pupil, his landscapes and group portraits altogether lacked the distinction of his master's work.

EGG, AUGUSTUS LEOPOLD (1816–1863). An English painter and amateur actor and intimate of Dickens and Wilkie Collins. His once popular genre pictures are largely forgotten today.

EICHENBERG, FRITZ (1901–). German-born American printmaker, illustrator and teacher, best known for his technical mastery of the woodcut.

EIFFEL, GUSTAVE-ALEXANDRE (1832–1923). French engineer. A leading bridge builder and early authority on aerodynamics, he was also responsible for the armature on which BARTHOLDI's "Statue of Liberty" was constructed in prefabricated sections, but is universally famous for the 985-foot-high Eiffel Tower constructed for the Paris Exposition Universelle of 1889.

EIFFEL TOWER. See above.

EILSHEMIUS, LOUIS MICHEL (1865–1941). American visionary painter, principally of rather clumsily depicted female nudes in idyllic landscapes. Although academically trained, he affected a somewhat naïve style that garnered little recognition during his lifetime but has steadily increased in popularity since.

EISEN, CHARLES (1720–1778). French painter, engraver and illustrator whose work accurately reflects the tastes and atmosphere of the court, where he was royal painter and a favorite of Mme. de Pompadour.

98

EITOKU (Kano Eitoku) (1543–1590). The most highly regarded Japanese painter of his time. His characteristic works, of which few survive, are notable for their bold, staccato brushwork and audacious disposition of form.

ELEPHANTA. Island in Bombay Harbor, India, and site of an impressive system of Brahmanic cave temples, of which the main temple was cut from the surrounding rock in the 7th century. Dedicated to Siva, it marks the final flowering of architectural sculpture in the region and is particularly distinguished by the magnificence of its relief sculptures.

ELEUSIS. Site of the 5th-, 4th- and 3rd-century B.C. Telestesion, or Hall of Mysteries, a Greek shrine of the cult of Demeter and Persephone, where the Eleusinian Relief (Athens: National Archaeological Museum) was discovered. The latter, extensively copied in Roman times, depicts Demeter giving wheat to Triptolemos while Persephone looks on.

ELGIN MARBLES (London: British Museum). Collection of Greek sculptures, largely from the PARTHENON and ERECHTHEUM, amassed in the early 19th century by Thomas Bruce, 7th Earl of Elgin, the British ambassador

Elgin Marbles, British Museum, London.

James Ensor, *Masks and Death*, Museum of Fine Arts, Liège.

to Turkey, and later sold by him to the British government. Of those fragments from the Parthenon, the metopes represent the Battle of the Centaurs and Lapiths and date from 447–442 B.C., while the slightly later frieze depicts a spirited procession of horsemen and convocation of the gods. Pediments represent the birth of Athena and her struggle with Poseidon for control of Athens and are notable for their lively animation. The collection's original public exposure created a sensation in London, where until then original Greek sculpture of the Classical age had been unknown.

ELIASZ. PICKENOIJ, NICOLAES (called **Pickenoy**) (ca. 1590–ca. 1655). Dutch painter and the leading portraitist of Amsterdam before being supplanted by REMBRANDT.

ELLORA. Site in Maharashtra State, India, of an extensive system of shrines of the Hindu, Jain and Buddhist religions, cut into the indigenous rock between the 5th or 6th and 9th centuries A.D. Particularly notable for the sculptured figures of the Hindu temples.

ELSHEIMER, ADAM (1578–1610). German painter and etcher who worked in Italy, where he was known as Adamo Tedesco and was influenced directly or indirectly by CARAVAGGIO and by TINTORETTO. Best known for his

small, poetic landscapes with figures in subdued, often unnatural, light, he exerted considerable influence on POUSSIN and CLAUDE LORRAINE, among others.

ELY CATHEDRAL. English ROMANESQUE cathedral renowned for its later octagonal lantern, designed by Alan of Walsingham and William Hurle and generally considered unique among the masterworks of GOTHIC architecture.

ENDELL, AUGUST (1871–1925). German architect who worked in the ART NOUVEAU style, embellishing his structures with complex and highly fanciful decorations.

ENGELBRECHTSZ, CORNELIS (1468–1533). Netherlandish painter of religious subjects and portraits and possible teacher of LUCAS VAN LEYDEN. His principal surviving works are marked by their intensity of feeling, rhythmic patterning and refulgent color.

ENSOR, JAMES (1860–1949). Belgian expressionist painter and printmaker. After studying in his native Ostend and Brussels, he returned to and rarely left his home city. Although he was to remain active for another half century, his style had fully developed, and his best work was completed, by 1900. After an early period that more or less parallelled that of VAN GOGH stylistically, he gradually turned to fantastic, often grisly subject matter

Max Ernst, *Collage and Gouache*, André-Grançois Petit Collection, Paris.

strongly infused with the imagery of death and change and informed by a sardonic view of human affairs. His masked figures are reminiscent of GOYA, BOSCH, BRUEGHEL and African sculpture (in which he was one of the first Europeans to take an interest, possibly because his parents ran a curio shop), and his influence on both the German expressionists and the surrealists was lasting and profound. He was a masterful colorist who invested both his paintings and prints with tremendous energy and emotive force.

EPICTETOS (fl. late 5th century B.C.). Attic vase painter who worked in the red-figured style and was renowned for his command of line.

EPIPHANIUS OF EVESHAM (1570–1634 or later). English sculptor and painter, best known for his surviving funerary sculptures and reliefs, who worked for a time in Paris.

EPSTEIN, SIR JACOB (1880–1959). American-born British sculptor of both monumental works and portraits. Working in the tradition of RODIN, he was an often controversial figure in the early part of his career, when he did much to advance the modernist movement in England. His later works, mostly bronze portraits, seem quite conventional today but are nonetheless notable for their expressiveness and emotional force.

ERECHTHEUM. An Ionic marble temple on the Acropolis, Athens, built late in the 4th century B.C., probably by Mnesicles, it is especially notable for the Porch of the Caryatids, six female figures that support the entablature on the south portico.

ERHART, GREGOR (fl. 1494–ca. 1540). German sculptor and woodcarver of whom little is known and to whom no existing works can be ascribed with certainty but who is believed to have been an influential figure of the transitional period.

ERNI, HANS (1909–). Swiss painter, illustrator and printmaker best known for his paintings and murals devoted to humanistic themes.

ERNST, JIMMY (1920–). German-born American abstract painter and son of MAX ERNST. Many of his works appear to be based on crystallike or architectural forms and are characterized by a somewhat splintered appearance and occasional passages of vibrant color.

ERNST, MAX (1891–). German painter and sculptor and father of JIMMY ERNST. Self-taught, he met ARP in Paris and was a founder of the Cologne branch of the DADA movement in 1919. Active in international Dadaism, he worked closely with the poets Paul Éluard and Tristan Tzara and was an editor of the Dada journals. In 1924 he turned to SURREALISM, a movement that was later to disown him and to which he brought great inven-

tiveness and originality of style. In the course of his career he has frequently shifted, in both his painting and sculpture, from fantasy to more or less pure abstraction, usually with notable wit and imagination. An important technical innovator, he was one of the first practitioners of collage, frottage and the use of ready-made elements in general.

ERRI, AGNOLO (fl. 1448–1463) and **BARTOLOMMEO** (fl. 1460–1476). Italian painters and brothers and the most notable members of a large family of artists, they worked in Modena, where their sole surviving work, a complex altarpiece in the GOTHIC style with Renaissance elements, is to be found in the Este Gallery.

ESCALANTE, JUAN ANTONIO (1633–1670). Spanish painter influenced by RUBENS and the Venetians and esteemed for his airy, highly colored religious works in the BAROQUE grand manner.

ESCHER, M. (Maurits) C. (1898–1972). Dutch visionary draftsman, printmaker and painter whose works are characterized by anomalous perspectives, enigmatic symbolism, visual punning and a kind of visual sleight-of-hand whereby various forms appear to undergo metamorphoses.

ESCORIAL, EL. A monastery and former royal residence northwest of Madrid, Spain, it was built during the years 1563–1584 by Philip II and takes its name ("The Slag Heap") from a nearby hamlet. Built of marble on a grid-iron plan inspired by the martyrdom of St. Lawrence, it is a massive and altogether forbidding walled complex of structures covering an area 675 feet long and 530 feet wide, with a domed monastery church at its center. The complex houses one of the finest libraries in the world and a superb art collection, both begun by Philip.

ESSEN: MINSTER. German church, largely built during the late 10th to mid-11th century and altered in the late 13th century. Notable for its beautifully proportioned west front and western choir, the latter based closely on the Palatine chapel at AACHEN CATHEDRAL.

ESTES, RICHARD (1936–). An American painter and exponent of PHOTO-REALISM. His characteristic subjects are glossy industrial surfaces and reflected images.

ETTY, WILLIAM (1787–1849). An English academic painter and pupil of LAWRENCE, he was best known in his time for vast, rhetorical compositions but is chiefly remembered today as a painter of nudes.

EUPHRANOR (fl. mid-4th century B.C.). Greek painter and sculptor who was highly regarded in the ancient world but of whose works almost nothing survives.

EUPHRONIOS (fl. late 5th century B.C.). An Attic vase painter and master of the red-figured style. His most famous work is a signed calyx krater (New York: Metropolitan Museum) depicting the death of Zeus' son Sarpedon.

EUSEBIO DE SAN GIORGIO (before 1470–ca. 1540). An Umbrian painter and probable student of PERUGINO, he was clearly influenced by PINTURICCHIO and RAPHAEL.

EUTHYCRATES (fl. late 4th–early 3rd century B.C.). Greek sculptor and son of LYSIPPUS of whose original works nothing survives.

EUTHYMIDES (fl. ca. 510–490 B.C.). Attic vase painter in the red-figured style, a draftsman of great assurance. His best works are notable for the movement of their figures.

EUTYCHIDES (fl. ca. 290 B.C.). Greek sculptor and pupil of LYSIPPUS. His work is known only through Roman copies but seems to have been notable for its individualization of character.

EVENEPOEL, HENRI (1872–1899). Belgian painter and student of MOREAU, best known for his portraits, especially of children, and colorful depictions of Algerian life.

EVERDINGEN, ALLART VAN (1621–1675). A Dutch landscape and marine painter and etcher and brother of CESAR PIETERSZ. VAN EVERDINGEN, his romantic works were much influenced by landscape forms observed during a trip to Scandinavia. He was a teacher of BAKHUYSEN and influenced RUISDAEL.

EVERDINGEN, CESAR PIETERSZ VAN (ca. 1616–1678). A Dutch painter and brother of ALLART VAN EVERDINGEN, he specialized in historical and allegorical pictures and portraits much influenced by Italian academic art and characterized by their close attention to texture.

EVERGOOD, PHILIP (1901–1973). An American painter and student, for a time, of LUKS, he is best known for his highly colored, somewhat caricatural themes of social protest.

EVREUX: CATHEDRAL OF NOTRE DAME. Eclectic edifice incorporating the remains of a largely destroyed ROMANESQUE cathedral. Its most notable feature is its sumptuous 14th-century stained glass, which is distinguished by its realism and advanced use of perspective.

EWORTH, HANS (ca. 1515–1573). Flemish-born English portrait painter known for the coloristic richness and clarity of draftsmanship typified in his *Portrait of Mary Tudor* (Antwerp: Fine Arts Museum) and for his allegorical portrait *Queen Elizabeth Confounding Juno, Minerva and Venus* (London: Royal Collection).

EXECIAS (fl. ca. 550–525 B.C.). Attic black-figured vase painter renowned for the compelling serenity of his figures and best known for an amphora depicting a game of chance between Ajax and Achilles (Vatican Museums).

EYCK, VAN. See VAN EYCK.

F

FABRITIUS, BARENT (1624–1673). A Dutch painter, probable pupil of REMBRANDT and brother of CAREL FABRITIUS, he is best known for his Rembrandtesque portraits and religious subjects.

FABRITIUS, CAREL (1622–1654). Dutch painter, pupil of REMBRANDT, possible teacher of VERMEER and brother of BARENT FABRITIUS. Generally regarded as the finest painter to be trained in Rembrandt's workshop, he was killed in the Delft powder exposion of 1654, which also destroyed most of his works. From those pictures that survive, he can be seen to have developed a highly individual style that was in many ways the opposite of Rembrandt's and that had a marked influence on the school of Delft generally and Vermeer in particular. His palette is much lighter than Rembrandt's, his touch drier and his underlying concerns are with the physical—and not Rembrandt's psychological—effects of light and atmosphere on his subjects. Whereas Rembrandt usually portrayed his sitters in strong light against dark backgrounds, Fabritius was inclined to reverse the approach, silhouetting his figures against pale-toned atmospheric grounds.

FAITHORNE, WILLIAM (1616–1691). English engraver who developed his characteristic monumental BAROQUE style while working in France with NANTEUIL. In his prime he was the finest English portrait engraver of the 17th century and a master of textural effects. His son William (1656–ca. 1701) also was a portrait engraver.

FALCONET, ÉTIENNE-MAURICE (1716–1791). French sculptor and writer. He worked under LEMOYNE for a time and later became a favorite of Mme de Pompadour. His masterpiece is the heroic equestrian statue of Peter the Great in St. Petersburg, which was commissioned by Catherine II and is notable for its vigor and technical ingenuity. An iconoclastic aesthetic theorist, he was admired by Goethe for his espousal of contemporary realism and contempt for the cold classicism of the ancients.

FALCONETTO, GIOVANNI MARIA (1468–before 1540). Italian architect and painter who emulated the works of classical antiquity.

FALGUIÈRE, JEAN-ALEXANDRE-JOSEPH (1831–1900). French painter and sculptor whose works are marked by a mixture of realism and classical influences.

FALLINGWATER. Architecturally innovative private home built by FRANK LLOYD WRIGHT on the bank of a stream at Bear Run, Pennsylvania, in 1936. A vigorous contrast of horizontals and verticals, much of the building consists of reinforced concrete balconies cantilevered dramatically over a waterfall.

FAN CH'I (1616–ca. 1693). Chinese traditionalist painter of figures, floral themes and landscapes.

FANGOR, WOJCIECH (1922–). Polish-born American painter whose circular or undulating abstract images, so subtly brushed into their backgrounds that the line of demarcation is impossible to posit, seem to hover and pulstate somewhere between the canvas surface and the viewer. Although he is loosely identified with the OP ART movement of the mid-1960s, his soft edges and extremely subtle gradations of color and value invest his works with a haunting, mesmeric quality entirely their own.

FAN K'UAN (fl. late 10th century). A Chinese painter and recluse, he was renowned as one of the foremost landscapists and his work is known to have been characterized by its monumentality, although no surviving works have been attributed to him with certainty.

FANTIN-LATOUR, (Ignace-) HENRI (-Jean-Théodore) (1836–1904). French painter and lithographer. One of the finest flower painters of all time, he knew and respected his impressionist contemporaries but never allied himself to their cause. Strongly influenced—and perhaps fatally intimidated—by such old masters as TITIAN, RUBENS, VELAZQUEZ and CHARDIN, whose works he assiduously copied in the Louvre, and by the Dutch little masters, he was a talented and popular salon painter whose least ambitious works, his floral still lifes, establish his claim to fame. Such allegorical works as his *Homage to Eugène Delacroix* (Paris: Louvre) and *Studio at Batignolles* (Louvre), group portraits crowded with artistic personalities of the day, now seem little more than harmless exercises in

Henri Fantin-Latour, *Flowers and Fruit,* Louvre, Paris.

Henri Fantin-Latour, *A Studio in the Batignolles Quarter*, Louvre, Paris.

visual name-dropping, but some of his single portraits are distinguished by their gravity and simple realism. His lithographs, many of them fanciful illustrations of works by Wagner and other romantic composers, were influential in the development of SEURAT's drawing style.

FANZAGO, COSIMO (1591–1678). An Italian architect and sculptor of the school of Naples, he is known for his spirited, elaborately decorated BAROQUE buildings, religious sculpture, fountains, altars and the like and for his tendency to make the underlying structure of his works subordinate to superficial embellishment.

FARNESE BULL (Naples: National Archaeological Museum). Roman 3rd-century copy of a lost 1st-century B.C. group sculpture executed in Rhodes. It depicts Circe being tied to a bull and is characterized by much twisting movement.

FARNESE HERCULES (Naples: National Archaeological Museum). Roman 1st-century B.C. copy, found in the Baths of Caracalla (see CARACALLA, BATHS OF), of a lost work by LYSIPPUS depicting Hercules as an old man worn out by his labors.

Farnese Hercules, National Archaeological Museum, Naples.

Lyonel Feininger, *On the Beach*, National Museum of Modern Art, Paris.

FATTORI, GIOVANNI (1825–1908). An Italian painter, etcher and teacher best known for his military subjects, he was a leading member of the MACCHIAIOLI.

FAUTRIER, JEAN (1898–1964). English-trained French abstract painter and a leader of the loosely knit movement known as "Art Informel," which derives from SURREALISM and Dada. His characteristic works resemble relief maps of barren islands.

FEELEY, PAUL (1927–1966). American sculptor and teacher whose characteristic late works were free-standing, symmetrical, painted in flat, high-gloss, hard-edge polychrome and made up of interlocking repeated elements.

FEININGER, LYONEL (1871–1956). Although he was born in the U. S. (of German parentage) and died there, he spent much of his life in Germany and was an essentially European painter, graphic artist and cartoonist. Influenced by CUBISM, DELAUNAY and the BAUHAUS (where he taught), he exhibited with the BLUE RIDER and returned to the U. S. in 1937, after 50 years abroad, having been branded a "degenerate" by the Nazis. Working almost exclusively in watercolor and the woodcut, he evolved a personal brand of Cubism distinguished by its clarity and the sharp definition of its planes. In his early work he retained recognizable elements, although his compositions were basically abstract. Such later pictures as *Tug* (New York: Solomon R. Guggenheim Museum) bear a distinct resemblance to those from the same period by his almost exact contemporary MARIN and rely more heavily on implicit subjective reaction.

FEITELSON, LORSER (1898–). American painter known for the extreme simplicity of works in which, characteristically, two or three thin loops or arcs of color are disposed on a flat, darker ground.

FEKE, ROBERT (ca. 1705–1752 or later). The preeminent American painter of the first half of the 18th century, he was obviously influenced by SMIBERT, but little else is known of his life or development. He was an apparently itinerant portraitist whose works, despite clumsy passages, are distinguished by their liveliness, elegance, dignity and skillful handling of texture. In one of his earliest and best-known works, *Isaac Royall and Family* (Cambridge, Massachusetts: Harvard Law School), the family resemblance shared by four of the five sitters is too pronounced for credibility, while the fifth relative, a baby, is ludicrously wooden. Nonetheless, the painting is an accurate reflection of Colonial American aspirations and attitudes.

FERBER, HERBERT (1906–). American sculptor loosely identified with ABSTRACT EXPRESSIONISM in the late 1940s and 1950s and later known for huge, cagelike openwork constructions that seem to invite the spectator into a strangely threatening ambit.

FERGUSON, WILLIAM GOUW (1632–1695). Dutch-influenced Scottish still-life painter who worked in Holland and England, where his work often was confused with that of various Dutch little masters.

FERGUSSON, JOHN DUNCAN (1874–1961). Eclectic Scottish painter and sculptor and member of a group called the Scottish Colorists, which was active between the world wars.

FERNANDES, VASCO (ca. 1480–1543). A Portuguese painter of religious subjects, he was influenced by Netherlandish art.

FERNANDEZ (Hernandez), ALEJO (ca. 1470–1543). Spanish painter, probably of German origin, whose variously influenced style in turn had considerable influence on Andalusian art.

FERNANDEZ (Hernandez), GREGORIO (ca. 1565–1636). Spanish BAROQUE sculptor and architect who worked in polychromed wood and is known chiefly for the theatrical facial expressions worn by his religious figures.

FERRARI, DEFENDENTE (fl. 1st half of 16th century). Italian painter, mainly of altarpieces, influenced by ROGIER VAN DER WEYDEN.

FERRARI, GAUDENZIO (ca. 1480–1546). Italian painter and the leading Milanese artist of his time. He is best known for frescoes crowded with figures, movement and dramatic incident.

FERRARI, GREGORIO DE' (1647–1726). An Italian fresco painter of the early ROCOCO influenced by CORREGGIO and CORTONA and known for his luminous use of color. He was the father of LORENZO DE' FERRARI.

FERRARI, LORENZO DE' (1680–1744). Italian ROCOCO painter who worked in and refined the manner of his father, GREGORIO DE' FERRARI.

FERREN, JOHN (1905–1970). American painter and printmaker who worked in HAYTER's Atelier 17 in Paris during the 1930s but is best known for his later abstract-expressionist paintings, which are characterized by their coruscating coils of heavy paint and frequent use of metallic pigments.

FERRER, RAFAEL (1933–). American sculptor whose work was for a time influenced by DAVID SMITH but since has radically departed from traditional means and sculptural concepts, making use of such unstable materials as melting ice, rotting leaves and the like.

FETI (Fetti), DOMENICO (1589–1623). Italian painter trained by CIGOLI and influenced by CARAVAGGIO, whose use of pronounced chiaroscuro he emulated, and by RUBENS and TINTORETTO. His characteristic later works couch religious themes in a genre syntax and make extensive use of rather atmospheric landscape elements.

FEUERBACH, ANSELM (1829–1880). A German romantic painter trained at the DÜSSELDORF Academy and by COUTURE, he is known for didactic treatments of classical themes, painted in a style derived from the Venetian grand manner.

FIELD, ERASTUS SALISBURY (1805–1900). American primitive painter, chiefly of portraits and religious subjects, whose best-known work is *Historical Monument of the American Republic* (Springfield, Massachusetts: Museum of Fine Arts), a vast, prolix canvas depicting a fantastic architectural complex festooned and encrusted with statuary, reliefs and inscriptions pertaining to the first century of U.S. history.

FIELDING, ANTHONY VANDYKE COPLEY (1787–1855). Popular English watercolorist whose landscapes and seascapes suffered from repetition and a reliance on facile formula.

FIGUEIREDO, CRISTOVAO DE (fl. 1515–1540). A Por-

Domenico Feti, *Hero and Leander*, Museum of Art History, Vienna.

Johann Bernhard Fischer von Erlach, Schönbrunn Palace, Vienna.

tuguese painter of religious subjects and a leading figure in the school of Lisbon, he is notable for his convincing likenesses of donors, which tend to lend a monochromatic note to his otherwise colorful compositions.

FILARETE (Antonio de Piero Averlino) (ca. 1st two thirds of 15th century). Italian sculptor and architect and possible apprentice to GHIBERTI. His best-known work of sculpture is the relief cycle he executed for the bronze doors of St. Peter's, Rome, and as an architect he is renowned chiefly for his innovative plan for the Ospedale Maggiore, Milan. He is of some interest, too, for a *Treatise on Architecture*, a pioneering work in the field of city planning.

FILIPPO DI MATTEO TORELLI (1409–1468). Florentine illuminator and miniaturist best known for his decorative embellishments to a series of choir books for S. Marco, Florence.

FINIGUERRA, MASO (Tommaso) (1426–1464). Italian goldsmith and engraver who is thought to have worked with GHIBERTI and POLLAIUOLO and who may have been the inventor of copper engraving. He was a master of niello, a medium in which incisions in gold are filled with an alloy to produce a black design on a yellow ground.

FINSONIUS, LODOVICUS (Louis Finson or **Fynson)** (ca. 1580–between 1617 and 1632). Flemish painter who worked in Naples under CARAVAGGIO, his major influence, and in France, where he introduced the Caravaggesque style into Provençal painting.

FIORE, ERNESTO DE (1884–1945). Italian-born German sculptor influenced by MAILLOL, MARCKS and others.

FIORENTINO, NICCOLO (Niccolo de Forzone Spinelli) (1430–1514). Italian goldsmith and medalist known for his mastery of portraiture.

FIORENZO DI LORENZO (ca. 1440–ca. 1524). Italian painter of the UMBRIAN SCHOOL who may have taught PINTURICCHIO, in whose circle, and PERUGINO's, he moved.

FISCHER VON ERLACH, JOHANNE BERNHARD (1656–1723). Austrian BAROQUE architect trained in Italy, where he was influenced by BORROMINI and BERNINI. The son of a sculptor, who also influenced his mature style, he became architectural tutor to the future Emperor Joseph I in 1689 and created a number of Viennese palaces for his patron, of which one, Schönbrunn Palace, represented a conscious attempt to emulate the splendor of VERSAILLES. His masterpiece is the Church of St. Charles, Vienna, a superlative melange of architectural elements—including a PALLADIAN portico flanked by replicas of TRAJAN's COLUMN—that stands as the embodiment of the universalist theories espoused in his influential writings and of the aspirations of his patron the emperor.

FLANDES, JUAN DE (fl. late 15th–early 16th century; d. 1519). Flemish painter who worked at the Spanish court, where his pictures were admired for a dimensionality unusual in Spain at the time.

FLANDRIN, HIPPOLYTE (1809–1864). French painter, primarily of religious murals, who studied with INGRES and was called by his contemporaries "the second FRA ANGELICO." His popularity won him many commissions for church frescoes, which he executed in a style derived in part from 15th-century Italian painting.

FLANNAGAN, JOHN (1895–1942). American sculptor best known for fieldstone carvings in which the nature of the material and the theme of birth were stressed.

FLAVIN, DAN (1933–). American sculptor whose characteristic works consist of standard factory-made fluorescent lights placed in juxtaposition to one another and/or the angles formed by corners of rooms.

FLAXMAN, JOHN (1755–1826). An English neoclassical sculptor, teacher and illustrator who was much admired in his time, both publicly and by such artists as INGRES and CANOVA. The son of a molder of casts, he grew up in the midst of classical figures, worked for WEDGWOOD and spent seven years in Italy, where he studied antique and Medieval art and established a considerable reputation for his book illustrations, which derived from Greek vase painting. After his return to England he was steadily employed as a sculptor of funerary monuments, a genre he claimed to have "Christianized."

FLINCK, GOVERT (1615–1660). Dutch painter who worked in REMBRANDT's workshop for a time and whose major commission, eight murals for the Amsterdam Town Hall, was finished by Rembrandt and others after his death.

FLORENCE: CATHEDRAL OF STA. MARIA DEL FIORE. Italian cathedral designed and begun at the turn of the 14th century by ARNOLFO DI CAMBIO and continued by GIOTTO, ANDREA PISANO, TALENTI and BRUNELLESCHI. Larger than any earlier church in Italy, it has an octagonal central crossing and three radiating apses, a campanile begun by Giotto, a Gothic front designed by

Talenti and—its most notable feature—Brunelleschi's vast, externally ribbed dome.

FLORIS, FRANS (Frans de Vriendt) (ca. 1516–1570). Flemish painter. The most prominent member of a family of artists, he was much influenced by MICHELANGELO's *Last Judgment*, whose unveiling he witnessed, and transmitted this influence to his many pupils, thus establishing and propagating the northern mannerist style.

FLOTNER, PETER (1490–1546). Swiss-German sculptor and woodcut illustrator and a conduit whereby Italian Renaissance and Saracenic influences were introduced into Germany.

FONTAINEBLEAU, CHATEAU OF. Located in a forest outside Paris, this former residence of the kings of France was built for the most part during the reign of François I (1515–1547), who added two sumptuously decorated wings and the Royal Chapel to the original edifice, and those of his successors. The most magnificient of the early French Renaissance buildings, it is particularly notable for the richness and variety of embellishment of the Galerie François I.

FONTANA, CARLO (1634–1714). Italian late BAROQUE architect who worked and taught in the tradition of BERNINI and whose influence extended as far afield as England and Spain.

FONTANA, DOMENICO (1543–1607). Italian architect and city planner, much of whose oeuvre was commissioned by Pope Sixtus V.

FONTANA, LUCIO (1899–1968). Argentine-born Italian painter best known for the slashed, punctured or otherwise spatially altered surfaces of his abstract works.

FONTANA, PROSPERO (1512–1597). Italian eclectic mannerist painter influenced by ZUCCARI, PARMIGIANINO and others.

FOPPA, VINCENZO (ca. 1428–ca. 1515). The leading painter of Lombardy before LEONARDO, he was influenced by MANTEGNA, JACOPO BELLINI and Flemish painting.

FORAIN, JEAN LOUIS (1852–1931). A French painter and printmaker who studied briefly with CARPEUX and

Galerie François I, Château Fontainebleau.

Cathedral of Sta. Maria del Fiore, Florence.

spent much of his artistic career as a newspaper caricaturist. Influenced by REMBRANDT, GOYA, DEGAS, MANET and DAUMIER, among others, neither his paintings nor his graphic works are distinguished by the originality and conviction he admired in others.

FORMENT, DAMIAN (ca. 1475–1540). Spanish TRANSITIONAL sculptor whose characteristic reredos placed Renaissance figures in GOTHIC settings.

FOSTER, JOHN (1648–1681). British graphic artist whose *Portrait of Richard Mather* is generally believed to be the first print executed in the American colonies.

FOSTER, MYLES BIRKET (1825–1899). English painter and illustrator best known for his watercolors of rustic subjects.

FOUGERON, ANDRÉ (1913–). Largely self-taught French painter of socially oriented figurative pictures.

FOUJITA, TSOUGHARU (1886–1968). Japanese-born French painter best known for his subdued, harmonious color.

FOUQUET (Foucquet), JEAN (ca. 1420–ca. 1480). The leading French painter of the 15th century, he traveled in Italy as a young man, supposedly to paint the portrait of Pope Eugene IV, and subsequently returned to his native Tours, where he eventually became court painter to Louis XI. Of the few surviving works generally attributed to him, a *Portrait of Charles VII* (Paris: Louvre) and a number of miniatures demonstrate his mastery of both the human figure and crowded, complex action pictures and the

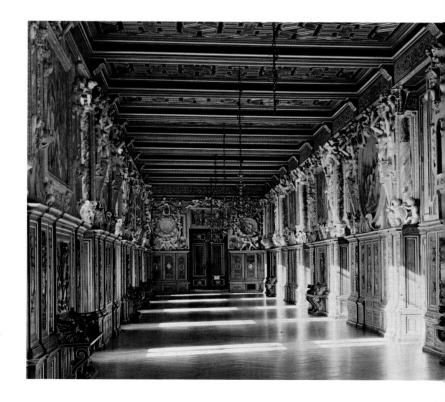

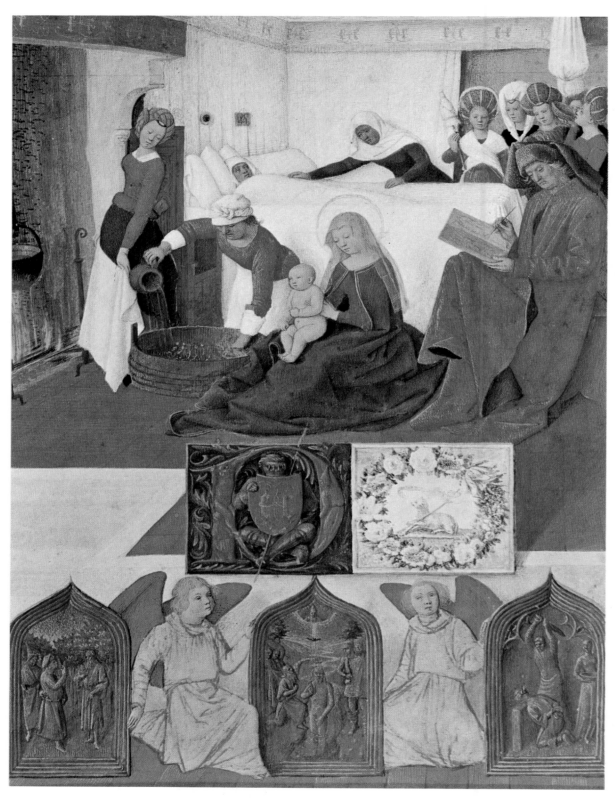

Jean Fouquet, *Birth of St. John the Baptist,* Musée Condé, Chantilly.

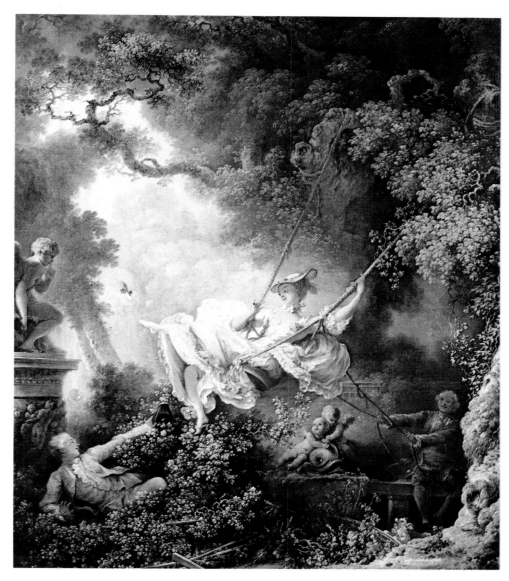

Jean-Honoré Fragonard, *The Swing*, Wallace Collection, London.

simple, straightforward monumentality that seems to have informed everything he produced.

FOWLER, ORSON S. (1809–1887). American architect and architectural writer best known for his influential advocacy of the octagonal houses he believed would provide maximum space and light for minimal labor and material costs.

FRAGONARD, JEAN-HONORÉ (1732–1806). French painter, decorator and etcher. He studied with CHARDIN and with BOUCHER, at whose urging he competed for and won the Prix de Rome, and later in Italy, where he absorbed a variety of influences and produced a number of landscapes. After unsuccessful—and rather halfhearted—attempts to paint in the grand manner, he

turned to the scenes of amorous dalliance to which his naturally joyful style best lent itself and with which he gave visible form to the values and mores of an era that ended with the French Revolution. At their best, his characteristic canvases and decorative cycles are full of charm, gaiety and a curiously affecting aura of innocence.

FRANCESCHINI, MARCANTONIO (1648–1729). Italian painter and decorator of the Bolognese school, best known for his sprightly handling of trite themes and compositional formulas.

FRANCESCO DI GIORGIO (1439–ca. 1501). Italian painter, sculptor, architect and engineer, sometimes called Martini. Esteemed by LEONARDO, he was a master at building fortifications and an architectural writer of some importance.

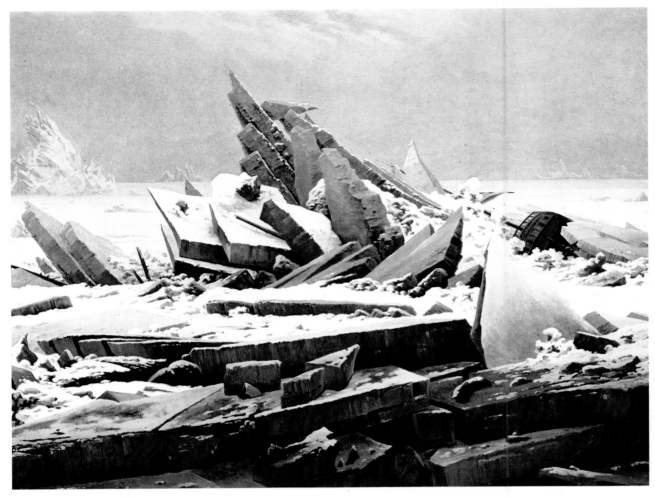

Caspar David Friedrich, *Shipwreck of the "Hope" in the Ice*, Art Gallery, Hamburg.

FRANCHOYS, PIETER (1606–1654). A Flemish painter best known for portraiture that bears the influence of VAN DYCK, he was the son and brother of the painters Lucas Franchoys the Elder and Younger.

FRANCIA (Francesco Raibolini) (ca. 1450–1517). Italian goldsmith and painter of Bologna, much influenced in his mature work by RAPHAEL.

FRANCIABIGIO (Francisco di Cristofano) (ca. 1482–1525). Italian eclectic painter who studied with PIERO DI COSIMO and whose most successful portraits, much influenced by RAPHAEL, are serene, elegant depictions of young men.

FRANCIS, SAM (1923–). American abstract painter who studied under STILL. His characteristic recent canvases have a vehemence and abruptness about them that mark a radical stylistic departure from his softer, more lyrical earlier works.

FRANCKE, MASTER (fl. ca. 1405–ca. 1425). German painter whose few surviving works are emphatically influenced by the French manuscript illumination of his time.

FRANCKEN, FRANS, THE ELDER (1542–1616). Flemish painter and father of the painter of the same name. A student of FLORIS, his typical late works make use of an unusually comprehensive palette.

FRANCKEN, FRANS, THE YOUNGER (1581–1642). A Flemish painter and student of his father (q.v.), he is perhaps best known for his paintings of his patrons' picture galleries.

FRANKENTHALER, HELEN (1928–). American abstract painter who studied under TAMAYO and FEELEY, among others, and whose original technique of saturating large areas of unprimed canvas with washes of thin pigment markedly influenced the work of LOUIS, NOLAND and the so-called WASHINGTON COLOR PAINTERS. At their best, her works are distinguished by their monumentality, virtuosity and compositional audacity.

FRANQUEVILLE, PIERRE (ca. 1550–1615). A French

sculptor and assistant to GIOVANNI BOLOGNA, whose style he emulated in a somewhat bloodless fashion.

FRASCONI, ANTONIO (1919–). Uruguayan-born American printmaker and illustrator, best known for his strongly contrasted woodcuts.

FRAZEE, JOHN (1790–1852). American sculptor and artisan whose early portrait busts are notable for their candor and naturalism.

FREAKE MASTER (fl. 1670–1680). Anonymous colonial American portrait limner, so called for his rather stereotyped portraits of John Freake and his family.

FREILICHER, JANE (1924–). An American figurative painter, typically of high-keyed outdoor subjects, whose style derives in part from ABSTRACT EXPRESSIONISM.

FREMINET, MARTIN (1564–1619). French painter and a leader of the second SCHOOL OF FONTAINEBLEAU. The little that survives of his work bears evidence of his admiration for, and incomplete understanding of, MICHELANGELO.

FRENCH, DANIEL CHESTER (1850–1931). An American monumental sculptor and chief rival of SAINT-GAUDENS, he is seen to best advantage in such rhythmic semi-nude figures as *Mourning Victory* (New York: Metropolitan Museum) but is best known for his seated figure of Lincoln in the Lincoln Memorial, Washington, D. C.

FRENCH, LEONARD (1928–). An Australian painter known for the surface richness and opulent finish of his religious pictures.

FREUNDLICH, OTTO (1878–1943). German semi-abstract sculptor who worked in a style derived chiefly from CUBISM but influenced by CONSTRUCTIVISM and the art of primitive cultures.

FRIEDRICH, CASPAR DAVID (1774–1840). German romantic painter whose starkly dramatic, coldly rendered landscapes represent attempts to symbolize his preoccupation with tragedy and death and who tried to convey his religious feelings in rather oppressive but quite forceful forest scenes. With his friend RUNGE he dominates German 19th-century romantic painting.

FRIESEKE, FREDERICK CARL (1874–1939). American impressionist painter best known for light-flooded garden scenes and country interiors.

FRIESZ, ACHILLE ÉMILE OTHON (1879–1949). French painter and student of BONNAT and MOREAU. After starting his career as an impressionist, he turned to FAUVISM and later to solidly worked-out compositions derived from CÉZANNE's middle period.

FRITH, WILLIAM POWELL (1819–1909). English genre and narrative painter, enormously popular during his lifetime. Such sentimental pictures as his *Railway Station* (Egham: Royal Holloway College) and *Derby Day* (London: Tate Gallery) teemed with figures and incident, and viewing them was one of the major entertainments of the day. In the course of his long life Frith knew almost every figure of consequence in England, and his guileless, somewhat smug memoirs are invaluable to social historians of the Victorian era.

FROMENT, NICOLAS (fl. 1450–1490). A Provençal painter in the court of René of Anjou. His two documented works reveal strong Flemish influences and a certain stiffness of gesture but show him to have been a master of portraiture, sculptural forms and compositional organization.

FRUEAUF, RUELAND I (ca. 1443–1507) and **RUELAND II** (ca. 1470–1545). Austrian painters of Flemish-influenced religious works.

FUGA, FERDINANDO (1699–1782). Italian architect best known for the façade of S. Maria Maggiore, Rome.

FULLER, R. BUCKMINSTER (1895–). American architect noted for his so-called Geodesic Domes: extremely light, self-supporting shells in which a framework of prefabricated modular units are covered with a thin, transparent plastic skin.

FULLER, GEORGE (1822–1884). American romantic painter and mezzotintist whose characteristic works are invested with a somewhat crepuscular aura.

FULLER, ISAAC (fl. ca. 1644–70; d. 1672). English eccentric painter of whose heavily impasted, spirited works few survive. John Evelyn objected to the excessive nudity in his now lost altarpiece for All Souls College, Oxford.

FU PAO-SHIH (1904–). Chinese painter esteemed for misty landscapes depicted in subtly harmonized pearly grays and sage greens.

FURINI, FRANCESCO (ca. 1600–1646). An Italian mannerist painter and student of ROSSELLI. His characteristic figures are sinuously outlined and painted in pallid, rather sickly colors and infinite gradations of tone.

FUSELI, HENRY (1741–1825). Swiss-born English romantic painter, writer and translator. At the urging of REYNOLDS, he concentrated on painting after successively embarking on religious, political and literary programs. Influenced by MICHELANGELO and Italian MANNERISM in general, he created a highly personal oeuvre that combined decadent eroticism with Gothic horror and obscure, strongly fetishistic symbolism.

FYT, JAN (1611–1661). Flemish painter who specialized in still-life and hunt scenes, often combining these themes in meticulous pictures of dead game. His infrequent flower paintings are sensitive and much prized.

G

GABO, NAUM (1890–). Russian-born American sculptor, painter and teacher and brother of PEVSNER, with whom he was instrumental as a theorist and publicist of CONSTRUCTIVISM and with whom he published the *Realistic Manifesto*, which rejected TATLIN's and RODCHENKO's advocacy of art as a political instrument. A pioneer of KINETIC SCULPTURE, he is known particularly for the elegant transparency and precise geometry of his forms.

GABRIEL, ANGE-JACQUES (1698–1782). A French architect noted for his judicious treatment of traditional forms and the purity of his designs.

GADDI, AGNOLO (fl. ca. 1369–1396). Florentine painter, grandson of GADDO GADDI and son and pupil of TADDEO GADDI. Like his father, he worked in the tradition initiated by GIOTTO. Distinguished by cool, almost

chalky color and rhythmic line, his works marked the culmination of that tradition.

GADDI, GADDO (before 1260–ca. 1328). Italian painter and mosaicist, father of TADDEO GADDI and grandfather of AGNOLO GADDI. A contemporary of GIOTTO and supposedly a friend of CIMABUE, who markedly influenced his style, he is known chiefly through the questionable writings of VASARI, and few works can be certainly identified as his.

GADDI, TADDEO (ca. 1300–1366). An Italian painter of the FLORENTINE SCHOOL and the godson and leading disciple of GIOTTO, he was the son of GADDO GADDI. He worked as Giotto's assistant for nearly a full quarter century and, through his son AGNOLO GADDI, transmitted the tradition of Giotto to the generation of Agnolo's pupil CENNINI. A major painter in his own right, he is known chiefly for his fresco cycle *The Life of the Virgin* (Florence: Sta. Croce), which was influenced by Giotto and by DADDI. A vastly accomplished narrative painter, he filled his pictures with incident and with an illusionism derived from the relief sculpture of his time.

GAGGINI FAMILY. Family of Italian sculptors consisting of Domenico Gagini (Gaggini) (ca. 1492) and his sons Giovanni (d. 1517) and Pace Gaggini (d. ca. 1522), all known chiefly for their architectural decoration.

GAILDE, JEAN (fl. ca. 1493–1519). French sculptor and stonemason known chiefly for his elaborate, somewhat disorganized screen in the Church of the Magdalen, Troyes, one of the last major works of the GOTHIC era.

GAILLARD, RENÉ (ca. 1719–1790). French etcher and engraver of portraits, landscapes and historical prints.

GAINSBOROUGH, THOMAS (1727–1788). English landscape and portrait painter influenced by HAYMAN and GRAVELOT, both of whom he knew well, along with VAN DYCK, RUBENS and such Dutch landscapists as WYNANTS, HOBBEMA and RUISDAEL. His most famous work, the exhaustively reproduced *Blue Boy* (San Marino, California: Henry E. Huntington Library and Art Gallery), tends to divert public attention from his skillful landscapes and superb drawings. Although his works are full of pat romantic formulae and conventionally "poetic" conceits, they are nonetheless informed by a prodigious talent and a joyous conviction that lend unexpected dimensions to what in other hands would have been mere set pieces executed by rote. Horace Walpole described his landscape *The Watering Place* (London: Tate Gallery) as "the most beautiful which has ever been painted in England," likened it to works by RUBENS and pronounced it "equal to the great masters."

GALILEI, ALESSANDRO (1691–1737). An Italian architect whose chief claim to fame is the façade of St. John Lateran, Rome, a design of stringent purity executed in an era of late BAROQUE excess.

Taddeo Gaddi, detail from *Nativity*, Baroncelli Chapel, Church of S. Croce, Florence.

Thomas Gainsborough, *Conversation in a Park*, Louvre, Paris.

GALLA PLACIDA, MAUSOLEUM OF. A 5th-century building in Ravenna, Italy, notable for its magnificent and well-preserved mosaics. Executed primarily in blues, greens and golds, these representations of Christ and various martyrs dramatically soften and lighten the effects of the massive barrel vaults they occupy.

GALLE FAMILY. A family of Flemish engravers that flourished in the 17th century and, from its headquarters in Antwerp, flooded Europe with reproductive prints.

GALLEGO(s), FERNANDO (ca. 1443–ca. 1508). A Spanish painter and the leading late-15th-century exponent of the Hispano-Flemish style.

Antoni Gaudí, façade of the Church of the Holy Family, Barcelona.

GALLEN-KALLELA (1865–1931). Finnish decorative painter who specialized in nationalistic themes rendered on rough sackcloth.

GALLO, FRANK (1933–). American sculptor, characteristically of polychrome plastic figures typified by a waxy, translucent surface reminiscent of Rosso and arabesques derived from ART NOUVEAU.

GANDON, JAMES (1743–1823). An English architect influenced by WREN, he designed the Custom House and Four Courts, both in Dublin.

GANDOLFI FAMILY. Family of Italian painters, sculptors and engravers active during the 18th and 19th centuries. The most important member was Gaetano Gandolfi (1734–1802), who painted frescoes in the manner of TIEPOLO.

GARGALLO, PABLO (1881–1934). Manila-born Spanish sculptor noted for his openwork iron figures and for having interested PICASSO in constructed metal sculpture.

GARNIER, CHARLES (1825–1898). French architect of such neo-BAROQUE edifices as the Paris Opéra and the Casino, Monte Carlo.

GARNIER, TONY (1869–1948). A French architect and city planner and a pioneer in the use of reinforced concrete. His theoretical plans for an ideal *Cité Industrielle* were influential in the redevelopment of his native city, Lyon.

GAROFALO (Benvenuto Tisi) (1841–1559). Italian painter and sometime collaborator with Dosso. Best known for Raphaelesque Madonnas and altarpieces.

GARTNER, FRIEDRICH VON (1792–1847). German architect, inventor of the so-called round-arched style and designer of Athens' GREEK-REVIVAL Old Palace.

GATCH, LEE (1902–1968). American painter and pupil of SLOAN, LHOTE and KISLING. Characteristic abstract works of his late period made much use of thin veneers of sandstone introduced as collage elements.

GATEWAY ARCH (Jefferson Westward Expansion Memorial). A 630-foot-high stainless-steel catenary curve on the west bank of the Mississippi River, St. Louis, Missouri, designed by EERO SAARINEN.

GAUDÍ (Gaudí i Cornet), ANTONI (1852–1926). Spanish visionary architect and designer. Working in the ART NOUVEAU style, he produced a body of work of striking originality and expressiveness, much of it incorporating Islamic forms and concepts of the surface reflection of light. His characteristic works are fanciful, "organic" and richly embellished in an agglomerative manner that anticipates the later development of collage and such collagelike constructions as the WATTS TOWERS OF RODIA. His fascination with "organic" form eventually evolved from a purely decorative to a basically structural concept, as embodied in such structures as the Casa Mila and the arcades of Güell Park, both in Barcelona, of which the former is constructed almost entirely of curved or undulating surfaces, while the latter is treated as an extension of the surrounding natural forms. Gaudí's magnum opus is the still-uncompleted Church of the Sagrada Familia, Barcelona, an extraordinary edifice that seems almost surrealistic in its riot of incongruous imagery and symbolism and that represents one of the most ambitious architectural undertakings of modern times.

GAUDIER (-Brzeska), HENRI (1891–1915). French sculptor who spent his brief working career in London, where he joined the VORTICISTS. Although his early death in World War I cut short his promise, his precocious works influenced HENRY MOORE and, by extension, much of British sculpture prior to the 1950s.

GAUGUIN, PAUL (1848–1903). French post-impressionist painter and the prototype for popular romantic notions of the uninhibited artist's life. Much has been made of his abandonment of the business world for a life of art, but the fact is that he did not give up his stockbroker's position until a financial crash more or less forced him to and seems to have believed thenceforth that his painting would make his fortune. His early work was heavily influenced by the impressionists, whose paintings he collected, and, through his friend PISSARRO, by the BARBIZON SCHOOL. By the 1880s, however, he was working with increased assurance and considerable independence, producing vibrant juxtapositions of color that had less to do with the appearance of reality and more with his arbitrary aesthetic notions. Later in the

Paul Gauguin, *Old Women of Arles,* Art Institute, Chicago.

same decade he met BERNARD in Brittany and with him formulated the ideas that provided the theoretical basis for SYNTHETISM—ideas Gauguin embodied in pictures characterized by heavy outlines that moved sinuously around areas of glowing arbitrary color, separating them from backgrounds consisting largely of rhythmic color patterns that suggested, but hardly attempted to represent, natural forms.

Along with many of his contemporaries, Gauguin long had harbored the notion that life in primitive societies was infinitely preferable to life in Europe. Unlike the vast majority of his contemporaries, however, he backed his theory with action, setting out for Tahiti in 1891. There he found neither the noble savages nor the simple life he had extolled with evangelical fervor before his departure. Moreover, although he later was to convey the impression that he had "gone native" and made an intensive study of the Tahitian language, customs, legends and religion, later research demonstrates that he chiefly dispensed with those trappings of civilization whose loss was no great inconvenience and that his knowledge of Tahitian native society and beliefs was superficial in the

116

Paul Gauguin, *Self-portrait*, Roger-Marx Collection, Paris.

Paul Gauguin, *Ia Orana Maria*, Metropolitan Museum of Art, New York.

extreme. But if the unspoiled Tahiti Gauguin depicted in his most famous canvases existed for the most part only in his imagination, those canvases nonetheless comprise persuasive evidence to support his claim that ''Primitive art comes from the spirit.'' And while it has been demonstrated that the iconography of his Tahitian pictures derives in large part from non-Tahitian sources, those pictures constitute a world no less real, mysterious or compelling for having no exact geographical counterpart. In his late masterpiece *D'Ou venons nous—Que sommes nous—Ou allons nous* (Boston: Museum of Fine Arts) and

such earlier works as *Manao Tupapau* (New York: A. Conger Goodyear Collection), Gauguin created pictures that were at once hauntingly poetic, profoundly mysterious and technically innovative. As a wellspring of non-naturalistic art, his influence on 20th-century painting, sculpture and printmaking has been incalculable.

GAUL, AUGUST (1869–1921). German animal sculptor best known for his fountain groups.

GAULLI, GIOVANNI BATTISTA (Baccicia) (1639–1709). An Italian BAROQUE painter and decorator noted for

Geertgen tot Sint Jans, *St. John the Baptist*, Staatliche Museen, Berlin.

his frescoes and portraits, he was influenced by CORREGGIO and BERNINI.

GAVARNI (Guillaume Sulpice Chevalier) (1804–1866). French lithographer, painter and caricaturist best known for his witty social commentary, particularly his satirical depictions of bourgeois life.

GEDDES, ANDREW (1783–1844). British painter and etcher esteemed for his technically accomplished portraits of the prominent Scottish figures of his time.

GEERTGEN TOT SINT JANS (ca. 1463–ca. 1493). A Dutch painter and probable pupil of OUWATER, he was one of the first northern artists to realize spatial continuity and, in his *Nativity* (London: National Gallery), to depict effectively a night scene containing its own sources of illumination. His treatment of landscape elements—handled as ambiance and not mere backdrop—was masterful in its time, and his figures are highly individualized and characteristically wear deeply pensive facial expressions.

GELDER, AERT DE (1645–1727). A Dutch painter and pupil of REMBRANDT, whose style he emulated although his palette was generally lighter in anticipation of the imminent advent of the ROCOCO.

GELDORP, GOLTZIUS (1553–1618). Flemish painter, primarily of brown-toned portraits.

GENGA, GIROLAMO (1476–1551). An Italian painter, decorator and architect and pupil of SIGNORELLI and PERUGINO, he was best known to his contemporaries for his theatrical designs and festival decorations.

GENOVES, JUAN (1930–). Spanish figurative painter of somewhat enigmatic scenes that rigorously avoid explicitness but convey a disturbing sense of social oppression. Characteristically, his pictures show crowds of anonymous figures, usually seen from high above, fleeing some unspecified threat.

GENTILE DA FABRIANO (ca. 1370–1427). Italian painter and, as a leading practitioner of the INTERNATIONAL GOTHIC style, a major influence on the development of Florentine art. Although little of his oeuvre survives, his altarpiece depicting the *Adoration of the Magi* (Florence: Uffizi) shows him to have been a master of the decorative elegance that characterized the International Gothic. BELLINI was one of his pupils.

GENTILESCHI, ARTEMISIA (1597–after 1651). Italian painter and daughter and pupil of ORAZIO GENTILESCHI. Like her father, she was strongly influenced by CARAVAGGIO. Her work, which is characterized by its earthy vigor, lurid subject matter and bright, lucid color, had a marked influence on subsequent Neapolitan painting.

GENTILESCHI, ORAZIO (Orzzio Lomi) (1563–1639). Italian painter and father of ARTEMISIA GENTILESCHI. Heavily influenced by CARAVAGGIO, whom he knew, he

spent the latter part of his career in London, where he was court painter to Charles I and where he produced such diluted essays in Caravaggism as *Joseph and Potiphar's Daughter* (London: Hampton Court). If he lacked Caravaggio's conviction and energy, he was an accomplished painter whose courtly style came to be much appreciated and emulated in northern Europe.

GENTILI FAMILY. Family of Italian 17th- and 18th-century majolica painters.

GÉRARD, BARON FRANÇOIS-PASCAL-SIMON (1770–1837). French painter and student of J.-L. DAVID. An influential official painter, he was best known for his portraits.

GERHARD, HUBERT (ca. 1540–1620). A Dutch sculptor and pupil, in Italy, of BOLOGNA, he was noted in his time as a bronzesmith.

GÉRICAULT, THÉODORE (1791–1824). French painter and, with DELACROIX, one of the leading figures in the ROMANTIC ART of the 19th century. After academic training under GUERIN, he undertook the study of such masters as RUBENS, CARAVAGGIO and the great Venetians and subsequently traveled in Italy, where he was influenced by MICHELANGELO and RAPHAEL, among others. Back in France in 1817, he became intrigued with a recent shipwreck as a possibly fitting subject for a major canvas that would treat a contemporary event in a monumental style. The merits of the resultant *Raft of the Medusa* (Paris: Louvre) were hotly debated when the vast picture was first exhibited, but it since has been recognized not only as Géricault's but also one of the 19th century's enduring masterpieces. Although he died young, with his full

Théodore Géricault, *The Raft of the Medusa*, Louvre, Paris.

Théodore Géricault, two sketches for *The Raft of the Medusa*, Museum of Fine Arts, Rouen.

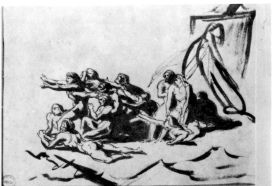

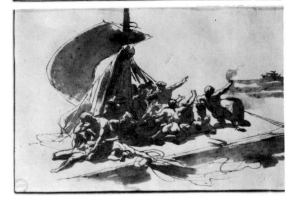

promise unrealized, his influence on Delacroix and less directly on COURBET, CÉZANNE and other subsequent painters was profound. Although he never dispensed with the classical tradition or abandoned his attempts to paint in the grand manner, he invested his efforts with a compelling, dramatic credibility such as European painting had not seen since the heyday of Caravaggio.

GERMAIN FAMILY. Four generations of French 17th- and 18th-century silversmiths, of whom the best known was François-Thomas Germain (1726–1791), who produced much work for various European courts.

GERMINY-DES-PRES, CHURCH OF. 9th-century CAROLINGIAN edifice near Orléans, France. A small oratory constructed on a Greek-cross plan with an apse at each of the cross's extremities, it bears influences of Near Eastern and Moorish architecture.

GÉRÔME, JEAN LÉON (1824–1904). A French painter and sculptor, an exponent of the academic tradition and a

vociferous opponent of IMPRESSIONSM. His meticulously researched, sharply linear neoclassic pictures were enormously popular in their time, in part perhaps because of their thinly veiled eroticism.

GESSNER, SALOMON (1730–1780). Swiss ROCOCO painter, etcher and poet influenced by CLAUDE LORRAINE.

GHEERAERTS, MARCUS I (ca. 1525–before 1599) and **MARCUS II** (1561–ca. 1635). Flemish artists, respectively, an engraver and a painter and popular portraitist.

GHENT ALTARPIECE. Panel depictions of *The Adoration of the Lamb* by HUBERT and JAN VAN EYCK (q.v.).

GHEYN, JACOB DE II (1565–1629). Dutch printmaker and pupil of GOLTZIUS. The author of some 400 etchings and engravings, he was also a print publisher of considerable importance.

GHIBERTI, LORENZO (1378–1455). Italian sculptor, architect, goldsmith, painter and writer. A leading figure of the early Renaissance (and an author whose *Commentarii* is one of the chief documents of the period), he began his

Lorenzo Ghiberti, detail of the Gates of Paradise, Baptistry of St. John, Florence.

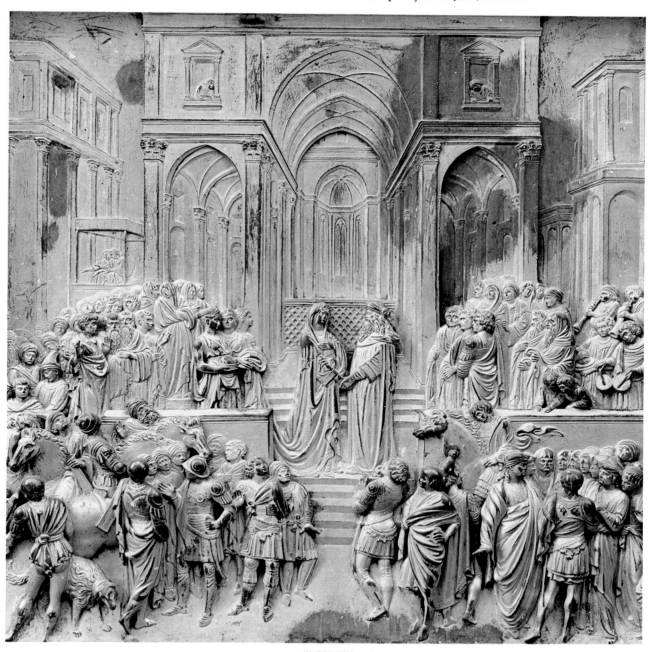

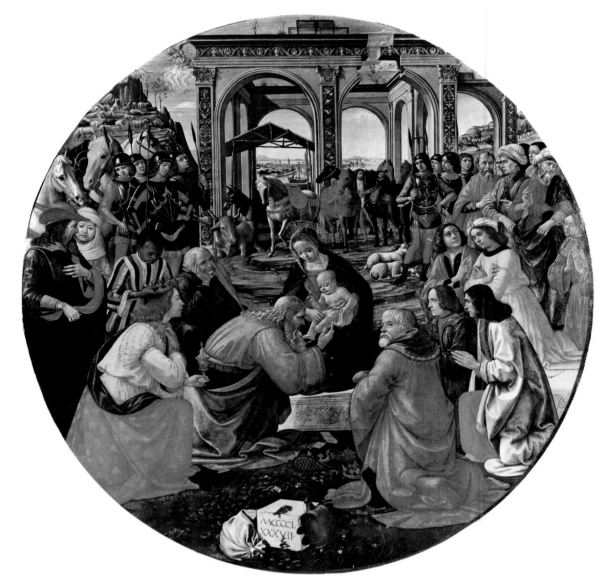

Domenico Ghirlandaio, *Adoration of the Magi*, Uffizi, Florence.

career as a painter but is best known for the relief sculpture on which he concentrated for the better part of his life. At age 23 he entered and won a competition for the commission of a second pair of bronze doors to complement those designed earlier for the Florence Baptistery by PISANO, beating out BRUNELLESCHI and DELLA QUERCIA, among others. In this work he closely followed Pisano's precedent, enclosing high reliefs and gilded figures in Gothic frames and against neutral backgrounds but substituting Old for New Testament scenes.

The warm reception accorded the doors led in 1425 to a second commission to make still another pair of doors for the Baptistery. For these Ghiberti radically departed from Pisano's and his own earlier models, working in very shallow relief, reducing the number of panels from 28 to 10, composing each scene as a complete "picture" and not merely a group of figures silhouetted against a void and making extensive use of principles of perspective worked out by DONATELLO and Brunelleschi (in his *Com-*

mentarii, the artist described his figures as being "so disposed on the planes that those which are nearest are seen to be larger than those further off").

Although Ghiberti's art was firmly based on Gothic craft traditions, he was intellectually very much a man of the Renaissance, a humanist and a collector of classical sculpture. His autobiography, included in the *Commentarii*, is believed to be the first by any visual artists, and his busy workshop, maintained after his death by his son Vittorio (1416–1496), produced many of the leading artistic figures of the Florentine Renaissance, including Donatello, MASOLINO and UCELLO.

GHIRLANDAIO, BENEDETTO DI TOMMASO (1458–1497). Florentine painter and brother of and assistant to DOMENICO GHIRLANDAIO. Almost none of his independently produced work survives, but he seems to have based his style on that of his more famous brother, infusing it with Flemish overtones.

GHIRLANDAIO, DAVIDE (1452–1525). Florentine painter, brother of BENEDETTO and DOMENICO GHIRLANDAIO and principal assistant in the latter's workshop.

GHIRLANDAIO, DOMENICO (1449–1494). Florentine painter, brother of BENEDETTO and DAVIDE GHIRLANDAIO and father of RIDOLFO GHIRLANDAIO. The outstanding Florentine fresco painter of his generation and the master of a large, active workshop that at one time numbered MICHELANGELO among its apprentices, he may have been a pupil of BALDOVINETTI. Although influenced by MASACCIO, his many public and religious fresco commissions fall short of Masaccio's monumentality in their preoccupation with incident and detail. They were extremely popular in their day but rarely with serious patrons.

GHIRLANDAIO, RIDOLFO (1483–1561). A Florentine painter and son of DOMENICO GHIRLANDAIO, he studied with FRA BARTOLOMMEO, was influenced by RAPHAEL, GRANACCI and PIERO DI COSIMO and is notable chiefly for his portraits.

GHISI, GIORGIO (1520–1582). An Italian engraver and pupil of GIULIO ROMANO. His output was restricted largely to reproductive prints made in Italy and Flanders.

GHISLANDI, GIUSEPPE (Fra Vittore del Galgario) (1655–1743). Italian portrait painter known for his bravura brushwork, brilliant color and keen insight.

GIACOMETTI, ALBERTO (1901–1966). Swiss sculptor and painter and student of BOURDELLE; the leading sculptor of the surrealist movement, with which he allied himself from 1929 until ca. 1935, during which time he produced at least one of the masterpieces of SURREALISM, *The Palace at 4 a.m.* (New York: Museum of Modern Art). His later, more characteristic, cubist-derived sculpture is instantly recognizable by its filamentlike attenuation and an elusiveness, when viewed from certain angles, that makes his human figures appear to be seen at great distances, where they move in isolation and anonymity. Many critics have seen in his work the essence of modern man, alienated, nervous, insubstantial and faceless, his existence bereft of meaning, his gestures remote from his being. In his paintings, Giacometti developed a style that was at once tentative and dogged, with each canvas constituting a gray record of the artist's struggle to give form and definition to the formless and indefinable.

GIBBONS, GRINLING (1648–1721). An English sculptor and decorative carver born in Holland, he is best known for his carvings of fruit, flowers, *putti* and animals.

GIBBS, JAMES (1682–1754). Scottish mannerist architect and pupil of CARLO FONTANA. His most widely known work is the London church St. Martin's-in-the-Fields, which was much imitated in Britain and the U.S. An admirer of, and unofficial successor to, WREN, he was very influential through his *Book of Architecture* and other publications.

GIBSON, JOHN (1790–1866). English sculptor, protégé of FLAXMAN and pupil, in Italy, of CANOVA. A leading practitioner of NEOCLASSICISM, he attempted, with indifferent success, to spur a revival of the use of polychrome in sculpture.

GILBERT, CASS (1858–1934). American eclectic architect of such buildings as the Minnesota, Arkansas and West Virginia state capitols, the U.S. Custom House, New York, and—his best-known work—the Woolworth Tower, New York. Although he broke no new ground and failed to realize that the skyscraper demanded a style of its own, he integrated existing forms into impressively well-designed structures.

GILL, (Arthur) ERIC (Rowton) (1882–1940). English sculptor, engraver, illustrator, typographer and author. Although he achieved a measure of eminence in typography that eluded him in his other pursuits, he was an illustrator of considerable talent and a skillful, if not altogether innovative, sculptor. He was also a versatile craftsman and crafts advocate in the tradition of WILLIAM MORRIS.

GILLEMANS, JAN PAUWEL, THE ELDER (1618–ca. 1676), and JAN PAUWEL, THE YOUNGER (1651–ca. 1704). Flemish painters. Both painted still lifes in the style of DE HEEM, but the son also produced ambitious works on mythological themes.

GILLOT, CLAUDE (1673–1722). A French painter, designer and draftsman and teacher of WATTEAU, he is known for his sprightly genre pictures and subjects derived from the *commedia dell'arte* and other theatrical sources.

GILLRAY, JAMES (1757–1815). One of the greatest of the English caricaturists, he was a largely self-taught artist who achieved enormous popularity during the Napoleonic Wars, when the demand for his work was described as "a veritable madness." Although he based much of his work on precedents set by HOGARTH, his satire was more specifically aimed and his attack more frontal than Hogarth's.

GILMAN, HAROLD (1875–1919). English painter. Influenced by SICKERT and the French post-impressionists and important chiefly for his efforts to bring contemporary English art into the European modernist mainstream.

GILPIN, SAWREY (1733–1807). English painter who specialized in animal subjects, particularly race horses.

GINNEVER, CHARLES (1931–). American sculptor who works in the minimalist vein.

GIOBBI, EDWARD GIOACHINO (1926–). American painter whose abstract and semi-abstract canvases are constructed around a system of imagery derived from the architecture of classical antiquity, with forms resembling arches and columns sculpturally rendered in close tonal gradations.

GIOCONDO, FRA GIOVANNI (ca. 1433–1515). Italian architect, engineer and scholar who shortly before his death shared architectural supervision of ST. PETER'S, Rome, with RAPHAEL.

Giorgione, *Rustic Concert,* Louvre, Paris.

GIORDANO, LUCA (1632–1705). Italian eclectic painter influenced by RIBERA and, indirectly, CARAVAGGIO and such northern masters as DÜRER and VAN LEYDEN. A precursor of the ROCOCO, he was one of the most prolific painters of his time.

GIORGIONE (ca. 1477–1510). Venetian painter of enormous influence in and long after his time. Little is known of his life, and relatively few works are ascribed to him with certainty. He is generally believed to have been a pupil of GIOVANNI BELLINI, a colleague at one time of TITIAN and one of the very first painters whose works were collected by his contemporaries. He was also the first painter of importance to produce works in which a consciously rendered mood or atmosphere was treated as a meaningful pictorial subject and he was considered by VASARI to vie with LEONARDO as a pioneer of modern painting. His greatest contribution to the history of art was his thorough integration of figures into their settings, an innovation that profoundly influenced Titian and, through him, subsequent painting throughout Europe.

GIOTTESCHI (Giottesques). Name given to various followers of GIOTTO, including the MASTER OF ST. CECILIA, TADDIO GADDI, BERNARDO DADDI and others.

GIOTTINO. An Italian painter, supposedly of the second and third quarters of the 14th century, recorded by several sources, including VASARI, who gave his name as Tommaso di Stefano. Probably the author of a superb *Deposition* (Florence: Uffizi).

GIOTTO (Giotto di Bordone) (1267–1337). Italian painter and architect and one of the seminal figures in Western art. With CIMABUE and, in sculpture, GIOVANNI PISANO, he spearheaded the revival of naturalism, which had lain dormant between the waning of classical antiquity and his own anticipation of the Renaissance. Although he may have overstated the case somewhat, VASARI was essentially correct in writing that, "although born amidst incompetent artists . . . he alone succeeded in reviving art and restoring her to the true path."

Giotto's importance lies in his having rejected the stereotyped formulas derived from Byzantine art and dominant in the Italian art of his time and in their stead substituting personal observation of nature and a resultant solidity and credibility unknown in Medieval painting and only hinted at in the art of Cimabue. (Writing of both artists, Dante remarked that Cimabue's glory was dimmed by the renown Giotto had come to enjoy.)

Giotto, detail from the *Descent from the Cross,* Scrovegni Chapel, Padua.

Gislebertus, *The Damned*, above main entry, Cathedral, Autun.

Almost nothing is known of his origins or the early part of his career. He is documented as having worked in Padua, Florence and Naples between ca. 1304 and 1330 and by 1334 was back in Florence, where he was named *capomaestro* (chief architect) of the cathedral, whose campanile he designed, although his design later underwent considerable alteration.

His best-known authenticated works include a fresco cycle in the Arena Chapel, Padua, frescoes and an altarpiece in Sta. Croce, Florence, and a *Madonna and Child Enthroned with Angels and Saints* (Florence: Uffizi). In the works of his maturity his composition was masterful, both within individual pictures and in the linked pictures of his fresco cycles, his expressivity was unprecedented and his forms attained a solidity all the more remarkable for the overall flatness of paintings that consistently maintained the integrity of the picture plane. His influence waned somewhat with the decline of the GIOTTESCHI in the late 14th century but re-emerged at the height of the Renaissance.

GIOVANNI D'ALEMAGNA (fl. 2nd quarter of 15th century; d. 1450). Venetian painter and collaborator with VIVARINI.

GIOVANNI DA MILANO (fl. 3rd quarter of 14th century). Painter of the FLORENTINE SCHOOL best known for his frescoes in Sta. Croce, Florence.

GIOVANNI DA UDINE (1487–1564). Italian painter, decorator and architect who studied with GIORGIONE and assisted RAPHAEL. He is notable chiefly for his decorative painting and stucco work.

GIOVANNI DEL BIONDO DAL CASENTINO (fl. 2nd half of 14th century). A painter of the FLORENTINE SCHOOL influenced by ANDREA ORCAGNA.

GIOVANNI DEL PONTE (Giovanni di Marco) (1385–1437). A Florentine painter and follower of MASACCIO.

GIOVANNI DI BARTOLOMMEO CRISTANI (fl. 2nd half of 14th century). Italian painter said by VASARI to have been a follower of CAVALLINI.

GIOVANNI DI FRANCESCO DEL CERVELLIERA (ca. 1428–1459). An eclectic painter of the FLORENTINE SCHOOL, he was influenced most strongly by BALDOVINETTI.

GIOVANNI DI PAOLO (Giovanni del Poggio) (1403–1483). A painter of the Sienese school and probable pupil of BARTOLO, he was a leading figure in the transition from Medievalism to the early Renaissance and is notable for his narrative interpretations of the *Life of St. John the Baptist* (Chicago: Art Institute).

GIOVANNI DE' GRASSI (ca. 1340–1398). Italian painter, sculptor and architect who worked on the MILAN CATHEDRAL and was a notable miniaturist.

GIOVANNI PISANO. See **PISANO, GIOVANNI.**

GIRARDON, FRANÇOIS (1628–1715). A French classical sculptor in the court of Louis XIV, he was influenced by BERNINI, BOLOGNA and the painter POUSSIN.

GIRODET-TRIOSON, ANNE-LOUIS (1767–1824). French romantic painter and pupil of J.-L. DAVID, who disapproved of his self-consiously poetic *sfumato*. He became independently wealthy in 1812, abandoned painting and spent the rest of his life writing tortuous poems.

GIROLAMO DA CREMONA (. mid-1460s-mid-1470s). Italian painter known chiefly for his miniatures, which were heavily influenced by MANTEGNA.

GIRTIN, THOMAS (1775–1802). English watercolorist and early colleague of TURNER. A leading figure in the development of naturalism in the landscape painting of the 19th century, he invested his views with a remote monumentality, characteristically placing the chief elements of his topographical views in the middle distance. He was technically inventive, too, and instead of following the then current practice of laying in a monochromatic underpainting, he attacked his subjects directly, using bold, decisive washes of color.

GISLEBERTUS (fl. lst third of 12th century). French sculptor, perhaps the greatest of the ROMANESQUE era, and, with his *"Gislebertus hoc fecit,"* inscribed on the west

tympanum of the Cathedral of St. Lazarus, Autun, the first great sculptor of the Middle Ages to proclaim his right to recognition as an artist and not a mere craftsman. His *Last Judgment*, carved on that tympanum, is one of the masterpieces of the 12th century, as are several of some 50 nave capitals and a superb relief of *Eve* (Autun: Musée Rolin) executed for the same cathedral. Gislebertus, who is known to have worked at Cluny and may have been at Vézelay before coming to Autun, is notable for his sure sense of form, lyrical rhythmic organization, great imaginative powers and an unprecedented ability to charge his figures (most notably *Eve*) with expressivity. He has been aptly described by André Malraux as "a Romanesque CÉZANNE."

GIULIO ROMANO (ca. 1499–1546). Italian architect and painter, a pupil and assistant of RAPHAEL and a pioneer of MANNERISM. Influenced in his own painting by MICHELANGELO, he is notable chiefly as the architect of the Palazzo del Tè, Mantua, one of the earliest mannerist buildings.

GIUNTA PISANO (fl. ca. 1230–ca. 1255). Italian painter who, with BERLINGHIERO BERLINGIERI, is one of the first artists known by name.

GIUSTO DI GIOVANNI DE' MENABUOI (ca. 1340–1393). Florentine painter who worked mostly in Padua, where he was known for frescoes influenced by TADDEO GADDI.

GIZA. Site in Egypt, near Cairo, of the pyramids of Cheops, Chephren and Mycerinus. See **CHEOPS, PYRAMID OF.**

GLACKENS, WILLIAM JAMES (1870–1938). American painter and illustrator influenced by MANET, HENRI and particularly RENOIR. He was a member of THE EIGHT but did not wholeheartedly share that group's interest in the seamier side of life.

GLARNER, FRITZ (1899–1972). Swiss-born American abstract painter strongly influenced by MONDRIAN.

GLEIZES, ALBERT (1881–1953). A French painter and writer, he was one of the leading theoretical practitioners of CUBISM in that style's early years. A member of the SECTION D'OR, he and METZINGER published *Du cubisme*, an extremely influential book in its time. In something of a throwback to Medieval religiosity, he attempted to codify aesthetic precepts in terms of Catholicism during a period notable chiefly for his production of 57 etched illustrations for Pascal's *Pensées*. His personal vision of the cubist ideal was characterized by a reliance on flat pattern and a palette derived from the impressionists.

GLICENSTEIN, ENRICO (1870–1942). Polish-born American figurative sculptor notable for a simplicity of form admired by RODIN, among others.

GLOCKENDON FAMILY. A large family of German artists who worked in most of the then existing media during the 15th and 16th centuries.

GLOVER, JOHN (1767–1849). English watercolorist, draftsman and teacher whose work is characterized by a simplification of form that often reduces objects to dark silhouettes seen against lighter grounds.

GOERG, EDOUARD (1893–). Australian-born French painter and teacher whose popular success rests on a rather superficial treatment of fashionable young women.

GOES, HUGO VAN DER (ca. 1435/40–1482). One of the outstanding Flemish painters of the 15th century and the most important painter in Ghent after JAN VAN EYCK, he was particularly notable for his ability—rare among Flemish painters—to work on a large scale, for his emotional intensity and for the influence his *Portinari Altarpiece*, painted for a Florentine client, wielded in Italy on such artists as DOMENICO GHIRLANDAIO.

GOGH, VINCENT WILLEM VAN. See **VAN GOGH, VINCENT WILLEM.**

GOINGS, RALPH (1928–). American photorealist painter, characteristically of automotive subjects.

GOLTZIUS, HENDRICK (1558–1617). A Dutch mannerist engraver of both reproductive and original prints, he is notable chiefly for his technical mastery of thick-and-thin line and for his use of color wood blocks. He was also a successful portrait painter who may have influenced the later work of FRANS HALS.

GONCALVES, NUNO (fl. 1450–1472). Portuguese painter, probably in the court of Alfonso V, known chiefly from literary sources and thought to be the author of an altarpiece (Lisbon: National Museum) depicting in a strongly realist style related to the Flemish art of the period members of the court praying to St. Vincent.

GONTCHAROVA, NATALIE (1881–1962). A Russian-born French painter, sculptor and, principally, scenic designer whose late theatrical work was distinguished by its austerity.

GONZALEZ, BARTOLOME (1564–1627). Spanish court painter whose portraits are undistinguished but whose infrequent religious paintings display considerable mastery of a chiaroscuro and realism derived from CARAVAGGIO.

GONZALEZ, JULIO (1876–1942). Spanish constructivist sculptor who helped PICASSO master the techniques of working directly in metal and markedly influenced the career of DAVID SMITH.

GONZALEZ CAMARENA, JORGE (1908–). A Mexican eclectic mural painter and pupil of RIVERA. His work is indebted to PRE-COLUMBIAN art, SIQUEIROS and the surrealists, among others.

GOODNOUGH, ROBERT (1917–). American abstract painter whose work is notable for its clarity of form and rhythmic patterning.

GORE, SPENCER FREDERICK (1878–1914). English painter, influenced by IMPRESSIONISM, POST-IMPRESSIONISM and SICKERT.

GORKY, ARSHILE (1904–1948). Armenian-born American painter and a pioneer of ABSTRACT EXPRESSIONISM. Influenced by MIRÓ, ARP and MATTA in his mature

126

period, he shared a studio with, and was influenced by, DE KOONING during the early 1940s and also was influenced by STUART DAVIS and, to a lesser degree, KANDINSKY. A transitional figure in the emergence of abstract expressionism from its partial origins in SUR-REALISM, he in turn influenced de Kooning, POLLOCK and other leading proponents of the abstract-expressionist movement. Like other members of that movement, he led a tormented personal life that ended in suicide.

GOSSAERT (Mabuse), JAN (ca. 1478–1533). Flemish painter who traveled in Italy, where he was influenced by Renaissance ideals he was not fully capable of grasping. Also influenced by VAN DER GOES, GERARD DAVID and DÜRER. His labored, prolix pictures were the first in Flanders to make use of classical subjects and nude figures.

GOTTLIEB, ADOLPH (1903–1974). American painter and a founder of ABSTRACT EXPRESSIONISM. A student of HENRI and SLOAN, he devised a so-called "pictographic" style in the early 1940s, consisting of semiabstract, compartmentalized symbols, independent of but suggestive of those employed by TORRES-GARCIA a decade earlier. By the 1950s he developed what was essentially to remain his personal image: simple, silhouetted round or rectangular forms that hovered against a skylike ground and above an energy field that first took an explosive form and

later was cut off by an arbitrarily placed horizon line. In an extensive, generically named "Burst" series, this basic image was further simplified to the point where a single disc of color was placed above a drastically simplified "foreground." Despite the increased simplification of his late works, however, Gottlieb remained an expressionist, increasing the subtlety of but never abandoning the painterly brushwork of his earlier periods.

GOUDT, HENDRICK (1585–1648). Dutch printmaker and draftsman, nobleman and amateur artist. His work was dominated by the influence of ELSHEIMER.

GOUJON, JEAN (ca. 1510–ca. 1566). French sculptor and architect known for attenuated figures based on PRIMATICCIO's theories of proportion.

GOYA (Goya y Lucientes), FRANCISCO JOSÉ DE (1746–1828). Spanish painter and printmaker and one of the giants of late 18th- and early 19th-century art. Although little is known of his training, he is known to have served an apprenticeship at Saragossa under the obscure José Luzán, to have worked at Madrid under the court painter BAYEU, whose sister he married, to have traveled

Goya, *The Third of May 1808,* Prado, Madrid.

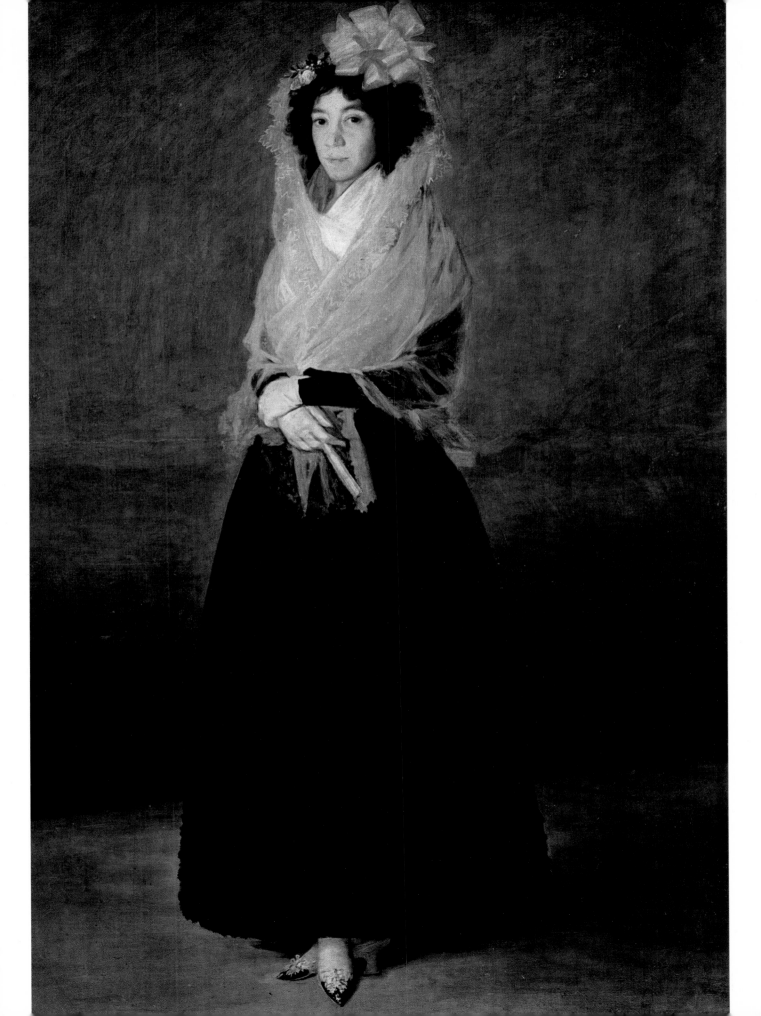

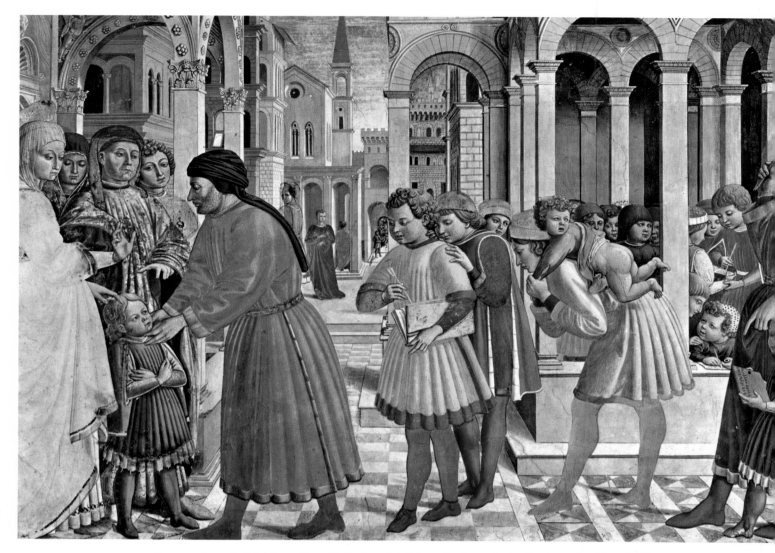

Benozzo Gozzoli, *Saint Augustine with Teacher*, detail from the fresco in the St. Augustine Church, Gimignano.

to Rome and to have been influenced early in his career by MENGS and TIEPOLO, French ROCOCO painters who were then working in the Spanish capital. Goya reached the summit of his own Rococo phase with a series of tapestry cartoons executed at the instigation of Mengs during the years 1774–1791, after which he fell increasingly under the technical influence of VELAZQUEZ and the demoralizing effects of an ailment that almost killed him and left him totally deaf and increasingly introspective.

By that time Goya was firmly established as a portraitist of the very first rank, a dazzlingly innovative frescoist, a leading court painter (he was later to be named Principal Painter to the King), Deputy Director of the Academy of San Fernando and a lion of Madrid society. Nonetheless, his finest work lay before him, and in the final three and a half decades of his life he produced many of his greatest individual portraits, his decorative masterpiece, the ceiling and wall paintings for Madrid's church of San Antonio de la Florida, and such celebrated canvases as the relentlessly frank *Family of Charles IV,* the beguiling *Naked Maja* and *Clothed Maja* and the monumental *Second of May* and *Third of May* (all in the Prado, Madrid). The latter

pair, celebrating Spanish resistance to the French invaders, constitute two of the most eloquent and dramatic statements of their kind ever made in any medium.

Despite all this well-received productivity, the more saturnine side of Goya's nature demanded other outlets of expression, and these took the form of three of the most imaginative—and technically most accomplished—etching suites ever produced, *The Caprichos, The Disparates* and *The Disasters of War*, and a cycle of 14 enigmatic but chillingly pessimistic "black" paintings

Toward the end of his life Goya turned to lithography, then a new medium and one that he did much to legitimize with several superb portraits and bullfight scenes. As a painter his stylistic metamorphosis was unusually complete, beginning, as it did, in the Rococo and ending on the threshold of IMPRESSIONISM. His influence on 19th-century painting was widespread and profound—especially in the case of MANET—and even the generation of Spanish abstractionists that came into prominence in the 1950s acknowledges its indebtedness to him.

GOYEN, JAN JOSEPHSZ. VAN (1596–1656). A leading

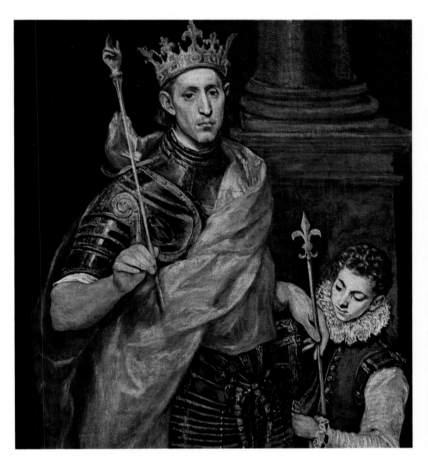

Dutch landscape painter and the father-in-law of JAN STEEN, he began his very prolific career in the workshop of ESAIAS VAN DE VELDE, who markedly influenced his early work. As he matured he developed a distinctively tonal style and a compositional mastery far beyond the talents of his master.

GOZZOLI, BENOZZO (1420–1497). An Italian painter and pupil of FRA ANGELICO, he is known chiefly for his sumptuous tapestry-like fresco *The Procession of the Magi* in the Medici Chapel of the Medici-Riccardi Palace, Florence, a work in which members of the Medici family appear as the magi.

GRAF, URS (ca. 1485–ca. 1527). Swiss printmaker, goldsmith and painter. Influenced by DÜRER, he was a prolific designer of woodcut book illustrations and the author of the earliest (1513) known dated etchings.

GRAFF, ANTON (1736–1813). A Swiss-born German painter and the leading 18th-century portraitist in Germany, he was influenced for a time by GAINSBOROUGH but later developed a heavier style characterized by psychological probity.

GRAFLY, CHARLES (1862–1929). An American naturalistic sculptor and pupil of EAKINS who carried 19th-century NEOCLASSICISM well into the 20th century.

GRANACCI, FRANCESCO (1477–1543). An Italian painter of the FLORENTINE SCHOOL, pupil of DOMENICO GHIRLANDAIO and friend of MICHELANGELO, for whom he worked briefly as an assistant on the ceiling of the SISTINE CHAPEL. His major influence was FRA BARTOLOMMEO, and he is counted among the masters of the transitional epoch.

GRANDE CHARTREUSE, LA. Headquarters of the Carthusian monastic order on the outskirts of Grenoble, France, noted for the impressive area it covers, its cloister, much of which dates from the 13th century, and its graceful adaption to the mountainous surrounding landscape.

GRANET, FRANÇOIS MARIUS (1775–1849). French painter and pupil of DAVID. Noted for his dimly lit interiors.

GRANT, DUNCAN (1885–). British painter, decorator and designer and one of the principal conduits whereby French POST-IMPRESSIONISM influenced painting in England.

GRANT, SIR FRANCIS (1805–1878). Scottish self-taught painter and successor of EASTLAKE as President of the Royal Academy.

GASSER, ERASMUS (ca. 1450–1518). German sculptor who worked in the late GOTHIC style.

GRAVELOT, HUBERT FRANÇOIS (1699–1773). French engraver and illustrator who worked in England, where he numbered GAINSBOROUGH among his pupils and became one of the first illustrators of the novel.

GRAVES, MORRIS (1910–). An American painter influenced by TOBEY and Eastern religion and philosophy, he is largely self-taught and has painted in a progressively more abstract style over the years.

GRAVES, NANCY (1940–). American sculptor who constructs assemblages of organic elements such as bones, feathers and the like.

GREAT WALL OF CHINA. 2,500-mile-long fortification winding across 1,500 miles of northern China, below the Mongolian plain, from Kansu to Hopeh provinces. Built in the Ch'in dynasty (227–207 B.C.), it was largely rebuilt during the Ming epoch, with later restorations dating from 1949. Constructed of compacted earth faced for the most part with brick and stone, it is punctuated with innumerable towers and topped with a wide paved road.

GRECO, EL (Domenikos Theotokopoulos) (ca. 1541–1614). Cretan-born painter who studied and worked in Italy before spending the major portion of his career in Toledo, Spain. Documented early in his career as "a follower of TITIAN," he was also influenced by a variety of sources that included JACOPO BASSANO, MICHELANGELO, RAPHAEL, BERRUGUETE, Byzantine icon painting, CLOVIO, PONTORMO and PARMIGIANINO. These influences notwithstanding, he seems early on to have considered himself a full-fledged master in his own right and, at ca. age 30, to have boasted to Pius V that he was ready to improve on the appearance of the SISTINE CHAPEL if the pope would first consent to the obliteration of Michelangelo's frescoes.

The exact reasons for El Greco's expatriation to Spain

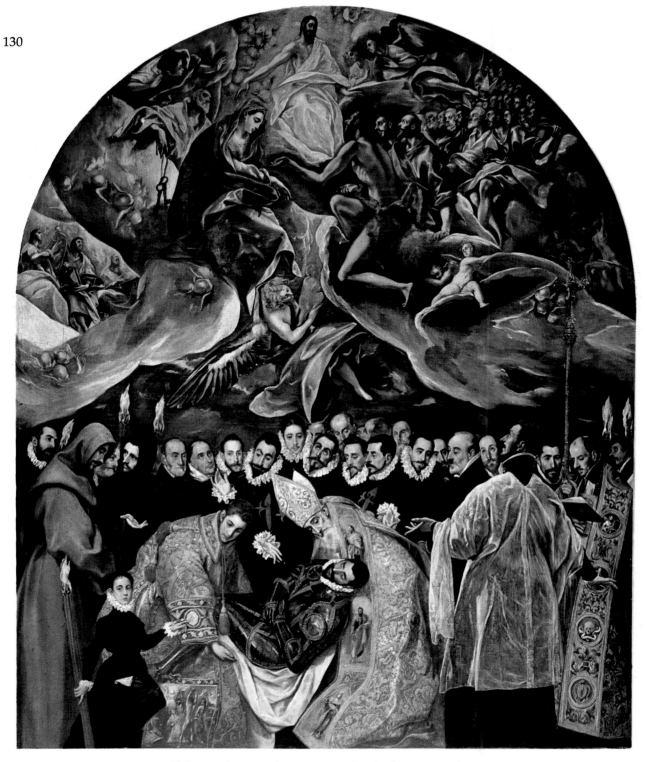

El Greco, *The Burial of Count Orgaz,* Church of S. Tomé, Toledo.

are unknown, but his and that country's fervent spirituality complemented each other perfectly, and his first commissions in Toledo won him immediate acceptance. Moreover, in Philip II, whom he pleased enormously at first, the artist seemed to have found the perfect patron. An abrupt change in his style, however, baffled the king, who, for all his own spirituality, failed to understand a visionary strain made manifest in the mannerist attenuation, uncertain sources of illumination, arbitrary alterations of scale and hard, eerie, acid color that are so distinctively characteristic of the painter's post-Italianate work. Deprived of royal favor, El Greco nonetheless found a number of patrons who admired his intensely personal, nervous, exalted style, with its electric energy, other-

Juan Gris, *Fruit Bowl and Carafe*, Kröller-Müller Museum, Otterlo, Netherlands.

wordly color contrasts and flamelike contortions, and maintained a busy workshop whose members included his son Jorge Manuel. Although the latter slavishly imitated his father's more superficial characteristics, El Greco's work was so intensely and so personally visionary that it had little stylistic influence and produced no followers of consequence.

GREENAWAY, KATE (1846–1901). English watercolor illustrator of children's books whose work was admired by RUSKIN and GAUGUIN, among others.

GREENE, BALCOMB (1904–). American painter. After attracting some notice with his geometric abstractions of the 1930s and early 1940s, he turned to a kind of broken figuration in which his subjects seem almost to dissolve into a play of pure light on their component planes.

GREENE, STEPHEN (1918–). American figurative painter whose early patterned compositions, flat, simplified, slightly distorted figures and somber expressivity bear strong resemblances to the works of SHAHN and whose later abstract paintings make use of an enigmatic personal symbolism.

GREENLY, COLIN (1928–). English-born sculptor who works in the United States on angular constructions of metal-framed plate glass in which reflected images play a salient role.

GREENOUGH, HORATIO (1805–1852). American neoclassical sculptor best known for his twenty-ton seated, semi-nude figure of Washington (Washington, D.C.: Smithsonian Institution), originally designed for installation in the Capitol rotunda and the first major public commission awarded a native sculptor. An important aesthetic philosopher, he was in advance of his time with his insistence that modern artists abjure antique formulae and "make the shapes" suitable to their ends.

GREENWICH ROYAL HOSPITAL. 16th-, 17th- and 18th-century complex of English hospital buildings (begun as a royal residence) designed by various architects, including WEBB, VANBRUGH, WREN and THORNHILL.

GREUZE, JEAN-BAPTISTE (1725–1805). French genre and portrait painter whose characteristic didactic works are marred by sentimentality and simplistic moralism. Although popular with a large public, he failed throughout his life to attain the official recognition he sought, except in Austria and Russia. His clumsy attempts to maintain his popularity during an upsurge of neoclassicism produced a number of embarrassing, mildly salacious paintings of provocative nymphets holding symbols of lost virginity, but his portraits have about them a probity that all his other work lacks.

GRIFFIER, JAN (ca. 1645–1718). Dutch landscape painter who worked in England, Germany and, possibly, Italy and is best known for his river views.

GRIMALDI, GIOVANNI FRANCESCO (Il Bolognese) (1606–1680). Italian painter in the CARRACCI tradition who enjoyed considerable success throughout Europe with his frescoes and cabinet pictures.

GRIS, JUAN (José Victoriano González) (1887–1927). Spanish-born school-of-Paris painter. An early associate of his countryman PICASSO, he was the chief architect of SYNTHETIC CUBISM and claimed that whereas CÉZANNE and the Cubists who derived from him translated reality into its abstract equivalents, he began with abstract form and from it created a new, poetic reality. His works are distinguished by their simplicity of form, severity and intellectuality. He was an articulate aesthetic theoretician and an early collagist.

GROMAIRE, MARCEL (1892–1971). A French painter influenced to some extent by MATISSE (although the influence is not apparent in his characteristic works) and by a variety of sources ranging from the Middle Ages to SEURAT, he evolved a rather stolid brand of EXPRESSIONISM characterized by gravity and solidity.

GROOMS, RED (1937–). An American painter-sculptor, printmaker, draftsman and filmmaker. His art, from his early HAPPENINGS to his recent tableaux, always has had strong theatrical associations. His seemingly ramshackle work is characterized by a deliberate crudity and bumptious good humor that tends at times to obscure his keen observation of life and previous art.

GROPIUS, WALTER (1883–1969). German-born American architect, a founder of the BAUHAUS and a pioneer in the use of curtain-wall construction. His architecture,

unlike, say, WRIGHT's, is rooted in logical, transmittable theory and not subjective feeling and is essentially technological rather than sculptural. His major concerns as an architect and teacher were the social obligations of architecture and the logical use of a rapidly developing industrial technology and the contemporary materials it produced. His buildings include the Harvard Graduate Center, Cambridge, Massachusetts, the Bauhaus Building, Dessau, and the University of Baghdad.

GROPPER, WILLIAM (1897–). American painter, lithographer and political cartoonist best known for his expressionistic illustrations for left-wing periodicals.

GROS, BARON ANTOINE-JEAN (1771–1835). A French protoromantic painter, student of J.-L. DAVID and protégé of Napoleon, he was influenced by the Venetians, RUBENS and VAN DYCK and in turn exerted considerable influence on DELACROIX and GÉRICAULT. His battle paintings, the results of his appointment as official artist of the Napoleonic campaigns, are notable for their rich color, compositional organization and vivid reportage, and his best-known work, *The Pest-house at Jaffa*, commemorates Bonaparte's Egyptian campaign of 1799. The last years of his life were marred by an aesthetic irresolution that culminated in suicide.

GROSS, CHAIM (1904–). Austro-Hungarian-born American sculptor known for the gracefully balanced disposition of his simplified figures.

GROSVENOR, ROBERT (1937–). American sculptor and a leading figures in the minimalist style that emerged in the mid-1960s. His best-known works project downward from the ceiling, then cantilever dramatically parallel to, and a scant few inches above, the floor.

GROSZ, GEORGE (1893–1959). German-born American expressionist painter, printmaker and draftsman. A leading member of the DADA movement at the end of World War I, he soon turned to the ruthlessly biting satire that was to characterize his art, except for an occasional lapse into landscape and more conventional figure painting, for the rest of his life. Despite his sardonic wit, he was essentially an outraged observer of warped human values and a chillingly trenchant commentator with an almost Medieval view of man's susceptibility to the Deadly Sins.

GRUNER, LUDWIG (1801–1882). German engraver and painter who traveled extensively throughout Europe and in England, where he introduced various Continental innovations and taught EASTLAKE.

GRUNEWALD, MATHIAS (ca. 1770/75–1528). The greatest German painter of the 16th century after DÜRER. His real name was Neithardt, but he was recorded as Gruewald by SANDRART. Almost nothing is known of his formative years and artistic training, although he seems to have been influenced by the HOUSEBOOK MASTER, HOLBEIN THE ELDER and perhaps SCHONGAUER. Unlike his contemporary Dürer, he was little influenced by the Renaissance in Italy, although he certainly was aware of its existence and made use of its ornamental devices. For the most part, he was content to draw upon northern GOTHIC traditions and his own rather saturnine vision to produce a unique body of mannered work distinguished by a powerful, somewhat morbid, often exalted expressivity that, in such pictures as his *Crucifixion* (Washington, D.C.: National Gallery), prefigures characteristics that later were to be identified with EL GRECO.

GUARDI, FRANCESCO (1712–1793). Italian view painter and the most eminent member of a family of painters that flourished in Venice during the 17th and 18th centuries. Influenced by MAGNASCO and MARCO RICCI and by his great predecessor CANALETTO (who may also have been his teacher), his work differs from Canaletto's in its even greater dependence on atmospherics and the effects of light—emphases that found technical expression in looser, more broken brushwork and less dependence on Canaletto's relative linearity and that became progressively more pronounced in his later years, when his work foreshadowed that of TURNER and the Impressionists.

GUARDI, GIANTONIO (1699–1760). Italian painter, brother of FRANCESCO GUARDI and head of the Guardi family workshop in Venice.

George Grosz, *Daum se marie avec son pédant automate Georges en mai 1920, John Heartfield en est très heureux*, Nierendorf Gallery, Berlin-Heiligensee.

Mathias Grünewald, *The Crucifixion*, Municipal Museum, Colmar, France.

GUARIENTO (1338–before 1370). Italian painter influenced by the BYZANTINE style and that of his possible teacher, GIOTTO.

GUARINI, GUARINO (1624–1683). The outstanding Italian architect of the late 17th century, he was influenced by BORROMINI and esteemed for the complex geometry of his interiors and for his theoretical writings on architecture. A Theatine monk, he appears to have sought to invest his work—and his airy domes in particular—with an aura of infinitude.

GUERCINO (Giovanni Francesco Barbieri) (1591–1666). An Italian painter influenced first by LUDOVICO CARRACCI and subsequently by the Carravaggesque style and DOMENICHINO, he eventually developed a somewhat stultified classical manner. His drawings are esteemed more highly than his paintings by many connoisseurs.

Francesco Guardi, *"Bucentaure" Departure for the Ascension Day Ceremony*, Louvre, Paris.

GUERIN, PIERRE-NARCISSE (1774–1833). French neoclassical painter who sought to emulate J.-L. DAVID but succeeded in producing a body of less rigorous, more anecdotal work closer to that of GROS.

GUERRERO, XAVIER (1896–). Mexican mural painter and associate of RIVERA and SIQUEIROS, with both of whom he collaborated on various projects.

GUERRERO GALVAN, JESUS (1910–). Mexican realist painter best known for his portraits of Indians.

GUGLIELMO, FRA (ca. 1238–1312). Italian sculptor in the workshop of PISANO, by whom he was most strongly influenced.

GUGLIELMO DA MODENA (fl. early 12th century). Italian sculptor, possibly of Germanic stock, noted for his narrative reliefs at Modena Cathedral.

GUIDO DA SIENA (fl. 13th century). Sienese painter and purportedly the founder of the SIENESE SCHOOL, although the claim is highly debatable. Almost nothing is known of him, and his little surviving work suggests a tentative humanizing of the BYZANTINE style.

GUILLAUMIN, JEAN BAPTISTE ARMAND (1841–1927). French Impressionist painter influenced by his close friend PISSARRO but largely self-taught.

GUIMARD, HECTOR (1867–1942). The outstanding French architect of the ART NOUVEAU style, he is known best for his cast-iron entrances to the Paris Métro stations.

GULBRANSSON, OLAF (1873–1958). Norwegian caricaturist and painter best known for his satirical drawings in the manner popularized in Munich around the turn of the 20th century.

GULLY, JOHN (1819–1888). Largely self-taught English-born painter who worked in New Zealand in a style derived from TURNER.

GUNTHER, IGNAZ (1725–1775). The leading Bavarian sculptor of the ROCOCO, he is notable chiefly for his vigorous polychromed wood depictions of New Testament episodes.

GUSTON, PHILIP (1912–). A Canadian-born American painter, he is associated with ABSTRACT EXPRESSIONISM despite his use of figural imagery.

GUTTOSO, RENATO (1912–). Italian social realist painter and satirist best known for his biting attacks on totalitarianism in his homeland and Germany.

GUYS, CONSTANTIN (1805–1892). French self-taught draftsman and illustrator whose sprightly drawings of Paris society during the Second Empire earned him Baudelaire's praise as "the painter of modern life."

GWATHMEY, ROBERT (1903–). American painter and printmaker known for his scenes of Southern black life depicted in flat, decorative patterns.

H

HAARLEM, CORNELIS CORNELISZ VAN (1562–1638). A Dutch painter influenced by Italian MANNERISM and a founder, with GOLTZIUS and VAN MANDER, of the Haarlem Academy, he specialized in religious, mythological and historical subjects.

HADEN, SIR FRANCIS SEYMOUR (1818–1910). English etcher and brother-in-law of his chief influence, WHISTLER.

HAENSBERGEN, JOHANN VAN (1642–1705). Dutch painter, teacher and art dealer known for his portraits and for landscapes in the style of MAES.

HAGENAU, NIKOLAS VON (fl. ca. 1470–1526). Alsatian architectural sculptor who worked in the late GOTHIC style.

HAGIA SOPHIA (Santa Sophia). A former Christian church (and, from 1453, Moslem mosque) at Constantinople and the supreme masterpiece of BYZANTINE architecture, it is now a museum of Byzantine art and was built in the years 532–537 on the site of two earlier churches. Designed and built by Anthemium of Tralles and Isidorus of Miletus, the first true architect-engineers of the Christian era, it is constructed on a square basilican plan with a nave and two aisles and a central dome 102 feet in diameter and a corona of 40 arched windows. (Four minarets were added at the exterior corners of the structure after the Moslem conquest.) Built almost entirely of brick, its interior surfaces are sheathed in polychrome marble and brilliant mosaics, the latter replacements of destroyed earlier works. The interior is particularly distinguished for its haunting play of light and its superb definition of form and spatial interrelationships.

HAJDU, ETIENNE (1907–). A Rumanian-born French sculptor and pupil of BOURDELLE, he is known for his rhythmic, undulating abstract works in beaten metal and his masterfully composed marble sculpture.

HALL, PETER ADOLPHUS (1739–1793). Swedish portrait miniaturist who worked in France and, for a miniaturist, employed an unusually fluent brush stroke.

HALLER, HERMANN (1880–1950). A Swiss sculptor in the tradition of RODIN, he specialized in sensitively rendered studies of adolescent girls.

HALPERT, SAMUEL (1884–1930). Polish-born American painter whose Cézannesque *Still Life* was included in the 1913 ARMORY SHOW.

HALS, CLAES FRANSZ (1628–1686). A Dutch painter and son of FRANS HALS, he produced landscapes, view pictures and genre subjects executed somewhat in the manner of RUISDAEL.

HALS, DIRCK (1591–1656). Dutch genre and portrait painter, brother and pupil of FRANS HALS and uncle of Claes Harmen and JAN HALS. Although stylistically derived from the teaching and example of his older brother, his subject matter was largely restricted to the revelry of burghers, a popular Dutch genre of which he was one of the initiators.

HALS, FRANS FRANSZ (1581/85–1666). Dutch painter, older brother of DIRCK and father of Claes Harmen and JAN HALS and pupil of KAREL VAN MANDER. He was one of the most distinctive portraitists in the history of Western art. His work is characterized by its extreme liveliness, bravura handling, certain grasp of carriage and gesture and masterful tonal contrasts. Although he produced a number of genre pictures early in his career and an occasional religious subject, he was essentially a portraitist, and while he has been criticized for an alleged

Frans Hals, *The Gypsy*, Louvre, Paris.

Frans Hals, detail from *Portrait of a Young Woman*, Thyssen-Bornemisza Collection, Lugano.

lack of psychological penetration, the charge is arguable, given the nature of his sitters, and in any case seems academic in the atmosphere of compelling immediacy that invests even his least important canvases. Influenced by such Dutch followers of CARAVAGGIO as TERBRUGGHEN and HONTHORST and, later in his career, by REMBRANDT, he was particularly notable for his group portraits. These include such vast canvases as *The Officers of the Militia*

Company of St. Hadrian and *The Officers of the Militia Company of St. George* (both in the Frans Hals Museum, Haarlem), canvases not altogether removed from genre painting in general and, in particular, from the "merry company" idiom popularized by his brother Dirck and such later and more somber works as *The Governors of the Old Men's Almshouse* and *The Lady Governors of the Old Men's Almshouse* (both in the Frans Hals Museum), two paint-

ings in which he brilliantly refutes charges of psychological superficiality.

Hals' influence on modern painting has been enormous. MANET—and, by extension, IMPRESSIONISM in general—was deeply indebted to him, as were SARGENT, BOLDINI. THE EIGHT and, less consciously, ABSTRACT EXPRESSIONISM and the sculpture of RODIN and MEDARDO ROSSO.

HALS, JAN FRANSZ. (fl. 1640–1670). Dutch painter and son of FRANS HALS, in whose manner he painted.

HAMILTON, GAVIN (1723–1798). English painter who worked and died in Italy, where he foreshadowed the NEOCLASSICISM of DAVID.

HAMMERSHØI, VILHELM (1864–1916). Danish painter, principally of interiors rendered poetically in muted tones.

HAMMURABI, STELE OF (Paris: Louvre). Black basalt monolith from Mesopotamia inscribed with the code of laws of the Babylonian King Hammurabi (1792–1750 B.C.). Seven feet tall and phallic in form, it also bears a relief depiction of Hammurabi and the sun god Shamash.

HAMPTON COURT PALACE. An English country residence in Greater London. Begun in 1514 by Thomas Cardinal Wolsey and later used by royalty until the time of George II, it was constructed by various architects over the years, notably WREN, whose colonnade leading to the King's Staircase is one of the palace's more renowned features.

HAN KAN (fl. 8th century). Celebrated Chinese painter of horses and muralist of whose fully authenticated works none survive, although one work in a London collection and another in the Freer Gallery, Washington, D. C., may be from his hand.

HANSEN, CHRISTIAN FREDERIK (1756–1845). Danish architect generally considered the pioneer of the classical style in northern Europe.

HANS VON TUBINGEN (fl. middle third of 15th century). Austrian painter who worked in the INTERNATIONAL GOTHIC style.

HARDING, CHESTER (1792–1866). An American portrait painter, largely self-taught, and rival of GILBERT STUART, he was immensely popular in his time. His best works are distinguished by their great clarity and acuity of observation.

HARDING, JAMES DUFFIELD (1797–1863). An English eclectic watercolor painter and lithographer. His chief influence was BONINGTON.

HARE, DAVID (1917–). American sculptor known for his welded metal constructions and surrealist imagery.

HARNETT, WILLIAM MICHAEL (1848–1892). Irish-born American *trompe l'oeil* still-life painter. Although he is celebrated chiefly as an illusionist, his mature works are

distinguished by a compositional mastery, respect for the picture plane and probing, witty philosophical curiosity that go far beyond the simple trumpery of most "magic realists." He used no collage elements but, in his use of two-dimensional print subjects, painted to look as though they were pasted or pinned onto relatively flat surfaces, may be said to have anticipated some aspects of the collage medium, especially as it was later exploited by SCHWITTERS.

HARPIGNIES, HENRI JOSEPH (1819–1916). French landscape painter and engraver and friend of COROT, by whom he was markedly influenced.

Stele of Hammurabi, Louvre, Paris.

Marsden Hartley, *Still Life No. 3,* Art Institute of Chicago.

HARRISON, PETER (1716–1775). An English-born architect, he was the first exponent of the PALLADIAN style in the American colonies.

HARRISON AND ABRAMOVITZ. American architectural firm of Wallace Kirkman Harrison (1895–) and Max Abramovitz (1908–), specializing in curtain-wall construction.

HART, GEORGE OVERBURY ("Pop") (1868–1933). An American genre painter, watercolorist and printmaker, he was mostly self-taught and is remembered chiefly as an eccentric.

HARTIGAN, GRACE (1922–). An American figurative expressionist painter. Her work derives in large part from ABSTRACT EXPRESSIONISM, and her style tends to change to meet the demands of specific canvases.

HARTLEY, MARSDEN (1877–1943). American painter influenced by German EXPRESSIONISM, RYDER and SEGANTINI. After exhibiting with the BLUE RIDER and working in the south of France and in Mexico, he returned to his native New England, where he painted the landscape of Maine in strong, simplified forms and glowing, weighty colors.

HARTUNG, HANS (1904–). German-born French

Harrison and Abramovitz, headquarters of the United Nations, New York.

painter and, under the influence of KANDINSKY, one of the first completely non-representational artists. His characteristic works consist of swirling masses and fine meshes of energetic brushwork, usually painted on a contrasting, amorphous ground.

HARTUNG, KARL (1908–). German abstract sculptor whose work occasionally betrays figural references.

HARUNOBU (Suzuki Harunobu) (1725–1770). Japanese UKIYO-E master renowned for the complexity and subtlety of his color printing, the suppleness of his line and his ability to deal with nocturnal subjects and convey the nuances of romantic love. Taught by Shigenaga and influenced by TOYONOBU, he pioneered the use and development of the "brocade" printing technique, which requires many more woodblocks than had been used before and achieves a coloristic richness and subtlety previously unknown in Ukiyo-e. He was much imitated in his time (and forged later on) and was particularly renowned for his portrayals of fragile, high-born maidens in hostile natural environments.

HASSAM, (Frederick) CHILDE (1859–1935). American impressionist painter, illustrator and printmaker who studied in Paris, where he was deeply influenced by MONET. Characteristically, his paintings depict the play of light on such complex subjects as tree-lined streets or flag-bedecked avenues in full sunlight after rain.

Hans Hartung, *Painting.*

Suzuki Harunobu, *The Gathering of Flowers,* National Museum, Tokyo.

HAUSSMANN, GEORGES EUGÈNE (1809–1891). Internationally influential French city planner who, under Napoleon, was responsible for major alterations in the aspect of Paris, whose present plan, consisting of a network of broad, straight boulevards punctuated by circular plazas, is largely of his design.

HAVELL, WILLIAM (1782–1857). English painter and watercolorist known chiefly for his river views.

HAVILAND, JOHN (1792–1852). An American architect best known for prison buildings in general and for their wheellike radial design in particular.

HAWKSMOOR(E), NICHOLAS (1661–1736). English architect associated with WREN throughout Wren's later years. Also a collaborator with VANBRUGH on Howard and Blenheim castles. His most notable independent works were the design of six London churches distinguished by a somber monumentality derived from classical antiquity and by their masterful organization of space.

HAYDON, BENJAMIN ROBERT (1786–1846). English history painter who attempted to work in the grand manner extolled by REYNOLDS but is chiefly remembered as a friend of Wordsworth and Keats, as a prime mover in the acquisition of the ELGIN MARBLES and for his *Autobiography* and *Memoirs*.

HAYMAN, FRANCIS (1708–1776). English portrait and scene painter, illustrator and engraver. An associate of GRAVELOT, he is important chiefly for his influence on the minor genre known as the "conversation piece," particularly as it was to be developed by GAINSBOROUGH.

HAYTER, STANLEY WILLIAM (1901–). English printmaker and painter. As the founder of Atelier 17, he became one of the most influential forces in the technology of modern printmaking and a pioneer in the development of mixed-media techniques. In a style derived from SURREALISM and EXPRESSIONISM, he characteristically produces bold, energetic, curvilinear images in large prints of great dynamism and textural variety. His paintings, although less well known, are distinguished by the same qualities.

HEADE, MARTIN JOHNSON (1819–1904). American luminist painter best known for atmospheric landscapes in which ominous, stormy moods were combined with great clarity of detail to produce such hauntingly poetic images as *Storm Approaching Narraganset Bay* (New York: Ernest Rosenfeld Collection).

HEAVEN, TEMPLE OF. Circular Ming dynasty temple in Peking, China, distinguished by its three blue-tiled roofs, marble balustraded base, circular interior lantern and the richness of its exterior and interior ornamentation. It has been much damaged and extensively restored over the centuries.

HECKEL, ERICH (1883–1970). More or less self-taught German expressionist painter denounced as "degenerate" during the Nazi era. His style is characterized by its hard blue tonality, jagged triangular forms and seemingly unstable structure.

HEDA, GERRIT WILLEMSZ (fl. 2nd half of 17th century). Dutch still-life painter and son and pupil of WILLEM CLAESZ HEDA, whose style he followed closely.

HEDA, WILLEM CLAESZ. (1594–ca. 1681). A Dutch still-life painter and father of GERRIT WILLEMSZ. HEDA, he specialized in the so-called "breakfast picture," producing elaborate compositions of tableware, fruit, leftovers and the like.

HEEM, JAN DAVIDSZ. DE (1606–ca. 1684). Dutch still-life painter taught by his father David (1570–1632), Balthasar van der Ast and David Baillie and influenced by REMBRANDT, WILLEM HEDA and DANIEL SEGHERS. After fleeing the French invasion of 1672, he spent the last years of his life in Antwerp, where his style, which had been

Bartholomeus Van Der Helst, detail from *The Banquet of the Civic Guard*, Rijksmuseum, Amsterdam.

somewhat stolid, took on the more florid characteristics of the Flemish BAROQUE. Many of his late works were richly elaborated, sleekly rendered memento mori in which flowers and fruits served as metaphors for the transience of the flesh. He was also a portrait painter of some distinction, an influential teacher and the father of two sons, Cornelis and Jan, who emulated his manner.

HEEMSKERCK, EGBERT VAN (ca. 1635–1704). Dutch genre and history painter who worked and died in England and is best known for scenes of peasant life.

HEEMSKERCK, MAERTEN VAN (1498–1574). Dutch painter and engraver who studied with SCOREL and traveled in Italy, where he developed a facility in the Italianate manner and a solid understanding of the antique. His Italian sketchbooks are of great documentary importance to archaeologists and historians.

HEILIGER, BERNARD (1915–). German abstract sculptor influenced by MAILLOL and banned as degenerate during the Nazi regime.

HEINE, THOMAS THEODOR (1867–1948). German painter, illustrator, caricaturist and writer associated with the avant-garde in the 1930s and known for his emphatic contour drawings.

Martin Johnson Heade, *Hummingbird and Passionflowers,*
Metropolitan Museum of Art, New York, gift of Albert Weather-
by, 1946.

HELD, AL (1928–). American painter who has pro-
gressed from ABSTRACT EXPRESSIONISM to a geometrical
brand of illusionism in which simply defined volumes are
dynamically juxtaposed.

HELIKER, JOHN (1909–). American painter of
abstractions based on landscape forms and natural
phenomena.

HELION, JEAN (1904–). Self-taught French abstract
and figurative painter influenced by CUBISM, MONDRIAN
and, for a time, SURREALISM.

HELMBREKER, THEODOR (1633–1696). Dutch genre
painter who worked and died in Italy, where he was
much in demand for his spirited scenes of peasant and
gypsy life.

HELST, BARTHOLOMEUS VAN DER (1613–1670).
Dutch portrait painter influenced by FRANS HALS and by
REMBRANDT, whom he superseded as the most popular
portraitist in Amsterdam.

HELT, NICOLAES VAN (1614–1669). A Dutch painter of
portraits and history pictures who worked for a time in
France as court painter to Louis XII. He sometimes added
the nickname "Stocade" to his signature.

Al Held, *South Southwest,* Whitney Museum of American Art,
New York.

Jan Sanders Van Hemessen, *The Surgeon*, Prado, Madrid.

HEMESSEN, JAN SANDERS VAN (fl. ca. 1520–1555 or later). Flemish genre, religious and portrait painter known for the Italianate monumentality of his figures and as one of the earliest exponents of a genre subject—as exemplified by the carousers in his *Loose Company* (Karlsruhe: State Art Gallery)—that was to become extremely popular in later Netherlandish painting.

HENNEQUIN, JAN (Jean Bandol) (fl. ca. 1370–1382). Franco-Flemish miniaturist and tapestry designer.

HENNER, JEAN-JACQUES (1829–1905). Alsatian painter, chiefly of nudes and female portraits in settings inspired by the Venetian masters.

HENRI, ROBERT (1865–1929). American painter and pupil of ANSHUTZ, BOUGUEREAU and FLEURY. A leader of THE EIGHT, he was much influenced by HALS, VELAZQUEZ and MANET, among others, and is known for his spirited, broadly stroked portraits of picturesque models. His great importance lies in his teaching, his influence on such followers as GLACKENS, LUKS, SLOAN and SHINN and his constant espousal of an art based on observation, not academic formulae.

Friedrich Herlin, *The Group of Donors*, detail of the High Altar for St. Georgskirche, Rathaus, Nördlingen.

Barbara Hepworth, *Biolite*, Arnold Collection, London.

HEPPLEWHITE, GEORGE (d. 1786). English furniture maker and designer best known for his shield-backed chairs.

HEPWORTH, DAME BARBARA (1903–). English sculptor of carved, usually pierced abstract works in stone or metal, sometimes augmented with string or wire. Influenced by ARP, BRANCUSI and HENRY MOORE, her work is notable for its contrasting forms and textures and its opposition of monumentality and lyricism. Since 1939 she has been the leader of an artists' colony at St. Ives, Cornwall.

HERCULANEUM. Site outside Naples, Italy, of a city destroyed by the eruption of Mt. Vesuvius in A.D. 79 and discovered in the 18th century. Since then various buildings and art works have been unearthed, of which several wall paintings are particularly notable.

HERING, LOY (ca. 1485–ca. 1554). German sculptor whose basically GOTHIC style was influenced by the Italian Renaissance, which he seems to have known largely through the engravings of DÜRER.

HERKOMER, SIR HUBERT VON (1849–1914). A Bavarian-born English artist, he was largely self-taught as a painter but was probably trained in sculpture by his father. Known mostly for his rather theatrical portraits, he was one of the last figures of any importance to paint in enamel.

HERLIN, FRIEDRICH (ca. 1435–ca. 1500). A Swabian painter influenced by ROGIER VAN DER WEYDEN and one of the finest German painters to work in the Netherlandish tradition. His work is particularly notable for its emotion-charged expressiveness and sensitive portraiture.

HERMOGENES (fl. 193–156 B.C.). Greek architect and architectural theorist, a leading advocate of the Ionic order and an influencial figure in the later history of European architecture.

HERRAN, SATURNINO (1887–1918). Mexican painter whose chief claim to fame is his role as a pioneer in the use of native motifs.

HERRERA, FRANCISCO, THE ELDER (ca. 1576–1656) and **FRANCISCO, THE YOUNGER** (1622–1685). Spanish father-and-son painter and painter-architect, respectively. The father was influenced by ZURBARÁN and the son by Italian painting. The latter's most important work, though, was the design of Saragossa's Church of El Pilar, of which design almost nothing remains today.

HERRERA, JUAN DE (ca. 1530–1597). Extremely influential Spanish architect whose work was based for the most part on scientific formulae, not aesthetic concept. He was for a time chief architect of EL ESCORIAL, although his functions there were more administrative than creative. His work is characterized by an austere lack of ornamentation that became the more or less official style during the reign of the ascetic Philip II. His masterpiece, the Cathedral of Valladolid, was unfinished at his death but had a considerable impact on later Spanish architecture.

HERRING, JOHN F. (1795–1865). Self-taught painter whose depictions of champion race horses were widely known, in Britain and the United States, through engraved reproductions.

HESDIN, JACQUEMART DE (fl. late 14th–early 15th centuries). A Franco-Flemish manuscript illuminator in the emply of Jean, duc de Berry, for whom he is believed to have produced some of the most magnificient of all Medieval breviaries, including the *Grandes heures du Duc de Berry* (Paris: National Library) and the *Très Belles Heures de Jehan de France* (Brussels: Royal Library).

HESSE, EVA (1936–1970). German-born American abstract sculptor, characteristically of suspended ribbon-like arrangements of plastic that loops and skeins.

HESSELIUS, GUSTAVUS (1682–1755) and **JOHN** (1728–1778). American father-and-son painters born in Sweden and the American colonies, respectively. The elder Hesselius is believed to have painted the first religious and mythological subjects produced in the colonies. His son specialized in ROCOCO portraits.

Nicholas Hilliard, *Portrait of Queen Elizabeth of England*, National Portrait Gallery, London.

HEYDEN, JAN VAN DER (1637–1712). Dutch painter and etcher known for his meticulously rendered views of Amsterdam and his etched illustrations of fire-fighting equipment of his own invention.

HICKS, EDWARD (1780–1849). American folk painter and Quaker preacher best known for his countless versions of *The Peaceable Kingdom,* a charmingly literal illustration of the prophecy in Isaiah XI: 6, into which in many instances Hicks incorporated a depiction of William Penn signing a peace treaty with the Indians. Hicks' backgrounds derive more or less *in toto* from various reproductions of the work of European artists. His figures —especially his animals—are his own, however, and, although crude, are lifelike and composed with decorative assurance.

HIGHMORE, JOSEPH (1692–1780). An English ROCOCO painter of portraits and illustrations, notably of the novel *Pamela* by his friend Samuel Richardson, he was influenced by RUBENS and VAN DYCK and was a rival of HOGARTH.

HILDEBRAND, ADOLF E. R. VON (1847–1921). The foremost classical German sculptor of the late 19th century and a leading aesthetic theorist, he is better known today for his writings than for his art.

HILDEBRANDT, JOHANN LUCAS VON (1668–1745). An Austrian architect born in Italy and influenced by GUARINI, he in turn influenced NEUMANN.

Hiroshige, print of Ishiyakushi, a scene from *The 53 Stations on the Tōkaidō Highway,* Musée Guimet, Paris.

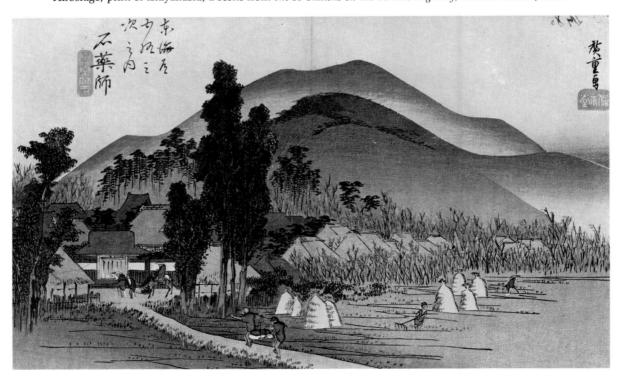

Meindert Hobbema, *The Avenue at Middelharnis,* National Gallery, London.

HILLIARD, NICHOLAS (ca. 1547–1619). English portrait miniaturist and goldsmith influenced by HOLBEIN. He is best known for his portraits of Elizabeth I and for his descriptions of the conversations that took place while she sat for him. His paintings were conceived as jewels rather than "pictures" and consequently tend to lack dimensionality, "for the lyne without shadowe showeth all to a good jugment..."

HINMAN, CHARLES (1932–). American painter best known as a pioneer of the SHAPED CANVAS in the 1960s.

HIPPODAMUS (fl. mid-5th century B.C.). Greek architect who originated the gridiron layout for cities.

HIROSHIGE (Ando Hiroshige) (1797–1858). Japanese woodblock printmaker influenced by HOKUSAI, with whom he is generally considered one of the very greatest UKIYO-E masters. Although he started his career as a portrayer of women, he later turned to flower and bird subjects and to the landscapes through which he won international renown and which are distinguished by their masterful evocation of mood. His prints enjoyed an enormous vogue in France in the late 19th century and influenced several impressionists and post-impressionists, notably VAN GOGH.

HIRSCH, JOSEPH (1910–). An American figurative painter and printmaker and student of LUKS, he is best known for his occasionally satirical genre subjects.

HIRSCHVOGEL, AUGUSTIN (1503–1553). German etcher, enamelist and glass painter best known for landscape prints influenced by HUBER.

HITCHINS, IVON (1893–). English painter of semi-abstract floral motifs and landscapes in which pure color is used as a spatial and rhythmic device.

HITTORFF, JACQUES IGNACE (1793–1867). French architect known for his use of exterior polychrome.

HOBBEMA, MEINDERT (1638–1709). Dutch landscape painter and pupil of RUISDAEL, with shom he worked closely in his career. He is often referred to as the last of the great 17th-century Dutch landscapists, and his masterpiece, *The Avenue at Middelharnis* (London: National Gallery), is generally considered one of the outstanding achievements in all Dutch art. Legend has it that he ceased to paint upon gaining a minor bureaucratic post in 1668, but there is good reason to believe he was still producing pictures as late as 1689. His river and village scenes are broadly painted in a straightforward fashion and are characterized by their golden tonality. His influence on English landscape painting was considerable and can be traced in the works of CONSTABLE.

HOCKNEY, DAVID (1937–). English painter associated with the early manifestation in England of the POP ART movement and known more recently for his fine draftsmanship.

HODLER, FERDINAND (1853–1918). Swiss proto-expressionist painter whose flat, linear mature style derived from PUVIS DE CHAVANNES, HOLBEIN, MILLET, the Symbolist movement and ART NOUVEAU. His works are characterized by their flatness, emphatic patterning, pale color and reiterated shapes.

HOETGER, BERNARD (1874–1949). German eclectic sculptor and architect best known for the Paula Modersohn-Becker House, Bremen.

HOFER, CARL (1878–1955). A German painter and student of THOMA, he was influenced by MARÉES and CÉZANNE. After a brief abstract period, he returned to a brand of figuration much like that of DÉRAIN and vaguely reminiscent of PICASSO's Blue Period. His art was officially branded as "degenerate" during the Nazi regime.

HOFFMAN, MALVINA (1887–1966). American figurative sculptor and student of GUTZON BORGLUM and RODIN. Her work is somewhat sentimental, generalized in form and characterized by its technical proficiency and meticulously burnished surfaces.

HOFMANN, HANS (1880–1966). German-born American painter and teacher and a leading figure in the rise of ABSTRACT EXPRESSIONISM. Influenced by FAUVISM and CUBISM, he painted more or less figuratively until the late 1930s, when he turned to full abstraction. In the 1950s he was in the vanguard of the abstract-expressionist movement, where he exerted considerable influence on JACKSON POLLACK, but by the 1960s he had begun to introduce hard-edged rectangles into canvases which consistently were characterized by great energy, vibrant color and spatial equilibrium.

William Hogarth, *Falstaff Examines the Recruits,* Lord of Iveagh Collection, London.

Hokusai, *View of Mt. Fuji*, Museum Guimet, Paris.

HOGARTH, WILLIAM (1697–1764). English painter, print designer and aesthetic theoretician. One of history's most engrossing narrative painters and a masterful satirist, he was indifferently schooled, principally under THORNHILL, whose daughter he married. After false starts as an illustrative engraver and a painter of portraits and conversation pieces, he turned to the production of narrative series "similar to representations on the stage." The first of these, *A Harlot's Progress* (the pictorial equivalent of Defoe's *Moll Flanders*), was reproduced in a suite of engravings in 1732, was an immediate popular success and was followed by such subjects as *The Rake's Progress, Marriage à la Mode* and *The Election*. Although his attempts to paint historical pictures in the grand manner never quite came off, his anecdotal and narrative works are among the finest manifestations of French-inspired ROCOCO painting in England (Hogarth's lofty disdain for French art notwithstanding), and such portraits of lower-class subjects as *Hogarth's Servants* and *The Shrimp Girl* were executed with an immediacy and candor unprecedented in English painting. His *Analysis of Beauty* is an important work of art theory.

HOKUSAI (Katsushika Hokusai) (1760–1849). Japanese printmaker and draftsman. One of the greatest of the UKIYO-E masters, he was trained by SHUNSHO but did not develop a distinctive style until he was nearing 60. He was a tireless experimenter who even went so far as to study Western perspective. His mature style is notable for its rough vigor and virtuoso brushwork (a virtuosity that is only hinted at in the woodblocks derived from his sketches). In such landscape prints as his famous *Great Wave*, with its figures dwarfed by the forces of nature, he made full use of Chinese concepts, and in his bird and flower prints he was the first ukiyo-e artist to employ motifs that until then had been the exclusive province of the painters. His multivolume *Manga* (sketchbooks) are invaluable both as a record of his insatiable interest in all forms of life and as a historical document of encyclopedic comprehensiveness.

HOLABIRD AND ROCHE. American architectural firm of William Holabird (1854–1923) and Martin Roche (1855–1927), instrumental in the development of steel-frame construction and, consequently, the skyscraper. Their Tacoma Building, Chicago, was the first fully to mount an exterior sheathing on a skeleton frame—a device derived from tentative efforts in the same direction by JENNEY, in whose office both men had worked.

HOLBEIN, HANS, THE ELDER (ca. 1465–1524). German painter and father of HANS HOLBEIN THE YOUNGER. He was a transitional figure. His early works derive from Netherlandish sources, but he later adopted the Renaissance style.

HOLBEIN, HANS, THE YOUNGER (ca. 1498–1543). German painter and woodcut designer and son and pupil of HANS HOLBEIN THE ELDER. After some training in his

· ANNO · ETATIS · · SVÆ · XLIX ·

Hans Holbein the Younger, *Henry VIII,* Barberini Palace, Rome.

father's workshop he was apprenticed to the minor Swiss artist Hans Herbster (1468–1550), through whom he seems to have absorbed some influences from BURGK-MAIR and Italian painting. While in Basel he met Erasmus, whose protégé he became and through whom he eventually was to become court painter to Henry VIII.

Although he produced a number of religious pictures during his early years in Basel, these are essentially GOTHIC works stylistically set apart from the Renaissance-derived portraits that constitute his mature oeuvre and are characterized by the subtle, burnished modulations of the flesh tones, their linear clarity and posterlike immediacy, richness of decorative detail and a scrupulous objectivity unique in the otherwise highly

expressive German art of his time. His portraits of *Thomas More* (New York: Frick Collection), *Erasmus* (Paris: Louvre), *Thomas Cromwell* (New York: Frick Collection), and *Henry VIII* (York: Castle Howard), among others, remain the definitive likenesses. His greatest and best-known graphic work is the woodcut series *Totentanz (Dance of Death)*, a series of small Gothic narrative plates that enjoyed enormous popularity upon their delayed publication in 1538.

HOLGUIN, MELCHOR PEREZ (ca. 1660–ca. 1725). Spanish colonial Bolivian painter and founder of the Potosí School. His meticulously detailed, highly anecdotal works incorporate native traditions with MANNERISM and the ROCOCO.

HOLL, FRANK MONTAGUE (1845–1888). English genre and portrait painter and illustrator. Although his works were popular during the Victorian era, his flattering portraits of men of affairs and sentimental scenes of life among the poor soon fell out of favor.

HOLLAR, WENCESLAUS (Wenzel) (1607–1677). Bohemian-born engraver of topographical views who settled and died in London, a city whose appearance before the Great Fire is known largely through his prints.

HOMER, WINSLOW (1836–1910). American painter, watercolorist, graphic artist and illustrator. After beginning his career as an illustrator for *Harper's Weekly* he turned to serious painting around 1862 with a number of Civil War scenes distinguished by a simplicity of form and keen sense of salient detail derived from his commercial background. To these he added an emphasis on light that paralleled (but ultimately did not go as far as) the researches undertaken independently by the French Impressionists around the same time and that recalled the earlier work of COURBET. After producing a considerable body of work dealing with rural and middle-class small-town life, he became increasingly reclusive and increasingly engrossed with the theme of solitary men wresting a living from the forests and seas. His late oils are distinctive for their firm structure, solid form, vigorous paint application and austere dignity. His watercolors, notable for their technical assurance, influenced a great deal of later American work.

HONDECOETER FAMILY. Three generations of Dutch painters active in the late 16th and 17th centuries, of whom the best known are Gisbert (1604–1653), his father Gillis (d. 1638) and *his* grandson Melchior (1636–1695), all of whom were known for their animal pictures.

HONE, NATHANIEL (1718–1784). Irish miniature painter who supposedly organized the first one-man exhibition held in England when one of his works, allegedly plagiaristic, was turned down by the Royal Academy.

Winslow Homer, *Prisoners from the Front*, Metropolitan Museum of Art, New York.

Gerrit Van Honthorst, *Adoration of the Shepherds*, Museum of Fine Arts, Nantes.

HONNECOURT, VILLARD D' (fl. 2nd quarter of 13th century). French architect known for a manuscript notebook-*cum*-treatise that provides valuable insights into the theory and technique of GOTHIC cathedral building.

HONTHORST, GERRIT VAN (1590–1656). A Dutch painter and pupil of BLOEMAERT, he traveled in Italy, where he was influenced by the work of CARAVAGGIO and, possibly, the CARRACCI. Known chiefly for his candlelit nocturnes and musical genre subjects, he also produced portraits and religious, mythological and historical subjects. Many of his works bear a superficial resemblance to those of FRANS HALS, but their apparent spontaneity seems rather labored on close inspection.

HOOCH, PIETER DE. See **PIETER DE HOOCH.**

HOOD AND HOWELLS. American architectural firm of Raymond Hood (1881–1934) and John M. Howells

(1868–1959), best known for such skyscrapers as the Chicago Tribune Tower and the Daily News Building, New York. Hood was the dominant figure and, independently of Howells, designed the McGraw-Hill Building and part of Rockefeller Center, both in New York.

HOOGH (Hooch), PIETER DE (1629–1684). A Dutch genre painter and pupil of BERCHEM, he was influenced by the painters of the Delft school, particularly CAREL FABRITIUS and possibly VERMEER. Best known for his placid, warm-toned interiors and garden and courtyard scenes, he was at his best in mid-career, before he abandoned his characteristically simple settings in favor of more grandiose interiors. Although his paint handling is somewhat gritty and his pictures lack the assurance and serenity of Vermeer, his rendering of light rivals that of his younger, greater contemporary.

HOOGSTRATEN, SAMUEL DIRCKSZ. VAN (1627–1678). Dutch painter, poet and playwright and pupil of REMBRANDT, whose style he emulated before falling under the influence of DE HOOGH and METSU. He also painted *trompe l'oeil* pictures and wrote aesthetic treatises and art criticism.

HOPKINS, BUDD (1931–). American painter and collagist whose characteristic works, often large in scale, employ various 20th-century abstract styles in an attempt to capture the kaleidoscopic quality of modern life.

HOPPER, EDWARD (1882–1967). American figurative painter and student of HENRI and KENNETH HAYES MILLER. Shunning the various movements of his era, he developed a singularly poetic, highly affecting style derived loosely from Henri (q.v.) and *his* influences but free of the bumptiousness of typical ASHCAN SCHOOL painting.

Edward Hopper, *Room in Brooklyn,* Museum of Fine Arts, Boston.

In such interiors as *Room in Brooklyn* (Boston: Museum of Fine Arts) he achieves something of the stillness and serenity of VERMEER, and all his work is informed by a sense of isolation—social, spatial and temporal—and melancholy.

HOPPNER, JOHN (ca. 1758–1810). An English portrait painter of German parentage, he was one of REYNOLDS' chief followers and SIR THOMAS LAWRENCE's principal rival, but, while much sought after, was the equal of neither man. He was rumored to be the illegitimate son of George III, which may or may not account for the patronage accorded him by the Prince of Wales.

Houdon, *Voltaire,* Metropolitan Museum of Art, New York, anonymous gift, 1952.

HORTA, VICTOR (1861–1947). Belgian architect whose Tassel House, Brussels, is a landmark work in the ART NOUVEAU style.

HOSKINS, JOHN (ca. 1595–1665). English portrait miniaturist whose early works were influenced by HILLIARD but who later devoted himself to miniature copies after VAN DYCK.

HOSMER, HARRIET GOODHUE (1830–1908). American sculptor who worked with GIBSON in Rome, where she produced monumental groups in white marble.

HOUBRAKEN, JACOB (1698–1780). The leading Dutch portrait engraver of the 18th century, he was renowned for his rendering of flesh and hair.

HOUCKGEEST, GERRIT (ca. 1600–1661). Dutch painter of the Delft school known for his interior views of churches.

HOUDON, JEAN ANTOINE (1741–1828). A French sculptor and child prodigy, he traveled to Italy as a Prix de Rome winner after studying with PIGALLE and LEMOYNE and, while there, was acclaimed for a figure of St. Bruno made for Sta Maria degli Angeli. His anatomical study of a flayed man is familiar to art students the world over, but he is best known to the general public for his portrait sculpture, which often—as in the case of his *Voltaire* (Paris: Comédie Française) and *George Washington* (Richmond, Virginia)—surmounted conventional, classically draped figures with heads remarkable for their lifelikeness and penetrating psychological insight.

HOWE AND LESCAZE. American architectural partnership of George B. Howe (1886–1955) and William Lescaze (1896–1969), pioneers in building skyscrapers in the international style.

HSIA KUEI (fl. early 13th century). Chinese landscape painter of whose life and training little is known but who was influenced by his contemporary MA YUAN and by LI T'ANG. He was particularly esteemed for the richness of his ink tones, which he invested with a distinctive "glow."

HSU PEI-HUNG (1896–1953). Chinese painter and teacher trained in Paris and best known for his ink-wash sketches of horses in action.

HSU WEI (1521–1593). Chinese painter and eccentric known for an erratic manner that supposedly reflected his life style.

HUANG KUNG-WANG (1269–1354). A leading Chinese landscape painter of the Yüan dynasty. Little of his work survives, but he appears to have had great influence on later Chinese painting, both directly through his landscapes and through his voluminous writings on art.

Hsia Kuei, *Boat,* Iwasaki Collection.

Emperor Hui Tsung, *Ladies Preparing Newly Woven Silk*, detail of a silk handscroll, Museum of Fine Arts, Boston.

HUBER, WOLF (ca. 1490–1553). Austrian painter and woodcut designer and apprentice in the workshop of ALTDORFER. A leading member of the Danube school, he was particularly adept in the depiction of landscape.

HUGHES, ARTHUR (1832–1915). English painter and illustrator closely associated with, but not a member of, the PRE-RAPHAELITE BROTHERHOOD.

HUGUET, JAIME (1415/20–1492). Catalan painter, principally of retables, and, through his extensive workshop, an influential figure in the history of Spanish art.

HUIJSUM (Huysum), JUSTUS VAN (1659–1716 or later). A Dutch flower painter and pupil of BERCHEM.

HUI TSUNG (1082–1135). Chinese emperor of the Northern Sung dynasty, calligrapher, art patron and one of the great masters of flower-and-bird painting. A stalwart proponent of realism, he was renowned for his meticulous rendering of textures, painstaking attention to detail and mastery of assymetrical composition. He was also a major collector of art and antiquities.

HULTBERG, JOHN (1922–). American abstract painter known for dynamic canvases strongly suggestive of industrial interiors and landscapes viewed from speeding automobiles.

HUNT, RICHARD (1935–). An American sculptor of semi-abstract constructions in welded metal. Much of his work makes use of industrial detritus.

HUNT, RICHARD MORRIS (1827–1895). An American architect trained in Paris and best known for his opulent private residences.

HUNT, WILLIAM HOLMAN (1827–1910). English painter and a founder, with ROSSETTI and MILLAIS, of the PRE-RAPHAELITE BROTHERHOOD. His output consists largely of minutely detailed religious pictures.

HUNT, WILLIAM MORRIS (1824–1879). American painter and teacher trained in Düsseldorf and, under COUTURE, in Paris and strongly influenced by MILLET. Like HOMER, he independently developed a rudimentary brand of IMPRESSIONISM but failed to develop it.

HUNTINGTON, ANNA HYATT (1876–1973). American sculptor of forceful portrayals of animals in action.

HURD, PETER (1904–). American tempera painter, lithographer and illustrator and pupil of N. C. WYETH. He is best known for Western American subjects and for a portrait rejected by President Lyndon Johnson.

HURTADO, FRANCISCO (1669–1725). Spanish BAROQUE architect whose richly ornamented church interiors were widely influential both in Spain and the Spanish colonies in the New World.

HYPPOLITE, HECTOR (1894–1948). Self-taught Haitian painter whose flat, decorative works were highly esteemed by several members of the surrealist movement.

I

IBBETSON, JULIUS CAESAR (1759–1817). English eclectic painter of genre scenes and Dutch-influenced landscapes that led WEST to call him "the BERCHEM of England."

ICTINUS (fl. 2nd half of 5th century B.C.). One of the greatest of ancient Greek architects, he collaborated on the building of the PARTHENON and probably built the temple of Apollo at Bassae. The formost proponent of the Doric order, he was also an author of architectural treatises.

IMOLA, INNOCENZO DA(Innocenzo Francucci)(1490/94–ca. 1549). An Italian painter and assistant to FRANCIA (and possibly to ALBERTINELLI), he was influenced chiefly by RAPHAEL and taught PRIMATICCIO and PROSPERO FONTANA.

IMPERIAL SUMMER PALACE. 19th-century imperial residence on the outskirts of Peking, China. Built on an artificial lakefront, it and its elaborately contrived surroundings are renowned for their extremely well-integrated, harmonious design.

INDIANA, ROBERT (Robert Clark) (1928–). American painter, sculptor and printmaker loosely identified with the POP ART movement. His style is in part a highly sophisticated derivation from 19th-century American folk art and sign painters' techniques and makes much use of stenciled letters and numerals. His laconic message-motifs (e.g., "LOVE," "EAT," "DIE") are often presented in seemingly contradictory, vaguely threatening contexts or formats.

INGLES, JORGE (fl. mid-15th century). Spanish painter of altarpieces and one of the first painters in Spain to absorb Netherlandish influences.

INGRES, JEAN-AUGUST-DOMINIQUE (1780–1867). French painter and one of the most influential artistic figures of the 19th century. A pupil of J.-L. DAVID, he won the Grand Prix de Rome for his neoclassical painting *The Envoys of Agamemnon*, a picture much admired by FLAXMAN. With his trip to Rome delayed by a French economic crisis, he turned to the portraits that were to constitute the major part of his oeuvre. From the outset his work was distinguished by a purity and expressiveness of line rarely approached in the history of painting and considered by Ingres himself to be "the probity of art" and to include "everything except the tint." Tint, indeed, and not color as most painters understood it, was applied merely as a sort of garnish to his impeccable contours, and his dogmatic insistence on its use led DELACROIX, his antithesis and arch-rival, to describe his art as "the complete expression of an incomplete intelligence."

In both his official academic capacities (he was at one time or another director of the French School in Rome and professor at the Ecole des Beaux-Arts) and unofficial role as leader of the opposition to the new ROMANTICISM, Ingres, the most lionized artist of his day, wielded enormous power. His influence was largely negative, however, for in his stubborn refusal to recognize the validity of any style but his own he had a stultifying effect on the many younger painters who sought advancement during his near-reign, while for the more independent-minded he became a symbol against which to react. Ironically, when he most closely approached the subjects exploited by Delacroix, Ingres came closest to breaking the frigid mold of academicism he imposed on himself, and his paintings of odalisques and female nudes in Oriental baths, rendered with the same chilly meticulousness as his portraits of the bourgeoisie, have been widely interpreted as the confessional outpourings of a repressed voluptuary.

Few of his pupils achieved any importance, but one artist of indubitable greatness, DEGAS, demonstrated the heights Ingres himself might have achieved had he been able to bring real vision to an extraordinary talent.

INMAN, HENRY (1801–1846). American painter and lithographer known for his highly realistic portraits and romantic narrative pictures.

INNES, GEORGE (1825–1894). A largely self-taught eclectic landscape painter, he was influenced by the HUDSON RIVER SCHOOL painters and by a variety of European sources that included RUISDAEL, HOBBEMA, POUSSIN, CONSTABLE, TURNER and CLAUDE LORRAINE. At his best, particularly in his later landscapes, his forms seem almost to dissolve in a haze of intricate brushwork, and a golden glow informs much of his work.

INNES, JAMES DICKSON (1887–1914). A Welsh landscape painter who was influenced by JOHN and GAUGUIN and seemed to be pointed in the direction of FAUVISM at his untimely death.

IPPEN SCROLL PAINTINGS (Tokyo: National Museum). Suite of 12 Japanese scrolls depicting the life and travels of the missionary Buddhist priest Ippen. Painted by the otherwise unknown artist En-i, they are almost novelistic in their episodic structure and evocation of passing time.

ISAACSZ, PIETER FRANSZ (1569–1625). A Dutch painter born in Denmark and pupil of HANS VON AACHEN, he worked in the Danish court, both in various artistic capacities and as a spy for Sweden.

ISABEY, JEAN BAPTISTE (1767–1855). A French portrait painter and miniaturist, student of J.-L. DAVID and protégé of Napoleon and Josephine, he was the father of LOUIS GABRIEL EUGÈNE ISABEY and is known for his limpid portrait minatures and as one of the first lithographers.

Jean-August-Dominique Ingres, *The Turkish Bath,* Louvre, Paris.

ISABEY, LOUIS GABRIEL EUGÈNE (1803–1886). A French painter, watercolorist and lithographer and son of JEAN BAPTISTE ISABEY, he specialized in dramatic seascapes.

ISAKSON, KARL (1878–1922). A Swedish painter who worked in Denmark. His still lifes, nudes and religious pictures are characterized by a formal structure derived from CÉZANNE and CUBISM.

ISENBRANDT (Ysenbrandt), ADRIAEN (fl. from 1510; d. 1551). Flemish painter who is believed to have trained in the workshop of GERARD DAVID and whose eclectic style is more or less a throwback to northern painting of the 15th century.

ISRAELS, JOSEF (1824–1911). Dutch painter, chiefly of fishermen and Jewish subjects, and father of Isaac Israels (1865–1934), who painted in the impressionist manner.

IVANOV, ALEXANDER ANDREYEVICH (1806–1858). A Russian painter and student of his father, Andrey Ivanov (1772–1848), he spent most of his career in Rome, where he worked for more than 20 years on his *magnum opus, Christ's First Appearance to the People* (Leningrad: Russian Museum), an enormous painting that excited public curiosity for years while in progress but was given an indifferent reception upon its completion.

IZQUIERDO, MARIA (1906–1955). Mexican pseudo-naïve painter influenced by TAMAYO and 20th-century French art.

J

JACA CATHEDRAL. A ROMANESQUE church in northeastern Spain, it was begun in the 11th century, largely completed in the 12th century and is noteworthy for its architectural purity and sculptural embellishments.

JACOBELLO DEL FIORE (fl. from late 14th century; d. 1439). A Venetian painter who turned from the BYZANTINE tradition to embrace the INTERNATIONAL GOTHIC style.

JACOBSEN, ARNE (1902–). Danish architect and designer best known for his fabric patterns and clean-lined mass-produced furniture.

JACOPO DA VERONA (fl. late 14th century). Italian painter whose frescoes are notable for their sculptural form, sure handling of space and lively naturalism.

JACQUET, ALAIN (1939–). A French painter loosely associated with the POP ART movement. His works characteristically make use of enlarged patterns derived from photomechanical printing processes.

JAEN CATHEDRAL. Renaissance cathedral in south-central Spain designed by André de Vandaelvira and notable for the imposing twin towers of its west front.

JAMES, JOHN (1672–1746). An English architect and assistant to WREN, VANBRUGH and HAWKSMOOR, he is remembered chiefly for St. George's Church, London, and for his theoretical writings.

JAMESONE (Jameson), GEORGE (1588–1644). Scottish portrait painter whose little surviving work reflects the influence of CORNELIUS JOHNSON.

JAMNITZER FAMILY. German family of goldsmiths and engravers active in the 16th and early 17th centuries. Its leading members were Wenzel Jamnitzer (1508–1585), who worked in the Renaissance style at the outset of his career but later turned to a richly ornamented form of MANNERISM, his son Hans (1538–1603) and grandson Christoph (1553–1618).

JANSSENS, ABRAHAM (ca. 1575–1631). A Flemish painter and an important conduit whereby the influence of CARAVAGGIO penetrated the north of Europe. He was most successful as a portraitist.

JARVIS, JOHN WESLEY (1780–1840). English-born American self-taught portrait painter and miniaturist known for his vigorous likenesses of notable contemporaries, particularly military figures.

JAWLENSKY, ALEXEY VON (1864–1941). Russian-born expressionist painter who spent most of his life in Germany. Influenced principally by MATISSE's fauvist works, his most characteristic paintings are of human heads outlined in heavy blacks and suffused with the rich reds and blues of stained glass.

JEAN DE CAMBRAI (fl. from ca. 1380; d. 1438). French sculptor in the employ of Jean, duc du Berry, whose funerary effigy he carved in a sedulously naturalistic but rather stiff fashion.

JEANNERET, PIERRE. See **LE CORBUSIER.**

JEFFERSON, THOMAS (1743–1826). Colonial American statesman, United States President and amateur architect. Rejecting the prevalently English architecture of Virginia as vehemently as he rejected English political rule, he turned first to PALLADIO and then to the classical architecture of Rome, applying them, respectively, to the designs for his own home, Monticello (later remodeled along classical lines), outside Charlottesville, Virginia, and to the Virginia State Capitol, Richmond. The latter, based on the Roman MAISON CARÉE at Nîmes, France, may be the first monumental building anywhere directly

Alexey Von Jawlensky, *Mediterranean Coast*, Stange Gallery, Munich.

Paul Jenkins, *Phenomena Star Dipper*, courtesy of Gimpel Weitzenhoffer, New York.

adapted from a classical temple and establishes Jefferson's claim as the first classical revivalist in the New World. His University of Virginia, Charlottesville, is one of the major American architectural achievements, and much of the layout of Washington, D.C., is based on his plans.

JEGHER, JAN CHRISTOFFEL (1596–ca. 1562). Flemish woodcut artist best known for his collaborative reproductions of paintings by RUBENS.

JELLET, MAINIE (1897–1944). English painter, taught by LHOTE and influenced by GLEIZES, whose work vacillated between CUBISM and a rather old-fashioned naturalism.

JEN JEN-FA (1254–1327). Chinese painter and engineer celebrated for his depictions of horses.

JENKINS (William), PAUL (1923–). An American abstract painter, watercolorist and printmaker. His characteristic works are composed of overlapping veillike washes of color punctuated by looping skeins or bands applied according to Zen Buddhist concepts.

JENNEY, WILLIAM LE BARON (1832–1907). American architect and a pioneer in the use of structural metal frames.

JERVAS, CHARLES (ca. 1675–1739). Irish painter and student of KNELLER, whom he succeeded as principal portrait painter to the king.

JOHN, AUGUSTUS EDWIN (1878–1961). Welsh-born English painter and brother of GWEN JOHN. Principally a portraitist, he is best known for his colorful, spirited depictions of Welsh gypsies and his more formal studies of such figures as G. B. Shaw, T. E. Lawrence and Lady

Ottoline Morell. He was also a skilled etcher and influential teacher.

JOHN, GWEN (Gwendolen Mary John) (1876–1939). English painter, pupil of WHISTLER and sister of AUGUSTUS JOHN. Her close-toned works are notable for their poetic sensitivity and economy of means.

JOHNS, JASPER (1930–). American painter, sculptor, collagist and assemblagist. With RAUSCHENBERG, he is an important transitional figure between ABSTRACT EXPRESSIONISM of the NEW YORK SCHOOL and POP ART. His work is characterized by irony, anomaly and a persistent questioning of the relationship between reality and its emblematic representations.

JOHNSON, CORNELIUS (1593–1661). English portrait painter of Flemish parentage who worked chiefly in Holland, where he was known by such Dutch phonetic var-

Augustus Edwin John, *Lawrence of Arabia*, Tate Gallery, London.

158

iants as Jonson, Janssen and the like. Until superseded by VAN DYCK, he was England's most successful portraitist.

JOHNSON, EASTMAN (1824–1906). European-trained American painter whose straightforward, Dutch-influenced genre scenes are characterized by simple dignity and are free of the anecdotal or sentimental overtones of much otherwise similar contemporaneous work.

JOHNSON, PHILIP CORTELYOU (1906–). American architect influenced by MIES VAN DER ROHE, with whom he collaborated on the Seagram Building, New York. His work is characterized by its extensive use of glass, as typified by his own all-glass residence in New Canaan, Connecticut. An influential writer, lecturer and museum official.

JONES, DAVID (1895–). An English watercolorist, engraver and author, best known for his landscapes and engraved illustrations. He was an associate of GILL in the 1920s.

JONES, INIGO (1573–1652). English architect and stage designer who became acquainted with the works of PALLADIO while in Italy and whose subsequent work in England introduced the PALLADIAN STYLE there. His best-

known works are the Queen's House, Greenwich, Banqueting Hall, London, St. Paul's Covent Garden, London, and the somewhat incongruous CORINTHIAN portico he added to St. Paul's Cathedral, London. He was famed in his lifetime as a designer of court masques and also seems to have been a "picture maker," although none of his paintings survive.

JONGKIND, JOHANN BARTHOLD (1819–1891). Dutch landscape and marine painter and etcher who worked and died in France, where he and BOUDIN paved the way for the advent of IMPRESSIONISM. Taught by the Dutch landscape painter Andreas Schelfhout (1787–1870) and by EUGÈNE ISABEY, he was influenced by the BARBIZON SCHOOL and the "little masters" of 17th-century Holland, and his informal watercolors, painted more or less directly from nature, markedly influenced the early work of the impressionists, SISLEY and PISSARRO and MONET in particular.

JOOS VAN GHENT (Justus of Ghent; Joos van Wassenhove) (fl. ca. 1430; d. after 1475). Flemish eclectic painter who worked in Italy from 1472 until at least 1475 and may have died there. His early works were

Johann Barthold Jongkind, *La Rue Notre-Dame-des-Champs,* Museum of Fine Arts, Algiers.

Jacob Jordaens, *The King of the Banquet Drinks*, Louvre, Paris.

influenced by a variety of Netherlandish predecessors but always were characterized by a spatial integration unprecedented in Flemish art. During his Italian sojourn his style became more diffuse, with Italian and Spanish influences, but maintained the clarity and simplicity of form that distinguished his entire oeuvre.

JORDAENS, HANS III (ca. 1595–1643). Flemish painter best known for religious pictures reflecting the influence of RUBENS.

JORDAENS, JACOB (1593–1678). Flemish painter and assistant to RUBENS, whom he superseded as the leading painter in Flanders. He was influenced principally by VAN DYCK and CARAVAGGIO, and his style is marked by an earthy realism reminiscent of BROUWER and STEEN. Many of his religious subjects and drinking scenes are depicted as seen from below, in "worm's eye" perspective.

JORGE INGLES (fl. mid-15th century). Spanish painter, possibly of English extraction, whose known works show French and Netherlandish influences.

JORN, ASGER (1914–1973). Danish painter associated during his career with a variety of more or less instinctive avant-garde movements of a basically expressionist nature.

JOSEPHSON, ERNST (1851–1906). Swedish romantic painter known for the intensity of his color. In his later years he became a schizophrenic and devoted himself to meticulously detailed pen drawings made up of innumerable dots.

JOSETSU (fl. early 15th century). Japanese painter-priest celebrated for the subtlety of his ink washes.

JOUVENET, JEAN-BAPTISTE (1644–1717). French BAROQUE history painter trained in the workshop of CHARLES LEBRUN and known for his anti-academic naturalism.

JUANES, JUAN DE (ca. 1523–1579). Spanish mannerist painter whose religious subjects are characterized by great fervor and executed in an idealized style derived from RAPHAEL.

JUAREZ, JOSE (ca. 1615–ca. 1690). Mexican painter and the outstanding member of a family of four generations of artists.

JUDD, DONALD (1928–). An American sculptor and a leading exponent of MINIMALISM. His works are characteristically simple, industrially fabricated rectangular boxes arranged singly or in series with varying intervals.

JUEL, JENS (1745–1802). Danish painter, chiefly of portraits, and teacher.

JULIOT FAMILY. Three generations of French 16th-century sculptors known chiefly for funerary works and altars.

JUNI, JUAN DE (ca. 1506–1577). Spanish sculptor, probably of French origin, known for dramatic figures that anticipated the BAROQUE style.

JUVARA, FILIPPO (1678–1736). Italian eclectic architect and student of CARLO FONTANA who worked and died in Madrid.

K

KAHN, LOUIS (1901–1974). Russian-born American architect and city planner known for his expressive use of materials and utilitarian forms (e.g., stairways, ventilating ducts) and for his designs for the capital at Dacca.

KAHN, WOLF (1927–). German-born American painter and pastelist, student of HANS HOFMANN. His characteristic works are highly atmospheric and, although they employ recognizable landscape elements, derive from ABSTRACT EXPRESSIONISM.

KAIGETSUDO, ANDO (fl. early 18th century). Japanese painter, chiefly of women, portrayed in boldly outlined, highly decorative patterns.

KALCKREUTH, LEOPOLD GRAF VON (1855–1928). German impressionistic painter and teacher known for marine subjects, portraits and scenes of peasant life.

KALF (Kalff), WILLEM (ca. 1620–1693). Dutch painter, chiefly of showpiece still lifes, who worked for a time in Paris. In his characteristic works, solidly painted fruits and foodstuffs are juxtaposed artfully with ornate silver and crystal vessels.

KANDINSKY, WASSILY (1866–1944). Russian painter and one of the major figures of modern art. After studying in Munich and traveling extensively throughout Europe and the Near East, he formed the New Artists Federation, the forerunner of the BLUE RIDER, in Munich. A 1910 watercolor generally is conceded to be the first consciously composed, completely non-representational picture, although its claim in this regard is arguable. Explaining his advocacy of a "spiritual" and "musical" art of pure color—a logical outgrowth of the theories of GAUGUIN—he wrote that a painting should be the "graphic representation of a mood and not . . . a representation of objects." Influenced by Eastern philosophies of human perfectability, he saw his art as one manifestation of an imminent "age of conscious creation" (as opposed to mere representation) and an "epoch of greater spirituality."

After his first somewhat expressionistic abstractions, Kandinsky (who occasionally returned to a more representational style) developed an increasingly geometric manner that anticipated certain innovations of KLEE (with whom he had a long-standing association) and, simultaneously, some cursive, whimsical elements characteristic of MIRÓ. He taught for a time at the BAUHAUS, was labeled "degenerate" by the Nazis in 1937, spent the last years of his life in France and was the author of an important body of theoretical writings on art. His influence on modern painting and sculpture, through both precept and example, was incalculable.

KANE, PAUL (1810–1871). Irish-born Canadian painter of landscapes and North American Indian life.

KANG HUI-AN (1419–1465). Korean painter, calligraphist and poet noted for landscapes, figures and birds derived from Chinese painting of the northern Sung dynasty.

KANOVITZ, HOWARD (1929–). American figurative painter and sculptor whose style bears a relationship to both POP ART and the PHOTO-REALISM of the late 1960s.

KANTOR, MORRIS (1896–). Russian-born American abstract painter and teacher.

KAO K'O-KUNG (1248–1310). Chinese landscapist of the Yüan dynasty of whose poetically mist-shrouded pictures few survive.

KAPROW, ALLAN (1927–). American artist generally credited with the invention of the HAPPENING, an environmental mixed-media form incorporating salient features of ABSTRACT EXPRESSIONISM and theatre, in 1958.

KATZ, ALEX (1927–). American painter known for his outsized, often drastically cropped portraits and free-standing cut-out painted figures.

Angelica Kauffmann, *Self-portrait*, Goethe Museum, Frankfurt.

Wassily Kandinsky, *With the Black Bow*, Nina Kandinsky Collection, Paris.

KATZEN, LILA (1932–). American sculptor of environmental constructions often incorporating electrically illuminated elements.

KAUFFMANN, ANGELICA (1741–1807). Swiss painter and musician whose decorative panels, influenced by MENGS, lacked vigor but were popular as adjuncts to houses designed by ROBERT ADAM and his brothers.

KAULBACH, WILHELM VON (1805–1874). A German painter and illustrator and student of CORNELIUS, he specialized in mural decoration.

KAZ, NATHANIEL (1917–). American figurative sculptor whose characteristic works are given to rhythmic, twisting attenuations.

KEENE, CHARLES SAMUEL (1823–1891). English painter, printmaker and illustrator best known for his satirical caricatures but admired for his draftsmanship by PISSARRO and DEGAS, among others.

KEIRINCKX, ALEXANDER (1600–1652). Flemish eclectic landscape painter influenced chiefly by CONINXLOO.

KELLS, BOOK OF (Dublin: Trinity College Library). A superbly illuminated manuscript of the Latin Gospels, dating from the 8th century and found at the town of Kells, County Meath, Ireland, it is considered an outstanding work of Hiberno-Saxon art.

KELLY, ELLSWORTH (1923–). American painter of bold hard-edged forms silhouetted against simple flat grounds. Using shapes derived from ARP, he characteristically explores a severely limited range of effects, with most aesthetic incident occurring in the narrow spaces between the clean contours of his forms and the edges of his pictures. He has also placed free-standing forms against actual or implied grounds and has experimented with juxtaposed single-color canvases.

KELS, HANS, THE ELDER (ca. 1480–1559) and **HANS, THE YOUNGER** (ca. 1508–1566). Austrian father and son, respectively a woodcarver and a medalist and sculptor, both of whom worked in the Renaissance style.

KEMENY, ZOLTAN (1908–1965). Hungarian-born Swiss sculptor, painter and architect best known for his abstract metal sculptures.

KENSETT, JOHN FREDERICK (1816–1872). An American landscape painter of the HUDSON RIVER SCHOOL, he studied in Europe and England and was influenced by CONSTABLE. Although his earlier works are somewhat turgid, he eventually developed an ordered style of great luminosity and serenity.

KENT, ROCKWELL (1882–1971). American painter, printmaker, illustrator and author. He was a student of CHASE and HENRI, among others. His works are characterized by strong, simple design, clearly delineated forms and rhythmic movement.

KENT, WILLIAM (ca. 1685–1758). An English architect, landscape architect, decorator, designer and painter, he is best—and somewhat unfairly—remembered as the target of HOGARTH's satire. His chief claim to fame is his design for the gardens of Burlington House, Kent.

KENZAN (Ogata Kenzan) (1664–1743). A Japanese potter and brother of KŌRIN, he specialized in square vessels for the tea ceremony, decorating them with calligraphically applied strokes of dark brown pigment.

KEPES, GYORGY (1906–). Hungarian-born American painter, designer and teacher known for his use of light in combination with various transparent substances.

KERSTING, GEORG FRIEDRICH (1785–1847). German painter and a leading designer of decorative ceramics.

KETTLE, TILLY (1735–1786). English painter, influenced by REYNOLDS and ROMNEY, who worked in India.

KEUNINCK, KERSTIAEN DE (ca. 1560–ca. 1634). Flemish landscape painter influenced by CONINXLOO.

KEY, ADRIAEN THOMASZ. (fl. mid-16th century). Flemish painter whose portraits and Biblical pictures are distinguished by their monumentality.

KEYSER, HENDRICK DE (1565–1621). A Dutch sculptor-architect, father of THOMAS DE KEYSER and member of a prominent family of artists, he worked in a style that blended elements of the late Italian Renaissance with English influences.

KEYSER, THOMAS DE (ca. 1596–1667). A Dutch painter and architect and son of HENDRICK DE KEYSER, his probable teacher, he is best known for his group portraits.

KHORSABAD, WINGED BULL OF (Paris: Louvre). Colossal alabaster figure from the 7th-century-B.C. Palace of Sargon II of Assyria. Incorporating a bearded human head, winged leonine torso and bull-like legs, it is embellished with multicolored semiprecious stones.

KIENBUSCH, WILLIAM (1914–). American painter and pupil of HARTLEY, best known for abstract interpretations of the Maine landscape.

KIENHOLZ, EDWARD (1927–). American sculptor known for tableaux of contemporary life constructed largely from actual objects (e.g., automobiles, bar stools and the like).

Ellsworth Kelly, *Atlantic,* Whitney Museum of American Art, New York.

Winged Bull of Khorsabad, Louvre, Paris.

tive art, developing a vigorous personal style designed to capture the essence of modern life in archetypal symbols. A leader of DIE BRUCKE, he eventually settled into a less strident manner marked by its poetic response to the landscapes of his adopted Switzerland and by a pervasive monumentality.

KISLING, MOISE (1891–1953). A Polish-born French painter influenced by CÉZANNE and, more especially, DERAIN, he specialized in richly colored nudes and portraits of women.

KIYONAGA (Torii Kiyonaga) (1752–1815). Japanese UKIYO-E printmaker best known for his representations of statuesque women.

KLEE, PAUL (1879–1940). Swiss painter, teacher, printmaker and one of the major figures of 20th-century painting. His art, the product of many thoroughly assimi-

KIESLER, FREDERICK JOHN (1892–1965). Austrian-born American architect and scenic designer best known for his unrealized architectural proposals and (with Armand Bartos) the Shrine of the Book, Jerusalem.

KIM HONG-DO (fl. last quarter of 18th century). A Korean painter of various subjects, he was esteemed for the assurance and delicacy of his brush stroke.

KING, PHILLIP (1934–). English sculptor of polychromed constructions, often with vaguely Oriental connotations.

KING, WILLIAM (1925–). American sculptor, principally of attenuated, more or less anonymous figures drawn from and gently satirizing modern life.

KIPP, LYMAN (1929–). American sculptor and one of the leading exponents of MINIMALISM.

KIRCHNER, ERNST LUDWIG (1880–1938). German expressionist painter and printmaker. Originally an architecture student, he fell under such various influences as MUNCH, VALLOTTON, VAN GOGH, FAUVISM and primi-

Ernst Ludwig Kirchner, *Five Women in the Street,* Wallraf-Richartz Museum, Cologne.

Paul Klee, *Fish Magic*, Museum of Art, Philadelphia, L. and W. Arensberg Collection.

lated and recombined influences, defies easy categorization but is always distinguished by the intelligence, wit and poetic sensibility of the artist. Trained in Munich, he worked and taught there from 1906 until 1933, when the Nazis closed the BAUHAUS, during which time he was associated with the MUNICH SEZESSION, the BLUE RIDER and the Blue Four, a splinter group composed of himself, JAWLENSKY, KANDINSKY and FEININGER. Until 1914 he worked mainly in black and white and became seriously interested in color only after a visit to North Africa—a visit that was to provoke a profound change in his work, much of which soon took on the shimmering, light-filled quality of the blue-tiled mosques of Islam. Klee's most characteristic works tend to be small, exploratory—"taking a line for a walk" was his own description of his method—and almost self-deprecating. Nonetheless, they are among the most influential pictures of the mod-

ern era and, although rigorously intellectualized, helped pave the way for ABSTRACT EXPRESSIONISM.

KLEIN, YVES (1928–1962). French painter associated with the avant-garde of the 1950s and somewhat notorious for strident monochromatic canvases devoid of incident or inflection and for a series of works executed by nude, paint-smeared women who printed impressions of parts of their bodies on canvases.

KLIMT, GUSTAV (1862–1918). The chief Austrian exponent of ART NOUVEAU and one of the founders of the VIENNA SECESSION, he was a highly successful muralist and designer and a formative influence on SCHIELE and KOKOSCHKA.

KLINE, FRANZ (1910–1962). American abstract expressionist painter of the NEW YORK SCHOOL whose mature works are unusually large for their era and characterized

by huge brush-strokelike forms, usually painted in black against a white ground and strikingly reminiscent of Oriental calligraphy.

KLINGER, MAX (1857–1920). German sculptor, painter and engraver, influenced by RODIN and known best for his expressive portrait busts.

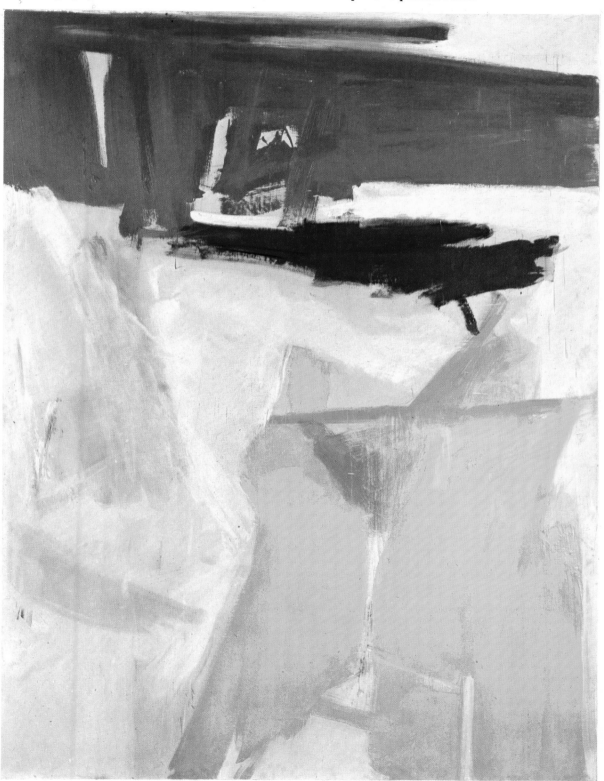

Franz Kline, *Mycenae*.

Sir Godfrey Kneller, *Portrait of John Churchill, First Duke of Marlborough*, Hudson's Bay Company, London.

KNATHS, KARL (1891–1971). American semi-abstract painter, mostly of cubist-influenced landscapes.

KNELLER, SIR GODREY (1646 or 1649–1723). German-born English portrait painter who trained in Holland under BOL. Immensely popular in the late 17th and early 18th centuries, he was the first painter in England to be made a baronet and maintained an active workshop from which pictures issued like appliances from an assembly line—often to the detriment of his posthumous reputation. At his best, however, he was capable of producing works of great immediacy and assurance.

KNIGHT, CHARLES (1743–1826). An English engraver and illustrator and follower of BARTOLOZZI. Most of his output consists of softly rendered reproductive engravings after works by various English painters.

KNIGHT, DAME LAURA (1877–1970). English painter and etcher, chiefly of circus and theatrical subjects.

KNOBELSDORFF, GEORG WENCESLAUS VON (1699–1753). German architect patronized chiefly by Frederick the Great, for whom he designed Sans Souci, Potsdam, a rather fanciful pleasure palace that added a note of Gallic gaiety to his previously stolid, self-consciously nationalistic style.

KOBELL, FERDINAND (1740–1799) and **WILHELM VON** (1766–1853). German father-and-son painters and printmakers. Ferdinand was an accomplished land-scapist, while his son and pupil was a leading German romantic painter in his time.

KOCH, JOHN (1909–). American realist painter, characteristically of sunlit figures in shadowed upper-middle-class interiors.

KOCH, JOSEPH ANTON (1768–1839). Austrian romantic painter who worked in Rome, where he was influenced by CARSTENS and, less directly but more profoundly, by POUSSIN.

KŌETSU (Honnami Kōetsu) (1558–1637). Japanese painter, potter, calligrapher and designer renowned as an art patron and for his superb Raku tea bowls. He was also an outstanding landscape gardener and a leading innovator in lacquerware.

KOKOSCHKA, OSKAR (1886–). Austrian expressionist painter influenced by KLIMT, HODLER, MUNCH and, indirectly, WILLIAM MORRIS. He is known chiefly for his early portraits, notable for their psychological acuity, and for an extended later series of "portraits of cities"—the modern counterparts to EL GRECO's *View of Toledo*. He was condemned as "degenerate" during the Nazi regime.

KOLBE, GEORG (1877–1947). German sculptor, principally of female nudes, influenced by KLINGER, RODIN and MAILLOL.

KOLLWITZ, KÄTHE (1867–1945). German graphic artist and scultptor. One of the great printmakers devoted to social commentary, she was influenced by GOYA and DAUMIER (and perhaps by MILLET and the early work of VAN GOGH). Her depictions of the downtrodden and politically oppressed fuse subject and medium into stark and compelling expressions of anguish that are distinguished by an empathy akin to that of Goya but without his underlying cynicism. Like Goya, she detested war, and many of her prints were strongly pacifistic.

KONINCK, PHILIPS DE (1619–1688). Dutch painter and possible pupil of REMBRANDT, by whom he was strongly influenced. Although he painted various subjects, he was most successful as a landscapist.

KONRAD VON SOEST (fl. ca. 1400–1425). German painter of altarpieces and one of the masters of the INTERNATIONAL GOTHIC style in Germany.

KŌRIN (Ogata Kōrin) (1658–1716). Japanese painter and decorative artist and brother of KENZAN. Renowned for his strongly patterned, well-disposed forms, he was a leading influence in the development of European appreciation of Japanese art.

KRAFT, ADAM (ca. 1457–1509). A leading German sculptor of the late GOTHIC period. His best work is distinguished by its great dramatic power.

KRASNER, LEE (1911–). American abstract-expressionist painter of the NEW YORK SCHOOL and wife of JACKSON POLLOCK. Her recent work has been more formally composed than her earlier ACTION PAINTING.

Oskar Kokoschka, *Dents-du-Midi,* private collection, Zurich.

KROHG, PER (1889–1965). A Norwegian painter who studied in Paris with Matisse and became known chiefly as a decorative muralist.

KRUSHENICK, NICHOLAS (1929–). An American painter of brightly colored, strongly outlined decorative abstractions, characteristically composed of overlapping curves set against striped grounds.

KUAN T'UNG (fl. lst quarter of 10th century). Famed as one of the greatest Chinese landscape painters, although little is known of his life, and few of his works survive.

KUBIN, ALFRED (1877–1959). An Austrian graphic artist and illustrator who worked in Munich, where he joined the BLUE RIDER, he was a rather morbid expressionist influenced by Ensor.

KUHN, WALT (1880–1949). American painter who worked in the Henri-Luks tradition, painting clowns and other circus performers for the most part, and who was instrumental in the organization of the ARMORY SHOW.

KU HUNG-CHUNG (fl. mid-10th century). Chinese painter of the Southern T'ang dynasty who specialized in figures.

KU K'AI-CHIH (ca. 345–405). Reputed to be one of the two greatest Chinese painters of his time. No known works are indisputably attributed to him, but he is the probable author of a seven-scene scroll, *Admonitions of the Instructress to the Court Ladies* (London: British Museum), esteemed for its linear mastery and coloristic subtlety.

KULMBACH, HANS SUSS VON (ca. 1480–1522). A German painter and follower of Dürer, he was influenced by his teacher Barbari and worked in an Italianate style of great delicacy.

KUNIYOSHI (Utagawa Kuniyoshi) (1797–1861). Japanese UKIYO-E printmaker influenced by European art.

KUNIYOSHI, YASUO (1893–1953). Japanese-born American painter and teacher. Influenced by Pascin while studying in Paris, he painted vaguely sinister, masked circus performers in a style akin to that of Shahn.

K'UN-TS'AN (ca. 1610–ca. 1693). Chinese eccentric painter and Buddhist priest who specialized in monumental landscapes.

KUO-HSI (fl. 2nd half of 11th century). Chinese landscape painter esteemed for the compelling realism of his works.

KUPKA, FRANK (Frantisek) (1871–1957). A Czechoslovakian painter and a pioneer of abstract art, he spent most of his career in Paris, where he was influenced by FAUVISM, CUBISM and ORPHISM. His brightly colored rectangles, seen in spatial perspective, may be the earliest geometric abstractions and anticipated many later styles still actively being explored.

KYLBERG, CARL (1878–1952). Swedish painter of simplified, moody seascapes notable for their refulgent color and compelling mysticism.

L

LABROUSTE, HENRI (1801–1875). French architect and teacher whose masterpiece is the Bibliotheque Ste-Geneviève, Paris, distinctive for the exposed structural ironwork in its interior.

LACHAISE, GASTON (1882–1935). A French-born American sculptor and assistant for a time to MANSHIP, he is known chiefly for elemental, massively volumetric, exaggeratedly pneumatic bronze female nudes.

LADBROOKE, ROBERT (1770–1842). An English landscape painter and lithographer influenced by his brother-in-law CROME.

LAER, PIETER VAN (1592–1642). Dutch genre painter who was called "Il Bamboccio" in Rome, where he spent much of his career painting working-class life.

LAERMANS, EUGENE (1864–1940). Belgian figure painter and engraver of working-class and peasant scenes.

LA FARGE, JOHN (1835–1910). American painter, watercolorist and stained-glass designer influenced by PUVIS DE CHAVANNES, ROSSETTI, HUNT, MILLAIS, Japanese prints and, in his mural decorations, the Venetians. A realist early in his career, he later turned to a rather stilted classicism. As a muralist, he was given many important commissions that were to influence a generation of wall painters.

LAFEVER, MINARD (1798–1854). Self-taught eclectic American architect whose handbooks of decorative details from various historical sources were of great influence in the U. S.

LA FOSSE, CHARLES DE (1636–1716). French decorative painter and assistant to LE BRUN. Influenced by RUBENS, PAOLO VERONESE and CORREGGIO, his work in turn influenced WATTEAU and anticipated the ROCOCO.

LA FRESNAYE, ROGER DE (1885–1925). A French painter and a founder of the SECTION D'OR, he is notable chiefly for the freshness, color and atmosphere with which he invested cubist works that derived from, but were more literal than, those of PICASSO and BRAQUE.

LA HIRE (La Hyre), LAURENT DE (1606–1656). French painter whose early works bear influences of PRIMATICCIO and who later adopted the early manner of POUSSIN. His output was divided between religious, classical and historical themes on the one hand and more intimate, more realistic landscapes on the other.

LAIRESSE, GERARD DE (1641–1711). A Flemish painter who worked in Amsterdam, he was the leading advocate of classicism in Holland during his lifetime, an outspoken critic of REMBRANDT (who nonetheless painted his portrait) and a highly influential writer on aesthetic theory.

LAM, WIFREDO (1902–). Cuban painter, protégé of PICASSO and a highly original proponent of SURREALISM who invests his pictures with forms and vigor reminiscent of African tribal sculpture.

LAMB, HENRY (1885–1961). Australian portrait painter and war artist who worked in England, where he became a Royal Academician.

LAMBERTI, NICCOLO DI PIETRO (ca. 1370–1451) and PIETRO DI NICCOLO (ca. 1393–1435). Father-and-son Italian sculptors. The elder Lamberti, who worked in the TRANSITIONAL style, was commissioned to provide sculptural embellishments for the façade of ST. MARK'S, Venice, a project on which his son assisted. The latter executed several important commissions of his own in a style marked by great vigor and consciousness of form.

LAMI, EUGÈNE-LOUIS (1800–1890). A French painter and pupil of VERNET and GROS, he is remembered chiefly for his battle scenes and the watercolors he produced during two sojourns in England.

LANCRET, NICOLAS (1690–1743). French painter, decorator and illustrator. He attended the studio of GILLOT with WATTEAU, whom he later imitated. Although his work never achieves the idyllic aura that informs Watteau's pictures, coming closer to 17th-century Dutch genre painting in spirit, he was very popular and well patronized in his time and known throughout Europe for his spirited depictions of ingenuous bucolic pleasures.

LANDSEER, SIR EDWIN HENRY (1802–1873). A child prodigy and immensely popular English animal painter. His work, while technically accomplished, is marred by excessive sentimentality.

LANE, FITZ HUGH (1804–1865). American painter and printmaker best known for harbor scenes painted with great clarity and verisimilitude.

LANFRANCO, GIOVANNI (1582–1647). Italian BAROQUE painter taught by the CARRACCI, influenced by CORREGGIO and notable for his compositional dynamics and exaggerated illusionism. He was DOMENICHINO's chief rival and on at least two occasions took over commissions originally awarded to his almost exact contemporary.

LANYON, PETER (1918–1964). English painter whose abstract canvases were based on the landscapes of Cornwall and influenced by HEPWORTH, NICHOLSON and GABO.

LAOCOÖN (Vatican Museums). Dramatically naturalistic Hellenistic sculpture, probably of the mid-2nd century B.C., representing the strangling of the Trojan priest Laocoön and his sons by serpents representing gods angered by Laocoön's opposition to the entry into Troy of the Greek wooden horse. Termed by Pliny "a work to be

preferred to all that the arts of painting and sculpture have produced," it was lost for centuries but rediscovered on the Esquiline in 1506 and had an immediate and sensational impact, particularly on MICHELANGELO and the future course of the BAROQUE.

LAON CATHEDRAL (Cathedral of Notre-Dame). Church in northern France. Begun in the mid-12th century, it was the earliest surviving great edifice to break completely with the ROMANESQUE style, and its dramatic, eccentric design had a widespread influence on the development of GOTHIC architecture in France and Germany, most notably in the design of the CATHEDRAL OF NOTRE-DAME, Paris. A complex arrangement of abruptly broken forms, its fantastic west front and square early-13th-century east end (in lieu of the traditional apse) are particularly notable, as are the sculptured oxen of its towers, which memorialize the animals used to haul stone to the cathedral site.

LARGILLIÈRE, NICHOLAS DE (1654–1746). French portrait and historical painter raised and trained in Antwerp, an assistant during a London sojourn of LELY and a protégé in Paris of LE BRUN. A follower of RUBENS, he was at his best a virtuoso who transcended his underlying academicism.

LARIONOV, MICHAEL (1881–1964). Russian abstract painter and theatrical designer who, with his wife GONTCHAROVA, developed RAYONISM.

LAROON (Lauron), MARCELLUS, JR. (1679–1774). English musician and amateur painter whose conversation pieces and genre scenes anticipate the style of GAINSBOROUGH despite their essentially monochromatic tonalities.

LASANSKY, MAURICIO (1914–). Argentine-born American printmaker of Lithuanian parentage, trained by HAYTER. His own print workshop has been a major force in the development of American printmaking techniques.

LASCAUX, CAVE PAINTINGS OF. A cycle of Paleolithic wall and ceiling paintings in a cave near Montignac, Dordogne, southwest France, that rivals ALTAMIRA for technical and stylistic virtuosity. Although found in a remarkably fine state of preservation, the paintings have deteriorated considerably since their discovery in 1940, largely because of atmospheric changes brought about by the presence of countless visitors. Various halls, passageways and chambers are embellished with a variety of painted and incised subjects, of which the most notable include a group of black bulls, groups of cattle and horses executed in two colors and a remarkable frieze of deer heads believed to date from the early Magdelenian period.

Frieze, caves at Lascaux.

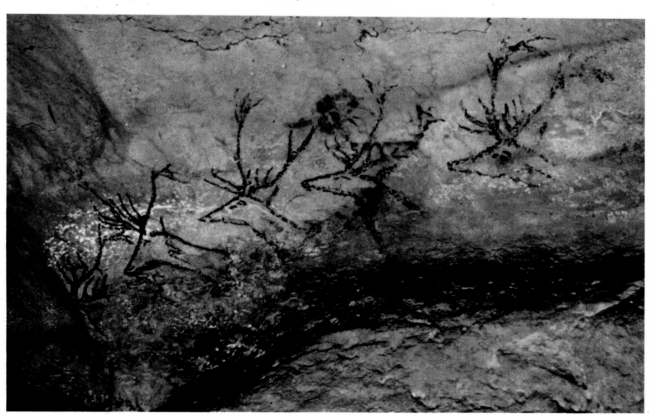

Georges de la Tour, *The Newborn,* Municipal Museum, Rennes.

LASSAW, IBRAM (1913–). Egyptian-born American sculptor and one of the first American abstract sculptors. His characteristic works are open cage- or cell-like constructions of welded metal in which surface incident suggests strong ties to ABSTRACT EXPRESSIONISM.

LASTMAN, PIETER PIETERSZ. (1583–1633). A Dutch history painter influenced by CARAVAGGIO and ELSHEIMER, he was the teacher of LIEVENS and, more importantly, REMBRANDT, on whose early period he exercised considerable influence.

LA TOUR, GEORGES DE (1593–1652). French painter who may have studied in Italy, possibly as a pupil of RENI, and who was markedly, if indirectly, influenced by CARAVAGGIO (possibly through HONTHORST or TERBRUGGHEN, both of whom shaped his style in various ways). He gradually accomplished a transition from MANNERISM to the BAROQUE, his oeuvre constituting a record of his constant striving for simplicity of form, exclusion of nonessentials and a resultant calm—a kind of pictorial stasis that prefigures that which VERMEER was to achieve a generation later and that was unprecedented in Baroque art. As a painter of nocturnal scenes (the source of light is usually a single candle), La Tour derived directly from Honthorst and Terbrugghen but invested the form with a nobility and spirituality seldom approached in Western painting. His mature works are notable for the soundness and logic of their structure, their absolute congruity and the pervasive calm that emanates from them.

LA TOUR, MAURICE-QUENTIN DE (1704–1788). French portrait painter. A more or less self-taught artist (who nonetheless founded an art school), he worked almost exclusively in pastel, was a superb draftsman and invested his portraits with an engaging liveliness and considerable psychological insight.

LATROBE, BENJAMIN HENRY (1764–1820). English-born American architect who pioneered the use of Greek-derived detail in the U. S. before attempting to create a native classical architectural order based on indigenous plants. Although consequently derided for his "corncob capitals," he imposed a high order of professionalism on American architecture. Except for its dome, much of the central portion of the U. S. Capitol, Washington, D. C., is his work.

LAURANA, FRANCESCO (ca. 1425–1502). An Italian sculptor, medalist and architect often confused with LUCIANO LAURANA. Little is known of his early years. He worked in France and Sicily as well as Italy and was a major vehicle for the spread of early Renaissance concepts and forms. He is best known for his extremely sensitive marble portrait busts of women.

LAURANA, LUCIANO (d. 1479). Dalmatian architect who worked in Italy and of whose buildings little is known with any degree of certainty. Often confused with FRANCESCO LAURANA.

LAURENCIN, MARIE (1885–1956). French painter,

lithographer and watercolorist noted for her somewhat etiolated depictions of young girls, vaguely derived from CUBISM.

LAURENS, HENRI (1885–1954). French Cubist sculptor, often of polychromed still-life subjects. He was also a noted book illustrator.

LAURENT, ROBERT (1890–). French-born American figurative sculptor whose best works were directly carved and monumental in concept.

LAUTENSACK, HANSS SEBALD (1524–after 1560). German printmaker, painter and medalist best known for his mastery of landscape.

LAVERY, SIR JOHN (1856–1941). Eclectic British painter, principally of portraits, but also of landscapes and genre subjects.

LAWRENCE, JACOB (1917–). American painter, principally of pictures protesting racial inequity, who works in a harsh, angular, flat-patterned style somewhat akin to that of SHAHN.

LAWRENCE, SIR THOMAS (1769–1830). English painter and child prodigy. Despite the most rudimentary training, he became a highly accomplished, phenomenally successful and much honored portraitist. Although uneven, he was at his best a dazzling stylist who invested his subjects with a compelling but ultimately superficial liveliness.

LEANING TOWER. See **PISA, TOWER OF.**

LEAR, EDWARD (1812–1888). English topographical artist and ornithological illustrator. A leading documentary landscape watercolorist in his time and a superb illustrator of birds (particularly members of the parrot family), he is remembered today chiefly for such nonsense poems as "The Owl and the Pussycat" and his inimitable illustrations for them.

LE BRUN, CHARLES (1619–1690). French painter, draftsman, decorator and, as an administrator under Louis XIV, one of the most powerful individuals in the history of French art. A pupil of VOUET and POUSSIN, he later was instrumental in making the latter master's aesthetic the foundation of French academicism. Like INGRES in a later era, he preached the supremacy of drawing over painting and wielded power that was historically more important for its negative than its positive influences. Although he was a classicist in theory, his more ambitious official works—particularly his decorations for VERSAILLES—were flamboyant to the point of pomposity, while his less ambitious pictures were almost poignantly naturalistic.

LEBRUN, RICO (Federico) (1900–1964). An Italian-born American painter, in his best works he achieved a masterful fusion of modern idioms and the Italian BAROQUE.

LECK, BART VAN DER (1876–1958). Dutch painter, printmaker and designer who vacillated between a

Luciano Laurana and others, the Ducal Palace, Urbino.

Le Corbusier, chapel of Notre-Dame-du-Haut, Ronchamp.

geometric figurative style and a nonobjective manner influenced by MONDRIAN.

LE COURBUSIER (Charles-Edouard Jenneret-Gris) (1887–1965). Swiss-born French architect, painter, sculptor, industrial designer, city planner and aesthetic theoretician. A pioneer in the use of ferroconcrete and contemporary technological concepts and one of the most influential architects of the 20th century, he characteristically raised his buildings on piers, leaving open space at ground level. Although most of his structures and unexecuted designs are severely geometric and mechanistic, his masterpiece is considered by many to be the superbly sculptural pilgrimage chapel of Notre-Dame-du-Haut at Ronchamp, a relatively late, intensely personal work that ranks among the most original pieces of architecture produced in the modern era. As a painter, he is remembered chiefly for his invention, with OZENFANT, of PURISM.

LE FAUCONNIER, HENRI (1881–1946). French Cubist painter influenced by GLEIZES and DELAUNAY.

LEFEBVRE, CLAUDE (1632–1675). A French portrait painter and printmaker and a pupil of LE SUEUR. His few surviving works obviously were influenced by LE BRUN.

LÉGER, FERNAND (1881–1955). French painter and a major figure in the development of CUBISM. After embarking on an architectural career, he studied painting under GÉRÔME and knew PICASSO and BRAQUE by 1910. From then until 1914 he was associated with GLEIZES, DELAUNAY, METZINGER and other adherents of ORPHISM and exhibited with them. By 1917 he had developed a personal variation of CUBISM based on his fascination with the forms and dynamics of industrial machinery. In creating pictures that combined flat, geometrical, more or less unmodulated patterns with massive cylindrical forms, he rid Cubism of its residual traces of the atmospherics of the Impressionist style, substituting for them a clean, hard appearance eminently suitable to an art of the 20th century. Simultaneously he developed a suitable iconography in which robotlike, monochromatic figures and "machined" natural forms seemed to function as adjuncts to powerful, highly colored mechanical systems. Although he was influenced in this development by the PURISM espoused by LE CORBUSIER and OZENFANT, he rejected that style's doctrinaire approach, thereby avoiding the ultimate sterility of the Purist movement.

LEGROS, ALPHONSE (1837–1911). A French painter, sculptor and printmaker and follower of COURBET who spent most of his life in London, where he was a popular portraitist, executed some public sculpture and produced a large body of influential, rather Gothic graphics.

LEHMBRUCK, WILHELM (1881–1919). German sculptor trained at Düsseldorf but influenced by RODIN and MAILLOL. With BARLACH he pioneered an early-20th-century sculpture revival in Germany, and, like Barlach's, his work was sharply reminiscent of German sculpture of the late Middle Ages. The characteristic figures of his truncated maturity (he committed suicide at 38) are lean, attenuated and imbued with the spirituality of Gothic church sculpture.

LEIBL, WILHELM (1844–1900). The leading German realist painter of the 19th century, he worked in a variety of styles closely based on those of various old masters, most notably HOLBEIN.

LEIGHTON, LORD FREDERIC (1830–1896). English eclectic painter and sculptor whose rather florid pseudo-classicism was enormously popular in the Victorian era but has been largely forgotten since.

LEIJSTER (Leyster), JUDITH JANSDR. (1609–1660). Dutch painter who may have studied with TERBRUGGHEN and HALS and was influenced by CARAVAGGIO's Utrecht followers, particularly HONTHORST. In style and subject her pictures point the way to VERMEER but without attaining any great heights.

LELY, SIR PETER (Peter van der Faes). (1618–1680) A German-born English portrait painter of Dutch parentage, he was trained in Holland, worked there for a time and, by 1647, settled in London, where, as portraitist to the court of Charles II, he succeeded VAN DYCK (one of his prime influences) as the leading painter in England. He invested his portraits of women with the rather muggy sensuality affected by court ladies of the Restoration but portrayed male sitters in a virile, straightforward manner.

LEMOYNE, JEAN-BAPTISTE (1704–1778). A French court portrait sculptor and influential teacher who numbered several noted sculptors, including HOUDON, among his pupils.

LE NAIN, ANTOINE (ca. 1588–1648), **LOUIS** (ca. 1593–1648) and **MATHIEU** (ca. 1607–1677). French painters and brothers and charter members of the Royal Academy. The data of their lives and attributions of their known works are clouded in speculation, although it is generally assumed that they were trained in France in the Netherlandish tradition; that Antoine was essentially a miniaturist; that Louis was the most advanced and important of the trio; and that Mathieu achieved the greatest worldly success. Louis also is believed to have worked in Rome, to have been influenced there by PIETER VAN LAER and to have used a less chromatic palette than his brothers. The pictures usually ascribed to him transcend their ostensible genre subjects by virtue of the calm, dignity and monumentality that inform them.

LENBACH, FRANZ VON (1836–1904). German portrait painter who worked in an eclectic style derived from RUBENS, REMBRANDT, VELAZQUEZ and REYNOLDS, among

Fernand Léger, *The Loisirs*, National Museum of Modern Art, Paris.

Leonardo da Vinci, *Self-portrait,* detail, Royal Library, Turin.

Leonardo da Vinci, *Mona Lisa,* Louvre, Paris.

others, and whose work is not notable for its keen analysis of character.

L'ENFANT, PIERRE CHARLES (1754–1825). A French-born American architect, military engineer and city planner best known for his magnificent plan for Washington, D. C., which superimposes a radial pattern derived from French landscape architecture on the typical American gridiron pattern, thereby combining New World efficiency with the stately vistas of VERSAILLES.

LE NOTRE, ANDRÉ (1613–1700). French landscape architect renowned—and employed—internationally as a designer of formal gardens, including those of VERSAILLES.

LENZ, PETER (1832–1928). German sculptor, architect, decorator and painter whose rather arid works, based on a doctrinaire theory of geometric proportions, had a minor influence, through SERUSIER, on SYMBOLISM.

LEONARDO DA BESOZZO (fl. 1421–1488). An Italian fresco painter and son and pupil of Michelino da Besozzo, he spent much of his career in Naples, where he was court painter to Alfonso I.

LEONARDO DA VINCI (1452–1519). Italian painter, sculptor, engineer, architect, inventor and scientist. The quintessential Renaissance man and perhaps the pre-eminent genius of all time, he was the bastard son of a Florentine notary and a peasant. Little is known of his upbringing, except that it took place in his father's house, but he was almost certainly a pupil and assistant of VERROCCHIO's and may have been the author of one of the

Leonardo da Vinci, *The Virgin and Child, St. Anne and the Infant St. John*, detail, National Gallery, London.

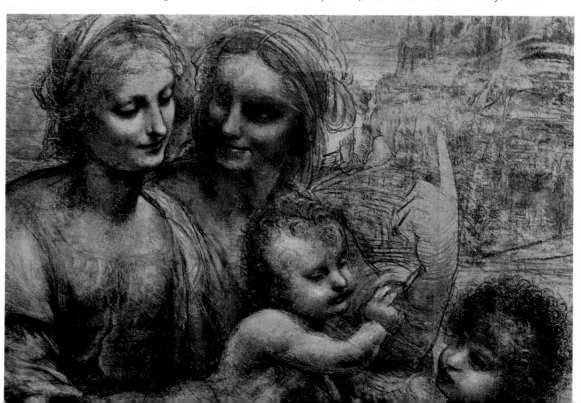

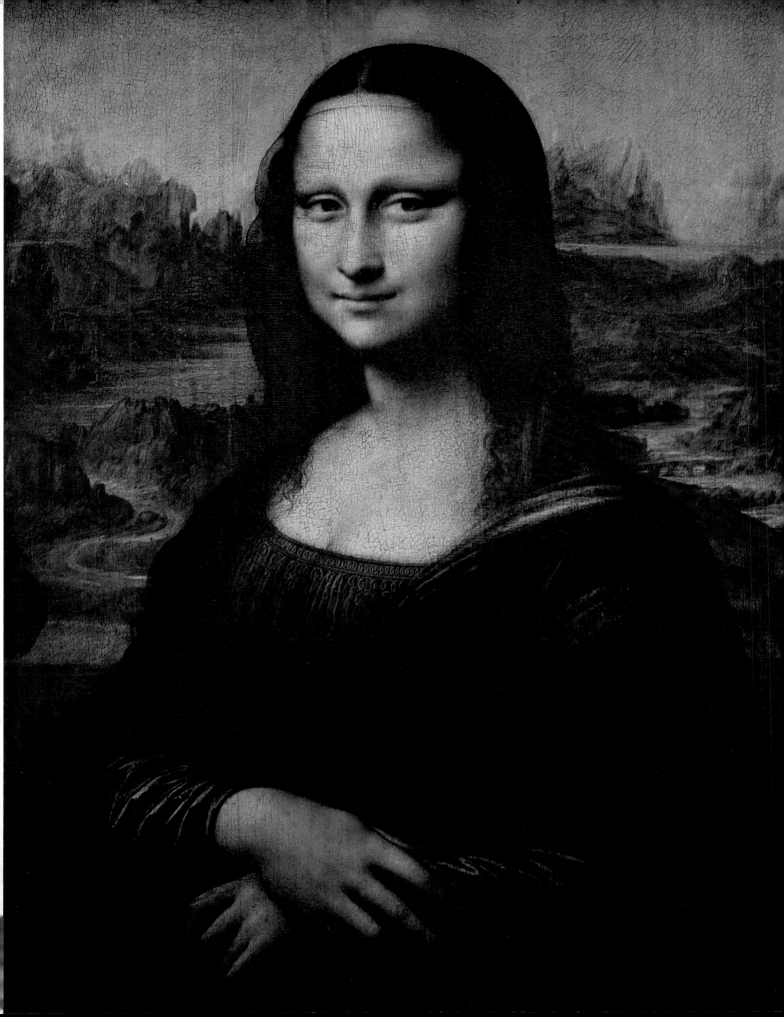

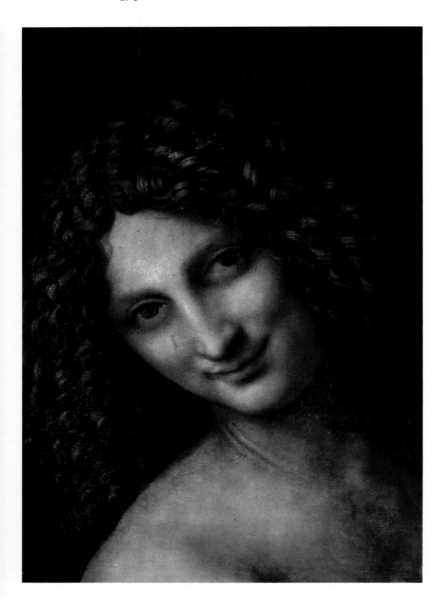

Leonardo da Vinci, *St. John the Baptist,* detail, Louvre, Paris.

quattrocento and a dynamism unknown to such contemporaries as PERUGINO and SIGNORELLI.

In 1482, Leonardo was summoned to Milan by Duke Lodovico Sforza, to whom he had been recommended as a musician but whom he petitioned for patronage in areas more to his liking, stating, "I believe I can give you as complete satisfaction as anyone in the construction of buildings. . . . I can further execute sculpture in marble, bronze or clay, and in painting I can do as much as anyone." Above all, he wrote, he was an "artificer of instruments of war." While in Milan, he produced a few pictures most notably *Lady with an Ermine* (Cracow: Czartoryski Museum), the *Madonna of the Rocks* (Paris: Louvre) and the world-famous fresco *The Last Supper* (Milan: S. Maria delle Grazie), a landmark work that, with its psychological probity and dramatic tension, ushered in the High Renaissance. He also produced a life-size clay horse for an ultimately abandoned equestrian statue of Francesco Sforza and designs for numerous unrealized architectural projects. More importantly, perhaps, he undertook his first empirical scientific studies and collaborated with the mathematician Luca Pacioli on a treatise on proportion.

With the French invasion and fall of his patron in 1499, Leonardo returned to Florence, where he was employed as a military engineer by Cesare Borgia, independently undertook the studies that were to make him the outstanding anatomist of his time and embarked on another of his unfinished masterworks, a vast wall painting depicting the *Battle of Anghiari*—a projected companion piece to a never-to-be-finished commission awarded MICHELANGELO. As he had with *The Last Supper,* Leonardo used the project as an excuse for experimentation with an unconventional medium—this time wax-based pigments. Unlike *The Last Supper,* which was painted in oils on plaster and only *began* to deteriorate in his own lifetime, the *Battle* seems to have been lost almost before it was begun. One of the few pictures he managed to finish during his second stay in Florence was the *Mona Lisa,* probably the best-known painting ever executed and, in its masterful handling of the then innovative *sfumato* technique, a *tour de force* of the first magnitude. (Unfortunately one result of that infinitely modulated technique, the "Mona Lisa smile" celebrated in song and story, led a host of inept imitators to flood the picture galleries of Europe with portraits of women wearing a variety of highly unsettling smirks and grimaces.)

Although he continued his voluminous production of drawings, his second sojourn in Milan to all intents and purposes marked the end of Leonardo's career as a serious painter and his emergence as a more or less full-time scientist. After a stay in Rome, during which his last known painting, *St. John the Baptist* (Paris: Louvre), was executed, he left in 1517 for Amboise and a post as first painter, architect and mechanic to the court of François I and died there two years later. On the basis of surviving evidence, he seems to have taken the last two-thirds of

angels in that master's *Baptism* (Florence: Uffizi)—a piece of work that legend credits with persuading Verrocchio to give up painting. Of his earliest independent works, the portrait *Ginevra de' Benci* (Washington: National Gallery) is the best known, most complete and most significant in that it presages his most renowned single work, the *Mona Lisa* (Paris: Louvre). A potentially much more important work of his initial period, a large *Adoration of the Kings* (Florence: Uffizi), commissioned by a monastery outside Florence, was, like almost everything he ever undertook, left unfinished, but enough of it was completed to indicate that in its conception it was crucial to Leonardo's later development and, indeed, stands as a summation of the pictorial aspirations of the late 15th century. The work, which makes use of a central pyramidal structure, represents, with its gesticulating figures and prancing horses, a turning away from the austere reserve of the

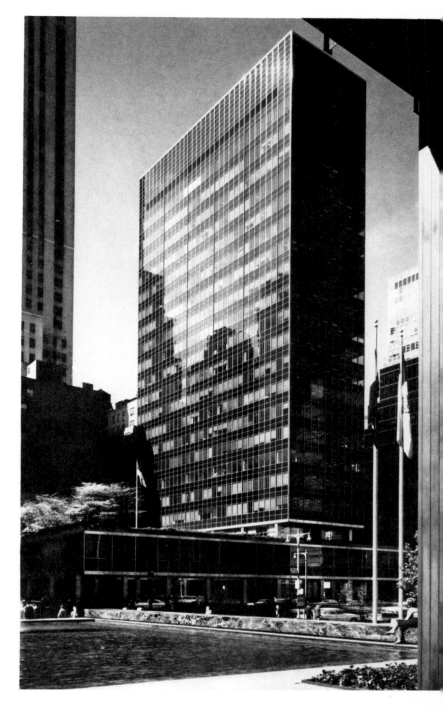

Skidmore, Owings and Merrill, Lever House, New York, courtesy of Lever Brothers Corporation.

his title far more seriously than the first.

It may be said that Leonardo was the victim of his voracious quest for knowledge, and, indeed, there was something Faustian in his unquenchable thirst to know all that could be known and a bit more. Given the range of his interests, however, what is perhaps most astonishing about his art is the extent to which it advanced *all* art in a very few efforts that amounted to quantum leaps. By sheer force of intellect, he escaped his own time, single-handedly forging an epochal style and redirecting the history of art. That he managed to do so while practicing what amounted to a mere sideline makes his achievement all the more awesome.

LEONI, LEONE (1509–1590) and **POMPEO** (ca. 1533–1608). Italian father-and-son sculptors and medalists. Leone, who worked in the mannerist style, was the leading medalist of his time. Pompeo, who worked in Spain, is best known for his elaborate altar in the church of EL ESCORIAL.

LEOPARDI, ALESSANDRO (fl. ca. 1482–ca. 1522). An Italian goldsmith, sculptor and architect. His chief claims to fame are his adjuncts to and castings of VERROCCHIO'S equestrian statue of Bartolommeo Colleoni, in Venice.

LEPICIE, BERNARD-FRANÇOIS (1698–1755) and **NICOLAS-BERNARD** (1735–1784). French father-and-son engraver and painter, respectively. The elder Lepicie was primarily a reproductive engraver and writer on art. His son (and pupil) was a history painter and portraitist and a genre painter of great sensibility.

LE PRINCE, JEAN-BAPTISTE (1734–1781). French ROCOCO painter, etcher and decorator best known for genre subjects and for technical innovations in etching.

LESLIE, CHARLES ROBERT (1794–1859). London-born American anecdotal painter who worked in England, where he was known for his depictions of literary episodes and for a first-rate biography of his close friend CONSTABLE.

LE SUEUR, EUSTACHE (1616–1655). A French painter whose once considerable reputation has diminished since the 18th century, he was a pupil of VOUET and was markedly influenced by POUSSIN and, later and to a lesser extent, RAPHAEL. A founder of the Royal Academy, he is best known for a cycle of 28 paintings depicting the *Life of St. Bruno* (Paris: Louvre), a personal synthesis of a variety of influences.

LEUTZE, EMMANUEL (1816–1868). German-born American history painter best known for his *Washington Crossing the Delaware* (Bremen: Art Gallery).

LEUX VON LEUXENSTEIN, FRANS, THE ELDER (1604–1668). Flemish painter whose portraits and religious paintings were respectively influenced by VAN DYCK and RUBENS.

LEVER HOUSE. A glass-walled office building in New York City, it was built in 1952 for the Lever Brothers Corporation by Gordon Bunshaft (1909–) of the architectural firm of Skidmore, Owings and Merrill and is probably the most influential and widely imitated building of its kind in the world. Raised on stiltlike square columns sheathed in stainless steel, its 21-story boxlike tower seems to float at a height of two stories above a paved platform that is completely open to the streets on two sides. Its blue-green exterior sheath stands free of the building's setback structural supports, thereby investing

Roy Lichtenstein, *Little Big Painting,* Whitney Museum of American Art, New York.

the whole with an appearance of extraordinary delicacy and lightness.

LEVI, JULIAN (1900–). American figurative painter, chiefly of the seashore and its activities, whose canvases characteristically project a sense of human isolation.

LEVINE, JACK (1915–). American expressionist painter of social satire. His works are distinguished by incisive psychological analysis and a great deal of surface movement.

LEWIS, JOHN FREDERICK (1805–1876). English painter and son of the engraver Frederick Christian Lewis (1779–1856). Although he began his career as a painter of animals and sporting subjects, he is best known for his meticulous, highly colored depictions of exotic peoples and landscapes.

LEWIS, WYNDHAM (1884–1957). English painter and writer and founder of VORTICISM. Something of an avant-garde eclectic, his major importance lies in his introduction and advocacy of new movements in England.

LEWITT, SOL (1928–). American sculptor and draftsman best known for severely geometric boxlike forms and, more recently, drawings whose content is the predeter˜ined number of dots, lines, etc., applied to a specific surface.

LEYDEN, LUCAS VAN (before 1495–1533). Dutch painter and graphic artist. A child prodigy, he was trained by his father, Hughe Jacobsz. Van Leyden (of whose own work nothing survives) and ENGELBRECHTSZ. Probably influenced in his painting style by GOSSAERT, he drew heavily on DÜRER and Italian Renaissance sources (possibly through Dutch intermediaries) in his exceptionally fine woodcuts and engravings. Where he learned to make woodcuts and engravings is unknown (neither of his teachers were printmakers), but his prints are marked by great technical assurance, although a tendency toward caricature and reliance on genre subjects prevented him from rising to the heights attained by Dürer.

LHERMITTE, LÉON-AUGUSTIN (1844–1925). French painter of peasant life and religious subjects, he worked in a style derived from COURBET.

LHOTE, ANDRÉ (1885–1962). French painter, critic, aesthetician and teacher. Influenced chiefly by CÉZANNE and to a considerable extent by PICASSO and CUBISM, he developed a lucid, clearly patterned style whereby he strove to express space and movement while avoiding the use of perspective and maintaining the integrity of the picture plane.

LIANG K'AI (ca. 1140–ca. 1210). Chinese painter who treated Zen Buddhist themes in a style distinguished by its terse, abrupt brushwork.

LIBERALE DA VERONA (ca. 1445–1526 or later). Italian miniaturist, frescoist and panel painter influenced by MANTEGNA.

LIBERI, PIETRO (1614–1687). Italian BAROQUE painter and teacher whose works in the Venetian tradition were influenced by CORTONA.

LIBERMAN, ALEXANDER (1912–).Russian-born American abstract painter and sculptor influenced by the NEW YORK SCHOOL artists.

LI CH'ENG (fl. ca. 960–990). An early Sung landscapist, he was particularly renowned for his depictions of twisting, stunted evergreens.

LICHTENSTEIN, ROY (1923–). American painter and sculptor and student of MARSH. One of the leading and most intellectual exponents of POP ART, he is known for his comic-strip imagery, use of hugely enlarged Benday dot patterns and reliance on the primary colors with black contours.

LIEBERMANN, MAX (1847–1935). The leading German adherent of IMPRESSIONISM, he was influenced by MILLET, Degas, LEIBL and THOMA and the artists of the BARBIZON SCHOOL.

LIEVENS, JAN (1607–1674). Dutch painter and graphic artist, pupil of LASTMAN and associate of REMBRANDT. His history and genre pictures, portraits and landscapes bear influences of RUBENS, BROUWER, VAN DYCK and, indirectly, CARAVAGGIO but particularly of Rembrandt, who in turn seems to have been influenced by him (their association was an early one). Although he had been something

Limbourg Brothers, from the *Très riches heures du Jean Duc de Berry*, Musée Condé, Chantilly.

of a prodigy whose talent was considered the equal of Rembrandt's at the outset of their careers, he never quite realized his potential.

LI KUNG-LIN (ca. 1045–1106). Chinese painter and scholar celebrated for his depictions of horses and sensitively rendered landscapes.

LIMBOURG BROTHERS. Three Franco-Flemish miniaturists who worked in France, particularly for Jean, Duc de Berry, in the late 14th and early 15th centuries. Of the three, Pol, Hermann and Jehanequin, Pol was probably the eldest and, like his siblings, was apprenticed to a Paris goldsmith, taken as a war prisoner in Brussels and ransomed by the Duke of Burgundy, possibly because of his kinship with a court painter. Their major achievement—and one of the supreme masterpieces of the INTERNATIONAL GOTHIC style—is the superbly illustrated breviary *Très riches heures du Jean Duc de Berry* (Chantilly: Musée Condé), of which the sumptuous calendar portion points the way to northern panel painting in general and genre subjects in particular. Stylistically, their work is distinguished by the harmonious richness of its color, its specificity of detail and masterful use of aerial perspective.

LINCOLN CATHEDRAL. One of the masterpieces of GOTHIC architecture in England, it was begun in 1192 on the site of (and incorporating some elements of) an 11th-century cathedral. It is particularly notable for its 13th-century Angel Choir, built in the English Decorated style, and polygonal chapter house.

LINDNER, RICHARD (1901–). A German-born American painter and precursor of POP ART. His characteristic works are rather programmatic embodiments of sado-masochistic fantasies, rendered in hard, bright, flat color and embellished with enigmatic symbols suggestive of the print media.

LINGELBACH, JOHANNES (1622–1674). Dutch painter influenced by VAN LAER, WOUWERMANS and other Italianate compatriots.

LINNELL, JOHN (1792–1882). An English painter of portraits, miniatures, landscapes and Biblical subjects, he was influenced by his son-in-law, PALMER, and, although almost universally detested by the English artists of his time, befriended and encouraged BLAKE.

LIOTARD, JEAN-ÉTIENNE (1702–1789). French realist portrait painter and pastelist. Called the "Turkish Painter," he had a propensity toward the exotic but, for better or worse, is chiefly memorialized by his meticulously rendered *Lady Taking Chocolate* (Dresden: State Art Collections), used as a trademark by an internationally known cocoa manufacturer.

LIPCHITZ, JACQUES (1891–1973). Lithuanian-born, French-trained American sculptor influenced by CUBISM. After an early period during which he produced somewhat superficial sculptural equivalents of contemporaneous Cubist paintings, he developed a more open, iconic style that eventually evolved into a powerful, and unabashedly BAROQUE, form of EXPRESSIONISM.

LIPPI, FILIPPINO (1457–1504). Italian painter and son of FRA FILIPPO LIPPI, influenced principally by his father and BOTTICELLI. His characteristic later works are marked by a restless, dodging movement and emotional tension that prefigure MANNERISM and by a sometimes incongruous use of details from classical antiquity.

LIPPI, FRA FILIPPO (ca. 1406–1469). Italian painter of the early FLORENTINE SCHOOL, father of FILIPPINO LIPPI and a major figure in the development of early Renaissance art. Possibly a student of MASACCIO, whose influence on his work gradually gave way to that of DONATELLO, FRA ANGELICO and the Flemish painters, he

was very probably the teacher of, and certainly exerted a formative influence on, BOTTICELLI. In his early works he made extensive use of bold, fully dimensional forms derived from Masaccio and of the then novel principles of perspective. From the early 1440s onward, however, his manner became increasingly two-dimensional, decorative and invested with GOTHIC devices. His oeuvre not only influenced several of his immediate successors but much later became a source of the PRE-RAPHAELITE style.

LIPPO DALMASIO DE' SCANNABECCHI (ca. 1352–ca. 1420). Italian painter, principally of suavely depicted Madonnas.

LIPPOLD, RICHARD (1915–). American sculptor, chiefly of intricate, radial constructions in gold or silver wire that are suspended in space by means of guy wires.

LIPTON, SEYMOUR (1903–). A largely self-taught American sculptor. His characteristic works project a vaguely ominous imagery through the use of open, coiling forms resembling unwinding scrolls or the broken shells of intricate mollusks and often are further characterized by the oblique upward thrust of a central axis.

LISS, JOHAN (ca. 1595–ca. 1630). A German eclectic painter who spent the last years of his brief career in Italy, he was a notable colorist and a masterly composer and introduced the genre picture to Venice.

LI SSU-HSUN (651–716). The outstanding member of a family of Chinese T'ang dynasty painters, he specialized in predominantly blue and green landscapes.

LI T'ANG (fl. mid-11th century; d. after 1130). Chinese painter of the Southern Sung dynasty of whose fully authenticated works few, if any, exist. By all accounts he was a great landscapist and a major figure in the transition between the Northern and Southern Sung.

LOCHNER, STEPHAN (1410–1451). A German painter in the INTERNATIONAL GOTHIC style and the leading figure of the school of Cologne in his time, he may have studied in the Netherlands. His works, which were much admired by DÜRER, among others, add a newer, more realistic quality to the traditional GOTHIC style and are distinguished by rhythmic composition and coloristic assurance.

LOMAZZO, GIOVANNI PAOLO (1538–1600). An Italian mannerist painter and art theorist. His writings were far more influential than his bombastic frescoes and altarpieces.

LOMBARD, LAMBERT (1505–1566). A Flemish painter, engraver and architect, he was probably a pupil of Gossaert and was influenced by SCOREL and (while in Italy) the antique. He was a major source of Roman forms and motifs in the north.

LOMBARDO, PIETRO (ca. 1435–1515). Italian sculptor and architect and father of the sculptors Antonio (ca. 1458–ca. 1516) and TULLIO LOMBARDO. Known for his forceful modeling and fine craftsmanship, he was a notable designer of tombs (including that of Dante's) and churches. His masterpiece, S. Maria dei Miracoli, may be

the finest Renaissance building of its type in Venice, and his importance as a pioneer of Renaissance art in that city is considerable.

LOMBARDO, TULLIO (ca. 1455–1532). An Italian sculptor and son and pupil of PIETRO LOMBARDO, he was renowned for his technical mastery of marble. His approach to classicism has been condemned as superficial, but he occasionally brought out the human forms underlying his elaborately constructed draperies.

LONGHENA, BALDASSARE (1598–1682). The outstanding Venetian architect of the 17th century, he is best known for his richly ornamented BAROQUE palaces and the octagonal church of S. Maria della Salute, which is distinguished by the massive spiraling volutes, surmounted with statuary, that support its central dome and by the general effect of both its interior and exterior, which are richly ornamented, somewhat Oriental in feeling and unusually effective in their use of complex spatial arrangements and shifting vistas.

LONGHI, ALESSANDRO (1733–1813). Italian painter and engraver and son and pupil of PIETRO LONGHI, he also studied under Giuseppe Nogari (1699–1793). A fashionable portrait painter, he tended to lavish his attentions on his sitters' attire, at the expense of psychological analysis.

LONGHI, PIETRO (1702–1785). Italian painter and pupil of BALESTRA. After an abortive start as a figure painter, he turned to genre subjects at the suggestion of GIUSEPPE MARIA CRESPI and produced a popular, lucrative oeuvre of undeniable charm and equally undeniable clumsiness. He was the father and teacher of ALESSANDRO LONGHI.

LOO, VAN, FAMILY. A family of Franco-Flemish painters that extended over several generations and included Jean-Baptiste van Loo (1684–1745), a portraitist who had considerable success in England, where he influenced HOGARTH, among others; his brother Carle (1705–1765), who was Principal Painter to the King of France and director of the Royal Academy; and Louis Michel (1707–1771), son of Jean-Baptiste, who enjoyed considerable success in Spain.

LOOS, ADOLF (1870–1933). Austrian architect influenced by SULLIVAN and the CHICAGO SCHOOL during a stay in the United States. A vociferous opponent of ART NOUVEAU and its decorative embellishments, he advocated an architecture of undecorated functionalism embodied by his Steiner House, Vienna, one of the first private residences in concrete and a notable work for its purity of design and rational organization of interior space. His work influenced numerous architects, including GROPIUS.

LOPEZ Y PORTANA, VICENTE (1772–1850). Spanish painter and art administrator influenced in his allegorical frescoes by MENGS but more successful as a rather bland portraitist.

LORENZETTI, AMBROGIO (fl. 1319–1347). Italian painter in the Sienese tradition and brother of PIETRO

Fra Filippo Lippi, *Coronation of the Virgin*, detail, Uffizi, Florence.

Ambrogio Lorenzetti, detail from *Good Government*, Sala Della Pace, Palazzo Pubblico, Siena.

LORENZETTI. One of the most innovative artists of his century, he is particularly notable for his mastery of landscape, and, indeed, his background view of Siena in the allegorical work *Good and Bad Government* (Siena: Palazzo Pubblico) is considered the earliest landscape masterpiece in Italian art. A superb composer, he handled spatial arrangements with complete assurance and represents a break from the tradition of DUCCIO and an acceptance of the revolutionary innovations of GIOTTO.

LORENZETTI, PIETRO (fl. 1320–1344). Italian painter of the SIENESE SCHOOL and brother of AMBROGIO LORENZETTI. Like Ambrogio, he rejected the tradition of DUCCIO in favor of GIOTTO's monumental naturalism but in a style of his own derived in part from the sculpture of GIOVANNI PISANO and based to a considerable extent on the then new theories of perspective. His work, while neither as innovative nor as influential as his brother's, is distinguished by its solid arrangements of figures and its emotional expressivity.

LORENZI, BATTISTA DI DOMENICO (ca. 1527–1594). An Italian academic sculptor and pupil of BANDINELLI. His chief claim to fame is an allegorical figure representing the art of painting (Florence: Sta Croce), executed for MICHELANGELO's catafalque.

LORENZO DA VITERBO (ca. 1437–1476). Italian eclectic painter influenced by PIERO, GOZZOLI, MELOZZO and CASTAGNO, among others. His surviving masterpiece is a rather static fresco cycle in S. Maria della Verità, Viterbo.

LORENZO DI NICCOLO GERINI (fl. 1392–1411). Italian painter of the FLORENTINE SCHOOL and son (and probable pupil) of NICCOLO DI PIETRO GERINI. Influenced by SPINELLO ARETINO and LORENZO MONACO, he specialized in altarpieces painted in the tradition of GIOTTO.

LORENZO MONACO (Piero de Giovanni) (ca. 1370–1425). Italian painter of the FLORENTINE SCHOOL and a follower of GADDI who was also influenced by GHIBERTI and the INTERNATIONAL GOTHIC. In his known oeuvre, a

gradual change is discernible, from flat Trecento figures painted on gold grounds to a more naturalistic treatment and spatial awareness that anticipates the work of GENTILE DA FABRIANO.

LORJOU, BERNARD (1908–). A self-taught French expressionist painter whose work is characterized by crude forms and impacted textures.

LORRAINE (Géllée; Gelée), CLAUDE (also called **LeLorrain**) (1600–1682). A French landscape painter and etcher taught by Agostino Tassi, a mannerist landscape painter of no particular distinction, DERUET and, possibly, the Flemish painter Gottfried Wals. Although he attempted to embrace MANNERISM early in his career, a natural tendency toward harmonious tonal values and a sensitivity to atmosphere invested his works with a natural classicism. By ca. 1640 he had rid his work completely of mannerist devices and invested his intensely poetic Roman landscapes with a haunting light and dreamlike calm that summoned up a sense of loss for some never-to-be-recaptured Golden Age. His compositions, often with foreground elements silhouetted and made up of progressively lighter receding planes, convey a sense of vast distances and often are marked by radical assymmetry. His influence on later landscapists, particularly in England, was profound.

LOTTO, LORENZO (ca. 1480–1556). Italian eclectic painter trained with GIORGIONE and TITIAN in the workshop of GIOVANNI BELLINI. His works reflect the influence of his teacher and fellow students, along with CATENA, VIVARINI, BOTTICELLI, FRA BARTOLOMMEO, CORREGGIO, RAPHAEL and a host of other masters, possibly including DÜRER and HOLBEIN. Nonetheless, he always projected an intensely personal vision and, despite some unevenness, was a masterful stylistic synthesizer and a superb portraitist.

LOUIS (Bernstein), MORRIS (1912–1962). American nonobjective painter influenced by FRANKENTHALER. His work is characterized by overlapping veils of color stained into his canvases with no discernible brushstrokes and, on occasion, by irregular abutting vertical stripes of contrasting, "bleeding" color.

LOUTHERBOURG, PHILIPPE-JACQUES (1740–1812). French painter, theatrical designer and engraver. A pupil of CARLE VAN LOO and other, lesser painters, he is remembered chiefly for his romantic landscapes, battle scenes and elaborate stage machinery.

Claude Lorrain, *View of the Campo Vaccino, Rome,* Louvre, Paris.

George Benjamin Luks, *Hester Street,* Brooklyn Museum, New York.

LUCCA DI TOMME (1330?–after 1389). An Italian eclectic painter of the SIENESE SCHOOL, he is best known for his mastery of color.

LUCAS, DAVID (1802–1881). English reproductive mezzotint engraver who worked mostly for CONSTABLE.

LUCAS Y PADILLA, EUGENIO (1824–1870). Largely self-taught Spanish painter and imitator of GOYA.

LUCE, MAXIMILIEN (1858–1941). French painter and student under DURAN. In his best-known phase, he employed a modified form of POINTILLISM influenced by his friends PISSARRO and SIGNAC.

LU CHIH (1495–1576). Chinese painter, calligrapher and scholar renowned for his restrained, poetic landscapes and floral subjects.

LUINI, BERNARDINO (ca. 1480/90–1532). A Milanese imitator of LEONARDO, he was immensely popular in his time, particularly for his Madonnas.

LUKS, GEORGE BENJAMIN (1867–1933). American painter, teacher and illustrator trained in Düsseldorf. A member of THE EIGHT, he was influenced by FRANS HALS and HENRI and is best known for his lively depictions of New York's Lower East Side and for portraits distin-

guished by virtuoso brushwork but often marred by structural looseness, sentimentality and an irritating tendency toward glibness.

LURÇAT, JEAN (1892–1966). French tapestry designer and painter. His tapestries, the finest produced in modern-day France, are distinguished by their strongly stylized imagery and rich, harmonious color.

LUXOR. Site, in Egypt, of the ruins of the Theban temple of Amun, built by Amenhotep III (1411–1375 B.C.) and altered by Rameses II. Surviving elements include a fragmentary double row of massive columns, heroic statuary and relief sculptures of unusual documentary interest.

LUYKEN, JAN (1649–1712). Dutch draftsman, printmaker, painter and literary figure best known for his etched illustrations for his own writings.

LYSIPPUS (fl. 2nd half of 4th century B.C.). Greek sculptor cited by Pliny for his innovative use of proportion, convincing naturalism and an imaginative use of composition that did away with the simple frontality of the preceding tradition. The *Farnese Hercules* (Naples: National Museum) is believed to be a creditable Roman copy of one of his works.

M

MABUSE. See JAN GOSSAERT.

MACDONALD-WRIGHT, STANTON (1890–1973). A pioneer American abstract painter and the chief exponent of Cubist-oriented SYNCHROMISM. Trained in France, he was successively influenced by the Dutch masters, the BARBIZON SCHOOL and IMPRESSIONISM before turning to CUBISM and, with MORGAN RUSSELL, founding the synchromist movement. In his richly chromatic abstractions, he attempted to paint "pure" form, using an elaborate system of color derived from a variety of theories. From the 1920s onward, he painted representationally.

MACHADO DE CASTRO, JOAQUIM (1731–1822). Portuguese sculptor best known for his monumental equestrian portrait of Joseph I in Lisbon.

MACHIAVELLI, ZANOBI (1418–1479). An Italian painter of the FLORENTINE SCHOOL and pupil of GOZZOLI. His somewhat eclectic style derived chiefly from FRA FILIPPO LIPPI.

MacIVER, LOREN (1909–). American figurative painter best known for her poetic interpretations of urban life.

MACKE, AUGUST (1887–1914). A German expressionist painter, associate of KLEE and a founder of the BLUE RIDER. His work derives from CUBISM and from the color theories of DELAUNAY.

McKIM, MEAD AND WHITE. American architectural firm of Charles Follen McKim (1847–1909), William Rutherford Mead (1846–1928) and Stanford White (1853–1906). Their eclectic collective style, made up of complementary individual styles, was characterized by great elegance and sophistication and derived in large part from HENRY HOBSON RICHARDSON, under whom both McKim and White had worked. Their more notable surviving buildings include the Public Library, Boston, modeled on the Bibliotheque Ste. Geneviève, Paris (see LABROUSTE); the Villard houses, New York, which derive from BRAMANTE and are considered the finest American interpretation of the Italian Renaissance style; the Morgan Library, New York; and the Isaac Bell House, Newport, Rhode Island, an outstanding example of the American shingle style.

MACKINTOSH, CHARLES RENNIE (1868–1928). Scottish architect and designer of the international modern movement whose work to some extent anticipated that of LE CORBUSIER in its insistence on undecorated functionalism.

MACLISE, DANIEL (1811–1870). An Irish academic painter and caricaturist. His literary and historical subjects were much admired in his day, but he is now best remembered for his caricatures.

MacMONNIES, FREDERICK (1863–1937). An American sculptor and student of SAINT-GAUDENS, he is best known for his technically proficient but rather superficial public monuments.

MADERNO (Maderna), CARLO (1556–1629). Perhaps the outstanding Italian architect of the early BAROQUE, he began his career as an assistant to his uncle DOMENICO FONTANA. His façade for Sta. Susanna, Rome, is generally considered the earliest Baroque façade. His other works include the reworking of MICHELANGELO's design for ST. PETER's, to which he added a technically ingenious but much criticized nave and façade.

MADRAZO Y AGUDO, JOSÉ DE (1781–1859) and MADRAZO Y KUNTZ (1815–1894). Spanish father-and-son painters. The elder studied with J.-L. DAVID, adopted his teacher's NEOCLASSICISM and, as director of the Prado Museum, was a powerful figure in Spanish "official" art. His son, also a director of the Prado, was a student and mediocre follower of INGRES.

Carlo Maderno, Palazzo Mattei di Giove, interior courtyard, Rome.

Réné Magritte, *The Signs of Evening*, Claude Spaak Collection, Paris.

MAES, NICOLAES (1634–1693). Dutch painter of genre, and history subjects and portraits and pupil of REM-BRANDT, in whose manner he worked during the early phases of his career, before his warm brown tones gave way to a coller, more indicudualistic palette and his style took on characteristics derived from CAREL FABRITIUS, DE HOOGH and VAN DYCK.

MAFFEI, FRANCESCO (early 17th century–1660). Italian painter influenced by PAOLO VERONESE and TIN-TORETTO.

MAGGIOTTO, FRANCESCO (1750–1805). Italian eclectic painter influenced by LONGHI and TIEPOLO, among others.

MAGNASCO, ALESSANDRO (1667–1749). Italian visionary painter known for his melodramatic landscapes, galvanic compositions, agitated figures and curiously etiolated light. His characteristic late works are marked by staccato, eerily highlighted surfaces painted in thick impasto and by the enigmatic nature of elongated figures that often play anomalous roles in his ostensible genre pictures.

MAGNELLI, ALBERTO (1888–). Italian abstract painter influenced by CUBISM, FUTURISM and, particularly, by LÉGER.

MAGRITTE, RÉNÉ (1898–1967). Belgian painter and one of the foremost exponents of SURREALISM, a movement he joined in 1925 after a brief flirtation with IMPRESSIONISM and to which he brought a personal, at once highly cerebral and poetic style that had little in common with the doctrinaire concepts of automatism advanced by BRETON. His clearly painted canvases constantly probe questions of reality and illusion, often incorporating mutually exclusive elements (e.g., night and day) into a single setting.

MAIANO, BENEDETTO DA (ca. 1442–1497), **GIOCANNI DA** (1438–1478) and **GIULIANO DA** (1432–1490). Italian sculptors, architects (except Giovanni), decorators, brothers and associates. Benedetto was a technically able carver of portraits notable for their fine detail, while Giuliano was primarily an architect influenced by BRUNELLESCHI and ALBERTI. The brothers

maintained an active workshop celebrated for its intarsia, or inlay work.

MAILLOL, ARISTIDE (1861–1944). French sculptor. After starting out as a tapestry maker and painter, he turned to sculpture when his eyesight became impaired. Although admired and aided by RODIN, he reacted against the older artist's volatile silhouettes and surfaces, seeking instead the solidity and monumentality of the Greeks. With rare exceptions, his works represent nude females of much the same type his friend RENOIR preferred to paint—sturdy, big-boned, unemotional country women with pillarlike limbs and full, firm torsos. He was also a woodcut illustrator of note and an occasional lithographer.

MAINARDI, SEBASTIANO (Sebastiano di Bartolo) (ca. 1460–1513). Italian painter and pupil and assistant of his brother-in-law DOMENICO GHIRLANDAIO, in whose manner he worked.

MAINO (Magno), JUAN BAUTISTA (1578–1649). Spanish painter trained in Italy, possibly under RENI and ANNIBALE CARRACCI. Influenced by VELAZQUEZ, he developed a naturalistic style resembling that of CARAVAGGIO.

MAINZ CATHEDRAL. Largely ROMANESQUE German church begun in the reign of Otto II (973–983), destroyed by fire on the day of its dedication in 1009 and rebuilt during the period 1060–1239. Notable for the symmetry of its silhouette and the apses at both its ends, it is surmounted by a somewhat incongruous octagonal crossing tower and stair towers that flank its eastern apse.

MAISON CARÉE. Roman Corinthian temple in Nîmes, southern France, built during the reign of Augustus in the late 1st century B.C. and noteworthy for its purity of design, the felicity of its proportions and its excellent state of preservation.

MAITANI, LORENZO (ca. 1275–1330). Sienese sculptor and architect who worked on the Siena Cathedral and, as *capomaestro* of Orvieto Cathedral, designed a façade influenced directly by GIOVANNI PISANO but quite innovative in its own right.

MALEVICH, KASIMIR (1878–1935). Russian abstract painter generally credited with the first completely geometric compositions and the founder of SUPREMATISM. His work, inspired by CUBISM during a sojourn in Paris, is characterized by its rigorous restraint and by its astonishing variety despite a severely limited vocabulary of forms. His composition *White on White* (New York: Museum of Modern Art) generated considerable notoriety when it first went on public view in the U.S.

MALOUEL, JEAN (fl. 1396–1415). A Flemish painter who enjoyed the patronage of Philip the Bold of Burgundy, he was an uncle of the LIMBOURG BROTHERS, and one of the two existing works ascribed to him with relative certainty, a *Pietà* (Paris: Louvre), represents one of the

earliest known uses of the tondo format. Stylistically, his work synthesizes Flemish, Byzantine, Italian and French court tendencies.

MANDER, KAREL VAN (1548–1604). A Flemish Italian-ate mannerist painter and writer best known as a biographer of Netherlandish artists, he was a founder, with GOLTZIUS and CORNELIS VAN HAARLEM, of an academy in Haarlem.

MANESSIER, ALFRED (1911–). A French abstract painter and stained-glass designer. His mosaiclike patterns are imbued with manifest religiosity.

MANET, EDOUARD (1832–1883). French painter. One of the salient figures in 19th-century art, he was also the most controversial painter of his generation and a major force in the development of IMPRESSIONISM.

A not altogether worshipful pupil of the academician COUTURE, he was decisively influenced by VELAZQUEZ, GOYA, FRANS HALS and, to a lesser extent, MURILLO and RIBERA, whose works he studied and in some cases copied at the Louvre. From the outset of his career he was

Edouard Manet, *Olympia*, Louvre, Paris.

a *bête noir* in official circles, first by submitting to the 1859 Salon a Velazquez-derived picture whose subject, an *Absinthe Drinker* (Copenhagen: Ny Carlsberg Glyptothek), offended the delicate sensibilities of the judges. Four years later his *Déjeuner sur l'herbe* (Paris: Louvre), a modern-dress (and undress) synthesis of two Renaissance works, scandalized both Salon judges and a general public that flocked to view it at the Salon des Refusés, or rejects' exhibition. Whether both injured parties objected more to the fraternization of a casually nude female with two soberly clad gentlemen in what appeared to be a public park, or to the flat, unmodulated light, tactless naturalism and sketchy arrogance of the execution, is a moot point. In any event, Manet again incurred the wrath of the public in 1865 with *Olympia* (Louvre), another starkly contemporary version of an earlier masterpiece, TITIAN's *Urbino Venus*. At about the same time he became the central figure in a group of young nonconformist painters who were soon to forge the Impressionist style. (While he never formally associated himself with the movement—whose adherents were nonetheless known as "Manet's gang"—he and they were sources of pro-

found reciprocal influences.)

Manet's oeuvre ranges from the sober, dark-toned depictions of Spanish subjects of his early period to such late, light-drenched works as *Bar at the Folies-Bergère* (London: Courtauld Institute), in which objects tend to dissolve into abstract forms. Throughout his career, however, he was a champion of pictorial integrity and a traditionalist at heart who might have infused new life into the official art that consistently spurned his advances.

MANFREDI, BARTOLOMMEO (ca. 1580–ca. 1620). An Italian painter and imitator (and perhaps forger) of CARAVAGGIO, he specialized in genre scenes featuring drunkards, gamblers and the like.

MANSART, FRANÇOIS (1598–1666). French architect and the most eminent exponent of CLASSICISM in France in the 17th century. After studying with his brother-in-law Germain Gaultier, he probably worked under DE BROSSE, whose influence can be found in his first major commission, the façade of the church of the Feuillants, Paris, and, in a more thoroughly realized way, in the Chateau of Balleroi, which he built while still in his twen-

ties. His Hotel de la Vrillière, Paris, set the style for French townhouses, and his reworking of the Chateau of Blois, although not completed, is considered a landmark of the classical style. He was not, as is widely held, the originator of the mansard roof.

MANSART, JULES HARDOUIN- (1646–1708). French architect and relative by marriage of FRANÇOIS MANSART, whose surname he incorporated into his own. Like his great-uncle, he won early recognition and at age 27 was architect to the king at VERSAILLES, for which he devised the final plan, which included extensive additions to the palace proper, the new stables, Orangerie and Trianon. His public works in Paris included designs for the Place Vendôme and Place des Victoires, along with the chapel of Les Invalides. Stylistically, his works are BAROQUE enrichments of his great-uncle's CLASSICISM.

Edouard Manet, *The Balcony,* Louvre, Paris.

MANSHIP, PAUL HOWARD (1855–1966). American figurative sculptor whose *rétardataire* public monuments enjoyed a vogue early in the 20th century but are no longer taken seriously.

MANSUETTI, GIOVANNI (fl. 1485–1527). Venetian painter and pupil of GENTILE BELLINI, with whom he collaborated and whom he emulated with indifferent success.

MANTEGAZZA, ANTONIO (fl. from 1470s; d. ca. 1489) and **CRISTOFORO** (fl. from 1460s; d. 1482). Italian sculptors, brothers and goldsmiths best known for their reliefs on the façade of the Certosa, Pavia.

MANTEGNA, ANDREA (1431–1506). Italian painter and engraver, pupil of SQUARCIONE and the most influential figure in the northern Italian art of his time and for years thereafter. A precocious artist, he was a certified master at 17, when he received his first important commission (now lost). Influenced by JACOPO BELLINI, CASTAGNO and DONATELLO, he also drew heavily on Classical antiquity, a subject on which he was one of the reigning experts of his era. The first practitioner of the extreme use of illusionistic perspective known as *sotto in sù* (a device subsequently left unexplored until the time of CORREGGIO and unexploited until the BAROQUE), he forged a style distinguished by great restraint, scholarly accuracy, scientific logic, spatial verisimilitude and sculptural modeling (modeling, incidentally, so monumental that VASARI referred to his "stony manner"). His influence is particularly evident in the works of his brother-in-law, GIOVANNI BELLINI, and was felt as far afield as the north of Europe, where it affected painters as early as DÜRER and as late as POUSSIN.

MANUEL, NIKLAUS (ca. 1484–1530). Called Deutsch, he was a Swiss painter, designer, printmaker, poet and politician. His most renowned work, a *Dance of Death* painted for a Dominican cloister at Bern, is known only through drawings.

MANZÙ, GIACOMO (1908–). Italian figurative sculptor, largely self-taught but influenced by the works of DONATELLO, RODIN, ROSSO and MAILLOL. He is best known for seated women and girls and figures of Catholic cardinals. His most important commission has been the relief decorations for the fifth bronze door of ST. PETER'S. His influence is markedly evident in the work of the American sculptor GALLO.

MARATTA (Maratti), CARLO (1625–1713). An Italian painter and pupil of SACCHI, whose RAPHAEL-influenced grand manner provided the basis for his early style. His later, more BAROQUE works derive in part from CORTONA.

MARC, FRANZ (1880–1916). A German expressionist painter, chiefly of animal motifs, he was an associate of MACKE and KANDINSKY in the BLUE RIDER. Just before his death at Verdun his style became more abstract under the influence of DELAUNAY.

MARCA-RELLI, CONRAD (1913–). American painter best known for semiabstract works composed of overlapping shapes cut from canvas.

MARCILLAT, GUGLIELMO DI PIETRO DE (ca. 1470–1529). Franco-Italian painter and stained-glass designer influenced by various High Renaissance masters and best known for his windows in the nave vaults of Arezzo Cathedral.

MARCKS, GERHARD (1889–). German figurative sculptor who combined a restrained EXPRESSIONISM with the neoclassical tradition to produce a somewhat sentimental personal style.

MARCOUSSIS (Markous), LOUIS (1878–1941). Polish-born French painter and engraver and an early exponent of CUBISM.

MAREES, HANS VON (1837–1887). A German landscape painter who spent the major part of his career in Italy, where he executed his best-known work, a mural cycle in a style similar to that of PUVIS DE CHAVANNES (Naples: Zoological Station).

MARESCALCHI, PIETRO DEI (ca. 1520–1589). Italian eclectic painter known for his loosely delineated, somewhat impressionistic portraits and religious subjects.

MARGARITONE (Margarito) D'AREZZO (fl. from ca. mid-13th century; d. 1275 or thereafter, possibly as late as 1293). One of the earliest Italian painters by whom signed works survive. His style was eclectic, with Byzantine, Florentine and Sienese formulas dominant.

MARIESCHI, MICHELE (ca. 1710–1743). Italian view painter and etcher influenced by CANALETTO.

MARIN, JOHN (1870–1953). An American painter best known for his semiabstract, somewhat expressionistic watercolor landscapes, he was a leader of the avant-garde in the United States in the early 20th century.

MARINI, MARINO (1901–). Italian figurative sculptor best known for his equestrian subjects, which derive from Chinese sculptures of the Han dynasty and from archaic Greek art. He is also a painter and printmaker.

MARISOL (Marisol Escobar) (1930–). An American sculptor born in Paris of Venezuelan parentage. Her characteristic works—often groups of figures or repeated images—are somewhat sardonic commentaries on contemporary life, usually made up of simple blocklike forms onto which drawn, painted or cast elements are superimposed.

MARLOW, WILLIAM (1740–1813). An English painter of French and Italian landscapes, he was very popular in his lifetime but since has been largely forgotten.

MARQUET, ALBERT (1875–1947). A French painter and pupil of MOREAU, he was associated with FAUVISM for a time, but his characteristic style is a modified form of IMPRESSIONISM marked by bold contours and flat, unbroken color. He is known best for harbor scenes observed from above.

MARSH, REGINALD (1898–1954). American painter and etcher of genre subjects. Taught by SLOAN and LUKS and influenced by RUBENS and DELACROIX, he is best known for almost BAROQUE depictions of the working classes at play.

Andrea Mantegna, *The Family of Lodovico Gonzaga,* Ducal Palace, Mantua.

Masaccio, *The Banishment from the Garden of Eden*, Brancacci Chapel, Church of the Carmine, Florence.

MARSHALL, BENJAMIN (1767–1835). An English painter of, and writer on, racing subjects. His style derives from STUBBS.

MARTIN, HOMER DODGE (1836–1897). An American landscape painter influenced by the BARBIZON SCHOOL artists and by WHISTLER. His works are characterized by a judicious use of color and a pervasive tranquility.

MARTIN, JOHN ("Mad") (1789–1854). An English visionary history painter who specialized in vast melodramatic canvases in which minute figures performed in fantastic architectural settings or apocalyptic landscapes. He was a minor influence on the ROMANTIC movement.

MARTINI, ARTURO (1887–1947). Italian sculptor of somewhat stylized figures based on antique sources.

MARTINI, SIMONE. See **SIMONE MARTINI.**

MARTORELL, BERNARDO (d. ca. 1452). Spanish painter, possibly of Flemish origin and certainly trained or influenced in Flanders; the earliest known Spanish painter so influenced.

MASACCIO (Tommaso Cassai; Tommaso di Ser Giovanni di Mone) (1401–1428). Florentine painter. Despite his abbreviated career and sparse surviving oeuvre, he is considered the first great painter of the Renaissance and one of the salient figures in 15th-century art. Influenced by the spatial concepts of BRUNELLESCHI and the innovative reliefs of DONATELLO, his fresco *Trinity with Donors* (Florence: S. Maria Novella)—one of four works ascribed to him with certainty—marks the earliest systematic use of perspective in painting—a development that was to revolutionize that art. Masaccio's modeling also derives in part from Donatello, as does his naturalistic, highly structural treatment of the human figure and his integration of the figure into a large context. His other major influence was GIOTTO, from whom his stately rhythms and orderly, classical compositions derive, and his other major contributions were his advancement of the use of light to define form and his espousal of humanism at a time when the INTERNATIONAL GOTHIC style prevailed. He stands in art history as the link between Giotto and MICHELANGELO.

MASANOBU (Okumura Masanobu) (1686–1764). A Japanese printmaker of the early UKIYO-E movement, he was known for his use of new techniques, formats and theories, the adoption of European perspective and his consummate craftsmanship.

MASEGNE, JACOBELLO (d. 1409) and **PIEPAOLO DALLE** (d. ca. 1403). Italian sculptors, brothers and collaborators who worked in the late Venetian GOTHIC style.

MASIP, JUAN VICENTE, THE ELDER (1495–ca. 1550). Spanish painter and father of JUAN DE JUANES. Possibly

André Masson, *The Bird Hunt,* private collection, Paris.

trained or directly influenced in Italy, he is known for a single major work, an altarpiece (Segorbe Cathedral) characterized by its emphatic use of diagonals.

MASO DI BANCO (fl. 2nd quarter of 14th century). Italian painter of the FLORENTINE SCHOOL and GIOTTO's most gifted pupil and follower. Much admired by GHIBERTI and others for his stately volumes, deep space, dignified severity, and firm contours, he influenced MASACCIO and PIERO DELLA FRANCESCA.

MASOLINO (Masolino da Panicale; Tommaso di Cristoforo Fini) (1383–1447?). Italian painter who worked more or less in the INTERNATIONAL GOTHIC style except during a brief period when he worked under and was influenced by MASACCIO. His work, though generally strong, is marred by its vacillation between flat decoration and a more volumetric approach.

MASON LIMNER (fl. 2nd third 17th century). Anonymous American primitive portraitist of the Mason family of Quincy, Massachusetts. His two known works are characterized by their flat decorative quality.

MASSON, ANDRÉ (1896–). French painter, printmaker and illustrator who, after associations with CUBISM and SURREALISM, developed an intensely personal mythology and an iconography made up largely of insect forms. Although his characteristic works are charged with energy, one phase of his career was devoted to landscapes marked by an almost Oriental serenity.

MASTER BERTRAM (Bertram von Minden) (fl. ca. 1370–1415). Anonymous German painter active in Hamburg and renowned for his naturalism.

MASTER E. S. (fl. ca. 1450–1468). Anonymous German printmaker and goldsmith and the leading engraver of his time. Prolific and innovative, he was influenced by Netherlandish painting and achieved a naturalism unprecedented in German printmaking and important for its influence on SCHONGAUER.

MASTER F.V.B. (fl. ca. 1480–1499). Flemish printmaker influenced by MASTER E. S., SCHONGAUER, BOUTS and MEMLING.

MASTER FRANCKE (fl. early 15th century). Anonymous German painter and a leading exponent of the INTERNATIONAL GOTHIC style in Germany. Influenced by French manuscript illumination, he in turn exerted considerable influence on north German art.

MASTER I. A. M. OF ZWOLLE (fl. last quarter of 15th century). Anonymous Dutch engraver influenced by SCHONGAUER and contemporaneous Dutch master painters and known for his earthy realism.

MASTER OF FLEMALLE (ca. 1375–1444). Flemish painter of uncertain identity believed by many to have been Robert Campin, who numbered ROGIER VAN DER WEYDEN and JACQUES DARET among his pupils. To com-

plicate matters further, some speculation has it that the Master of Flemalle is none other than the young Rogier. Whomever he may have been, he was certainly one of the—and perhaps *the*—first of the great Netherlandish masters. With his chronological place in art history uncertain, it is impossible to tell whether he influenced or was influenced by those artists he most resembles, but a kinship between his work and Flemish manuscript illumination seems obvious. His known works are characterized by their expressiveness and plasticity.

MASTER OF MOULINS (fl. last quarter of 15th century). Anonymous painter, probably Franco-Flemish, of a triptych representing the *Madonna with Saints and Donors* (Moulins Cathedral). Certain other works have been ascribed to the same hand on grounds of stylistic affinity and are distinguished by their clarity of color and sculptural plasticity.

MASTER OF THE AMSTERDAM CABINET (Master of the Housebook) (fl. last quarter of 15th century). Anonymous German painter and engraver whose lively drypoint engravings influenced DÜRER.

MASTER OF THE BARBERINI PANELS (Giovanni Angelo de Antonio da Camerino) (fl. 3rd quarter of 15th

Henri Matisse, *The Odalisque in Red Trousers,* National Museum of Modern Art, Paris.

century). Recently identified Italian painter whose style derives from FRA FILIPPO LIPPI and VENEZIANO.

MASTER OF THE PLAYING CARDS (fl. mid-15th century). Anonymous early German engraver and possible associate of the printer Gutenberg. He was esteemed for his draftsmanship. His known oeuvre consists of 60 engraved playing cards.

MASTER OF THE ROHAN HOURS (fl. 1410–1430). Anonymous French illuminator of *Les Grandes Heures de Rohan* (Paris: National Library), a work renowned as one of the glories of the INTERNATIONAL GOTHIC style and surprising for the degree of its expressivity.

MASTER OF THE VIRGO INTER VIRGINES (fl. 3rd quarter of 15th century). Anonymous Dutch painter known for his fervent depictions of gaunt figures in desolate landscapes and for the Oriental headdresses worn by the women in his pictures.

MATHIEU, GEORGES (1921–). French abstract painter known for his looping skeins of paint, squeezed directly from the tube onto light monochromatic grounds.

MATISSE, HENRI EMILE (1869–1954). French painter, sculptor, draftsman, lithographer, collagist and illustrator. One of the giants of 20th-century art and leader of its first revolutionary movement, FAUVISM, he studied under BOUGUEREAU and MOREAU and, independently, as

a copyist at the Louvre. After working in a dark, old-fashioned style, he brightened his palette and boldly simplified his forms after exposure to works by CÉZANNE and the post-impressionists and to African scupture and Near Eastern art, producing pictures that were shown publicly in 1905, when they and canvases by like-minded painters were dubbed the works of "wild beasts."

In his insistence throughout his career on the supremacy of color, Matisse spearheaded an aesthetic that proved to be the most viable alternative to CUBISM developed in the 20th century. Like DELACROIX before him, he traveled to the Near East. Unlike Delacroix, however, he allowed not only the content but the form of his work to be altered by what he saw there, thenceforth giving far greater emphasis to sinuous arabesques, stunningly vibrant colors and the flat decorative patterns of Oriental mosaics.

As a sculptor, Matisse was influenced by and reacted against the work of RODIN. Unlike Rodin's, his bronzes tend to be stolid, compact and structurally simple, resembling the forms of African tribal effigies despite their elaborately modulated surfaces. As color was paramount in his view of painting, so form was for him the be-all and end-all of sculpture. In both mediums, his approach was

Henri Matisse, *Flowers and Pottery,* Thompson Collection, Pittsburgh.

at once passionate, logical and quintessentially Gallic. He was a superb draftsman, incomparable colorist and masterful decorator and his last major work, the complete decoration of the Vence Chapel, down to its last liturgical appurtenance, is the summation of the joyous use he made of the plastic media during his long, distinguished career.

MATTA (Roberto Sebastian Antonio Matta Echaurren (1912–). A Chilean-born painter of Franco-Spanish parentage, he has combined SURREALISM with a Freudian-derived vocabulary of machinelike abstract forms to create a system of imagery that ranks among the most original ever developed. In his pictures, enigmatic but vaguely threatening products of an other-worldly technology seem to perform indeterminate, somewhat erratic and highly agitated functions while moving through space that is palpably charged with energy.

MATTEO DI GIOVANNI (ca. 1435–1495). Italian painter and a leader of the SIENESE SCHOOL probably taught and certainly influenced by VECCHIETTA. His style, decorative and basically linear, also was influenced by POLLAIUOLO.

MATTEO GIOVANETTI DA VITERBO (ca. 1300–1368). An Italian painter influenced by SIMONE MARTINI and best known for his monumental frescoes in the former Papal Palace at Avignon.

MAULBERTSCH, FRANZ ANTON (1724–1796). Austrian fresco painter of decoratively handled religious subjects and etcher.

MAURER, ALFRED HENRY (1868–1932). An American painter best known for Cubist still lifes and a compulsive cycle of portraits of a young woman with exaggeratedly large eyes and a swanlike neck.

MAUVE, ANTON (1838–1888). A Dutch landscapist influenced by the BARBIZON SCHOOL painters and by DAUBIGNY.

MA YUAN (fl. early 13th century). A Chinese court painter of the Southern Sung dynasty, he specialized in landscapes with figures and was celebrated for unorthodox compositions in which incident and landscape elements are crowded into one sector of the picture surface, with forms and ground held in a kind of yin-yang equilibrium. He belonged to a notable family of painters.

MAZO, JUAN BAUTISTA MARTINEZ DEL (1614–1667). Spanish painter and student and son-in-law of VELAZQUEZ, whom he succeeded as court painter. Basically a genre painter, he also executed landscapes in the manner of CLAUDE LORRAINE.

MAZZONI, SEBASTIANO (ca. 1611–1678). An Italian painter and poet known for his highly original treatment of mythological themes. His pictures are characterized by a nervous intensity expressed in swirling rhythms and coruscations of light.

MEADMORE, CLEMENT (1929–). An Australian exponent of MINIMAL SCULPTURE whose characteristic works resemble elongated black coffins twisted into loops and knots.

MECKENEM, ISRAEL VAN (before 1450–1503). A German engraver and goldsmith and pupil of MASTER E. S., he is known principally as a copyist.

MEDICI-RICCARDI PALACE. Renaissance palace in Florence, Italy, designed by MICHELOZZO for Cosimo de' Medici. Influenced by BRUNELLESCHI, it boasts an imposing façade and houses a number of important works of art, notably GOZZOLI's fresco *The Procession of the Magi.*

MEDINA, SIR JOHN BAPTIST (ca. 1657–1710). Brussels-born English portrait painter who worked in the manner of KNELLER.

MEER, VAN DER, FAMILY. Family of Dutch painters, of whom the most eminent members were Barent van der Meer (1659–1702), a specialist in still life; his father, Jan II (1628–1691), a landscapist influenced by RUISDAEL and KONINCK; and his brother Jan III (1656–1705), who painted genre and animal subjects and landscapes.

MEHRING, HOWARD (1913–). American abstract painter of the WASHINGTON COLOR SCHOOL and, early in his career, a precursor of the LYRICAL ABSTRACTIONISM of the early 1970s.

MEIDIAS PAINTER (fl. ca. 410–390 B.C.). Attic vase painter in the late red-figured style.

MEISSONIER, ERNST (1815–1891). French painter of meticulously detailed battle pictures and other military subjects.

MELANTHIUS (fl. 350–300 B.C.). Greek painter and aesthetic theorist known for his rejection of graceful forms.

MELOZZO DA FORLI (1438–1494). Italian painter and follower of PIERO DELLA FRANCESCA known for his use of extreme foreshortening in ceiling decorations.

MEMLING, HANS (ca. 1435–1494). German-born Flemish painter and probable pupil of ROGIER VAN DER WEYDEN. One of the most popular figures in Netherlandish painting of the later Middle Ages, he ran a highly successful and extremely prolific workshop in Bruges, where he became one of that city's most heavily taxed citizens. Stylistically, his work remained much the same throughout his career and is characterized by its superficial resemblance to Rogier and BOUTS—a resemblance limited by a total absence of compositional or expressive dynamism. Both his religious and mythological subjects have about them an almost trancelike placidity that reduces their protagonists to people much like the comfortable burghers he depicted in his portraits.

MEMMI, LIPPO (fl. 1317–1356). An Italian painter who worked in the manner of his brother-in-law, SIMONE MARTINI, whom he sometimes assisted.

Hans Memling, *Portrait of a Man,* Uffizi, Florence.

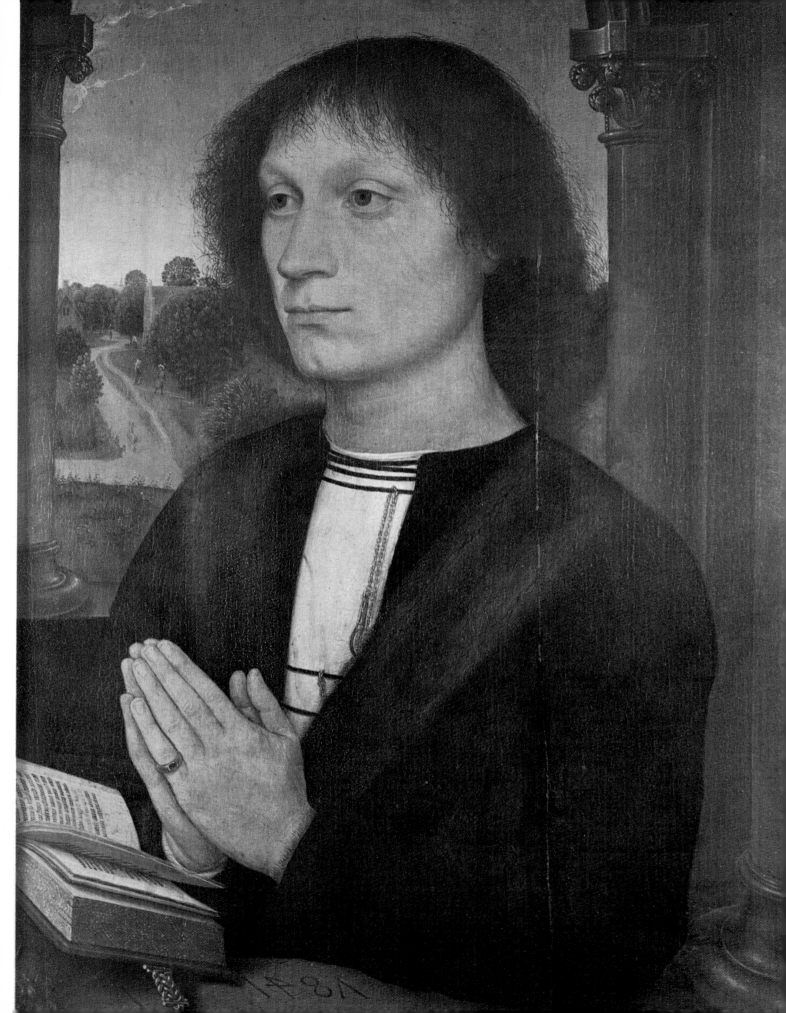

MENA (Mena Y Madrozo), PEDRO DE (1628–1688). A Spanish sculptor and pupil of CANO. His work is notable for its piety and its convincing treatment of mood.

MENDELSOHN, ERIC (1887–1953). German-born American architect known for expressionistic, curvilinear designs in which form took precedence over function.

MENDEZ, LEOPOLDO (1902–). Mexican muralist and printmaker best known for his highly expressive—and highly political—graphic works.

MENGS, ANTON RAPHAEL (1728–1779). A German painter and the leading exponent of NEOCLASSICISM in his generation, he was trained by his father, the Dresden court painter Ismael Mengs. Named for CORREGGIO and RAPHAEL, he was taken to Italy as a child prodigy who specialized in pastel portraits and there met the German art historian Winckelmann, whose Neoclassical theories deeply influenced him. While in Rome he executed his best-known work, *Parnassus* (Rome: Villa Albani), generally believed to be the first ceiling painting to eschew completely the BAROQUE illusionistic device called *sotto in sù*. Mengs' attempts to exploit Neoclassical theory were tentative at best, lacked the conviction that later motivated J.-L. DAVID and were more or less abandoned while he collaborated with TIEPOLO in Spain. He was also an accomplished portraitist and, as such, a major influence on GOYA.

MENZEL, ADOLF VON (1815–1905). A German painter and illustrator whose drawings were admired by DEGAS and whose paintings from nature, influenced by CONSTABLE, anticipate IMPRESSIONISM even though he scorned that style when it evolved in France. He is known best for his scenes from the life of Frederick the Great.

MEO DA SIENA (Meo di Guido da Siena) (fl. late 13th–early 14th century). Italian GOTHIC painter influenced by the BYZANTINE style and by DUCCIO.

MERCADANTE, LORENZO (fl. 1453–ca. 1475). Spanish sculptor, probably of Breton or English origin, influenced by Flemish realism and best known for his polychromed terra-cotta figures for the façade of Seville Cathedral.

MERIDA, CARLOS (1893–). Guatemalan-born Mexican abstract painter influenced in Europe by the leading SCHOOL OF PARIS painters and in Mexico by native Indian motifs and techniques. His characteristic forms are geometric and overlapping and his color is lively and pure.

MESA, JUAN DE (1586–1627). Spanish sculptor and pupil of MONTAÑES, in whose style he worked closely, although he sought greater expressivity toward the end of his short life.

MESHED. City in Khurasan province, northeast Iran, and site of the shrine-tombs of Caliph Harun al-Rashid (d. 809) and his successor, Ali al-Riza, and a vast complex of surrounding buildings, including the magnificent Gauhar Shad Mosque.

MESSERSCHMIDT, FRANZ XAVER (1736–1783). Austrian sculptor best known for agitated busts purporting to analyze human character but generally considered reflections of the artist's psychotic mentality.

MEŠTROVIĆ, IVAN (1883–1962). Yugoslavian figurative sculptor, political activist and teacher who worked in France, Switzerland, Italy and, finally, the U. S. His style derived from a variety of antique sources, including Greek, Roman, Medieval Slavic, Assyrian and Babylonian sculpture, and his more ambitious projects were carved directly in stone.

METSU, GABRIEL (1629–1667). Dutch genre, history and portrait painter. Probably a pupil of DOU, he was influenced by TER BORCH, DE HOOCH and, to a lesser extent, REMBRANDT and VERMEER.

METSYS (Matsys; Massys), CORNELIS (before 1508–after 1550) and **JAN** (ca. 1509–1575). Flemish painters and sons and pupils of QUENTIN MATSYS. Cornelis was an indifferent draftsman but had some talent for landscape. Jan excelled in genre subjects.

METSYS (Matsys; Massys), QUENTIN (1466–1530). A Flemish painter and father of CORNELIS and JAN METSYS, he was an unusual and highly expressive painter who did not hesitate to make use of stylistic anachronisms, satire, caricature and grotesque facial expression to convey mood and character. He made judicious use of Italian innovations and motifs, combining them with the detailed realism of earlier Netherlandish painting—the first such synthesis of the Medieval northern and Italian Renaissance styles and one that profoundly affected the further course of painting in the Low Countries.

METZINGER, JEAN (1883–1956). French Cubist painter and associate of GLEIZES, with whom he wrote *Du Cubisme* in 1912, the first book on the then new style that was to revolutionize modern art.

MEUNIER, CONSTANTIN (1831–1905). A Belgian painter, sculptor and printmaker whose naturalistic works were concerned for the most part with peasants and workers and who was influenced while in Spain by GOYA.

MEYER DE HAAN, JACOB (1852–1895). A minor Dutch painter and imitator of GAUGUIN, whom he assisted financially, he is remembered chiefly as the subject of one of the latter's most expressive portraits.

MICHEL, GEORGES (1763–1843). A French painter influenced by the Dutch BAROQUE landscapists, he was one of the first *plein air* painters and, as such, pointed the way to the BARBIZON SCHOOL.

MICHELANGELO BUONARROTI (1475–1564). Florentine painter, sculptor, architect and poet. One of the supreme geniuses of the Renaissance and, in the magnitude and variety of his achievements, probably the greatest artist who ever lived. His long career spanned and shaped an era that stretched from the last years of the early Renaissance through the High Renaissance and into MANNERISM, radically changed the status of the artist in society and served as the very embodiment of 16th-century humanism.

Michelangelo, *David*, detail of the head, Academy, Florence.

Born into the minor Florentine nobility, he was apprenticed at thirteen to the workshop of DOMENICO GHIRLANDAIO (where he probably learned little more than the rudiments of fresco techniques) and shortly thereafter was transferred to the school run by BERTOLDO DI GIOVANNI in the Medici gardens. There he soon came to the attention of Lorenzo de' Medici, under whose influence he absorbed the Neoplatonic ideas then in vogue in the Medici circle. With the death of Lorenzo and the political changes that followed, the artist left Florence, first for Bologna, then Rome, where he executed the work that won him recognition throughout Italy as a force to be reckoned with: his *Pietà* (Vatican: St. Peter's). His only signed work, it achieves an audacious solution to a perennial iconographical problem—the physical appearance of the Madonna at Christ's death—by conceiving her as sinless and, therefore, eternally young and beautiful. Just as imaginatively, it solved a compositional problem, representation of a full-grown man lying on the lap of a grieving woman, through a brilliantly conceived

Michelangelo, *Pietà*, St. Peter's, Rome.

pyramidal structure that seems to lock a variety of rather fragile forms into an elemental geometrical shape. Finished in the last year of the 15th century, it marks a culmination that sculptors had striven for since the century's beginning. This and a *Bacchus* of the same period also mark the culmination of Michelangelo's early sculptural style, which is characterized by a degree of finish and openness of form that were to be supplanted by more monumental conceptions, increasing convexity and a disdain for polished light-reflecting surfaces concerned with sculptural virtuosity.

On his return to Florence in 1501 Michelangelo was commissioned to create several sculptures and a major fresco. Of these, a single sculpture, the gigantic *David* (Florence: Academy) was completed and served as a metaphor for Florentine aspirations and self-esteem in particular and the Renaissance spirit in general. Carved from an eighteen-foot monolith abandoned by an earlier

OVERLEAF: Michelangelo, detail of the ceiling in the Sistine Chapel, Rome.

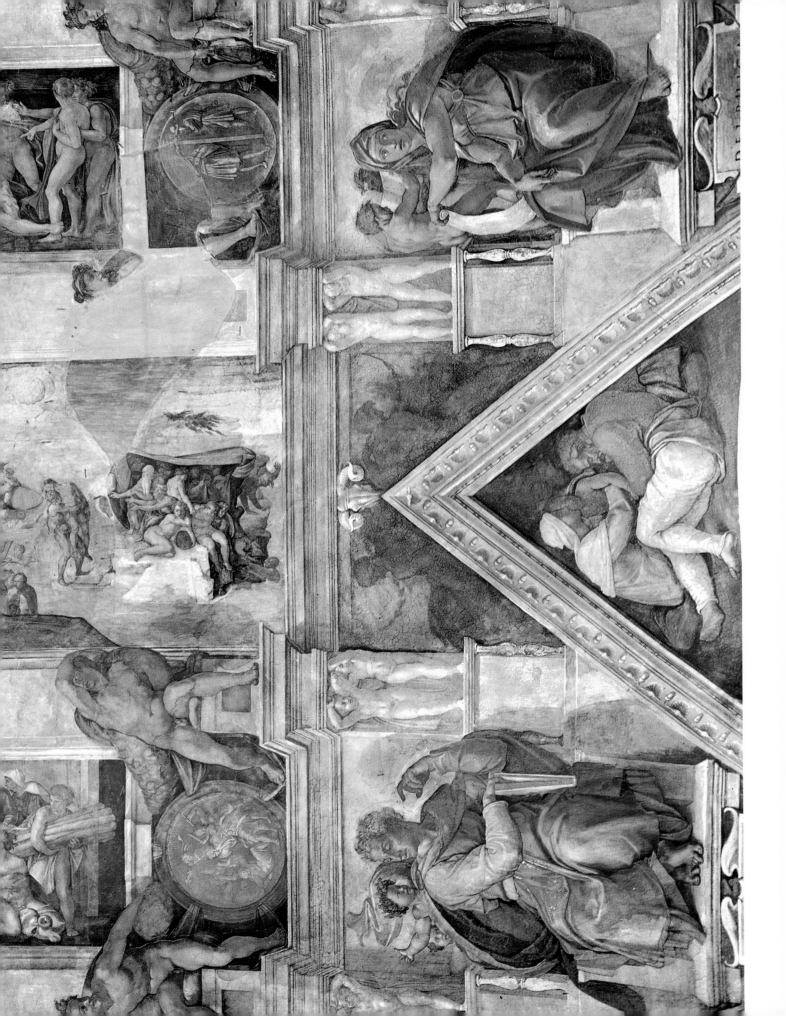

sculptor, it is a technical *tour de force* and aesthetic triumph—a work in which the manifest intelligence and bristling self-confidence of the subject reflect the same qualities in its author. Of the unfinished works of this period, the most significant historically was Michelangelo's share of a project for which he and LEONARDO were to make the major contributions and of which only fragmentary evidence survives. From this, it can be seen that the artist had by then determined that for him the unclothed figure was the ideal expressive vehicle and sufficient in itself to convey the entire range of human emotion—a determination that ultimately produced MANNERISM.

From 1505 to 1516, Michelangelo worked in Rome under the patronage of Pope Julius II, who originally had commissioned the artist to design a tomb for him and who hoped eventually to see Florence supplanted by Rome as the artistic capital of the world. The relationship between these two strong-willed men was stormy, and work on the tomb, frequently interrupted, was little more than an ongoing series of disasters (Michelangelo's heroic bronze of an enthroned Julius, for example, executed for the façade of S. Petronio, Bologna, was destroyed by the hostile Bolognese within three years of its unveiling), and the only element of the finished product actually carved by the artist is his figure *Moses*, although the monumental *Bound Slave* and *Dying Slave*, now in the Louvre, Paris, were among its projected components.

Despite the troubles Michelangelo experienced in Rome, Julius' patronage was to establish him as a universal genius, for it was the Pope who commissioned the artist's vast fresco cycle for the ceiling of the Vatican's SISTINE CHAPEL (although Julius hardly anticipated the magnitude of the finished project or the degree of control the artist ultimately was to exercise over its content)—the most awesome work of plastic art ever produced by the hand of one man working virtually alone and one that earned its creator the sobriquet *"il divino"* at a time when such giants as Leonardo and RAPHAEL walked the earth.

The Sistine decorations represent a complex Neoplatonic system open to a variety of arguable interpretations. Physically, they occupy a barrel vault divided into illusionistic "openings" by painted architectural elements—framing devices on which the nude figures of young male slaves perch in a variety of attitudes—and a number of mural frescoes. Scenes within the ceiling "openings" (which are of variable size) depict such Old Testament episodes as the Creation, Fall, Flood, and Drunkenness of Noah; the ancestors of Christ occupy window spandrels and lunettes, figures, prophets and sybils punctuate the action, and the whole comprises a writhing, muscular mass unprecedented in its scope, audacity of design and conveyance of energies that seem cosmic in their intensity and breadth. Stylistically, the work synthesizes the contributions of such earlier painters and sculptors as GIOTTO, MASACCIO, DONATELLO, CASTAGNO and POLLAIUOLO, while conceptually it stands alone as the manifestation of an artistic imagination—and a degree of creative energy—unprecedented and unsurpassed in the annals of human endeavor.

During the latter half of his long career Michelangelo (the first artist, incidentally, to be made the subject of biographies within his own lifetime) undertook a number of major sculptural projects (most notably the reclining figures symbolizing *Day* and *Night* in the Medici Chapel, Florence); produced a significant body of poetry; painted several frescoes, including a *Last Judgment* for the Sistine Chapel; and, after more or less inventing mannerist architecture, was awarded the most important architectural commission the Christian world could offer: completion of ST. PETER'S, which had progressed little since the death of BRAMANTE in 1514. Over the years, the confidence of his Florentine youth had been replaced by a profound pessimism and an increasing dependence on religion. ("Neither painting nor sculpture," he wrote, "can soothe the soul which is turned toward that Divine Love that opened, on the cross, His arms to embrace us.") Stylistically, his late works are somber, weighty, resigned and devoid of the twisting *contrapposto* that, in retrospect, seems symbolic of a time when men challenged fate and defied the human condition. Fittingly enough, his career ended with the artist at work on a *Pietà* (Milan: Sforzesco Castle), the theme of his first great triumph. Although unfinished, it represents the spiritual—as well as chronological—end of a long pilgrimage; virtuosity, verisimilitude, all forms of artistic vanity are abandoned in favor of an almost abstract spiritual intensity. Unfinished or not, it represents the culmination of an oeuvre so awesome that a new term, *terribilita*, was required to describe it.

MICHELOZZO (Michelozzo Michelozzi) (1396–1472). Florentine architect and sculptor and associate of GHIBERTI and DONATELLO. Commissioned by Cosimo de' Medici, his Rucellai Palace, Florence, with its central arcaded court, rusticated exterior and classical cornice, set the style for 15th-century palace design.

MIEREVELT, MICHIEL JANSZ (1567–1641). Dutch portrait painter to the princes of Orange. One of the most prolific artists of his time, he specialized in small, straightforward depictions of his sitters. He also produced mannerist history pictures earlier in his career.

MIERIS, FRANS JANSZ. VAN, THE ELDER (1635–1681). A Dutch painter, the outstanding pupil of DOU and father of WILLEM VAN MIERIS, he is best known for highly finished interiors.

MIERIS, WILLEM VAN (1662–1747). Dutch genre and portrait painter; son and pupil of FRANS VAN MIERIS THE ELDER, whose works he copied and style he emulated.

MIES VAN DER ROHE, LUDWIG (1886–1969). German-born American architect and designer. Celebrated for his dictum "More is less," he was director of the BAUHAUS in Dessau during the 1930s. His early buildings, influenced by DE STIJL, made much use of brick, but his mature manner is characterized by its judicious interplay of voids and solids, its economy of means and its use of rare and costly materials. He was generally considered the most influential architect of the mid-20th cen-

Jean-François Millet, *The Gleaners*, Louvre, Paris.

tury. His buildings include Tugendhat House, Brno, Czechoslovakia; National Gallery, West Berlin; Lakeshore Drive Apartments, Chicago; and (with PHILIP JOHNSON) the Seagram Building, New York.

MI FEI (1051–1107). A Chinese landscape painter, calligrapher and critic of the Sung dynasty, he was celebrated for his depictions of mist and for an antiacademic style whereby form was built up through an accumulation of minute dotlike washes. His son, MI YU-JEN, was a noted painter.

MIGNARD, PIERRE (Le Romain) (1610–1695). A French painter and pupil of VOULET, he is remembered chiefly for his lifelong rivalry with LE BRUN and as the chief exponent of a sycophantic style of portraiture that eventually came to bear his name.

MIJTENS (Mytens), DANIEL (ca. 1590–1647). A Dutch painter and probable pupil of MIEREVELT, he worked for a time in London, where he was the leading portraitist until the arrival there of VAN DYCK.

MILLAIS, SIR JOHN EVERETT (1829–1896). English painter and a founder, with HUNT and ROSSETTI, of the PRE-RAPHAELITE BROTHERHOOD. His works are characterized by acute observation of nature, sedulous delineation of detail, excessive sentimentality and psychological

vapidity. He was immensely popular in his day.

MILLARES, MANOLO (1926–1972). Spanish abstract painter known for his calligraphic brushwork on rough canvas which was often rent and stitched.

MILLER, ALFRED JACOB (1810–1874). American painter of meticulously rendered scenes of Indian life and tribal dignitaries.

MILLER, KENNETH HAYES (1876–1952). American painter and teacher known for his not altogether successful attempts to invest urban genre scenes with a Renaissance monumentality.

MILLES, CARL (1875–1955). A popular Swedish eclectic sculptor and protégé of RODIN, he is best known for mannered bronze public fountain groups that might best be described as profoundly shallow.

MILLET, JEAN-FRANÇOIS (1814–1875). French genre and landscape painter influenced by DAUMIER, Japanese art and THÉODORE ROUSSEAU. A principal member of the BARBIZON SCHOOL and of peasant stock himself, he is best known for such depictions of peasant labor as *The Sower* (Philadelphia: Museum of Art), *The Man with the Hoe* (private collection) and *The Gleaners* (Paris: Louvre). His sentimental canvas *The Angelus* was widely reproduced

Joan Miró, *Hand Catching a Bird*, Marie-Laure de Noailles Collection, Paris.

in the 19th century and his solidly structured, highly empathetic testimonials to honest toil influenced painters as stylistically disparate as VAN GOGH, SEURAT, PISSARRO and JOSEF ISRAELS.

MILLS, ROBERT (1781–1855). An American architect and engineer and a leading proponent of NEOCLASSICISM, he worked with JEFFERSON and LATROBE and claimed to be the first native-born U.S. architect. In some respects his bulky style anticipated the later notion that form follows function, and he was one of the earliest users of modular elements. As a government architect, he designed several public buildings in Washington, D.C.

MINIO, TIZIANO (1517–1552). Italian stucco decorator, sculptor and bronze caster who worked mainly in Venice, where he assisted SANSOVINO and executed some independent commissions.

MINO DA FIESOLE (1429–1484). Italian sculptor of the FLORENTINE SCHOOL best known for his spirited naturalistic portrait busts, especially one of Piero dé Medici (Florence: National Museum), believed to be the earliest Renaissance portrait bust in existence.

MIRÓ, JOAN (1893–). Spanish abstract painter, ceramist, printmaker and designer and a leading exponent of SURREALISM. A Catalan, he was trained in Spain but exposed early in life to the French avant-garde. His first works derive from CÉZANNE, VAN GOGH, FAUVISM and, less directly, Spanish music and poetry. From around 1923 onward he has worked in a strongly personal style that blends abstract, sinuously decorative and slyly whimsical figurative elements to achieve colorful, extremely decorative and nonetheless powerful fantasies that produce the evocative effects of most surrealist works while avoiding their narrow specificity. Of the major 20th-century painters, only KLEE has employed humor to a comparable degree, while perhaps only Matisse has conveyed as unabashed an enjoyment of sensuous arabesques and bold, decorative patterning. There is a manifest affinity between such ceramic murals as his wall for the UNESCO headquarters in Paris and certain public works by his fellow Catalan, GAUDÍ, but here as elsewhere Miró's style and formal vocabulary are unique.

MI YU-JEN (1086–1165). Chinese painter of the Southern Sung dynasty and son of the painter MI FEI, whose style he emulated.

MOCETTO, GIROLAMO (ca. 1458–ca. 1532). Italian engraver and painter influenced primarily by ALVISE VIVARINI.

MOCHI, FRANCESCO (1580–1654). An Italian sculptor of the early BAROQUE, he was the greatest sculptor in Rome until the advent of BERNINI. His *Annunciation* (Orvieto Cathedral) is probably the first Baroque sculpture

Amadeo Modigliani, *The Little Girl in Blue*, Netter collection, Paris.

created and has been likened to a fanfare that awoke the art from its long Medieval slumber.

MODERSOHN-BECKER, PAULA (1876–1907). A German painter influenced by GAUGUIN and other post-impressionists. Her abbreviated career was spent in relative obscurity, but her simplicity of form and color, decisiveness of contour and tendency to silhouette figure against ground herald the devices of later expressionists.

MODIGLIANI, AMADEO (1884–1920). Italian painter and sculptor who worked in Paris, where he lived and died in a notoriously dissolute style. After academic training in Italy, he absorbed a variety of influences that included BOTTICELLI, the Sienese primitives, MANNERISM, CÉZANNE, TOULOUSE-LAUTREC, CUBISM and AFRICAN SCULPTURE, forging them into a personal style characterized by glowing color, dry brushwork, elegance of contour and an insistent physicality (despite their considerable stylization, his nudes are as emphatically naked and heavily erotic as any in art, as the Paris police were quick to note before closing one of his exhibitions). As a sculptor, his major influences were BRANCUSI and African tribal carving, and while his output was limited it constitutes a distinctive body of works that, like his finest paintings, is at once sensitive and monumental.

Piet Mondrian, *Composition with Red, Yellow and Blue,* Alfred Roth Collection, Zurich.

MOHOLY-NAGY, LASZLO (1895–1946). A Hungarian-born American Constructivist painter, sculptor, designer and teacher, he was a pioneer in the use of 20th-century industrial materials and techniques, variable modular elements, kinetic sculpture and light in motion. His works are characterized by logic, clarity and impersonality. Associated at various times with SUPREMATISM, DE STIJL and DADA, he taught at the BAUHAUS and was a respected writer on aesthetics.

MOLA, PIER FRANCESCO (1612–1666). Italian painter and an influential figure in the development of the later BAROQUE.

MOLENAER, JAN MIENSE (ca. 1610–1668). A Dutch genre painter influenced (and possibly taught) by FRANS HALS. His pictures are much like those of JUDITH LEIJS-TER, his wife.

MOLIJN (Molyn), PIETER DE (1595–1661). A Dutch painter born in London of Flemish parents, he pioneered the realistic landscape style later developed more fully by RUYSDAEL and VAN GOYEN.

MOMPER, JOOST (Josse) DE, II (1564–1635). The leading member of a family of Flemish painters, he enlarged the landscape palette and influenced such later painters as TENIERS THE YOUNGER and SEGHERS.

MONDRIAN, PIET (1872–1944). A Dutch painter and singular figure in the history of 20th-century art. His rectilinear abstractions have brought about an appreciable change in the appearance of the modern world. After starting his career as a more or less academic landscapist, he responded with enthusiasm to avant-garde works he saw on trips to Paris in 1910 and 1912 and replaced his own style with one derived from a synthesis of CUBISM and FAUVISM, gradually reducing landscape elements to purely abstract forms while restricting, flattening and purifying his previously modulated color. A co-founder of DE STIJL in 1917, he had by then eliminated curved forms from his paintings and adopted an underlying grid structure, thereby creating the style he was constantly to refine but leave basically unchanged for the rest of his life. His characteristic works are rigorously precise but manage to avoid an appearance of austerity despite a palette restricted to black, white and the primary colors and a vocabulary of forms so restricted as to consist of a single basic module. Although his style constantly has been debased by imitators and entrepreneurs, it has had a deep and lasting effect on art, architecture and design throughout the Western world.

MONE, JEAN (Jean de Metz; Jean Lartiste) (ca. 1495–ca. 1550). Franco-Flemish sculptor who worked in Spain and Italy before settling in Flanders, where he radically modified the prevailing GOTHIC style through his introduction of Italianate forms and motifs.

MONET, CLAUDE (-Oscar) (1840–1926). French painter, the foremost exponent of IMPRESSIONISM and one of the salient artistic figures of the 19th century. After showing a precocious talent for caricature, he took up painting from nature with the encouragement of BOUDIN and later studied in Paris, where he befriended PISSARRO. After a summer spent painting with Boudin and JONGKIND, he returned to Paris, studied with GLEYRE and familiarized himself with the work of COURBET, COROT and MANET. He and RENOIR (whom he had met in 1862–1863, along with SISLEY and BAZILLE) painted together for some time before the outbreak of the Franco-Prussian War in 1870, at which time he traveled to London, where Pissarro joined him. Two years later he was back in France and, with Renoir, had worked out the essentials of Impressionism, a style whose derogatory name he inadvertently inspired with his 1872 *Impression, Sunrise* (Paris: Marmot-

Claude Monet, *Houses of Parliament,* Louvre, Paris.

Claude Monet, *Woman with Parasol*, Louvre, Paris.

tan Museum) and of which he was to become the purest adherent, as Cézanne acknowledged when he characterized him as "only an eye, but what an eye!"

Monet's—and Impressionism's—overriding aim was to capture on canvas optical data as received at a given moment (see IMPRESSIONISM). To this end, he painted several series of pictures in which a single scene or object (e.g., a haystack or a cathedral) is depicted from exactly the same viewpoint but in varying atmospheric circumstances, thereby demonstrating that the concept of optically apprehendable local color (i.e., the inherent, unaffected color of objects) was untenable. In his last years Monet, like TURNER (one of his major influences), tended to dissolve even the most vestigial traces of form in canvases saturated with pure light. This tendency culminated in a series of large paintings of water lilies—pictures that have been retrospectively hailed as precursors of ABSTRACT EXPRESSIONISM but that are neither abstract nor expressionistic, although both abstract and expressionistic painting existed by the time they were executed. Like Impressionism itself, Monet represented a reaction to an established style (the "official" style set by INGRES) and in turn served as a force against which a newer style (Cézanne's) could react. As such, his importance as a key link in the evolution of modern art cannot be overstressed.

MONNOYER, JEAN-BAPTISTE (1636–1699). Called simply "Baptiste," he was a French flower painter, decorator and engraver known for his botanical accuracy and sprightly style.

MONREALE CATHEDRAL. Church near Palermo, Sicily, built by King William II in the late 12th century and renowned for its splended cloister and the fusion of BYZANTINE and Western forms in its architecture and mosaic decoration, as exemplified by a magnificient depiction of Christ Pantocrator.

MONTAÑES, JUAN MARTINEZ DE (1568–1649). A Spanish sculptor, principally of religious figures in polychromed wood, whose somewhat ascetic naturalism is echoed in the paintings of ZURBARÁN.

MONTELUPO, BACCIO DA (1469–ca. 1535) and **RAFFAELE DA** (1505?–1566). Italian father-and-son sculptors and architects, of whom the younger assisted and was influenced by MICHELANGELO.

MONTICELLI, ADOLPHE (1824–1886). French painter, primarily of gentlefolk at leisure, known for his warmth and richness of color and heavy, sumptuous impastoes.

MONTICELLO. Home near Charlottesville, Virginia, designed by the American statesman THOMAS JEFFERSON (q.v.) for his own use.

Henry Moore, *The Family*, bronze, Museum of Modern Art, New York.

MONTORSOLI, GIOVANNI ANGELO (ca. 1507–1563). Italian mannerist sculptor who assisted MICHELANGELO, his principal influence, and is best known for elaborate fountain groups.

MONT SAINT-MICHEL. French fortified island-abbey off the Normandy coast. Part of the church's original ROMANESQUE nave survives, along with a number of ancillary buildings constructed during the 12th century and notable 13th-century GOTHIC cloisters.

MOOR, KAREL DE (1656–1738). Dutch portrait and genre painter and printmaker who studied with DOU and FRANS VAN MIERIS, among others.

MOORE, HENRY (1898–). The pre-eminent English sculptor of the modern era, he has produced both abstract and figurative work, some carved, some modeled and cast and some incorporating CONSTRUCTIVIST elements. Based largely on the art and artifacts of primitive cultures and on the forms taken by bones, fieldstones and the like, his style is notable for its energy and characterized by piercing—a development whereby Moore and HEPWORTH were able to add new dimensions to more or less conventional forms. He is also a painter and draftsman whose depictions of life during the World War II aerial bombardments of London combine great expressivity with a monumentality reminiscent of GIOTTO.

MOR, ANTHONIS (Antonio Moro) (1517/21–ca. 1577). Dutch portrait painter and pupil of SCOREL who became a court painter in Brussels and worked in Lisbon, Madrid and, possibly, London. Influenced by TITIAN, he characteristically worked some indication of his sitters' attributes into their portraits.

MORA, JOSE DE (1642–1724). A Spanish sculptor and pupil of CANO, he worked at the court of Charles II, where he produced decadent polychromed figures to which glass eyes, real hair, crystal tears, and the like added verisimilitude or did not, depending on the sophistication of the viewer.

MORALES, LUIS DE (ca. 1510–1586). Like MICHEL-ANGELO, this somewhat eclectic Spanish mannerist painter was called "the divine one." There the resemblance ended.

MORAN, THOMAS (1837–1927). An English-born American landscape painter and printmaker, he is known for vast landscapes full of windy rhetoric but was at his best in his less ambitious sketches.

MORANDI, GIORGIO (1890–1964). An Italian painter who, after brief flirtations with FUTURISM and metaphysical painting, evolved a highly personal, intensely poetic still-life style whereby simple forms and homely objects seem to convey subtle implications concerning human society.

MOREAU, GUSTAVE (1826–1898). French visionary painter who studied under and was influenced by CHASSERIAU. His art, primarily literary and not visual, is romantic in the extreme and concerns itself with prolix, heavily ornamented images derived from obscure mythologies and rendered in a style vaguely reminiscent of 15th-century Italy and, unwittingly, of 17th-century still-life painting. An influential teacher, his pupils included MARQUET and MATISSE, along with ROUAULT, whose color he influenced markedly.

MOREELSE, PAULUS (1571–1638). Dutch painter and architect best known for his portraits in the manner of his teacher, MIEREVELT.

MORETTO DA BRESCIA (Alessandro Bonvicino) (1498–1554). An Italian painter of religious subjects and portraits, he influenced PAOLO VERONESE and, especially, his pupil MORONI.

MORISOT, BERTHE (1841–1895). French Impressionist painter, pupil of COROT and protégé of her brother-in-law and primary influence, MANET, for whom she posed frequently. Her interiors are well composed and structurally sound, but her *plein-air* pictures tend to be somewhat etiolated and diffuse.

MORLAND, GEORGE (1763–1804). An English genre and landscape painter whose stable and tavern scenes were quite popular in his day.

MORLEY, MALCOLM (1931–). English-born American painter known for his sedulously detailed pictures in the photo-realist style.

MORONI, GIAMBATTISTA (ca. 1525–1578). An Italian painter who specialized in portraits distinguished by elegance, restraint and sobriety.

MORONOBU (Hishikawa Moronobu) (1618–1694). Japanese printmaker and pioneer of the UKIYO-E form. One of the first Oriental artists to depict the life of the common man.

MORRIS, GEORGE L. K. (1905–). A pupil of LÉGER and OZENFANT in Paris, he was one of the first American painters to employ an abstract geometrical idiom.

MORRIS, ROBERT (1931–). An American sculptor and early adherent of MINIMALISM. His rather stolid forms were among the first to be presented without pedestals.

MORRIS, WILLIAM (1834–1896). English painter, designer, craftsman, poet, writer and printer. A lifelong friend of BURNE-JONES and loosely associated with the PRE-RAPHAELITE BROTHERHOOD, he was a socialist reformer of some importance, a minor poet and accomplished essayist, but his real significance lies in his impassioned advocacy of such crafts as furniture and wallpaper making, stained glass, tapestry, fine illustrated books and the like and his insistence that aesthetic experience was not confined to the "fine arts" but should imbue every facet of life. Although his underlying ideas were anachronistic and impractical, his espousal of good design provoked a widespread response both in England and abroad.

MORSE, SAMUEL F. B. (1791–1872). American painter and inventor and pupil of ALLSTON and WEST. Although best known for his invention of the telegraph, he was a serious painter and art teacher, a successful portraitist and landscapist and a founder and first president of the National Academy of Design. Although he fell somewhat

Berthe Morisot, *The Cradle*, Louvre, Paris.

Edvard Munch, *Anxiety*, Municipal Collection of Fine Arts, Oslo.

short of his ambition "to rival the genius of a RAPHAEL, a MICHELANGELO, or a TITIAN," he was a realist of considerable talent and originality.

MORTIMER, JOHN HAMILTON (ca. 1741–1779). English romantic painter and pupil of Thomas Hudson (1701–1779). Little of his work survives, but he was respected by BLAKE, among other younger contemporaries.

MOSER, LUKAS (ca. 1400–1450). A German painter of whom little is known and the author of a single authenticated work, an altarpiece in the church of Tiefenbronn (near Constance) depicting scenes from the legend of *St. Mary Magdalen and Martha,* he was stylistically in advance of the Swabian painters of his time and may consequently have been unappreciated. At least, speculation to that effect has been generated by the startling inscription on the altarpiece: "Weep, Art, wail . . . none desires you any more. . . . "

MOSES, GRANDMA (Anna Mary Robertson Moses) (1860–1961). An American naïve painter who turned to art late in life and won an enormous following for her sprightly, detailed depictions of 19th-century farm life in upper New York State.

MOSTAERT, JAN (ca. 1475–ca. 1556). Dutch painter, primarily of court portraits in which Italianate motifs are rendered in the meticulous style of the Netherlandish realists, while landscape elements may derive from PATINIR.

MOTHERWELL, ROBERT (1915–). American painter, writer and editor, member of the NEW YORK SCHOOL and exponent of ABSTRACT EXPRESSIONISM. His characteristic works, although they frequently contain large coruscating forms, are generally less gestural and improvisational than most ACTION PAINTING.

MOTONOBU (Kano Motonobu) (1476–1559). A Japanese painter celebrated for his versatility, mastery of color and the compositional assurance with which he executed inordinately large mural decorations.

MOUNT, WILLIAM SIDNEY (1807–1868). An American genre painter who specialized in scenes of rural life distinguished by a simple unaffected realism that lent great dignity to subjects usually patronized or sentimentalized in other hands.

MU CH'I (fl. mid-13th century). Chinese painter from Szechuan who worked in the Ch'an (Zen) style more admired in Japan than his homeland. He worked in monochromatic ink washes punctuated with explosive splashes and ragged brush strokes and had enormous influence on Japanese painting.

MULLER, OTTO (1874–1930). A German expressionist painter and member of DIE BRUCKE, he was influenced by LEHMBRUCK and GAUGUIN and painted in a variety of obscure mediums that to some extent shaped his thinly painted, largely unmodulated style.

MULREADY, WILLIAM (1786–1863). Irish-born English genre painter and pupil of his brother-in-law VARLEY. His works are distinguished by sure draftsmanship, rightness of gesture and gentle humor.

MULTSCHER, HANS (ca. 1400–1467?). German sculptor and painter best known for his softly naturalistic sculptures and reliefs at Ulm Cathedral.

MUNCH, EDVARD (1863–1944). Norwegian painter and printmaker and a pioneer of EXPRESSIONISM. After starting his career more or less as a realist, he traveled to Germany and France, where he absorbed influences from IMPRESSIONISM and POST-IMPRESSIONISM, the latter particularly as exemplified by VAN GOGH and GAUGUIN. Even earlier, however, he had begun to subordinate naturalism and conventional pictorial means to emotive and psychological considerations, eliminating detail and emphasizing contour, pattern and the expressive possibilities of color in the process. His mature style is charac-

Murillo, *The Holy Family with a Little Bird,* Prado, Madrid.

terized by morbidity and neuroticism, with reverberations of GOYA much in evidence. His most famous work, *The Cry* (Oslo: National Museum), is one of the most unsettling pictures ever created and comes as close as any work of plastic art has to conveying sound visually. He was an extremely accomplished and very influential printmaker.

MUNKACSY, MIHALY VON (Leo Lieb) (1844–1909). A Hungarian painter whose style derived in part from COURBET but was far more melodramatic. He is best known for genre pictures and flashily romantic landscapes.

MÜNTER, GABRIELLE (1877–1962). German expressionist painter, student and close friend of KANDINSKY and a founder of the BLUE RIDER. Her landscapes derive from FAUVISM and are characterized by strong color and rhythmic patterning.

MURCH, WALTER TANDY (1907–1967). A Canadian-born American painter and pupil of GORKY, he is known for pallid, luminous depictions of mechanical objects, electrical devices and the like, which he imbued with vaguely spectral, enigmatic and highly poetic qualities.

MURILLO, BARTOLOME ESTEBAN (1617–1682). Spanish painter, principally of religious subjects, peasants and children. Trained by the mannerist painter Juan del Castillo and influenced by ZURBARÁN, VELAZQUEZ, RIBERA, RUBENS and TITIAN, among others, he began his career as a hack, churning out pictures for sale at fairs. His first major commission, a cycle of eleven pictures for the Franciscan cloister of San Francisco in his native Seville, established him as the most lionized artist in the city, Zurbarán—a far better painter—included, but his popularity did not impede his absorption of additional influences, notably VAN DYCK. In the course of his career he underwent a series of radical stylistic changes, the last of which, his *estilo vaporoso,* as sanctimoniously vapid as it was vaporous, was extensively imitated until the end of the 19th century, when his inflated popularity began to wane.

MYRON (fl. ca. 480–450 B.C.). An Athenian sculptor of great renown, he is known to have specialized in bronze animals but is best known today through Roman copies, particularly of his DISCOBOLUS.

N

NADELMAN, ELIE (1882–1946). Polish-born American figurative sculptor. Originally influenced by RODIN, he soon turned to geometric theory as a basis for a unique manner characterized by simplification and stylization of form, a rather whimsical, often facetious aspect, a mock ingenuousness inspired by European and American folk art and a seemingly casual but nonetheless judicious mixing of material.

NAKIAN, REUBEN (1897–). An American sculptor and student of MANSHIP and LACHAISE, loosely identified with ABSTRACT EXPRESSIONISM. His characteristic works are monumental, heavily encrusted, more or less abstract evocations of the effects of time on the works of man. His 1964–1965 bronze *Goddess of the Golden Thighs* (Detroit: Institute of Arts), for example, is an amalgam of powerful abstract forms that can be "read" figuratively, as an eroded figure resembling the classical *Winged Victory* and surrounded by thighlike fragments and plinths of antique sculpture.

NAMATJIRA, ALBERT (1902–1959). An aboriginal Australian watercolorist known for his widely reproduced landscapes. His work is notable for its great vigor and brilliant color.

NANNI D'ANTONIO DI BANCO (ca. 1384–1421). An Italian sculptor and sometime colleague of DONATELLO who worked in the late INTERNATIONAL GOTHIC style.

NANNI DI BARTOLO (fl. 1st half of 15th century). A transitional Italian sculptor and assistant of DONATELLO.

NANTEUIL, ROBERT (1623–1678). A French draftsman and engraver best known for portraits, in the manner of CHAMPAIGNE, of the prominent political figures.

NASH, JOHN (1752–1835). A much patronized English architect and pupil of TAYLOR, he specialized in picturesque country houses, usually in stucco, for which he designed logical and homogeneous settings.

NASH, PAUL (1889–1946). An English painter, designer, illustrator and writer, he was, like many English painters before him, deeply influenced by the English poets. His style, which always contained elements of SURREALISM, was well suited to his duties as an official documentary artist in two world wars.

Unfinished head of Queen Nefertiti from Tell el Amarna, Egyptian Museum, Cairo.

NATOIRE, CHARLES JOSEPH (1700–1777). A French painter, designer, etcher and pupil of LEMOYNE, he was a rival of BOUCHER and a pioneer of the ROCOCO.

NATTIER, JEAN-MARC, THE YOUNGER (1683–1766). A French court painter who specialized in portraits of fashionable women in mythological or allegorical guises.

NEAGLE, JOHN (1796–1865). An American painter of vigorous, realistic portraits and landscapes.

NEER, AERT VAN DER (ca. 1603–1677). A Dutch landscapist known for nocturnal and winter scenes. Father of EGLON VAN DER NEER.

NEER, EGLON HENDRICK VAN DER (ca. 1634–1703). A Dutch painter and son and pupil of AERT VAN DER NEER, he produced history pictures, landscapes, genre subjects and portraits, all influenced by NETSCHER.

NEFERTITI (Berlin: Former State Museums). Portrait bust of the wife of Akhenaten. Carved by the Egyptian sculptor Thutmose, it is famous for its graceful naturalism and the beauty of its subject.

NELLI, OTTAVIANO DI MARTINO (fl. 1st half of 15th century). An Italian painter known for the delicacy and refinement of his color, composition and decorative devices that appear to derive from manuscript illumination.

NEROCCIO DI BARTOLOMMEO LANDI (1447–1500). An Italian painter and sculptor of the SIENESE SCHOOL. His pictures are characterized by delicate but vivid color suggestive of SIMONE MARTINI, while his sculpture reflects the influence of DONATELLO.

Christopher Richard Wynne Nevinson, *Queueing for Foodstuffs.*

NERVI, PIER LUIGI (1891–). Italian architect and engineer and a leading advocate of the use of ferroconcrete. He was one of the architects of the UNESCO complex in Paris, and his other works include the Municipal Stadium, Florence, and the Olympic Buildings, Rome.

NESCH, ROLF (1893–). German painter, mosaicist, printmaker and pupil of KIRCHNER. Important chiefly for his technical innovations in printmaking.

NETSCHER, CASPAR (ca. 1636–1684). German-born Dutch history, genre and portrait painter influenced chiefly by his teacher, TER BORCH. His work is characterized by its meticulous renderings of rare fabrics and other rich textures.

NEUMANN, JOHANN BALTHASAR (1687–1753). The pre-eminent architect of the late German BAROQUE.His style is marked by spatial richness, ingenuity of construction and delicacy of form. In such works as his Bruchsal Palace (destroyed) and Church of Vierzehnheiligen, he made particularly effective use of light by piercing curved walls with tall, gracefully arched windows.

NEUTRA, RICHARD (1892–). Austrian-born American architect who in the 1920s worked for HOLABIRD AND ROCHE and with WRIGHT. His Lovell House, Los Angeles, introduced modern European concepts to the United States and pioneered the use there of industrial production techniques. He has written a number of influential works on architectural theory and environmental planning.

NEVELSON, LOUISE (1900–). Russian-born American sculptor. A student of KENNETH HAYES MILLER and HOFMANN, she is best known for large, shallow, intricate wall-like constructions, usually painted in monochrome, in which a variety of *objets trouvés* are combined and juxtaposed in pigeonholelike compartments to produce hauntingly evocative ensembles.

NEVINSON, CHRISTOPHER RICHARD WYNNE (1889–1946). An eclectic English painter who at one time or another was associated with CUBISM, VORTICISM and FUTURISM but who is remembered chiefly for his documentary depictions of action in World War I.

NEWMAN, BARNETT (1905–1970). An American painter and a leader of the NEW YORK SCHOOL, he is best known for large, austere and difficult canvases almost devoid of incident and divided by widely spaced vertical stripes of varying density and texture.

NICCOLO DELL'ARCA (1435–1494). An Italian sculptor best known for his intensely emotional terra cotta, *Lamentation over the Body of Christ* (Bologna: Sta. Maria della Vita).

NICCOLO DI LIBERATORE DA FOLIGNO (ca. 1425/30–1502). Italian painter who worked in the synthesized styles of GOZZOLI, ALVISE VIVARINI and CRIVELLI.

215

Louise Nevelson, *Sky Cathedral,* Museum of Modern Art, New York, gift of Mr. & Mrs. Ben Mildwoff.

NICHOLSON, BEN (1894–). A leading English abstract painter and son of Sir William Nicholson. His chief influences have been cubism and Mondrian. He is known for his very shallow painted reliefs and vestigial traces of still-life forms, and his works are characterized by reticence, tact and restraint. With his former wife, Barbara Hepworth, and others, he was instrumental in making St. Ives, Cornwall, a leading center of artistic activity.

NICHOLSON, FRANCIS (1753–1844). English painter, watercolorist and printmaker known best for landscapes and animal subjects.

NICHOLSON, SIR WILLIAM (1872–1949). English painter and poster designer and father of Ben Nicholson. Influenced by Whistler and Manet, he was best known as a painter of still lifes.

NICOLA PISANO (fl. 1260–1278). Italian sculptor and architect and one of the most innovative figures of all time, he occupies much the same position in sculpture that Giotto does in painting. His origins and training are obscure, but with his first great work, a pulpit for the Pisa

Nicola Pisano, pulpit in the Baptistery at Pisa.

Emile Nolde, *The Sisters*, private collection, Essen.

Baptistery, he laid the foundation for the aesthetic concepts that opened the way to the Renaissance, using classical antiquity as a point of departure and attempting to imbue the stereotypes and hieratic forms of Christian art with the humanistic naturalism of late Roman sculpture and the whole structure with a rational plan that was to become a hallmark of Renaissance classicism. Although VASARI esteemed him as the chief architect of his era, no concrete documentation of Nicola's activity in this sphere exists. Stylistic evidence, however, suggests a role in the design of SIENA CATHEDRAL. He maintained an active workshop and was assisted by artists of great accomplishment, including his son, GIOVANNI PISANO, and ARNOLFO DI CAMBIO.

NICOLAS DE VERDUN (fl. late 12th–early 13th centuries). Flemish goldsmith, enameler and sculptor generally considered the last of the great ROMANESQUE figures to work in those forms.

NIEMEYER, OSCAR (Oscar Niemeyer Soares Filho) (1907–). The leading Brazilian architect and once a collaborator with LE CORBUSIER, he is known chiefly as the supervising architect and main designer of Brasilia.

NINEVAH, PALACES OF. Royal residences in one of the former capitals of Assyria in present-day Iraq, including the palaces of Sennacherib (705–681 B.C.). And ASSURBANIPAL (668–627 B.C.), and important for their relief decorations commemorating the military exploits of both rulers in narrative form and with convincing naturalism.

NIOBID PAINTER (fl. 2nd quarter of 5th century B.C.) An Attic vase painter named for his known masterpiece, a krater (Paris: Louvre), on which is depicted the slaughter of Niobe's children by Apollo and Artemis.

NI TSAN (1301–1374). Considered the greatest of the "Four Great Masters" of the Yüan dynasty, he specialized in serene landscapes depicted in pallid washes and dry-brush strokes and in bamboo motifs used as vehicles for a form of EXPRESSIONISM ("I am really setting forth only . . . untrammeled feelings").

NOGUCHI, ISAMU (1904–). Japanese-American abstract sculptor, architect and designer who studied with GUTZON BORGLUM and BRANCUSI. His work in stone and wood is characterized by its simplicity of form, elegance of finish and superb craftsmanship. He is also well known as a designer of lamps and of gardens and playgrounds.

NOLAN, SIDNEY (1917–). Generally considered Australia's most eminent modern painter, he is known for his evocative treatments of folk mythology and regional subjects depicted with Surrealist overtones.

NOLAND, KENNETH (1924–). An American painter and associate of LOUIS. His vast canvases, characteristically composed of flat, hard-edged stripes and bands of varying thicknesses, emphasize the format and directional thrust of the canvas, eliminating all incident but the interaction of color and shape and all external association.

NOLDE, EMIL (Emil Hansen) (1867–1956). A German painter and printmaker and member of DIE BRUCKE. His rather vivid, often violent brand of EXPRESSIONISM (condemned as degenerate during the Nazi regime) was influenced by ENSOR, FAUVISM and a variety of primitive and other exotic art forms. Concentrating mostly on religious themes rendered in strident color and crude, aggressive patterns, he was a major influence in the development of modern German expressionism.

NOORT, ADAM VAN (1562–1641). A Flemish painter trained by his father, Lambert van Noort, he was a highly influential teacher who numbered JORDAENS and RUBENS among his many workshop assistants.

NOORT, PIETER PIETERSZ VAN (fl. 1st half of 17th century). A Dutch still-life painter who specialized in depictions of fish.

NOTKE, BERNT (ca. 1440–1509). German painter and sculptor who worked in Sweden and maintained an active and influential workshop in Lübeck.

NOTRE-DAME, PARIS. World-renowned GOTHIC cathedral begun in 1163 and largely completed by 1245. A five-aisled basilica with a double ambulatory at its perimeter, its transept crosses the nave at its center. Its twin west towers lack spires, but a superb rose window and many fine sculptural figures make its west front particularly worthy of note, as do the rose windows and delicate architecture of its north and south façades and the striking buttresses that radiate from its apse. The edifice was significantly restored and much embellished by VIOLLET-LE-DUC in the 19th century.

NUZI, ALLEGRETTO (ca. 1315–1373). An Italian painter of the UMBRIAN SCHOOL influenced by GIOTTO, DADDI and MASO DI VANCO and known for his elaborate ornamentation.

Notre Dame Cathedral, Paris.

O

OBIN, PHILOMÉ (1891–). Largely self-taught Haitian painter of prolix historical pictures.

OCHTERVELDT, JACOB LUCASZ. (fl. mid-17th–early 18th century). A Dutch genre and portrait painter and pupil of BERCHEM. His style shows influences of DE HOOGH and TERBORCH.

O'GORMAN, JUAN (1905–). A Mexican architect best known for the rich surface decoration, derived from ancient native motifs, of his relatively simple forms and a painter of meticulously rendered murals.

O'HIGGINS, PABLO (1904–). American-born Mexican painter, printmaker and teacher and onetime assistant of RIVERA, whose style he emulates.

OKADA, KENZO (1902–). Japanese-born American painter of close-toned, flatly patterned abstractions.

O'KEEFFE, GEORGIA (1887–). American painter, characteristically of large, simple images, often drastically cropped and sexually suggestive, of flowers, bovine skulls and other natural objects. Her style recalls SHEELER, DEMUTH and STRAND, and she tends to define form by smoothly graduating areas of color with little or no regard to conventional principles of chiaroscuro.

OLDENBURG, CLAES (1929–). Swedish-born American painter, sculptor and creator of happenings, he is one of the most provocative and inventive of the artists associated with the POP ART movement. His oeuvre, which emerged from ABSTRACT EXPRESSIONISM, has gone through a series of radically changed stages, of which the best-known products have been "soft" sculptures (i.e., outsize flaccid replicas, in cloth, plastic and other pliable materials, of common objects ordinarily manufactured in hard substances; occasionally reversing the formula, he has produced hard sculptures of soft objects), simulated environments and a witty series of projected public monuments, some of which, if executed, might bring about the downfall of civilization such as it is now known.

OLITSKI, JULES (1922–). Russian-born American painter, characteristically of vast flat stains that are modulated only as they approach thin blank irregular strips of ground at the canvas edge.

Claes Oldenburg, *Soft Giant Drum Set,* collection of John G. Powers, Aspen, Colorado.

OLIVER, ISAAC (ca. 1565–1617). French-born English miniaturist and pupil of HILLIARD, much of whose popularity he eventually usurped.

OLIVIER, FERDINAND VON (1785–1841). German romantic painter and printmaker best known for landscapes and religious subjects.

OLMSTED, FREDERICK LAW (1822–1903). American landscape architect, city planner and author. He was the most influential designer of public parks in U.S. history. His masterpiece, Central Park, New York (with Calvert Vaux), served as a model throughout the nation. His published theories of city planning were almost a century ahead of their time and might immeasurably have benefited the quality of modern urban life had they been heeded.

OOST, VAN, FAMILY. Two generations of Flemish painters, of whom the most prominent members were Jacob van Oost (1601–71) and his sons Jacob II (1639–1713) and Willem (1651–1686).

OPIE, JOHN (1761–1807). An English painter admired by REYNOLDS as a youthful prodigy. His mature portraits and history pictures never fulfilled his early promise.

OPPENHEIMER, MAX (Maximilian Mopp) (1885–1954). Austrian-born American painter and printmaker whose early expressionist style gradually gave way to increasingly abstract forms.

ORCAGNA, ANDREA (Andrea di Cione) (ca. 1308–ca. 1368). Italian sculptor, painter, architect and administrator. As a sculptor, he was influenced and possibly taught by ANDREA PISANO, while in his painting he looked back beyond the innovations of GIOTTO, hoping to invest GOTHIC and BYZANTINE traditions with contemporary relevance. In both mediums, his work is distinguished by vigorous handling and great expressivity, but his pictorial style seems a deliberate rejection of Giottesque space.

ORCHARDSON, SIR WILLIAM QUILLER (1832–1910). A Scottish genre and portrait painter, chiefly of upper-middle-class society.

ORDOÑEZ, BARTOLOME (d. 1520). The first Spanish sculptor appreciably influenced by the Italian High Renaissance, which he observed while working in Naples, he was influenced by DONATELLO, MICHELANGELO, LEONARDO and RAPHAEL, among others.

ORLEY, BERNARD VAN (ca. 1490–ca. 1542). A Flemish painter, he was called "the RAPHAEL of the Low Countries"—a sobriquet that might not have been appreciated by Raphael, with whom he is supposed to have studied during a sojourn in Italy. His masterpiece, *The Trials of Job* (Brussels: Fine Arts Museum), itself a trial of

sorts, aspires to Michelangelesque grandeur and achieves slapstick.

OROZCO, JOSÉ CLEMENTE (1883–1942). The preeminent figure in the so-called Mexican Renaissance, he was an expressionist painter who rejected the oppressive official manner of the early 20th century and, with RIVERA, SIQUEIROS and TAMAYO, waged an artistic revolution in Mexico. Although his murals were excessively bombastic on occasion, his concern for his fellow man was passionate in the extreme and, in his best work, expressed with overpowering conviction. He was also a printmaker of uncommon forcefulness, and some of his finest work was done in simple black and white.

ORPEN, SIR WILLIAM N. M. (1878–1938). An Irish-born English painter who was enormously successful in his lifetime but now seems rather glib and overly literate.

ORTMAN, GEORGE (1926–). American abstract painter of hard-edged emblematic forms.

OSSORIO, ALFONSO (1916–). Filipine-born American painter known for heavily encrusted abstract collages.

OSTADE, ADRIAEN VAN (1610–1685). Dutch painter, primarily of genre subjects, and printmaker influenced by BROUWER and possibly taught by FRANS HALS. He was a brother of ISAAK VAN OSTADE, who was his pupil. His style is naturalistic and, in its tonality, derives somewhat from REMBRANDT.

OSTADE, ISAAK VAN (1621–1649). A Dutch landscape and genre painter and brother and pupil of ADRIAEN VAN OSTADE, he was an accomplished landscape painter influenced in some respects by REMBRANDT.

OUDRY, JEAN-BAPTISTE (1686–1755). A French painter, decorator, tapestry designer and illustrator, he specialized in animal subjects executed in the ROCOCO style.

OUWATER, ALBERT VAN (fl. ca. 1460–1475). A Dutch painter of the early school of Haarlem. Little is known of his activities, although he is thought to have been the teacher of GEERTGEN TOT SINT JANS and a master of landscape painting, no examples of which survive. He is known by a single authenticated work, *The Raising of Lazarus* (Berlin: State Museums), a masterful arrangement of figures in space and similar coloristically to works by BOUTS.

OVERBECK, JOHANN FRIEDRICH (1789–1869). A German painter of the NAZARENE movement who worked in a manner derived from the Italian masters of the High Renaissance.

OZENFANT, AMÉDÉE (1886–1966). A French painter and co-inventor, with LE CORBUSIER, of PURISM, he was an influential art theorist and writer.

P

PACH, WALTER (1883–1960). American painter, printmaker, art critic and historian. A student of LEIGH HUNT, CHASE and HENRI, he was an accomplished portraitist, co-organizer of the ARMORY SHOW and an influential writer on 19th- and 20th-century painting and sculpture.

PACHECO, FRANCISCO (1564–1654). A minor Spanish painter, teacher and art administrator remembered primarily as the father-in-law of VELAZQUEZ.

PACHER, MICHAEL (ca. 1435–1498). A Tyrolean sculptor of polychromed figures in the late GOTHIC style and a painter influenced (perhaps in Italy) by DONATELLO and MANTEGNA, among others. He was a superb artist in his own right and an important conduit whereby the principles of the Italian Renaissance penetrated northward.

PAIK, NAM JUNE (1932–). Korean-born American artist who uses video as a medium, characteristically distorting its imagery.

PAJOU, AUGUSTIN (1730–1809). A French sculptor, pupil of LEMOYNE, and popular portraitist.

PALAMES STEVENS (Stevers), ANTONIE (1601–1673). Dutch portrait and genre painter and possible student of MIEREVELT and member of the HALS workshop.

PALISSY, BERNARD (ca. 1510–1590). A French ceramist and enameler and protégé of Catherine de Médicis, he specialized in reliefs of animals.

PALLADIO, ANDREA (1508–1580). The outstanding Italian architect of the later 16th century. His style was drawn from a thorough understanding of the principles of Roman antiquity and based on a theory of mathematically structured proportion. At the height of the mannerist epoch, his designs are notable for their symmetry and balance. His various villas are characterized by the use of colonnades that seem to extend a welcoming embrace to approaching visitors, and his church façades are modeled on classical temples. Both his buildings and writings were extremely influential, especially in En-

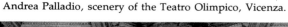

Andrea Palladio, scenery of the Teatro Olimpico, Vicenza.

land, where they shaped the style of INIGO JONES and, ultimately, the PALLADIAN movement.

PALMA, JACOPO (Jacopo Negretti) (1544–1628). A Venetian painter possibly trained by TITIAN, he was the leading follower of TINTORETTO and PAOLO VERONESE.

PALMA VECCHIO (Jacopo d'Antonio Negretti) (1480–1528). Italian painter, uncle of JACOPO PALMA and probable student in the BELLINI workshop. Influenced by GIORGIONE, he evolved a characteristic female figure—blond and full-bellied, with a low center of gravity and vaguely introspective mien—that appears in a variety of Biblical, secular and classical guises throughout his lushly sensuous oeuvre.

PALMER, ERASTUS DOW (1817–1904). A more or less self-taught American sculptor. Such of his works as the mildly erotic *White Captive* (New York: Metropolitan Museum), a more vigorous variation on POWERS' *Greek Slave* (Newark, New Jersey, Museum), were extremely popular in the mid-19th century.

PALMER, FLORA BOND (Fanny) (1812–1876). American lithographer. One of the finest artists employed by CURRIER AND IVES, she was renowned for the technical exactitude, compositional acumen and tonal richness of such prints as the celebrated *Midnight Race on the Mississippi*.

PALMER, SAMUEL (1805–1881). An English visionary landscapist, child prodigy and follower of BLAKE. His early work, especially his nocturnal subjects, is charged with an intensity he was unable to maintain as he grew older.

PALMYRA. Syrian city northeast of Damascus and site of important ruins dating from the time of the Roman Empire. Notable examples of Palmyran art and architecture include impressive temples, a theater, colonnaded thoroughfares, sculptured tombs and monumental arches.

PALOMINO DE CASTRO Y VALASCO, ANTONIO (1655–1726). A Spanish court painter of importance today chiefly for his documentary writings on his close predecessors and contemporaries.

PANKOK, BERNARD (1872–1943). German painter, designer and architect known for his use of organic motifs and curvilinear forms in the ART NOUVEAU style.

PANNINI, GIOVANNI PAOLO (ca. 1692–1765). The greatest of the Roman view painters and, in his innovative use of ruins as pictorial elements, an influential forerunner of ROBERT and PIRANESI, he also influenced CANALETTO and those French painters who specialized in *fêtes galantes*. Originally trained as a scenic designer, he taught perspective at the French Academy in Rome.

PANTHÉON, LE. Neoclassical building in Paris designed by SOUFFLOT as a church in 1757 and completed after his death. Although its function has varied over the years, it is now used as a tomb site for illustrious Frenchmen. It is of importance architecturally as the first monumental example of NEOCLASSICISM in France.

PANTHEON, ROME. Temple in circular form begun in A.D. 120 by Hadrian, its main components comprising a vast, massively walled, domed rotunda.

PANTOJA DE LA CRUZ, JUAN (1553–1608). A Spanish painter trained by COELLO, whom he succeeded at court, he is best known as the author of a number of rather dispirited portraits.

PAOLO VENEZIANO (fl. 2nd third of 14th century). An Italian painter notable for his fusion of spatial concepts with the essentially flat BYZANTINE style.

PAOLOZZI, EDUARDO (1924–). An English sculptor born in Scotland of Italian parents, he was part of the British POP ART movement but since has turned to abstraction.

PARET Y ALCAZAR, LUIS (1746–1799). A versatile, eclectic Spanish painter taught at one point by VELAZQUEZ, he is best known for scenes of court life and waterfront views.

PARKER, RAYMOND (1922–). An American abstract painter of large, slightly unfocused, vaguely levitational forms.

PARLER FAMILY. A family of 14th-century German stonemasons and sculptors, of whom the most highly regarded was Peter Parler (ca. 1330–1399), who was also an architect of considerable importance in Bohemia.

PARMIGIANINO (Francesco Mazzola) (1503–1541). Italian mannerist painter and etcher influenced thematically by RAPHAEL and MICHELANGELO and stylistically by CORREGGIO. A short-lived controversial personality, he changed, according to VASARI, "from [a] delicate, amiable and elegant person . . . to a bearded, long-haired, neglected . . . savage or wild man"—in short, a 16th-century hippie. At his best, he imbued his works with great spirituality, and as an etcher who used the medium creatively and not just as a reproductive vehicle his importance in Italy approached DÜRER's in the north.

PARODI, GIACOMO FILIPPO (1630–1702). An Italian BAROQUE sculptor taught by BERNINI and influenced by PUGET.

PARRISH, MAXFIELD FREDERICK (1870–1966). An American painter and illustrator of mannered, idealized and meticulously rendered archaic subjects.

PARROCEL FAMILY. A family of French painters active in the 17th and 18th centuries whose most notable members included Barthélemy Parrocel (ca. 1600–ca. 1660), who specialized in religious subjects, his sons Louis (1634–1694) and Joseph-François (1646–1704), who was known for his battle scenes, and the latter's son and pupil Charles (1688–1752), also a battle painter and etcher.

PARTHENON, ATHENS. Temple on the ACROPOLIS, Athens, dedicated to Athena Parthenos and built 447–432 B.C. by the architects ICTINUS and Callicrates. The supreme masterpiece of the Periclean Age, it has eight Doric columns at its ends and 17 at its sides and was embellished with sculpture and reliefs executed under the supervision of PHIDIAS, including a frieze of which 335

feet of the original 525-foot length now comprise a major portion of the ELGIN MARBLES.

PASCIN, JULES (Julius Pincas) (1885–1930). Bulgarian-born French painter best known for his sensuous depictions of nude women posed revealingly in intimate, disordered settings. Primarily a draftsman, he used color as a more or less abstract decorative adjunct that had little to do with representation of objects or definition of form.

PASITELES (fl. 1st century B.C.). A Greco-Roman sculptor, teacher and writer on art and organizer of a workshop-school that produced vast numbers of eclectic figures and reliefs.

PASMORE, VICTOR (1908–). English painter, sculptor and teacher whose early work was influenced by WHISTLER and the Impressionists and was characterized by its subtle tonal nuances but who later turned to geometrical abstract paintings and constructed reliefs derived from GABO.

PASSE, CRISPIN VAN DE, THE ELDER (ca. 1565–1637). A Dutch printmaker and illustrator known best for his widely disseminated reproductive engravings.

PASSERI, GIOVANNI BATTISTA (1610/16–1679). Italian painter remembered chiefly as the biographer of contemporaneous artists.

PASTI, MATTEO DI ANDREA DE' (ca. 1411–ca. 1468). An Italian medalist, painter, sculptor and architect, he was a follower, and possibly an associate, of PISANELLO.

PATEL, PIERRE, THE ELDER (ca. 1620–1676). A French landscape painter and pupil of VOUET who worked in the manner of CLAUDE LORRAINE.

PATER, JEAN-BAPTISTE-JOSEPH (1695–1736). French painter, the only pupil of WATTEAU. His style was slavishly imitative of his master's but lacked both depth and assurance.

PATINIR, JOACHIM (ca. 1485–1524). A Flemish painter and pioneer landscapist of whose training nothing is known but who was influenced by GERARD DAVID, in turn influenced ISENBRANDT and was much admired by his contemporaries, including DÜRER, who owned one of his works and made a drawing of him in 1521. He was also influenced by BOSCH. His greatest importance lies in the emphasis he gave to the landscape settings of his ostensibly narrative pictures, an emphasis that was later to be exploited more fully by PIETER BRUEGHEL THE ELDER. He was a master of aerial perspective, his pictures receding from warm-toned foregrounds to increasingly cooler overlapping planes of green and, ultimately, blue. Like Bosch, he made use of a bird's-eye viewpoint and, in a more limited way, a fantastic iconography. Unlike Bosch, however, he seems to have regarded figure painting as a necessary evil, and there is good evidence to suggest that his foreground groups were the work of such other hands as QUENTIN METSYS and JOOS VAN CLEVE, among others.

PAVIA, PHILIP (1912–). American sculptor loosely associated with ABSTRACT EXPRESSIONISM.

Charles Willson Peale, *Staircase Group,* Museum of Art, Philadelphia.

Joachim Patinir, *The Baptism of Christ*, Museum of Art History, Vienna.

PEALE, CHARLES WILLSON (1741–1827). An American painter and progenitor of the PEALE FAMILY who studied in London with WEST. He was generally regarded as the outstanding portraitist in America after the departure of COPLEY for England. His mature style is characterized by a clarity and forthrightness that reflect his early training as a skilled craftsman. An officer of the militia during the War for Independence and a member of the Pennsylvania Assembly, he was also the founder of the first art gallery in the U.S.—a venture that later was to become Peale's Museum and to embrace the natural sciences—and a prime mover in the foundation of the nation's oldest art school, the Pennsylvania Academy of Fine Arts.

PEALE FAMILY. A large and prominent family of American artists of the Colonial and Federal periods, its most prominent members were CHARLES WILLSON PEALE, JAMES PEALE, RAPHAELLE PEALE and REMBRANDT PEALE. Other members included Rubens Peale (1784–1865), Titian Ramsey Peale (1799–1885), James Peale the Younger (1789–1876), Maria Peale (1787–1866), Anna Claypoole Peale (1791–1878), Margaretta Angelica Peale (1795–1882) and Sara Miriam Peale (1800–1885).

PEALE, JAMES (1749–1831). American painter and brother and pupil of CHARLES WILLSON PEALE, he is best known as one of the finest still-life painters of the early 19th century.

PEALE, RAPHAELLE (1774–1825). An American painter and son and pupil of CHARLES WILLSON PEALE, he succeeded his uncle JAMES PEALE as the finest still-life painter in the U.S.

PEALE, REMBRANDT (1778–1860). American portrait painter and pupil of his father, CHARLES WILLSON PEALE, and of WEST.

PECHSTEIN, MAX (1881–1955). German expressionist painter and member of DIE BRUCKE. He was influenced by CÉZANNE, VAN GOGH, MATISSE and others but principally by GAUGUIN and, consequently, primitive art. Like Gauguin, he worked for a time in the South Pacific but never managed to develop a wholly personal style, although his best work is distinguished by a crude vigor.

PECORI, DOMENICO (ca. 1480–1527). An Italian painter and stained-glass designer whose style derived largely from PERUGINO.

PEETERS FAMILY. A 17th-century family of Flemish painters of whom the best known were Bonaventura Peeters (1614–1652), a painter of romantic seascapes and an etcher and poet, his brother Gillis Peeters (1612–1653), a landscapist, and a third brother, Jan Peeters (1624–1680), whose paintings were much like those of Bonaventura.

PEI, I.M. (Ieogh Ming) (1917–). A Chinese-born American architect known for the John Hancock Building, Boston, the Everson Museum, Syracuse, New York, and the National Airlines Terminal, Kennedy Airport, New York, among other works.

PELLEGRINI, CARLO (1605–1649). An Italian painter who worked under the supervision of BERNINI, his chief influence.

PELLEGRINI, GIOVANNI ANTONIO (1675–1741). A leading Venetian decorative painter, he was a pupil of SEBASTIANO RICCI and precursor of TIEPOLO who worked in France, Flanders, Germany and England.

PELLIPARIO, NICOLA (Nicola da Urbino) (fl. lst half of 16th century). The outstanding Italian majolica painter of the Renaissance, he was renowned for his minutely detailed figures in complex architectural settings.

PENALBA, ALICIA (1918–). Argentinian-born French abstract sculptor and pupil of ZADKINE.

PENCZ, GEORG (1500–1550). A German painter and printmaker, he specialized in small engravings derived from his probable teacher DÜRER and from RAIMONDI, whose influence he absorbed while traveling in Italy.

PENICAUD FAMILY. 16th-century family of French enamelers whose individual identities and attributions are somewhat confused but who collectively produced a body of superb enamels in the Italian Renaissance style.

PENNELL, JOSEPH (1857–1926). An American printmaker, illustrator, writer and teacher best known as a prolific etcher and lithographer.

PÉRCIER AND FONTAINE. A French architectural partnership consisting of Charles Pércier (1764–1838) and Pierre Fontaine (1762–1853) and notable for such classical Paris structures as the Arc de Triomphe du Carrousel.

PEREIRA, I. (Irene) RICE (1907–1971). An American painter whose geometric abstractions, often made up of successive transparent or translucent surfaces, are characterized by powerful if somewhat enigmatic spatial effects.

PEREYRA, MANUEL (1588–1683). A Portuguese-born Spanish sculptor known for his dramatically expressive polychromed figures.

PERMEKE, CONSTANT (1886–1952). A Belgian expressionist painter and sculptor best known for his forceful brushwork, monumental figures and heavy impasto.

PERMOSER, BALTHASAR (1651–1732). A German sculptor who worked in Italy and later in Germany, specializing in the embellishment of architecture.

PEROV, VASILI GRIGOREVICH (1833–1882). Russian genre painter whose characteristic works vehemently attacked social injustice.

PERREAL, JEAN (ca. 1460–1530). A French portrait painter and miniaturist often confused with the MASTER OF MOULINS and the most important painter of his day in France, he traveled and was influenced in Italy and was also influenced by ROGIER VAN DER WEYDEN.

PERRET, AUGUSTE (1874–1954) and **GUSTAVE** (1876–1952). French architects and partners, of whom Auguste, the more successful, is known for his pioneering use of ferroconcrete.

PERRIER, FRANÇOIS (1590–1650). A French history and decorative painter and engraver, associate of VOUET and teacher of CHARLES LEBRUN. His style derived from THE CARRACCI, CORTONA and LANFRANCO.

PERRONNEAU, JEAN-BAPTISTE (1715–1783). A French pastel portraitist who pursued an itinerant career throughout Europe, where his delicate draftsmanship and ingratiating color were admired but where he was unfavorably compared with MAURICE QUENTIN DE LA TOUR.

PERSEPOLIS. Ancient Persian city northeast of Shiraz established as the ceremonial capital of the Persian empire during the reign of Darius I (521–486 B.C.). The site of important ruins and monuments, including the vast audience hall and palace of Darius, the throne hall, palace and harem of Xerxes, private dwellings and a city wall.

PERUGINO (Pietro di Cristoforo Vannucci) (ca. 1450–1523). Italian painter of obscure artistic origins and training who probably assisted VERROCCHIO, PIERO DELLA FRANCESCA, LEONARDO DA VINCI and LORENZO DI CREDI. A major figure in his own right, his style derives in part from Piero, SIGNORELLI and the Flemish masters and is characterized by order, simplicity, symmetry, sound draftsmanship, compositional mastery, superb modeling and the judicious use of architectural and landscape settings. In 1481 he was commissioned (along with DOMENICO GHIRLANDAJO, SANDRO BOTTICELLI, PIERO DI COSIMO and COSIMO ROSSELLI) to execute a cycle of murals for the SISTINE CHAPEL, a project that established his reputation, on which he was assisted by PINTURICCHIO and of which half was later to be obliterated by *The Last Judgment* of MICHELANGELO.

Perugino, *Apollo and Marsyas,* Louvre, Paris.

Perugino's art was gentle and pietistic but lacked real fervor and occasionally lapsed into sentimentalism and artificiality. Nevertheless, he was the leading Umbrian painter of the late 15th century, one of the great masters of perspective and one of the stabilizing forces in the somewhat confused period that heralded the High Renaissance. He was also the teacher of RAPHAEL, whom he outlived and some of whose unfinished early works he completed after the younger artist's death.

PERUZZI, BALDASSARE (1481–1536). An Italian painter, architect, decorator and set designer best known for the Massimo alle Colonne Palace, Rome.

PESELLINO, FRANCESCO (ca. 1422–1457). Italian painter of the FLORENTINE SCHOOL and probable pupil of his grandfather, GIULIANO PESELLO, for whom he was named ("Little Pesello") and with whom he has been confused. Influenced by FRA FILIPPO LIPPI, among others, he was not a notable innovator, but his lyrical *cassone* (painted wooden chests) were much emulated by minor followers, as were his many depictions of the Madonna and Child.

PESELLO, GIULIANO (Giuliano di Arrigo) (1367–1446). Italian painter of the FLORENTINE SCHOOL and grandfather and teacher of PESELLINO. Although no fully authenticated works survive, he was renowned among his contemporaries as one of the great painters of his day.

PESNE, ANTOINE (1683–1757). French painter and decorator who spent almost his entire career in Germany, where he was First Painter to three Brandenburg kings. Both his portraits and decorative frescoes are characterized by the sprightly, healthy and engaging—albeit smug—appearance of their protagonists and by a somewhat distracting attention to frippery.

PETERBOROUGH CATHEDRAL. A superb Anglo-Norman ROMANESQUE church in Northhamptonshire, England, it stands on the site of a succession of destroyed edifices and is particularly notable for its ornate west front, made up of three vast recessed arches, a remarkably light nave with three splendid vaulted aisles and a unique painted wooden ceiling and the three-tiered galleried walls of its transept ends and apse.

PETERDI, GABOR (1915–). A Hungarian-born American printmaker, painter and teacher and former associate of HAYTER, he is best known for large abstract color intaglios suggestive of cosmic or geological formations.

PETO, JOHN FREDERICK (1854–1907). An American *trompe l'oeil* still-life painter and pupil of HARNETT, to whom many of Peto's works were previously attributed. Although he lacked Harnett's compositional mastery and spatial command, his often ironic juxtapositions of weathered, corroded and otherwise altered common objects—what his rediscoverer and principal advocate,

the critic-historian Alfred Frankenstein, called "the pathos of the discarded"—anticipate to a startling degree the works of RAUSCHENBERG, JOHNS and ARMAN, among others.

PEVSNER, ANTOINE (1886–1962). Russian-born French sculptor and painter and brother of GABO. Influenced in turn by BYZANTINE art, CUBISM, FUTURISM and SUPREMATISM, he was a leading figure of the CONSTRUCTIVIST movement and a co-author, with Gabo, of its manifesto. Although his work was intended to be a thoroughly objective reflection of modern technological methods, it, like Gabo's, ultimately took on the instantly recognizable, highly individual characteristics of a major personal style.

PEYRONNET, DOMINIQUE PAUL (1872–1943). A self-taught French painter and lithographer best known for his intricately patterned marine subjects and convincing sense of depth.

Picasso

Pablo Picasso, *Three Dutch Girls,* National Museum of Modern Art, Paris.

PHIDIAS (fl. ca. 470–425 B.C.). Athenian sculptor. The salient artistic figure of the Periclean era and the prime mover in the development of the classical style. His greatest works—colossal figures of Athena and Zeus—are known only from literary descriptions, while the bulk of his life-size statuary has survived only in copies. As director of Pericles' program for the beautification of Athens, he wielded enormous influence, particularly through his designs for the sculptures of the PARTHENON (also see ELGIN MARBLES) and through works from his own hand so awesome that some commentators credited them with having expanded the scope and impact of ancient religion.

PHILOXENUS (fl. ca. late 4th century B.C.). A Greek painter of Eritrean birth from one of whose works the ALEXANDER MOSAIC is supposed to have been copied.

PHYFE, DUNCAN (1768–1854). A Scottish-born American cabinetmaker best known for the SHERATON furniture produced by his extremely successful New York workshop.

PIAZZETTA, GIOVANNI BATTISTA (1683–1754). A Venetian painter and rival of (and influence on) TIEPOLO,

he was trained for the most part under CRESPI and was influenced to some extent by REMBRANDT. His works are characterized by their great plasticity, monumentality and underlying seriousness—qualities that were largely lost on his ROCOCO successors.

PICABIA, FRANCIS (1878–1953). A French painter sometimes credited with having produced the first abstract picture in 1908–1909 (see KANDINSKY), he began his career as an Impressionist, subsequently embraced CUBISM, DADA and SURREALISM and augmented his painted oeuvre with verse, writings on aesthetics, theatrical design and film-making.

PICASSO, PABLO (Pablo Ruiz y Picasso) (1881–1973). Spanish expatriate School of Paris painter, sculptor and printmaker and the foremost artistic innovator of the 20th century. The son of an art teacher, he was a youthful prodigy who in 1904 settled in Paris, where within a few years he and BRAQUE were to wage a revolution that drastically and irrevocably altered the course of modern art.

Although recognized as a master draftsman while still in his mid-teens, he soon won more widespread recognition for his uninhibited use of distortion, arbitrary color harmonies and other unconventional approaches to greater expressivity. After briefly imitating the style of TOULOUSE-LAUTREC and absorbing such other influences as MUNCH, GAUGUIN, VAN GOGH, STEINLEN and, possibly, EL GRECO, he entered the first of a series of distinctive phases: his so-called Blue Period (ca. 1902–1904), during which his work was characterized by its predominantly blue-gray tonality, attenuated figures and pervasive melancholy. This was followed by his Rose Period, with its concentration on warmer, mostly pink tones and circus themes and its elegiac mood. By 1906 he had been introduced to African sculpture by MATISSE and had tentatively incorporated it into the increasingly formal style that shortly would culminate in the invention of CUBISM. A year later he had painted *Les Demoiselles d'Avignon* (New York: Museum of Modern Art), a watershed in the development of 20th-century painting, a work in which Picasso combined the emergent influence of CÉZANNE with his earlier influences and one that led directly to his and Braque's invention, shortly thereafter, of Cubism.

By 1912 Picasso and Braque had progressed from ANALYTICAL CUBISM to SYNTHETIC CUBISM, the latter characterized by its use of collage elements. From his initial involvement with such fortuitous materials as newsprint, caning, wallpaper, wood veneers and the like, Picasso was throughout his career to make inspired use of ready-made elements and industrial detritus, especially in his sculpture, although never carrying the idea to the extremes explored by DUCHAMP. By so doing he profoundly influenced later developments, not only in painting, sculpture, collage and assemblage but, indirectly at least, in such forms as happenings, process art and conceptual art.

Pablo Picasso, *The Guitar Player,* National Museum of Modern Art, Paris.

Pablo Picasso, *She-Goat*, bronze, Museum of Modern Art, New York, Mrs. Simon Guggenheim Fund.

Pablo Picasso, detail of *Guernica,* Museum of Modern Art, New York.

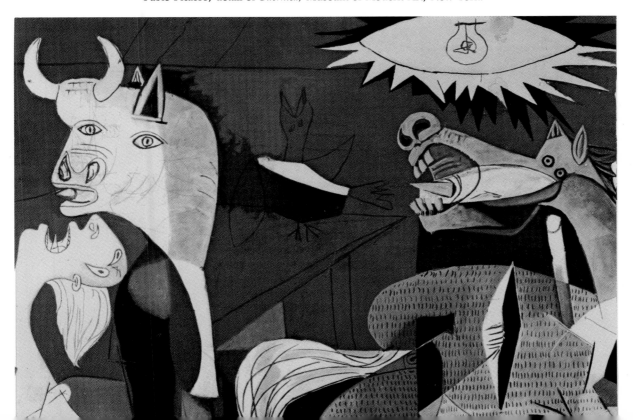

Pablo Picasso, *Les Demoiselles d'Avignon*, Museum of Modern Art, New York.

By the time Cubism had been firmly established around 1914, Picasso had abandoned the sober, somewhat doctrinaire style that concomitantly had established his reputation and, throughout the remainder of his inordinately long and prolific career, produced in a bewildering variety of styles thousands of works that—with a few notable wartime exceptions—were infused with all the gaiety, vivid color and *joie de vivre* that his earliest efforts lacked. The salient exception is *Guernica* (New York: Museum of Modern Art; on indefinite loan), a personal expression of anguish at the Fascist bombing of a Basque town in the form of a large monochromatic painting that curiously reverses the artist's experiments in Synthetic Cubism by investing a purely painted surface with the appearance of newsprint.

During his career Picasso moved impulsively from

such decorative arrangements of flat pattern and forceful color as *Three Musicians* and *Girl before a Mirror* (both New York: Museum of Modern Art) to figures of astonishing monumentality and classical dignity; from linear virtuosity to rival that of Matisse, to bronzes as elemental and direct in their impact as African tribal sculpture. His major contribution, Cubism, aside, he was a protean creative force of the first importance, contributing significantly to SURREALISM, DADA and every facet of 20th-century sculpture. Aesthetically and technically, he was one of the most versatile printmakers who ever lived. His ceramics rank with the greatest produced in modern times, as do his theatrical designs, and he was a not inconsequential playwright.

PICKETT, JOSEPH (1848–1918). Self-taught American painter known for his richly agglomerative surfaces.

PIER FRANCESCO FIORENTINO (fl. 4th quarter of 15th century). A minor Italian painter of the FLORENTINE SCHOOL and a follower of GOZZOLI. His somewhat stilted works are essentially linear.

PIERO DELLA FRANCESCA (Piero de' Franceschi) (1410/20–1492). One of the greatest Italian painters of the 15th century and a major theorist, he was associated early in his career with DOMENICO VENEZIANO in an uncertain capacity and may have studied under FRA ANGELICO. His characteristic mature works are dominated by firmly contoured, solidly sculptural figures, posed against simple, pristine backgrounds derived from Netherlandish painting and painted in broad, clear colors. His style is characterized by strict symmetry, impeccable logic and a masterful use of perspective and, although long neglected, appeals strongly to contemporary tastes. He is believed to have been the teacher of SIGNORELLI and PERUGINO, but neither artist tried to emulate his more or less inimitable style.

PIERO DI COSIMO (1462–1521). An Italian painter of the FLORENTINE SCHOOL and pupil of COSIMO ROSSELLI, he was influenced by LEONARDO, SIGNORELLI, FILIPINO LIPPI and BOTTICELLI. He worked in two styles, painting more or less conventional religious subjects and intensely personal, altogether bizarre mythological scenes that accord more closely with VASARI's description of his eccentric nature.

PIGALLE, JEAN-BAPTISTE (1714–1785). A French sculptor, pupil of LEMOYNE and protégé of Mme. de Pompadour, he is best known for his nude *Voltaire* (Paris: Palais de l'Institut) and his tomb for Maréchal de Saxe (Strasbourg: St. Thomas). He worked in both the classical and ROCOCO styles.

PIJNACKER, ADAM (ca. 1622–1673). A Dutch landscape painter and muralist who worked in the manner of JAN BOTH.

PILLEMENT, JEAN-BAPTISTE (1728–1808). A French ROCOCO landscape painter influenced by BOUCHER and a leading proponent of CHINOISERIE, he was also one of the great technicians of the color-etching medium.

PILON, GERMAIN (ca. 1530–1590). A French sculptor associated at an early stage of his career with PRIMATICCIO. His characteristic mature works derive in part from MICHELANGELO and PONTORMO but are infused with a dramatic intensity that raises them above the merely imitative.

PILOTY, KARL VON (1826–1886). A German painter known for his vast, prolix, sedulously researched canvases depicting some of the more melodramatic incidents from European history.

PINTURICCHIO (Bernardino di Betto) (ca. 1454–1513). Italian painter and associate of PERUGINO, his dominant influence, whom he probably met in the workshop of

Piero della Francesca, *Portrait of Federigo da Montefeltro*, Uffizi, Florence.

Giovanni Battista Piranesi, *The Prison,* etching.

Fiorenzo di Lorenzo (1445?–?1525). A prolific and popular painter of Madonnas and portraits, he is best remembered for narrative fresco cycles and for his frequent use of unusual subjects.

PIPER, JOHN (1903–). An English painter, designer and art critic, he is best known for his romantic landscapes and architectural subjects and as a war artist.

PIPPIN, HORACE (1888–1946). A more or less primitive American painter (he attended art classes late in life) known for his well-designed, straightforward depictions of remembered scenes and historical and Biblical episodes.

PIRANESI, GIOVANNI BATTISTA (1720–1778). Italian printmaker, archaeologist and architect. After training as an etcher, engraver, set designer and architect, he may have worked in TIEPOLO's studio in Venice, where he grew up. First attracting attention as an etcher of Roman views and classical ruins, he undertook the visionary cycle *Imaginary Prisons*, for which he is best know today. His style is characterized by dramatic chiaroscuro, superb draftsmanship, textural richness, a masterful command of perspective and a unique ability seemingly to infuse his every line with the look, feel and smell of old stone. His prolific output was widely reprinted and circulated during and after his lifetime and, with that of PANINI, formed the popular conception of Rome's appearance for generations of armchair travelers.

PISA, CATHEDRAL AND BAPTISTERY OF. Located in the Tuscan city of Pisa, the cathedral was designed by Buschetus (d. ca. 1080) and begun in 1063. Sheathed in black and white marble, it is notable for its arcaded west front, bronze doors, vaulted crossing and pulpit by GIOVANNI PISANO. The free-standing circular baptistery was begun about a century after the cathedral, conforms to the same exterior color scheme and contains a pulpit by Nicola Pisano, who may also have remodeled the exterior in the GOTHIC style. With its arcaded exterior, it harmonizes well with the cathedral and the tower that completes the group.

PISA, TOWER OF (Leaning Tower of Pisa). Campanile of the CATHEDRAL OF PISA, begun in 1153 and designed by Bonanno da Pisa (fl. 1174–1186) to conform with and complete the principal religious complex of the Italian city of Pisa. Because of its inadequate foundation, it inclines roughly 13 feet from the perpendicular.

PISANELLO, ANTONIO (before 1395–ca. 1455). An Italian painter and medalist and the chief exponent of the INTERNATIONAL GOTHIC style after the death of GENTILE DA FABRIANO, his probable teacher. A fine narrative painter, he is known best as a portrait medalist and a superb draftsman, particularly in his treatment of animal subjects.

PISANO, GIOVANNI (ca. 1248–after 1314). Italian sculptor and architect and son, pupil and collaborator of Nicola Pisano. Generally credited with the major portion, if not the sole authorship, of a series of monumental saints and prophets on the exterior of the Pisa Baptistery, he later executed much of the façade of Siena Cathedral and, still later, his masterful reliefs for the pulpit of S. Andrea, Pistoia. He carried the tradition of his father into the GOTHIC era and opened the way for the "modern" sculpture of GHIBERTI, DONATELLO and JACOPO DELLA QUERCIA.

PISANO, GIUNTA (ca. 1200–1258). An Italian painter of the school of Pisa. His surviving works are painted crosses with portraits of the Virgin and St. John flanking the expressionistically rendered crucified Christ.

PISSARRO, CAMILLE (1830–1903). West Indian-born French painter and one of the leading exponents of IMPRESSIONISM. After studying in Paris under the obscure Danish painter Anton Melbye (1818–1875), he became a disciple of COROT, whose influence eventually was superseded by concepts picked up from COURBET and MANET—so, at least, the indignant Corot charged. He was later influenced, with MONET, in whose company he

Camille Pissarro, *Banks of the Oise*, private collection.

traveled to England, by CONSTABLE and remained receptive to new ideas and fresh influences throughout his life. Primarily a landscape painter, he attempted to paint the figure in his middle years with indifferent success. Still later, he became a follower of the much younger SEURAT, but his finest works are the landscapes and cityscapes, much like those of Monet, painted in a purely impressionistic style. He was the father of LUCIEN PISSARRO.

PISSARRO, LUCIEN (1863–1944). French-born English painter, printmaker and son and pupil of CAMILLE PISSARRO. His paintings were derivative of his father's and SEURAT's, and he is remembered chiefly as a printer of fine books.

PITTI PALACE, FLORENCE. An Italian Renaissance palace built in rusticated stone by BRUNELLESCHI for Luca Pitti, a rival of the Medici, it was altered and enlarged a century later by AMMANATI and now houses a superb painting gallery.

PITTONI, GIOVANNI BATTISTA (1687–1767). A Venetian predecessor of TIEPOLO, he was known in his lifetime throughout Europe and in England.

PLEYDENWURFF, HANS (ca. 1420–1472) and **WILHELM** (d. 1494). German father-and-son painters of the school of Nuremberg. Hans is a transitional figure whose essentially GOTHIC style was influenced by Netherlandish realism. Wilhelm was the pupil and stepson of WOLGEMUT and a prolific woodcut artist.

POELENBURGH, CORNELIS VAN (1586 or later–1667). A Dutch landscape painter and pupil of BLOEMAERT, he worked for a time in Rome, was highly respected by such contemporaries as RUBENS and was a key figure in the transmission of Italianate influences to Holland.

POLIAKOFF, SERGE (1906–1969). Russian-born French painter and lithographer. His simple abstractions, painted mostly with the palette knife and made up of carefully fitted angular shapes, are influenced by MALEVICH.

POLIDORO DA CARAVAGGIO (Polidoro Caldara) (1490–1543). An Italian painter and follower of RAPHAEL, he specialized in monochrome paintings, characterized by heavy chiaroscuro, that were imitative of relief sculpture.

POLLAIUOLO, ANTONIO DEL (ca. 1431–1498). Italian painter, sculptor, goldsmith and engraver and brother of PIERO POLLAIUOLO. Possibly trained by GHIBERTI and influenced as a painter by ANDREA DEL CASTAGNO, he is perhaps best known for his copper engraving (the first by a major Italian artist) *Battle of the Nude Gods*, one of the first anatomical studies of consequence since classical antiquity and a work that was to have widespread influence, notably on DÜRER. In his painting, graphic works and sculpture, he fully exploited the potential of line to convey a sense of movement, and in his keen study of anatomy and use of drawing as an experimental tool he was a direct precursor of LEONARDO DA VINCI. As a sculptor, he is particularly renowned for his tomb of Pope Innocent VIII, the first ever to be embellished with a figure representing a contemporary subject.

POLLAIUOLO, PIERO DEL (ca. 1443–ca. 1469). An Italian painter and artisan whose career was overshadowed by that of his brother, ANTONIO DEL POLLAIUOLO.

POLLOCK, JACKSON (1912–1956). An American painter, the foremost exponent of ACTION PAINTING and one of the major artists of the mid-20th century. A pupil of THOMAS HART BENTON, he worked in the regionalist vein until the late 1930s, when his style was radically influenced by the Mexican muralists, SURREALISM (especially as exemplified by MIRÓ) and Southwestern American Indian sand painting. In his characteristic works of the 1940s and early 1950s he laid large expanses of unstretched canvas on his studio floor and, crouching over them, let skeins and coruscations of paint drip onto them, eschewing the use of brushes and other conventional tools in an effort toward the direct expression of his emotions. Typically, his large paintings are densely impacted tracks left by his own comings and goings, actions and gestures as he hovered above the canvas surface. Ideally, each of his works is a continuum without beginning or end and with reference to nothing outside the work itself.

POLYCLEITUS (fl. 2nd half of 5th century B.C.). A Greek sculptor and aesthetician, he was renowned in his time as a major theoretician, principally through his Canon, a treatise on ideal proportion whose precepts he illustrated in works now known only through Roman copies. He was the chief rival of PHIDIAS, whom he bested, according to Pliny, in a competition to make the most beautiful and convincing statue of an Amazon.

POLYGNOTOS (fl. 475–450 B.C.). A Greek painter known through the descriptions of contemporaries, among whom he was famous for his transparent draperies, convincing depictions of space and ability to imbue his subjects with nobility of character.

POMODORO, ARNOLDO (1926–). Italian sculptor, characteristically of spherical forms broken open to reveal coglike shapes.

POMPEII. Ancient city in southern Italy buried by an eruption of Mt. Vesuvius in A.D. 79 and excavated from the mid-18th century until the present. Much of its art and architecture is in a remarkably fine state of preservation, and its wall paintings and villas are among the most superb that survive from their period.

PONT-DU-GARD. Roman aqueduct, built ca. A.D. 14, on the River Gard in southern France. One of the most impressive surviving structures of the Augustan era, it is 160 feet high, almost 900 feet long and comprises three tiers of arches of varying size.

PONTE VECCHIO, FLORENCE. 14th-century bridge on the River Arno. A popular tourist attraction, it is famous for the goldsmiths' shops that line either side of its central causeway, many of them cantilevered over the river.

PONTI, GIOVANNI (1891–). An Italian architect and designer best known for the elegant simplicity of his

Spring, from Pompeii, National Museum, Naples.

chairs and for the Pirelli Building, Milan, which he designed in collaboration with NERVI.

PONTORMO (Jacopo Carucci) (1494–ca. 1557). Italian painter of the FLORENTINE SCHOOL. A pupil of ALBERŒ TINELLI and assistant of ANDREA DEL SARTO, he was a pioneer of MANNERISM, developing a nervous, almost neurotic style that at various stages of his development was influenced by DÜRER, PIERO DI COSIMO, LEONARDO, MICHELANGELO and FRA BARTOLOMMEO. His *magnum opus,* a fresco cycle for the choir of S. Lorenzo, Florence, occupied the last 11 or 12 years of his life but was obliterated in the 18th century. A *Deposition* painted for S. Felicita, Florence, his finest surviving work and one of the masterpieces of early Florentine MANNERISM, is characterized by coloristic and compositional dissonance.

POONS, LARRY (1937–). An American abstract painter, he was loosely identified with OP ART in the mid-1960s, when his flat, uniform grounds were dotted with small ovals of varying intensity, which seemed to generate both surface and spatial movement. His more recent work is less calculated and more expressionistic.

POOR, HENRY VARNUM (1888–1970). An American figurative painter who studied in London (with SICKERT) and Paris. He is also a ceramist and textile designer.

POPE, JOHN RUSSELL (1874–1937). An American neoclassical architect trained in Rome and Paris and known for such public works as the National Gallery of Art and Jefferson Memorial, both in Washington, D.C.

PORDENONE (Giovanni Antonio de' Sacchi) (ca. 1483–1538). North Italian painter who worked mostly in fresco and was influenced by TITIAN, GIORGIONE, MANTEGNA, CORREGGIO and MICHELANGELO. He slightly influenced TITIAN, with whom he competed for favor in Venice, and RUBENS.

PORTA, GIACOMO DELLA (1533–1602). An Italian architect and assistant to MICHELANGELO, he is best known for his completion of the central dome of ST. PETER's and his radical alteration of Michelangelo's original, less vertical design for it.

PORTA, GUGLIELMO DELLA (Fra Guglielmo del Piombo) (ca. 1490–1577). Italian sculptor and architect and Cistercian lay brother. He worked in a mannerist style influenced by MICHELANGELO and is best known for his monument for Pope Paul III (Vatican: St. Peter's).

POST, FRANS (ca. 1612–1680). Dutch landscape painter who specialized in precisely rendered views of Brazil, a country in which he spent the early years of his career. He was a brother of PIETER JANSZ. POST.

POST, PIETER JANSZ. (1608–1669). A Dutch architect, painter and brother of FRANS POST, he collaborated with JACOB VAN CAMPEN on the design of the Mauritshuis, The Hague.

POT, HENDRICK GERRITSZ. (ca. 1585–1657). A Dutch painter decisively influenced by FRANS HALS, he produced portraits, history pictures and genre subjects.

POTTER, PAULUS PIETERSZ. (1625–1654). Dutch animal painter and child prodigy whose masterpiece, *The Young Bull* (The Hague: Mauritshuis), was produced when he was 22. The picture was much more highly regarded in the 19th century than it is today, especially by the French, who, while it was in their possession, accorded it a respect usually reserved for works of the very first rank.

POURBUS FAMILY. A family of three generations of Flemish portrait painters whose more prominent members were Pieter Pourbus (1510–1584), a son-in-law and pupil of BLONDEEL who was influenced by MICHELANGELO, his son Frans Pourbus the Elder (1545–1581), who produced a number of religious works characterized by their unusual clarity, and *his* son Frans the Younger, who worked in Italy and in France, where he died.

Nicolas Poussin, *Mars and Venus*, Museum of Fine Arts, Boston, A. Hemenway and A. Wheelwright Fund.

POUSETTE-DART,RICHARD (1916–). A largely self-taught American abstract painter, characteristically of cool-toned, symmetrical motifs rendered in countless, heavily impasted little strokes.

POUSSIN, NICOLAS (1594–1665). French painter who worked and died in Rome. His work, in many ways the personification of French art and thought, was intensely cerebral, impeccably ordered and thoroughly didactic. Throughout his mature career he strove to suppress sensuousness from his pictures and to impose on them a severity and stability he equated with the Dorian mode of Plato and Aristotle. His training was accomplished under several minor painters and through observation and experimentation, and his initial inclination toward the BAROQUE gave way to a more restrained style when, after a serious illness, he turned to the production of smaller pictures, gradually eliminated Venetian color from his work in favor of a heightened plasticity and more limited palette derived in part from RAPHAEL and substituted classical for religious themes. As he grew older, his style became increasingly austere and even more insistent on the suppression of coloristic hedonism, and the works of his last years are characterized by pure, almost geometrical logic undiluted with any attempt to invest them with life or charm. At their most characteristic, his pictures are put together with a machined precision that subordinates all detail to the greater cohesiveness of the whole and populated by robotlike figures whose gestures are remote, lifeless and undistracting. He is generally regarded as the initiator of French classical painting.

POWERS, HIRAM (1805–1873). An American sculptor who worked in Italy in the neoclassical style and won international acclaim for a time for his technical proficiency and for his insipidly erotic life-size marble *Greek Slave* (Washington, D. C.: Corcoran Gallery), of which he made several copies.

POZZO, ANDREA (1642–1709). Italian painter, designer and architectural writer influenced by RUBENS and renowned for his mastery of perspective, as exemplified in his vertiginously illusionistic ceiling painting *The Triumph of St. Ignatius* (Rome: S. Ignazio). As a theorist, he had widespread influence during the late BAROQUE and ROCOCO eras, particularly on SOLIMENA and TIEPOLO.

PRATT, MATTHEW (1734–1805). American ROCOCO portrait painter and pupil of WEST.

PRAXITELES (fl. mid-4th century B.C.). An Athenian sculptor and, with PHIDIAS, one of the two greatest artists of ancient Greece. Only one existing work, *Hermes and Dionysos* (Olympia Museum), actually may be from his hand, but from it and Roman copies of other works his style is known to have been graceful, soft, fluid, less idealized than that of Phidias and typified by a relaxed assymetry.

PRENDERGAST, MAURICE (1859–1924). Canadian-born American post-impressionist painter and watercolorist. Trained in Paris, where he was first influenced by WHISTLER and MANET, he later became a member of THE EIGHT. His works are characterized by simplicity and strength of composition and a mosaiclike application of flat planes of color that tend to dissolve forms in a generalized glitter that has little to do with observable effects of light on objects.

PRETI, MATTIA (1613–1699). An Italian eclectic painter influenced primarily by GUERCINO and LANFRANCO as a frescoist and, in his oil paintings, by CARAVAGGIO.

PREVITALI, ANDREA (fl. lst quarter of 16th century). An Italian painter and pupil of GIOVANNI BELLINI. His style derives chiefly from CARPACCIO, and his subjects are mostly Madonnas and saints.

PRIEUR, BARTHÉLEMY (1545–1611). A French sculptor in the court of Henri IV and a follower of PILON, he is known best for his tomb effigies of Constable Montmorency and his wife (Paris: Louvre).

PRIMATICCIO, FRANCESCO (1504–1570). Italian painter, sculptor, architect and decorator. While still studying under GIULIO ROMANO, he was sent to France by the Duke of Mantua and worked at Fontainebleau with Rosso. After a return to Rome during which he seems to have acted primarily as a purchasing agent for François I, he returned to France, where, except for occasional visits to his native land, he spent the rest of his life and where he created the school of Fontainebleau. Little of his painting survives, and he is known today chiefly through his sculpture.

PROCACCINI, GIULIO CESARE (1574–1625). An Italian painter and sculptor of the school of Milan whose style derives primarily from RUBENS.

PROVOST, JAN (1465–1529). A Flemish painter influenced by QUENTIN METSYS, with whose works his often have been confused, as they have been with those of MEMLING.

PRUD'HON, PIERRE-PAUL (1758–1823). A French painter, illustrator and draftsman of the First Empire. His style derives from RAPHAEL, LEONARDO and CORREGGIO, whose works he studied in Rome. Although held in little esteem by J-L. DAVID, he was much admired for his romantic tendencies by GROS. Unfortunately, his experimentation with untried materials has led to the deterioration of many of his paintings, and he is now known chiefly through his softly modeled drawings.

PRYDE, JAMES FERRIER (1866–1941). Scottish-born English painter and graphic artist, known for his rather GOTHIC treatment of architectural subjects and for his poster designs.

PUCELLE, JEAN (Jehan) (fl. lst half of 14th century). A French miniaturist who traveled in Italy, where his style was influenced by the painters of the FLORENTINE and SIENESE SCHOOLS. He is known for his naturalism and for the easy integration of his central illustrations and marginal decorations.

PUGET, PIERRE (1620–1694). A French sculptor who did much of his work in Italy, where he assisted PIETRO DA CORTONA in the decoration of the PITTI PALACE, he is considered the founder of the French BAROQUE style. His best-known work is the Michelangelesque *Milo of Crotona* (Paris: Louvre) and typifies his personal revolt against the tepid linear style prevalent in France during his lifetime.

PUVIS DE CHAVANNES, PIERRE (1824–1898). French painter and the leading muralist of his time. His style is characterized by its flatness, etiolated color and the occasional insipidity that resulted from his striving for absolute harmony and a sense of repose. He was much admired by contemporaries of varying aesthetic persuasions.

Q

QUARENGHI, GIACOMO (1744–1817). Italian-born Russian architect influenced by PALLADIO and known for the simplicity of his style.

QUAYTMAN, HARVEY (1937–). American abstract painter of large, swinging, gestural shapes.

QUERCIA, JACOPO DELLA (ca. 1374–1438). Italian sculptor of whose training nothing certain is known but who was probably influenced early in his career by the works of Nicola and GIOVANNI PISANO. Considered the greatest Sienese sculptor of his day, he lost out to GHIBERTI in the competition for the Siena Baptistery doors but maintained his reputation as the pre-eminent sculptor in Italy outside Florence. He was a transitional figure, his style combining GOTHIC and early Renaissance elements. He was much admired by MICHELANGELO, whose style his own tenuously anticipates.

QUERCIA, PRIAMO DELLA (fl. 1438–1467). An Italian painter, brother of JACOPO DELLA QUERCIA and pupil of DOMENICO DI BARTOLO.

QUIDOR, JOHN (1801–1881). An American painter and pupil of JARVIS who specialized in anecdotal pictures based on the writings of Washington Irving and James Fenimore Cooper and painted in a loose, nervous, somewhat expressionistic style.

Jacopo della Quercia, marble tomb of Ilaria del Carretto, Cathedral of S. Martino, Lucca.

R

RAEBURN, SIR HENRY (1756–1823). Largely self-taught Scottish portrait painter whose work is characterized by directness, simplicity and convincing plasticity at its best and clumsy insensitivity at its worst.

RAFFAELE, JOSEPH (1933–). American sharp-focus realist painter.

RAFFAELINO DEL GARBO (ca. 1466–ca. 1525). Florentine painter. Described by VASARI as an assistant to FILIPPINO LIPPI, he was the teacher of BRONZINO. Much confusion surrounds his origins, identity and the works ascribed to him.

RAIMONDI MARCANTONIO (ca. 1480–ca. 1534). An Italian printmaker and associate of RAPHAEL, whose work was known in its time largely through Raimondi's engraved copies, copies that were instrumental in awakening northern awareness of the Italian Renaissance. His technique was somewhat dry and mechanical, and his even-handed, rather monotonous treatment gave his work a cold, sculptural appearance.

RAINOLDI, GIROLAMO (1570–1655) and **CARLO** (1611–1692). Italian father-and-son architects, of whom Carlo is best known, especially for his BAROQUE Church of S. Maria in Campitelli, Rome.

RAMOS, MEL (1935–). American painter and printmaker usually associated with POP ART and known for sleekly rendered female nudes—often juxtaposed incongruously with exotic fauna—derived from advertising art, magazine illustration and the like.

RAMSAY, ALLAN (1713–1784). Scottish portrait painter and writer who studied in Italy under SOLIMENA and was more or less accurately described by Walpole as "all delicacy." Comparing him with REYNOLDS, Walpole further noted that "Mr. Reynolds seldom succeeds in women, Mr. Ramsay is formed to paint them."

RAPHAEL (Raffaello Sanzio) (1483–1520). Italian painter and architect of the FLORENTINE SCHOOL and one of the major figures of the High Renaissance. Taught at first by his father, the painter SANTI, he worked in the studio of PERUGINO while still in his teens, by which time his pro-

digious talent was already well developed, and while still in his twenties was acclaimed the peer of LEONARDO and MICHELANGELO, both of whom decisively influenced his style.

Most of his abbreviated career was spent in Rome, where he was summoned by the great patron-pope, Julius II, in 1508 and where he immediately embarked on the major project of his life, the mural decorations for a series of small rooms (collectively, the Stanze) in the Vatican. In the first of these rooms, the Stanza della Segnatura, his two frescoes, representing Philosophy (*The School of Athens*) and Theology (*Disputation Concerning the Blessed Sacrament*), epitomize the High Renaissance with their pervasive harmony, easy balance, classical allusions, masterful use of perspective and intensely humanistic outlook. Ancillary ceiling decorations sym-

Raphael, *Madonna and Child and St. John the Baptist,* Louvre, Paris.

bolized the two disciplines depicted, along with Jurisprudence and Poetry, the other subjects to be treated in the succeeding Stanze. Although Raphael is probably responsible for the general plan and concept of all the Stanze, he seems personally to have executed only the first two, after which, in the press of other projects, he turned the work over to numerous assistants, of whom the most important (and possibly the most detrimental to the stylistic unity of the cycle) was his outstanding pupil, the mannerist GIULIO ROMANO.

With the death of BRAMANTE in 1514, Raphael was appointed architect of ST. PETER'S, an appointment that on top of an increasing number of major commissions forced him to rely increasingly on the use of assistants. Nonetheless, he managed to produce several superb portraits and a series of Madonnas, a number of tapestry cartoons and a considerable body of architecture. His reputation underwent a decline in the years after his death, but his serene classicism was re-evaluated in the 17th century and for the next two hundred years had a profound effect on classical painting in Europe.

RATTNER, ABRAHAM (1895–). An American expressionist painter influenced principally by ROUAULT. His semi-abstract compositions are characterized by rich, glowing color and encrusted, jewellike surfaces.

RAUSCHENBERG, ROBERT (1925–). American painter, sculptor, assemblagist and printmaker. A pupil of ALBERS, he also studied elsewhere in the U.S. and in Paris and is generally considered to be one of the major transitional figures of the period between the decline of ABSTRACT EXPRESSIONISM as an innovative force and the advent of POP ART. Heavily influenced by the attitudes of DUCHAMP, his work is audaciously experimental, was highly iconoclastic and hotly debated earlier in his career and continues to defy easy categorization. Like Duchamp's, much of his work is predicated on the proposition that art is anything the artist chooses to designate as such. In advancing this concept he has considerably enlarged the range of materials and attitudes now accepted as legitimate vehicles of artistic expression.

RAVENNA. An Italian city on the Adriatic coast, it is a former capital of the Roman Empire and was the most important Byzantine city in Europe. Its many Byzantine remains are among the purest examples extant and include a number of notable structures and some exceptionally fine mosaics.

RAY, MAN (1890–). An American painter and photographer and a leading figure in the DADA movement and SURREALISM. He is known chiefly for such innovations as "Rayographs" (silhouettes formed by placing objects on photographic paper), for Surrealist incongruities such as a flatiron studded with tacks and has executed at least one painting of real distinction: *Observation Time—The Lovers* (New York: collection of William Copley).

Raphael, *Baldassare Castiglione*, Louvre, Paris.

REDON, ODILON (1840-1916). A French romantic painter and printmaker, he opposed the optical literalism of the Impressionists with subjects taken from his own fantasies and depicted with extraordinary coloristic richness in his oils and pastels and with a dramatic command of chiaroscuro in his drawings and lithographs. He was much admired by the SYMBOLISTS and generally is regarded as an important precursor of SURREALISM.

REGNAULT, ALEXANDRE-GEORGES-HENRI (1843–1871). A French painter of portraits, historical and literary subjects and allegories.

REGOYOS Y VALDES, DARIO DE (1857–1913). Perhaps the first Spanish painter in the international avant-garde, he was an adherent of DIVISIONISM.

REICHLE, HANS (ca. 1570–1642). A German sculptor and architect and pupil of BOLOGNA, whose influence he introduced into northern art.

REINHARDT, AD (Adolf) (1913–1967). An American abstract painter and teacher who, in keeping with his interest in Oriental philosphies, sought to induce a meditative trance by creating "black" paintings in which content was brought to the irreducible minimum. In these, the works of his last years, barely perceptible rectilinear configurations—usually a simple cross—seem, on close examination, gradually to emerge from an apparently flat, monochromatic ground.

REMBRANDT (Rembrandt Harmensz. van Rijn) 1606–1669). Generally considered the greatest of the Dutch master painters and one of the finest printmakers and draftsmen who ever lived, he combined breathtaking technical assurance, a thoroughly innovative outlook and profound psychological penetration of his subjects to produce a body of work unparalleled in its richness and van Swanenburgh, an obscure painter of architectural views and cautionary depictions of the nether world, he was sent to Amsterdam, where he was further trained by LASTMAN, who had considerable influence on his early style. Returning to Leyden around 1625, he set up as an independent master and soon began producing works characterized by emphatic chiaroscuro, the use of shadowed areas as active compositional elements and close observation of facial structure and expression—interests (or, rather, preoccupations) that were to become distinctive features of his mature style. During this period his chief influence was CARAVAGGIO, whose style he seems to have known through the Italian's followers in Utrecht.

By 1632 he was back in Amsterdam, where he was to work for the rest of his life and where he soon produced a steady flow of fashionable portraits that were technically masterful but less than inspired. Also more successful technically than aesthetically was a *Self-Portrait with Saskia*, painted a year or so after his marriage in 1634. Very much in the "merry company" manner of TERBRUGGHEN and FRANS HALS, it depicts the artist as a jolly, lecherous toper and strikes an incongruous note in an oeuvre

otherwise largely given to brooding on life's deeper mysteries. *The Anatomy Lesson of Dr. Tulp*, the highly finished group portrait with which he made his reputation, is the apotheosis of his early period. Around 1640 his style had begun to change radically, taking on a warmer tonality, a heightened exploitation of the qualities of paint itself and a greater concern for dramatic effect. The theatrical *Night Watch* (Amsterdam: Rijksmuseum) epitomizes his work of the period.

Although *The Night Watch* (properly *The Company of Captain Frans Banning Cocq and Lieutenant Willem van Ruytenburch*) appears to have pleased the militiamen who commissioned it, Rembrandt's popularity waned soon after its completion—a circumstance that had a markedly deleterious effect on his financial condition but probably contributed to the betterment of his art. Freed from the obligation to satisfy paying customers, the artist was able to devote himself to greater experimentation, a less superficial treatment of less superficial subjects and the substitution of psychological drama for BAROQUE theatricality.

In the course of an extremely prolific career, Rembrandt explored almost every facet of human experience as deeply, perhaps, as it is given to man to see into himself. And nowhere did he turn so steadfast a gaze as he did on himself, in an incredible series of self-portraits that spans the forty years of his working life and records the vicissitudes and unquenchable aspiration of those years with an unflinching candor almost frightening in its intensity. In his last years his fortunes improved some-

Rembrandt, detail, *Self-portrait* (1661), Rijksmuseum, Amsterdam.

Rembrandt, detail, *The Syndics of the Drapers' Guild*, Rijksmuseum, Amsterdam.

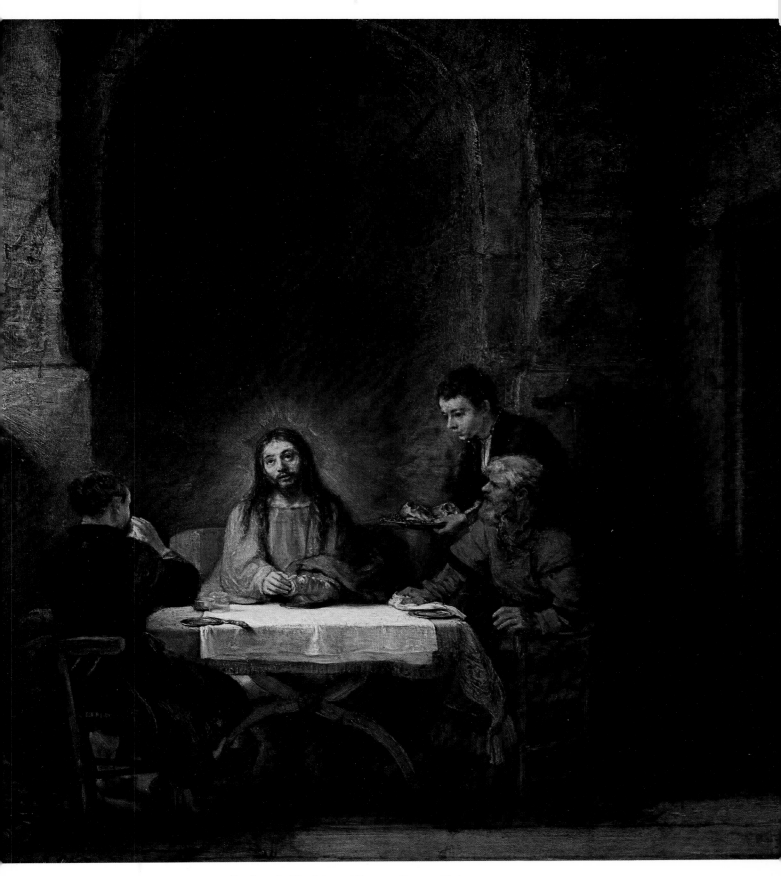

Rembrandt, *The Supper at Emmaus*, Louvre, Paris.

training as a porcelain decorator, he entered the studio of Marc Charles Gabriel Gleyre (1806–1874), a painter and teacher whose chief claim to fame is his having taught Renoir, MONET, SISLEY and BAZILLE at the same time.

Renoir's major contributions to Impressionism were the use of the "rainbow palette," a spectrum of pure pigments that did not include the customary black; a drastic suppression of outline and the espousal of divisionism, whereby colors, instead of being mixed on the palette, were applied purely onto the canvas, in juxtapositions that caused them to "mix" in the eye of the viewer. Unlike most of his confreres, Renoir was essentially a figure painter, not a landscapist, and specialized in depicting nude females in nacreous tones derived as much from his porcelain painter's background and from RUBENS as from a strict Impressionist's observation. Although his subjects tend throughout his oeuvre to dissolve in mists of color, his late works are distinguished by a classical monumentality unique among Impressionist paintings.

RENWICK, JAMES (1818–1895). One of the leading American architects of the GOTHIC Revival. His buildings include Grace Church and St. Patrick's Cathedral, New York, and the Smithsonian Institution and Corcoran Gallery, Washington, D.C.

REPIN, ILYA EFIMOVICH (1844–1930). A pioneer Russian social-realist painter whose style was indebted to a degree to IMPRESSIONISM and DEGAS and whose dramatic canvases, such as *Volga Boatmen* (Leningrad: Russian Museum), were enormously popular throughout Europe in their day. He was also an accomplished portraitist known for his depictions of Tolstoy.

RESNICK, MILTON (1917–). A Russian-born American abstract-expressionist painter.

RESTOUT, JEAN, THE YOUNGER (1692–1768). A French painter and tapestry designer and pupil of JOUVENET, his uncle, he specialized in ceiling paintings and ambitious decorative projects.

RETHEL, ALFRED (1816–1859). A German painter whose early works derive from the NAZARENES and the Düsseldorf school and whose mature style is distinguished by its strong linearity.

REVERE, PAUL (1735–1818). American silversmith and engraver known for the graceful elegance of his metalwork and the stilted clumsiness of his most famous print, *The Bloody Massacre*. He is also a well-known figure in American Revolutionary history, largely thanks to a somewhat fanciful poem by Longfellow.

REYMERSWAELE, MARINUS VAN (ca. 1492–after 1567). A Flemish derivative painter who executed a severely limited number of themes, based on works by DÜRER and METSYS, in a harshly caricatural style.

REYMOND FAMILY. Three generations of French enamelers, of whom the best known and most innovative was Pierre Reymond (fl. 1535–1580).

what, and he was given several important commissions, of which the best known is *The Syndics of the Draper's Guild* (Amsterdam: Rijksmuseum). Ironically, these late works profoundly influenced the last works of Hals, whose manner Rembrandt had imitated some three decades earlier.

As an etcher, Rembrandt was an incomparable virtuoso who vastly broadened the scope of the medium. As a teacher of such painters as DOU, MAES and CAREL and BARENT FABRITIUS, his importance hardly can be overestimated, and, whether through them or directly through his own works, the influence he exerted for two centuries after his death is incalculable.

REMINGTON, FREDERIC (1861–1909). An American painter, sculptor and illustrator of Western plains life. His works are more praiseworthy for accuracy and exuberance than finesse.

RENI, GUIDO (1575–1642). Italian painter and student under CALVAERT and at the CARRACCI Academy. Influenced to a degree by CARAVAGGIO (who returned the compliment by threatening his life) and LUDOVICO CARRACCI, he worked out a personal style based on classical ideals and characterized by cool, light color, graceful composition, balance and refinement. Possibly misled by Reni's insipid imitators, the critic John Ruskin vehemently disparaged the painter in the 19th century, effectively destroying his reputation for a time.

RENOIR, PIERRE-AUGUSTE (1841–1919). French painter and one of the creators of IMPRESSIONISM. After

Pierre-Auguste Renoir, *Le Moulin de la Galette,* Louvre, Paris.

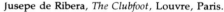

Sir Joshua Reynolds, *Lady Elizabeth Delmé and Her Children,* National Gallery, Washington, D. C., A. Mellon Collection.

1596–1628). Spanish father-and-son painters. Both worked in the mannerist style, although Francisco's later works anticipate the realism of VELAZQUEZ, RIBERA and ZURBARÁN.

RIBERA, JUSEPE (José) DE (1591–1652). A Spanish painter who may have studied under FRANCISCO RIBALTA and who was influenced in Italy by the CARRACCI and CARAVAGGIO, he spent his working years in Naples, which was then part of the Spanish empire. After an early period marked by violent or macabre themes, dark tonalities and harsh chiaroscuro, his style gradually lightened and became increasingly spiritual. A pioneer of the Spanish realist tradition, he unfailingly invested his subjects with a highly credible individuality, eschewing utterly the idealization of the Renaissance. He was a virtuoso with the brush, and his techniques markedly influenced a succession of painters that began with VELAZQUEZ, was continued by MANET and even extended into 20th-century American art in the person of such painters as LUKS. His late works include some of the most compelling studies of old age ever produced.

RHEIMS CATHEDRAL. A superb Gothic church in the Ile-de-France, east of Paris, it occupies a site in continuous use since Roman times. The present edifice was begun after a fire destroyed a previous ROMANESQUE cathedral in the early 13th century. Its design, by Jean d'Orbais, derives from NOTRE DAME, Paris, and is notable for its unity and beauty. Much damaged during World

Jusepe de Ribera, *The Clubfoot*, Louvre, Paris.

REYNOLDS, SIR JOSHUA (1723–1792). English portrait painter, teacher, critic and aesthetic theorist. A pupil of the hack portraitist Thomas Hudson, he was influenced at first by RAMSAY and HOGARTH, but an early trip to Rome converted him to the grand manner, especially as exemplified by MICHELANGELO, and a later journey to the Low Countries added RUBENS to his major influences.

Reynolds was an unusually well-educated and articulate man as painters of his day went and a good friend of Dr. Johnson, Garrick, Goldsmith and Burke. Through these connections and his own literary efforts, he did much to make the English artist—until then regarded as a mere craftsman—a member of a respected profession. His work is studded with learned allusions to classical antiquity and past masters and represents a conscious striving to elevate painting to a position of parity with literature. As an author, his most significant effort was a series of *Discourses* originally delivered as lectures at the Royal Academy, of which he was the first president. In these, he espoused the moral purpose of art, use of uplifting themes and the superiority of ideal over particular forms.

RIBALTA, FRANCISCO (1555–1628) and **JUAN** (ca.

Diego Rivera, *Flower Seller*, Valdés Collection.

War I, it has been completely reconstructed. It is embellished with a profusion of particularly fine sculpture.

RICCI (Rizi), FRAY JUAN ANDRES (1600–1681). A Spanish painter and priest and pupil of MAINO. His work is marked by simplicity, monumentality and intense spirituality.

RICCI, MARCO (1676–1730). An Italian painter, etcher and scenic designer and nephew of SEBASTIANO RICCI, under whom he studied, he is best known for his small, sprightly landscapes.

RICCI, SEBASTIANO (1659–1734). An Italian painter and etcher and uncle of MARCO RICCI, he was an itinerant who worked throughout northern Italy and, briefly, in London, Paris and Vienna. He was influenced by PAOLO VERONESE, and his decorative schemes in turn influenced TIEPOLO.

RICHARDSON, HENRY HOBSON (1838–1886). An American architect who studied in Paris and worked there for a time in the office of LABROUSTE. His most notable achievement is Trinity Church, Boston, a building that profoundly influenced American architecture. Derived from the French ROMANESQUE, it was conceived almost as a metaphor for his vision of a vigorously expanding U.S., and, like the nation itself, it welded a diversity of foreign elements into a powerful, energetic and cohesive whole.

RICHIER, GERMAINE (1904–1959). A French sculptor and assistant of BOURDELLE. Her imagery is concerned with change and decay.

RICHIER FAMILY. French 16th- and 17th-century family of sculptors, decorators and medalists of whom Ligier Richier (ca. 1500–ca. 1566) was the most prominent.

RICHMOND, GEORGE (1809–1896). An English portrait painter and pupil of FUSELI, he was influenced by BLAKE and was an exceptionally fine draftsman.

RIEMENSCHNEIDER, TILMAN (ca. 1460–1531). German sculptor and civic official. His late GOTHIC style is softened somewhat by a tendency toward Italian Renaissance forms, but his clearly defined, rather zigzag planes invest his carvings with considerable energy.

RIEMERSCHMID, RICHARD (1868–1957). A German painter, architect, designer and typographer, he is best known for his highly functional furniture and utilitarian objects.

RIETVELD, GERRIT THOMAS (1888–1964). Dutch designer and architect whose work embodied the theories of DE STIJL, of which he was a member.

RIGAUD, HYACINTHE (1659–1743). A French painter in the courts of Louis XIV and Louis XV. His portraits stressed the attributes and attitudes of his sitters but tended to avoid individuation.

RILEY, BRIDGET (1931–). An English painter and a leading exponent of OP ART. Her black-and-white canvases, characteristically composed of ranked hard-edged discs or parallel lines, maintain the absolute flatness of the picture plane while appearing to explore a third dimension.

RIMMER, WILLIAM (1816–1879). An English-born American sculptor, he was self-taught, displayed his knowledge of anatomy in powerful but somewhat hyperbolic figures and was an important teacher and writer on art theory.

RINCON, FERNANDO DEL (fl. 1491–ca. 1520). A Spanish painter who may have traveled in Italy. His work shows influences of RAPHAEL.

RIVERA, DIEGO (1886–1957). Mexican painter who, with OROZCO and SIQUEIROS, spearheaded the so-called Mexican Renaissance. After more or less academic training in Mexico, he spent years in Europe, where he was influenced by such figures as GAUGUIN, HENRI ROUSSEAU, MODIGLIANI and PICASSO and evolved a personal style derived from CUBISM. Although these influences remained discernible in all his subsequent work, from about the time he returned to Mexico in 1921 he became less responsive to avant-garde innovations and more concerned with the development of a nationalistic style

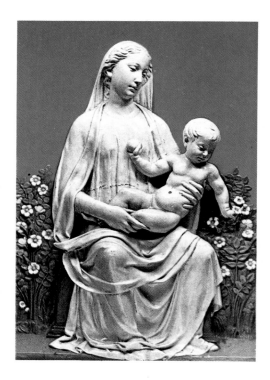

Luca della Robbia, *Madonna of the Rose Garden*, Bargello Museum, Florence.

that could serve as a vehicle for social and political didacticism. To this end, he attemped to incorporate PRE-COLUMBIAN Aztec and Mayan forms into his work, but any meaningful connections with native styles were tenuous in the extreme. His many public murals are characterized by monumentality and simplification of form but often marred by prolixity and propagandistic stridency. A longtime Marxist, he was a figure of controversy throughout most of his life. Ironically, however, while his insistence on including a figure of Lenin led to the obliteration of a mural commissioned for Rockefeller Center, New York, he seems to have had no compunction about flattering the subjects of portrait commissions.

RIVERS, LARRY (1923–). An American painter, student of HOFMANN and transitional figure between ABSTRACT EXPRESSIONISM and POP ART. His characteristic paintings and assemblages tend to be thinly painted, with rather academic figurative elements garnished with stenciled lettering and expressionistic passages.

RIZZO, ANTONIO (fl. after 1465; d. ca. 1500). An Italian sculptor of whom little is known and whose small surviving oeuvre is distinguished by a grace, vigor and naturalism unusual for their time.

ROBBIA, ANDREA DELLA (1435–1525). Italian sculptor and enamelist and pupil, nephew and follower of LUCA DELLA ROBBIA.

ROBBIA, GIOVANNI DELLA (1469–1529). An Italian sculptor and son of ANDREA DELLA ROBBIA, he worked mostly in glazed terra cotta.

ROBBIA, LUCA DELLA (ca. 1400–1482). Italian sculptor and the foremost exponent of glazed terra-cotta sculpture

in the history of art. The uncle of ANDREA DELLA ROBBIA and founder of a family workshop of importance and renown, he was influenced by GHIBERTI and DONATELLO. Although a sculptor in marble and bronze, he is indissolubly associated with glazed terra-cotta half-length Madonnas, with white figures on a deep-blue ground. These are characterized by a warmth, humanity and near sentimentality with no exact precedent in Italian art.

ROBERT, HUBERT (1733–1808). A French landscape painter who worked in Italy for more than a decade in association with PIRANESI and PANINI, he was also a close friend of FRAGONARD, with whom he exchanged influences. Although primarily a painter of decorative schemes for great houses, he is best known for smaller views and landscapes in which antique ruins figure prominently.

ROBERT-FLEURY, JOSEPH-NICOLAS (1797–1890). The most prominent member of a family of French painters, he was a specialist in history pictures and a director of the French Academy in Rome.

ROBERTI, ERCOLE DE' (ca. 1450–1496). An Italian painter of the school of Ferrara, he may have been a pupil of COSSA, by whom he was influenced, as he was by TURA, GIOVANNI BELLINI and PIERO DELLA FRANCESCA. His style is incisively linear, with a good deal of the twisting movement associated with Cossa.

ROBERTS, TOM (1856–1931). English-born Australian painter. Trained at the Royal Academy, London, he was influenced by BASTIEN-LEPAGE and IMPRESSIONISM and is generally considered the founder of the Heidelberg School, the first native Australian school of painting, which was based on impressionist principles and numbered STREETON among its adherents. He is known best for his portraits and genre subjects.

ROBINSON, BOARDMAN (1876–1952). An American mural painter, illustrator and teacher best known as a cartoon journalist.

ROBINSON, THEODORE (1852–1896). An American landscape painter and pupil, in Paris, of Charles-Emile-Auguste Carolus-Duran (1838–1917) and GÉRÔME. Influenced by MONET, he was, with HASSAM, in the vanguard of American IMPRESSIONISM.

RODARI, TOMASO (fl. ca. 1st quarter of 16th century). The most prominent member of a family of Italian sculptors, he is known for his decorative sculpture for the Cathedral of Como, a project that occupied most of his life.

RODCHENKO, ALEXANDER (1891–1956). Russian painter, sculptor and designer and a pioneer of CONSTRUCTIVISM. Initially influenced by FUTURISM and MALEVICH (against whom he later rebelled), he later followed the lead of TATLIN, constructing three-

Auguste Rodin, *The Kiss*, Rodin Museum, Paris.

dimensional works whose forms and materials paralleled those of engineering and industry.

RODIA (Rodilla), SIMON (1879–1965). Italian-born American self-taught sculptor-architect-assemblagist and professional tile setter. His astonishing single work of art, *Watts Towers*, Los Angeles, is the product of three decades of solitary labor: a cluster of graceful openwork spires (of which the tallest is nearly 100 feet high) encrusted with mosaiclike fragments of bottles, dishware, seashells and the like. Undertaken as a gesture of gratitude to his adopted country ("I wanted to do something for the United States because I was raised here"), his fantastic structures bear a curious resemblance to GAUDÍ's Church of the Sagrada Familia, Barcelona, a work Rodia could not have known, and eerily presage much of the junk sculpture and assemblage of the 1960s. Aside from their ethereal beauty and compelling harmony, the towers represent a formidable feat of engineering, as civic authorities found when, after condemning them as "unsafe," they were unable to pull them down.

RODIN, AUGUSTE (1840–1917). French romantic sculptor and one of the most celebrated and influential artistic figures of the late 19th and early 20th centuries. After studying with a minor classicist, he became the pupil of BARYE and absorbed influences from PUGET. In 1875 he went to Italy, where he was decisively influenced by the works of MICHELANGELO, who, as he wrote to BOURDELLE, "freed me from academicism." His first major work, *The Age of Bronze*, elicited charges that the startlingly lifelike male nude had been cast from a living figure. With this and the subsequent bronzes *John the Baptist* and *Walking Man*, he established his characteristic style, which was distinctively naturalistic and full of movement—in short, the antithesis of the stilted, idealized academic style then prevalent.

Rodin's first major commission was awarded him in 1880, in the form of a large bronze door for a still-unbuilt Museum of Decorative Arts in Paris. The project, whose subject derived from Dante's *Divine Comedy* and was known as *The Gates of Hell*, occupied almost all Rodin's energies for a decade and, after the 1880s, intermittently for the rest of his life. Although uncompleted at his death, it was the source of many of his most famous individual works, including *The Thinker* and *The Kiss*.

Although he was immensely popular during his lifetime, Rodin's major commissions were for the most part artistic triumphs but practical failures. His monumental *Balzac*, for example, provoked a storm of adverse criticism when displayed for the first time and was rejected by the commissioning committee. Nonetheless, he was celebrated in his lifetime for his exuberant confrontation of life, as a technician without peer and as the inventor of a new sculptural form, the fragment conceived as a complete work. He was a notable draftsman and the author of innumerable watercolor studies, and countless copies, casts and replicas of his works were produced by the

large, active workshop he maintained. Throughout his oeuvre he was committed to fluent, nervous, vibrant, brilliantly modeled surfaces as barometers of human emotions and the human spirit.

RODRIGUEZ, LORENZO (1704–1774). Spanish-born Mexican architect and designer, principally of retables.

ROGERS, ISAIAH (1800–1869). An American Greek-revivalist architect best known for the Tremont House, Boston, generally considered the first modern, architecturally integrated American hotel.

ROGERS, JOHN (1829–1904). An American sculptor whose small genre groups were mass-produced and widely circulated in the 19th century.

248

ROHLFS, CHRISTIAN (1849–1938). A German expressionist painter and printmaker influenced by MUNCH, MONET and VAN GOGH, he is best known for townscapes and floral motifs painted in tempera.

ROLDAN, PEDRO (ca. 1624–ca. 1700). A Spanish sculptor, painter and architect known best for his theatrically integrated altarpiece in La Caridad, Seville.

ROMANO, SALVATORE (1925–). An American minimalist sculptor, principally of works in which one large geometric form floats in a pool of water concealed in a second, or base, form, turning slowly and creating a variety of spatial, temporal and volumetric relationships.

ROMBOUTS, THEODOOR (1597–1637). A Flemish painter and probable pupil of JANSSENS, he was one of the many followers of CARAVAGGIO in the Low Countries and was also influenced by RUBENS.

ROMNEY, GEORGE (1734–1802). An English portrait painter who in his time was regarded the peer of GAINSBOROUGH and REYNOLDS but since has been downgraded. He aspired to the grand manner and made innumerable preliminary sketches for history pictures but rarely completed the projects. At his best, his work was fluent, bold and rapidly executed.

RONCHAMP: CHAPEL OF NOTRE-DAME-DU-HAUT. Pilgrimage Church in eastern France, near the Swiss frontier, built in 1950–1955 by LE CORBUSIER and regarded as one of the masterpieces of 20th-century architecture. Atypically curvilinear, it is essentially a work of sculpture in which Le Corbusier discarded the functional, rational approach that characterizes all his other works, arriving seemingly by intuition and sheer inspiration at a complex interplay of free forms with light.

George Romney, *Anne, Lady de la Pole,* Museum of Fine Arts, Boston, gift of the Fuller Foundation in memory of Alvan T. Fuller.

ROOT, JOHN WELLBORN (1850–1891). American architect, writer and partner of DANIEL HUDSON BURNHAM. A pioneer in the development of the skyscraper, he stressed functionalism and suppressed ornamentation.

ROPS, FELICIEN (1833–1898). A Belgian printmaker and painter who worked in France, he was largely self-taught, specialized in decadent, erotic subjects, often drawn from a private mythology, and was a masterful etcher and aquatintist.

ROSA, SALVATOR (1615–1673). Italian painter and etcher. An accomplished Jack-of-all-trades, he was also a poet, satirist, musician, composer and celebrated actor. As a painter, he is best known for battle scenes, landscapes and marine subjects executed in a romantic style. His later, classical period was less successful.

ROSENQUIST, JAMES (1933–). American painter and printmaker and a leading figure in the POP ART movement. His characteristic canvases approach the scale of advertising billboards, often are made up of several interlocking panels that suggest bill posters' sheets and are rendered in the sleek, vacuous style of commercial illustration. Subjects are often fragmentary and jarringly juxtaposed in combinations that recall SURREALISM, and much of his work is informed with obvious, if inexplicit, social commentary.

ROSENTHAL, BERNARD (1914–). An American sculptor best known for his work of the 1960s, in which the surfaces of dark monolithic shapes—often huge cubes balanced on single corners—are broken up by rigidly geometric planes that appear to interlock like the components of a Chinese puzzle.

ROSLIN, ALEXANDRE-CHARLES (1718–1793). A Swedish portrait painter active in the courts of Europe and known for his bravura treatment of finery.

ROSSELLI, COSIMO (1439–1507). A Florentine painter and pupil of GOZZOLI, he is remembered chiefly for his workshop, which produced ANDREA DEL SARTO, PIERO DI COSIMO and FRA BARTOLOMMEO, among others.

ROSSELLINO, ANTONIO (1427–1479). An Italian sculptor and member of a large family of artists that included his older brother BERNARDO ROSSELLINO, by whom he was probably trained. His work is characterized by its gentle modeling and credible form.

ROSSELLINO, BERNARDO (1409–1464). Italian architect and sculptor and brother of ANTONIO ROSSELLINO. His sculpture is essentially decorative and influenced by MICHELOZZO, LUCA DELLA ROBBIA and DONATELLO. As an architect, he is known best for the Cathedral and Piccolomini Palace, Pienza.

ROSSETTI, DANTE GABRIEL (1828–1882). English painter and poet. Trained briefly by FORD MADOX BROWN and influenced by HOLMAN HUNT, with whom he shared a studio, he was a leader of the PRE-RAPHAELITE BROTHERHOOD and, from a technical standpoint, its worst painter.

Medardo Rosso, *Bust of Yvette Guilbert*, National Gallery of Modern Art, Rome.

strife and struggle.''

ROTHENSTEIN, SIR WILLIAM (1872–1945). An English landscapist and portraitist influenced by WHISTLER, IMPRESSIONISM and DEGAS. He is also known as a war artist.

ROTHKO, MARK (1903–1970). Latvian-born American painter and a leading exponent of ABSTRACT EXPRESSIONISM. He was student of MAX WEBER, and his early work was heavily influenced by SURREALISM, but in the late 1940s he turned to an abstract idiom in which soft-edged rectangular areas of color were positioned on uniformly colored grounds. Gradually he simplified his style, often allowing the colors of his underpainting to suffuse shapes that seemed to hover at some distance from his receding grounds. Unlike those of most abstract expressionists, his works are serene, meditative and vibrant with a curiously spiritual luminosity.

ROUAULT, GEORGES (1871–1958). French expressionist painter and student of MOREAU, among other teachers. After starting his career as an academic painter, he developed a crude, forceful style based to a considerable extent on his early experience in a stained-glass workshop. Although he exhibited with the original adherents of FAUVISM in 1905, he was more or less an outsider among them and a loner throughout his career. A devout Catholic, he was one of the last major painters to occupy

Theodore Roszak, *Thorn Blossom*, Whitney Museum of American Art, New York.

ROSSO, MEDARDO (1858–1928). An Italian sculptor and assistant for a time of DALOU, he was influenced to some extent by DAUMIER. Like the painters who developed IMPRESSIONISM, he was fascinated with the ability of light apparently to dissolve form, and his figures, with their meticulously modulated surfaces and blurred features, reflect that preoccupation. The translucency of the wax he employed as his customary medium heightened the effects he strove for, which often seem analogous to the painterly technique of glazing. He and RODIN influenced each other to some degree.

ROSSO FIORENTINO (Giovanni Battista di Jacopo di Gaspare) (1495–1540). An Italian painter and the leading exponent of early Florentine MANNERISM, he was trained under ANDREA DEL SARTO and, after working in various parts of Italy, traveled to France, where, with PRIMATICCIO, he was a founder of the FONTAINEBLEAU STYLE and a major influence on the subsequent development of French painting. Influenced by Andrea and MICHELANGELO, his works are characterized by nervousness, emotionalism, occasional compositional confusion and an expressive use of color.

ROSZAK, THEODORE (1907–). A Polish-born American sculptor. His early CONSTRUCTIVIST works were superseded in the 1940s by organic forms and a somewhat overwrought style similar to what ABSTRACT EXPRESSIONISM was producing in painting. At their best, his works have a brutal, unsettling quality that reflects his stated aim: to produce ''blunt reminders of primordial

Georges Rouault, *Face of Christ*, National Museum of Modern Art, Paris.

himself for the most part with religious subjects, making his fervor manifest in rich, glowing, jewellike color, heavy black outlines and movingly expressive figures. A resolute perfectionist, he publicly burned some 300 works late in his career because he found them wanting in quality. He was also a printmaker of the first magnitude.

ROUBILIAC, LOUIS FRANÇOIS (ca. 1705–1762). A French ROCOCO sculptor who worked and died in England, he was renowned in his time for his statue of *Handel* (London: Victoria and Albert Museum) and for his lively portrait busts.

ROUSSEAU, HENRI (1844–1910). A French naïve painter called "Le Douanier" for his vocation as a customs agent. Generally considered the greatest primitive painter of modern times, he was much admired by such contemporaneous masters as SIGNAC, RENOIR, REDON,

TOULOUSE-LAUTREC and PICASSO. His subjects ranged from military bands (he had played the saxophone in one during his army service) and football players to such exotica as sleeping gypsies watched over by lions and nudes reclining on plush sofas in the deep jungle, all imbued with a haunting, dreamlike quality. His clean, simple forms are among the very few by naïve painters that have had any influence on professionals.

ROUSSEAU, (Pierre-Etienne-) THÉODORE (1812–1867). A French painter of the BARBIZON SCHOOL, of which he was a leading figure. A youthful prodigy, he was one of the first painters to work out of doors, directly from nature. Influenced by RUISDAEL and UKIYO-E woodcuts, he made in his late works an objective study of atmospheric effects that had little to do with his earlier romanticism.

Henri Rousseau, *The Snake Charmer*, Louvre, Paris.

Peter Paul Rubens, *Portrait of Isabella Brandt*, Uffizi, Florence.

ROWLANDSON, THOMAS (ca. 1756–1827). An English draftsman, illustrator and caricaturist who studied in Paris, he supported himself, after squandering an inherited fortune, by churning out drawings satirizing manners and mores. His line is notable for its fluency, and his style is characterized by a Gallic lightness.

ROY, PIERRE (1880–1950). A French painter and printmaker loosely associated with SURREALISM, he depicted incongruous elements in a meticulously realistic style.

RUBENS, PETER PAUL (1577–1640). A Flemish painter and the foremost genius of the northern BAROQUE, he was born in Westphalia but was taken to Antwerp, whence his Calvinist father had fled, at age ten. After studying with three minor painters, of whom the best known was OTTO VAN VEEN, he established an independent workshop in 1598 and two years later traveled to Italy, where he copied works by TITIAN and PAOLO VERONESE and was named court painter to Vincenzo Gonzaga, Duke of Mantua. Fluent in German, French, Flemish and Latin, he was sent on an embassy to Philip III of Spain in 1603 and further familiarized himself with Titian and RAPHAEL in Madrid. After several more years in Italy, he settled in Antwerp as court painter to the Spanish Governors and embarked in earnest on his career, establishing one of the busiest, most prolific workshops in the history of art.

Rubens' earliest works on his return to Antwerp were influenced by Titian and MICHELANGELO, but he soon simplified his style so that a multitude of assistants would not be overwhelmed by the magnitude of his conceptions. (Unlike the masters of many workshops, Rubens sought to maintain control over everything he produced. Even with assistants of the caliber of VAN DYCK, SNYDERS and JORDAENS, he did not simply delegate authority but started and finished most pictures, the extent of his further personal participation being determined by the price of a given work.)

In the decade commencing ca. 1620, Rubens' style, previously characterized by Italianate balance and clarity, became increasingly Baroque and more subtly colored. During this period he produced several major cycles of pictures, including a series of 21 paintings on the life of Marie de Médicis (Paris: Louvre). Concurrently, his diplomatic activities increased, and in 1629 he was entrusted with peace negotiations at the Court of St. James's, where he was eventually knighted, as he was to be by Spain.

In the subsequent decade his style underwent further refinement as he increasingly retired to the seclusion of his studio and indulged in the pleasure of singlehandedly executing pictures, a pleasure too often denied him earlier because of the great demand for his work. That style, which derived essentially from Titian, is characterized by a coloristic audacity unprecedented in its time, a brushstroke of breathtaking fluidity, a luminosity—particularly in the flesh tones—that has seldom been approached subsequently and draftsmanship of the highest order. Above all, Rubens' art was an art of assurance, and his prodigious talent informed everything he undertook, while never leaving the slightest impression of strain or effort.

RUBLEV, ANDREI (fl. late 14th century–ca. 1430). A Russian painter and monk of whom little is known with

Peter Paul Rubens, *The Arrival of Marie de Médicis at Marseilles*, Louvre, Paris.

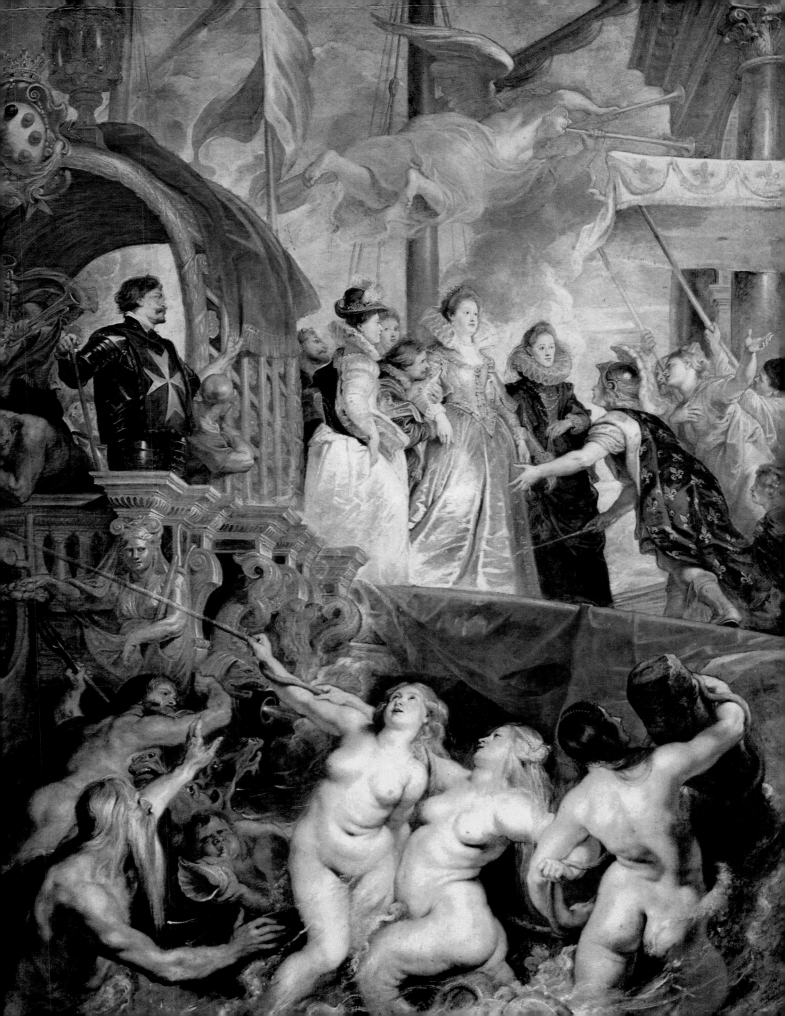

certainty, he is generally regarded as his nation's greatest painter of icons. He was also a frescoist whose style was renowned for its linear simplicity.

RUDE, FRANÇOIS (1784–1855). The leading French sculptor of his time, he is best known for his naturalistic treatment of patriotic themes, as exemplified by his bas-relief *La Marseillaise* on the Arc de Triomphe de l'Etoile, Paris, a work notable for its movement, elaborate composition and emotional intensity.

RUDOLPH, PAUL MARVIN (1918–). An American architect and teacher, he is best known for his Art and Architecture Building, Yale University, New Haven, Connecticut.

RUGENDAS, GEORG PHILIPP (1666–1742). A German painter and engraver and the most prominent member of a family of artists active for three generations. He is known best for military subjects.

RUISDAEL, JACOB ISAACKSZ. VAN (ca. 1629–1682). The finest and most influential of the Dutch landscape painters who worked in a naturalistic vein, he was a pupil of his father, Isaac van Ruisdael, an obscure painter and frame-maker, and, possibly, of his uncle SALOMON VAN RUYSDAEL. A friend of BERCHAM, who may have painted the figures in some of his compositions, he did not enjoy Bercham's popularity in his lifetime but later was recognized as by far the superior artist. His landscapes are distinctive for their broad range of color, luminous skies and vague air of melancholy. He was an influential teacher, of HOBBEMA among others.

Albert Pinkham Ryder, *Autumn Meadows,* Metropolitan Museum of Art, New York.

RUNGE, PHILIPP OTTO (1777–1810). German romantic painter. Although trained in Denmark, he never attained technical proficiency and remained a near-primitive. He developed a sophisticated theory of color nonetheless and a complex symbolism based in part on German mystical writings. Despite his short career, he had a significant influence on later German romantic art.

RUPERT (Ruprecht von der Pfalz), PRINCE (1619–1682). German-English amateur engraver who extended the technical range of the mezzotint.

RUSH, WILLIAM (1756–1833). An early American folk sculptor, primarily of ships' figureheads, and a founder of the Pennsylvania Academy of Art.

RUSSELL, CHARLES (1864–1926). An American painter of Indian life and other western subjects.

RUSSELL, JOHN (1745–1806). An English pastelist, chiefly of portraits.

RUSSELL, MORGAN (1886–1953). An American painter taught by HENRI and influenced by MATISSE, he was a co-founder, with MACDONALD-WRIGHT, of SYNCHROMISM.

RUSTICI, GIOVANNI FRANCESCO (1474–1554). An Italian-born French sculptor influenced by LEONARDO, DONATELLO and VERROCCHIO, he is best known for battle scenes executed in bas-relief.

RUYSDAEL, JACOB SALOMONSZ. VAN (ca. 1629–1681). Dutch landscape painter, son and pupil of SALOMON VAN RUYSDAEL and cousin of JACOB ISAACKSZ. VAN RUISDAEL. His style derives from both his more illustrious relatives.

RUYSDAEL, SALOMON VAN (ca. 1600–1670). Dutch landscape and genre painter, father of JACOB SALOMONSZ. VAN RUYSDAEL and uncle of JACOB ISAACKSZ. VAN RUISDAEL. Influenced chiefly by JAN VAN GOYEN and SEGHERS, he was an important early landscapist, particularly because of his influence on his nephew Jacob. He also produced still lifes in his later years.

RYDER, ALBERT PINKHAM (1847–1917). A largely self-taught American visionary painter. His characteristic works are broadly painted, dark-toned and heavily impasted, with a few large masses held in balance. Much of his work has deteriorated badly because of his use of unconventional and unstable material. Whatever their condition, however, his pictures, whether of storm-tossed ships or themes drawn from literature, have a haunting, other-worldly quality unique in Western art.

RYSSELBERGHE, THEO VAN (1862–1926). A Belgian painter, decorator and printmaker heavily influenced by SEURAT during much of his career.

S

SAARINEN, EERO (1910–1961). Finnish-born American architect and son of ELIEL SAARINEN, in whose office he worked from 1936 until 1950. A leading exponent of the use of cast concrete, he is best known for his lyrical Trans World Airlines Flight Center, John F. Kennedy International Airport, New York City, a building devoid, in its basic conformation, of rectilinear elements. His other designs include the Dulles International Airport Terminal, near Washington, D.C.; the General Motors Technical Center, Warren, Michigan; the Auditorium and Chapel, Massachusetts Institute of Technology, Cambridge, Massachusetts; and the Gateway Arch, St. Louis, a 630-foot-high catenary curve executed in stainless steel.

SAARINEN, ELIEL (1873–1950). Finnish-born American architect and father of EERO SAARINEN. Trained in Finland as both an architect and painter, he was known throughout Europe before emigrating to the U. S., where he first attracted widespread attention with his unrealized design for a Chicago newspaper building, a design that stressed verticality and sculptural form and that had a decisive effect on the future development of the skyscraper. His buildings include the Helsinki Central Station, the Cranbook Academy of Art, Bloomfield Hills, Michigan, and the Tabernacle Church of Christ, Columbus, Indiana.

SACCA FAMILY. A family of Italian sculptors, architects and artisans who flourished in the late 15th and early 16th centuries.

SACCHI, ANDREA (1599–1661). An Italian classical painter and pupil of ALBANI, he was markedly influenced by RAPHAEL.

SAENREDAM, JAN PIETERSZ. (1565–1607). A Dutch engraver, publisher of prints and the father of PIETER JANSZ. SAENREDAM, he was a pupil of GOLTZIUS and won renown for the richness of his blacks and the purity of his whites. Much of his oeuvre consists of engravings after paintings by Dutch and Italian masters.

Eero Saarinen, Trans World Airlines Terminal, Kennedy International Airport, New York.

View from the dome of the plaza of St. Peter's, Rome.

SAENREDAM, PIETER JANSZ. (1597–1665). A Dutch painter, chiefly of church interiors, and son of JAN PIETERSZ. SAENREDAM, he is known for his fidelity to his models, particularly in his drawings.

SAFTLEVEN, CORNELIS (ca. 1607–1681), and **HERMAN HERMANSZ., THE YOUNGER** (1609–1685). Brothers in a Dutch family of artists, Cornelis specialized in genre subjects and anthropomorphic satires, while Herman occupied himself chiefly with topographical views.

SAGRERA, GUILLEM (fl. 1st half of 15th century). A Spanish architect and sculptor who played roles of varying importance in the construction of cathedrals at Perpignan, Gerona and Palma and designed the entire village of Cordidola, near Naples.

SAINT-AUBIN, AUGUSTIN DE (1736–1807). A French engraver, chiefly of reproductive prints, and member of a family of artists.

ST. BASIL'S CATHEDRAL, MOSCOW. Russian cathedral in Red Square built by Ivan IV during the years 1555–1560. Extremely sculptural, it consists of a large central tower surrounded by smaller towers, all capped with onion-shaped cupolas and richly decorated and polychromed.

SAINT-DENIS, ABBEY OF. The first major work of architecture in the GOTHIC style, it is located some seven miles from Paris and was built between 1137 and 1144 under the direct supervision of the statesman-abbot Suger. Located on the site of at least three earlier churches, the edifice was largely rebuilt during the years 1231–1239 by Pierre de Montreuil, who completely altered its CAROLINGIAN nave. The abbey contains several superb tombs, and the 12th-century sculptures of the west front, although much deteriorated, remain.

SAINT-GAUDENS, AUGUSTUS (1848–1907). An American sculptor born in Dublin of French-Irish parents, he was one of the best-known exponents of NEOCLASSICISM in his time and was associated with the architectural firm McKIM, MEAD AND WHITE, for which he executed many commissions.

SAINT-GILLES, ABBEY CHURCH OF. Church in southern France renowned for the triple portals of its 12th-century ROMANESQUE façade, the CORINTHIAN columns and sculptures that surround the doorways and the 12th-century crypt that originated as a subterranean church on the pilgrimage route to Compostela.

ST. MARK'S CATHEDRAL, VENICE. Constructed as a basilica in the late 11th century and raised to cathedral status in 1807, it is a five-domed BYZANTINE edifice built on a Greek-cross plan and elaborately embellished with Oriental booty from the conquest of Constantinople and Venetian ornamentation of the ROMANESQUE, GOTHIC and Renaissance eras. Its interior mosaics represent a uniquely successful blending of the Byzantine and Romanesque styles, and the building *in toto* is one of the most splendid ever erected.

ST. MICHAEL'S, HILDESHEIM. A German OTTONIAN church built in the early 11th century and bearing rudimentary ROMANESQUE characteristics, it is historically notable for the latter and for its superb and highly influential bronze doors.

ST. PAUL'S CATHEDRAL, LONDON. English Renaissance church built by WREN between 1675 and 1710. Celebrated for its ingenious engineering, imposing twin towers and huge (350 feet high) crossing dome, it is Wren's greatest work and served as a training ground for a multitude of his assistants.

ST. PETER'S, ROME. The supreme church of Roman Catholicism and seat of the papacy, it was begun in 1452, but construction was given real impetus during the papacy of Julius II (1503–1513), who conceived of a much more grandiose edifice than the one originally planned and entrusted the project to BRAMANTE. The exact extent of Bramante's work is unknown, and his plans underwent considerable alteration after his death, but it is certain that, in preparing the supports for an inordinately large dome, he set the scale for the immense edifice that ultimately resulted.

Bramante was followed as architect-in-chief by RAPHAEL and ANTONIO DA SANGALLO, neither of whom

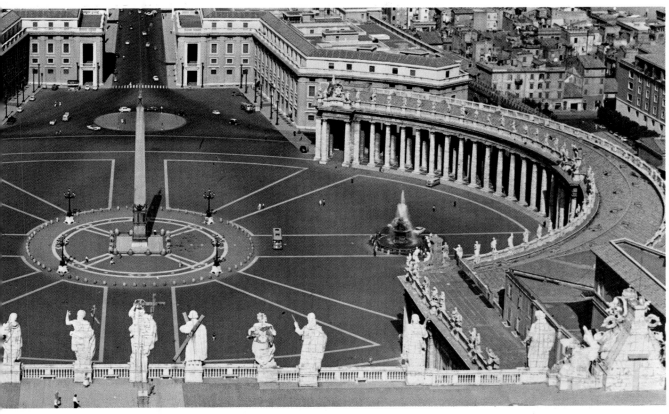

added significantly to the work, and then by MICHELANGELO, who returned to Bramante's discarded original scheme for a centralized church, enlarged the overall concept considerably, eliminated several expendable features and developed a workable scheme for the erection of the dome—a scheme that was altered after his death, when a taller dome than the one he had envisioned was finally constructed. A nave was added by MADERNO in the early 17th century, as were truncated towers at the ends of the façade. The magnificent plaza created by BERNINI, as well as his BAROQUE interior, were the last major additions to the church, which houses many of the finest art treasures ever produced.

SAINT-PIERRE, CATHEDRAL OF, BEAUVAIS. A cathedral in northern France, it is one of the masterpieces of GOTHIC architecture and the ultimate expression of that style's underlying verticalism, with choir vaults more than 157 feet from the ground (a crossing tower and spire attained an altitude of over 500 feet but collapsed in 1573, bringing a substantial portion of the surrounding architecture down with it). Although the edifice was never finished, it remains one of the most imposing monuments ever constructed and is notable for its huge double flying buttresses and vast expanses of stained glass.

ST. SOPHIA CATHEDRAL, NOVGOROD. A Russian church notable for a superb pair of bronze-faced ROMANESQUE doors executed in the mid-12th century and depicting scenes from the life of Christ and the Old Testament in low relief.

SAINT-TROPHIME, ARLES. A cathedral in southern France renowned for its 12th-century portal, one of the outstanding masterpieces of Provençal architectural sculpture, and its superb cloister. Built on the site of a 7th-century church, remnants of which remain in the present building, it served as the coronation church as Frederick Barbarossa took the crown of Arles in 1178.

SAKAKURA, JUNZO (1904–). A Japanese architect and pupil of LE CORBUSIER, whose design for the Tokyo Museum of Modern Art he helped execute.

SALIMBENI DA SANSEVERINO, JACOPO (d. after 1427) and LORENZO (1374–ca. 1420). Italian painters and brothers who worked mostly in collaboration on narrative frescoes.

SALISBURY CATHEDRAL. An English GOTHIC cathedral begun in 1220 and notable for its cloisters and tower, the latter begun in the 1330s by Master Richard of Fairleigh. It is renowned for its unity of design and integration with its setting.

SALVADOR CARMONA, LUIS (1708–1767). A Spanish sculptor and pupil of Juan Ron (d. ca. 1730), he worked in the late BAROQUE style and is best known for his polychromed wood religious sculpture.

SALVI, NICOLA (1697–1751). An Italian architect best known for the Trevi Fountain, Rome.

SALVIATI, FRANCESCO (Francesco de' Rossi) (1510–1563). An Italian painter and tapestry designer and pupil

258

of ANDREA DEL SARTO, he was influenced by PARMAGIANINO and is known primarily for his mannerist frescoes and intense portraits.

SAMPLE, PAUL STARRETT (1896–1973). American painter of stylized genre subjects.

SANCHEZ COELLO, ALONSO (ca. 1531–1588). A Spanish court painter to Philip II. His prolific portrait output derives from MOR, under whom he studied in Flanders.

SANCHEZ COTAN, JUAN (1561–1627). Spanish painter and Carthusian monk known best for his masterfully composed still lifes.

SANDBY, PAUL (ca. 1725–1809) and **THOMAS** (1721–1798). English topographical draftsmen and brothers. Paul, also a watercolorist and printmaker, was a pioneer of the aquatint medium in England and was much admired as a landscapist by GAINSBOROUGH.

SANDRART, JOACHIM VON (1606–1688). A German painter, writer and teacher who was highly esteemed in his lifetime but whose reputation soon declined. His attempts to compose in the grand manner were rather mechanical, but his portraits are worthy of notice.

SANDYS, ANTHONY FREDERICK AUGUST (1829–1904). English painter and illustrator influenced by his friend ROSSETTI.

SANGALLO, ANTONIO DA, THE YOUNGER (1483–1546). Italian architect and city planner and a prominent member of the SANGALLO FAMILY. He designed the Farnese Palace, Rome, and succeeded RAPHAEL as architect in charge of ST. PETER'S.

SANGALLO FAMILY. Two generations of Italian architects, the family was comprised of Antonio da Sangallo the Elder (ca. 1455–1535), whose best-known work is the Church of S. Biagio, Montepulciano, ANTONIO DA SANGALLO THE YOUNGER and Giuliano da Sangallo (ca. 1445–1516), the elder Antonio's brother and collaborator.

SANGALLO, FRANCESCO DA (1494–1576). Italian sculptor. A pupil of SANSOVINO, he was an eclectic best known for his tomb sculptures.

SANMICHELI, MICHEL (1484–1559). An Italian architect and engineer and pupil of BRAMANTE and Giuliano da Sangallo (see SANGALLO FAMILY), he is best known as a designer of palaces in the High Renaissance style.

SANO DI PIETRO (1406–1481). An Italian painter of the SIENESE SCHOOL and pupil of SASSETTA, he worked in an essentially decorative, somewhat uninspired style, mainly in fresco, and left an unusually large body of authenticated works for an artist of his time.

SANSOVINO, IL (Jacopo Tatti) (1486–1570). Italian sculptor, architect and pupil of ANDREA SANSOVINO and BRAMANTE. He is known best for such classical sculptures as *Bacchus* (Florence: National Museum) and for a considerable architectural oeuvre in the High Rennaisance style.

SANSOVINO (Contucci), ANDREA (1460–1529). Italian sculptor and architect and pupil of ANTONIO DEL POLLAIUOLO. His best-known carvings, his marble tombs for Cardinals Sforza and Basso (Rome: Sta. Maris del Popolo), are distinguished by their classical elegance and sympathetic treatment of their subjects.

SANT'AMBROGIO, MILAN. Italian church, parts of which date from the 9th and 10th centuries but most of which was built in the late 11th and 12th centuries and which is regarded as the finest example extant of Lombard ROMANESQUE architecture.

SANTI, GIOVANNI (ca. 1431/40–1494). Italian painter and poet best known as the father of RAPHAEL.

SANTIAGO DE COMPOSTELA, CATHEDRAL OF. Great pilgrimage shrine in Galicia, northwest Spain, built largely between ca. 1075 and 1211. Its west front is considered Spain's outstanding example of the CHURRIGUERESQUE style.

SANTI FAMILY. A family of Italian sculptors and their assistants active in Venice and Padua in the 14th century.

SAN VITALE, RAVENNA. A superbly preserved 6th-century Italian BYZANTINE octagonal church, it is notable for its unity, masterful use of space and magnificent mosaic decorations.

SARACENI, CARLO (Carlo Veneziano) (ca. 1583–1620). An Italian painter and follower of CARAVAGGIO. His style also derived from ELSHEIMER and GENTILESCHI and may indirectly have influenced REMBRANDT. His landscapes are distinguished by their great luminosity and his later altarpieces by distinctively homely facial types and rather exotic costumes.

SARACCHI (Sarachi) FAMILY. Three Italian goldsmiths and crystal carvers and engravers, active in the 2nd half of the 16th century, who worked in the mannerist style.

SARGENT, JOHN SINGER (1856–1925). An American painter born in Italy and student of CAROLUS-DURAN, he was the most popular and successful portraitist of his day. Esteemed for his virtuoso brushwork and bravura handling in general, he was capable of great psychological insight but too often—especially in his later works—portrayed his subjects superficially. His *Madam X* (New York: Metropolitan Museum) was a *cause célèbre* in its time, but its "shocking" décolletage raises no eyebrows today.

SARRAZIN, JACQUES (1592–1660). A French sculptor who spent much of his career in Rome, he is also recorded as a painter, but no works are known.

SARTO, ANDREA DEL (1486–1530). An Italian painter and pupil of PIERO DI COSIMO, he was the greatest colorist of his time outside Venice and one of the most important artists working in Florence. Influenced by MICHELANGELO, FRA BARTOLOMMEO, LEONARDO, FRANCIABAGIO and the engravings of DÜRER, his work anticipates to a degree the MANNERISM of his greatest pupil, PONTORMO, although it remained within the classical tradition until the end of his short career, when he in turn was influenced by Pontormo.

John Singer Sargent, *Lady Macbeth Impersonated by Ellen Terry*, Tate Gallery, London.

SASSETTA (Stefano di Giovanni) (ca. 1400 or earlier–1450). Italian painter and, with Giovanni di Paolo, a major figure in Sienese painting of the 15th century. A transitional figure who was in large part responsible for the replacement in Siena of the gothic by the Renaissance style, he was influenced by Masolini and Gentile da Fabriano and by contemporary developments in Netherlandish painting.

SASSOFERRATO (Giovanni Battista Salvi) (1609–1685). An Italian painter influenced by Raphael, Perugino and the Carracci and an associate of Domenichino, he affected an out-of-date style to produce a large body of sentimentalized religious paintings.

SAVERY, ROELANT-JACOBSZ. (1576–1639). A Flemish painter and member of a prominent family of artists, he is best known for forest scenes influenced by Coninxloo, animal subjects and floral still lifes.

SAVOLDO, GIOVANNI GIROLAMO (ca. 1485–after 1548). A Venetian painter influenced by Giorgione, Titian, Cima and Vivarini. His nocturnal scenes anticipate Caravaggio.

SBARRI, MANNO DI BASTIANO (fl. mid-16th century). An Italian goldsmith and pupil of Cellini, to whom much of his work formerly was attributed.

SCAMOZZI, VINCENZO (1552–1616). An Italian eclectic architect and follower of Palladio, he was also an aesthetic theoretician who espoused strict adherence to classical norms.

SCHADOW, WILHELM VON (1788–1862). A German painter and son of the sculptor Gottfried Schadow (1764–1850), he was associated with the Nazarenes, whose aesthetic he advocated as director of the Düsseldorf Academy.

SCHALKEN, GODFRIED CORNELISZ. (1643–1706). Dutch painter of Biblical, allegorical and genre subjects and portraits. A pupil of Hoogstraten and Dou, he was much esteemed in his time for his candlelight scenes.

SCHÄUFELEIN (or Schäuffelein or Scheufelein), HANS LEONARD (ca. 1480–1539). A German painter, clearly influenced by his teacher, Dürer, and woodcut designer.

SCHEEMAKERS, PETER (1691–1781). An Antwerp-born sculptor who worked mostly in England, he is best remembered for his Shakespeare monument in Westminster Abbey.

SCHEFFER, ARY (1795–1858). A Dutch-born French painter, printmaker and illustrator. His classical style was laden with sentimentality.

SCHIAVONE, ANDREA (ca. 1522–ca. 1563). A Dalmatian-born Venetian painter and etcher influenced by Parmigianino and Titian, he was, with Tintoretto, a pioneer of Venetian mannerism.

SCHIELE, EGON (1890–1918). An Austrian expressionist painter influenced by his teacher Klimt, Hodler and Freudian theory, he had developed an intense, heavily linear and highly colored style when his career was cut tragically short.

SCHINKEL, KARL FRIEDRICH VON (1781–1841). A German architect whose best work is distinguished by its simple, logical form and Greek-derived detail.

SCHLEMMER, OSKAR (1888–1943). A German painter, sculptor and stage designer. His characteristic works in all media are recognizable by their somewhat dehumanized, theoretical appearance. He was influenced to some extent by purism, and his overriding concern was with figures in space. He was an influential teacher at the

Kurt Schwitters, "Merz" *Construction. Ausgerenkte Kräfte*, M. Huggler Collection, Berne.

BAUHAUS and, in both his sculpture and theatrical design, was essentially a Constructivist.

SCHLUTER, ANDREAS (ca. 1662–1714). A German court architect and sculptor. Little of his architecture, which was marred by pompousness and unsound engineering, survives. His BAROQUE sculptural style is best exemplified by his masterpiece, a bronze equestrian statue of Frederick III (Berlin: Charlottenburg Palace).

SCHMIDT (Kremser-Schmidt), MARTIN JOHANN (1718–1801). An Austrian ROCOCO painter of spirited, light-keyed decorative frescoes characterized by their bravura brushwork and sometimes inspired treatment of ephemeral effects of light on objects.

SCHMIDT-ROTTLUFF, KARL (1884–1970). German expressionist painter and printmaker and a founder of DIE BRÜCKE, he was influenced by the post-impressionist painters, CUBISM and African sculpture and proscribed as a "degenerate" artist during the Nazi regime. His woodcuts are powerfully contrasted and highly esteemed.

SCHNORR VON CAROLSFELD, JULIUS (1795–1872). A German painter and illustrator and member of the NAZARENES, he was particularly well known for his Bible illustrations.

SCHON, ERHARD (after 1491–1542). A German painter and woodcut illustrator whose fortunes followed the waxing and waning of Nuremberg as a printing capital.

SCHONGAUER, MARTIN (before 1445–1491). A German painter and engraver probably trained by his goldsmith-father, he was influenced chiefly by ROGIER VAN DER WEYDEN. The only painting definitely by his hand, *The Madonna of the Rose Arbor*, is one of the greatest works of the late GOTHIC era. As a prolific engraver of powerful, widely circulated works, he had immense influence, particularly on the young DÜRER, who set out on a virtual pilgrimage to Schongauer's home in Breisach, only to arrive there after the object of his veneration had died.

SCHRIMPF, GEORG (1889–1938). A German painter, characteristically of monumental female figures, often with their backs to the viewer, in dreamlike settings.

SCHWEIKHER, PAUL (1903–). An American architect, influenced by FRANK LLOYD WRIGHT, and teacher of architecture.

SCHWIND, MORITZ VON (1804–1871). An Austrian romantic painter, printmaker and stained-glass designer known for his use of legends, fairy tales and similar themes.

SCHWITTERS, KURT (1887–1948). A German abstract painter, collagist, poet and environmental sculptor, he was the first artist of importance to make collage his principal medium. Originally influenced by KANDINSKY and later by DADA, he devised a one-man offshoot of the latter called MERZ. Although not explicitly, his works convey a strong sense of mockery—often self-mockery—by their seeming refusal to take anything as seriously as it would like to be taken. Complex official forms, for example, are torn to tatters and pasted down in aesthetically dictated arrangements that deny their strictly utilitarian aims, while viewers are constantly reminded that what they are looking at is, quite literally, trash. Of Schwitters' three most ambitious projects, enormous environmental junk constructions called *Merz-bau*, two were destroyed, while the third was left unfinished at his death.

SCOPAS OF PAROS (fl. 370–355 B.C.). Greek sculptor and architect, one of the most renowned artists of his age. His work was characterized by an unprecedented intensity of expression, at least to judge by surviving copies and ancient descriptions.

SCOREL, JAN VAN (1495–1562). A Dutch painter who traveled extensively in Italy, where he acquired Renaissance influences and a familiarity with the antique that he later combined with his own heritage of northern naturalism.

SCOTT, SIR GEORGE GILBERT (1811–1878). An English architect and leading exponent of the Victorian GOTHIC revival, he was one of the busiest entrepreneurs on record, both as a builder and a restorer.

Martin Schongauer, *Virgin and Child in a Room*, Public Art Collections, Basel.

André Dunoyer de Segonzac, *Still Life with Bread and Wine,* National Museum of Modern Art, Paris.

SCOTT, SAMUEL (ca. 1702–1772). An English painter of topographical views influenced by CANALETTO.

SCOTT, WILLIAM (1913–). A Scottish-born English abstract painter who describes his work as deriving from the French still-life tradition, he has been influenced also by American ABSTRACT EXPRESSIONISM.

SEBASTIANO DEL PIOMBO (Sebastiano Luciani) (ca. 1485–1547). A Venetian painter who may have trained in the workshop of GIOVANNI BELLINI, he was primarily a follower of GIORGIONE and later absorbed influences from RAPHAEL, with whom he eventually quarreled, and MICHELANGELO, who acted as his protector. A masterful portraitist, he was less skillful with more complex themes and was unable to cope with Michelangelo's overwhelming attempts to assist him by supplying figure drawings for some of his compositions.

SEGAL, GEORGE (1924–). An American sculptor who characteristically creates tableaux in which figures cast roughly in plaster from living models convey a strong sense of alienation from society and their surroundings.

SEGANTINI, GIOVANNI (1858–1899). A Swiss painter, chiefly of rural life, landscapes and religious subjects depicted in a modified version of IMPRESSIONISM.

SEGHERS, DANIEL (1590–1661). A Flemish flower painter and pupil of JAN BREUGHEL THE ELDER, he frequently added floral details to works by other artists, including RUBENS.

SEGHERS, HERCULES (ca. 1589–1633). A Dutch landscape painter and etcher and pupil of CONINXLOO, he was influenced by ELSHEIMER and in turn influenced the landscapes of REMBRANDT, who was an avid collector of his works. His few surviving paintings are mostly of mountainous terrain, painted in a romantic style and touched with fantasy but convincingly atmospheric. He was a superb etcher, often experimenting with the medium and enhancing its effects with colored papers.

SEGNA DI BONAVENTURA (fl. late 13th century–1331). An Italian painter and pupil of DUCCIO, on whose style his own is based.

SEGONZAC, ANDRÉ DUNOYER DE (1884–1974). A French painter, engraver and draftsman. Although he was not an adherent of FAUVISM, his style is somewhat akin to what might be termed a generalized Fauve style, with simplified forms and warm, strong color dominant. His prints, more somber than his paintings, are very highly regarded.

SELLAIO, JACOPO DEL (1442–1493). An Italian painter of the FLORENTINE SCHOOL and probable pupil of FRA LIPPO LIPPI.

SEMPERE, EUSEBIO (1924–). A Spanish geometric painter, sculptor and printmaker and former associate of VASARELY. His work has strong ties to OP ART and makes elegant, often ambiguous use of rectilinear modules.

SENEFELDER, ALOIS (1771–1834). A German commercial printer and publisher, he is generally credited with the invention of lithography in 1798.

SEQUEIRA, DOMINGOS ANTONIO DE (1768–1837). A Portuguese romantic painter and educator, he was forced to flee Portugal in 1824 because of his liberal political views and that year won out over such painters as DELACROIX and GÉRICAULT in a Paris competition. His strong point was his treatment of light.

SERAPHINE (Seraphine Louis) (1864–1942). A French naïve painter and mystic known for her tapestrylike arrangements of motifs from nature.

SERLIO, SEBASTIANO (1475–1554). Italian architect, architectural writer and painter. A student of PERUZZI, he was widely influential as the author of a six-volume treatise, *L'Architettura*, which served as a pattern-book throughout Europe.

SERPOTTA FAMILY. Two generations of Sicilian stucco sculptors comprising Giacomo Serpotta (1656–1732), his son Procopio (1679–1755) and brother Giuseppe (1653–1719).

SERRA FAMILY. Three Spanish painters and brothers, Jaime Serra (fl. ca. 1360–1395), Pedro (ca. 1343–ca. 1406) and Juan. Their late-GOTHIC style shows traces of Sienese influence.

SERT, JOSÉ LUIS (1902–). Spanish-born American architect, city planner and educator. After working for LE CORBUSIER and in Barcelona he emigrated to the U.S., where he has taught at Yale and Harvard. His designs include the U.S. Embassy, Baghdad, and the Charles River Campus, Boston University.

SÉRUSIER, PAUL (1864–1927). A French painter, he was a disciple of GAUGUIN and is better remembered as a founder of the NABIS than for his weakly organized, rather simplistic paintings.

SEURAT, GEORGES (1859–1891). French postimpressionist painter and inventor of POINTILLISM. After academic training he became interested in IMPRESSIONISM and in a variety of scientific color theories, particularly

Georges Seurat, *Sunday Afternoon on the Island of the Grande Jatte,* Art Institute, Chicago, Helen Birch Bartlett Memorial Collection.

those of Michel-Eugène Chevreul, who espoused a system of achieving harmony through the selective use of analagous or contrasting hues. Other early influences include DELACROIX, the BARBIZON school and PUVIS DE CHAVANNES. His own great contribution was the devising of Pointillism, a more precise and systematic method of achieving what the Impressionists had striven for in an empirical fashion. Distrustful of instinct, sensuousness or virtuosity, he also developed a theory of composition whereby he hoped to impose an aura of serenity on his pictures through a judicious disposition of horizontal and vertical elements. He meticulously constructed his pictures by first making myriad drawings of a richness and monumentality unique in modern art and then painstakingly applying tiny uniform dots of pure color to his canvases until their surfaces were covered. Throughout his tragically short career Seurat railed against admirers who professed to "see poetry in my work," insisting that he "merely applied my method." In his masterpiece, *A Sunday Afternoon on the Isle of La Grand Jatte* (Chicago Art Institute), and other works, however, he painted some of the most poetic pictures ever produced.

SEVERINI, GINO (1883–1966). An Italian painter and proponent of FUTURISM who spent most of his career in Paris, he studied with BALLA and was influenced by SEURAT and CUBISM. Although an influential advocate of Futurism, he was less concerned with the glorification of the machine than his fellow Futurists and eventually abandoned the movement.

SHAHN, BEN (1898–1969). A Lithuanian-born American painter, printmaker and illustrator. His work was socially and politically oriented and executed in a spare, arid, strongly linear style.

SHARAKU (Toshusai Sharaku) (fl. late 18th century). A Japanese UKIYO-E printmaker. His known oeuvre, upward of 150 works, was produced in less than a year and consists almost exclusively of psychological intensive, markedly caricatural portraits of actors.

SHAW, RICHARD NORMAN (1831–1912). The dominant English architect of the late 19th century, he was an anti-academic revivalist who specialized in country houses but also designed London's Albert Hall Mansions.

SHEELER, CHARLES (1883–1965). American Precisionist painter, photographer and pupil of CHASE. Influenced by CÉZANNE and CUBISM, his work is characterized by its clean precision, suppression of extraneous detail and almost startling clarity. Characteristically, he painted industrial plants, steamships, farm buildings and the like but with decreasing literalism in his later years.

SHEN CHOU (1427–1509). A Chinese painter and poet of the Ming dynasty renowned for his vigorous, somewhat prickly reworkings of masterpieces of the Yüan epoch.

SHERATON, THOMAS (1751–1806). A leading English furniture designer and pattern-book author. His style is marked by crisp, simple forms, elegantly slender legs and the tactful use of classical motifs.

SHIH K'O (fl. late 10th century). A Chinese painter and eccentric who specialized in religious subjects. His style is notable for its dynamic brushwork and great expressivity and the subtle balance of his asymmetrical compositions and highly contrasting tones.

SHINN, EVERETT (1876–1953). An American painter, muralist and illustrator and member of THE EIGHT.

SHUBUN (Tonsho Shubun). A Japanese painter and sculptor, he was renowned for his use of inks, but none of his works have been positively identified.

SHUNSHO (Katsukawa Shunsho) (1726–1792). A Japanese UKIYO-E printmaker known for his portraits of women and actors.

SIBERECHTS, JAN (1627–ca. 1703). A Flemish landscape painter who spent the last 25 years of his career in England. He began his career in the Dutch Italianate tradition, later developed a rather grandiose style and finally painted views of great country houses in a monochromatic and somewhat stilted fashion.

SICKERT, WALTER RICHARD (1860–1942). A Munich-born English painter and etcher, he studied briefly under LEGROS, then worked in the studios of WHISTLER and DEGAS. Applying the basic techniques of IMPRESSIONISM to rather dark interiors, he specialized in theatrical subjects. The influence of Degas is apparent in much of his work.

SIEGEN, LUDWIG VON (1609–1680). A German painter, engraver and soldier, he claimed—and is generally credited with—the invention of the mezzotint ca. 1641.

SIGNAC, PAUL (1863–1935). A French painter and follower of SEURAT who eventually abandoned his strict adherence to the principles of POINTILLISM, applying strong, pure colors with broad, square brush strokes to create mosaiclike surfaces and effects. Unlike his self-effacing mentor, he had a strong personality, and his work is characterized by an exuberance foreign to Seurat. His watercolors are particularly felicitous, and his writings on NEOIMPRESSIONISM, JONGKIND and other subjects were highly respected during his lifetime.

SIGNORELLI, LUCA (ca. 1441–1523). Italian painter of the Umbrian school and pupil and collaborator of PIERO DELLA FRANCESCA, he was markedly influenced in his early years by POLLAIUOLI. Although he is known to have been quite active in Cortona, Arezzo, Voterra, Perugia and elsewhere before moving on to Siena in the late 15th century, relatively little of his work of the period survives. Between 1499 and 1506 he was in Orvieto for the most part and there painted his masterpiece, a fresco cycle for the cathedral. In these paintings he depicted with compelling realism major episodes from Dante's *Divine Comedy*, accomplishing the most incisive treatment of human anatomy before the advent of MICHELANGELO, whom he influenced deeply, as he did RAPHAEL. His later works, mostly altarpieces, tend toward overelaboration, but he remained one of the seminal artists of his time.

SILOE, DIEGO DE (ca. 1495–1563). Spanish sculptor and architect and son of GIL DE SILOE. After studying in

Paul Signac, *The Palace of the Popes,* National Museum of Modern Art, Paris.

Italy he returned to Spain, where his first known work, the Gilded Stairway of BURGOS CATHEDRAL, reflected the influence of contemporaneous Italian styles, as did his contributions to a collaborative altarpiece in the cathedral's Condestable Chapel. During the course of his career his High Renaissance sculptural style gradually took on a heightened expressivity more compatible with Spanish tastes. His architectural masterpiece is his proto-PLATERESQUE design for Granada Cathedral.

SILOE, GIL DE (fl. ca. 1483–1500). A Spanish sculptor and father of DIEGO DE SILOE, he was probably of northern European origin and is generally considered the last great GOTHIC sculptor in Spain. His style was a synthesis of Flemish and Mudéjar (Moorish-Gothic) influences.

SILVESTRE, ISRAEL (1621–1691). The most prominent member of a French family of etchers, he specialized in views of architecturally landscaped sites.

SIMONE DEI CROCEFISSI (ca. 1330–1399). An Italian painter of the Bolognese school and follower of VITALE DA BOLOGNA, with whose works his own have been confused. His name derives from his predilection for Crucifixion pictures.

SIMONE MARTINI (ca. 1283–1334). A major Sienese painter and pupil of DUCCIO, he was also influenced by French GOTHIC art and the sculpture of GIOVANNI PISANO. Little concerned with notions of plasticity, space or verisimilitude, his style is essentially linear, with color used to exploit flat decorative patterning, not to approximate the appearance of nature. An *Annunciation* (Florence: Uffizi), painted in collaboration with his brother-in-law MEMMI, is generally considered his masterpiece. Painted into a Gothic architectural format, it is a magnificent example of Simone's distinctive approach, with its figure of the Virgin forming a dark, sinuous arabesque silhouetted against a luminous, subtly contrasting ground of burnished and dull matte gold. Simone spent the last years of his working life in France, in the then papal city of Avignon, whence he exerted considerable influence on manuscript illumination in France and Flanders for years to come.

David Alfaro Siqueiros, *Peasant Mother*, National Museum of Fine Arts, Mexico City.

was one of the founders and purest practitioners of IM-PRESSIONISM. Influenced by COURBET and COROT, he concentrated more or less exclusively on landscape and was particularly adept at the depiction of water in full sunlight. His forms are solider than those of most of the Impressionists, his palette somewhat warmer and his compositions more consciously planned, with more poetic results.

SITTOW, MICHIEL (Master Michiel) (ca. 1469–1525). An Estonian-born Flemish painter influenced by MEMLING and HUGO VAN DER GOES, he was employed at one time or another by many of the courts of Europe, where he produced several fine portraits and religious pictures.

SKIDMORE, OWINGS AND MERRILL. An American architectural partnership made up of Louis Skidmore (1897–1962), Nathaniel A. Owings (1903–), John O. Merrill (1896–) and, later, Gordon Bunshaft (1909–). The most influential of its many buildings is LEVER HOUSE, New York.

SLEVOGT, MAX (1868–1932). A German Impressionist painter, printmaker and illustrator.

SLOAN, JOHN (1871–1951). An American painter and printmaker and pupil of ANSCHUTZ and HENRI, he was possibly the finest painter of THE EIGHT. His characteristic pictures, depicting the life of the urban working class, are notable for their easy evocation of time and place. Sloan was also a respected teacher and writer and an organizer of the ARMORY SHOW.

SLUTER, CLAUS (fl. ca. 1340; d. ca. 1405). A Dutch-born sculptor who worked in France, he was the pre-eminent realist of his era. Most of his career was spent in the employ of Philip the Bold, Duke of Burgundy, for whom he executed an ambitious sculptural program for the Charterhouse of Champmol, near Dijon. In his portal sculptures there he achieved an unprecedented degree of integration between his lifelike figures and their architectural setting and broke through the conventional stylization of GOTHIC drapery to devise a new and intensely personal, passionately spiritual vehicle of expression. With his startling expressivity, Sluter anticipated the work of DONATELLO by almost a full generation and exerted a widespread influence over subsequent art, especially in Flanders.

SLUYTERS, JAN (1881–1957). A Dutch expressionist painter influenced by most of the modern movements from IMPRESSIONISM onward, he specialized in loosely painted figures, usually setting them in intimate interiors.

SMET, GUSTAVE DE (1877–1943). A Belgian expressionist painter best known for his simple lyrical landscapes.

SIMONINI, FRANCESCO (1686–1753). An Italian painter, primarily of battle pictures.

SIMS, CHARLES (1873–1928). An English painter, primarily of figures in landscapes, influenced by PUVIS DE CHAVANNES.

SINTENIS, RENÉE (1888–1965). A German figurative sculptor and teacher best known for her animal bronzes.

SIQUEIROS, DAVID ALFARO (1896–1974). Mexican painter and one of the leaders, with OROZCO and RIVERA, of the Mexican mural renaissance. A lifelong political activist and labor-union partisan, he spent several years in prison in the 1960s for what the Mexican government termed "social dissolution" and had fought on the Loyalist side during the Spanish Civil War. A tireless technical experimenter, he devoted considerable research to the development of techniques and materials that would insure the durability of outdoor wall paintings and to concepts that would extend and enlarge traditional ideas of the limitations of the flat wall. His style is marked by expressive vigor and exaggerated foreshortening.

SISLEY, ALFRED (1840–1899). An English national who was born, spent most of his life and died in France, he

John Sloan, *McSorley's Bar*, Institute of Arts, Detroit.

SMIBERT, JOHN (1688–1751). Scottish-born Colonial American portrait painter. Influenced by KNELLER, he worked in an elaborate BAROQUE vein that gradually became more realistic and plainer after his arrival in America in 1728. His publicly exhibited collection of antique casts and old-master copies exerted a widespread influence among early American painters.

SMITH, DAVID (1906–1965). Generally considered the greatest sculptor the U.S. has produced, he was a metal worker as a young man but began his artistic training as a pupil of the painters SLOAN and Jan Matulka (1890–1973). Inspired by a photograph of a metal sculpture by PICASSO, he made his first welded sculpture in 1933, thereby embarking on a path he was to follow throughout his career. Until then he had painted in an abstract style derived from STUART DAVIS and XCERON and laden with Surrealist overtones, occasionally appending three-dimensional objects to his canvases, and had experimented with a few constructions combining found objects with carved wood and soldered metal. Given his early training as a welder, it is reasonable to assume that he would eventually have found openwork welded sculpture a logical extension of his experimentation and that his discovery of the Picasso merely hastened the process.

In the 1940s Smith's style was airy, open and, while much concerned with the relationships of objects in space, substantially linear and almost calligraphic (indeed, letters and numbers frequently were components of his imagery of this period). His works tended to reduce themselves to intricate silhouettes, like drawings in space, when seen in the open air or against the neutral backgrounds of gallery settings. Discarded tools and other ready-to-hand metal objects were combined with cut, bent and twisted shapes, while surfaces were left unfinished, as though in reaction to the sleekness of CONSTRUCTIVISM. Gradually his style became simpler, less linear, more geometric and more volumetric. In his late works his old proclivity toward silhouetting (al-

David Smith, *Lectern Sentinel*, Whitney Museum of American Art, New York.

though still expressed in the many monochrome drawings he made by interposing objects between the paper and a spray gun) often is supplanted by its opposite: an insubstantiality produced by the play of light over roughly abraded stainless-steel surfaces. In such late works as those of his "Cubi" series, Smith achieved a soaring monumentality and formal assurance distinctively his own. His influence, both in the U.S. and abroad, has been widespread and continuing and, as exemplified by CARO and others, has virtually revolutionized sculpture in Britain.

SMITH, JOHN "WARWICK" (1749–1831). An English watercolor landscapist much patronized by the 2nd Earl of Warwick, he used a full range of rich color on a gray ground.

SMITH, LEON POLK (1906–). An American abstract painter, much of whose work is based on grid schemes derived from MONDRIAN.

SMITH, SIR MATTHEW (1879–1959). A British painter influenced by GAUGUIN and MATISSE and an adherent of FAUVISM, he acted as a conduit for the introduction into England of various aspects of modern French painting.

SMITH, TONY (Anthony Peter) (1912–). An American sculptor, architect and painter and assistant to FRANK LLOYD WRIGHT, he is best known for his massive black-painted geometric sculptures.

SMITHSON, ROBERT (1938–1973). American sculptor known for his alterations of the natural topography, usually executed on a vast scale.

SNELSON, KENNETH (1927–). An American abstract sculptor, characteristically of taut constructions of metal tubing and wire cables.

SNYDERS, FRANS (1579–1657). A Flemish painter and pupil of PIETER BRUEGHEL THE YOUNGER, he was associated with and influenced by RUBENS, many of whose larger paintings contain animals by Snyders, as do works by VAN DYCK and JORDAENS. As an independent artist he is best known for animated hunting scenes masterful enough to be confused with those of Rubens' late period.

SOANE, SIR JOHN (1753–1837). An English architect of great originality and integrity, he combined a fine understanding of structure with a respect for basic geometrical form to produce such superb buildings as the Bank of England, London (since disfigured by the addition of a superstructure), and the Dulwich College Art Gallery, also in London.

SODOMA (Giovanni Antonio Bazzi) (1477–1549). An Italian painter of whose early training all that is known is that he was apprenticed at 13 to a glassmaker. He worked for the most part in Siena and its environs and was influenced by LEONARDO, PINTORICCHIO, SIGNORELLI and RAPHAEL. He had difficulty depicting spatial relationships and his compositions are often confused, but he was a fine draftsman and colorist.

SOFFICI, ARDEGNO (1879–1967). An Italian figurative painter who was associated with FUTURISM early in his career.

SOLANA, JOSÉ GUTIERREZ (1886–1945). A largely self-taught Spanish painter of powerful, often friezelike images rendered in somber colors and heavy impastoes. His work was influential in the development of Spanish abstract painting of the 1950s.

SOLARI, GIOVANNI (ca. 1410–1480) and **GUINFORTE** (1427–1481). Italian father-and-son architects. Giovanni worked chiefly for the Sforzas in Lombardy and was involved to an undetermined extent with the construction of MILAN CATHEDRAL and the Certosa of Pavia, projects in which his son also participated. Guinforte completed FILARETE's Ospedal Maggiore, Milan, adding an upper story that contrasts markedly with Filarete's lower portion of the building.

SOLIMENA, FRANCESCO (1657–1747). An Italian BAROQUE painter active in Naples, he was influenced by LANFRANCO, PRETI and GIORDANO. His unusually long career spanned much of the Neapolitan Baroque era, and his prolific output of boldly decorative frescoes was widely influential within and outside of Italy. The preliminary oil sketches for his murals are much admired. He was described in his time as "by universal consent the greatest painter in the world."

Chaim Soutine, *Still Life with Turkey*, M. P. Lévy Collection, Bréviandes.

SOLOMON, SIMEON (1840–1905). An English painter influenced by his friend ROSSETTI and by the Italian Old Masters. His mythological subjects, painted in a style derived from LEONARDO, were appreciated by his peers but not the general public

SOROLLA Y BASTIDA, JOAQUIN (1863–1923). A Spanish painter and youthful prodigy, he was immensely popular in his lifetime for his rather flashy, brilliantly sunlit pictures, virtuosity with the brush and a general liveliness that reflects his work as an illustrator.

SOTATSU (Tawaraya Sotatsu) (fl. early 17th century). A Japanese painter of whom little is known. His work shows his indebtedness to earlier artists and to such literary figures as Lady Murasaki, author of *The Tale of Genji*.

SOTO, JESUS (1923–). A Venezuelan artist who works in the Constructivist tradition, he is loosely associated with OP ART.

SOULAGES, PIERRE (1919–). A French abstract painter, characteristically of broad, overlapping, expressionistically painted glossy black rectangles on a bright, pale-toned ground.

SOUTINE, CHAIM (1894–1943). A Lithuanian-born French painter who developed a distinctive form of EXPRESSIONISM, he was one of Paris' *peintres maudits* and

spent most of his life in abject poverty. His work derives from a variety of sources, including REMBRANDT, COURBET and, possibly, ROUAULT, but is chiefly the expression of his own neurotic personality. His paintings are characterized by rich, raw color, heavy, rutted impasto, violently distorted forms and manifest emotional intensity.

SOYER, ISAAC (1907–), **MOSES** (1899–) and **RAPHAEL** (1899–1974). Russian-born American painters and brothers, of whom two, Moses and Raphael, were twins. All three are known for their urban genre subjects.

SPADA, LIONELLO (1576–1622). An Italian painter trained at the CARRACCI Academy and influenced by CARAVAGGIO.

SPENCER, NILES (1893–1952). An American painter who studied under HENRI and BELLOWS, he was an exponent of PRECISIONISM.

SPENCER, STANLEY (1891–1959). An English painter known chiefly for religious scenes depicted in anachronistic contemporary settings and made up of highly stylized, meticulously detailed figures.

SPHINX, GREAT. Colossal figure of a sphinx, carved from a limestone hill at Giza, Egypt, ca. 2680–2665 B.C. and excavated, along with a related temple, in 1926.

SPINELLO, ARETINO (Spinello di Luca de Spinelli) (fl. from 1373; d. ca. 1410). An Italian painter of the FLOREN-

TINE SCHOOL and probable pupil of AGNOLO GADDI, he was a throwback to the style of GIOTTO and precursor of MASACCIO.

SPITZWEG, KARL (1808–1885). A characteristic German painter of the BIEDERMEIER style, he was more or less self-taught and influenced by the Dutch Masters and the BARBIZON SCHOOL painters. His romantic compositions tend toward sentimentality.

SQUARCIONE, FRANCESCO (1397–ca. 1468). An Italian painter active in Padua, he is remembered chiefly as an influential teacher, particularly of MANTEGNA, and as a pioneer of the resurgence of interest in classical antiquity.

STAËL, NICOLAS DE (1914–1955). A Russian-born French painter and pupil of LÉGER, he is known best for his BRAQUE-influenced abstractions. His work is simple in form and sober in color, with the paint applied as though with a trowel, and often bears vague references to figural or landscape sources.

STAGI, LORENZO (ca. 1455–1506) and **STAGIO** (ca. 1496–1563). Italian father-and-son sculptors renowned for their ability as carvers of marble.

STAMOS, THEODOROS (1922–). An American abstract-expressionist painter, typically of vaguely biomorphic shapes that seem to float over a loosely defined ground.

STANKIEWICZ, RICHARD (1922–). An American sculptor who studied with HOFMANN and under LÉGER and ZADKINE. His characteristic works are composed of industrial detritus and other junk.

STARININA, GHERARDO (fl. ca. 1385–ca. 1409). An Italian painter of the FLORENTINE SCHOOL and possible pupil of AGNOLO GADDI.

STEEN, JAN HAVLCKSZ. (ca. 1625–1679). A Dutch painter known chiefly for his genre subjects, he studied under Nicolas Knupfer (1603–1660), ADRIAEN VON OSTADE and JAN VAN GOYEN, whose son-in-law he became. Influenced at various times by his teachers—DOU, DE HOOGH and FRANS HALS, among others—he nonetheless retained his own identity and even anticipated to some extent the ROCOCO style of WATTEAU and the simple monumentality of CHARDIN. A sometime brewer and innkeeper, he is popularly associated with tavern scenes and candid slices of life that border on the raffish but was in fact an extremely versatile artist who was equally adept at landscape, portraits, history pictures and Biblical subjects.

STEENWINKEL FAMILY. Several generations of Flemish artists and architects active from ca. 1470 until well into the 18th century. The most prominent family members were the architect-sculptors Hans Steenwinkel I (ca. 1545–1601), Hans II (1587–1639) and Hans III (ca. 1638–1700).

STEER, PHILIP WILSON (1860–1942). An English landscape and figure painter taught by BOUGUEREAU and CABANEL and influenced by TURNER and IMPRESSIONISM.

STEFANO DA ZEVIO (Stefano da Verona) (ca. 1375–1451?). An Italian painter and exponent of the INTERNATIONAL GOTHIC style.

STEINBERG, SAUL (1914–). Rumanian-born American graphic artist, printmaker, painter and cartoonist. His highly inventive style derives from a bewildering variety of sources, all of which he has transformed, to their occasional detriment, in the process of assimilation. He was trained as an architect, and his understanding of architecture—and horror of official architecture—colors much of his work, which is devoted to depicting the foibles of human, canine and feline society and to meditating visually on the nature of art, language, literature, popular culture and life in general.

STEINLEN, THÉOPHILE-ALEXANDRE (1859–1923). A Swiss-born French satirical printmaker, painter and illustrator influenced by DAUMIER.

STELLA, FRANK (1936–). An American painter who, after initially coming under the influence of HOFMANN and ABSTRACT EXPRESSIONISM, adopted a geometrical style marked by severity of form and sensuousness of color. Since the mid-1960s his characteristic works have made use of shaped canvases and a sort of pin-striped motif.

STELLA, JACQUES (1596–1657). A French painter and engraver and follower of POUSSIN, he enjoyed the protection of the powerful and specialized in religious subjects.

STELLA, JOSEPH (ca. 1877–1946). An Italian-born American painter who studied under CHASE and associated with the leaders of Italian FUTURISM in the years 1910–1912, he soon found a personal style that anticipated PRECISIONISM. That style was made up of sharply delineated vertical forms that are particularly well suited to his frequent depictions of city structures and growing plants. Its color is the color of artificial lighting, and while no attempt is made to capture the movement sought by the futurists, his work is distinguished by an intense dynamism. Stella also produced a large body of very sensitive drawings and some interesting early assemblages.

STERNBERG, HARRY (1904–). An American painter, graphic artist and teacher, he is best known for his social commentary.

STEVENS, ALFRED (1817–1875). An English sculptor, painter and youthful prodigy who traveled in Italy at the outset of his career and there was influenced by MICHELANGELO. He is known best for his monument to the Duke of Wellington (unfinished at his death) in ST. PAUL'S CATHEDRAL.

STILL, CLYFFORD (1904–). An American painter and a leading exponent of ABSTRACT EXPRESSIONISM, he characteristically produces vast canvases in which a number of ragged shapes, painted in thick impasto, are arranged in precarious relationships.

STIMMER, TOBIAS (1539–1584). The leading member of a family of Swiss painters and engravers, he is best

Joseph Stella, *The Brooklyn Bridge: Variation on an Old Theme*, Whitney Museum of American Art, New York.

known for his portraits in the manner of HANS HOLBEIN THE YOUNGER.

STONE, EDWARD DURRELL (1902–). An American architect known best for his filigreelike screen façades, he collaborated on the design of the Museum of Modern Art, New York, and independently has produced many buildings, including the U.S. Embassy, New Delhi, India.

STOSS, VEIT (ca. 1447–1533). A German realist sculptor and woodcarver, he produced elaborate, essentially decorative works in the late GOTHIC style and is known best for his large complex altarpiece for the Cracow Cathedral.

STRAET, JAN VAN DER (Giovanni Stradano) (1523–1605). A Flemish-born Italian painter and pupil of AERTSEN, he was associated with CORNEILLE DE LYON and VASARI.

STRANG, WILLIAM (1859–1921). A Scottish etcher, illustrator and painter taught by LEGROS and influenced by REMBRANDT and DAUMIER.

STRASBOURG CATHEDRAL. A French GOTHIC cathedral begun in the late 12th century on the site of at least two earlier structures, it is an excellent example of the French RAYONNANT style, despite its characterization by Goethe as the essence of German architecture.

STRAUB, JOHANN BAPTIST (1704–1784). A German court sculptor and proprietor of an active workshop, he is known for his painfully elongated figures.

STREETON, ARTHUR (1867–1943). An Australian landscape painter who worked mostly in Europe. He is known for his mosaiclike brush strokes and blue-and-gold tonalities.

STRICKLAND, WILLIAM (1788–1854). An American architect and engineer, he was a pupil of LATROBE and worked in a revivalist idiom.

STROZZI, BERNARDO (1581–1644). An Italian painter and Capuchin friar, he was deeply influenced by RUBENS and a number of Italian masters. His masterful handling of paint and general sprightliness make him one of the most beguiling of Venetian artists in the 17th century.

STUART, GILBERT (1755–1828). American portrait painter and pupil of WEST. He began his career in Britain but returned to America in 1792. He is known above all else for his portraits of George Washington but acquitted himself better in other works, particularly his sharply objective portraits of women.

STUBBS, GEORGE (1724–1806). An English painter, self-taught for the most part, and anatomist, he is renowned for his pictures of animals, particularly horses.

STUCK, FRANZ VON (1863–1928). A multitalented German artist best known for his allegorical nudes and as the architect of his own villa in Munich.

STUEMPFIG, WALTER (1914–). An American painter of meticulously rendered genre subjects, landscapes and cityscapes.

SUBLEYRAS, PIERRE (1699–1749). A French academic painter of religious subjects who worked mostly in Rome.

SU HAN-CHEN (fl. early 12th century). A Chinese painter of the Southern Sung, he was celebrated for his depictions of children at play.

SULLIVAN, LOUIS HENRI (1865–1924). An American architect, the leading figure of the CHICAGO SCHOOL and a figure generally conceded to be the first major architect of the modern era. After brief training at the Massachusetts Institute of Technology, he arrived in Chicago at 17, was immediately impressed with "a sense of big things to be done" and went to work for JENNEY. After a brief, disillusioning sojourn in Paris, where he studied at the Ecole des Beaux-Arts, he returned to Chicago, entered the office of DANKMAR ADLER in 1879 and was made a partner two years later. It was a partnership that was to result in

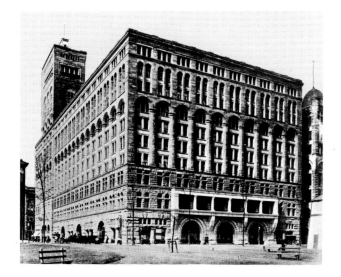

more than 100 buildings and an architectural revolution.

After designing the vast Chicago Auditorium, a structure influenced by RICHARDSON's recently completed MARSHALL FIELD WAREHOUSE, Sullivan's next major project was the WAINWRIGHT BUILDING, which he and Adler built in St. Louis in 1890, and on the design of which the skyscrapers of the next half century were to be modeled. Constructed according to Sullivan's theory that form must follow function and express structure, it was the partnership's first skeletal building and stressed the unimpeded verticality Sullivan deemed appropriate to tall buildings.

Although his name is associated principally with the skyscraper, Sullivan was a thoroughly versatile and adaptable architect, as he demonstrated in such commissions as the emphatically horizontal, largely glass-sheathed Carson-Pirie-Scott Building, Chicago, and the brilliantly inventive Transportation Building, the one bright note in the architectural shambles of the Chicago Columbian Exposition of 1893, a fair that, as Sullivan bitterly and prophetically noted, was to wreak damage that "will last a half century."

SULLY, THOMAS (1783–1872). An English-born American portrait painter and pupil of STUART and WEST, he was heavily influenced by LAWRENCE, whose facile manner he emulated. At his best he was a probing, forceful painter, but much of his work is marred by superficiality, sentimentality and a desire to please his sitters.

SU SHIH (1036–1101). A Chinese painter, calligrapher and man of letters, he was an Oriental equivalent of the universal genius of the European Renaissance. Little of his painting survives, but he is known to have specialized in depictions of bamboo.

SUSTERMAN (Sutterman; Soestermans), JUSTUS (Joost) (1597–1681). A Flemish portrait painter who worked throughout Europe and died in Italy, he was a student of Frans Pourbus the Younger (see POURBUS FAMILY) and executed numerous commissions for the Medicis.

SUTHERLAND, GRAHAM (1903–). An English semiabstract painter influenced by PICASSO, he began his career as a romantic etcher whose work derived in part from the visionary PALMER. Employed as an official war artist during World War II, he avoided the conventionally literal depictions common to the genre, substituting for them a kind of personal expressionism that affectingly captured the spirit, if not the exact appearance, of the devastation wrought by bombing raids. He has painted several religious subjects and portraits of W. Somerset Maugham, Winston Churchill and other notable figures.

SWAN, JOHN MACALLAN (1847–1910). An English painter who studied under GÉRÔME and BASTIEN-LEPAGE, among others, he is known best for landscapes and animal pictures and produced some sculpture.

SWANEBURGH, ISAAK NICOLAI VAN (1538–1614). A Dutch painter, possible student of FLORIS, teacher and public official. He worked in the mannerist style, producing genre and history pictures, portraits and religious paintings on glass. His son Jacob van Swanenburgh (1571–1638) was one of REMBRANDT's teachers.

SWANEVELT, HERMAN VAN (ca. 1600–1655). A Dutch landscape, history and genre painter who spent most of his career abroad, painted in an Italianate style and influenced CLAUDE LORRAINE, who influenced him in turn.

SWEBACH, JACQUES-FRANÇOIS-JOSEPH (1769–1823). A French painter, ceramic designer and child prodigy, he is remembered mostly for his battle scenes, particularly those involving cavalry units.

SYRLIN, JORG, THE ELDER (1421–1491). A German GOTHIC sculptor and cabinetmaker best known for his realistic choir-stall sculptures in Ulm Cathedral.

SZINYEI MERSE, PÁL (1845–1920). Hungarian painter and pupil of PILOTY. His genre subjects were executed impressionistically.

T

TACCA, PIETRO (1577–1640). A Florentine sculptor and bronze caster, he was a pupil and follower of GIOVANNI DA BOLOGNA. His equestrian subjects influenced the standard poses of BAROQUE sculpture.

TADDEO DI BARTOLO (ca. 1362–1422). A Sienese painter who worked in the INTERNATIONAL GOTHIC style, he was influenced by a number of older painters, including BARNABA DA MODENA, DUCCIO, SIMONE MARTINI and GIOVANNI DA MILANO. His masterpiece is *The Life of the Virgin* (Siena: Palazzo Pubblico), a fresco cycle characterized by the animation of its figures, their expressivity and the artist's original handling of drapery.

TAEUBER-ARP, SOPHIE (1889–1943). A Swiss sculptor associated with DADA and the wife of ARP.

TAFT, LORADO (1860–1936). An American sculptor trained in Paris and a follower of RODIN. He is best known for *The Fountain of Time* (Chicago: Washington Park), a horizontally attenuated group of figures that is too diffuse to succeed as a single sculptural group but contains some strong individual figures.

TAI CHIN (fl. early to mid-15th century). A Chinese painter, he was a professional in an era dominated by amateurs and the founder of a Chekiang Province school later called the Che School. He is best known for the spirited brushwork that distinguishes such paintings as *Fishermen* (Washington, D.C.: Freer Gallery).

TAIGA (Ike Taiga) (1723–1776). A Japanese painter whose style was influenced to some extent by European painting, he specialized in bucolic subjects and was also respected as a calligrapher.

TAJ MAHAL, AGRA. A domed Indian mausoleum built on the Jumna River in the mid-17th century by Shah Jahan to house the remains of his wife, Mumtaz Mahal. It is one of the few buildings in the world to which the adjective "lovely" applies.

TALENTI, FRANCESCO (ca. 1300–after 1368). Italian architect and sculptor who participated in the building of Florence Cathedral and, possibly, the Cathedral of Orvieto. He was the father of SIMONE DI FRANCESCO TALENTI.

TALENTI, SIMONE DI FRANCESCO (between 1340 /45–after 1380). Italian sculptor and architect and son of FRANCESCO TALENTI, his teacher. For some years he was chief architect of Florence Cathedral.

TAMAYO, RUFINO (1899–). A Mexican painter and muralist influenced by the SCHOOL OF PARIS and, to a lesser extent, the arts of PRE-COLUMBIAN cultures. His characteristic works are saturated with vibrant color.

TANGE, KENZO (1913–). A Japanese architect influenced by LE CORBUSIER, he has designed several city halls and the Hiroshima Peace Center.

TANGUY, YVES (1900–1957). A French seaman who was impelled to take up painting when he saw a work by CHIRICO, he developed a distinctive brand of SURREALISM. Although he was completely self-taught, his academic technique is impeccable, with none of the characteristics of the naïve painter, and, content aside, resembles that of DALI more than any other Surrealist painter. His forms, although painted with the utmost "realism," are his own inventions and often evoke some interstellar culture from science fiction.

T'ANG YIN (1470–1523). A Chinese painter of the Ming dynasty, he based his style on that of the Yüan dynasty and specialized in landscapes and richly colored portraits of women. He was an extremely prolific artist, and much of his work survives. He is one of the Chinese painters best known to Occidentals.

Rufino Tamayo, *Portrait of Olga,* Private Collection, Mexico City.

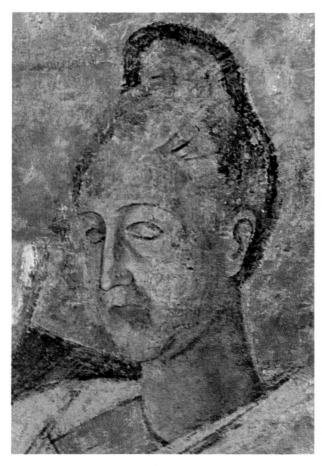

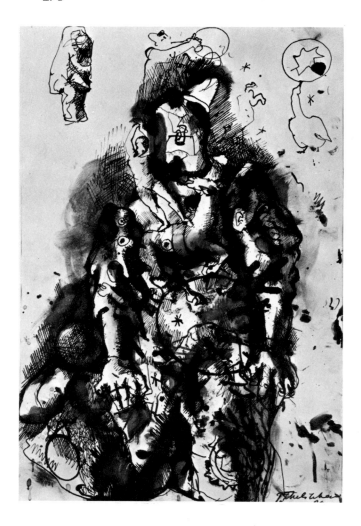

Pavel Tchelitchew, study for *The Blue Clown,* Museum of Modern Art, New York.

TANNER, HENRY OSSAWA (1859–1937). An American expatriate painter who was trained, worked and died in Paris. His genre and Biblical subjects were influenced by REMBRANDT. Though he was long neglected, his reputation has grown with the recent interest in the art of American blacks.

TANNYU (Kano Tannyu) (1602–1674). A Japanese painter of the KANO school who received much official patronage. Little of his strongly linear work survives.

TAO-CHI (Shih-tao) (1630–1717). Chinese painter of royal Ming birth and monk. An aesthetic iconoclast with a high opinion of his own considerable talent, he startled his contemporaries with antitraditional writings and self-advertisements. His paintings are manifestly based on his theory that "the best method is no method" and have contributed to his reputation as an eccentric. He was also a poet and calligrapher.

TAPIES, ANTONIO (1923–). Spanish self-taught painter and collagist. He was a founder of Dau Al Set, the Catalonian movement that, with El Paso in Madrid, gave impetus, in the period immediately after World War II, to the first wave of abstract art produced in Spain. His work

employs a large vocabulary of simple forms (some recognizable in the rudimentary fashion of children's imagery) and stresses the nature of the wide range of materials and textures he uses. His earth colors, blood-reds and blacks are vaguely suggestive of the bullring.

TARBELL, EDMUND CHARLES (1862–1938). An American painter and teacher best known for portraits and intimate interiors.

TATLIN, VLADIMIR EVGRAFOVITCH (1885–1956). Russian sculptor and pioneer of CONSTRUCTIVISM. After training as a painter, he was impelled by a visit to PICASSO's studio to experiment with the idea of making works of art of unconventional, largely industrial materials. Restrictive government policies in Russia prevented much of his abstract work from being realized (e.g., a huge projected *Monument for the Third International,* a glass-and-wood tower of which only a model was completed), and he devoted much of his career to industrial and theatrical design.

TCHELITCHEW, PAVEL (1898–1957). A Russian-born American painter and theatrical designer, he worked in a variety of rather somber romantic styles derived from several influences but is known best for *Hide and Seek* (New York: Museum of Modern Art), a large canvas in which myriad images coalesce to form a large single image.

TEGLIACCI, NICCOLO DI SER SOZZO (fl. 2nd third of 14th century). An Italian illuminator and painter who, in the latter capacity, worked in collaboration with LUCA DI TOMME.

TEMPEL, ABRAHAM LAMBERTSZ. VAN DEN (ca. 1622–1672). A Dutch portrait and history painter and teacher.

TENIERS, DAVID, THE ELDER (1582–1649). Flemish painter and father of DAVID TENIERS THE YOUNGER and probable pupil of RUBENS and ELSHEIMER. Little of his authenticated work survives.

TENIERS, DAVID, THE YOUNGER (1610–1690). Flemish painter and engraver of genre subjects, portraits and landscapes. The son of DAVID TENIERS THE ELDER, under whom he studied, he was also the son-in-law of JAN BREUGHEL THE ELDER. Influenced early in his career by BROUWER, he later abandoned Brouwer's disreputable subjects, endowing genre painting in the Netherlands with an acceptability it had not enjoyed almost since the time of PIETER BREUGHEL THE ELDER. At his best, Teniers was capable of great delicacy and rendered his subjects in a distinctive soft, silvery light. Much of his energies were spent as an entrepreneur, however, to the benefit of his social and financial standing—and the detriment of his art. He was also a prolific engraver and indefatigable cataloguer of works by other artists.

TENNIEL, SIR JOHN (1820–1914). An English draftsman, painter and cartoonist remembered chiefly for

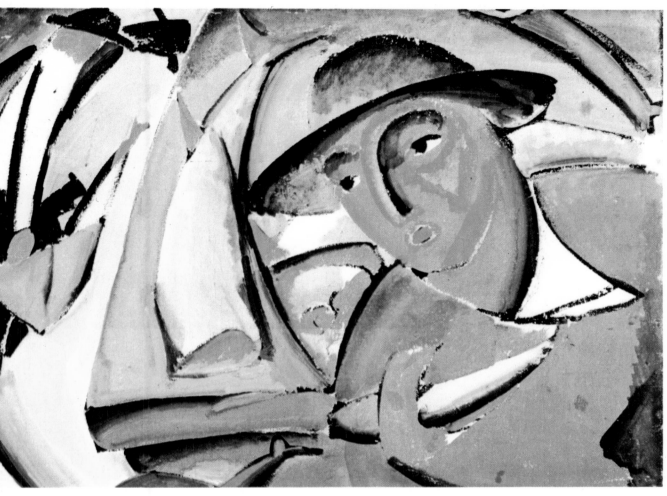

Vladimir Tatlin, *The Fishmonger*, Tret' Yakov Gallery, Moscow.

his superbly appropriate illustrations for Lewis Carroll's "Alice" books.

TERBORCH (Ter Borch), GERARD (1617–1681). A Dutch painter, chiefly of indoor genre subjects and portraits, he was trained by his father, a minor painter, and MOLIJN. An extremely precocious artist, he dated his first drawing at the age of eight and had embarked on travels to England and Italy at 18. His characteristic works are small in format and tend toward subdued, rather cool colors. A superb renderer of textures, he was particularly masterful in his handling of satin. His pictures are distinguished by a dignity and gravity few figure painters in the Netherlands achieved, VERMEER excepted.

TERBRUGGHEN, HENDRICK (1588–1629). A Dutch painter—according to RUBENS, the only Dutch painter of his time—of history and genre subjects. A pupil of BLOEMAERT, he spent a decade in Rome, of which nothing is known and no works survive, at the outset of his career. Like many other Utrecht painters in Rome, however, he came under the influence of CARAVAGGIO at some point and became perhaps the finest and most independent of that master's followers. Terbrugghen's frequent use of candlelight derives from HONTHORST (another member of the Caravaggisti) but surpasses him, while his daylight scenes anticipate to some extent those of VERMEER.

TETRODE (Tetroede; Tetteroede), WILLEM DANIELSZ. VAN (active 2nd third of 16th century). Dutch (?) architect and sculptor who worked for a time in Italy, where he was called "Guglielmo Tedesco" and "Il Fiammingo" ("The Fleming"). He is best known for the high altar of Delft's Chapel of the Oude Kerk, one of the most beautiful ever created.

THAYER, ABBOTT HANDERSON (1849–1921). A Paris-trained American painter who studied under GÉRÔME, he is known for his technically proficient but mawkish portraits of women in allegorical guises.

THEODORIC, TOMB OF. 6th-century circular mausoleum, in Ravenna, Italy, of King Theodoric of the Goths. Its salient feature is its massive dome (36 feet in diameter) carved from a single slab of stone.

THEODORUS (fl. mid-5th century B.C.). A Greek artist and architect credited by ancient writers with a variety of innovations with which—if he indeed existed—he may or may not have had anything to do.

THEOPHANES THE GREEK (Feofan Grek) (fl. 1370s–1405). A BYZANTINE painter who worked in Russia, where he may have been the teacher of RUBLEV, he is known to have executed both icons and frescoes, although only one positively attributed work, a fresco, survives. Contemporaneous accounts state that he worked without models and was a famous illuminator of manuscripts.

THEOTOCOPULI, JORGÉ MANUEL (1578–1631). Spanish painter and architect and bastard son of EL GRECO, whom he assisted, emulated and copied outright.

THIEBAUD, WAYNE (1920–). American still-life and figure painter. Although he is usually identified with POP ART because of his choice of subject matter (cafeteria desserts, mass-produced products and the like), his style, with its heavy impastoes reminiscent of VAN GOGH and close observation of his models, is far too painterly for that label.

THOMA, HANS (1839–1924). A German painter influenced first by COURBET and the BARBIZON SCHOOL and later by BOCKLIN and MAREES. Much of his work is oversentimental and overly symbolic, but his landscapes are often sensitive.

THOMASSIN, PHILIPPE (1562–1622). The leading member of a family of French artists, he was trained as a goldsmith but later turned to copperplate engraving. Most of his 400-odd prints are copies of French and Italian paintings.

THONET, MICHAEL (1796–1871). A German furniture designer and manufacturer who worked mostly in Vienna, he is known chiefly for the graceful bentwood chair of 1876 that bears his name and is still manufactured in quantity.

THORNHILL, SIR JAMES (1675–1734). The only English decorative painter who worked in the BAROQUE grand manner, he was influenced by Louis Laquerre (1636–1721) and Antonio Verrio (d. 1707), both of whom worked in England, and outstripped them both. While he was not a great painter, he was the only home-grown product who could compete with a host of imported decorators and, as such, was much esteemed in England, where, until the advent of REYNOLDS, he raised the social acceptability of the artist to its highest level. He was also the teacher and father-in-law of HOGARTH.

THORWALDSEN, ALBERT BERTEL (1768 or 1770–1844). A Dane who spent most of his career in Rome, he was second only to CANOVA among the Neoclassic sculptors of his time. To modern tastes his work, once praised as "noble" and "serene," may seem insipid and numb.

TIBALDI, DOMENICO (1541–1583) and **PELLEGRINO** (1527–1596). Italian brothers and, respectively, an architect, painter and engraver, and a painter. PELLEGRINO

Giovanni Battista Tiepolo, *Neptune Offering Venice the Gifts of the Ocean*, detail, Doges Palace, Venice.

was the dominant figure of the two. Working in a late mannerist style, he was primarily a bravura frescoist who eventually became court painter to Philip II of Spain.

TIEPOLO, GIOVANNI BATTISTA (1696–1771). A precocious Italian decorative painter, the greatest exponent of the Italian ROCOCO and the most sought-after artist of his day, he was trained by a relative nonentity named Lazzarini and influenced primarily by RICCI, PIAZETTA and PAOLO VERONESE. After painting a number of tenebrist pictures, he lightened his palette ca. 1719, the time of his marriage to GUARDI's sister, and adopted a looser, more spirited manner better suited to fresco decoration. His first major fresco commission, a cycle of ceiling decorations in the Archbishop's Palace at Udine, further freed him from the murky coloration of his earlier work and gave him the necessary scope for the virtuosity that was to become his trademark and the vertiginous *sotto in sù* perspective (worked out by an assistant) that was to become a familiar feature of his oeuvre.

The years leading up to ca. 1740 saw the refinement of Tiepolo's style and the culmination of a remarkable series of altarpeices with two 30-foot-high works, *The Gathering of the Manna* and *The Sacrifice of Melchizedek* (Verolanuova: Parish Church). By then he was becoming internationally known, and in 1750 he was invited to decorate the Rococo Kaisersaal at Würzburg and to execute a ceiling fresco in the prince-bishop's residence. His works there constitute the high point of his career and served to further enhance his reputation both at home and abroad. Soon after his return to Italy he was elected first president of the Academy of Venice and in 1761 was invited to decorate the royal palace in Madrid. He died in that city after completing the commission and other works, but his stay there was marred by the enmity of partisans of the Neoclassicist Mengs. If his sojourn south of the Pyrenees accomplished nothing else, it provided a great deal of inspiration for the young GOYA, who eventually was to render the Mengs–Tiepolo debate academic by thrusting Spain into the modern age.

TIEPOLO, GIOVANNI DOMENICO (1727–1804). Italian painter and son of GIOVANNI BATTISTA TIEPOLO. Although a brilliant handler of genre subjects, he has been almost completely obscured by the reputation of his father, with whom he collaborated for much of his career.

TIFFANY, LOUIS COMFORT (1848–1933). An American painter, designer and pupil of INNESS, he is remembered almost exclusively for his iridescent glass lamps, goblets and the like, which were executed in the ART NOUVEAU style.

TILGNER, VICTOR OSCAR (1844–1896). An Austrian ROCOCO sculptor, frequently of polychrome figures.

TINGUELY, JEAN (1925–). A Swiss sculptor known for his humorous, somewhat satirical kinetic machines, most of which operate unpredictably, in eccentric, non-

Titian, *Woman at the Mirror,* Louvre, Paris.

repetitive cycles. Among his better-known works are coin-operated machines that paint "abstract expressionist" pictures and others that have destroyed themselves (or, more accurately, perished in the attempt).

TINO DI CAMAINO (1280 or 1285–1337). A Sienese sculptor, chiefly of tombs, who may have studied under GIOVANNI PISANO. His figures, monumental rather than dramatic, have much in common with those in the paintings of LORENZETTI and are characterized by their massive, almost clumsy forms.

TINTORETTO (Jacopo Robusti) (1518–1594). Venetian painter. By his own account, he was a pupil of TITIAN, but he probably spent little time in that master's studio and may have studied under SCHIAVONE, BONIFAZIO VERONESE or PARIS BORDONE. Except for a brief excursion to Mantua, he seems to have spent his entire life in Venice, where he executed numerous commissions and fathered three minor artists (see TINTORETTO FAMILY).

An apparently quite insecure personality, Tintoretto, so called after his father, a dyer (*tintore*), seemed constitutionally unable to turn down a commission, competition or any other opportunity to add to his fame and/or fortune. Consequently, a large body of his work, some of it woefully compromised, survives, as does a reputation for cupidity in the pursuit of patrons. At his best he was a painter of genius and one of the salient figures of the 16th century.

Stylistically, Tintoretto's art attempted to synthesize MICHELANGELO's draftsmanship and Titian's color. Technically, he devised a method of painting from miniature settings peopled by wax figures, a practice that probably accounts for a certain amount of repetition in the poses struck by his protagonists and that produced a distinctive sense of enclosed space in his characteristic pictures. His masterwork is a cycle of canvases for the Scuola di San Rocco depicting the life of Christ. Although considerably deteriorated, it is one of the greatest efforts of the Renaissance and has been favorably compared with RAPHAEL's *Stanze* and Michelangelo's decorations in the Sistine Chapel.

TINTORETTO FAMILY. The painter TINTORETTO and his three children: Domenico Tintoretto (fl. 1577–1635), his brother Marco (fl. 1583–1637) and sister Marietta (ca. 1556–1590). Domenico was his father's assistant.

TISCHBEIN FAMILY. Related German 18th-century painters of whom the best known was Goethe's friend and portraitist, Johann Heinrich Wilhelm Tischbein (1751–1829).

TISSOT, JAMES JOSEPH JACQUES (1836–1902). A French painter and etcher who spent his last years working on religious pictures but is remembered chiefly for his depictions of Victorian English high life.

TITIAN (Tiziano Vecellio) (ca. 1487–1577). The outstanding Venetian painter of his era and one of the great painters of all time. His earliest training is uncertain, but he appears to have studied at some point with GENTILE BELLINI and, later, with Gentile's brother GIOVANNI and to have been associated with and decisively influenced by GIORGIONE. From the latter he derived the concept of atmospheric homogeneity, with all elements of a picture bathed in the same light and subject to the same strictures of aeriel perspective.

Titian's dates are problematical. Although those given above are generally accepted, the artist himself claimed that he was born earlier, and the claim is given credence by his having been so highly regarded as early as 1508 that he was assigned to paint part of a fresco cycle the most prominent portions of which were awarded to Giorgione. (After the latter's death two years later, several of his unfinished works were completed by Titian and SEBASTIANO DEL PIOMBO, who departed for Rome in 1511, leaving the young Titian the pre-eminent painter in Venice.)

Tintoretto, *Paradise,* detail, Louvre, Paris.

Titiàn, *Deposition*, Louvre, Paris.

In 1516 Giovanni Bellini died at 86, Titian succeeded him as Painter to the Republic and, thus firmly established, began a series of mythological pictures (a genre that was to become his special province) for the Duke of Ferrara. In the same year he started a huge altarpiece, *The Assumption* (Venice: Frari), which derives in its muscularity from MICHELANGELO and may, with its soaring composition, mark the earliest intimation of the BAROQUE. It also marks the end, to all intents and purposes, of Giorgione's influence on its author. Thenceforth, at any rate, there was little of Giorgione's poetry in his work but an increasing reliance on realism to provide the grandeur he ultimately sought.

For a decade and a half the painter produced a veritable torrent of religious pictures, mythological subjects and portraits, all distinguished by a mastery of color and dramatic vigor as distinctive as the style of any artist in history. About 1530, however (possibly as a result of his wife's death), his style took a more subdued, contemplative turn, his palette became more restrained and more harmonious and his compositions more sedate, even somewhat archaic. At about the same time, his reputation became known throughout Europe, and, as a result, he met the Emperor Charles V, for whom he painted his own version of a court portrait, a version that resulted in his appointment as Court Painter and a personal friendship with the emperor, a rare honor for a painter of that—or any—era. After Charles's abdication Titian was employed by his successor, Philip II of Spain. The pictures painted for Philip are loosely composed, mannerist in concept and clearly anticipate IMPRESSIONISM in their handling. They are also somewhat erotic—surprisingly so, given Philip's public demeanor and Titian's advancing age. During the last two decades of his long life the works Titian produced for his own enjoyment and edification (as opposed to the commissions executed largely by his workshop) took on the soft, meditative appearance that might be expected of an old man ruminating on the imminence of the sunset. In the great works of his final phase, forms dissolve in a flood of light.

TITUS, ARCH OF. A triumphal arch, built in Rome in A.D. 81, to commemorate the conquest of Jerusalem, it is especially notable for a pair of highly illusionistic relief sculptures.

TOBEY, MARK (1890–). A largely self-taught American abstract painter. His best-known works, which he terms "white writing," are made up of calligraphic forms disposed in all-over patterns and to a degree anticipate the characteristic work of POLLOCK, although they derive from different aesthetic premises.

TOCQUE, LOUIS (1696–1772). French portrait painter and pupil and son-in-law of JEAN-MARC NATTIER THE YOUNGER. He was a court and society portraitist, his style more or less a synthesis of RIGAUD's and LARGILLIERRE's.

TOEPUT, LODEWYCK (ca. 1545–before 1605). A Flemish painter who spent the bulk of his career in Italy, where he was influenced by PAOLO VERONESE, he is best known for small, painstakingly detailed landscapes that reflect his Netherlandish heritage.

TOHAKU (Hasegawa Tohaku) (1539–1610). A Japanese painter who worked both in color and monochromatic inks, he was a highly regarded decorator of palaces and temples in and around Kyoto.

TOLEDO, JUAN BAUTISTA DE (d. 1567). Spanish architect. He was trained in Italy, where he is supposed to have assisted MICHELANGELO with the building of ST. PETER's and is known best for his design for EL ESCORIAL.

TOLSA, MANUEL (1757–1816). A Spanish sculptor and architect who worked, taught and died in Mexico, he was a leader of the NEOCLASSICAL reaction against the excessive Mexican CHURRIGUERESQUE style.

TOMLIN, BRADLEY WALKER (1899–1953). An American painter who worked realistically for some time after studying in the U.S. and Paris. His characteristic later works are abstract and essentially geometric but freely painted and made up of a vocabulary of forms suggestive of SURREALIST AUTOMATISM. Although not himself an exponent of ACTION PAINTING, his work to some extent anticipates POLLOCK's.

TOMMASO DA MODENA (ca. 1325–before 1379). An Italian painter, miniaturist and frescoist influenced by VITALE DA BOLOGNA and SIMONE MARTINI.

TONKS, HENRY (1862–1937). An English painter and watercolorist. His influence as a teacher at the Slade School of Art, London, was considerable.

TOOKER, GEORGE (1920–). An American painter, characteristically of scenes conveying a strong sense of social alienation, rendered in a more or less academic style.

TOOROP, CAROLINE (1891–1955). A Dutch painter and daughter of JAN TOOROP, she depicted a variety of subjects in a harshly realistic style and is known best for larger-than-life portraits of workers and peasants.

TOOROP, JAN (Johann) THEODORUS (1858–1928). A Dutch painter, printmaker and illustrator born in Java, he was the father of CAROLINE TOOROP. His characteristic mature works were highly symbolic, reflected his conversion to Catholicism and were painted in the ART NOUVEAU style.

TORI BUSSHI (fl. early 7th century). A Japanese sculptor whose scanty surviving oeuvre comprises the earliest known Buddhist sculpture in Japan.

TORRENTIUS, JOHANNES (Jan Simonsz. van der Beeck) (1589–1644). Dutch painter and scapegrace. He specialized in still lifes and risqué genre scenes, many of which were publicly burned by the authorities—a fate he narrowly escaped himself after being convicted of heresy and immorality. He is known to have used optical implements to facilitate his work, and his single fully authenticated work, ironically enough, allegorizes temperance.

TORRES-GARCIA, JOAQUIN (1874–1949). A Uruguayan painter and teacher trained in Barcelona (where he assisted GAUDÍ with a stained-glass project), he spent much of his career in New York and Paris. One of the leading theorists of CONSTRUCTIVISM, he evolved a personal and highly poetic monochromatic style in which pictographlike images occupy the squares and rectangles of a boldly delineated grid.

TORRIGIANI (Torrigiano), PIETRO (1472–1528). A Florentine sculptor whose most durable claim to attention is his reworking of MICHELANGELO's profile in a fist fight that occurred when they were fellow apprentices —a feat that earned him the everlasting hatred of Florence's citizenry and that has obscured his considerable artistic achievement. After a sojourn in England, where he created that country's greatest example of Italian Renaissance art, the tomb of Henry VII and his wife (London: Westminster Abbey), he traveled to Spain, where he executed a *Virgin and Child* in the High Renaissance style and a superb mannerist *St. Jerome* (both, Seville: Provincial Museum of Fine Arts). Imprisoned by the Inquisition, he starved himself to death.

TORRITI, JACOPO (fl. late 13th century). An Italian painter and mosaicist of whose life and training nothing is known. His only certain surviving works, mosaics in two Roman churches, St. John Lateran and S. Maria Maggiore, are prime examples of the late Roman Italo-BYZANTINE style.

TOULOUSE-LAUTREC, HENRI DE (1864–1901). French post-Impressionist painter, printmaker and poster designer. The son of a nobleman, he broke both legs in childhood falls, inhibiting their growth and giving him a dwarflike appearance that profoundly affected his psychology and lifestyle.

Artistically precocious, he began his formal study of painting at 14, under a specialist in equestrian pictures named René Princeteau, and soon outstripped his master. He next studied with BONNAT and then with Fernand Cormon (1845–1924). By the age of 21 he had his own Montmartre studio and had been given several illustrating assignments by various newspapers. He also had met

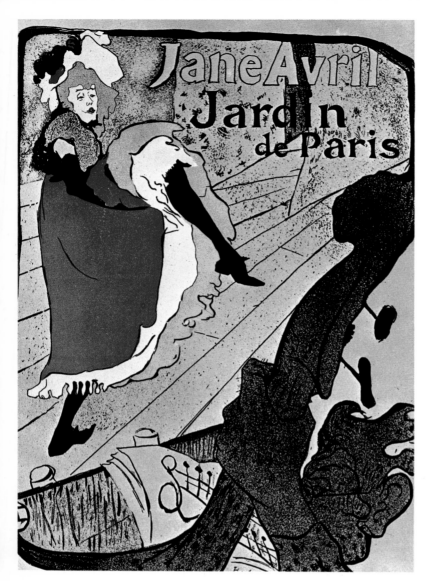

Toulouse-Lautrec, *Jardin de Paris: Jane Avril,* poster.

a man of great elegance and dignity who produced an oeuvre at once shocking and aristocratic, coarse and refined. He had an immense influence on PICASSO during that artist's early period.

TOWNE, FRANCIS (1740–1816). An English watercolorist who specialized in "picturesque" landscapes. His work is notable for its solid underlying structure.

TOYONOBU (Ishikawa Toyonobu) (1711–1785). A Japanese designer of UKIYO-E prints who specialized in figures of semi-draped women.

TRAINI, FRANCESCO (ca. 1321–ca. 1350 or later). The leading Pisan painter of his era, he apparently specialized in fresco painting, but few of his works survive.

TRAJAN, COLUMN OF. A marble structure, about 125 feet high, in Rome, it was erected in A.D. 113, commemorates Trajan's wars against the Dacians and is notable for its decorative spiral relief frieze depicting episodes from the Dacian campaigns.

TRESGUERRAS, FRANCISCO EDUARDO (1759–1833). Mexican architect, painter, poet and man of letters, best known for his provincial architecture. His basically

Toulouse-Lautrec, *La Toilette,* Louvre, Paris.

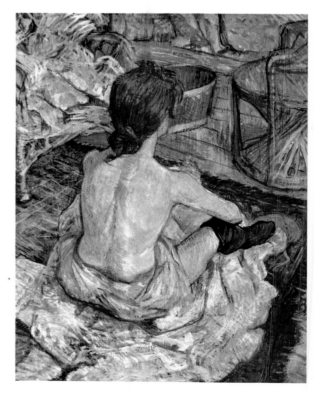

VAN GOGH and soon got to know many of the leading figures of IMPRESSIONISM. By 1885, when he was 21, he had developed a distinctive style characterized by an emphasis on contour and large areas of flat pattern. At about the same time his subject matter began to take on the raffish character it was to maintain throughout his career. His mature style, which he developed ca. 1890, was basically a synthesis of Impressionism and DEGAS, tempered by personal observation and a distinctive talent for immediacy of effect remotely reminiscent of HANS HOLBEIN THE ELDER. His color, although quite arbitrarily selected, has a peculiar verisimilitude, given the theatrical nature of his subjects.

Much of Toulouse-Lautrec's oeuvre is devoted to the delineation of characters from the demimonde: whores, low entertainers, social misfits and outcasts much like himself. To his great credit, he always portrayed them with complete objectivity, his obvious fondness for them never coloring or distorting the cold probity with which he observed them. Despite his all but repulsive physical presence and his predilection toward life's losers, he was

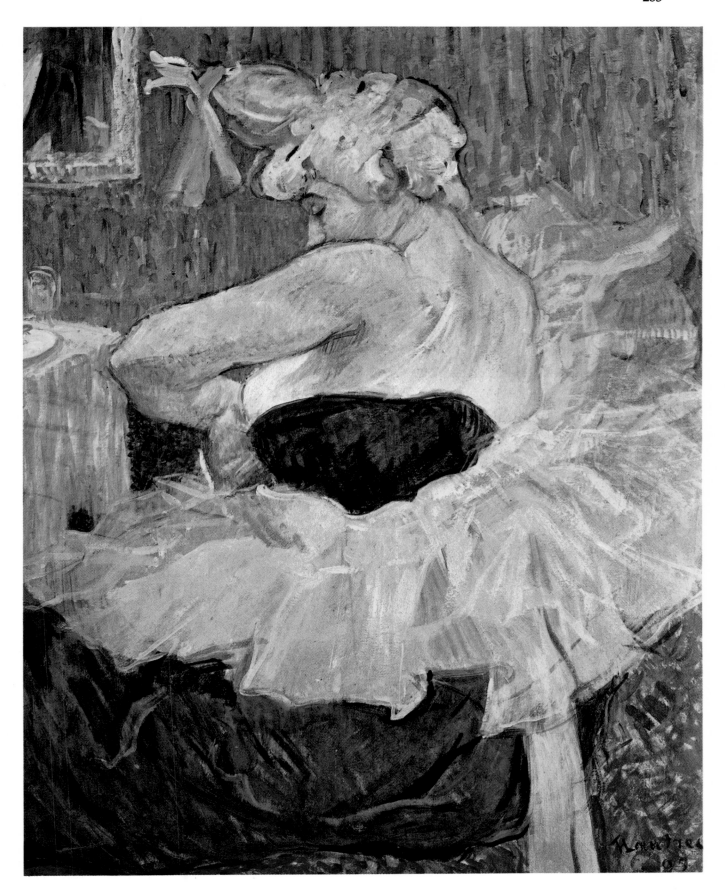

Neoclassical style contained an admixture of the BAROQUE.

TREVI FOUNTAIN, ROME. Famous ornamental fountain begun on the site of earlier fountains in the 1730s by SALVI and completed by Giuseppe Panini in 1762.

TRIBOLO, NICCOLO (1500–1550). Italian sculptor, pupil of IL SANSOVINO and sometime assistant of MICHELANGELO.

TRISTAN DE ESCAMILLA, LUIS (ca. 1586–1624). Spanish painter. A pupil and assistant of EL GRECO, whose compositional structure he emulated, he was also indirectly influenced by CARAVAGGIO.

TROGER, PAUL (1698–1762). An Austrian painter influenced by the Venetian ROCOCO, he is known for his luminous ceiling paintings and as an influential teacher.

TROVA, ERNEST (1927–). An American sculptor known for a single motif, an altogether depersonalized, mannequinlike, armless figure, often cast in gleaming metal, combined with various contrasting elements and used as a metaphor for an industrialized society.

TROY, JEAN FRANÇOIS DE (1679–1752). French painter, decorator and educator. The leading member of a French family of painters and tapestry designers, he was taught by his father and studied in Rome while in his early teens. A fashionable portraitist and painter of mythological, religious, historical and genre subjects, more or less in the manner of WATTEAU, he designed two notable series of Gobelins tapestries and collaborated with BOUCHER in the decoration of a room at VERSAILLES.

TROYON, CONSTANT (1810–1865). A largely self-taught French painter who was influenced by the BARBIZON SCHOOL and celebrated for his depictions of farm animals.

TRUBETSKOI, PRINCE PAUL (Pavel) PETROVICH (1867–1938). Russian self-taught sculptor and teacher, influenced by RODIN and best known for his equestrian statue of Alexander III in Leningrad. GONTCHAROVA was one of his pupils.

TRUBNER, WILHELM (1851–1917). A German painter and teacher who worked in a variety of styles before turning to IMPRESSIONISM late in his career.

TRUITT, ANNE (1921–). An American minimalist sculptor known for the extreme simplification of her massive, monochromatically painted forms.

TRUMBULL, JOHN (1756–1843). An American painter of historical subjects and portraits, he was the youngest member of his class at Harvard, where his tutor noticed his "natural genius and disposition" for limning. After brief service as Washington's aide-de-camp during the Revolutionary War, he set up as a professional portrait painter, teaching himself in the process, and by copying SMIBERT's copies of Old Masters. Later, he studied in

London under WEST. His oeuvre was largely concerned with the events and personalities of the American Revolution, reflects the influence of WEST, COPLEY and RUBENS and is more notable for his small, spirited preliminary sketches than for his somewhat stilted large finished canvases.

TSCHACBASOV, NAHUM (1899–). A Russian-born American painter and pupil of various teachers, including GROMAIRE and LEGER. His works are fanciful and painted in rich colors and often are highly textured.

TSOU FU-LEI (fl. mid-14th century). A Chinese painter and poet celebrated for his depictions of plum blossoms.

TS'UI PO (fl. after ca. 1050). A celebrated and often plagiarized Chinese painter of birds and flowers.

TUNG CH'I-CH'ANG (1555–1637). Chinese painter, calligrapher and writer on art theory. An advocate of a strictly codified system of representing nature symbolically and not by recording empirical observations, he exerted considerable influence on later painting in China. His own work is labored, overtheoretical and relatively lifeless. He was also a high government official.

TUNG YUAN (fl. late 10th century). A Chinese painter active in Nanking, where he was the reigning master of his era, he painted sumptuous, atmospheric landscapes in progressively softer receding planes.

TURA, COSIMO (Cosmè) (ca. 1430–1495). An Italian painter and the first major artist of the Ferrarese school, he worked in a style derived from MANTEGNA and, possibly, ROGIER VAN DER WEYDEN and characterized by bright, hard surfaces and hectic, twisting rhythms that anticipate MANNERISM and even EXPRESSIONISM. Few of his works survive.

TURNER, JOSEPH MALLORD WILLIAM (1775–1851). Perhaps the greatest English painter of all time, he was conventionally trained, primarily as a topographical watercolorist. A precocious artist, he was elected an associate of the Royal Academy in 1799 and a full Academician—at age 27—in 1802, the year of GIRTIN's death at the same age. (Turner had been a collaborator and imitator of Girtin's, and his later observation, "If Tom Girtin had lived I should have starved," invites speculation of his short-lived friend's potential magnitude. That Girtin may have had as high an opinion of Turner is indicated by his practice of merely outlining the topographical views on which they both worked and allowing Turner to apply the watercolor—a medium Girtin was later to revolutionize, even as Turner would still later on.)

Turner had begun to paint in oils around 1796, and his efforts in that medium were influenced in rapid succession by Dutch marine painting of the 17th century, RICHARD WILSON and Wilson's own chief influence, CLAUDE LORRAINE. Concurrently, however, he had begun to work out a distinctive personal style characterized by dramatic content and movement and an in-

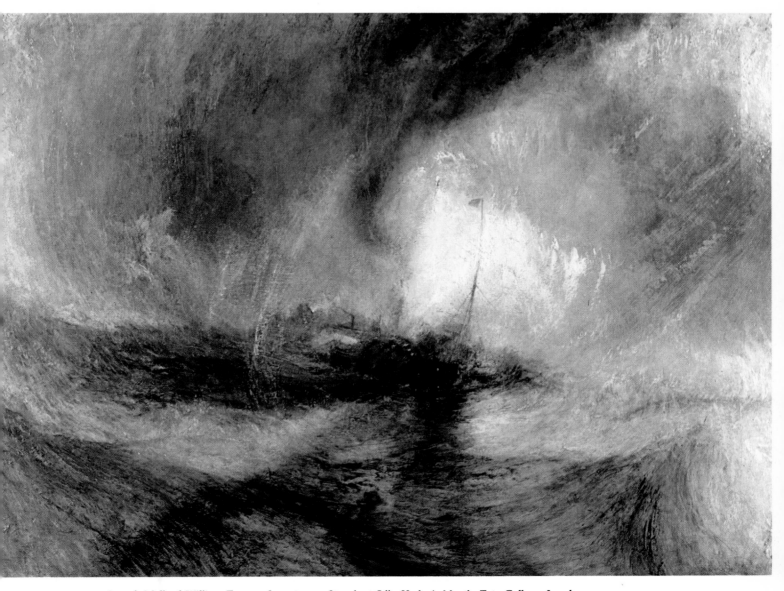

Joseph Mallord William Turner, *Snowstorm—Steamboat Off a Harbor's Mouth*, Tate Gallery, London.

creasing preoccupation with atmosphere, luminosity and the orchestration of color. These, indeed, became the chief concerns of his career and led to frequent attacks on the lack of "finish" in his "pictures of nothing." (Although he had more than his share of detractors, not least of whom was CONSTABLE, who called his pictures "tinted steam," Turner had some influential defenders, including LAWRENCE and, above all, Ruskin.)

The works of Turner's maturity are dazzling exercises in the evocation of pure light. Unfortunately, many of his oils—particularly his magnificent evocations of Venice—have undergone chemical changes with time, but the freshness of his vision remains uncompromised in his voluminous watercolors. His influence on IMPRESSIONISM was incalculable, and it could be argued that he was the first abstract painter.

TWACHTMAN, JOHN HENRY (1853–1902). An American painter, etcher and teacher trained chiefly by DUVENECK and also in Munich, he was a leading exponent of IMPRESSIONISM in the U. S. and a founder of THE TEN. His typical canvases are delicate, soft and reduced to essentials.

TWORKOV, JACK (1900–). Polish-born American abstract-expressionist painter influenced by DE KOONING. His later works have been characterized by their use of repetitive overall patterns.

TYTGAT, EDGARD (1879–1957). A Belgian Expressionist painter, illustrator and printmaker who affected a naïve style.

U

UCELLO, PAOLO (1397–1475). Italian painter. Often erroneously credited with the invention of Renaissance one-point perspective and long relatively overlooked because of VASARI's condemnation of him as overly "scientific," he was nonetheless one of the greatest decorative painters of his era. Little is known of his early life and training, except that he seems to have attached himself to the workshop of GHIBERTI in his early boyhood and was a fully fledged professional while still in his teens. His work is characterized by considerable use of foreshortening and often employs more than one vanishing point but consistently avoids any attempts at rendering deep space. His best-known frescoes are *The Flood* (Florence: S. Maria Novella). His most famous panel paintings comprise a cycle depicting incidents in *The Battle of San Romano* (Paris: Louvre; London: National Gallery; Florence: Uffizi).

UDEN, LUCAS VAN (1595–1672). A Flemish landscape painter and engraver heavily influenced by RUBENS, for some of whose works he is supposed to have executed the backgrounds.

UFFIZI PALACE, FLORENCE. A 16th-century Italian palace designed by VASARI for Cosimo I de' Medici to house offices of the Florentine Mint, it is partly mannerist in style and houses the state archives of Tuscany and the Uffizi Gallery, one of the world's great art museums.

UGOLINA DA SIENA (fl. late 13th century; d. ca. 1339). An Italian painter of whose works only one example survives and who appears to have been influenced by DUCCIO and CIMABUE (his teacher, according to VASARI).

Paolo Uccello, *The Battle of San Romano*, Uffizi, Florence.

Maurice Utrillo, *Rue des Poissonniers*, private collection.

UHDE, FRITZ VON (1848–1911). A German painter who depicted religious subjects in a realistic manner, using contemporary settings and peasant types.

UNKEI (d. 1223). A Japanese sculptor and master of a large, influential workshop, he is known for large figures, rapidly carved in wood by an army of assistants working under his supervision.

URENA, FELIPE (fl. 1st half of 18th century). A Mexican architect and designer, principally of retables.

UTAMARO (Kitagawa Utamaro) (1753–1806). A Japanese designer of UKIYO-E prints, he was influenced by KIYONAGA and, with HARONOBU, is considered Japan's greatest portrayer of beautiful women.

UTRILLO, MAURICE (1883–1955). A more or less self-taught French painter and illegitimate son of SUZANNE VALADON, he was an adolescent alcoholic and was encouraged to take up painting as a therapeutic measure. Primarily influenced by PISSARRO and possibly SISLEY, he specialized in Parisian street scenes, especially of the Montmartre district, and often worked from photographs. With MODIGLIANI, he was one of the legendary *peintres maudits* of Montmartre and Montparnasse.

V

VAGA, PERINO DEL (Pietro Buonaccorsi) (1501–1547). An Italian painter and stucco decorator taught by RIDOLFO GHIRLANDAJO and lesser masters, he worked as an assistant to RAPHAEL and as a much-sought-after independent frescoist. His style, influenced by Raphael and ANDREA DEL SARTO, was mannerist and notable for its clear color and pleasing rhythms.

VAILLANT, WAILLERANT (1623–1677). A French-born painter, pastelist and printmaker of Flemish parentage, he spent most of his career in Amsterdam and is known chiefly for his early use of the mezzotint medium.

VALADON, SUZANNE (1865–1938). French painter. More or less self-taught, she had been a circus acrobat and a popular Montmartre model in her teens but turned to drawing after becoming the mother of UTRILLO. Her work was brought by TOULOUSE-LAUTREC to the attention of DEGAS, who encouraged her enthusiastically. She subsequently took up painting, developing a style characterized by harsh probity, clear (if not always harmonious) color and bold, decorative use of line. Influenced to some extent by GAUGUIN, she is known best for sturdy, acutely observed nudes in realistic, unromanticized poses and settings.

VALCKENBORCH FAMILY. Two generations of Flemish painters, of whom the most notable were Martin van Valckenborch (1535–1612), his brother Lucas (before 1535–1597) and his sons Frederick (ca. 1570–ca. 1624) and Gillis (ca. 1570–1622).

VALDAMBRINO, FRANCESCO DI (fl. early 15th century). An Italian sculptor and goldsmith. One of the great carvers of his era, he was a sometime collaborator of JACOPO DELLA QUERCIA.

Suzanne Valadon, *Blue Bedroom*, National Museum of Modern Art, Paris.

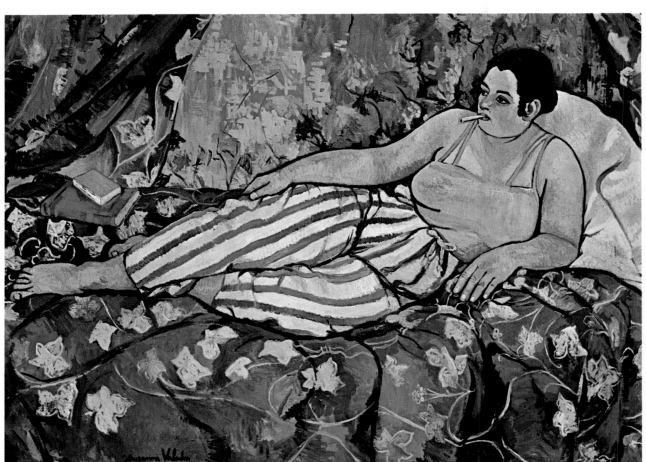

Félix-Edmond Vallotton, *Beach at Vidy,* Cantonal Museum of Fine Arts, Lausanne.

VALDES LEAL, JUAN (1622–1690). A Spanish BAROQUE painter and co-founder (with MURILLO) and president of the Seville Academy. His style derives from FRANCISCO HERRERA THE ELDER and is characterized by nervous movement, a rather theatrical use of color and a preoccupation with mortality and fleshly corruption.

VALENTIN, MOISE LE (fl. lst third of 17th century). A French painter, possibly of Italian parentage, he was also called Jean de Boullogne and Jean Rasset, worked in the Caravaggesque manner as derived from MANFREDI and spent most of his career in Rome.

VALLOTTON, FELIX EDMOND (1865–1925). A Swiss-born French painter, printmaker, illustrator and writer, he is known best for strongly contoured, highly contrasted woodcuts influenced by GAUGUIN, BEARDSLEY and others.

VANBRUGH, SIR JOHN (1664–1726). An English architect and playwright and collaborator of HAWKSMOOR, he was one of the leading English exponents of the BAROQUE, although nothing is known of his architectural training or activity (if any) before 1699, when he and Hawksmoor designed Castle Howard, Yorkshire. His style is characterized by its attention to form, mass and monumentality and its relative slighting of detail. His masterpiece is Blenheim Palace, near Oxford, again exe-

cuted in collaboration with Hawksmoor and notable for its interrelationship and articulation of forms, its majestic sweeping movement and distinctive skyline.

VANDERLYN, JOHN (1775–1852). An American painter and pupil of STUART, he also studied in France and Italy and is best known for such historical pictures as *The Death of Jane McCrea* (Hartford: Wadsworth Atheneum) and for his classical nude *Ariadne Asleep on the Island of Naxos* (Philadelphia: Pennsylvania Academy of the Fine Arts).

VAN EYCK, HUBERT (ca. 1370–ca. 1426). Putatively a Flemish painter and brother and collaborator of JAN VAN EYCK, he is a shadowy figure who conceivably may never have existed. An inscription on the GHENT ALTARPIECE (Ghent: St. Bavo) states that the work was begun by him, that he was the greatest painter alive and that "Jan, second in art," completed it. Some scholars dispute the authenticity of the inscription, and what scanty additional documentation exists may have to do with one or more painters variously known as "Master Luberecht," "Master Hubrechte" and "Lubrecht van Heyke" and active in Ghent.

VAN EYCK, JAN (ca. 1380–1441). Flemish painter. A pioneer in the use of oil paint on panels and the initiator of the great Netherlandish tradition, he is generally acclaimed as one of the outstanding masters in all of art

Jan Van Eyck, *The Madonna with Chancellor Rolin*, Louvre, Paris.

before the northward sweep of the Renaissance. He is also believed to be the younger brother of HUBERT VAN EYCK, but, if Hubert indeed existed, might have been his son or otherwise related.

Nothing significant is known of his training or life before ca. 1422, when he was employed as a painter and *"varlet de chambre"* to John of Bavaria, for whom he is believed to have illuminated part of the superb Turin–Milan Hours (Turin: Municipal Museum of Art). From 1425 onward he was employed by Philip the Good, duke of Burgundy, although he also worked independently after 1430. His earliest signed work, the GHENT ALTAR-PIECE (Ghent: St. Bavo), dated 1432, is a large polyptych comprising two tiers of narrative pictures and portraits, with additional portraits of saints and donors on its outside—twenty separate components in all. Judged by internal evidence, the arrangement would seem to represent a reworking of one or more original plans, since the ensemble of the inner surface is decidedly top-heavy and the compositional focus uncertain. Nonetheless, it is the landmark work of early Flemish painting and the first in which monumental nudes—near life-sized figures of Adam and Eve—appear in northern art. *Trompe l'oeil* effects used on the exterior surface, where the individual panel frames seem to cast actual shadows on a painted floor, and the outdoor scene depicting the Adoration of the Lamb make the most consistent and extensive use of

aerial perspective seen in Netherlandish painting until that moment.

A number of signed and dated works by Jan exist, including both religious subjects, portraits and the extraordinary wedding picture *The Arnolfini Marriage* (London: National Gallery), the high-water mark in the northern realist tradition. Jan's mastery was widely acclaimed in his own time as far abroad as Naples. His works were extensively collected by the artists of the Italian Renaissance and praised by admirers as unlike as VASARI and DÜRER. His principal follower was CHRISTUS, but every later painter in oils may be said to owe something to his influence.

VAN GOGH, VINCENT WILLEM (1853–1890). Dutch post-impressionist painter. After beginning his career as an art dealer, he became a lay preacher in the Borinage, a depressed mining district of Belgium, where he made his first drawings and eventually turned to painting. After copying reproductions, mostly of works by MILLET, he went to The Hague, studied briefly with MAUVE and turned to painting independently, in a dark-toned, freely brushed style composed mostly of greens, blacks and earth colors. A typical work of the period is *The Potato*

Jan Van Eyck, *Portrait of Cardinal Albergati*, Museum of Art History, Vienna.

Vincent Van Gogh, *Cornfield and Cypresses*, National Gallery, London.

formations and outlined boldly, in much the same manner as the Japanese prints he had discovered and begun collecting in Paris. And whereas Impressionism had sought above all to reproduce light as it is optically perceived, Van Gogh's work, with its jarring, arbitrary colors, dazzling swirls of paint and staccato fusillades of brush strokes, seemed not so much to reproduce natural light as to generate an intense light of its own.

During this period GAUGUIN came to Arles at Van Gogh's urging, but what the latter had envisioned as a creative idyll soon turned into an ongoing clash of contrasting temperaments that aggravated Van Gogh's mental instability (since diagnosed as psychotic epilepsy) and culminated in the celebrated incident wherein he cut off a portion of an ear and delivered it to a brothel. Van Gogh's work underwent corresponding stylistic changes at about the same time, becoming darker, less broadly patterned and more expressionistic, with a manic application of brushstrokes serving to define form and even a new, hectic brand of perspective. After entering a hospital at St. Rémy he produced upward of 150 pictures in a mere six months, works that reached into a subjectively expressive range never explored before or since by an artist so fully in control of his vehicle of expression. A few months later he died of a self-inflicted gunshot wound, putting an end to one of the most turbulent careers in the history of art and to an output that might best be described as volcanic. His oeuvre falls into four clearly defined styles: the dark, concerned works of his stay in the Borinage; a more or less conventionally Impressionistic period in Paris; the lyrical transitional style of his early months in Provence; and the tormented projections, characterized by boiling skies, writhing cypress trees and heaving mountains, of his last half year in the south and in Auvers. His influence on subsequent expressionist painting has been enormous, and his letters to his brother, the art dealer Theo Van Gogh, are among the most moving and edifying ever published.

VAN HOEYDONCK, PAUL (1925–). A Belgian sculptor, characteristically of white-painted assemblages having to do with space flight and exploration.

VAN LOO FAMILY. See LOO, VAN, FAMILY.

VANNI, ANDREA (ca. 1332–ca. 1414). An Italian painter and political figure and colleague of BARTOLO DI FREDI, he was influenced by SIMONE MARTINI at the outset of his career but lapsed into a stilted manner soon thereafter.

VANNI, LIPPO (fl. from 1340s; d. 1375). Italian miniature painter and frescoist. From his meager surviving oeuvre he seems to have been influenced at separate periods by AMBROGIO LORENZETTI and SIMONE MARTINI.

Eaters (Laren: V. W. Van Gogh Collection), an expressive, highly empathetic depiction of the poor of the Borinage. At about the same time—the mid-1880s—he underwent a series of unhappy and melodramatic experiences with women; experiences that have been advanced as both the cause and effect of a neurotic condition that was progressively to worsen, with decisive effects on his life and art.

After moving to Paris in 1886, he met and was encouraged by the leaders of IMPRESSIONISM and POST-IMPRESSIONISM and changed his style to conform more closely with theirs. Two years later he went to Arles, where, enthralled by the distinctive light of Provence, he embarked on an incredibly prolific fifteen months that saw the development of his characteristic style—a style that eliminated the tentative brushwork and gauzy atmospherics of Impressionism, substituting for them clear, intense color laid on in thick, energy-charged con-

Vincent Van Gogh, *Self-portrait,* Louvre, Paris.

VANTONGERLOO, GEORGE (1886–1965). A Belgian artist, architect and aesthetic theorist, he was an influential proponent of CONSTRUCTIVISM, a member of DE STIJL and an associate of MONDRIAN and DOESBURG. His constructions are characterized by assymetry, rectangularity and a severity derived from a system of proportions based on GOTHIC architecture.

VANVITELLI (Van Wittel), GASPARE (1653–1736) and **LUIGI** (1700–1773). Respectively, a Dutch-born Italian painter of topographical views and his son, an Italian architect best known for the Palace of Caserta.

VARLEY, JOHN (1778–1842). An English watercolorist and teacher. His work falls between topographical rendering and true watercolor painting.

VASARELY, VICTOR (de) (1908–). A Hungarian-born French painter and a pioneer in the development of OP ART. His style derives from BAUHAUS theory and CONSTRUCTIVISM and is characterized by sumptuous effects produced by carefully worked-out color harmonics and by a geometric, modular "vocabulary" of forms used in infinitely variable relationships. He is also a prolific printmaker and designer of multiples.

VASARI, GIORGIO (1511–1574). Italian painter, architect and biographer. As a painter he was influenced chiefly by Rosso FIORENTINO and is known best for his frescoes in the Palazzo Vecchio, Florence, and in the Vatican. His architectural masterpiece is the UFFIZI PALACE, Florence. Vasari is primarily important for his "Lives" (*Lives of the most excellent Painters, Sculptors and Architects*), a work published in 1550 and enlarged in 1568 and one that established its author as the first art historian of consequence and remains an invaluable, if not impeccably accurate, source of information on the arts between the time of GIOTTO and its publication.

VAZ, GASPAR (fl. ca. 1514–1568). A Portuguese painter of religious subjects related stylistically to Netherlandish painting of the 15th century.

VEDDER, ELIHU (1836–1923). An American visionary painter, muralist and illustrator who spent much of his career in Rome. He is best known as an illustrator of the *Rubáiyát* and for such canvases as *The Lair of the Sea Serpent* (Boston: Museum of Fine Arts), in which exotic elements are combined with conventional settings, often to powerful and vaguely disturbing effect.

VEIT, PHILIPP (1793–1877). A German painter of the NAZARENE group best known for his religious frescoes and workshop-produced paintings on the life of Christ.

VELASCO, JOSÉ MARIA (1840–1912). A Mexican landscape painter, lithographer and teacher best known for minutely detailed depictions of tropical vistas.

VELAZQUEZ, DIEGO RODRIGUEZ DE SILVA Y (1599–1660). The greatest of Spanish painters and a youthful prodigy, he was a pupil of FRANCISCO HERRERA THE ELDER and of PACHECO, whose daughter he married and whom, in a startling reversal of roles, he influenced while still in his teens. He himself was influenced more strongly by Herrera at the start of his career, when he produced a number of dark-toned genre scenes, and, later, by TITIAN. Appointed court painter to Philip IV while in his early twenties, he executed numerous portraits of his royal patron, all distinguished by a spatial and atmospheric verisimilitude that are all the more impressive for their lack of conventional props and reference points and their complete eschewal of BAROQUE theatricality (although he befriended RUBENS during the latter's stay in Madrid, he was altogether uninfluenced by the Flemish master's more ornate style).

During a sojourn in Italy in 1629–1631 Velazquez adopted a more fluent brush stroke and made more extensive use of the nude figure and landscape backgrounds. While there he met his countryman RIBERA and seems to have been influenced by that master's predilection for facial character and still-life detail. While in Italy he met the Marchese Spinola, the general who accepted the surrender of Justin of Nassau at Breda and, soon after his return to Madrid, recorded the event in *The Surrender of Breda* (Madrid: Prado), a brilliantly conceived composition, full of resonant color, with the foreground action played out against a panoramic landscape background. And while it was conceived as one of a series of battle pictures, it altogether transcends the traditional limitations of what had until then been for the most part a hollow, rhetorical genre, achieving the monumentality demanded of such subjects but infusing it with an unaccustomed humanity.

After a second trip to Italy (1648–1651), undertaken as a member of an official embassy and during which he painted his only female nude, the *Rokeby Venus* (London: National Gallery), and two of his finest portraits, *Juan de Pareja* (New York: Metropolitan Museum) and *Pope Innocent X* (Rome: Doria Pamphili), he returned to Madrid, where he produced a number of court portraits, a form that was to reach its culmination in his renowned *Las Meninas* (Madrid: Prado), the quintessence of the artist's subdued, reflective approach to the Baroque and a technical and imaginative tour de force. Velazquez long had been fascinated by the peculiar property that allows mirrors to put before their users what actually is behind them and had tentatively explored the pictorial use of this device in such works as the *Rokeby Venus*. In *Las Meninas* he employed a large mirror to involve the viewer fully, both psychologically and in the picture space, portraying the Spanish king and queen not directly but as reflected from a point "outside" the picture, a point normally occupied by the viewer. As a study of variegated character and of the peculiar, almost musty atmosphere of the Spanish court, it is a thoroughly compelling work and one that makes full use of its author's mastery of both two- and three-dimensional organization, and reveals his acuity of observation, control of atmosphere and un-

Velazquez, *The Infanta Margarita*, Prado, Madrid.

canny ability to obliterate the point of demarkation between the real and painted worlds.

Velazquez was the compleat painter and seems to have had little or no interest in any other medium. His influence on succeeding generations was enormous and unusually prolonged, affecting in turn his immediate successors, GOYA, a host of 19th-century painters, particularly MANET, and extending well into the 20th century, as evidenced by PICASSO, who in 1957 painted 44 variations on *Las Meninas*, a picture from which he had drawn inspiration since he saw it for the first time at age 15.

VELDE, ADRIAEN VAN DE (1636–1672). Dutch landscape and history painter, brother of WILLEM VAN DE VELDE THE YOUNGER and son of WILLEM VAN DE VELDE THE ELDER. Taught by his father and Wijnants, he was particularly adept at capturing the atmosphere of landscapes under sunny skies. A skillful animal painter (influenced in that respect by POTTER), he was also a fine etcher.

VELDE, ESAIAS VAN DE (ca. 1590–1630). A Dutch painter, pupil of CONINXLOO and teacher of JAN VAN GOYEN, he was a pioneer of the realistic landscape tradition.

VELDE, HENRY VAN DE (1863–1957). A Belgian architect and designer, he also studied painting under Carolus-Duran and was one of the leading exponents of ART NOUVEAU, although eschewing the naturalistic forms favored by most of the style's adherents. He was also an influential teacher.

VELDE, JAN JANSZ. VAN DE III (ca. 1620–after 1663). A Dutch still-life painter and son of JAN VAN DE VELDE II, he is known for breakfast settings painted in near monochrome.

VELDE, JAN VAN DE II (1596?–1635 or later). A Dutch printmaker and draftsman and cousin of ESAIAS VAN DE VELDE and brother of JAN JANSZ. VAN DE VELDE III, he produced original landscape and genre subjects and reproductive prints.

VELDE, WILLEM VAN DE, THE ELDER (1611–1693). Dutch painter, draftsman and father and teacher of WILLEM VAN DE VELDE THE YOUNGER and ADRIAEN VAN DE VELDE. A sailor in his youth, he later turned to the depiction of marine subjects, which he rendered with more accuracy than inspiration. Because he lacked a command of color, almost all his paintings are executed in grisaille. His works are of importance chiefly to naval historians who value them for their documentary accuracy.

VELDE, WILLEM VAN DE, THE YOUNGER (1633–1707). A Dutch marine painter, brother of ADRIAEN VAN DE VELDE and son and pupil of WILLEM VAN DE VELDE THE ELDER, he also studied under VLIEGER. With his father he left Holland for England in 1672 and entered the service of Charles II, who gave him a yearly stipend of £100 "for putting the said draughts [of sea fights drawn by his father] into colours for our own particular use." A far better painter than his father in every respect, he was expert in the depiction of calm seas and treated his representations of ships almost as though they were portraits.

VELLERT, DIRK (1511–1544). A Flemish printmaker and painter known for his precision of detail and technical proficiency.

VENUS OF WILLENDORF (Vienna: Museum of Natural History). Highly stylized statuette of a female fertility figure. It was found at Willendorf, Austria, and is one of the earliest known works of Upper Paleolithic art.

VERBRUGGEN FAMILY. A Flemish family of artists of whom the salient figures were Caspar Pieter I (1635–1681), a flower painter; his son and imitator Caspar Pieter II (1664–1730); Hendrick Frans (ca. 1655–1724), a sculptor of the late BAROQUE–early ROCOCO and son of Pieter Verbruggen the Elder (ca. 1609–1686), also a sculptor and an influential teacher.

VERESHCHAGIN, VASILI VASILEIVICH (1842–1904). A Russian painter who studied in Paris with GÉRÔME, he is known for his documentation of various military campaigns (he was an ardent pacifist) and for scenes of the life and landscape he observed in the course of his extensive travels in the Near East and the Orient.

VERGOS FAMILY. A family of Catalan painters, primarily of altarpieces and the like, active in and around Barcelona in the 15th century.

VERMEER, JOHANNES (Jan) REYNIERSZ. (1632–1675). Dutch painter and one of the distinctive masters of all time. Almost nothing of significance is known with any certainty of his life or training, although he was probably a pupil of CAREL FABRITIUS and undoubtedly was influenced by him and collected his works. He is known to have kept a tavern inherited from his father and to have been an art dealer and assessor of works of art but not, apparently, a successful one. After his death his estate, such as it was, was put in the care of the Delft microscopist Anthony van Leeuwenhoek.

Because his surviving oeuvre is extremely small, it is generally assumed that Vermeer was a slow, meticulous craftsman who produced little more than the 30-odd works now ascribed to him. The notion is difficult to credit. For one thing, it is extremely unlikely that any mortal artist could have attained the level he eventually reached at the outset of his career with almost no false starts or immature efforts. For another, he was in constant financial straits and probably never sold one of his own paintings—circumstances tending to indicate that much of his abbreviated working life was spent in his "primary" roles as barkeep and picture seller, leaving him little time for what, in effect, was a hobby from which

Johannes Vermeer, *Woman in Blue Reading a Letter*, Rijksmuseum, Amsterdam.

Paolo Veronese, *The Wedding at Cana,* detail, Louvre, Paris.

he derived no income. Certainly nothing in the works themselves, which to a considerable extent anticipate IMPRESSIONISM (a style largely dependent on speed of execution), support the notion of a painstaking artisan. On the contrary, there is about all his work an immediacy, what MONET termed a "simultaneity" in describing his own pictorial goal, that would be all but impossible for any but a fast-working painter to achieve. (A theory exists that all of an extensive early output but two works unrelated to his mature oeuvre was destroyed in the explosion of a powder magazine at Delft in 1654—a disaster that took Fabritius' life; it may have some merit.)

Whatever Vermeer's working methods and the extent of his productivity may have been, his works prove him to have been a singular figure in the history of art—a figure on the order of BOSCH, who produced an immediately recognizable body of works that make any discussion of influences and historical continuity irrelevant. His pictures, characteristically of one or two figures, their lives suspended in a placid, ordered, almost audibly hushed interior, in an atmosphere curiously like aspic, are unique and inimitable. He had no significant followers, exerted hardly a ripple of influence and was almost completely neglected during his lifetime and for two cen-

Andrea del Verrocchio, *David*, Bargello Museum, Florence.

turies after his death. Ironically, the obscurity surrounding his life and works made it possible for a skillful nonentity, Hans van Meegeren, to perpetrate in the 1940s the most sensational series of forgeries in history.

VERMEIJEN, JAN CORNELISZ. (ca. 1550–1559). A Netherlandish history and portrait painter, tapestry designer and printmaker, he was influenced chiefly by JAN VAN SCOREL.

VERNET, CLAUDE-JOSEPH (1714–1789). A French landscape and marine painter influenced principally by CLAUDE LORRAINE and ROSA and a member of a prominent family of artists. With ROBERT he reacted against the prevailing ROCOCO style, producing pictures characterized by serenity and expansiveness.

VERNET, ÉMILE-JEAN-HORACE (1789–1863). A French painter and lithographer and son of CLAUDE-JOSEPH VERNET, he specialized in horses.

VERONESE (Caliari), PAOLO (1528–1588). Venetian painter. Trained in his native Verona by several minor masters, he was influenced principally by TITIAN and also by MICHELANGELO, PARMIGIANINO and various others, including DÜRER. A precocious artist, he worked in the grand manner from his teens onward, filling his pictures with handsome, well-turned-out people, a wealth of architectural detail and all manner of picturesque incident. Indeed, his penchant for colorful irrelevancies aroused the suspicions of the Inquisition, which found his *Feast in the House of Levi* (Venice: Academy) offensively indecorous and demanded of the artist whether he deemed it "fitting" to introduce such "ornaments and inventions" as "buffoons, drunkards, German soldiers, dwarfs, and

similar scurrilities" into a representation of the Last Supper. To his great credit as an artist, he conducted a spirited defense of his right to paint as he saw fit, but, impressive as his argument may have been, he was forced to delete the offending details at his own expense.

Veronese was the quintessential Venetian painter, reveling in color for its own sake, uninterested in dramatic expressivity or events of great moment but eternally fascinated by the pageantry and texture of life. Although he is ranked slightly below Titian and TINTORETTO, his less alliterative name with theirs sums up the flavor and breadth of the Venetian style.

VERONICA MASTER (fl. 2nd decade of 15th century). An anonymous German painter so called for his panel *St. Veronica Holding the Miraculous Veil* (Munich: Old Pinakothek), a masterpiece of the early Cologne school.

VERROCCHIO, ANDREA DEL (1435–1488). Florentine sculptor, painter and goldsmith, generally believed to have been a pupil of DONATELLO, whom he succeeded as the leading sculptor in Florence. His sculptural style is neither as monumental nor as tragic as Donatello's, but lighter, more delicate and more graceful, perhaps as a result of his early training as a goldsmith. His primary concern was with movement and his work—again probably the result of his goldsmith's training—is flawed somewhat by a tendency toward overelaboration.

Andrea del Verrocchio, bronze equestrian statue, Piazza di SS. Giovanni e Paolo, Venice.

Andrea del Verrocchio, *The Baptism of Christ*, Uffizi, Florence.

Nonetheless, he was an artist of manifold talents, maintained an important workshop and numbered LEONARDO and LORENZO DA CREDI among his assistants. Few fully authenticated paintings from his own hand survive, but his workshop pictures display a sculptor's command of form combined with a goldsmith's love of fine detail.

VERSAILLES, PALACE OF. A French royal residence outside Paris, it was built as a hunting lodge by Louis XIII but extensively enlarged under Louis XIV and, later, by MANSART. It is notable chiefly for the magnificent decoration of its interior, added under the direction of LE BRUN.

VERSPRONCK, JOHANNES CORNELISZ. (1597–1662). Dutch portrait painter and possible pupil of FRANS HALS.

VERTES, MARCEL (1895–1961). A Hungarian-born French painter, printmaker and illustrator known for spirited, rather shallow pictures influenced by DUFY.

VERTUE, ROBERT (d. 1506) and **WILLIAM** (d. 1527). English architects and brothers whose work exemplified the PERPENDICULAR STYLE.

VEZELAY: CHURCH OF LA MADELEINE. An abbey church in north-central France, it is one of the outstanding monuments of the ROMANESQUE era. Built in the late 11th and early 12th centuries, it was enlarged ca. 1120 with an ogival narthex considered by some historians to be proto-GOTHIC. Its partially groin-vaulted nave constitutes the earliest example of its kind in France, and the sculptures of the central portal of the narthex are outstanding among Medieval reliefs.

VICENTE, ESTEBAN (1906–). Spanish-born American painter of the abstract-expressionist school.

VICKREY, ROBERT (1926–). An American painter and student of MARSH and KENNETH HAYES MILLER, he is known for enigmatic, finely rendered realistic tempera paintings.

VICTORY (Nike) OF SAMOTHRACE (Winged Victory) (Paris: Louvre). Hellenistic statue of Nike consisting of a headless and armless figure in marble, originally used as a ship's figurehead and supposedly carved by Pythokritos of Rhodes (fl. early 2nd century B.C.).

VIEN, JOSEPH-MARIE (1716–1809). A French painter, engraver and decorator, he is known chiefly as the teacher of JACQUES-LOUIS DAVID and as an early exponent of NEOCLASSICISM.

VIERZEHNHEILIGEN, CHURCH OF. An 18th-century pilgrimage church northwest of Bamberg, Germany. It is a superb example of the elaborately decorative style of the period, was designed by NEUMANN and is notable for lightness that seems to border on insubstantiality.

VIGAS, OSWALDO (1926–). A Venezuelan painter of highly abstracted natural forms rendered in thick impastoes and with a nearly monochromatic palette.

VIGÉE-LEBRUN, LOUISE-ELISABETH (1755–1852). A French painter who studied with GREUZE, CLAUDE-JOSEPH VERNET and others, she was a protégée of Marie Antoinette, of whom she painted many portraits. Influenced by RUBENS to the point where she was nicknamed "Madame Rubens," she traveled extensively and was widely admired (by REYNOLDS, among others). She occasionally worked—very convincingly—in the manner of JACQUES-LOUIS DAVID.

VIGELAND, GUSTAV (1869–1943). A Norwegian sculptor who studied for a time with RODIN, he is known best for the work that occupied most of his career, a *Park of Sculpture* outside Oslo that serves as an approach to a huge monolithic column made up of myriad writhing nude figures.

VIGNOLA, GIACOMO BAROZZI (1507–1573). An Italian architect influenced by BRAMANTE, he collaborated with VASARI and AMMANATI on the Villa Giulia, completed the Villa Farnese and built several churches in Rome. He was MICHELANGELO's successor at ST. PETER'S.

VIGNON, CLAUDE, THE ELDER (1593–1670). A French painter who studied in Rome, where he was influenced by ELSHEIMER and, indirectly, CARAVAGGIO.

VILLON, JACQUES (Gaston Duchamp) (1875–1963). French painter and brother of DUCHAMP and DUCHAMP-VILLON. An early adherent of ANALYTICAL CUBISM, he later turned to abstractions based on landscapes and a pyramidal system of construction based on the theories of LEONARDO.

VINCKEBOONS, DAVID (1576–1629). A Flemish genre and landscape painter influenced primarily by CONINXLOO and to a lesser extent by PIETER BRUEGHEL THE ELDER.

VIOLLET-LE-DUC, EUGÈNE-EMMANUEL (1814–1879). A French architect, archaeologist and architectural restorer, he is best known for his influential writings on the GOTHIC style.

VISCHER, PETER, THE ELDER (ca. 1460–1529). A German sculptor representing the second of three generations of prominent bronzeworkers and sculptors, he was trained by his father Hermann Vischer (d. 1488). Although he himself seems not to have traveled in Italy, he absorbed Italian influences from his father, who did, and from other German sources, combining them with the northern GOTHIC tradition. He was one of the greatest bronze casters of all time, his mastery of intricate form and minute detail shown to best advantage in his masterpiece, the Tomb of St. Sebald, Nuremberg. Although his work was richly elaborated, surface decoration was never permitted to overwhelm sculptural form. Just how much of the St. Sebald project actually was executed by Vischer and how much is the work of his four sons is conjectural, but it is safe to assume he was responsible for the overall concept.

VISENTINI, ANTONIO (1688–1782). An Italian architect, painter and engraver and pupil of PELLEGRINI, he produced a number of engravings after CANALETTO and a suite of romantic, somewhat fanciful view paintings in collaboration with ZUCCARELLI.

VISSCHER, CORNELIS (1619–1662). A Dutch engraver of genre subjects, animals and, chiefly, portraits, some after his own drawings and others after works by various European painters.

VITI, TIMOTEO (ca. 1470–1523). Italian painter and, possibly, goldsmith. Believed to have been a pupil of GIOVANNI SANTI, he was influenced by FRANCIA, PERUGINO and particularly RAPHAEL, whom he may have influenced in Raphael's early youth and for whom he may at one point have worked as an assistant.

VITRUVIUS (Vitruvius Pollio) (fl. 1st century B.C.). A Roman architect and engineer whose reputation rests on a ten-volume book of architectural theory and technique, a work that profoundly affected Renaissance architecture.

VITTONE, BERNARDO (ca. 1705–1770). An Italian architect of the late BAROQUE, best known for intricate vaulting techniques that produced fanciful, airy effects.

VIVARINI, ALVISE (ca. 1446–ca. 1504). Venetian painter and son of ANTONIO VIVARINI. Taught by his uncle, the painter Bartolommeo Vivarini (ca. 1432–ca. 1491), he was influenced for the most part by GIOVANNI BELLINI, whose manner he emulated but failed to advance. He was an influential teacher whose pupils included LOTTO and JACOPO DE' BARBERI.

VIVARINI, ANTONIO (ca. 1417–1476 or later). A Venetian painter in the late GOTHIC style, he was a rather unoriginal artist who only late in life began to explore the new ideas then being advanced by such painters as GIOVANNI BELLINI and MANTEGNA. He was the father of ALVISE VIVARINI and worked mostly in collaboration with his brother Bartolommeo (ca. 1432–ca. 1491).

VLAMINCK, MAURICE (1876–1958). French painter and writer. Largely self-taught and militantly anti-academic, he was, with his friend DERAIN, a precursor and then an exponent of FAUVISM. Decisively influenced by VAN GOGH and to a lesser extent by African sculpture and CÉZANNE, he finally adopted a rather gloomy, mildly expressionistic, heavily impacted style, abandoning the exuberant use of color that marked his vital early work. His novels and memoirs are written in the same tough, vigorous style that distinguishes the best of his paintings.

VLIEGER, SIMON JACOBSZ. DE (ca. 1600–1653). A Dutch painter and tapestry designer best known for stormy, dramatic seascapes painted in subtly modulated tones of silvery gray.

VOGELS, GUILLAUME (1836–1896). A self-taught Belgian impressionist painter who took up art late in life and is known for his virtuoso brushwork and ability to capture the atmosphere and "mood" of landscapes.

VOLTERRA, DANIELE RICCIARELLI DA (1509–1566). Italian mannerist painter and sculptor trained by SODOMA and an intimate and follower of MICHELANGELO. His most famous work is a bronze bust of that master executed shortly after Michelangelo's death and not long before his own.

VON RINGELHEIM, PAUL (1934–). An Austrian-born American minimal sculptor whose recent work has consisted for the most part of very large works, often suspended by cables, closely related to the architecture that surrounds them.

VON SCHLEGELL, DAVID (1920–). An American sculptor and exponent of minimalism, much of whose work derives from engineering concepts and principles employed in the aircraft industry.

VOS, CORNELIS DE (ca. 1584–1651) and **PAUL DE** (ca. 1596–1678). Flemish brothers and painters who specialized, respectively, in portraits of well-to-do burghers and animal pictures. Paul occasionally collaborated with their brother-in-law SNYDERS, and both brothers participated in various projects in the workshop of RUBENS.

VOS, MARTIN DE (ca. 1532–1603). A Flemish history and portrait painter and pupil of FLORIS and, during a sojourn in Venice, TINTORETTO. His Italianate style was very popular during his lifetime, particularly as manifested in a large body of graphic works.

VOUET, SIMON (1590–1649). The most precocious and influential French painter of the first half of the 17th century, he had established a reputation for portraiture while still in his early teens and was well known in Italy when he arrived there at age 23. Unfortunately, his undeniable talent was not accompanied by depth or originality, and the style he adopted, a blend of CLASSICISM and the early BAROQUE with an eclectic garnish derived in large part from POUSSIN, was more fashionable than profound. Nonetheless, he was much admired and, after Poussin's final departure from France in 1642, dominated the field of decorative painting in that country, profoundly influencing several pupils, most notably LE BRUN.

VOULKOS, PETER (1924–). An American sculptor and ceramist influenced by the NEW YORK SCHOOL. His works are characterized by monumentality.

VRIES, ABRAHAM DE (1590–ca. 1651). A Dutch portrait painter of whom little is known and who seems to have been an itinerant who shuttled back and forth among such cities as Bordeaux, Paris, Antwerp, Rotter-

Simon Vouet, *Louis XIII Between France and Navarre*, detail, National Museum, Versailles.

Edouard Vuillard, *Au Lit,* National Museum of Modern Art, Paris.

dam, The Hague and Amsterdam. His style betrays the influence of REMBRANDT.

VRIES, ADRIAEN DE (ca. 1548–1626). A Dutch late mannerist sculptor and pupil of BOLOGNA, he worked in Italy and Germany in an Italianate style.

VRIES, ROELOF VAN (ca. 1630–after 1681). A Dutch landscape painter and follower of RUISDAEL.

VROOM, CORNELIS HENDRICKSZ (ca. 1590–1661). A Dutch landscape painter whose style derives chiefly from ELSHEIMER and to a lesser extent from RUISDAEL, with whom he exchanged influences.

VRUBEL, MIKHAIL ALEKSANDROVICH (1856–1911). A Russian painter whose highly personal, demon-ridden iconography reflects a mentality that finally drove him to an insane asylum.

VUILLARD, ÉDOUARD (1868–1940). A French intimist painter, printmaker and decorator who studied under GÉRÔME and BOUGUEREAU, was associated with the NABIS and shared a studio for a time with BONNARD, whose career his own closely paralleled. He was influenced by GAUGUIN and PUVIS DE CHAVANNES, the late MONET and the Japanese UKIYO-E prints. His works are simple, restrained, introspective and often characterized by tapestrylike surfaces.

VYTLACIL, VACLAV (1892–). An American semi-abstract painter whose characteristic mature work is strongly expressionistic.

W

WALDMULLER, FERDINAND GEORG (1793–1865). An Austrian painter who worked in the BIEDERMEIER style, he is most notable for his portraits but was also an accomplished landscapist.

WALKOWITZ, ABRAHAM (1880–1965). Siberian-born American painter, pupil of LAURENS and participant in the 1913 ARMORY SHOW. He is known best for figures in landscapes painted in a style derived from CÉZANNE.

WALLIS, ALFRED (1855–1942). An English primitive painter who turned to art as a septuagenarian and produced strong images of landscapes and incidents remembered from his earlier life.

WANG CHIEN (1598–1677). Chinese painter of the Ch'ing dynasty who specialized in copies after older masters.

WANG HUI (1632–1717). One of four Ch'ing masters named Wang, he was prolific, eclectic and tended to work on an outsize scale.

WANG MENG (ca. 1310–1385). A Chinese painter of the Yuan dynasty, he was particularly esteemed for his virtuoso brushwork and the variety of his strokes.

WANG SHIH-MIN (1592–1680). Chinese painter of the Ch'ing dynasty and one of the so-called "four Wangs." He specialized in copying the works of older masters—an art form much more highly esteemed in the Orient than in the West.

WANG WEI (699–759). Chinese painter and poet considered a pioneer of pure landscape painting and of monochrome ink painting. He is generally credited with founding the "southern school" of Chinese painting.

WANG YUAN-CHI (1642–1715). A Chinese painter of the Ch'ing dynasty and grandson of WANG SHIH-MIN, he was a landscapist who often has been compared with later French painters, particularly CÉZANNE.

WAPPERS, GUSTAVE (1803–1874). Belgian history and portrait painter influenced by DELACROIX.

WARD, JAMES (1769–1859). A British landscape and animal painter influenced by RUBENS.

WARD, JOHN QUINCY ADAMS (1830–1910). American naturalist portrait sculptor.

WARD, LYND (1905–). American graphic artist and illustrator.

WARHOL, ANDY (1930–). American painter, serigraphist and filmmaker. One of the leaders of the POP ART movement and the creator of its best-known images (e.g., his paintings and prints of Campbell's soup cans), he specializes in the single-work and multi-image iteration of such subjects as motor accidents, electric chairs, cows and flowers. His iconography is often deliberately banal and mechanically reproduced, with differentiation—sometimes glaringly obvious and at other times quite subtle—provided either mechanically (by changing the register of a second color) or by the addition of manually applied tints. Perhaps to a greater extent than any other artist, he has obliterated the lines dividing his work, his subject matter and his persona. All three are reticent, apparently ingenuously commercial and enigmatic.

WASTELL, JOHN (d. 1515). An English architect best known for the bell tower he designed for CANTERBURY CATHEDRAL.

WATTEAU, JEAN-ANTOINE (1684–1721). French painter of Flemish parentage. Perhaps the greatest painter in French history before the Revolution, he was trained by minor painters and began his career as a theatrical designer—an experience that was to have lasting effects on his art. He was influenced by RUBENS, whose *Life of Marie de Médicis* he got to know intimately while working at the Luxembourg Palace (it was also there that he produced a body of landscape sketches that later were to be converted to backgrounds for his paintings), TITIAN, PAOLO VERONESE and, earlier, by TENIERS—an influence that occasionally cropped up in such later works as *L'Enseigne de Gersaint* (Berlin: former State Museums).

Andy Warhol, *Mao Tse-tung,* detail, Whitney Museum of American Art, New York.

Jean-Antoine Watteau, *Les Comédiens Italiens,* National Gallery, Washington, D. C. (Samuel Kress Collection).

With his *Embarkation for Cythera* (Paris: Louvre) of 1717—a picture RENOIR was to consider the most beautiful ever painted—Watteau became known as a master of the *fête galante*, a genre in which he was to have no peer. His art is an amalgam of gentle conceits that harked back to the games of courtly love played in France in the Middle Ages. His pictures are peopled by maskers, clowns, actors and musicians, all seemingly healthy, happy and well fed—and none quite real. It is almost as though Watteau—himself a chronic consumptive who was to die at 37—were showing the world not life as it is but as the world would like to pretend it is. In Walter Pater's words, "He was always a seeker after something in the world that is there in no satisfying measure, or not at all." Stylistically, his work was a gentler, less fustian, more poetic version of that of Rubens and more akin to

Flemish painting in general than anything that had preceded it in France. His historical importance lies in his having broken with the Italianate academic style that dominated French painting until then.

WATTS, GEORGE FREDERICK (1817–1904). An English painter and sculptor who spent three years in Florence early in his career and there was influenced by MICHELANGELO and the Venetian painters (he had been influenced still earlier by ETTY). He was enormously popular during the later stages of his career but now seems merely a typical artist of the Victorian period.

WEBER, MAX (1881–1961). A Russian-born American painter, he was one of the first Americans to recognize the modernist revolution that was occurring in Europe in the early 20th century and probably the first to incorporate many of its salient innovations into his own art. His early stylistic evolution led him from FAUVISM to CUBISM, but he adopted a less radical CÉZANNE-derived manner around 1917—one that allowed him greater coloristic freedom. Still later (ca. 1938) he turned to religious themes painted with great expressivity and richness.

WECHTLIN, HANS (ca. 1460–ca. 1526). German printmaker, illustrator and painter. DÜRER's first pupil, he specialized in the woodcut.

WEDGWOOD, JOSIAH (1730–1795). English potter and pottery manufacturer, After concentrating on functional pottery during the first half of his career, he turned to the production of purely ornamental works in the NEOCLASSICAL style. These characteristically are decorated with low-relief figures against a darker solid-color ground.

WEENIX, JAN (ca. 1640–1719) and **JAN BAPTIST** (1621–1663). Dutch painters and, respectively, son and father. Jan, the pupil of his father, specialized in still lifes and portraits. His father, the more important of the two, was at one point a pupil of BLOEMAERT and spent some time in Rome. He is said to have worked with almost unbelievable speed—a claim that often seems quite believable on examination of the results.

WEIDITZ, HANS (ca. 1500–after 1536). A German woodcut designer. The bulk of his work was devoted to book illustration.

WEIR, J. ALDEN (1852–1919). An American painter and founding member of THE TEN, he is known for rather self-consciously poetic landscapes and figure pieces.

WEN CHENG-MING (1470–1559). Chinese painter and one of the outstanding masters of the Ming dynasty. His style was based on various past masters.

WERFF, ADRIAEN VAN DER (1659–1722). A Dutch painter and pupil of EGLON VAN DER NEER. His works are characterized by their high, precise finish.

WESSELMANN, TOM (1931–). An American painter and exponent of POP ART, he is best known for sleekly rendered female nudes, characteristically depicted singly, in interiors.

WEST, BENJAMIN (1738–1820). A Colonial American painter who spent most of his life in England. After absorbing classical influences in Italy, he set up as a portraitist in London in order to support his penchant for history pictures. He was stylistically influenced by MENGS. His most important contribution was his use of modern dress in depictions of recent contemporary historical events. He succeeded REYNOLDS as president of the Royal Academy and was the first native-born American painter to attain an international reputation.

WESTMINSTER ABBEY. English abbey in London. The present edifice was begun on the site of a destroyed ROMANESQUE church in the mid-13th century, probably by an architect imported from France. Its chapter house and late-14th-century nave are notable, as are its 18th-century towers by HAWKSMOOR and the late PERPENDICULAR Chapel of Henry VII. It serves as a burial place for England's most distinguished figures.

WEYDEN, ROGIER VAN DER (ca. 1400–1464). One of the greatest of the 15th-century Flemish primitive painters, he was probably an apprentice of the MASTER OF FLEMALLE (although some authorities maintain the two painters actually are one). He was strongly influenced by JAN VAN EYCK early in his career, when his works were painted with a certain austerity. In 1450, however, he made a pilgrimage to Rome, where contact with Renaissance art—and works by FRA ANGELICO in particular—had a softening and enriching effect on his style.

Although the chronology and authenticity of works ascribed to Rogier are problematical, his style may be said to be more expressive than that of Van Eyck and more refined than that of the Master of Flemalle. His palette was typically GOTHIC, with much gold in evidence, along with clear, bright, relatively unmodulated colors. He maintained a large, active workshop, numbered BOUTS and MEMLING among his pupils and exerted enormous influence on Netherlandish painting—and particularly portraiture—of the later 15th century.

WHISTLER, JAMES ABBOTT MCNEILL (1834–1903). An American painter and etcher who spent most of his career abroad, he was an intermittent pupil, in Paris, of GLEYRE but learned his craft largely by copying Old Masters (particularly VELAZQUEZ) at the Louvre. He developed an early and lasting interest in Japanese prints and for a time was influenced by COURBET. His mature pictures are characterized by their coloristic restraint, judicious arrangement of forms and carefully calibrated tonal relationships. He was a leading wit and contentious personality, and his celebrated libel suit against Ruskin, who accused him of "flinging a pot of paint in the public's face," resulted in a token award for damages—and bankruptcy—in 1879. Although he added little to the etching medium, he was a superb technician.

Rogier van der Weyden, *Portrait of a Lady*, National Gallery, London.

WHITE, STANFORD (1853–1906). An American architect and partner in the firm of McKim, Mead and White, he is known best as the designer of the original Madison Square Garden, New York (no longer in existence), and as the victim of a sensational murder.

WILKIE, SIR DAVID (1785–1841). A Scottish-born painter who worked in London, where he was extremely popular. Influenced by Teniers and 17th-century Dutch genre painting early in his career, his later works derive from Velazquez and Murillo.

WILLMAN, MICHAEL (1630–1706). A German baroque painter influenced by Ruisdael and Altdorfer.

WILSON, RICHARD (1713–1782). A Welsh landscape painter who studied independently in Italy, where he was deeply influenced by Claude Lorraine. Although his work is markedly Italianate, he is generally considered the pioneer of the great English landscape tradition that culminated in the art of Constable and Turner.

WINDSOR CASTLE. British royal residence at Windsor, England, constructed in various stages beginning ca. 1070. It is one of the world's most splendid castles.

WINTERHALTER, FRANZ XAVER (1806–1873). A German painter and lithographer who enjoyed the patronage of various royal personages, including Queen Victoria.

WIT, JACOB DE (1695–1754). A Dutch painter trained in Flanders who specialized in rococo ceiling decorations and altarpieces.

WITTE, EMANUEL DE (ca. 1617–ca. 1692). A Dutch painter, chiefly of architectural interiors and market scenes, he is best known for depictions of church interiors in which shafts of light fall on significant details.

WITTE, PIETER DE (1544/48–1628). A Flemish mannerist painter, sculptor and architect.

WITZ, KONRAD (ca. 1400–ca. 1445). A German painter, details of whose origins and training are obscure but who appears to have been influenced by Jan Van Eyck and the Master of Flemalle. He worked mostly in what is now Switzerland in an intricate but solidly conceived style.

WOESTIJNE, GUSTAV VAN DE (1881–1947). Belgian visionary painter and printmaker who specialized in religious subjects depicted in broad, simplified patterns.

WOLGEMUT, MICHAEL (1434–1519). German painter and woodcut designer. One of the seminal forces in the development of and enlargement of the woodcut as a serious vehicle of expression, he worked in the Netherlandish tradition as exemplified by Memling, Rogier van der Weyden and the Master of Flemalle. He was an accomplished painter of altarpieces but not an inspired one. His greatest importance was his innovative use of the woodcut, particularly as transmitted to his pupil Dürer, who, working from the basis supplied by Wolgemut, brought that medium to heights never attained before or since.

WOOLASTON, JOHN (fl. ca. 1736–d. 1770). An English painter who worked as an itinerant portraitist in Colonial America, where he endowed most of his sitters with common characteristics, dress and bearing.

WOOD, CHRISTOPHER (1901–1930). An English painter, erroneously considered a primitive, who, after painting in a more or less conventionally eclectic style influenced by early-20th-century masters, toward the end of his truncated career turned to more intensely personal and imaginative subject matter.

WOOD, GRANT (1892–1942). An American painter who worked in a precise decorative style to produce landscapes and history pictures, along with satirical pieces, such as *American Gothic* (Chicago Art Institute) and *Daughters of the American Revolution* (Cincinnati Art Museum), for which he is known best.

WOTRUBA, FRITZ (1907–). Austrian semi-abstract sculptor who characteristically bases direct stone carvings on the human figure.

WOUTERS, FRANS (1612–1659). A Flemish painter taught by Rubens who, with Van Dyck, was his chief influence.

WOUTERS, RIK (1882–1916). A Belgian painter and sculptor who was influenced by impressionism, Bonnard and fauvism but died in World War I before fully

Sir Christopher Wren, St. Paul's Cathedral, London.

Frank Lloyd Wright, Kaufmann House, Bear Run, Pennsylvania.

realizing a style that pointed the way toward later Belgian EXPRESSIONISM.

WOUWERMANS (Wouwerman) BROTHERS. Dutch painters of landscape and animals, all trained by their father, who was also a painter. Jan Pauwelsz (1629–1666) was also a graphic artist whose rare surviving paintings seem to be influenced by his brother Philips (1619–1668), an apparent pupil of FRANS HALS and an accomplished landscapist and painter of horses who sometimes painted figures into the landscapes of RUISDAEL and others. Pieter (1623–1682) worked closely in the style of Philips.

WREN, SIR CHRISTOPHER (1632–1723). English architect, geometrician and teacher. One of the most brilliant men of his time, he began his architectural career at age 30, after first distinguishing himself in the sciences. He was appointed Surveyor General to the Crown in 1669, three years after the Great Fire of London, although his plan for an entirely rebuilt ideal city previously had been rejected as too costly. He built a number of churches between 1670 and 1686, basing their plans on the simple, functional proposition that "all should hear the service, and both see and hear the preacher." Their designs were classical, and, because of usually crowded settings that obviated the possibility of effective exterior decoration, their most distinguishing characteristics were their widely variegated steeples.

Wren's true genius lay in his adaptability. His buildings do not impose his preconceptions on inhospitable surroundings but conform to the exigencies of particular situations. His masterpiece is ST. PAUL'S CATHEDRAL, an outgrowth of his slightly earlier St. Stephen Walbrook and perhaps the most serene and majestic example of monumental BAROQUE architecture in existence and certainly one of the greatest churches ever constructed entirely under the direction of one man. A project that engaged all Wren's powers of invention and drew on much of his earlier scientific training, it is as impressive as a feat of engineering as it is aesthetically. The devices employed to support its vast dome—fake walls acting as buttresses in the upper story of the nave and choir and a conical reinforcing structure inserted between the inner and outer domes—represent ingenious solutions to troublesome problems—which might be said to be the chief characteristic of his works in general. His influence was considerable, although it was transmitted directly to only one pupil of significance, HAWKSMOOR.

WRIGHT, FRANK LLOYD (1869–1959). American architect. With no previous architectural training, he entered the Chicago office of ADLER and SULLIVAN in 1887, remaining there until 1893, during which time he absorbed the influence of Sullivan and after which he worked independently. His first commissions were

Andrew Newell Wyeth, *Albert's Son*, National Gallery, Oslo.

mostly for the design of private homes in the more affluent suburbs of Chicago. Unfortunately, many of the buildings he designed around the turn of the century, when he evolved a distinctive personal style, have since been destroyed. His works of the period were characterized by marked horizontality, however, and foreshadowed his so-called "Prairie" houses of the years 1900–1909—elaborately decorated structures built around central chimneys, with open, variable spaces substituted for strictly defined rooms, interlocking volumes, broad planes and deliberate loss of definition between interiors and the surrounding terrain. Of these, the Robie House, Chicago, was the last and most influential. During the same period Wright designed the Larkin Building, Buffalo, and the Unity Church, Oak Park, Illinois, two of the most widely admired and imitated buildings of the century.

By the second decade of the 20th century Wright's reputation was worldwide, and one of his more celebrated commissions of the period—mainly because it survived the earthquake of 1923—was the Imperial Hotel, Tokyo. His greatest works of the next decade were

FALLINGWATER (1936), Bear Run, Pennsylvania, and the superb S. C. Johnson Wax Company Administration Building (1939), Racine, Wisconsin. Like the earlier Larkin Building, the latter excludes its surroundings, turning inward to embrace an open central space. There is an organic, almost plantlike quality in its organization, with a variety of functional containers (garages, storerooms, utility units, offices, etc.) supported at different levels by huge sculptural columns. A research tower, with horizontal working spaces cantilevered like leaves from a central stalk or trunk, was added in 1950. Wright's last major building, the Guggenheim Museum (1959), New York, is open to criticism on functional grounds and perhaps for aesthetic reasons too. Like almost everything he created, however, it is daringly innovative and unabashedly expressive of an ego with which his talents were almost commensurate.

WRIGHT, JOSEPH ("Wright of Derby") (1734–1797). An English painter and pupil of Thomas Hudson (1707–1797), he painted many nocturnes and artificially illuminated interiors in a manner somewhat resembling that of HONTHORST.

WU CHEN (1280–1354). Chinese painter of the Yüan dynasty, known for his ink sketches of bamboo and paintings of fishermen.

WU LI (1632–1718). Chinese painter of the Ch'ing dynasty and pupil of WANG SHIH-MIN. Although a convert to Christianity, he remained uninfluenced by Western art, and his paintings, chiefly of mountains, are evidence of his admiration for the painters of the Yüan dynasty.

WU TAO-TZU (fl. 8th century). Chinese painter of the T'ang dynasty. Most, if not all, of the works from his hand have been lost, but he is one of the most revered figures in the history of Chinese art. From existing copies and works by known admirers, his style seems to have been characterized by directness, vigor, spontaneity and a greater naturalism than had previously been known.

WYATT, JAMES (1746–1813). English architect who won immediate fame for his first major commission, the Pantheon, London (since destroyed), and lasting notoriety for his restorations of the great English cathedrals—works that earned him the sobriquet "The Destroyer."

WYETH, ANDREW NEWELL (1917–). An American tempera painter trained by his father, the illustrator N. C. Wyeth, he has developed a large following for his meticulously detailed depictions of the people, landscapes and artifacts of rural Pennsylvania and Maine.

X Y

Fernando Yáñez de La Almedina, *St. Catherine*, detail, Prado, Madrid.

XANTO AVELLI DA ROVIGO, FRANCESCO (ca. 1500–after 1542). An Italian painter of majolica whose motifs derived from prints by RAIMONDI and others.

XCERON, JEAN (1890–1967). Greek-born American nonobjective painter. His characteristic mature work is distinguished by rigorous two-dimensionality and clarity of color and form. He had a marked influence on the early development of DAVID SMITH.

YANEZ DE LA ALMEDINA, FERNANDO (fl. 1506–1531). A Spanish painter and pupil, in Florence, of LEONARDO, he was responsible for the introduction of sfumato into Spain.

YEATS, JACK BUTLER (1871–1957). Irish expressionist painter and brother of the poet William Butler Yeats. Although he remained a figurative painter throughout his career, much of his work anticipates ABSTRACT EXPRESSIONISM to a startling degree.

YEN HUI (fl. 14th century). Chinese painter and interpreter of Taoist and Buddist themes, usually in terms of grotesque motifs rendered in monochromatic inks.

YEN LI-PEN (d. 673). Chinese painter of the T'ang dynasty. A court painter of Taoist and Buddist subjects and portraits of dignitaries.

YING YU-CHIEN (fl. mid-13th century). A Chinese painter renowned for a technique that made use of "splashes" of ink and expanses of blank ground to express the atmosphere of a particular landscape.

YOUNG, MAHONRI MACKINTOSH (1877–1957). An American figurative sculptor trained in part in Paris, he worked mostly in bronze and was also an accomplished printmaker.

YRISARRY, MARIO (1933–). A Philippine-born American nonobjective painter influenced by MONDRIAN. His characteristic works consist of simple repetitive shapes or zigzag lines arranged on an implied underlying grid, often according to an arithmetic scheme of alternation and usually producing effects resembling those of OP ART.

YUNKERS, ADJA (1900–). Latvian-born American painter and printmaker whose style may be described as symbolic abstraction.

After Yen Li-Pen, *Philosophers Collating Classical Texts*, detail, Museum of Fine Arts, Boston.

Z

ZADKINE, OSSIP (1890–1967). Russian-born French semi-abstract sculptor. Influenced at the outset of his career by CUBISM and African sculpture, he later adopted a more personal and lyrical manner. He was also an influential teacher.

ZALCE, ALFREDO (1908–). A Mexican painter, muralist and printmaker important chiefly for his exploitation of innovative technical procedures.

ZANDOMENEGHI, FEDERIGO (1841–1917). An Italian painter who spent most of his career in Paris, where he developed a style closely resembling that of DEGAS.

ZAO WOU-KI (1921–). Chinese-born French painter and printmaker influenced by the School of Paris painters and KLEE. His late works are nonobjective and calligraphic.

ZEGERS, GEERHAARD (1591–1651). A Flemish painter and probable pupil of JANSSENS, he was a member of the CARAVAGGISTI and also was influenced by RUBENS, whom he succeeded as the most successful painter, commercially at least, in Antwerp.

ZERBE, KARL (1903–1972). German-born American painter and teacher known for landscapes and still lifes executed in a semi-abstract expressionistic style.

ZEUXIS (fl. late 5th–early 4th century B.C.). A Greek painter born in southern Italy, he was renowned as one of the outstanding artists of antiquity and a masterful realist, but none of his works survive.

ZIMMERMANN, DOMINIKUS (1685–1766) and **JOHAN BAPTIST** (1680–1758). Respectively, a Bavarian architect and stuccoist, and a stuccoist and frescoist who usually collaborated on ecclesiastical projects. They worked in the ROCOCO style, investing it with great freshness, lightness and delicacy.

ZOAN, ANDREA (1475–1505). Italian engraver and painter influenced successively by MANTEGNA and DÜRER but altogether lacking in their originality and depth.

ZOBEL, FERNANDO (1924–). A Spanish abstract painter born in Manila and educated in the U.S. His works, tenuously reminiscent of the landscape around Madrid, are subtle, delicate and, despite his frequent use of an underlying grid pattern, quite lyrical.

ZOFFANY, JOHANN (ca. 1734–1810). A German-born English painter specializing in portraits and conversation pieces and a founder of the Royal Academy. Influenced by HOGARTH, he sedulously recorded details of costume and setting and is valuable chiefly as a documenter of his times.

ZORACH, WILLIAM (1887–1966). Lithuanian-born American sculptor who began his career as a painter and exhibited his canvases in the 1913 ARMORY SHOW. His sculptural style derives from various archaic and primitive styles, and his simplified figurative works, employing such subjects as maternity, childhood and animals, are carved directly in stone.

ZORN, ANDERS LEONARD (1860–1920). A Swedish painter, etcher and, to a lesser extent, sculptor, he worked in a style derived closely from IMPRESSIONISM but characterized by greater solidity of form.

ZOX, LARRY (1936–). An American abstract painter of simple geometric motifs, often angular in form and rendered in flat close-toned colors.

ZUCCARELLI, FRANCESCO (1702–1788). An Italian painter of the Venetian school, he was the leading landscapist in Venice after the death of MARCO RICCI and, like CANALETTO, much patronized by Englishmen on the Grand Tour—so much so, indeed, that he spent much of his career in London, where he became a member of the Royal Academy. His atmospheric light-flooded landscapes markedly influenced RICHARD WILSON.

ZUCCARI (Zuccaro), FEDERICO (ca. 1542–1609). A late-mannerist Italian painter and brother, pupil and follower of TADDEO ZUCCARI. A highly controversial figure, he was often commissioned to complete works left unfinished by other artists (MICHELANGELO included), to their detriment if his critics are to be believed. He spent two years in Spain as court painter to Philip II, for whom he worked on the high altar of EL ESCORIAL, and was an influential teacher and writer.

ZUCCARI (Zuccaro), TADDEO (1529–1566). Italian painter and brother and teacher of FEDERICO ZUCCARI. One of the last exponents of MANNERISM, he is best known for fresco cycles in the Sala Regia of the Vatican and the Villa Farnese, outside Viterbo. He was influenced by CORREGGIO, RAPHAEL and MICHELANGELO and maintained a large, active workshop.

ZUCCHI, ANTONIO (1726–1795). The most important member of an Italian family of artists, he was a decorative painter much admired by ROBERT ADAM and his brothers, many of whose buildings he decorated.

ZUCCHI, JACOPO (ca. 1541–ca. 1590). An Italian mannerist painter and pupil and assistant of VASARI, he specialized in fresco.

ZULOAGA Y ZABOLETA, IGNACIO (1870–1945). A Spanish painter who studied in Paris, where he was influenced by MANET, although he was largely self-taught. Later on he was influenced by VELAZQUEZ, GOYA and particularly EL GRECO. He painted the stock situations of Spanish folklore with a palette restricted largely to earth colors (a common Spanish characteristic) and was an accomplished landscapist.

ZURBARÁN, FRANCISCO DE (1598–1664). Spanish painter, one of the most distinctive artists of the BAROQUE era. His works are characterized by gravity, simplicity, monumentality and deep spirituality. Influenced primarily by the sculptor MONTANES and possibly by CARAVAGGIO and RIBERA (although he may have developed his tenebrist style independently), he is known primarily for single figures of monks and saints, austere and highly sculptural in form, extremely pietistic and sharply delineated against dark backgrounds devoid of incident. He maintained a prolific workshop, exporting many pictures to the New World, and exerted a considerable influence not only in the Americas but on French painting of the 19th century. Toward the end of his life he tried to compete with the extremely popular MURILLO on that artist's terms, to the detriment of an otherwise unique oeuvre.

Francisco de Zurbarán, *Santa Casilda*, detail, Prado, Madrid.

STYLES, SCHOOLS AND MOVEMENTS

ABSTRACT ART. Term applied to nonrepresentational or highly simplified or stylized representational forms of artistic expression.

ABSTRACT EXPRESSIONISM. That form of nonrepresentational or relatively nonrepresentational painting that was developed in New York in the post-World War II years by such artists as POLLOCK, NEWMAN, ROTHKO, GOTTLIEB, HOFMANN, DE KOONING and others. Characteristically emotive and concerned with the physicality of the painting process, it frequently concerns itself with fortuitous effects and also has been called ACTION PAINTING. By and large, its adherents comprised the NEW YORK SCHOOL.

Jackson Pollock, *Number 7*, estate of the artist.

ABSTRACTION-CREATION GROUP. An international school of painting and sculpture that flourished in the 1930s and was characterized by its dependence on geometric form.

ACADEMIC ART. Any of various styles based on rules or concepts established by an officially sanctioned or unofficial academy. In current usage, a term of opprobrium directed at worn-out, noninnovative idioms.

ACTION PAINTING. Term coined by the American art critic Harold Rosenberg to describe ABSTRACT EXPRESSIONISM.

ADA SCHOOL. A group of Middle Rhemish manuscript illuminators and ivory sculptors that flourished in the late 8th and early 9th centuries and supposedly was patronized by Ada, a purported sister of Charlemagne.

AESTHETICISM. The doctrine, especially in its extreme form, that art exists solely for its own sake and is self-contained, autonomous and independent of extra-aesthetic associations or purposes. Its spirit gained widespread currency in the 19th century and informs much subsequent art.

AFRICAN TRIBAL ART. Term loosely applied to the arts (primarily ceremonial sculpture and masks, utilitarian artifacts and pottery) of various cultures of black Africa. Until such artists as PICASSO, MODIGLIANI and BRANCUSI "discovered" and were markedly influenced by African sculpture, these objects were regarded as mere ethnographic curiosities devoid of aesthetic merit or interest. African tribal art is as various as the many independent cultures that produced it, ranging from the "classical" naturalism and extreme refinement of Ife portrait sculpture to the highly abstract effigies of the Bakota; from the technically sophisticated bronzes of the Benin to the roughly carved fetish figures of the Babembe. With certain salient exceptions, however, the generalization that African tribal art tends toward vigor of expression, simplification of form, stylization and abstraction has some validity. Much of surviving African art is of relatively recent vintage, primarily because wooden and straw objects deteriorate quickly in tropical Africa, while the use of more durable materials developed rather late. Although several tribes made extensive use of polychrome and mixed materials, the overwhelming majority of surviving African artifacts are monochromatic and shaped from single substances.

ALEXANDRIAN STYLE. Term applied (with little precision) to the Hellenistic art produced during the Ptolemaic dynasty and characterized by a certain softness and sentimentality. Whether a distinct Alexandrian School actually existed is debatable.

ALMOHAD STYLE. The style introduced into Spain by the Almohads, a Moroccan Berber Moslem dynasty, in the 12th and 13th centuries.

AMARNA STYLE. Term given to Egyptian art as it developed under the Pharaoh Akhenaten (1375–1358 B.C.). The style was characterized by a loosening of traditional strictures and an increased naturalism based on a new devotion to "truth" but soon lapsed into MANNERISM.

ANGLO-SAXON STYLE. The prevailing style, along with the Hiberno-Saxon style, in England from the 7th through the 11th century, it was developed by the Angles and Saxons and characterized by interlaced motifs.

ANIMAL STYLE. Designation for an artistic tradition developed by the nomadic peoples of Europe and Asia, beginning in the 6th century B.C. by tribesmen of Iranian stock and characterized by highly stylized sculptural representations of birds and beasts.

ARCHAISM. The tendency, which has appeared at various stages of history, to emulate earlier, outmoded artistic styles. The works of the PRE-RAPHAELITE BROTHERHOOD are examples of archaism.

ANTWERP SCHOOL. An Italianate Flemish style of painting established in the late 15th century by METSYS, it culminated in the 17th century with RUBENS and his followers.

ARMORY SHOW, THE. An exhibition of avant-garde European and American art held in the 69th Regiment Armory, New York, in 1913, it was the first comprehensive showing in the U.S. of the works of important innovators of the 20th century and was organized by leading members of THE EIGHT, the ASHCAN SCHOOL and artists in sympathy with them. Its advanced works—particularly DUCHAMP's *Nude Descending a Staircase* (Philadelphia Museum of Art)—were subjected to public derision and sold poorly but eventually had an incalculable impact on American painting and sculpture and on art collecting in the U.S.

ART BRUT. French term, meaning "raw art," coined to describe his own style by DUBUFFET.

ART NOUVEAU. The dominant international style of the 1890s, at least as far as architecture and the applied and decorative arts were concerned, it was characterized by sinuous organic motifs and numbered among its adherents such men as BEARDSLEY, WILLIAM MORRIS, GAUDÍ and ENSOR and, to a lesser extent, TOULOUSE-LAUTREC and GAUGUIN.

ARTS AND CRAFTS MOVEMENT. An English movement that arose in the second half of the 19th century in reaction to the standardization and poor aesthetic quality of machine-made furnishings, artifacts, printing and the like. It was spearheaded by WILLIAM MORRIS.

ASHCAN SCHOOL. A group of late-19th- and early-20th-century American painters, notably members of THE EIGHT, so-called for its use of sordid urban subject matter.

ASTURIAN STYLE. The prevailing style in Spanish church architecture in the Asturias region in the 9th century, it derived in part from Moorish and Visigothic antecedents.

AUTOMATISM. An offshoot of SURREALISM in which the artist strives to give free rein to the "creative unconscious" by letting the uncontrolled hand produce designs with as little mental direction as possible.

AVIGNON SCHOOL. Late-15th- and early-16th-century school of painting centered in Avignon, southern France, and incorporating Flemish and Italian influences.

BACKSTEIN GOTHIC. Term used for the northern German variant of GOTHIC architecture, developed in the 14th century, that employed brick as its primary building material instead of the stone found more readily elsewhere.

BARBIZON SCHOOL. A group of French landscape painters, led by THÉODORE ROUSSEAU, headquartered in the village of Barbizon, near the forest of Fountainebleau, in the mid-19th century and loosely formed in opposition to classical conventions and for the purpose of advancing pure landscape painting as a self-sufficient medium of expression instead of an ancillary feature of mythological or religious subjects.

BAROQUE. The international style that succeeded MANNERISM in the late 16th century and dominated European art until the early 18th century and was in turn supplanted by the ROCOCO. It originated largely in Italy and was more or less centered in Rome at its in-

ception and grew out of an increasing dissatisfaction with Mannerism, which had been exhausted as a meaningful vehicle of expression. It is usually divided into three phases: Early (ca. 1585–ca. 1625), High (ca. 1625–ca. 1675) and Late (ca. 1675–ca. 1715) and generally may be described as balanced, united, dynamic, emotive, harmonic and fully orchestrated, its characteristics having been likened to a choir in full voice, with its parts brought to a high degree of finish but always subordinate to the effect of the whole. It was based partly on observed reality, as epitomized by CARAVAGGIO, and partly on a return to the classicism of the High Renaissance led by ANNIBALE CARRACCI and DOMENICHINO, while its coloristic emphasis derived from the traditions of the VENETIAN SCHOOL. At its apogee, the style was embodied in the works of BERNINI.

BAUHAUS. A highly influential German school of architecture and the applied arts founded in Weimar in 1919 by GROPIUS, it was dedicated to the aesthetic exploitation of modern industrial production, thereby diametrically opposing the position of the ARTS AND CRAFTS MOVEMENT. Before it was closed by the Nazi regime in 1933 (after moving to Dessau in 1925), it numbered among its teachers such luminaries as KLEE, FEININGER, KANDINSKY, BREUER and MIES VAN DER ROHE, who succeeded Gropius as its director.

BIEDERMEIER; BIEDERMEIERSTIL. Term coined from the name of a fictional Philistine poet and applied to the prevailing style of German and Austrian art and architecture in the period 1815–1845. The style itself, modest, realistic and geared to the tastes of the bourgeois middle class, corresponded to that of the early Victorian era in Britain.

BLAUE REITER. See BLUE RIDER.

BLUE RIDER (Blaue Reiter). A group of loosely affiliated painters, active in Munich in the years 1911–1914, formed by KANDINSKY and MARC and later joined by KLEE.

BOLOGNESE SCHOOL. A general, rather loose designation for the painters who were active in and around Bologna, Italy, from the 12th to the 17th century achieving their greatest influence at the end of the 16th century, when the CARRACCI and their followers broke with the then dominant MANNERISM.

BRÜCKE, DIE. Name (meaning ''The Bridge'') taken by a loose affiliation of Expressionist painters and printmakers active in Dresden from 1905 until 1913. Principal members were KIRCHNER, SCHMIDT-ROTTLUFF and HECKEL.

BURGUNDY, SCHOOL OF. A group of Flemish court artists in the service of Philip the Bold of Burgundy and his brother, the great Medieval patron Jean, Duke of Berry, during the period 1390–1420. The term usually is extended to include their successors, the MASTER OF FLEMALLE and HUBERT and JAN VAN EYCK. The school combined Flemish naturalistic traditions with Italian influences to form a firm basis for the INTERNATIONAL GOTHIC style.

CARAVAGGISTI. The followers, in Rome, of CARAVAGGIO (e.g., ORAZIO GENTILESCHI, MANFREDI, HONTHORST).

CAROLINGIAN ART. Art produced during the cultural revival instituted by Charlemagne (768–814) and during the rest of the Carolingian dynasty. It was modeled on the painting and sculpture of Rome in the reigns of Constantine and Theodosius and on Byzantine art of the 6th and 7th centuries but was also influenced by Celtic, Germanic and Anglo-Saxon traditions.

CHICAGO SCHOOL. A term variously applied to American architectural movements centered in Chicago. In one usage, it applies to those architects who rebuilt the city between the Great Fire of 1871 and the emergence of SULLIVAN and FRANK LLOYD WRIGHT with the World's Columbian Exhibition of 1893. In another, it designates those architects active from 1893 until World War I and influenced by Sullivan and Wright.

CHINOISERIE. The term given to Occidental art based on or derived from Chinese styles or motifs.

CHURRIGUERESQUE. Term designating the elaborately decorative architectural style that evolved in Spain during the BAROQUE era.

CLASSICAL ART. Art based on standards and models derived from antiquity, particularly ancient Greece. The term also is used as the antithesis of ROMANTIC ART.

COLOR PAINTING. The term applied loosely to a style evolved in Washington, D.C., during the 1960s which gave precedence to the effects of flatly applied color over painterly values, form or content.

COLOR FIELD PAINTING. An abstract style, evolved in the U.S. in the late 1960s and early 1970s, characterized by broad expanses of usually single colors applied more or less uniformly to the picture surface.

CONCEPTUAL ART. A style developed in the late 1960s and early 1970s, whose content or subject matter is the idea behind or description of the work of art itself.

CONCRETE ART. A term used to designate thoroughly abstract art from which all figurative references have been excluded.

CONSTRUCTIVISM. An abstract sculptural movement, initiated by PEVSNER and GABO, that has had widespread influence on succeeding sculpture, painting and architecture in the 20th century. Its basic tenets are that art must be useful to society and not merely of aesthetic value and that modern industrial materials and kinetic action are viable components of works of art. TATLIN was a leading theorist and practitioner of the movement.

COPTIC ART. The art produced by Egyptian Christians from the 5th century to the 8th century.

CUBISM. The style of painting invented by PICASSO and BRAQUE ca. 1907 and developed by GRIS, LÉGER and others, it represented the first radically innovative departure of the 20th century and formed the basis for all succeeding abstract styles. Essentially, Cubism grew out of a reaction to IMPRESSIONISM's emphasis

Pablo Picasso, *Portrait of Ambroise Vollard*, Pushkin Museum, Moscow.

on a purely visual perception of subject matter and was the logical outgrowth of CÉZANNE's explorations in the same direction. Its development also was influenced by certain works of AFRICAN TRIBAL ART, whose forms suggested some that eventually appeared in Picasso's *Les Demoiselles d'Avignon*, generally regarded as the watershed of Cubism. Its underlying tenets were a concern for the integrity of the plane surface of the picture (a concern that previously had occupied GAUGUIN and been enunciated by DENIS); a repudiation of the importance of subject matter, sensuousness, lyricism and the transitory effects of light; and a conviction that volumes could be represented as they are known "in the round" rather than seen from a particular static viewpoint. Unlike recent previous styles, Cubism was based neither on subjective emotionalism nor on the dispassionate reception of visual data but strove instead to arrive at a logical and purely intellectual basis for a more penetrating kind of realism—a realism devoid of imitation and one that would depict not single aspects of subjects but what might be termed their external totality. Also see PICASSO; BRAQUE.

DADA; DADAISM. A movement that developed in Zürich in 1916, taking its name from the French for "hobby horse." Deliberately anti-artistic, irreverent, nihilistic and absurd, it was designed to *épater la bourgeoisie*. Originally propounded by a group largely made up of literary figures, it soon attracted such artists as ARP, MAN RAY, PICABIA and DUCHAMP and eventually had considerable influence on SURREALISM.

DECORATED STYLE. The Medieval English architectural style of the period ca. 1250–ca. 1350. So called primarily because of the elaboration of its window tracery, it preceded the PERPENDICULAR STYLE.

DE STIJL. See STIJL, DE.

DIRECTOIRE STYLE. The characteristic style of interior and costume design and the applied arts in France in the late 18th century, it was a simplified version of the LOUIS XVI STYLE and preceded the EMPIRE STYLE.

DIVISIONISM. The system of painting devised by SEURAT, SIGNAC and others and foreshadowed by various earlier artists, notably WATTEAU, and the adherents of IMPRESSIONISM, in which colors are not mixed on the palette but applied in pure form to the picture surface in juxtapositions that "mix" in the eye of the viewer. Its principal advantages are its great luminosity and clarity.

ECLECTICISM; ECLECTIC. Noun and adjective applied to artistic styles deriving from a multiplicity of earlier influences or styles.

EIGHT, THE. A group of American painters (HENRI, DAVIES, PRENDERGAST, LUKS, SLOAN, SHINN, LAWSON, BELLOWS) formed in 1907, primarily for the purpose of abjuring ACADEMIC ART and coming into closer contact with real life. Also see ASHCAN SCHOOL.

EMPIRE STYLE. A style of furniture design and interior decoration that originated in Paris after the French Revolution and became internationally fashionable, it combined the NEOCLASSICISM style with an overlay of motifs unearthed by then recent archaeology and forms popularized by Napoleon's Egyptian campaigns.

EXPRESSIONISM. A 20th-century movement, primarily but not exclusively in painting and printmaking, concerned with the communication of the emotions rather than the representation of nature or the creation of beauty. Directly derived from the work of VAN GOGH, it originated in France ca. 1905 but cropped up almost simultaneously elsewhere in Europe, notably Belgium, Germany and Scandinavia. In general, Expressionism is characterized by distortion, stridency and exaggeration, and it might reasonably be argued that it is a form hospitable primarily to the neurotic. Its principal practitioners include ENSOR, SOUTINE, KIRCHNER, ROUAULT, MUNCH, KOLLWITZ and BARLACH.

Edvard Munch, *Self-portrait.*

FAUVES; FAUVISM. Terms designating the proponents and style of a painting movement that originated in France in the early 20th century and was based on the exuberant use of pure, vivid color, often arbitrarily applied. Like most art movements, it was derogatorily named ("beasts"). Its principal adherents (MATISSE, MARQUET, VLAMINCK, ROUAULT, DERAIN and others) for the most part turned to other styles by ca. 1908.

FEDERAL STYLE. The term given to NEOCLASSICAL architecture and design as practiced in the U.S. between ca. 1780 and ca. 1820.

FERRARESE SCHOOL. The artists, Italian and Flemish, who gathered in Ferrara in the mid-15th century under the patronage of the Este princes and who created a style that combined GOTHIC and RENAISSANCE elements. Its members included PIERO DELLA FRANCESCA, PISANELLO, JACOPO BELLINI and, later, Dosso Dossi.

FLAMBOYANT STYLE. The 19th-century term coined for late GOTHIC architecture (i.e., from ca. 1370 onward) and descriptive of the flamelike tracery forms then in use. The west front of Rouen Cathedral is the earliest example.

FLORENTINE SCHOOL. A loose designation for the painters, sculptors and architects—many of them among the greatest artists who ever lived—who worked in Florence from the 11th century until well into the 18th—a period so long and varied as to render the term meaningless. If any generalizations can be applied to such longevity and diversity, they would include a continuing concern with the problems and principles of design, a lively intellectual and scientific curiosity and a well-justified and quite manifest conviction of pre-eminence.

FONTAINEBLEAU, SCHOOLS OF. The First School of Fontainebleau is the commonly accepted designation for the Italian mannerist masters imported into France by François I to work at the royal palaces at Fontainebleau and elsewhere. The Second School of Fontainebleau was active during the second half of the 16th century and consisted of obscure French artists commissioned by Henri IV.

FUNCTIONALISM. The architectural concept, evolved in antiquity and enunciated most recently by FRANK LLOYD WRIGHT ("Form follows function"), that aesthetic excellence is dependent on and indissoluble from functional efficiency.

FUTURISM. An Italian artistic movement founded in 1909 by the poet Filippo Tommaso Marinetti. It sought to free Italian art from its past, inveighing against established institutions and hailing the alleged aesthetic superiority of modern machinery over traditionally accepted masterpieces. On the theory that movement was in closer tune with reality than the depiction of static objects, such painters as BUCCIONI, CARRA, BALLA and SEVERINI produced multiple-image pictures resembling stroboscopic photographs. The movement lost its momentum by ca. 1916 but exerted some continuing influence on DADA, CONSTRUCTIVISM and VORTICISM.

GEORGIAN STYLE. The term given to English architecture, furniture design and decoration produced in the period 1714–1820.

GIOTTESCHI (Giottesques). Various 14th-century followers of GIOTTO.

GLAZE. The vitreous substance, either colored and translucent or clear and transparent, applied decoratively or protectively to earthenware pottery or ceramics. By common consent, Chinese potters produced the finest glazes known. Also see GLAZING.

GOTHIC. The dominant architectural style of northern Europe from the early 12th century until the 16th century and, by extension, the painting and sculpture of the same period. Although characteristic elements of the Gothic style can be found separately in earlier types of architecture, the Gothic represents the first systematic and concerted use of such devices as rib vaulting, pointed arches, buttresses, flying buttresses, pinnacles, finials, tracery and stained glass. In simple terms, the Gothic may be described as a much lighter type of architecture than the ROMANESQUE that it supplanted and, consequently, an architecture of soaring verticality. By common consent, the Abbey of SAINT-DENIS, outside Paris, which was begun in 1140, is the earliest true Gothic building, and AMIENS CATHEDRAL, begun in 1220, the purest.

GOTHIC REVIVAL. A revival of the GOTHIC style of architecture that swept England in the 18th and 19th centuries and had a somewhat later and less noticeable impact in the U. S.

GRAND MANNER. A term originally applied to the style of MICHELANGELO, it was later reserved for history painting executed on a heroic scale in pursuit of the loftiest aesthetic ideals.

GREEK REVIVAL. The dominant architectural style in the U.S. in the first half of the 19th century, it was introduced by LATROBE and based on classical Greek architecture and is perhaps best known in the form of the Southern plantation house.

HAGUE SCHOOL. A group of Dutch realist painters active at The Hague during the latter half of the 19th century.

HAPPENING. An art form pioneered in the early 1960s, by KAPROW, OLDENBURG and others, in which a transitory event or occurrence is the chief medium of expression, although often manifested in combination with more traditional elements.

HARD-EDGE PAINTING. An abstract painting technique prevalent in the mid-20th century whereby brushwork is eliminated (or evidence of it suppressed) and forms delineated in a clean, precise, unequivocal fashion. It has been used by artists of varying stylistic persuasions.

HIGH GOTHIC. The pure GOTHIC style in architecture, painting and sculpture at its apogee, before its clarity and firmness were weakened by picturesque effects.

HISPANO-MORESQUE. A type of pottery made in Spain by Moors and characterized by its lustrous finish.

HUDSON RIVER SCHOOL. A 19th-century school of ROMANTIC painting that celebrated the glories of the American landscape, particularly in the Hudson River Valley. Its adherents included COLE, INNESS and DURAND.

IDEAL ART. Art that strives to represent imagined perfection rather than realistically to portray subjects as they are.

ILLUSIONISM. The attempt, in painting, to deceive the viewer by convincing him that two dimensions actually are three. Broadly speaking, all realistic art (and such ABSTRACT ART styles as OP ART) is illusionistic to a greater or lesser degree, but the term is commonly restricted to pictorial styles that make exaggerated use of such techniques as chiaroscuro, foreshortening and perspective or illogical use of lighting. As the equivalent French term TROMPE L'OEIL ("trick the eye") suggests, Illusionism depends for its effects on the ignorance or gullibility of the viewer.

Claude Monet, *Portrait of Madame Hoschedé-Monet*, Museum of Fine Arts, Rouen.

IMPRESSIONISM. The name (originally derisive) given to the style of painting that emerged in France in the 1870s and generally is considered the first and most influential of the movements that comprise what is commonly called modern art. Like all epochal styles, Impressionism arose out of dissatisfaction with the prevailing style—in this case, the sterile academicism that dominated French painting in the mid-19th century. And like most major art movements—ABSTRACT ART included—its underlying aim was credibility. Perhaps because of its name, Impressionism has generated more popular confusion than almost any other style of painting. The term is not, as is commonly supposed, synonymous with sketchiness or lack of finish (theoretically, if not practically, Impressionism can be as highly finished and meticulously detailed as any other kind of painting, while mere lack of finish or quick execution in no way qualifies as Impressionism). Basically, Impressionism strove to attain the highest possible degree of naturalism through a precise empirical analysis of the tones and colors reflected by objects bathed in the particular light of a particular moment. Of all painting styles, Impressionism is the most "photographic," although the term is commonly applied to styles that are the antithesis of Impressionism. Although such painters as MANET, DEGAS and CÉZANNE tend to be loosely associated with Impressionism, their roles in the movement were peripheral, and its major adherents were MONET, PISSARRO and SISLEY.

INTERNATIONAL GOTHIC. A style of painting that arose in the late 14th century in the courts of France and Burgundy and soon spread to Italy, Germany and Bohemia. It was characterized by elegance and refinement, an interest in secular themes and a heightened realism in such details as landscape backgrounds, animals and costume.

INTIMISM (Intimisme). A painting style derived from IMPRESSIONISM, principally by BONNARD and VUILLARD, and used for the depiction of figures engaged in prosaic pursuits in interior or garden settings.

ITALIANATE; ITALIANIZERS. A Netherlandish manner and its practitioners in which Italian motifs were introduced into pictures that essentially conformed to native stylistic traditions.

JACOBEAN STYLE. The English architectural and decorative style of the first third of the 17th century, it tended toward rich decoration and heaviness.

JUGENDSTIJL. The German designation for ART NOUVEAU.

KANŌ SCHOOL. A school of Japanese painting that arose in the mid-15th century and remained active until the 19th century, it was characterized by a bold use of line, an indulgence in color that bordered on excess and an insistence on professionalism in an art form practiced largely by amateur-scholars.

KINETIC ART. .Art based on movement, generally motivated by mechanical means (as opposed to the mobiles of Calder and similar forms). Allied to CONSTRUCTIVISM, its early exponents include GABO and DUCHAMP and its later practitioners, TINGUELY and BURY.

KORIN SCHOOL. A school of Japanese painting characterized by sensuousness and decorative elaboration.

LOUIS XV STYLE. The French ROCOCO style as manifested in interior decoration and the minor arts.

LOUIS XVI STYLE. The last phase of the French ROCOCO as it applied to the decorative arts, it was characterized by a return to antique motifs and rectilinearity.

LYRICAL ABSTRACTION. A rather pallid outgrowth of ABSTRACT EXPRESSIONISM that arose in the early 1970s, it tends toward large picture surfaces, muted color and harmony, rather than dynamism.

MACCHIOLI, I. A group of mid-19th-century Italian painters, active mostly in Florence, who in reaction against ACADEMIC ART exploited the nature of the individual brush stroke and the texture and physical properties of paint.

MANNERISM; MANNERIST ART. Terms denoting the principal style in Italian art during the period ca. 1520–1600, or between the Renaissance and BAROQUE eras. Primarily a reaction against Renaissance CLASSICAL ART, Mannerism was characterized by vivid, often strident color, distorted, elongated figures, violent movements, exaggerated poses and a marked tendency toward grotesque, self-

conscious inventiveness, as in the works of ARCIMBOLDO. A subjective, highly emotional style, it prefigured EXPRESSIONISM and often made use of colors that tended to "bleed" into one another in defiance of visual logic. The style originated in Rome and numbered among its adherents the aging MICHELANGELO, PONTORMO, PRIMATICCIO, PARMAGIANINO and TINTORETTO. It spread erratically, to the Netherlands for the most part, and to Spain, notably in the person of EL GRECO, and came to an end in Italy with the emergence of CARAVAGGIO and the CARRACCI.

MANSARD STYLE. Name sometimes applied to the SECOND EMPIRE STYLE.

MANUELINE STYLE. The late-GOTHIC style in Portugal, which was heavily modified by MUDÉJAR and Renaissance influences.

MARUYAMA SCHOOL. An 18th-century school of Japanese painting that combined traditional Chinese features with European techniques. It was named for its founder, Maruyama Ōkyo (1733–1795).

MERZ. The name given by SCHWITTERS to his own brand of DADA.

MESTIZO STYLE. A term applied to a style of carved architectural ornamentation that flourished in the central Andes from the mid-17th to the mid-18th centuries, combining native and Christian elements worked into complex, deeply undercut all-over patterns.

METAPHYSICAL PAINTING. The antilogical style of painting practiced by CHIRICO and CARRA during the period 1915–1918 and, during its later phase, by MORANDI. It was best defined by Chirico himself as art that "stand[s] completely outside human limitations . . . [and] approximates dream and infantile mentality." Developed in reaction to FUTURISM, it had a marked influence on SURREALISM.

MOZARABIC. Name given to the art and architecture produced by Spanish Christians under Moslem domination. The Mozarabic style combined Moslem and native folk elements and gradually was discontinued with the rise of the ROMANESQUE.

MUDÉJAR. The Islamic-GOTHIC architectural style prevalent on the Iberian peninsula from the 12th to 15th centuries. Characterized by the richness and intricacy of its detail, the style appears to best advantage in the ALCAZAR, SEVILLE.

NABIS, THE. The name (from the Hebrew for "prophet") taken by a group of French artists active during the decade beginning ca. 1889 and including BONNARD, DENIS, VUILLARD and ROUSSEL, along with the Swiss VALLATON. They were influenced primarily by GAUGUIN (although most of them had little in common stylistically), their unifying impetus a reaction against IMPRESSIONISM.

NAGASAKI SCHOOL. An 18th-century Japanese school of realistic painting in a style derived from Chinese and European sources.

NANGA SCHOOL. A Japanese school of Chinese-style painting active from the late-

17th until the late-19th century and made up of cultivated amateurs, men of letters and the like.

NAZARENER; THE NAZARENES. Name derisively applied to a small group of German religious painters founded in 1809. A quasi-religious order, its members reacted against ACADEMIC ART by turning for inspiration to such past masters as DÜRER and PERUGINO. They emulated Medieval guild practices, working communally on frescoes, and eventually influenced the PRE-RAPHAELITE BROTHERHOOD. Their most important members were CORNELIUS and OVERBECK, the latter much admired by INGRES.

NEOCLASSICISM. A general aesthetic and social movement and resultant artistic style that arose in Rome in the mid-18th century and soon spread throughout Europe and North America. Brought about by a reaction against the late BAROQUE and ROCOCO and stimulated enormously by the writings of the German art historian Johann Winckelmann and the then recent excavations at HERCU-LANEUM and POMPEII, Neoclassicism represented an attempt to emulate the art of classical antiquity. Unlike adherents of earlier classical revivals, however, those of the Neoclassical movement had reliable models from which to work. The painter MENGS was Neoclassicism's great proselytizer, and adherents of the movement included the sculptors CANOVA, THORWALDSEN, HOUDON, POWERS and GREENOUGH; the painters VIEN, WEST and KAUFFMANN; and such architects as WYATT, ROBERT ADAM, LATROBE and JEFFERSON.

NEOIMPRESSIONISM. The movement originated by SEURAT as a scientific extension of IMPRESSIONISM and a reaction against that style's simple realism and enunciated by SIGNAC. The basic device of Neoimpressionism was DIVISIONISM, and its style was described by Signac as "a method of securing the utmost luminosity, color and harmony." Other adherents of the movement, which was essentially CLASSICAL in nature, were CROSS, LUCE and RYSSELBERGHE. Also see POINTILLISM.

NEOPLASTICISM. MONDRIAN's term for his rectilinear brand of ABSTRACT ART.

NEUE SACHLICHKEIT. A German realist movement formed in the 1920s in reaction against ABSTRACT ART and EXPRESSIONISM. Its major proponents were DIX and GROS.

NEW ENGLISH ART CLUB. A society of English artists (notably SICKERT, AUGUSTUS JOHN and WHISTLER) founded in 1886 in opposition to what it considered the sterile aesthetic of the Royal Academy.

NEW YORK SCHOOL. Generally, the very loosely knit body of avant-garde painters and sculptors active in New York City from the time of the 1913 ARMORY SHOW until the present; more specifically, those adherents of ABSTRACT EXPRESSIONISM who worked in New York during the emergence of the style.

NONOBJECTIVE ART. ABSTRACT ART in which no trace of recognizable subject matter is manifest. KANDINSKY was its first consistent exponent.

NORMAN STYLE. The loose designation for the architectural style, derived largely but not wholly from the architecture of Normandy, prevalent in England from the time of the construction of WESTMINSTER ABBEY until the rise of the GOTHIC.

NORWICH SCHOOL. English regional school of landscape painting of historical importance chiefly because its members included CROME and COTMAN. It was based on no clear underlying principle.

NOUVEAU REALISME. The French equivalent of POP ART.

OP (Optical) ART. The style (or, more accurately, variety of more or less sympathetic styles) that disposes or juxtaposes lines, patterns, forms or colors in such a way as to create a sensation of movement, pulsation, breakdown of form or changes of color in the eye of the viewer. Based on principles incidental to painting for centuries, its immediate forerunners were ALBERS, VASARELY and CUNNINGHAM, among others, and its better-known practitioners include ANUSZKIEWICZ, RILEY and AGAM.

ORDERS OF ARCHITECTURE. The various types of CLASSICAL columns and entablatures considered as the units or modules of their particular styles. The Greeks evolved three orders—the Doric, Ionic and Corinthian—and the Romans added the Tuscan and Composite.

ORGANIC ARCHITECTURE. A theory of architecture named, expounded and embodied in the work of FRANK LLOYD WRIGHT which holds that the form and materials of a structure should conform as closely as possible to the nature of its surroundings, seeming to grow out of them.

ORPHISM; ORPHIC CUBISM. An ABSTRACT movement derived from CUBISM that arose ca. 1912, was led by DELAUNAY and briefly numbered several leading Cubists among its adherents. It was named by Appolinaire and was based on the notion that "pure" art is composed of invented elements altogether independent of observed reality.

OTTONIAN ART. The art and architecture produced in Germany ca. 950–1060, beginning with the reign of Otto I. It combined the CAROLINGIAN and BYZANTINE styles.

PALLADIANISM; PALLADIAN STYLE. The terms for an English architectural style of the early 18th century that arose in reaction against the BAROQUE and was influenced by PALLADIO and his follower, INIGO JONES.

PARIS, SCHOOL OF. The historic designation for the manuscript illuminators who worked in Paris under St. Louis in the 13th century, the term is much more commonly applied, collectively, to the representatives of the main currents in French painting since IMPRESSIONISM.

PERPENDICULAR STYLE. The term given to the final phase of Medieval architecture in England, which was characterized by the extensive use of tracery and, later, fan-vaulting and by its application chiefly to modestly scaled structures.

PHOTOREALISM. A largely American style derived from POP ART in the late 1960s and early 1970s. Its characteristics are high finish, sedulous attention to detail and utter banality.

PITTURA METAFISICA. The Italian for METAPHYSICAL PAINTING.

PLATERESQUE. A Spanish architectural style bridging the late GOTHIC and Renaissance and characterized by vast expanses of relief ornamentation influenced by the MUDÉJAR style.

PLEIN AIR PAINTING. Painting executed in the open, from nature, and not in the studio from drawings or sketches. Less commonly, any painting convincingly suggestive of the open air.

POINTILLISM. The technique developed by SEURAT and employed by other adherents of NEOIMPRESSIONISM, it is simply a more refined degree of DIVISIONISM and consists of applying pure color directly to the canvas in uniform minuscule dots that are indistinguishable at normal viewing distances.

POP ART. A movement that evolved independently in England (where it was given its name by the critic Lawrence Alloway) and the U.S. and that derives its imagery and style, and in some cases techniques, from commercial art, the communications media and mass-produced products and objects, characteristically presenting its subjects dispassionately and often enlarged to heroic proportions. Although the English version originated slightly earlier, it failed to produce the impact that was felt in America, where the style derived from JOHNS and RAUSCHENBERG and where its chief exponents are OLDENBURG, LICHTENSTEIN, WARHOL, ROSENQUIST, INDIANA and WESSELMANN. One of the most hotly debated of American painting styles, it has been called incisively satirical, passively imitative and everything between those extremes. Although widely dismissed as an ephemeral phenomenon at its inception, it has proved to be quite durable.

POST-IMPRESSIONISM. A very inexact term for the French painting that came after IMPRESSIONISM but did not include NEOIMPRESSIONISM. CÉZANNE, VAN GOGH, GAUGUIN, TOULOUSE-LAUTREC and others who had little in common but their occupation of record are often lumped together in this catch-all category.

PRE-COLUMBIAN ART. The art and architecture of the Americas, from Mexico southward, created before their conquest by Spain; most notably the Indians of Mexico, Central America and western South America.

PRE-RAPHAELITE BROTHERHOOD (PRB). A Victorian English school of art that attempted to recapture the purity its adherents thought they detected in the Italian art that immediately preceded the advent of RAPHAEL. Its founders included ROSSETTI, WILLIAM HOLMAN HUNT and MILLAIS, who were later joined by FORD MADOX BROWN, BURNE-JONES, RUSKIN and others. Their pictures were literary, sententious, romantic, sentimental and often characterized by a thinly veiled eroticism. By and large they were also poorly painted.

PRIMITIVE. The common (and all-but-meaningless) designation for naïve or incompletely self-taught artists and for Netherlandish and Italian painters active before ca. 1500.

PRIMITIVE ART. The chauvinistic term commonly applied by Westerners to the arts of various tribal cultures, much of which is highly sophisticated and distinguished by great sensitivity.

PROCESS ART. A style of the late 1960s and 1970s in which the subject of a work of art is the change (decay, growth, etc.) the work undergoes during the course of its existence.

PUBLIC WORKS OF ART PROJECT (WPA Project). A project organized by the U.S. Government in 1933 for the purpose of providing relief for artists during the Great Depression by hiring them to decorate public buildings and later transferred to the administration of the Works Progress Administration. It supported thousands of artists who produced some 16,000 works and some of whom achieved great importance after World War II.

PURISM. A short-lived movement founded by OZENFANT and LE CORBUSIER for the purpose of rectifying the "destruction of the object" allegedly brought about by CUBISM.

QUEEN ANNE STYLE. The style of English furniture and silver produced in the reign of Queen Anne and characterized by solid but gracefully curved forms.

RAYONISM (Rayonnism; Rayonnisme). A Russian abstract movement, begun in 1911 by LARIONOV and GONCHAROVA, which had something incomprehensible to do with a fourth dimension that could be visited by painting raylike lines that appeared to radiate into space. It was short-lived but embodied concepts that proved to be more durable.

RAYONNANT STYLE. The phase of GOTHIC architecture that occupied the late 13th and the 14th centuries and was characterized by the vast, elaborately mullioned rose windows of the churches of the period and an extensive use of tracery.

REALISM; REALIST ART. A term with a history of indiscriminate use and with little or no meaning. Almost all art is realistic in the sense that it strives to create its own reality, and perhaps the only art that is not is purely decorative art or pure ILLUSIONISM.

RÉGENCE STYLE. A decorative style that flourished in France from around 1705 until 1730, was produced by a reaction against the glittering pomposity of VERSAILLES and characterized by intimacy, lightness and elegance.

REGENCY STYLE. The style of furniture and decoration prevalent in England during the period 1811–1830 and characterized by its refined use of classical forms.

REICHENAU SCHOOL. A German school of manuscript illumination active ca. 965–1025 at the Abbey of Reichenau and renowned for the richness of its gold initials, which often occupied full pages.

REIMS SCHOOL. A French school of manuscript illumination active in the CAROLINGIAN era and notable for its expressive use of line.

RELIEF. In sculpture, a work executed not in the round but as though partially emerging from a flat background. Relief sculpture is used primarily as a decorative adjunct to architecture, furniture, coins, medals and gems. Also see PRINTMAKING.

RENAISSANCE. The revival in the arts and letters that began in Italy in the 14th century and spread throughout Europe before it was gradually superseded by what is now called the modern period. It was characterized by a passionate devotion to humanism and an intense desire to emulate the ideals of classical antiquity. In the visual arts, the Renaissance by common consent begins with GIOTTO and ends with the late works of MICHELANGELO which heralded the rise of MANNERISM. The Renaissance usually is divided into two parts by historians: the Early Renaissance, which ended ca. 1500 and was characterized by the humanism of Giotto and his successors, and the High Renaissance, which combined that humanism with CLASSICAL ideals and unexcelled virtuosity and ended with the sack of Rome—a period of little more than a quarter century but one that produced the early works of Michelangelo, the most important works of RAPHAEL, the better part of LEONARDO's oeuvre and scores of other artists of nearly equal importance.

Leonardo da Vinci, *Mona Lisa*, detail, Louvre, Paris.

ROCOCO. The prevailing style of art and ornamentation in France during the reign of Louis XV, it reached its apogee there around 1730 and elsewhere in Europe (in the confectionary church architecture of Germany and Austria and in Italy and Spain in the person of TIEPOLO) somewhat later. The style was characterized by a gaiety and sprightliness that seemed even more so after the GRAND MANNER of the BAROQUE, by a predilection for high color, pretty conceits and playful amorousness and by an extensive use of scrollwork, rose-tinted clouds, intricate curves and assymmetry. The masters of the style were WATTEAU and BOUCHER, but FRAGONARD might be described as its somewhat belated embodiment.

ROMANESQUE. The international Medieval architectural style that preceded the GOTHIC, it emerged ca. mid-11th century and began to be superseded toward the end of the 12th century. Essentially, the Romanesque was eclectic in origin, with elements derived from Roman, Byzantine, CAROLINGIAN and barbarian models and motifs but integrated into a powerful new style with a distinct identity. The style was characterized by an order and simplicity that reflected the monastic way of life, by massive forms, a masterful organization of space and an extensive use of radiating chapels, tunnel vaults and intersecting groin vaults. Because of the weight of the vaulting, outer walls were thick, heavy and sparingly pierced by small windows. Romanesque cloisters and ambulatories, such as those at ST. TROPHIME, Arles, were particularly beautiful, and sculptural decoration ranged from the stately to the capricious.

ROMANISTS. Northern European artists, principally Dutch, who after visiting Rome strove to rival the great Renaissance masters who worked there.

ROMAN SCHOOL. Broadly speaking, the artists and architects gathered in Rome during the pontificate of Julius II and their successors. Actually, to characterize as a "school" the various phases of artistic production in Rome, which embraced a succession of stylistic epochs created by artists from all over Italy, is to make the term so inclusive as to be meaningless. By general consent, however, a Roman School functioned until well into the 19th century.

ROMANTIC ART. The antithesis of CLASSICAL ART and the result of a reaction against it, Romantic art is characterized by a passionate involvement with subject matter and, in many cases, a marked tendency toward exoticism. As a movement it reached its zenith in France toward the end of the first third of the 19th century. The polarities of Romantic and Classical art are personified, by common consent, by DELACROIX and INGRES, respectively.

RUBENISM; RUBENISME. The pictorial application of freely applied, highly colored paint, as exemplified by RUBENS and in contradistinction to the primacy of draftsmanship over painterly values, as exemplified by POUSSIN. The Rubenists were considered radical modernists in France in the late 17th and early 18th centuries, when WATTEAU was the leading exponent of the movement.

SECOND EMPIRE STYLE. An architectural style prevalent in the U. S. after the Civil War, based on the style of the French Second Empire and characterized by its use of multiple MANSARD roofs. Its leading exponent was RENWICK.

SECTION D'OR. The French for "Golden Section," a system of ideal pictorial proportion in use since the time of Euclid, the term was used by several adherents of ORPHISM, both as a label for their movement and the title of an exhibition of their works held in Paris in 1912.

SEZESSION; SECESSION. The name taken by several groups of late-19th- and early-20th-century avant-garde German artists who, unable to exhibit under conservative auspices, "seceded" to found their own exhibiting bodies.

SFUMATO. Term (from Italian *fumo* = smoke) for the technique in painting, generally attributed to LEONARDO, whereby a tran-

sition from one form or color to another is accomplished softly, with no discernible line of demarcation.

SIENESE SCHOOL. The Italian artists active in and around Siena in the 14th century, notably DUCCIO and SIMONE MARTINI, who combined elements of the GOTHIC style and Byzantine art to create a type of painting characterized by pervasive charm.

SOCIAL REALISM. An American representational art movement of the 1930s in which paintings and prints were used as vehicles of social protest (e.g., SHAHN's *The Passion of Sacco and Vanzetti*).

SOCIALIST REALISM. The "official" style of the U.S.S.R., it is representational, propagandistic, hortative and, with few exceptions, execrable.

STIJL, DE. The name of a group of artists associated with NEOPLASTICISM and, later, DADA and of the Dutch magazine (1917–1928) that propounded their theories.

SUPREMATISM. A Russian ABSTRACT movement begun by MALEVICH in 1913, on the theory that paintings should be composed exclusively of simple geometric forms. His *White on White* (New York: Museum of Modern Art) is a quintessential example of the principle.

SURREALISM. A literary and artistic movement, derived in part from DADA and to a lesser extent from CUBISM, that arose ca. 1922, largely under the leadership of the French poet and critic André Breton, who explained that its purpose was to create a "superreality" by resolving "the previously contradictory conditions of dream and reality into an absolute reality." Essentially Freudian, Surrealism sought to allow full play to unconsciously or subconsciously formed associations and what Breton called "purely psychic automatism." In practice, Surrealism developed along two stylistically disparate lines. One, closely akin to Dada, was fanciful, capricious and hospitable to abstract and ready-made forms. The other, stylistically traditional, sought to reproduce dreams, hallucinations and similar phenomena with the utmost clarity and verisimilitude, depicting incongruously combined objects or situations in a meticulously detailed manner. Adherents of the former included ARP, KLEE, GIACOMETTI, PICABIA and ERNST. The principal exponents of the latter style were TANGUY, DALI and MAGRITTE, while CHIRICO fell somewhere between the two manners and MAN RAY worked in both.

SYMBOLISM. An imprecise term used by a group of loosely associated French artists of the last decades of the 19th century and for a general aesthetic then current. A precursor of EXPRESSIONISM, Symbolism sought not so much to represent external reality as to convey moods, emotions and intellectual attitudes through the use of color, form and line as expressive means in themselves. To some extent, Symbolism was independently explored by VAN GOGH, SEURAT, ENSOR, MUNCH and others, but as a conscious movement it was developed by GAUGUIN and his followers.

SYNCHROMISM. An abstract movement founded in 1913 by the American painters MACDONALD-WRIGHT and MORGAN RUSSELL, influenced by ORPHISM and NEOIMPRESSIONISM and based on the use of pure color.

SYNTHETIC CUBISM. The branch of CUBISM, initiated chiefly by GRIS, in which an attempt is made to recreate the object through emblematic forms, rather than through simultaneously presented differing aspects.

SYNTHETISM; CLOISONNISME. Terms synonymous with SYMBOLISM. The term "Cloisonnisme" derives from the resemblance between the brightly colored, heavily outlined paintings of the Symbolists and the enamel work called cloisonné.

TACHISM. A painting style whereby dabs, blots or splotches of pigment comprise the chief elements of a work. It was developed in Europe (chiefly in France) in the 1950s and is tenuously connected with ABSTRACT EXPRESSIONISM.

TEN, THE. A group of American artists, exponents to greater and lesser degrees of IMPRESSIONISM, who exhibited together in 1895. Members included HASSAM, DEWING, TWACHTMAN and WEIR.

TENEBRISM; TENEBRISTI. The style (and painters, respectively) developed by Neopolitan and Spanish followers of CARAVAGGIO, it was characterized by the dramatic use of chiaroscuro and a low-keyed palette.

TOSA SCHOOL. A school of YAMATO-E painting that flourished in Kyoto from the 15th until the late 17th century.

TRANSITIONAL STYLE. Term given to the style of English architecture of the period ca. 1145–1190 that embodied vestigial features of the NORMAN STYLE and rudimentary GOTHIC elements.

TROMPE L'OEIL. The French term for ILLUSIONISM.

TUSCAN SCHOOL. A collective and largely useless name for the individual schools of Pisa, Lucca, Arezzo, the FLORENTINE SCHOOL and the SIENESE SCHOOL.

UKIYO-E. Japanese genre pictures, or pictures of the "floating world." The Ukiyo-e movement flourished in the Edo period (1615–1867), when it catered to the tastes of the rising middle class of Tokyo by producing countless woodblock prints of the popular actors and courtesans of the time. MORONOBU is generally credited with having provided the movement's major impetus, although a master of the TOSA SCHOOL, Iwasa Matabei (1578–1650), is supposed to have originated it. Before ca. 1740 Ukiyo-e prints were hand-colored, but from that time onward the color print, involving multiple blocks, evolved rapidly. Although the term "Ukiyo-e" applies to any pictorial medium, its great popular appeal lay in the block print, whose infinitely —and cheaply—reproducable nature made it accessible to the common man. The form was despised by Japanese connoisseurs but since has come to be recognized as a legitimate means of expression, especially since

its "discovery" by the adherents of IMPRESSIONISM. Its leading exponents included HOKUSAI, HIROSHIGE, UTAMARO and SHARAKU.

UMBRIAN SCHOOL. A central Italian school of painting that came to prominence in the 14th century and reached its zenith in the art of PERUGINO.

UTRECHT SCHOOL. An early-17th-century Dutch school of painting whose adherents, notably BABUREN, TERBRUGGHEN and HONTHORST, all of whom had been in Rome at the height of CARAVAGGIO's influence, strove to emulate the style of that BAROQUE master. As a conduit through which Italian ideas spread to the north, the school's influence was incalculable.

VENETIAN SCHOOL. One of the greatest manifestations of Renaissance painting, it was characterized by the splendor and radiance of its color, qualities derived directly from BYZANTINE ART. Begun in the 14th century by such masters as PAOLO VENEZIANO and Lorenzo Veneziano (fl. 1356–1379), it included many of the greatest names in the history of Italian art, including FABRIANO, PISANELLO, the BELLINIS, TITIAN, GIORGIONE, TINTORETTO, PAOLO VERONESE, CANALETTO and GUARDI.

VORTICISM. An English offshoot of CUBISM and FUTURISM invented by WYNDHAM LEWIS, it was characterized by simplified, angular and arched forms disposed in centripetal patterns.

WASHINGTON COLOR PAINTING. See COLOR PAINTING.

YAMATO-E. A type of Japanese painting that stressed native traditions (as opposed to Chinese derivations), basing the emphasis on subject matter, not style.

Kitagawa Utamaro, *Young Woman*, Guimet Museum, Paris.

GLOSSARY OF ART TERMS

ACRYLIC PAINT. A water-soluble synthetic plastic paint, much used since the early 1960s, it combines the properties of watercolor and oil paint and can be used in the manner of either medium.

AERIAL PERSPECTIVE. See PERSPECTIVE.

AIR BRUSH. A mechanically powered device for spraying paint or varnish, it has long been a tool of commercial art but has been used with increasing frequency by fine artists in recent years.

ALLA PRIMA. An oil-painting technique in which the entire picture surface is covered in one session with pigments opaque enough to cover completely any underpainting or sinopia.

ANAMORPHOSIS. A distorted representation recognizable only when viewed through a special lens or from a point almost alongside the picture instead of frontally. The best-known example is a skull in the foreground of *The Ambassadors* (London: National Gallery) by Hans Holbein the Younger.

APPLIED ART. A term coined since the Industrial Revolution to distinguish design applied to useful artifacts from fine art produced solely for aesthetic or didactic purposes.

AQUATINT. A type of etching made by dusting a metal plate with finely powdered resin, which is then melted to a state of semi-fusion that produces a tone resembling a watercolor wash in the final print.

ARABESQUE. A flowing linear decoration derived from or resembling an organic motif.

ASSEMBLAGE. A work of art, or the method of its production, made up of various materials, usually, but not always, combining created and ready-made elements and usually to some extent three-dimensional.

ATTRIBUTION. The ascription to a particular artist of a work of uncertain authorship.

BAS-RELIEF. Relief sculpture employing shallow convexities (as opposed to high relief).

BATTLE PIECE; BATTLE PICTURE. A pictorial representation of a battle.

BISTRE. A transparent brown pigment often used in wash drawings.

BOZZETTO. A small model for a sculpture; a maquette.

BURIN (Graver). The engraver's tool. It comprises a short steel rod, usually diamond-shaped in section and obliquely pointed at the cutting end, with a rounded handle. It is pushed with the palm of the hand while the plate to be engraved is turned and cuts a furrow in much the same manner as a plow.

CABINET PICTURE. A small picture designed for intimate display.

CALLIGRAPHIC. Term denoting pictorial styles or techniques that resemble calligraphy. Much Chinese and Japanese brush painting is calligraphic, as is the work of Tobey in the West.

CAMERA OBSCURA; LUCIDA. Devices for projecting images of objects onto plane surfaces to facilitate their representation by an artist. The former is based on the principle of the photographic camera, allowing light from objects to pass through an aperture into a darkened chamber to form an image on the rear surface. The latter employs mirrors and/or prisms to much the same effect.

CARTOON. A full-scale drawing designed to be transferred to the base surface of a painting, mosaic, tapestry, stained-glass window, etc.; in more recent usage, a humorous drawing or comic strip.

CASTING. A sculptural technique for duplicating a model, usually of wax, clay or plaster, in some more permanent form, such as bronze. In metal sculpture casting can be either solid or hollow, but the former method is practical only for small works. The most common form of hollow casting is the Lost Wax, or Cire-Perdue, process, in which a relatively thin wax layer, indirectly cast from a clay model, is mounted on a solid core and then embedded in a heatproof mold. The wax is then melted and poured out of the surrounding mold, and the space it occupied is filled with molten metal. When the metal has solidified, both mold and core are removed, leaving the hollow metal shell that constitutes the final sculpture after superficial adjustments and finishing have been accomplished.

CELADON. Semi-translucently glazed Chinese or Korean pottery.

CHARCOAL DRAWING. A drawing made by using a charred twig as though it were a crayon.

CHIAROSCURO. The pictorial distribution of light and shade.

CHINOISERIE. European *objets d'art* patterned on Chinese styles; or, more accurately, mistaken ideas of Chinese styles.

COLLAGE. A pictorial form in which two-dimensional elements—clippings, cut or torn paper, veneers and the like—are pasted to a surface, often in combination with painted passages. The technique was used by Picasso and Braque shortly after their invention of cubism and has since been used by painters as disparate as Max Ernst, Schwitters, Motherwell and Bearden.

CONTÉ. A hard red, brown or black chalk.

CONTRAPPOSTO. A pose in which the human torso is turned one way and the hips and legs another, it was most originally and successfully exploited by Michelangelo.

CONVERSATION PIECE. A genre form once popular in England in which specific people are depicted informally, in domestic surroundings. Its best-known exponent was Hogarth.

CRAQUELURE. The network of fine cracks that appears as the surface of an oil painting becomes brittle with age.

DANCE OF DEATH; TOTENTANZ; DANSE MACABRE. English, German and French designations, respectively, for a type of picture in extensive use in the Middle Ages. Traditionally, it depicted members of the various social classes and stations being conducted to their deaths by skeletal figures.

DANSE MAÇABRE. See DANCE OF DEATH.

DIPTYCH. A hinged pair of painted or otherwise decorated panels.

DRYPOINT. An intaglio print (or the method of its production) made by cutting lines directly into soft metal, thereby creating on each side of the furrow a burr, or ridge, which gives the finished print its characteristically fuzzy appearance.

EGG TEMPERA. See TEMPERA.

ENCAUSTIC PAINTING. A method of painting employing pigments mixed with hot wax, it was prevalent in the ancient world but is little used today.

ENGRAVING. Any of various intaglio printmaking processes, which is to say processes in which lines are incised or otherwise caused to penetrate a plane surface and filled with ink before the paper to receive the printed image is pressed into them.

ETCHING. A type of engraving in which the plate to be engraved is covered with a waxy acid-repellent substance called a ground. A design is then scratched into the ground with a needle, leaving corresponding areas of the plate exposed. When the plate is dipped in an acid bath these areas are "bitten" into by the acid, creating furrows into which first ink and then dampened paper is pressed, producing a reverse image on the paper.

FIXATIVE. A transparent, diluted shellac, acrylic or similar substance sprayed on a charcoal, pencil, chalk or pastel drawing to keep it from smudging or otherwise deteriorating.

FORESHORTENING. The representation of single figures and objects in a perspective that causes them to diminish in size as they recede into pictorial space.

FOUND OBJECT; OBJET TROUVÉ. The English and French terms, respectively, for a serendipitous element incorporated into, or made in itself to constitute, a work of art. In combining a bicycle handle and saddle to represent a bull's head, Picasso made use of found objects, as Duchamp did with his ready-mades.

FRESCO. A method of wall painting in which water-soluble pigments are applied to a freshly laid plaster ground while it is still wet. It is the most difficult of all painting techniques and, properly executed, the most durable.

FROTTAGE. A pictorial technique, developed largely by MAX ERNST, in which paper is placed on a roughly textured surface and rubbed until it takes on a similar texture, which is used as the starting point for the artist's final image.

GENRE. A type of pictorial art in which scenes from ordinary life are depicted—a subject particularly favored by Dutch painters of the 17th century.

GLAZE. The vitreous substance, either colored and translucent or clear and transparent, applied decoratively or protectively to earthenware pottery or ceramics. By common consent, Chinese potters produced the finest glazes known. Also see GLAZING.

GLAZING. A term in oil painting for the modification of opaque undercolors by the overlay of thin transparent layers of lightly tinted paint. It is a device for imparting depth, luminosity and iridescency to pictures and was much used by RUBENS.

GOLDEN SECTION; GOLDEN MEAN. Terms for a theory of ideal compositional proportion known since classical antiquity and definable as a line so divided that the smaller part is to the larger as the larger is to the whole.

GOUACHE. A watercolor painting medium in which opacity is achieved by binding pigments with glue and mixing white with them. It is frequently used in combination with transparent color, but the term "watercolor" is commonly reserved for works in which no gouache additions appear.

GRAFFITO; SGRAFFITO. The technique of producing a drawing or design by scratching through a layer of one color to expose another color beneath it.

GRAPHIC ART; GRAPHICS. A misapplied term commonly used to denote printmaking or, more rarely, printmaking and drawing both.

GRISAILLE. Monochrome painting in tones of gray. It was commonly used during the Renaissance in illusionistic imitation of sculpture.

GROUND. Commonly, the surface on which any picture is painted; more explicitly, a treated or primed surface.

HALFTONES. The intermediate tones, in a painting or drawing, between the darkest and lightest.

HANDLING; FACTURE; FATTURA. The English, French and Italian terms, respectively, for the "touch," or most intensely personal and individual component of the creative process. A painter, for example, may share a style with others but his handling will be his own.

HATCHING. Halftones produced by a series of parallel lines. Cross-hatching is effected by superimposing a second series on the first at an angle that renders both individually distinguishable.

HISTORY PAINTING. Generally, the depiction of historical events; more specifically, their depiction in the GRAND MANNER.

ICON; IKON. The image of a Christian saint or other holy personage depicted in accordance with the artistic tradition of a particular branch of Christianity, such as the Russian or Greek Orthodox.

ICONOGRAPHY. The subject matter and readily communicable symbolism of a work of art (e.g., a lily as used in a depiction of the Annunciation, as opposed to a color or juxtaposition of colors as used in SYMBOLISM).

ICONOLOGY. The study and exegesis of ICONOGRAPHY.

ILLUMINATION; ILLUMINATED MANUSCRIPT. The process and result of decorating manuscripts with fanciful initials and border designs and/or miniature paintings. Illumination was one of the great arts of the Middle Ages.

IMPASTO. The application of oil paint in thick, even three-dimensional, strokes or masses, often by means of a spatula, as exemplified in the early work of CÉZANNE and the late work of VAN GOGH.

INTAGLIO. The printmaking process wherein areas to receive ink or pigment lie beneath the surface of the printing plate (e.g., etching, engraving); also, gems decorated concavely, as opposed to cameo, in which designs are rendered in relief.

LINEAR. Characterized by a predominance of line; a term sometimes used in opposition to "painterly."

LINOLEUM CUT; LINOCUT. A print made with a plate of linoleum onto which either an intaglio or relief design has been cut. In the relief process, the printed image will be the inked portion of the plate and in intaglio the uninked portion.

LITHOGRAPHY. A printmaking method, generally attributed to SENEFELDER, based on the mutual antipathy of oil and water. Lithography is neither an intaglio nor relief process but planographic, or surface, printing in which a design is drawn on the polished face of a stone slab with a greasy ink or crayon and then chemically fixed. The entire surface is then washed with water, which is absorbed by the undecorated portions of the stone but repelled by the grease drawing. The application of a greasy ink then reverses the process, and when the stone is passed through a printing press an exact reverse image is received on paper. The great advantages of lithography are its directness and elimination of painstaking craftwork, its exactitude of reproduction and its capacity to withstand deterioration regardless of the number of impressions taken from the original design.

LITTLE MASTER. A term originally used to designate a printmaker who worked on plates of small dimension, it has since come to mean a painter of considerable but less than surpassing accomplishment.

LUSTER POTTERY; LUSTER WARE. Pottery decorated by applying metallic oxides to a pre-glazed surface and refiring it at relatively low temperatures, thereby producing a lustrous, iridescent surface.

MANNER. A term vaguely descriptive of style and handling and often used somewhat pejoratively.

MAQUETTE. A small model for a projected work of sculpture; a bozzetto.

MASSES. In artistic parlance, the largest, most broadly considered forms, shapes or patterns in a particular work; the first elements apprehended by the viewer.

MASTER. Originally, an artist who, having been an apprentice and journeyman, was certified as qualified to maintain his own workshop; by extension, a teacher. More recently, any artist of considerable attainment. The term also is coupled with some descriptive word, phrase or place name by art historians to designate anonymous creators of certain works or bodies of work (e.g., MASTER OF FLEMALLE, MASTER OF THE BARBARINI PANELS).

MASTERPIECE. Originally a diploma piece, a work with which a craftsman demonstrated his worthiness of being designated a guild master; more recently, an (or the) outstanding work in any artist's oeuvre.

MEDIUM. The binding liquid used in combination with pigments to make paints.

MEZZOTINT. An engraving process used for creating extensive halftones, or the finished product of that process. In mezzotint, a serrate tool called a rocker is methodically worked over the surface of a copper plate to produce an even texture over the entire surface. Parts of this roughened surface are then burnished or scraped to varying degrees of smoothness so that the roughest remaining portions of the plate will hold the most ink, thereby producing the darkest tones, and vice versa, with appropriate gradations in between. Mezzotint was used extensively before the invention of photoengraving as a means of reproducing paintings.

MINIATURE. A picture in an illuminated manuscript; a small painting, particularly a portrait, often in a round or oval format and designed to be worn as a pendant or carried on the person.

MOBILE. A sculptural form associated almost exclusively with CALDER (although its origins go back to Oriental antiquity) in which one or more delicately balanced elements of a work are moved through the air by random currents.

MODELLO. A preliminary sketch or painting designed to provide a patron with an idea of the ultimate appearance of a commissioned work.

MONOTYPE. A unique print, usually in color, produced by pressing paper against a still-wet painting.

MONTAGE. A form related to collage in which several photographs, illustrations and the like are arranged, in whole or in part, on a pictorial surface to produce a pictorial work. Montage differs from collage in that it makes no use of the printed word or painted passages.

MOSAIC. An art form in which small chips of colored glass, stone or ceramic are pressed into cement or a similar adhesive to form a cohesive picture or design.

MURAL; WALL PAINTING. Any kind of painted decoration or picture applied directly to a wall except fresco.

NARRATIVE PAINTING. The depiction of a single episode or moment with implications of action that has preceded or will follow that which is depicted. GREUZE's *Broken Eggs* (New York: Metropolitan Museum of Art) is such a work.

NIELLO. A kind of goldsmith's work in which a pattern incised into a plate of gold or silver is filled with a dark alloy, after which the whole is polished. Test prints (Niello Prints) were sometimes pulled from the plate before the addition of the alloy.

NOCTURNE. A pictorial night scene.

OBJET TROUVÉ. See FOUND OBJECT.

ODALISQUE. A female slave or concubine, especially in Turkey and the Near East. A staple motif of ROMANTIC ART, notably the art of DELACROIX, Odalisques also figured in works by RENOIR and MATISSE, among others.

OEUVRE. The total output of a particular artist; a life's work.

OIL PAINTING. The principal painting method in the West since the time of JAN VAN EYCK (who may or may not have invented it) and the product of that method. Oil paint is pigment combined with an oil (usually linseed oil) medium. It is the most versatile of all painting substances, hospitable to the widest range of styles, handling, manners and techniques and to easy, rapid correction or revision. Since its advent, only the recent development of faster-drying acrylics has threatened its supremacy, but the majority of contemporary painters still favor its use, pending evidence of the durability of acrylics.

PAINTERLY. Term assigned by art critics to works in which masses, handling color and texture take precedence over linear design.

PALETTE. A tray used by painters for mixing colors or disposing pure colors prior to their application to canvas; the range of colors used by a particular painter.

PANEL. A rigid painting surface, such as wood, metal or glass, as opposed to the more flexible canvas or linen, which did not appear until the 15th century.

PAPIER COLLÉ. See COLLAGE.

PASTEL; PASTEL PAINTING. A method of painting without the use of a medium, in which designs are executed directly on paper or canvas with chalklike sticks of dry pigment. An opaque substance, it does not admit of glazing or impasto, is extremely fragile and does not adhere well to the painting surface. It can produce a peculiar dry brilliancy, however, and has been used by many great artists, notably DEGAS, who is said to have invented a fixative that would insure permanency without the usual alteration of color.

PATINA. Normally, the mellowing effect produced in metal sculpture (and to a lesser extent in wood, ceramics and even oil paint) by age and chemical change. Patina often is deliberately induced.

PENTIMENTO. The equivalent of the palimpsest that often appears in old manuscripts, a pentimento is evidence in a painting of an earlier element of design that shows through the final surface.

PERSPECTIVE. The means whereby pictorially depicted objects appear to recede in space. In Western painting, perspective takes two basic forms, usually used in combination since the Renaissance: linear perspective, in which parallel lines converge at a vanishing point on the horizon (a principle most readily illustrated by a straight railroad track receding into the distance), and aerial, or atmospheric, perspective, in which forms and colors grow progressively hazier as they recede into the picture space. Although a general idea of linear perspective was current in the Middle Ages (when aerial perspective also was tentatively explored), it did not develop into a coherent system until the Early Renaissance.

PICTURE PLANE. The hypothetical plane separating the space of a picture from the space of the viewer, defined by the physical surface of the picture. According to modern aesthetic theory, no element of a picture should violate "the integrity of the picture plane" by seeming to project beyond it, as objects often do in ILLUSIONISM.

PIETÀ. A depiction of the dead Christ on the lap of the Virgin.

PLASTICITY. The appearance, in painting, of dimensionality.

POINTING MACHINE. A device for reproducing a work of sculpture or a clay model in stone, it is similar in principle to the pantograph used by mapmakers and seldom has been used since the 19th century.

POLYCHROME SCULPTURE. Sculpture painted in more or less lifelike colors. Contrary to popular belief, most sculpture of classical antiquity was polychromed.

PRIMING. A uniform undercoat applied to a sized canvas before the picture is begun.

PRINTMAKING. The art of producing multiple works on paper by a combination of direct manual and mechanical means. Traditionally, there were three basic types of print: intaglio, in which the design to be reproduced is deeper than the surface of the printing plate or block; relief, in which the image is raised above the rest of the plate or block; and planographic, in which the print is pulled from a flat surface. Etching, engraving and drypoint belong to the first category; the woodcut and some linoleum cuts to the second; and the lithograph to the third. To these methods a more recent development has been added: silkscreen printing or serigraphy, which is the product of a stencil process. In theory, the prime virtue of printmaking is that it permits the widest possible dissemination of works of art. In recent practice, however, editions of prints have been arbitrarily limited to enhance their market value.

PROOF. A print made before the run of an edition to apprise the artist of the state of a graphic work in progress. Once a plate has been subjected to final revisions, a certain number of proofs, customarily marked "artist's proof," are reserved for the artist's personal use.

PROVENANCE. The pedigree of a work of art; the history of its ownership since its creation. The usefulness of a particular work's provenance is that it insures authenticity if it can be traced in an unbroken line of owners to the artist. If those owners were prestigious collectors or institutions, the market value of the work usually is enhanced.

PUTTO. A male child—often a derivation of Cupid—used as a decorative motif in painting or sculpture.

READY-MADE. A found object presented in and of itself as a complete work of art. The pioneer and only significant exponent of the form was DUCHAMP, who declared such objects as urinals, bicycle wheels and bottle racks to be works of art if he so designated them.

RELIEF. In sculpture, a work executed not in the round but as though partially emerging from a flat background. Relief sculpture is used primarily as a decorative adjunct to architecture, furniture, coins, medals and gems. Also see PRINTMAKING.

SAND PAINTING. An artistic form, prevalent among, but not exclusive to, the Indians of the southwest United States, in which pictorial compositions are executed directly on the ground in sands of various colors.

SANGUINE. A reddish crayon.

SCHOOL. In the parlance of art historians, a group of stylistically similar artists, categorized commonly because of geographic proximity and a continuing aesthetic heritage (e.g., the VENETIAN SCHOOL, the UTRECHT SCHOOL).

SCHOOL OF. A designation (used by art historians and, with more cupidity, by art auctioneers) for works of unknown authorship in the manner of a known master.

SCUMBLE; SCUMBLING. Painting terms for a technique whereby an opaque layer of pigment is applied roughly and irregularly

over another layer, thereby allowing the color of the latter to modify that of the former. Compare GLAZING.

SERIGRAPHY; SILKSCREEN PRINTING. A printmaking method in which nonporous substances are painted onto a porous screen, thereby allowing inks or pigments to pass through the porous areas onto the printing paper. A stencil process.

SFUMATO. A technique perfected by LEONARDO whereby the painted contours of figures or objects seem to dissolve into their surroundings with no precise line of demarcation. The antithesis of HARD-EDGE PAINTING.

SGRAFFITO See GRAFFITO.

SILKSCREEN PRINTING. See SERIGRAPHY.

SILVERPOINT. A drawing implement constructed much like a pencil, except for the substitution of silver for graphite. Old silverpoint drawings are characterized by a mellow tarnish.

SINOPIA. A red ochre underdrawing used in fresco painting.

SOTTO IN SÙ. A type of ILLUSIONISM used in ceiling painting, principally in the 17th century.

STABILE. A term devised to differentiate the static works of CALDER from his mobiles.

STATE. The term for any distinct phase in the development of an etching or engraving from the pulling of the first proofs until the edition is exhausted.

STILL LIFE. A painting of inanimate objects, dead game, flowers or the like, usually arranged in a felicitous manner, on a table or other piece of furniture, in an interior setting. In the past, still lifes often were allegorical in character, symbolizing the brevity of life, the Passion of Christ and like subjects.

STIPPLE. A pictorial technique in which modeling is accomplished by the application of myriad dots or flecks in varying degrees of density.

STUDY. An exploratory sketch.

STYLIZATION. The representation of objects according to conventional decorative schema rather than close observation of their appearance.

TEMPERA. The prevailing panel painting medium prior to the advent of oil painting, tempera is pigment bound with egg and used with water as its medium. Difficult to use because of its quick-drying properties and the fact that it dries several shades lighter than it looks when wet, it was largely abandoned after the invention of oil paints but is still used by a few painters.

TERRA COTTA. A sculptural clay, usually of a reddish earth color, that hardens when baked and can be glazed.

TERRIBILITA. A word descriptive of the awesome properties to be found in the works of MICHELANGELO.

TONDO. A circular painting format.

TOTENTANZ. See DANCE OF DEATH.

TRIPTYCH. A painting or group of related paintings disposed over the surfaces of three connected panels.

VANISHING POINT. The imaginary point where receding parallels converge. See PERSPECTIVE.

VANITAS. A pictorial reminder of the vanity of human existence.

VEDUTA; VIEW PAINTING. A painting of a specific place, usually in or near a city, town or the ruins thereof, as opposed to landscape painting or pastoral scenes.

VIEW PAINTING. See VEDUTA.

WALL PAINTING. See MURAL.

WATERCOLOR. The method or end product of painting on paper with transparent water-soluble pigments.

WOODCUT. A relief print made from a wooden block and usually characterized by strong, bold contrasts of black and white.

WORKSHOP. The studio of a guild master and its staff of apprentices and journeymen.